WITHDRAWN

D1223957

WHO
WE
ARE
...

President and Publisher
Ira Shapiro

Senior Vice President
Wendl Kornfeld

Vice President Marketing
Ann Middlebrook

Director of Illustration
Rob Drasin

Director of Production
Zulema Rodriguez

Marketing

Marketing Communications
Manager
Carrie Bloom

Marketing Coordinator
Lisa Wilker

New Projects Coordinator
Christina Tamagni

Labels to Go Coordinator
Michael McGruder

Book Sales Administrator
William Wright

Advertising Sales

Sales Coordinator
Verlyn Gilbert

Sales Representatives
John Bergstrom
Pam Glaser
Jo Ann Miller
Joe Safferson

Administration

Controller
Brenda Massy

Office Manager
Elaine Morrell

Accounts Manager
Connie MacLeod

Accounting Assistants
Mila Livshatz
Michelle Roberts

Administrative Assistant
Paula Cohen-Martin

Published by:

American Showcase, Inc.
915 Broadway, 14th Floor
New York, New York 10010
(212) 673-6600
(800) 894-7469
FAX: (212) 673-9795

American Illustration
Showcase 19 Book 1 of 2
ISBN 1-887165-02-9
ISSN 0278-8128

Cover Credits:

Front Cover Illustration
Rich Borge

Lead Page Illustration
Brad Weinman

Production

Production Manager
Chuck Rosenow

Production Coordinators
Mary Prevosti
William Price

Production Assistants
Martha Jercinovich
Suzanne Welker

Creative

Creative Director
Monica Perez

Assistant Art Director
Laura Herzberg

Data Systems Coordinator/
Studio Assistant
Hardy Hyppolite

Digital Communications/
Distribution

Digital Communications Manager
Adolfo Vargas

Database/Distribution Coordinator
Julia Curry

Database/Grey Pages Coordinator
Monica Bhagwan

Special Thanks to:

Craig Adams
Sabrina Brantley
Angela Ellington
Lucie Fernandes
Rachel Grumman
Cordis Heard
Wayne Hoffman
Helen Kalipetsis
Louis Marino
Katharine S. Moorehead
Emily Rubin
Margaret Sheehan
Julisa Soriano
Tricia Ann Solsaa
Tony Walters
Stephen Watson
Nakesha Williams

Typesetting
The Ace Group

Color Separation
**Daiichi Systems Graphics Co., Inc.
through PrintPro Ltd.**

Printing and Binding
Tien Wah Press

Grey Page Production
Goodman/Orlick Design

U.S. Book Trade Distribution:
Watson-Guptill Publications
1515 Broadway
New York, New York 10036
(212) 764-7300

For sales outside the U.S.:
Rotovision S.A.
9 Route Suisse
1295 Mies, Switzerland
Telephone: 022-755-3055
Telex: 419246 ROVI
FAX: 022-755-4072

AMERICAN SHOWCASE

illustration
Vol.19 Book 1

contents

REPRESENTATIVES....... 5

ILLUSTRATORS....... 927

DESIGN & LETTERING....... 1485

COMPS....... 1503

SHOWCASE ILLUSTRATION

INDEX

920 - 926 & 1507 - 1513....... Illustrators & Representatives

GREY PAGES

1515....... Representatives, Illustrators, Graphic Designers, Quick Find Index

vol. 19 book 1

representatives

American Artists
NYC 484-507
Ciccarelli, Gary 485
Depew Studios 488
Effler, Jim 490
Farley, Malcolm 504, 505
Farrell, Russell 489
Glazier, Garth 487
Hamilton, Pamela 494
Henry, Doug 492
Hill, Michael 484
Holm, John 501
LoFaro, Jerry 498, 499
McKelvey, Shawn 493
Miller, Dave 491
Randazzo, Tony 496, 497
Roda, Bot 486
Summers, Ethan 506, 507
Vass, Rod 502
Watts, Stan 500
Young, Eddie 503
Zito, Andy 495

➤ **Artco**
NYC 82-119
Acuna, Ed 82, 83
➤ Angelini, George 84, 85
➤ Ben-Ami, Doron 116, 117
Burgio, Trish 86, 87
➤ Di Fate, Vincent 88, 89
➤ Drucker, Mort 90, 91
➤ Edholm, Michael 92, 93
➤ Henderling, Lisa 94, 95
➤ Kirkland, James 96, 97
➤ Mead, Kimble Pendleton 118, 119
Porter, John 98, 99
➤ Sherman, Oren 100, 101
➤ Stephens, John 102, 103
➤ Struthers, Doug 104, 105
➤ Studio Macbeth 106, 107
➤ Taillefer, Heidi 108, 109
➤ Taugher, Larry 110, 111
➤ Vitsky, Sally 112, 113
➤ Wiley, Paul 114, 115

Arts Counsel
NYC 794-797
Anderson, Robert Clyde 795
Christie, Greg 796

Pardo, Jackie 794
Sturman, Sally Mara 797

Artworks
NYC 600-615
Bachem, Paul 604
Barnes, Kim 612
Benson, Linda 603
Brennan, Steve 610
Brown, Dan 613
Chabrian, Deborah 611
Chesterman, Adrian 607
Fiore, Peter 600, 601
Hooks, Mitchell 606
Jones, Bob 612
Laslo, Rudy 609
O'Leary, Daniel 605
Pyner, Marcia 609
Rotunda, Matthew 602
Siu, Peter 614, 615
Steadman, Broeck 608
Teare, Brad 605

Baker, Kolea
Seattle, WA 435-445
Abe, George 440, 441
Baker, Don 442, 443
Brice, Jeff 435
Chodos-Irvine, Margaret 438
De Musee, Christina 444, 445
Nelson, Hilber 439
Ragland, Greg 436
Smith, Jere 437

➤ **Bartels Associates, Ceci**
St. Louis, MO
571-585, Front Flap Book 1
Bruning, Bill 578
Carroll, Justin 571
Evans, Jonathan 581
Klanderman, Leland 573
Lempa, Mary Flock 585
Porfirio, Guy 576
Probert, Jean 577
Rodriguez, Francisco 572
➤ Schudlich, Steve 574
Thomas, Charles 575

Thompson, Stephen 579
Watford, Wayne 580
Wright, Ted 582-584

➤ **Berendsen & Associates, Inc.**
Cincinnati, OH 715-719
➤ Ellison, Jake 718
➤ Fox, Bill 719
➤ Nichols, Garry 718
➤ Reed, Dave 718
➤ Richardson, Gary 716
➤ Torline, Kevin 715
➤ Wheatley-Maxwell, Misty 717

Bernstein & Andriulli Inc.
NYC 12-47
Anatoly 31
Bailey, Pat 30
Brennan, Neil 18
Brown, Rick 47
Camp, Barbara 45
Castillo, Julie 44
Cornner, Haydn 25
Craig, Dan 29
Finger, Ronald 43
Fleming, Dean 46
Graves, Keith 32
Gray, Lynda 21
Grimwood, Brian 24
Gurney, John 41
Haynes, Bryan 13
Holmes, David 26
Kramer, Peter 19
Lasher, Mary Ann 15
Lawrence, John 28
McMacken, David 34
Micich, Paul 40
Moore, Chris 37
Mueller, Pete 42
Nelson, Craig 33
Nishinaka, Jeff 39
Paulsen, Larry 16
Phillips, Laura 38
Roberts, Peggi 35
Sancha, Jeremy 27
Sasaki, Goro 14
Sheehy, Michael 22
Spilsbury, Simon 20

Tibbles, Jean Paul 23
Wall, Pam 17
Watkinson, Brent 36

Bernstein, Joanie
Minneapolis, MN 812, 813
Molloy, Jack A. 813
Picasso, Dan 812

Braun Represents, Kathy
San Francisco, CA 782-786
Bull, Mike 782, 783
Matthews, Scott 786
McCollum, Sudi 784
Schmidt, Heidi 785

Bruck & Moss
NYC 824-833
Black, Dave 830
Curry, Tom 827
Gebert, Warren 828
Johnson, Joel Peter 824
Lada, Elizabeth 826
LeVan, Susan 831
Meredith, Bret 832
Niklewicz, Adam 825
Park, Chang 833
Rüegger, Rebecca 829

Chislovsky Design Inc., Carol
NYC 835-839
Adams, Gil 836
Blank, Jerry 838
Gall, Chris 837
Kimber, Murray 835
Shap, Sandra 836
Shigley, Neil 839

Collier, Jan
Mill Valley, CA 402-410
Baseman, Gary 402, 403, 406
Borge, Rich 410
Clarke, Greg 408
Ecklund, Rae 409
Masuda, Coco 407
Wilton, Nicholas 404, 405

➤ Artist portfolio featured on The Showcase CD number 2.

Collignon, Daniele
NYC 653-661
Bennett, Dianne 658
Chan, Harvey 654, 655
Cosgrove, Dan 653
Frampton, Bill 660
Tiani, Alex 659
Weller, Don 661
Yiannias, Vicki 657
Ziemienski, Dennis 656

Conrad Represents
San Francisco, CA 798-801
Cheung, Phil 799
Commander, Bob 798
Foster, Phil 801
Lopez, Rafael 800

Creative Freelancers
NYC 696-705
Bordei, Marcel 702
Carpenter, Carolyn 702
Celusniak, Chris 697
Chandler, Roger 704
Cooper, M.D., James 702
Delapine, Jim 704
Edens, John 703
Faust, Clifford 696
Geary, Rick 698
Jezierski, Chet 703
Larson, Keith 700
Lawson, Rob 703
Miller, A.J. 702
Newbold, Greg 701
Owens, Jim 698
Sipp, Geo 699
Sullivan, Steve 704
Tamura, David 700
Tarnowski, Glen 703
Trang, Winston 700
Vaccaro, Lou 698
Webb, Quentin 698
Yemi 705

Das Grüp
Redondo Beach, CA 841-845
Akopyan, Loudvik 844

Fujimori, Brian 842
Köerber, Nora 845
Weinman, Brad 841
Wepplo, Michael 843

de Moreta, Linda
Alameda, CA 847-849
Collier, Michele 849
Hays, Diane 848
McDonnell, Peter 847

➤ **Dedell Inc., Jacqueline**
NYC 120-151
➤ Bleck, Cathie 126, 127
Davis, Nancy 134, 135
➤ Fairman, Dolores 144, 145
➤ Frichtel, Linda 136, 137
Gaz, Stan 124, 125
➤ Griesbach Martucci 140, 141
➤ Leister, Bryan 128, 129
➤ Loftus, David 138, 139
➤ Munck, Paula 130, 131
➤ Nacht, Merle 142, 143
Parker, Edward 150, 151
➤ Sibthorp, Fletcher 146
➤ Soltis, Linda DeVito 147
➤ Tuschman, Richard 132, 133
Wiggins, Mick 122, 123
➤ Younger, Heidi 148, 149

Dodge, Sharon
Seattle, WA 850, 851
Nelson, Jerry 850
Szpura, Beata 851

Foster Artists Representative, Pat
NYC 810, 811
Blair, Dru 811
Henderson, Louis 810

Friend & Johnson
NYC 727-731
English, John 731
Lambase, Barbara 729
McDonald, Mercedes 727

Mosberg, Hilary 730
Smith, James Noel 728

Garden Studio
London, UK 814, 815
Atkinson, Mike 814
Austin, Graham 814
Bannister, Philip 814
Climpson, Sue 815
Diggory, Nick 814
Enthoven, Antonia 814
Frances, Siàn 814
Oliver, Mark 814
Riley, Andrew 814
Greenhead, Bill 814
Williams, Simon 814

Gatlin Represents, Rita
San Francisco, CA 673-677
Dudley, Don 674
Hennessy, Tom 677
Peterson, Ron 675
➤ Ross, Mary 673
Traynor, Elizabeth 676

Goldman Agency, David
NYC 852-868
Akgulian, Nishan 858, 859
Barnes, Michelle 866
Bendell, Norm 852, 853
Dininno, Steve 856, 857
Fortin, Pierre 864, 865
Fox, Rosemary 867
Nitta, Kazushige 860, 861
Rigie, Mitch 868
Taxali, Gary 862, 863
Yang, James 854, 855

Gordon Associates, Barbara
NYC 870-878
Dietz, Jim 874
Harrington, Glenn 873
Hunt, Robert 875
Jakesevic, Nenad 871
Kiwak, Barbara 877
Lamut, Sonja 871

Le Masurier, James 878
Lundgren, Tim 870
Paul, Keith J. 876
Shimamoto, Michiko 872

Graham Represents, Corey
San Francisco, CA 642-652
Ansley, Frank 648, 649
Boehm, Roger 650
Coon, Jim 646, 647
Magovern, Peg 652
Nakamura, Joel 644, 645
Sawyer, Scott 651
Tillinghast, David 642, 643

Grien, Anita
NYC 879
Johnson, Julie 879

HK Portfolio
NYC 772-777
Brooks, Nan 776
Carol, Estelle 777
Carter, Abby 775
Chau, Tungwai 772
Chewning, Randy 776
Clar, David Austin 775
Croll, Carolyn 772
Daily, Renée 774
Davis, Jack E. 775
Doty, Eldon 772
Ember, Kathi 773
Ghaboussi, Sina 773
Keeter, Susan 774
Kennedy, Anne 777
Lemant, Albert 773
Meisel, Paul 775
O'Shaughnessy, Stephanie 777
Palmer, Jan 774
Reed, Mike 773
Simard, Rémy 776
Smith, Theresa 772
Ulrich, George 777
Verougstraete, Randy 776
Wenzel, David 774

➤ Artist portfolio featured on The Showcase CD number 2.

Hillman, Betsy
San Francisco, CA 880, 881
Banyai, Istvan 880
South, Randy 881

Holmberg, Irmeli
NYC 616-627
Aizawa, Kaz 626
Barsky, Alexander 625
Bote, Tivadar 627
Cole, Lo 622
Kaloustian, Rosanne 624
Lund, Jonathan Charles 618
Magiera, Rob 616
Mysakov, Leonid 617
Nelson, John 620
Riding, Lynne 621
Sweet, Melissa 623
Zingone, Robin 619

➢ **Hull Associates, Scott**
Dayton, OH 411-434
Beck, David 417
Braught, Mark 418
Britt, Tracy 434
Buttram, Andy 426
➢ Ceballos, John 432
➢ Cho, Young Sook 416
➢ Dearth, Greg 430
➢ Gast, Josef 424
➢ Grandpré, Mary 414
➢ Hammond, Franklin 415
Harritos, Pete 427
James, Bob 423
➢ LaFever, Greg 419
➢ LaFleur, Dave 420, 421
➢ Maggard, John 431
➢ Martin, Larry 428
➢ Mueller, Kate 412
➢ Parker, Curtis 425
Patrick, John 413
Phillippidis, Evangelia 422
➢ Pitts, Ted 429
Riedy, Mark 433

Jaz & Jaz
Seattle, WA 586-599
Aldredge, Vaughn 594
Baldwin, Christopher 598
Chow, Jim 593
Drew, Kim 595
Eggleston-Wirtz, Kate 588
Fretz, John 592
Frisino, Jim 597
Konz, Stephen 587
Milam, Larry 589
Nordling, Todd 596
Paschkis, Julie 599
Rieser, Bonnie 590, 591
Saunders, Fred 586

Jett & Associates, Clare
Prospect, KY 546-563
Bell, Ron 555
Bolten, Jennifer 548, 549
Brawner, Dan 553
Cable, Annette 552
Eagle, Cameron 559
Hammer, Claudia 554
Jonason, Dave 557
Kimura, Hiro 556
Mattos, John 547
Noche, Mario 558
Siboldi, Carla 561
Torp, Cynthia 560
Wariner, David 563
Wiemann, Roy 550, 551
Wolf, Paul 562

Kimche, Tania
NYC 882-888
Blakey, Paul 887
Brandon, Bill 888
Caldwell, Kirk 885
Colvin, Rob 882
McMillan, Ken 884
Olbinski, Rafal 883
Zacharow, Christopher 886

Kirchoff/Wohlberg, Inc.
NYC 890, 891
Backer, Marni 890

Bootman, Colin 891
Han, Oki 891
Hoffman, Rosekrans 891
San Diego, Andy 890
Schwark, Mary Beth 890

Kirsch Represents
Rhinelander, WI 820
Kimble, David 820

Klein, Jane
Oakland, CA 892, 893
Cabossel, Jannine 893
Fujisaki, Tuko 892

Larkin, Mary
NYC 755-757
Fallin, Ken 756, 757
Long, Loren 755

Lavaty, Frank & Jeff
NYC 526-545
Adler, Steve 537
Anzalone, Lori 534, 535
Attebery, Craig 542
Baehr, Richard C. 541
Chen, David 536
D'Andrea, Domenick 544
Demers, Don 543
DiMare, Paul 532
Duke, Chris 530, 531
Gallardo, Gervasio 526
Hughes, Neal 527
Hunter, Stan 540
LoGrippo, Robert 538
Ochagavia, Carlos 533
Scanlan, Peter 539
Studio Liddell 545
Verkaaik, Ben 528, 529

➢ **Leff Associates, Inc., Jerry**
NYC 207-235
➢ Accornero, Franco 228, 229
➢ Adel, Daniel 217
➢ Aru, Agnes 226

Beecham, Greg 213
➢ Begin, Maryjane 230
➢ Callanan, Brian 222, 223
➢ Crawford, Denise 232
➢ Fleming, Joe 208, 209
➢ Geerinck, Manuel 218, 219
➢ Gehm, Charles 216
➢ Hilliard, Fred 225
Hoff, Terry 224
Kung, Lingta 231
➢ Livingston, Francis 210, 211
➢ Maddox, Kelly 233
Manning, Michele 234, 235
➢ Olson, Rik 212
➢ Rother, Sue 220, 221
Stentz, Nancy 227
➢ Thelen, Mary 214, 215

Lehmen Dabney Inc.
Seattle, WA 894, 895
Heavner, Obadinah 895
Lu, Kong 894

Leighton & Company
Beverly, MA 758, 764
Atkinson, Steve 763
Breakey, John 760
Frisari, Frank 759
Jarecka, Danuta 758
Nash, Scott 762
Stankiewicz, Steven 764
Thermes, Jennifer 761

Lilie, Jim
San Francisco, CA 748-754
Chan, Ron 748
Hannah, Halstead 754
Marshall, Craig 753
Schongut, Emanuel 750
Stermer, Dugald 749
Tucker, Ezra 752
Ziemienski, Dennis 751

➢ Artist portfolio featured on The Showcase CD number 2.

➤ **Lindgren & Smith**
NYC 48-81
Banthien, Barbara 78
Baradat, Sergio 50, 51
Bergman, Eliot 66, 67
Dearwater, Andy 54, 55
Dundee, Angela 80
Dunnick, Regan 77
Fiedler, Joseph Daniel 73
Fraser, Douglas 57
Heiner, Joe & Kathy 62, 63
Hyman, Miles 56
Jackson, Jeff 61
Leopold, Susan 71
Lohstoeter, Lori 49
Mantel, Richard 68
McIndoe, Vince 52, 53
Nascimbene, Yan 72
O'Leary, Chris 69
Paraskevas, Michael 60
Pyle, Chuck 76
➤ Salerno, Steven 81
Steele, Robert Gantt 79
Stewart, J.W. 58, 59
Thornburgh, Bethann 75
Vitale, Stefano 70
Wisenbaugh, Jean 74
Yaccarino, Dan 65
Zick, Brian 64

Lott Representatives
NYC 742-747
Beavers, Sean 745
Kurtzman, Ed 746
Lee, Eric J.W. 747
Nagata, Mark 744
O'Brien, Tim 742, 743

Lulu Creatives
Minneapolis, MN 896, 897
Hill, Tina 896
Novak, Tony 897

Lynch, Alan
Long Valley, NJ 898, 899
Gudynas, Peter 899
Woolley, Janet 898

Marie and Friends, Rita
Chicago, IL 688-695
Consani, Chris 689
Farrell, Rick 694
Rieser, William 692, 693
Rogers, Paul 690, 691
Smythe, Danny 695

Marlena
NYC 900, 901
Zwolak, Paul 900, 901

Mattelson, Judy
Great Neck, NY 739-741
Kluglein, Karen 741
Mattelson, Marvin 740
Singer, Phill 739

➤ **Mendola Artists**
NYC 268-327
Barnes-Murphy, Rowan 270, 271
Beilfuss, Kevin 309
Benger, Brent 295
Berg, Ron 318
Blackman, Barry 327
Cassler, Carl 325
Chorney, Steven 289
Cieslawski, Steven 292
Combs, Jonathan 324
➤ Crampton, Michael 269
➤ Dellorco, Chris 315
Denise & Fernando 316
Dowd, Jason 290
Ellis, Jon 305
Franké, Phil 324
Gaber, Brad 303
Gillies, Chuck 291
Greenblatt, Mitch 306
Guida, Liisa Chauncy 317
➤ Gustafson, Dale 313
➤ Halbert, Michael 278, 279
➤ Hejja, Attila 323
Henderson, David 320
Hynes, Robert 321
James, Bill 282, 283
Keifer, Alfons 288
Kitchell, Joyce 280, 281
Krogle, Robert 300

MacDougall, Rob 304
➤ Mangiat, Jeff 276, 277
Manz, Paul 296
Martinez, Ed 308
Maughan, Bill 322
McCormack, Geoffrey 297
McGowan, Dan 314
Milne, Jonathan 307
Motown Animation 274, 275
➤ Newsom, Tom 286
➤ Notarile, Chris 287
Radencich, Mike 302
Riccio, Frank 319
Richards, Linda 312
Santalucia, Francesco 285
Schleinkofer, David 301
Silvers, Bill 294
➤ Tanenbaum, Robert 293
➤ Terreson, Jeffrey 311
Thompson, Thierry 326
➤ Vann, Bill 298
➤ Vincent, Wayne 272, 273
➤ Wieland, Don 299
➤ Wimmer, Mike 268
Winborg, Larry 310
Zlotsky, Boris 284

Morgan Associates, Vicki
NYC 380-401
Blessen, Karen 381
Bliss, Rachel 398
Gaetano, Nicholas 382, 383
Giacobbe, Beppe 399
Lafrance, Laurie 400
Low, William 384, 385
Parisi, Richard 386, 387
Patti, Joyce 388, 389
Schwarz, Joanie 390, 391
Soderlind, Kirsten 396
Steam 401
Taylor, Dahl 392, 393
Wiltse, Kris 394, 395
Wray, Wendy 397

Morgan, Michele
Irvine, CA 821
Davidson, Kevin 821
Maschler, Lorraine 821

Munro Goodman
NYC 790-793
Dypold, Pat 792
Kasun, Mike 793
Klauba, Douglas 790, 791

➤ **Neis Group, The**
Shelbyville, MI 903-907
➤ Bookwalter, Tom 903
Ingle, Michael 905
➤ Kirk, Rainey 907
➤ Knox, Berney 906
LeBarre, Erika 904

➤ **Newborn Group, The**
NYC 508-525
➤ Carruthers, Roy 509
➤ Fasolino, Teresa 516, 517
➤ Giusti, Robert 522, 523
➤ Goldstrom, Robert 512, 513
➤ Hess, Mark 524, 525
➤ Howard, John H. 510, 511
➤ Juhasz, Victor 520, 521
➤ McLean, Wilson 518, 519
➤ Wilcox, David 514, 515

Nowicki & Associates, Lori
Cambridge, MA 818, 819
Argus 818
Hirashima, Jean 819

Penny & Stermer Group, The
NYC 720-726
Buske, Gregory A. 726
Ellis, Steve 723
Gordley, Scott 725
Noonan, Julia 720, 721
Osher, Glynnis 722
Stromoski, Rick 724

Prentice Associates Inc., Vicki
Los Angeles, CA 765-767
Farber, Joan 765
Pesek, Marjorie E. 767
Voss, Tom 766

➤ Artist portfolio featured on The Showcase CD number 2.

Rapp, Inc., Gerald & Cullen
NYC 152-206, Back Cover Book 1
Anderson, Philip 152, 153
Biers, Nanette 154, 155
Briers, Stuart 156, 157
Busch, Lon 202
Davis, Jack 158, 159
deMichiell, Robert 160, 161
Devlin, Bill 203
Duggan, Lee 162, 163
Dynamic Duo 164, 165
Gelb, Jacki 166, 167
Glass, Randy 204
Hart, Thomas 168, 169
Hoey, Peter 170, 171
Johnson, Celia 172, 173
Keller, Steve 205
Kubinyi, Laszlo 174, 175
Maisner, Bernard 176, 177
Mayforth, Hal 178, 179
Meyerowitz, Rick 180, 181
Morser, Bruce 182, 183
Murawski, Alex 184, 185
Najaka, Marlies Merk 186, 187
Pifko, Sigmund 206
Przewodek, Camille 188, 189
Rosenthal, Marc 190, 191
Steinberg, James 192, 193
Struzan, Drew 194, 195
Ventura, Andrea 196, 197
Witte, Michael 198, 199
Ziering, Bob 200, 201

➢ **Renard Represents**
NYC 328-379
➢ Björkman, Steve 329
➢ Bozzini, James 352, 353
➢ Brooks, Rob 362, 363
➢ Cigliano, Bill 346, 347
➢ Daigle, Stéphan 367
➢ Eldridge, Gary 344, 345
➢ Garrow, Dan 356, 357
➢ Geras, Audra 374, 375
Girvin Design, Inc., Tim 378, 379
➢ Guitteau, Jud 364, 365
Harrison, William 368, 369
➢ Herbert, Jonathan 334, 335
Hill, Roger 336, 337
➢ Holmes, Matthew 360, 361

➢ Martin, John 342
➢ Matsu 332, 333
➢ McGurl, Michael 358, 359
➢ McLoughlin, Wayne 348, 349
➢ Milot, Rene 330, 331
Newton, Richard 370, 371
➢ Pelo, Jeffrey 354, 355
➢ Rodriguez, Robert 350, 351
➢ Rudnak, Theo 340, 341
Schwab, Michael 376, 377
Sinclair, Valerie 338, 339
➢ Suchit, Stu 366
Sumichrast, Józef 372, 373
➢ Whitesides, Kim 343

Rep Art
Seattle, WA 706-714
Bolesky, John 707
Carter, Stephanie 711
Huynh, Si 713
McKinnell, Michael 710
Rogers, Adam 714
Takagi, Michael 709
Thomsen, Ernie 706
Winters, Lorne 708
Wortsman, Wendy 712

Repertory
NYC 802-805
Botero, Kirk 805
Cristos 805
Hanley, John 804
Knowles, Philip 803
Stewart, Don 804
Urbanovic, Jackie 802

Riley Illustration
NYC 768- 771
Bramhall, William 770
Dervaux, Isabelle 768
Fisher, Jeffrey 771
Linn, Warren 768
Pyle, Liz 769
Shanahan, Danny 771
Simpson, Gretchen Dow 770
Weisbecker, Philippe 769

➢ **Rogers, Lilla**
Arlington, MA 732-738
➢ Bigda, Diane 733
Boyajian, Ann 736
➢ Farrington, Susan 734
➢ Ingemanson, Donna 735
Katz, Aliona 737
Rogers, Lilla 732
➢ Witschonke, Alan 738

Rohani, Mushka
Edmonds, WA 822
Rohani, Michael Sours 822

Rosenthal Represents
Los Angeles, CA 662-672
Akins, Kelly 664
Alavezos, Gus 670
Anderson, Terry 670
Brooks, Nan 662
Buckley, Marjory 670
Caporale, Wende 663
Dunne, Kathleen 671
Edinjiklian, Teddy 671
Evans, Robert 665
Galloway, Nixon 669
Genzo, John Paul 666
Huerta, Catherine 668
Knoll, Kimberly 671
Ross, Scott 667
Tachiera, Andrea 664
Wunderlich, Dirk J. 672

Sanders Agency, Liz
Laguna Niguel, CA 908, 909
Bee, Johnee 908
Ning, Amy 909

Schuna Group, The
St. Paul, MN 910, 911
Dryden, Jim 911
Huber, Cathy Lundeen 910

Seigel, Fran
NYC 778-781
Deeter, Catherine 780
Hokanson/Cichetti 778
Keleny, Earl 779
Sneberger, Dan 781

Shannon · Associates
NYC 446-483
Austin, Cary 446, 447
Bollinger, Peter 448-451
Brodner, Steve 452, 453
Call, Greg 454, 455
Cowdrey, Richard 456, 457
Dacey, Bob 458, 459
DeGrace, John 460, 461
Duranceau, Suzanne 462, 463
Elliott, Mark 464, 465
Elwell, Tristan 466, 467
Fine, Howard 468, 469
Gazsi, Ed 470, 471
Hamlin, Janet 472, 473
Johnson, Stephen T. 474, 475
Koelsch, Michael 476, 477
Kramer, Dave 478, 479
LaCava, Vincent 480, 481
Torres, Carlos 482, 483

Solomon, Richard
NYC 236-267
Barton, Kent 238, 239
Bennett, James 240, 241
Cline, Richard 242, 243
Collier, John 244, 245
Cox, Paul 246, 247
Davis, Jack E. 248, 249
Johnson, David 250, 251
Kelley, Gary 252, 253
Manchess, Gregory 254, 255
Mattotti, Lorenzo 256, 257
Nelson, Bill 258, 259
Payne, C.F. 260, 261
Smith, Douglas 262, 263
Spirin, Gennady 264, 265
Summers, Mark 266, 267

➢ Artist portfolio featured on The Showcase CD number 2.

Susan and Company
Seattle, WA 564-570
Barnard, Bryn 566
Cheney, George 569
Edelson, Wendy 568
Ingram, Fred 564, 565
Jost, Larry 570
Stadler, Greg 567

➣ **Three In A Box**
Toronto, Ontario 628-641
➣ Adams, Kathryn 637
➣ Cangemi, Antonio 629
➣ Chestnutt, David 639
➣ Colquhoun, Eric 641
➣ Hanson, Glen 636
➣ Jimminy 638
➣ Pariseau, Pierre-Paul 630
➣ Ritchie, Scot 635
➣ Stampatori, Riccardo 628
➣ Stanley, Anne 634
➣ Todd, Susan 631
➣ Watson, Paul 640
➣ Whamond, Dave 632
➣ Zgodzinski, Rose 633

Tise, Katherine
NYC 816, 817
Burgoyne, John 816, 817

Tonal Values, Inc.
Miami, FL 912-919
Brooker, Philip 915
Buchanan, Nigel 912
Chernishov, Anatoly 914
MacAdam, Dean 917
Punin, Nikolai 918, 919
Schroder, Mark 916
Speers, Pauline Cilmi 913

➣ **2H Studio**
Southport, CT Back Flap Book 1
➣ Huerta Design, Inc., Gerard

Watson and Spierman Productions
NYC 823
Wiener, Mark 823

➣ **Weber Group, The**
NYC 678-687
➣ Colon, Raul 678, 679
Fluharty, Thomas L. 682, 683
➣ Morris, Burton 684, 685
➣ Paciulli, Bruno 687
➣ Shohet, Marti 680, 681
➣ Weinstein, Ellen 686

Wiley, David
San Francisco, CA 806-809
Chaffee, James 808
Hill, Charlie 806
Toyama, Ken 807
Witmer, Keith 809

Wolfe Limited, Deborah
Philadelphia, PA 787-789
Campbell, Jenny 787
Hughes, Marianne 788
Pomerantz, Lisa 789

➣ Artist portfolio featured on The Showcase CD number 2.

The Showcase

no.CD *two*

WE'VE INCLUDED A WAY FOR YOU TO SEE ARTISTS' PORTFOLIOS WITHOUT WAITING FOR AN OVERNIGHT DELIVERY!

IT'S THE SHOWCASE CD AND THIS YEAR, FOR YOUR CONVENIENCE, WE'VE ATTACHED IT TO THE SHOWCASE ILLUSTRATION SLIPCASE IN YOUR POSSESSION RIGHT NOW.

JUST POP IN THE DISK AND VIEW COMPLETE PORTFOLIOS BY SOME OF YOUR FAVORITE ARTISTS RIGHT AT YOUR COMPUTER. (SEE INDEX FOR PARTICIPATING ARTISTS).

WATCH OUT FED EX!!!

BERNSTEIN & ANDRIULLI INC

60 EAST 42ND STREET NEW YORK, NY 10165

TEL (212) 682-1490 FAX (212) 286-1890

REPRESENTATIVES

SAM BERNSTEIN TONY ANDRIULLI HOWARD BERNSTEIN FRANCINE ROSENFELD

REGIONAL REPRESENTATIVES

NEW ENGLAND	MOLLY BIRENBAUM	203 272 9253
ATLANTA	SUSAN WELLS	404 255 1430
CHICAGO	RANDI FIAT	312 663 5300
TEXAS	LIZ McCANN	214 526 2252
SAN FRANCISCO	IVY GLICK	510 944 0304

EUROPEAN AFFILIATE

CENTRAL ILLUSTRATION AGENCY/LONDON

IF YOU WOULD LIKE A COPY OF OUR 104 PAGE TALENT PORTFOLIO, WHICH INCLUDES A SPECIAL STOCK ILLUSTRATION SECTION, WRITE TO US ON YOUR COMPANY LETTERHEAD. PLEASE INCLUDE $15 TO COVER HANDLING COSTS.

ILLUSTRATION BY KEITH GRAVES

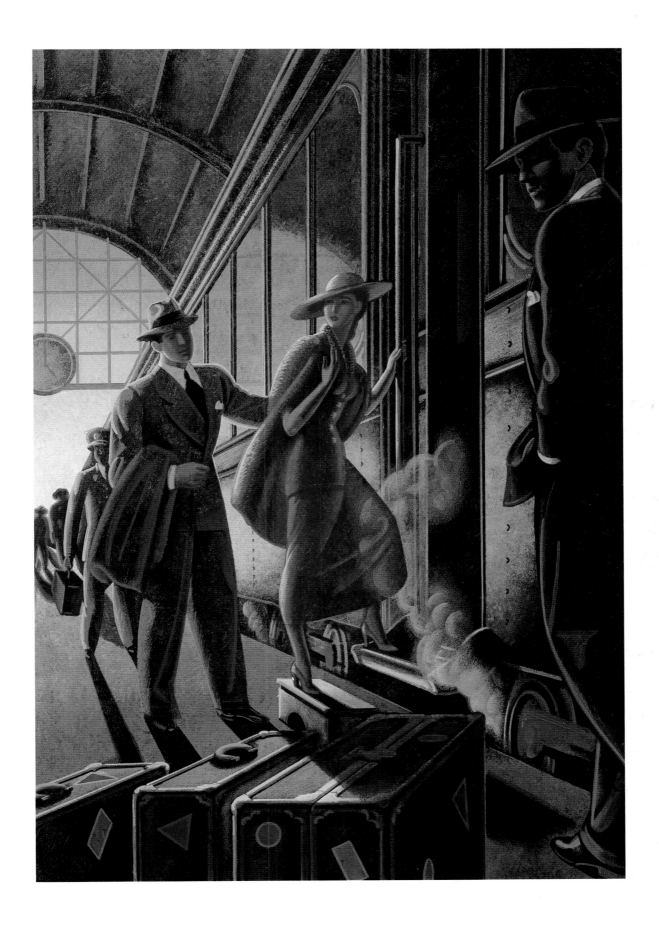

B E R N S T E I N & A N D R I U L L I R E P R E S E N T A T I V E S TEL (212)682-1490 FAX (212)286-1890

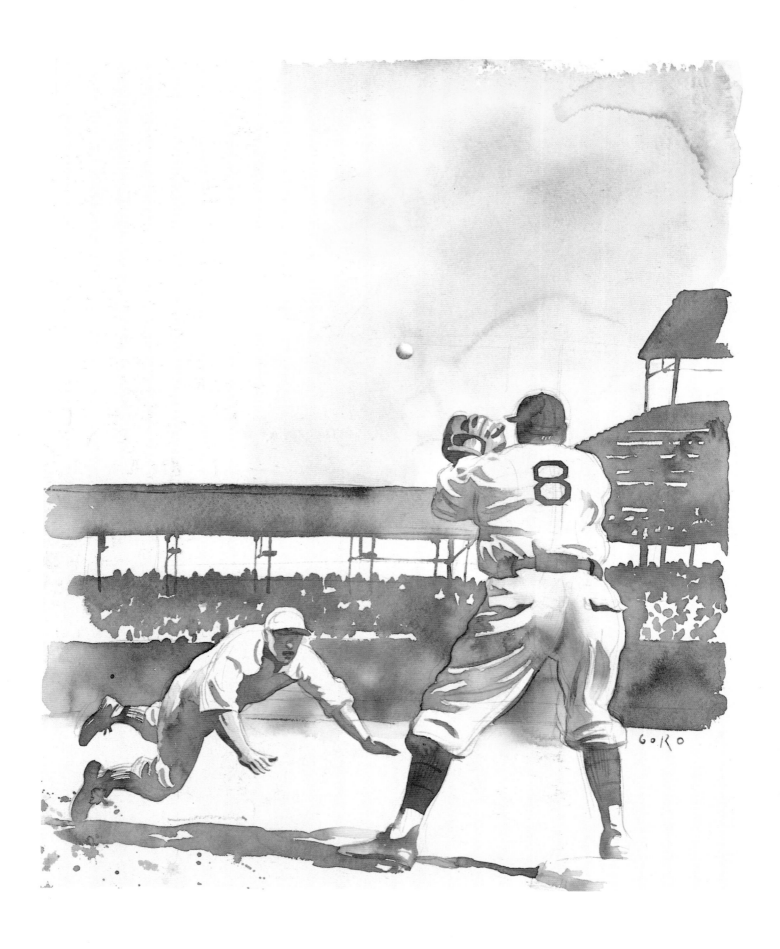

B E R N S T E I N & A N D R I U L L I R E P R E S E N T A T I V E S TEL (212)682-1490 FAX (212)286-1890

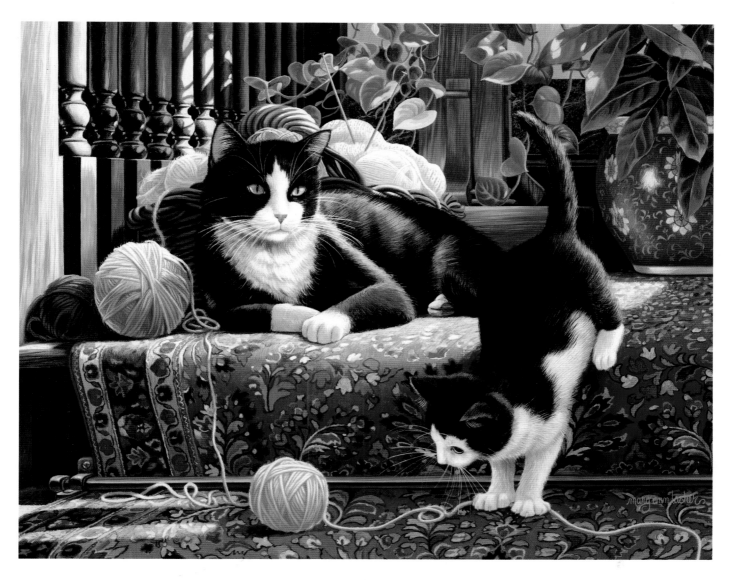

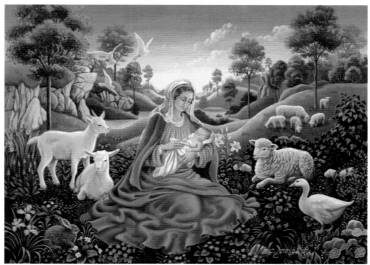

B E R N S T E I N & A N D R I U L L I R E P R E S E N T A T I V E S TEL (212)682-1490 FAX (212)286-1890

[P A M W A L L]

COMPUTER ILLUSTRATION

B E R N S T E I N & A N D R I U L L I R E P R E S E N T A T I V E S TEL (212)682-1490 FAX (212)286-1890

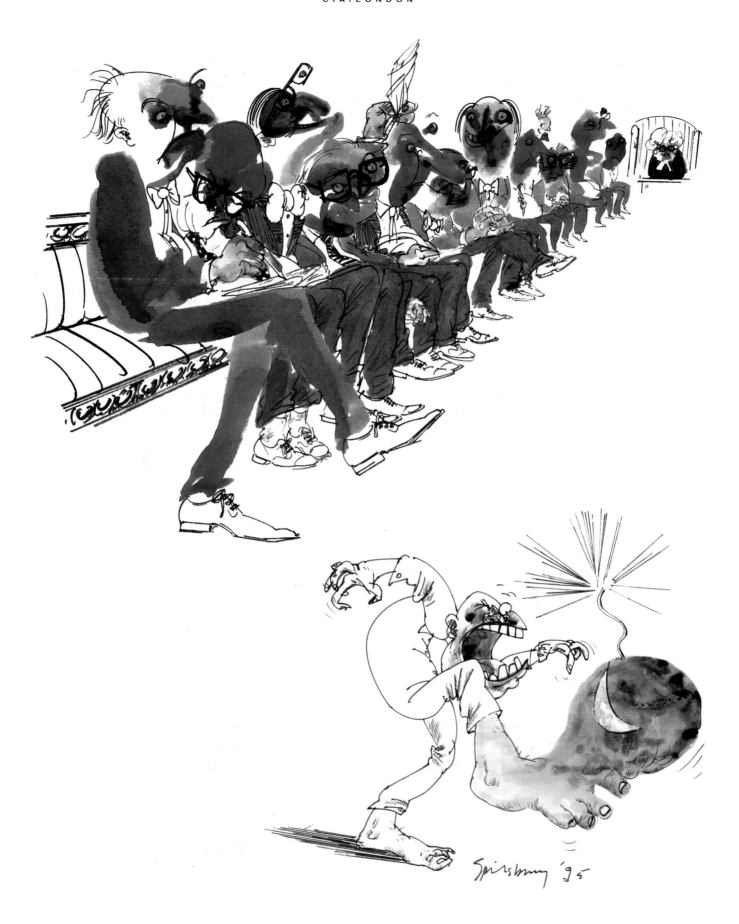

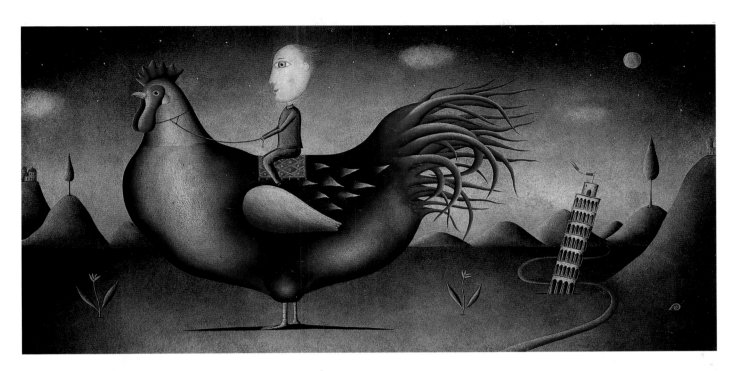

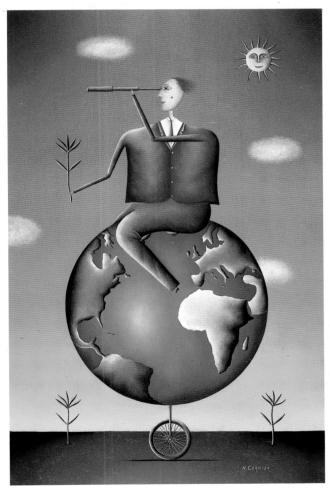

B E R N S T E I N & A N D R I U L L I R E P R E S E N T A T I V E S TEL (212)682-1490 FAX (212)286-1890

BERNSTEIN & ANDRIULLI REPRESENTATIVES TEL (212)682-1490 FAX (212)286-1890

Vision

Calculation

Instinct

Disguise

Agility

Scent

BERNSTEIN & ANDRIULLI REPRESENTATIVES TEL (212)682-1490 FAX (212)286-1890

BERNSTEIN & ANDRIULLI REPRESENTATIVES TEL (212)682-1490 FAX (212)286-1890

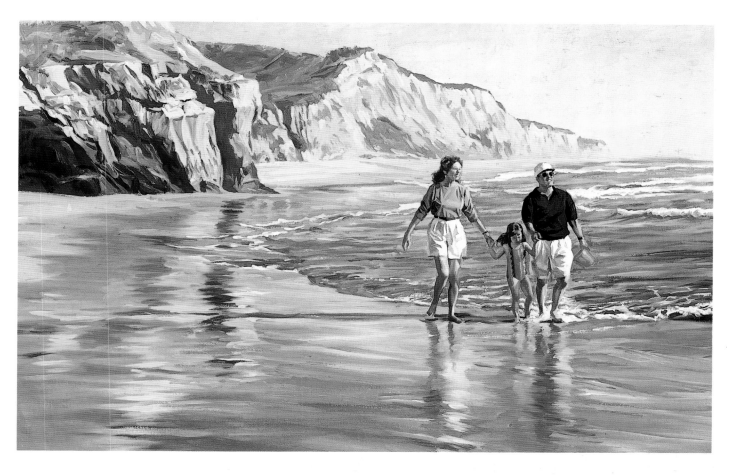

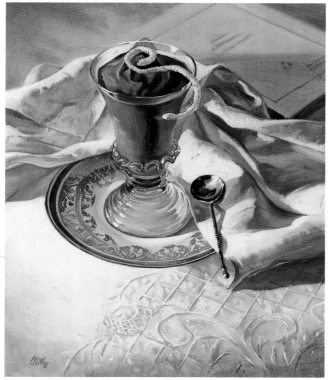

B E R N S T E I N & A N D R I U L L I R E P R E S E N T A T I V E S TEL (212)682-1490 FAX (212)286-1890

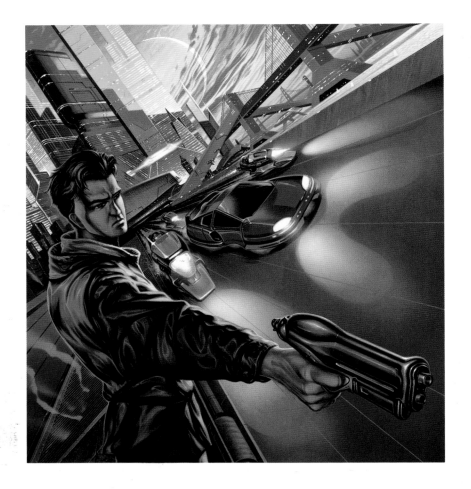

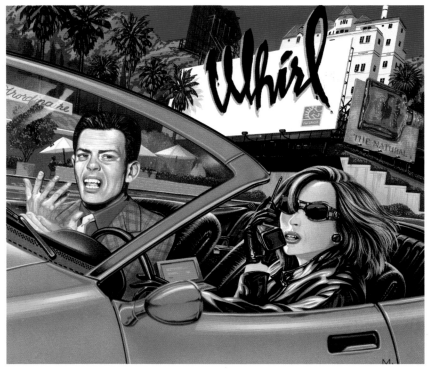

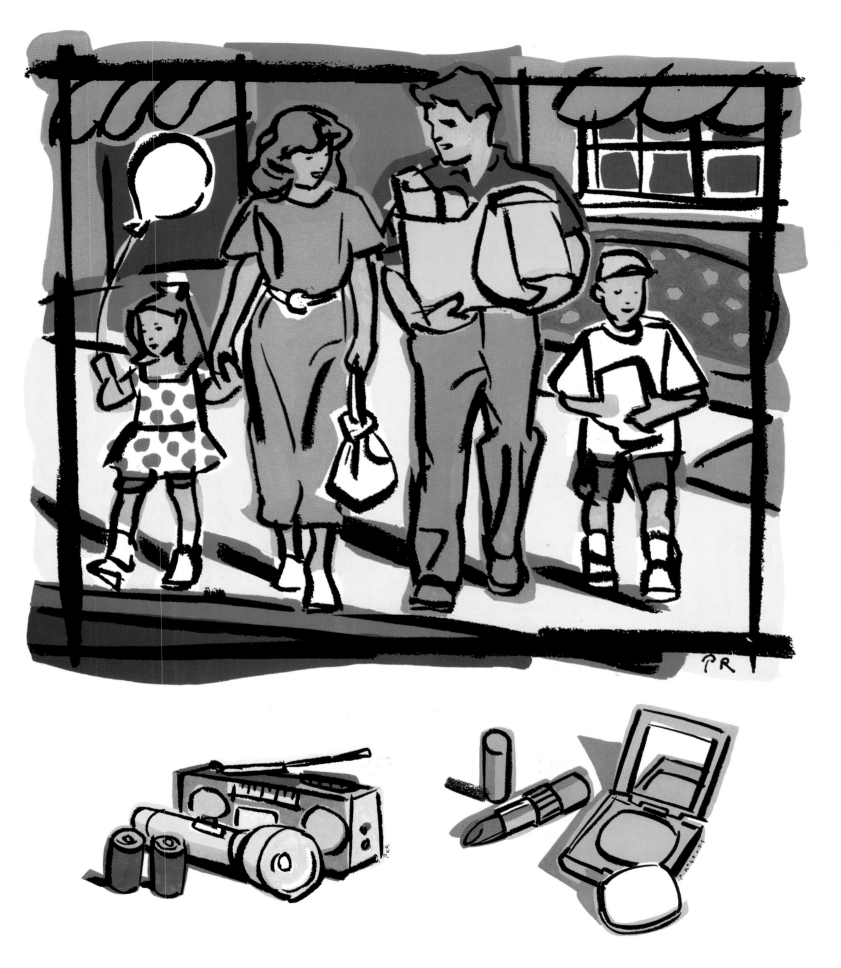

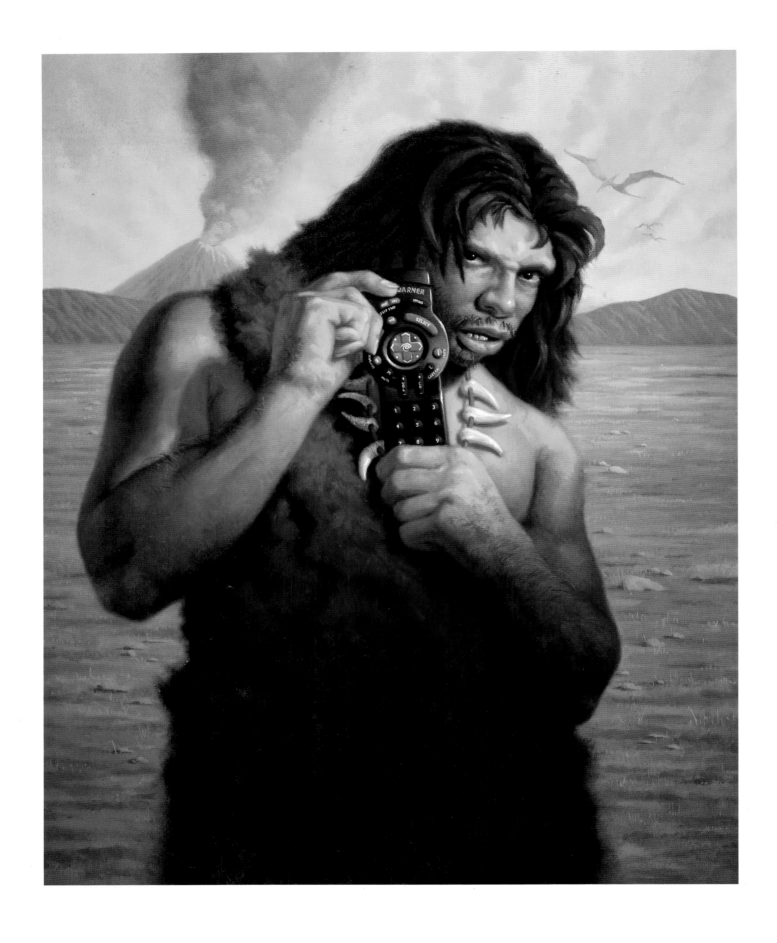

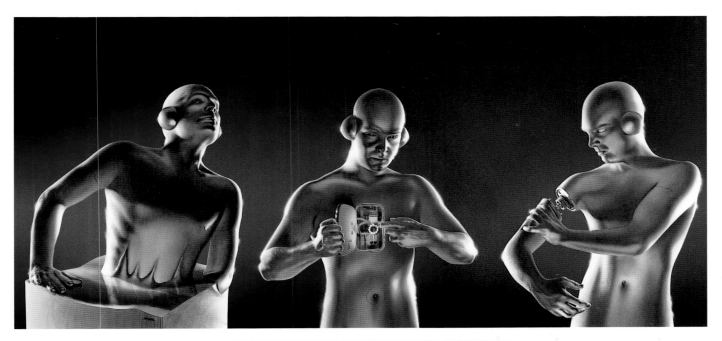

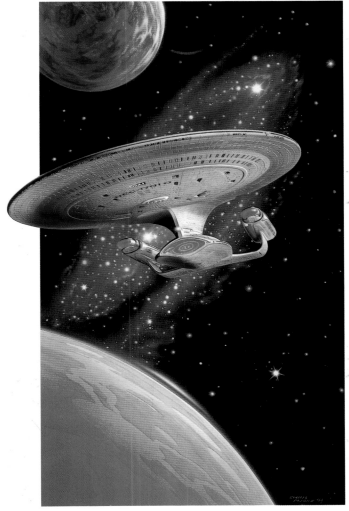

[C H R I S M O O R E]

B E R N S T E I N & A N D R I U L L I R E P R E S E N T A T I V E S TEL (212)682-1490 FAX (212)286-1890

B E R N S T E I N & A N D R I U L L I R E P R E S E N T A T I V E S TEL (212)682-1490 FAX (212)286-1890

BERNSTEIN & ANDRIULLI REPRESENTATIVES TEL (212)682-1490 FAX (212)286-1890

B E R N S T E I N & A N D R I U L L I R E P R E S E N T A T I V E S TEL (2 1 2) 6 8 2 - 1 4 9 0 FAX (2 1 2) 2 8 6 - 1 8 9 0

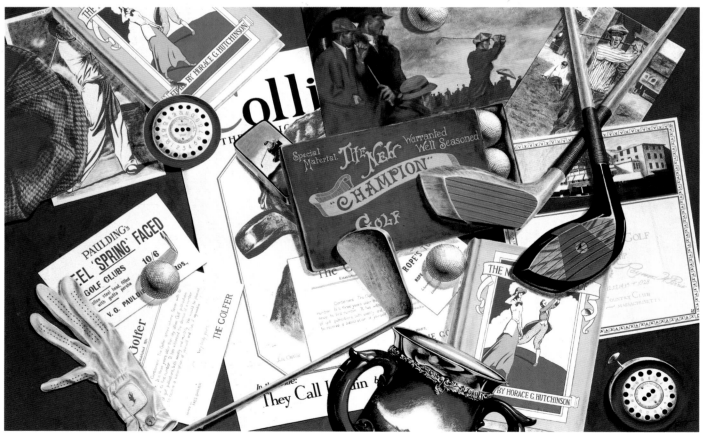

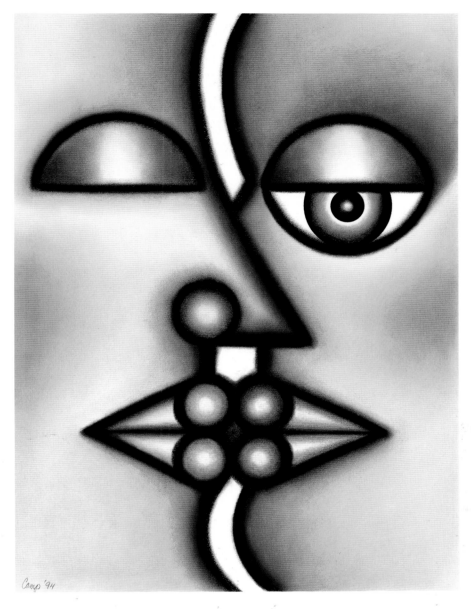

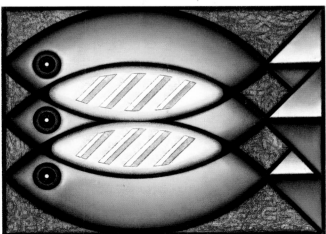

B E R N S T E I N & A N D R I U L L I R E P R E S E N T A T I V E S TEL (212)682-1490 FAX (212)286-1890

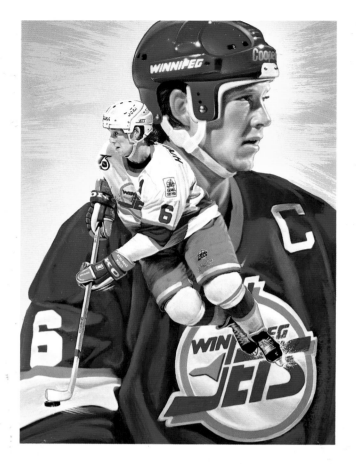

B E R N S T E I N & A N D R I U L L I R E P R E S E N T A T I V E S TEL (212)682-1490 FAX (212)286-1890

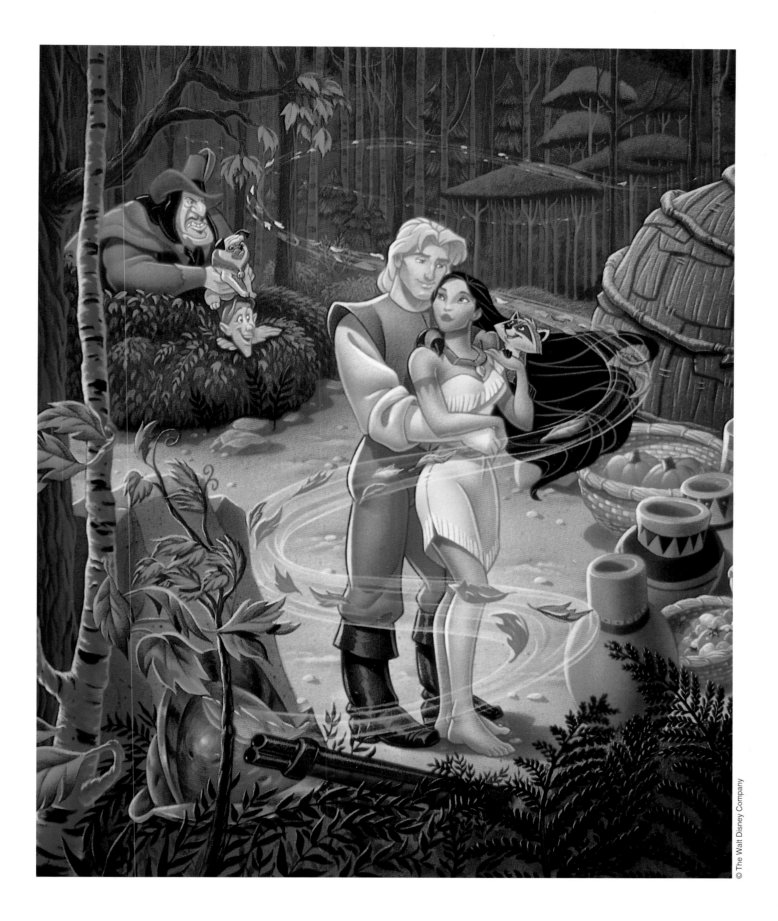

B E R N S T E I N & A N D R I U L L I R E P R E S E N T A T I V E S TEL (212)682-1490 FAX (212)286-1890

lori lohstoeter

lindgren & smith

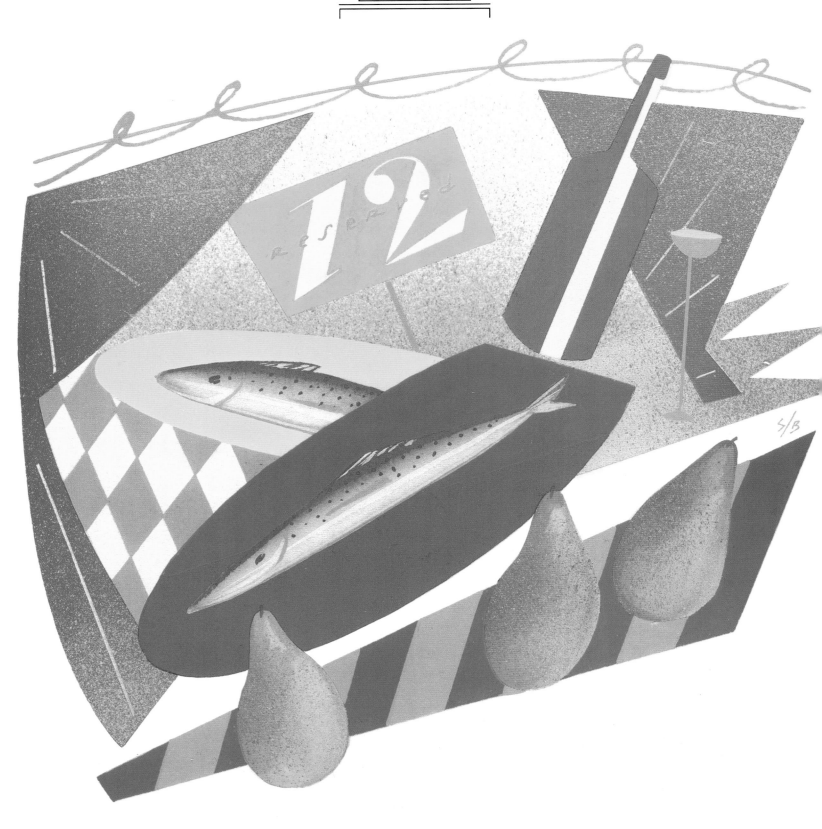

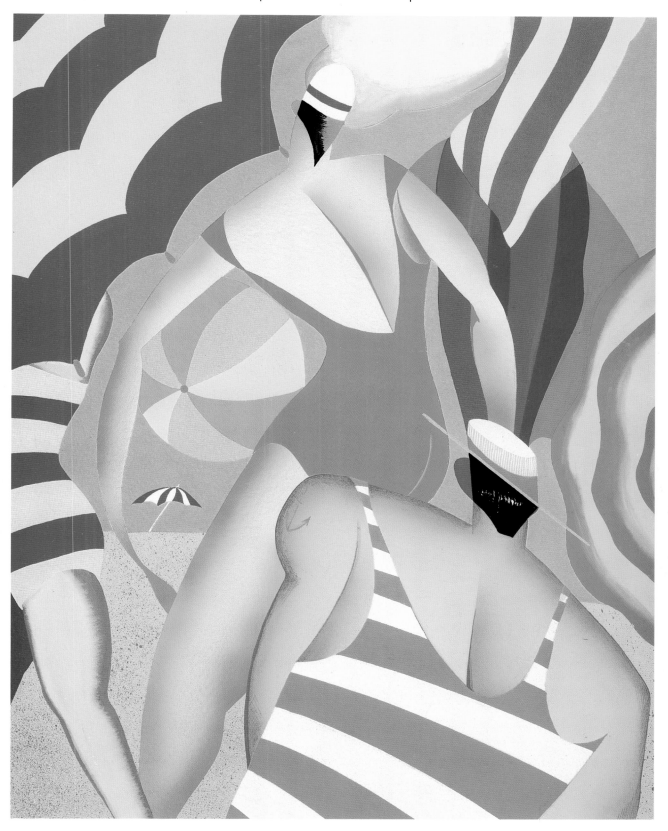

vince mcindoe

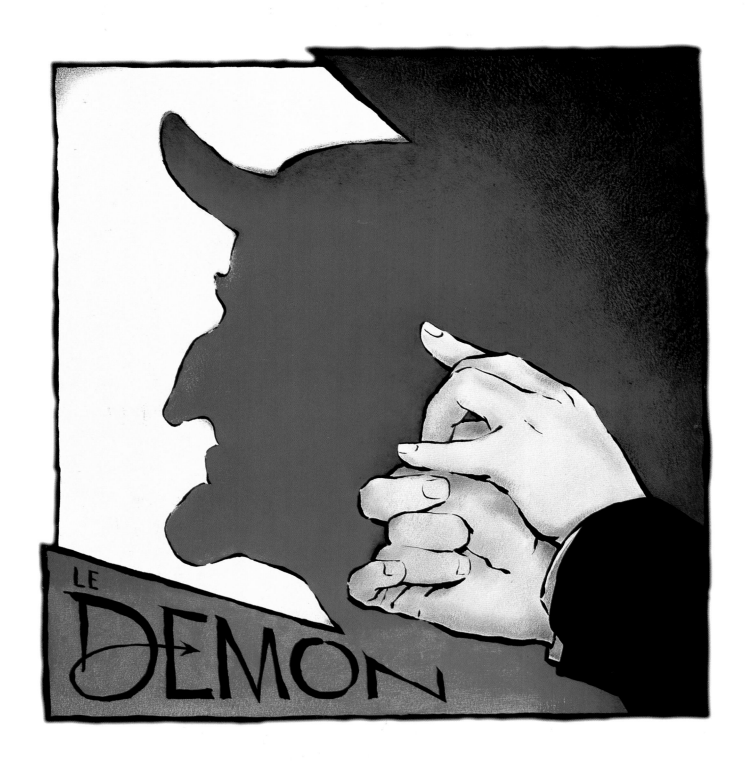

lindgren & smith

chicago 312.819.0880　　　new york 212.397.7330　　　san francisco 415.788.8552

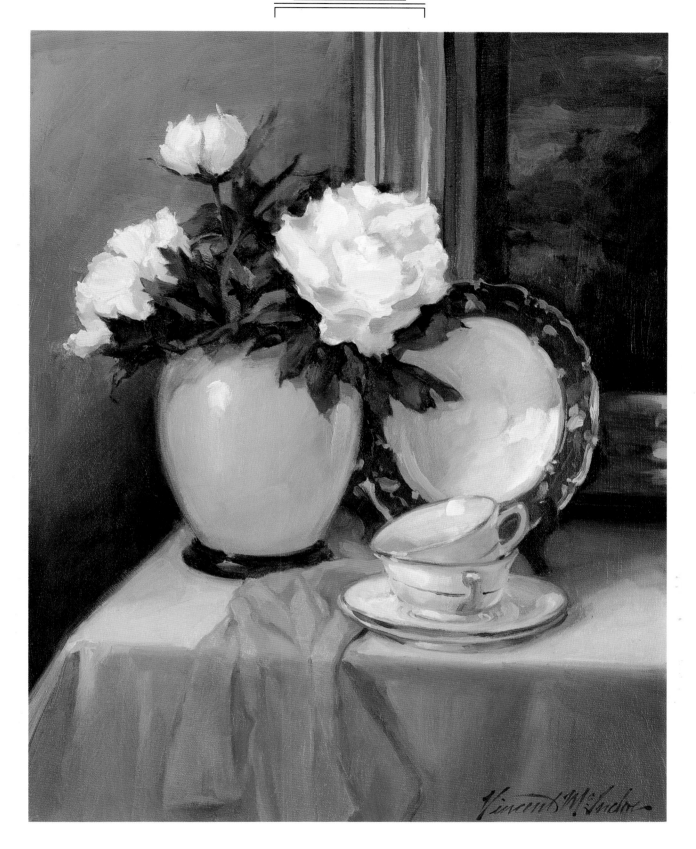

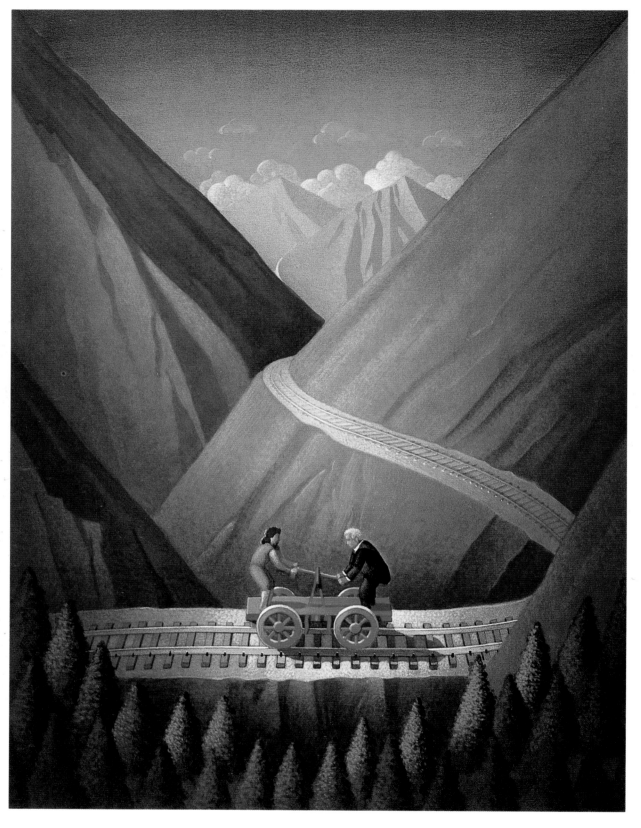

andy dearwater

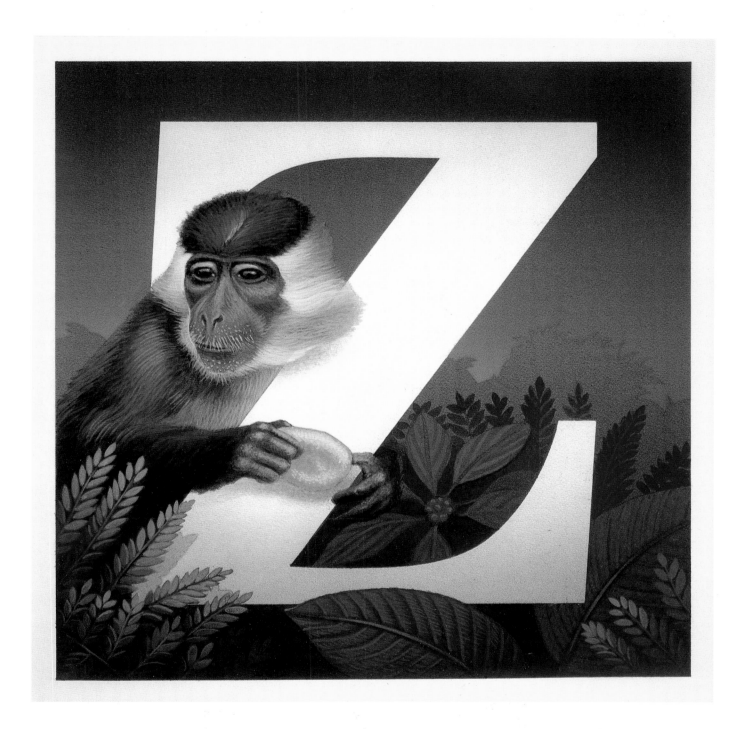

lindgren & smith

chicago 312.819.0880 new york 212.397.7330 san francisco 415.788.8552

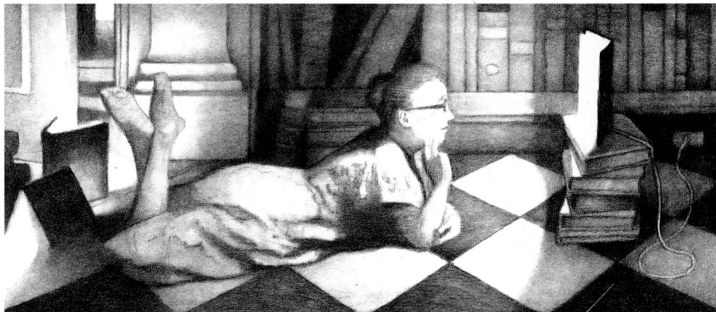

56

douglas fraser

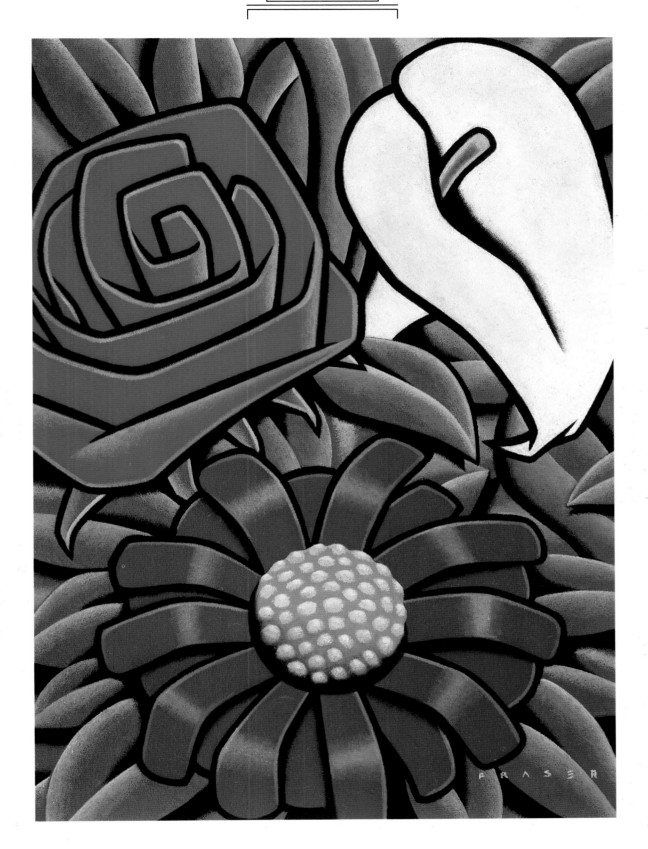

lindgren & smith

212.397.7330

outside the northeast jan collier 415.383.9026

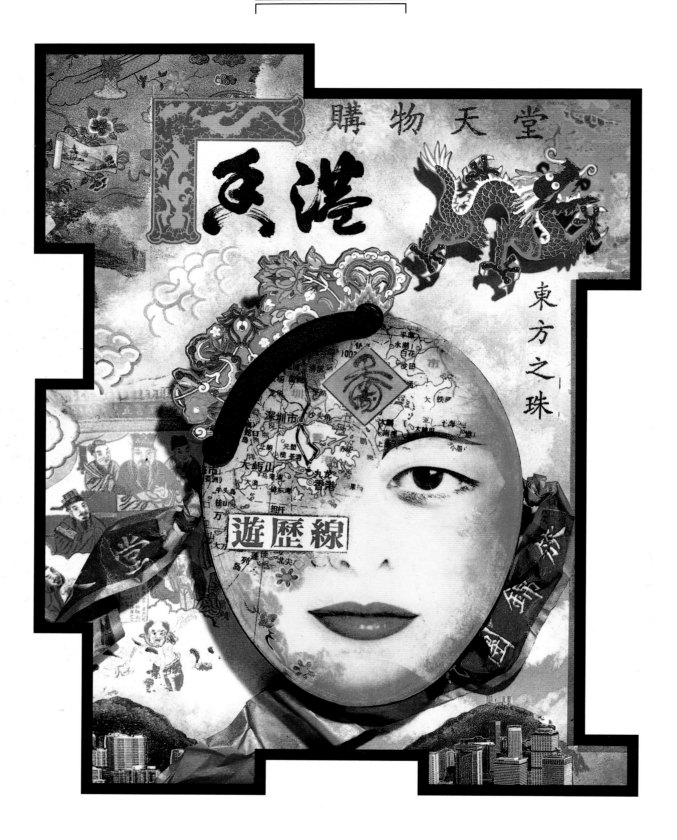

lindgren & smith

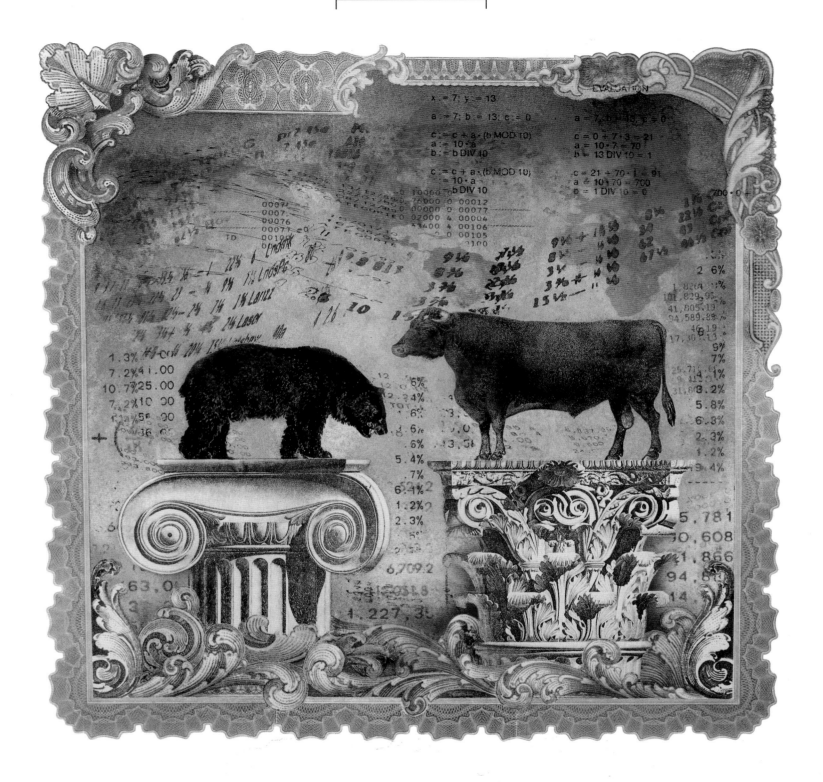

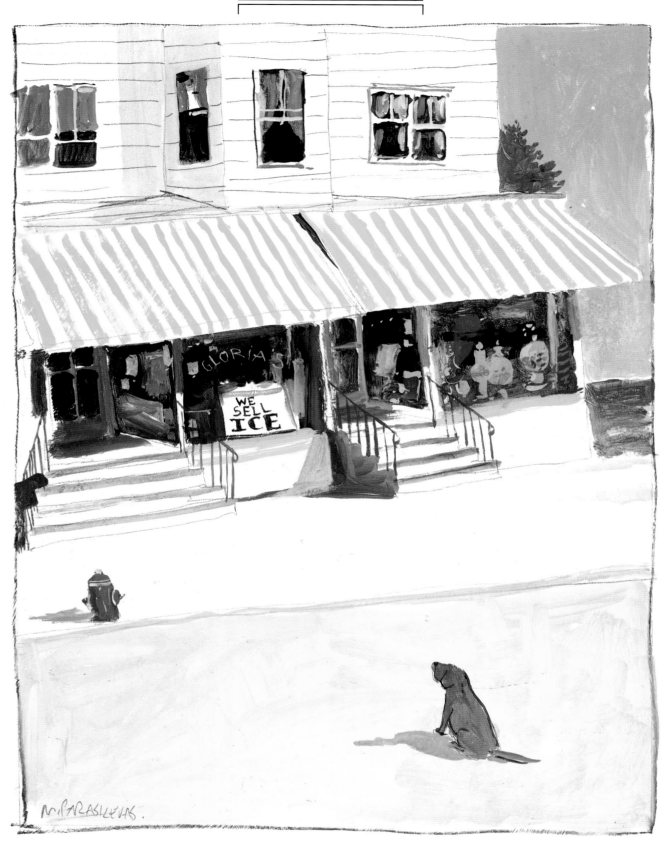

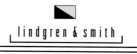

lindgren & smith

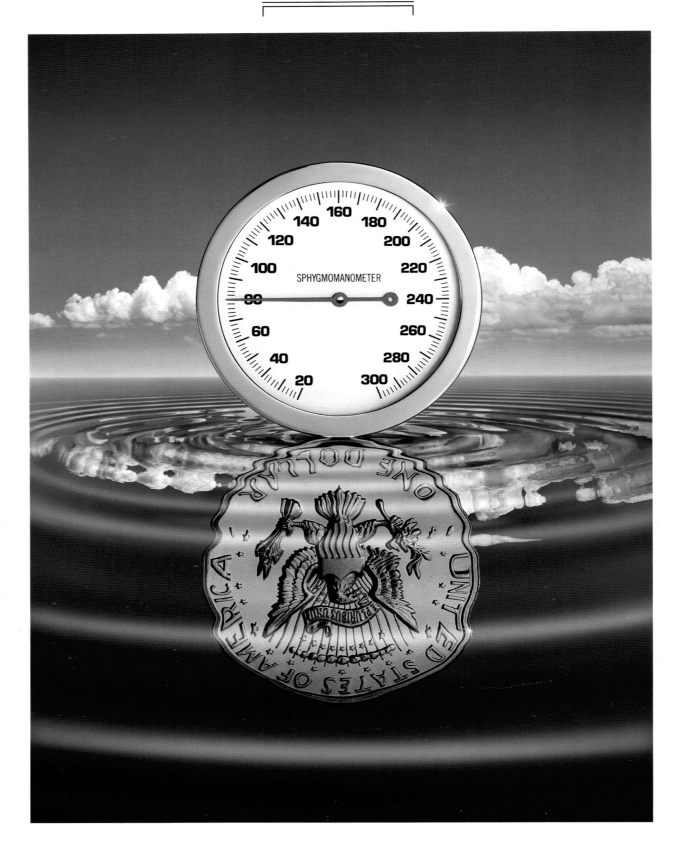

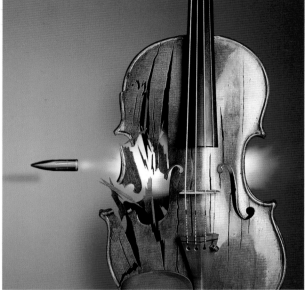

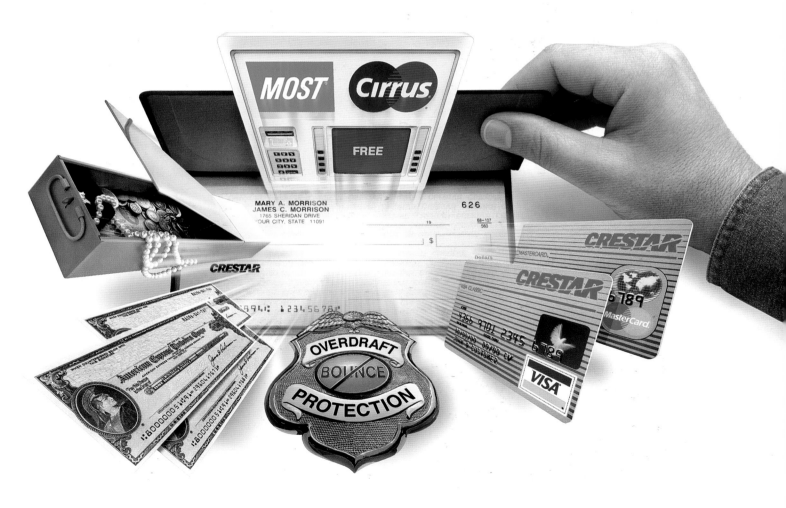

lindgren & smith

212.397.7330

in chicago joel harlib assoc. 312.329.1370 in los angeles martha productions 310.204.1771 in san francisco missy pepper 415.543.6881

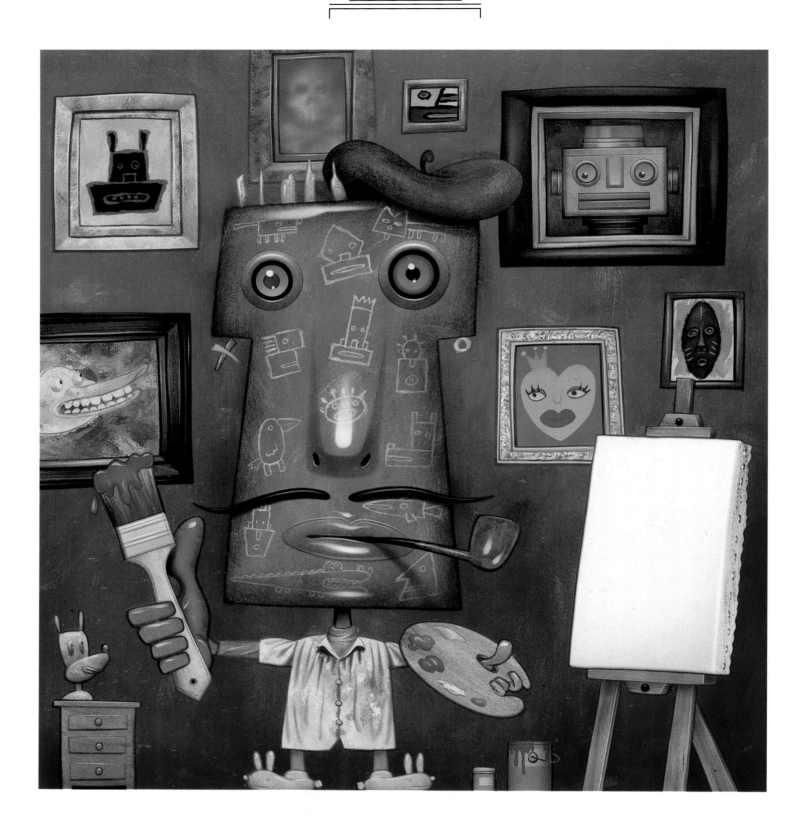

dan yaccarino

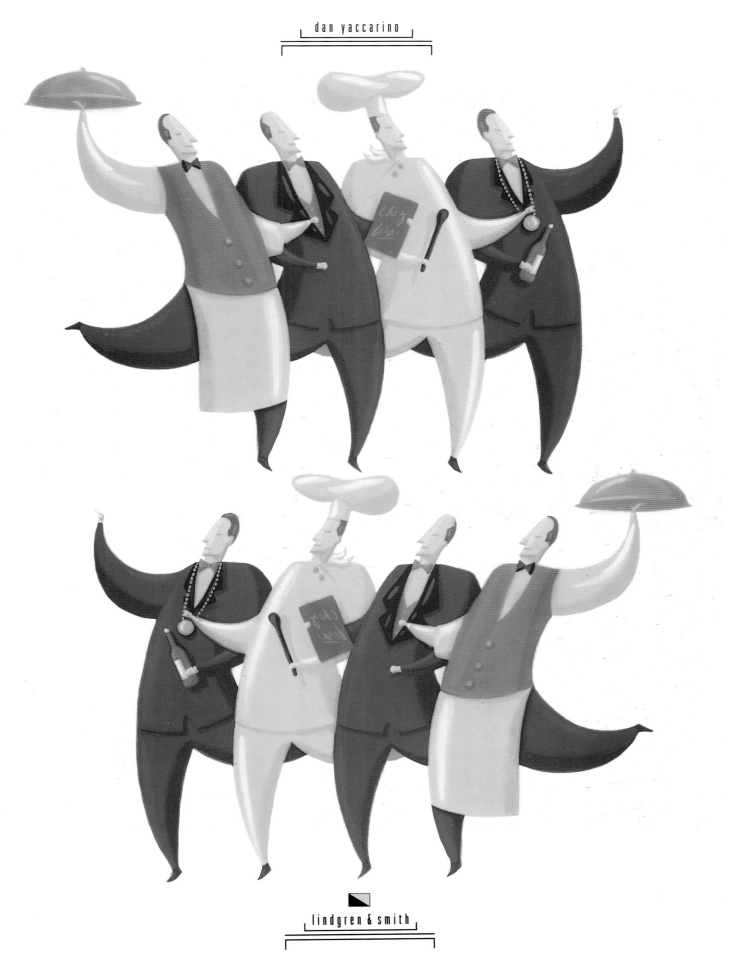

lindgren & smith

chicago 312.819.0880 new york 212.397.7330 san francisco 415.788.8552

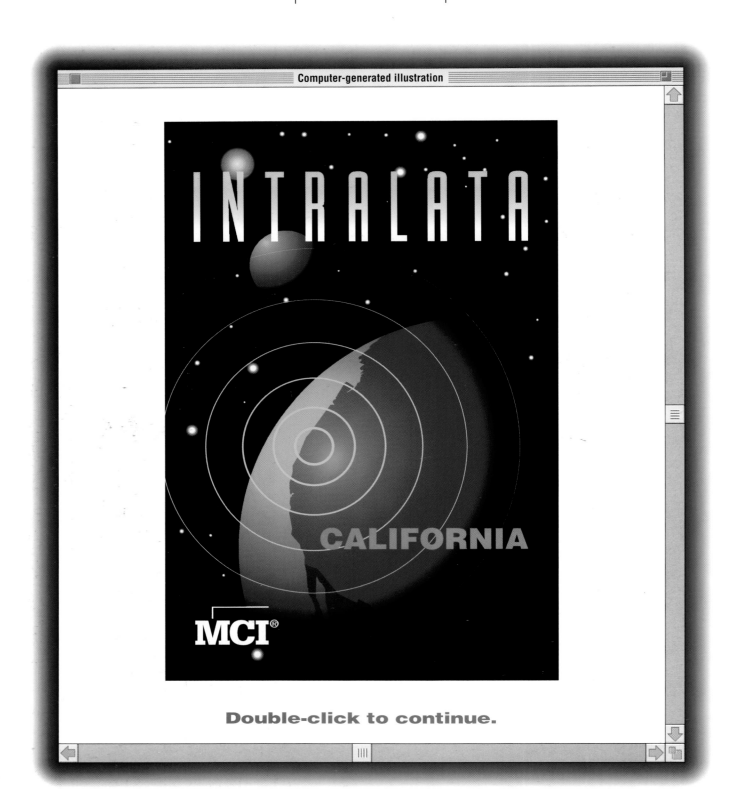

Computer-generated illustration

Isetan

Games

Kobe Relief Fund

US Pharmacist

Scitex

Datamation

IBM

Primo Angeli

Fidelity Investments

Jobson Publishing

Bush Boake Allen

Fidelity Investments

Double-click to continue.

lindgren & smith

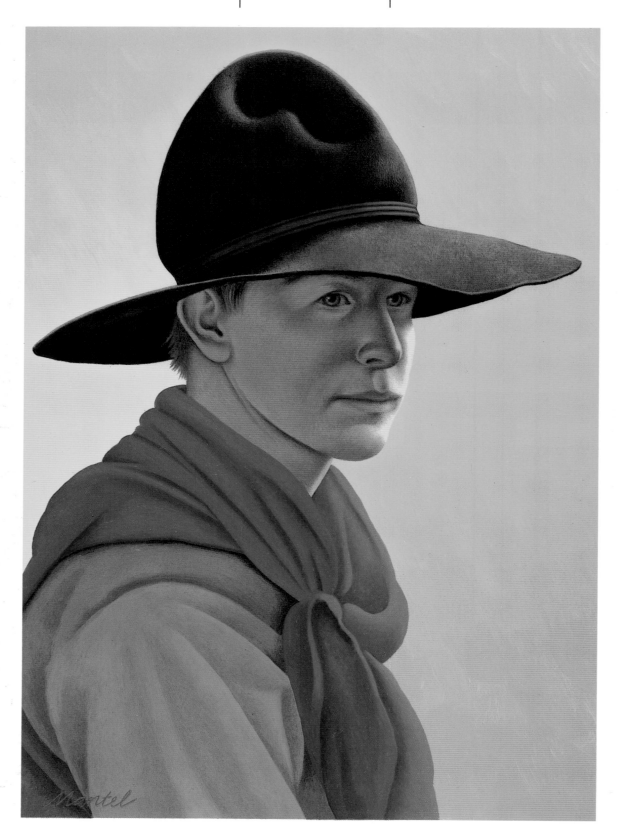

lindgren & smith

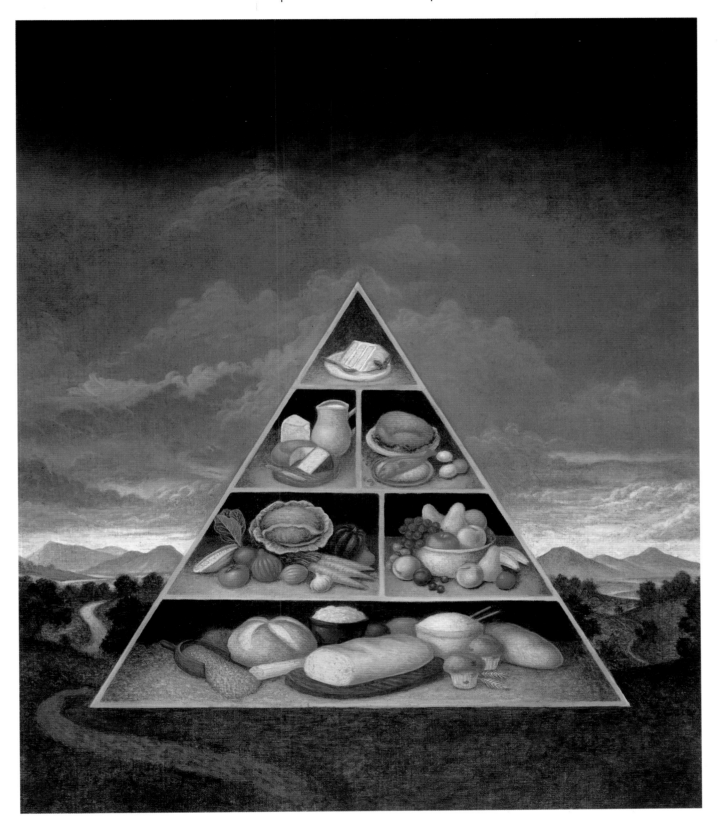

chicago 312.819.0880 *new york 212.397.7330* *san francisco 415.788.8552*

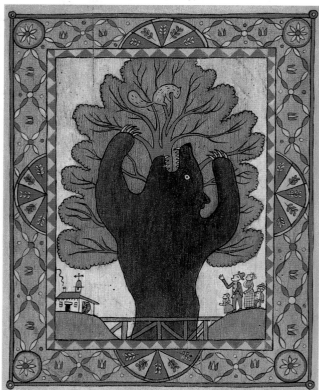
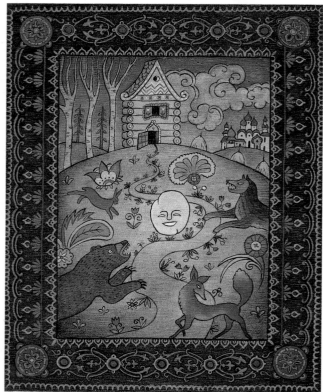

70

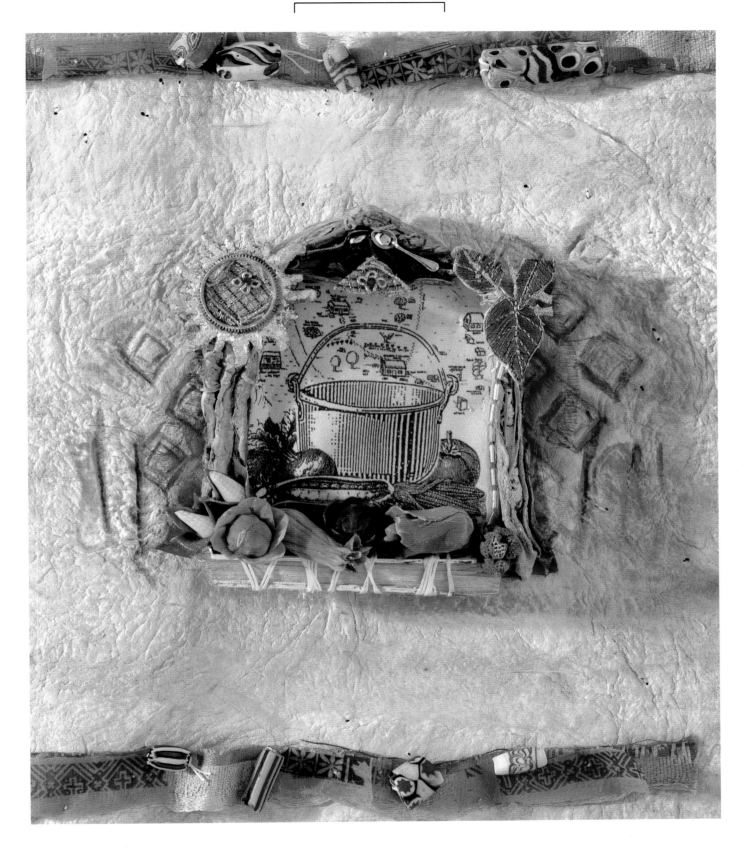

lindgren & smith

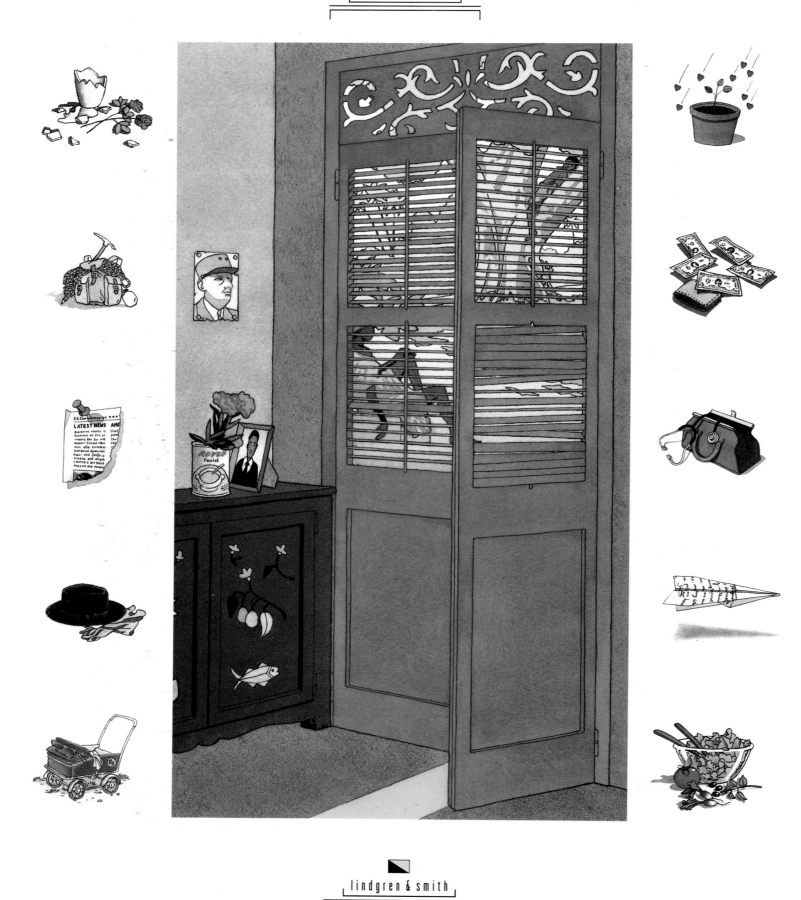

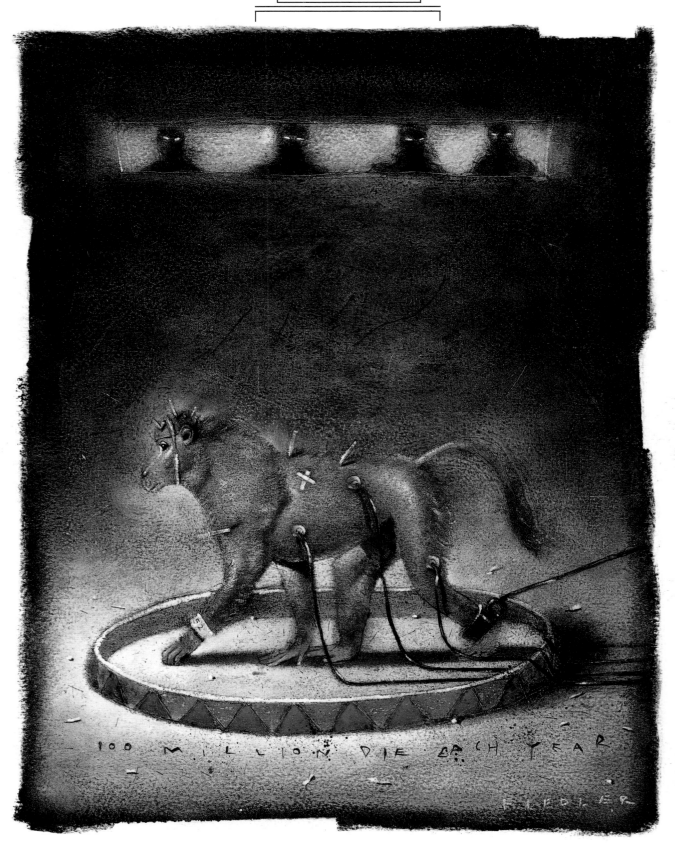

A Wasteful Society

Average amount of waste generated per capita per day in the U.S. in pounds.

2.9 3.5 6.5

1960 1988 2000

Source: Franklin Associates

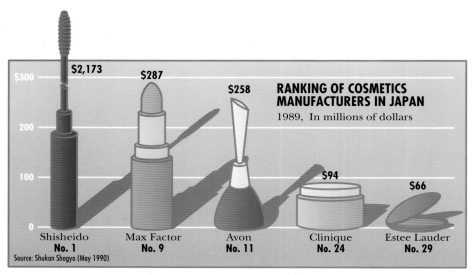

RANKING OF COSMETICS MANUFACTURERS IN JAPAN

1989, In millions of dollars

$2,173 $287 $258 $94 $66

| Shisheido No. 1 | Max Factor No. 9 | Avon No. 11 | Clinique No. 24 | Estee Lauder No. 29 |

Source: Shukan Shogyo (May 1990)

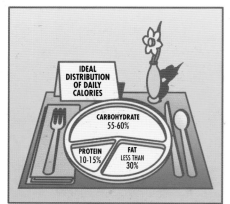

IDEAL DISTRIBUTION OF DAILY CALORIES

CARBOHYDRATE 55-60%

PROTEIN 10-15% FAT LESS THAN 30%

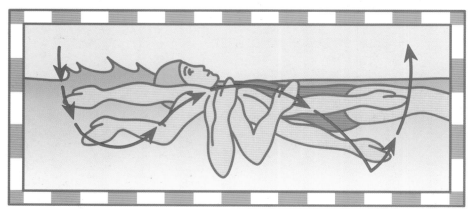

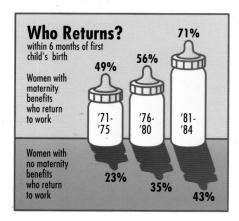

Who Returns?

within 6 months of first child's birth

Women with maternity benefits who return to work

49% 56% 71%

'71-'75 '76-'80 '81-'84

Women with no maternity benefits who return to work

23% 35% 43%

TORAY WATERLESS PLATE

CONVENTIONAL WET OFFSET PLATE

Ink Silicone Rubber Layer

Ink Receptive Polymer

Ink Dampening Water

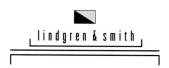

lindgren & smith

chicago 312.819.0880 *new york* 212.397.7330 *san francisco* 415.788.8552

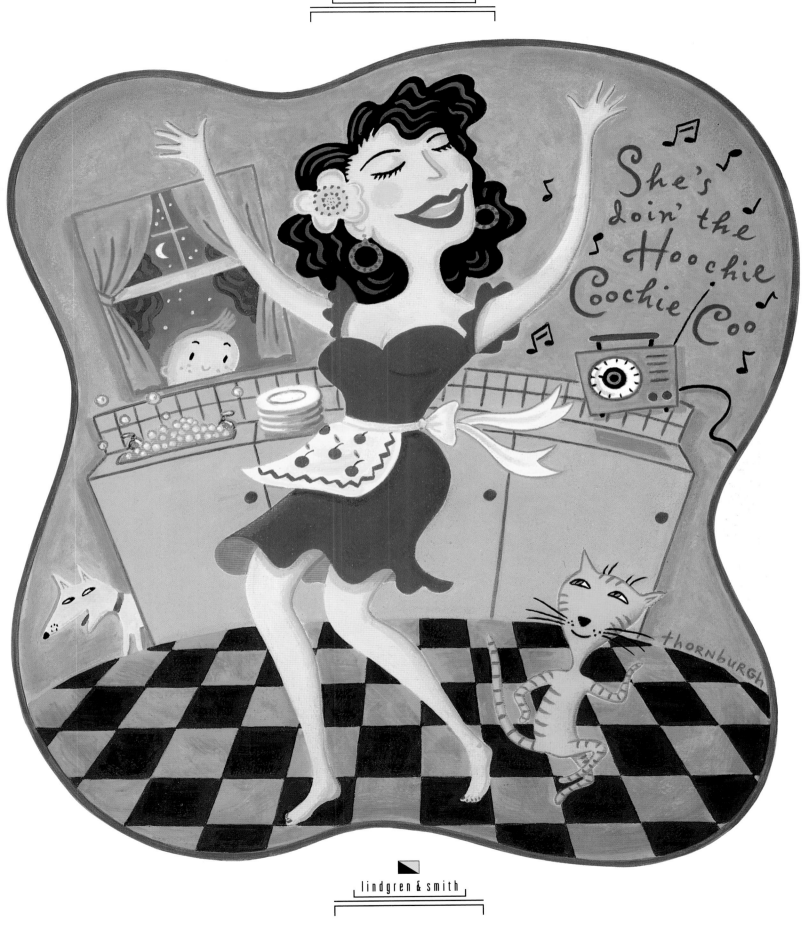

lindgren & smith

lindgren & smith

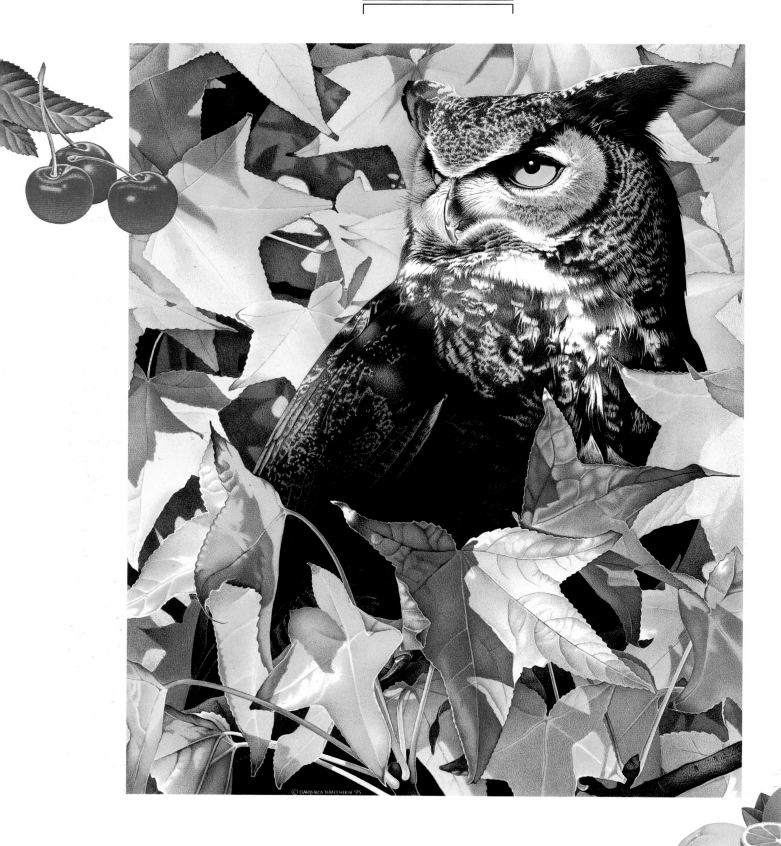

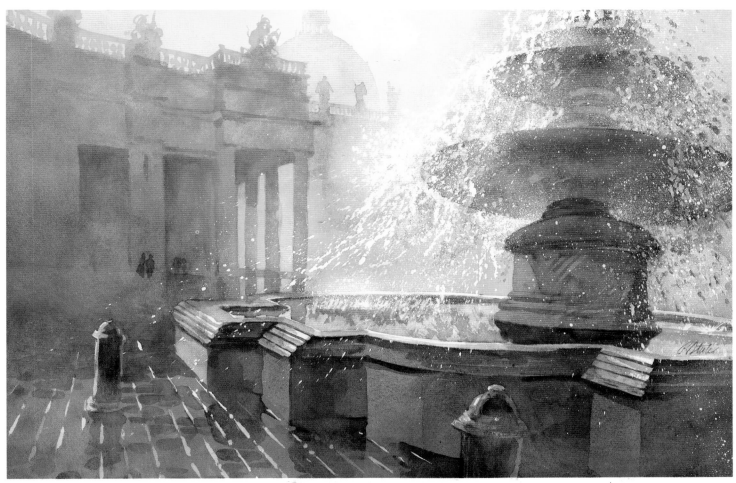
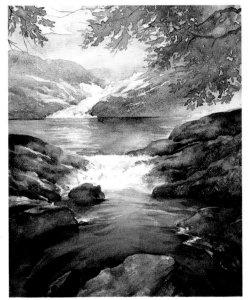
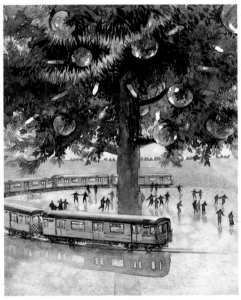
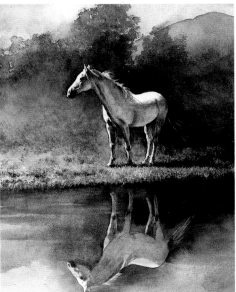
79

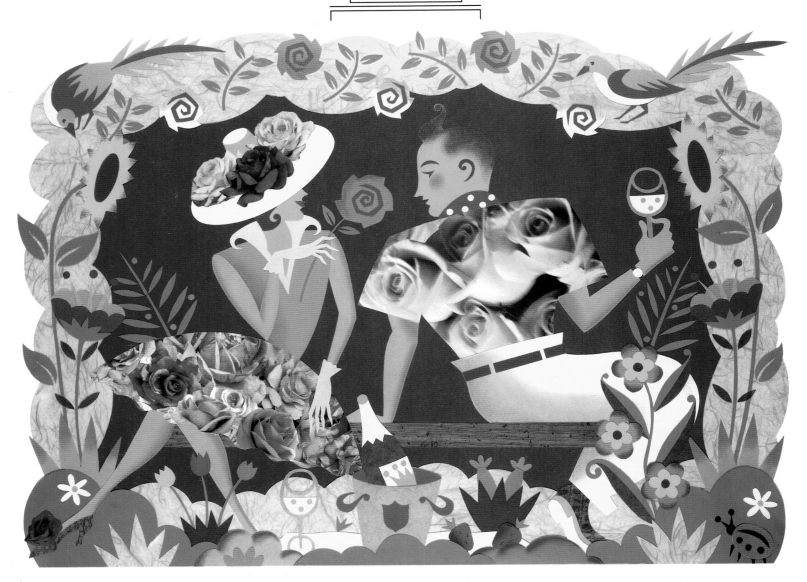

visa

continental airlines

nestlé

urban outfitters

microsoft

yoplait

lindgren & smith

chicago 312.819.0880 new york 212.397.7330 san francisco 415.788.8552

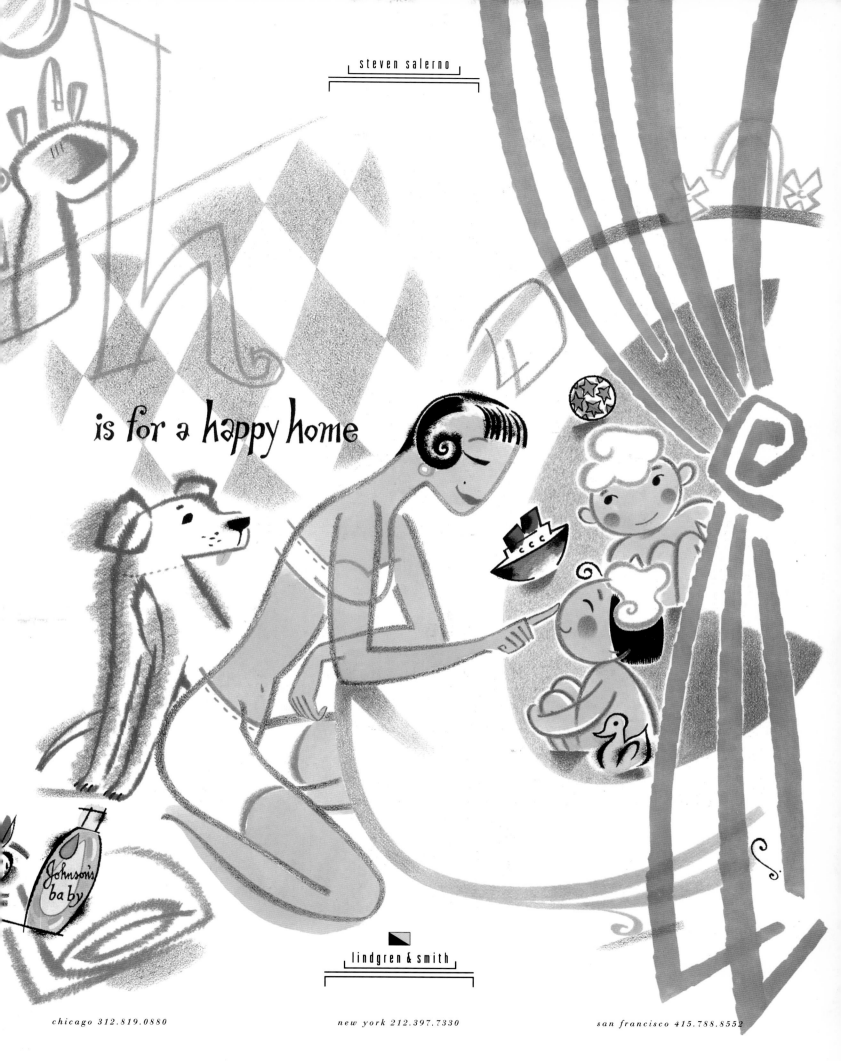

ARTCO

ED ACUNA

ARTCO ♦ Gail Thurm and Jeff Palmer

Serving Clients within New York City: 232 Madison Avenue ♦ Room 402 ♦ New York, NY 10016 (212) 889-8777 ♦ fax (212) 447-1475

Serving Clients outside New York City: 227 Godfrey Road ♦ Weston ♦ CT 06883 (203) 222-8777 ♦ fax (203) 454-9940

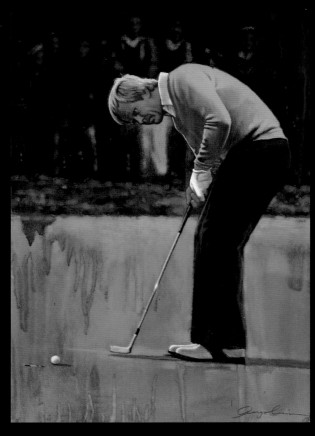
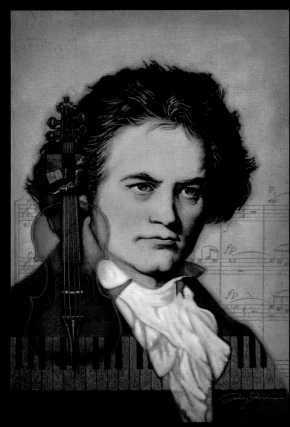

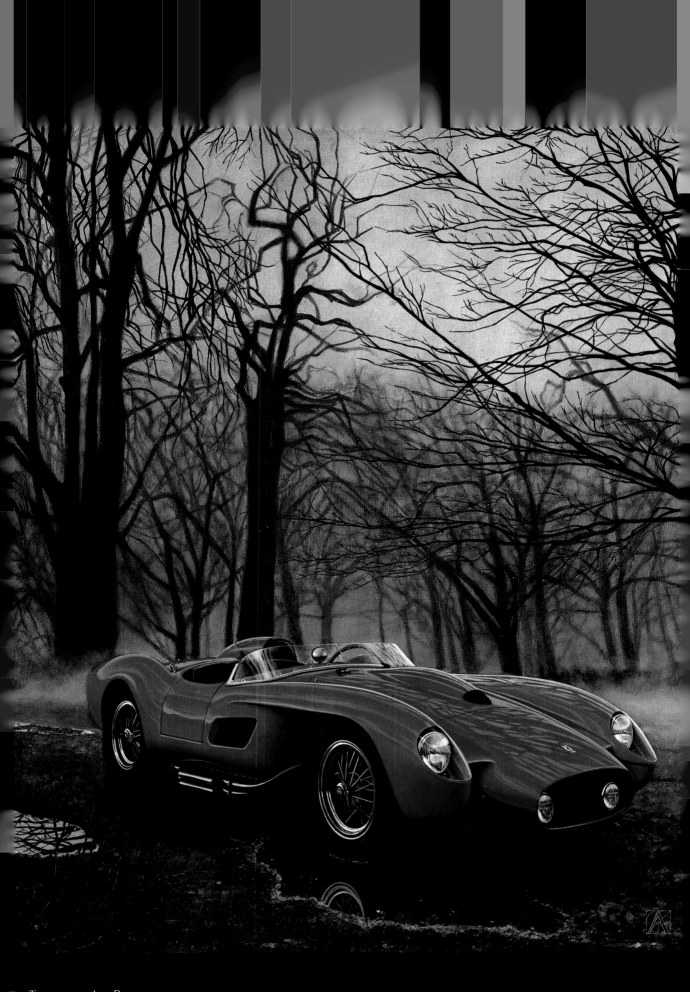

GAIL THURM AND JEFF PALMER

'S WITHIN NEW YORK CITY: 232 MADISON AVENUE ♦ ROOM 402 ♦ NEW YORK, NY 10016 (212) 889-8777 ♦ FAX (21᠁

ARTCO

VINCENT DI FATE

MORT DRUCKER

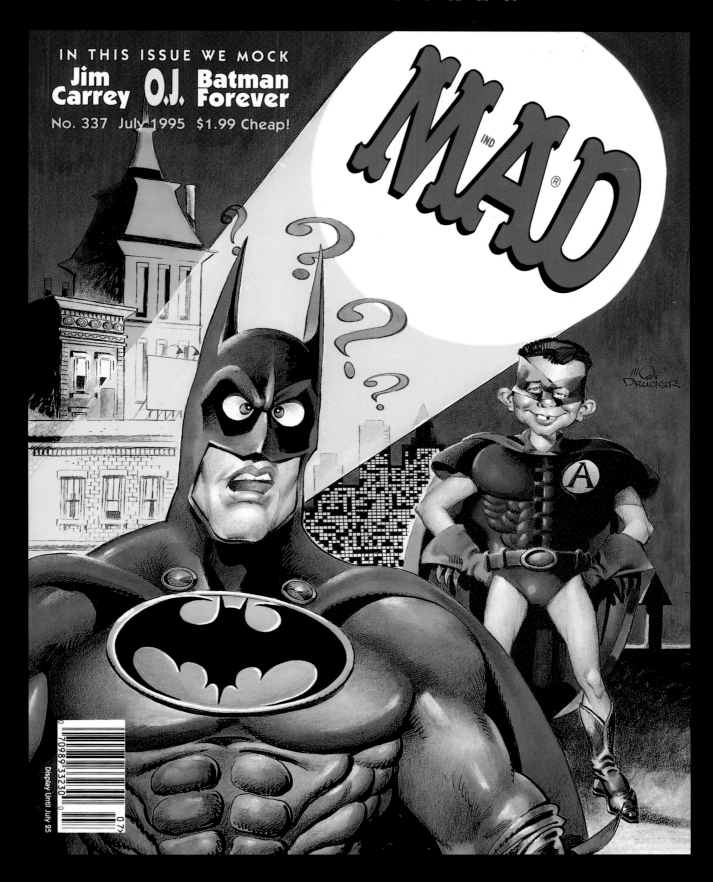

ARTCO ◆ Gail Thurm and Jeff Palmer

Serving Clients within New York City: 232 Madison Avenue ◆ Room 402 ◆ New York, NY 10016 (212) 889-8777 ◆ fax (212) 447-1475
Serving Clients outside New York City: 227 Godfrey Road ◆ Weston ◆ CT 06883 (203) 222-8777 ◆ fax (203) 454-9940

ARTCO

MICHAEL EDHOLM

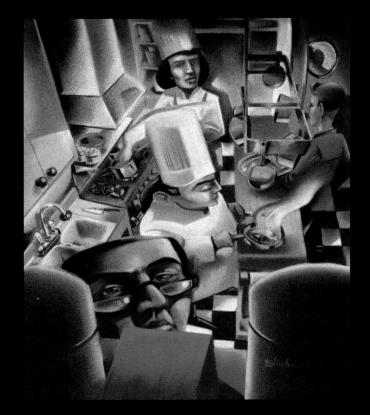

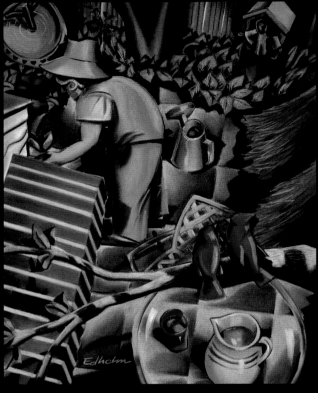

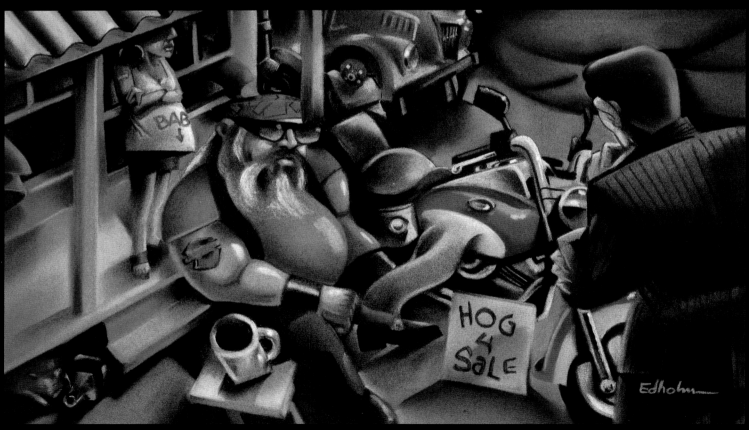

ARTCO ♦ GAIL THURM AND JEFF PALMER

SERVING CLIENTS WITHIN NEW YORK CITY: 232 MADISON AVENUE ♦ ROOM 402 ♦ NEW YORK, NY 10016 (212) 889-8777 ♦ FAX (212) 447-1475
SERVING CLIENTS OUTSIDE NEW YORK CITY: 227 GODFREY ROAD ♦ WESTON ♦ CT 06883 (203) 222-8777 ♦ FAX (203) 454-9940

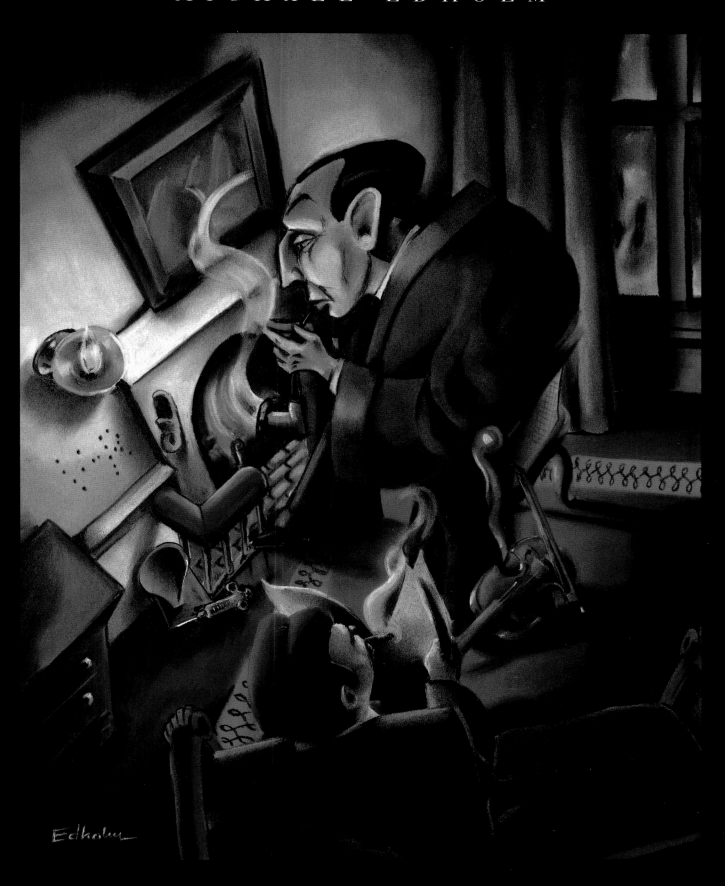

ARTCO

LISA HENDERLING

ARTCO ♦ Gail Thurm and Jeff Palmer

Serving Clients within New York City: 232 Madison Avenue ♦ Room 402 ♦ New York, NY 10016 (212) 889-8777 ♦ fax (212) 447-1475
Serving Clients outside New York City: 227 Godfrey Road ♦ Weston ♦ CT 06883 (203) 222-8777 ♦ fax (203) 454-9940

JAMES KIRKLAND

ARTCO ♦ Gail Thurm and Jeff Palmer

Serving Clients within New York City: 232 Madison Avenue ♦ Room 402 ♦ New York, NY 10016 (212) 889-8777 ♦ fax (212) 447-1475
Serving Clients outside New York City: 227 Godfrey Road ♦ Weston ♦ CT 06883 (203) 222-8777 ♦ fax (203) 454-9940

ARTCO

JOHN PORTER

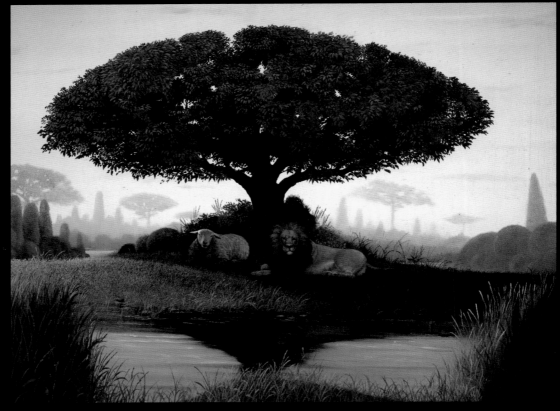

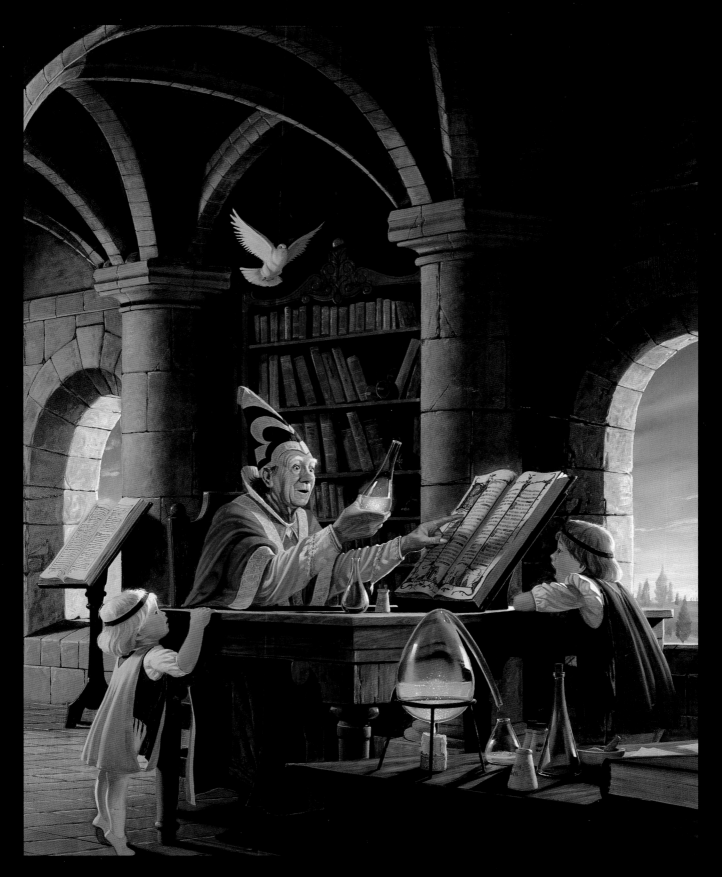

ARTCO ♦ Gail Thurm and Jeff Palmer

Serving Clients within New York City: 232 Madison Avenue ♦ Room 402 ♦ New York, NY 10016 (212) 889-8777 ♦ fax (212) 447-1475
Serving Clients outside New York City: 227 Godfrey Road ♦ Weston ♦ CT 06883 (203) 222-8777 ♦ fax (203) 454-9940

ARTCO

OREN SHERMAN

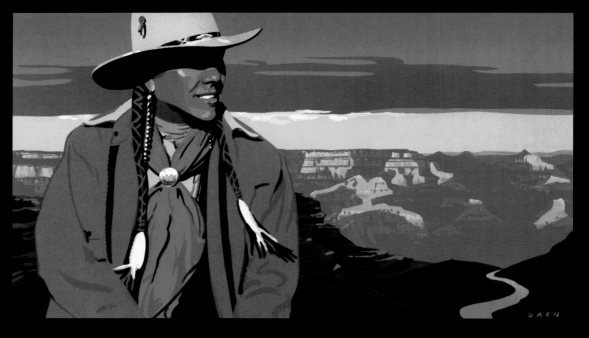

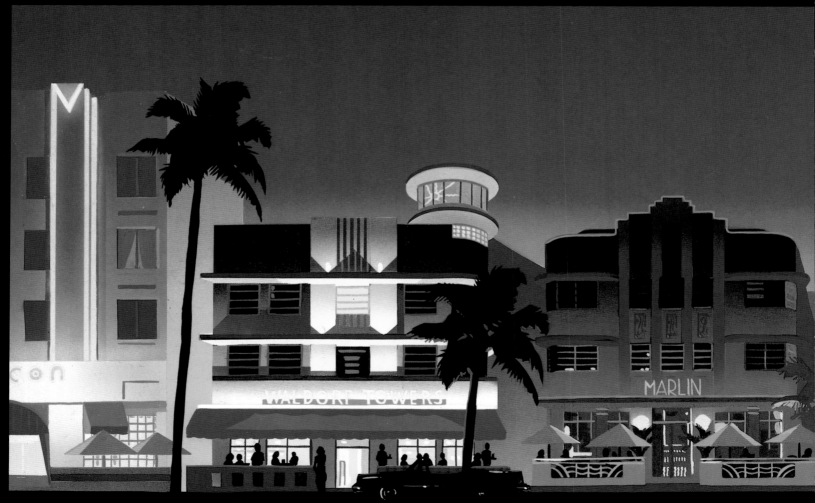

ARTCO ♦ Gail Thurm and Jeff Palmer

Serving Clients within New York City: 232 Madison Avenue ♦ Room 402 ♦ New York, NY 10016 (212) 889-8777 ♦ fax (212) 447-1475

Serving Clients outside New York City: 227 Godfrey Road ♦ Weston ♦ CT 06883 (203) 222-8777 ♦ fax (203) 454-9940

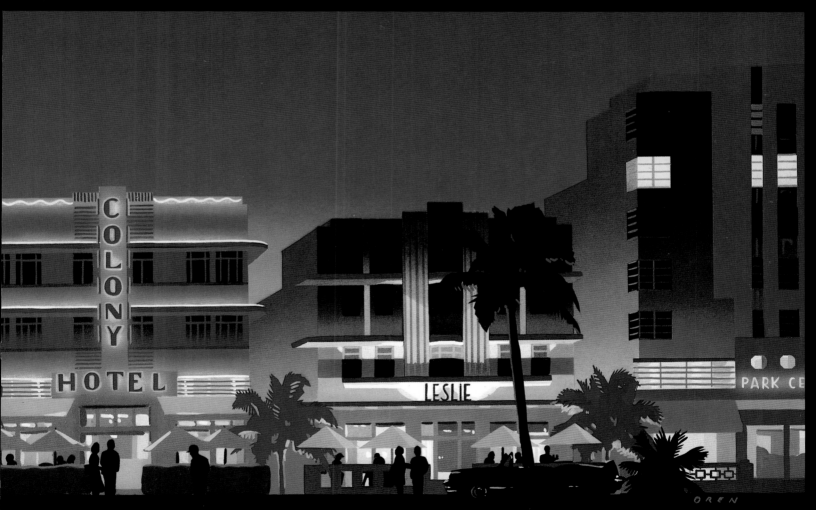

ARTCO ◆ Gail Thurm and Jeff Palmer

Serving Clients within New York City: 232 Madison Avenue ◆ Room 402 ◆ New York, NY 10016 (212) 889-8777 ◆ fax (212) 447-1475
Serving Clients outside New York City: 227 Godfrey Road ◆ Weston ◆ CT 06883 (203) 222-8777 ◆ fax (203) 454-9940

ARTCO

JOHN STEPHENS

JOHN STEPHENS

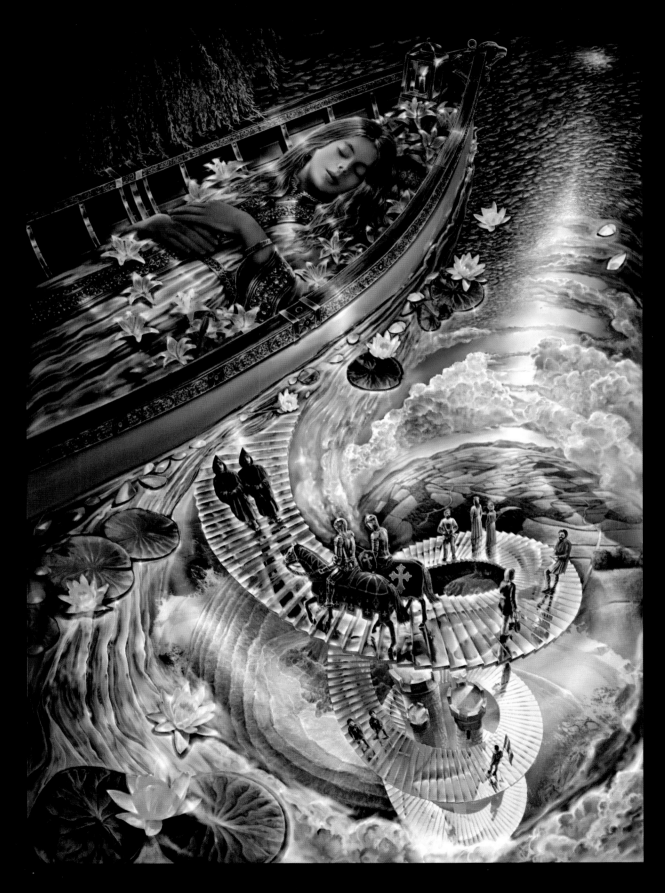

ARTCO L.L.C. • Gail Thurm and Jeff Palmer

Serving clients within New York City:
Serving clients outside New York City:

232 Madison Avenue, Suite 402 • New York, NY 10016
227 Godfrey Road • Weston, Connecticut 06883

(212) 889-8777 • Fax (212) 447-1475
(203) 222-8777 • Fax (203) 454-9940

DOUG STRUTHERS

COMPUTER ILLUSTRATION, ANIMATION

0 ◆ GAIL THURM AND JEFF PALMER

CLIENTS WITHIN NEW YORK CITY: 232 MADISON AVENUE ◆ ROOM 402 ◆ NEW YORK, NY 10016 (212) 889-8777 ◆ FAX (212) 44

CLIENTS OUTSIDE NEW YORK CITY: 227 GODFREY ROAD ◆ WESTON ◆ CT 06883 (203) 222-8777 ◆ FAX (203) 45

DOUG STRUTHERS

Computer Illustration, Animation

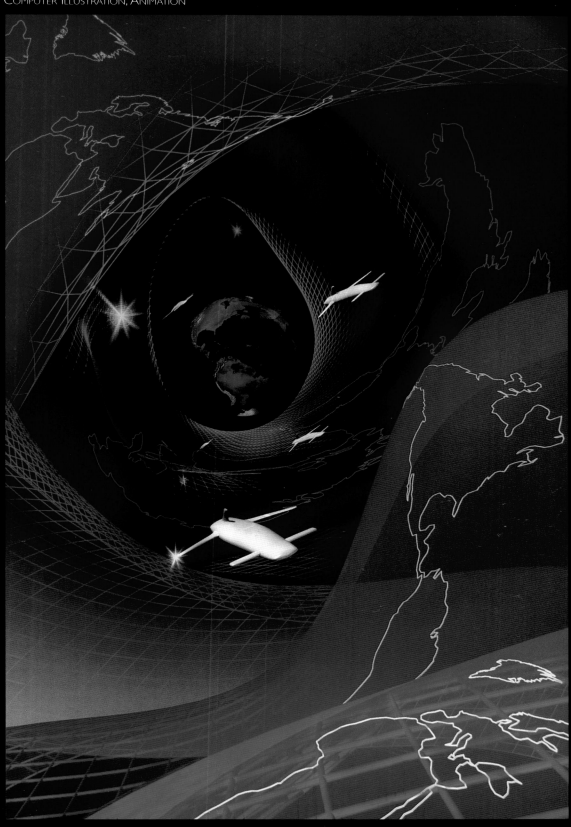

ARTCO ◆ Gail Thurm and Jeff Palmer

Serving Clients within New York City: 232 Madison Avenue ◆ Room 402 ◆ New York, NY 10016 (212) 889-8777 ◆ fax (212) 447-1475
Serving Clients outside New York City: 227 Godfrey Road ◆ Weston ◆ CT 06883 (203) 222-8777 ◆ fax (203) 454-9940

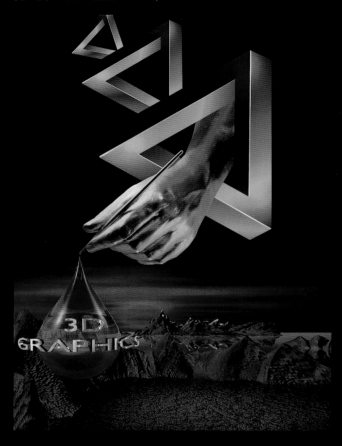
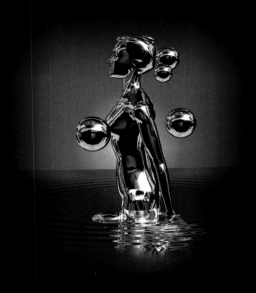

STUDIO MACBETH

3D COMPUTER ILLUSTRATION, ANIMATION

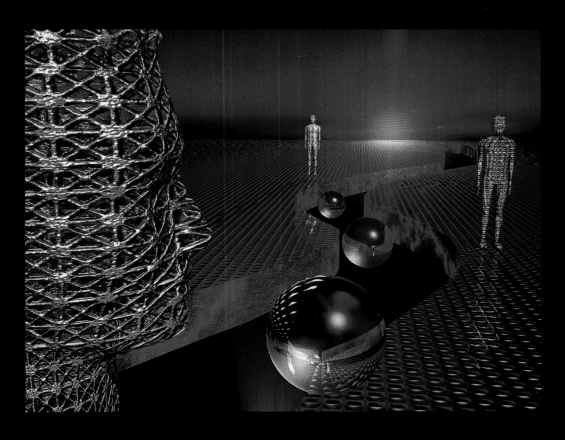

ARTCO ♦ GAIL THURM AND JEFF PALMER

SERVING CLIENTS WITHIN NEW YORK CITY: 232 MADISON AVENUE ♦ ROOM 402 ♦ NEW YORK, NY 10016 (212) 889-8777 ♦ FAX (212)
SERVING CLIENTS OUTSIDE NEW YORK CITY: 227 GODFREY ROAD ♦ WESTON ♦ CT 06883 (203) 222-8777 ♦ FAX (203)

HEIDI TAILLEFER

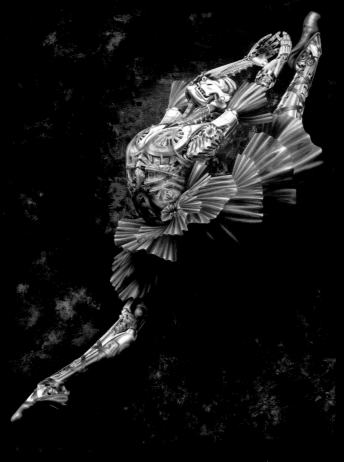

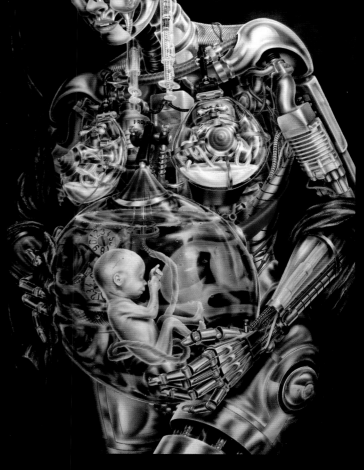

ARTCO ♦ Gail Thurm and Jeff Palmer

Serving Clients within New York City: 232 Madison Avenue ♦ Room 402 ♦ New York, NY 10016 (212) 889-8777 ♦ fax (212) 447-1475

Serving Clients outside New York City: 227 Godfrey Road ♦ Weston ♦ CT 06883 (203) 222-8777 ♦ fax (203) 454-9940

HEIDI TAILLEFER

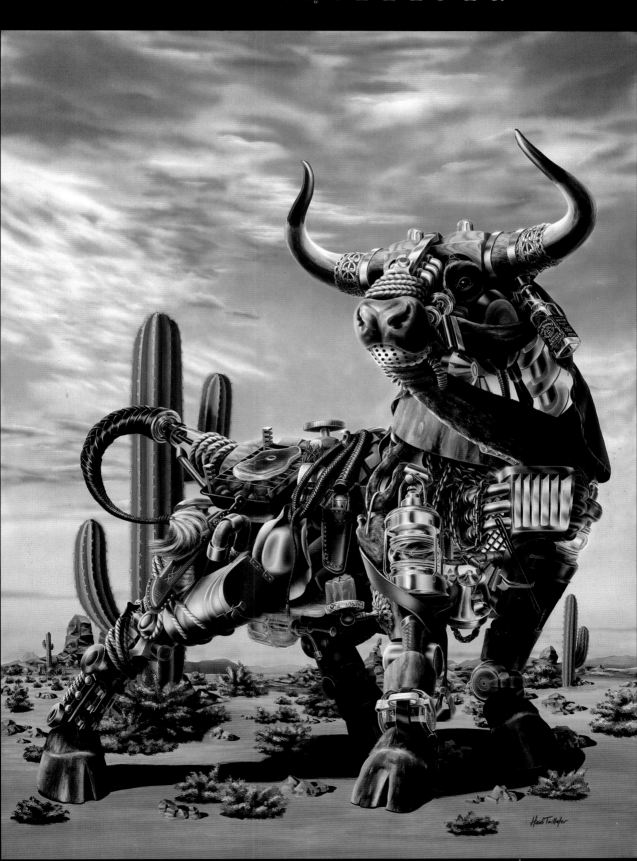

ARTCO

LARRY TAUGHER

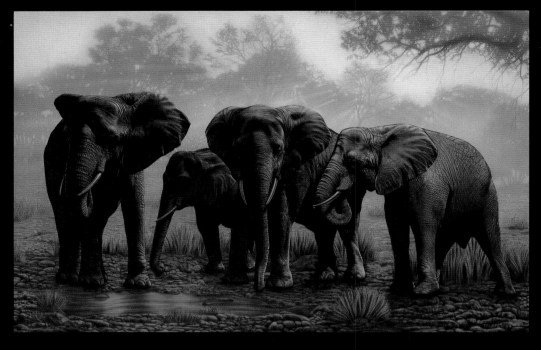

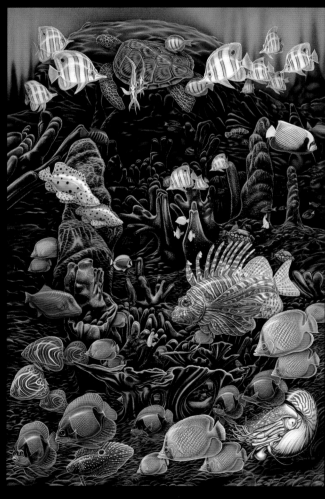

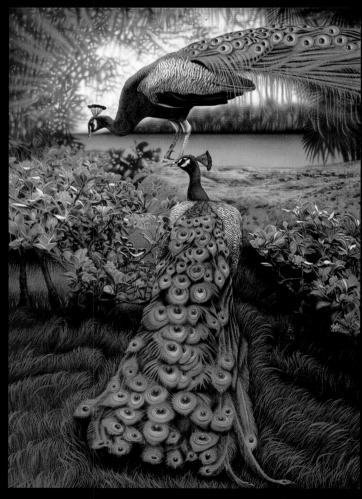

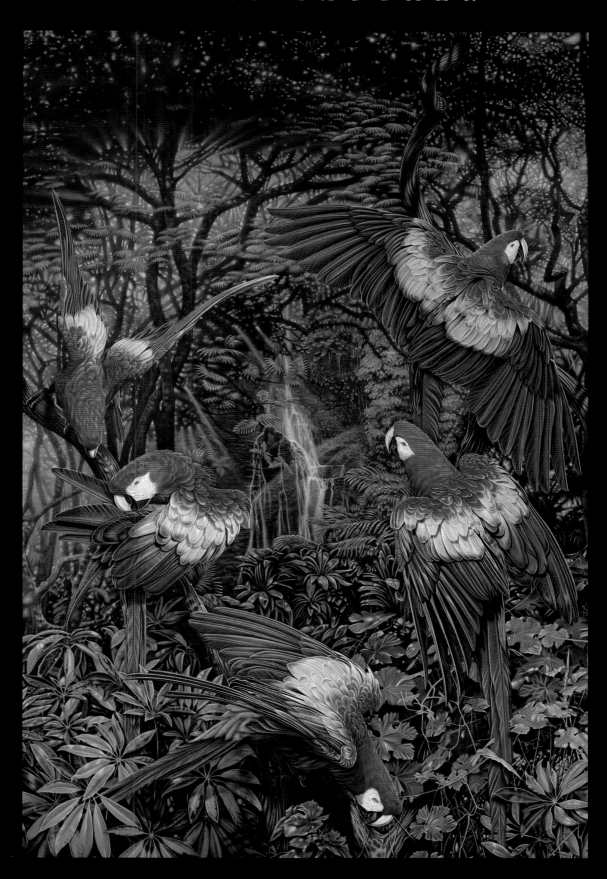

S A L L Y V I T S K Y

Things to take into the New Year

ARTCO
SALLY JOVITSKY
I·L·L·U·S·T·R·A·T·I·O·N
(804) 359-4726
4116 Bromley Lane
Richmond, Virginia 23221

PAUL WILEY

ARTCO

DORON BEN-AMI

KIMBLE PENDLETON MEAD

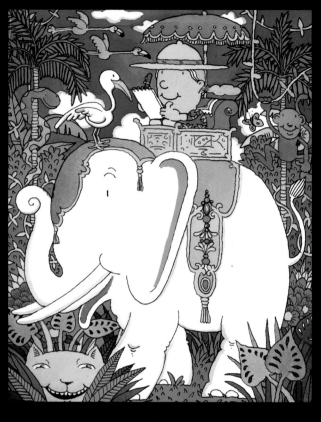

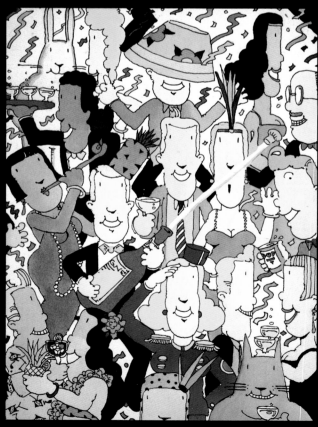

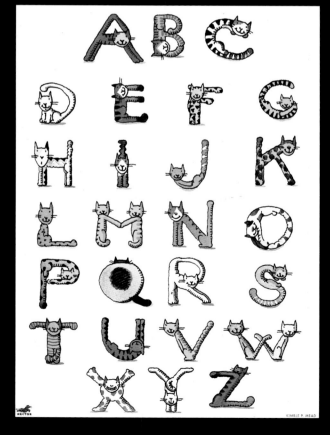

ARTCO ◆ GAIL THURM AND JEFF PALMER

SERVING CLIENTS WITHIN NEW YORK CITY: 232 MADISON AVENUE ◆ ROOM 402 ◆ NEW YORK, NY 10016 (212) 889-8777 ◆ FAX (212) 447-1475
SERVING CLIENTS OUTSIDE NEW YORK CITY: 227 GODFREY ROAD ◆ WESTON ◆ CT 06883 (203) 222-8777 ◆ FAX (203) 454-9940

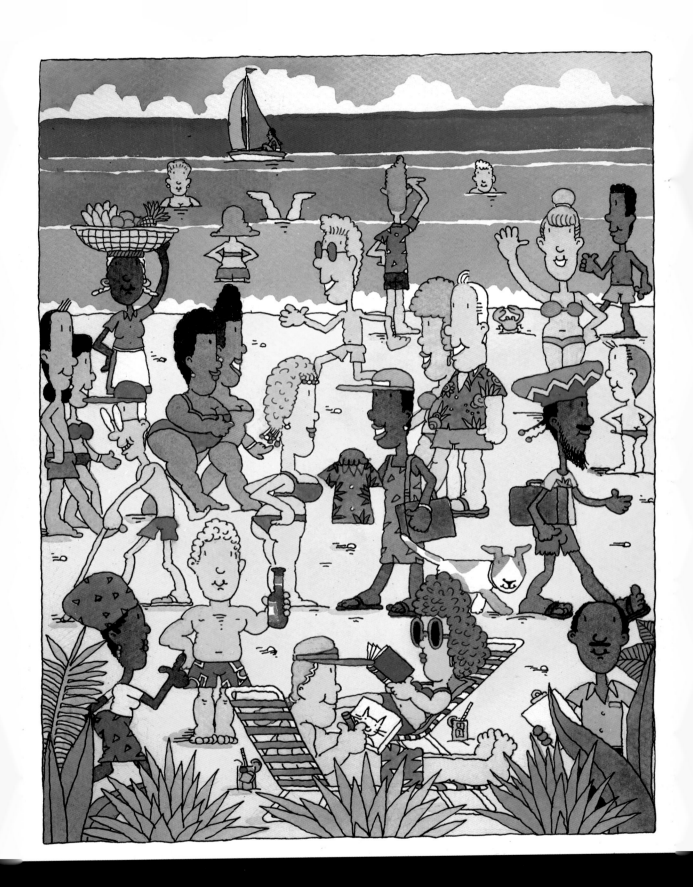

L THURM AND JEFF PALMER

WITHIN NEW YORK CITY: 232 MADISON AVENUE ♦ ROOM 402 ♦ NEW YORK, NY 10016 (212) 889-8777 ♦ FAX (

DELL COMPUTERS

ZETHCON

THE ATLANTIC MONTHLY

JACQUELINE DeDELL *Inc*

WINDOW SOURCES

JACQUELINE DeDELL *Inc.* 58 WEST 15TH STREET, NEW YORK, NEW YORK, 10011 **TEL:** (212) 741-2539 **FAX:** (212) 741-4660

REPRESENTING *Stan* GAZ

AMERICA'S AGENDA

MEETINGS & CONVENTIONS

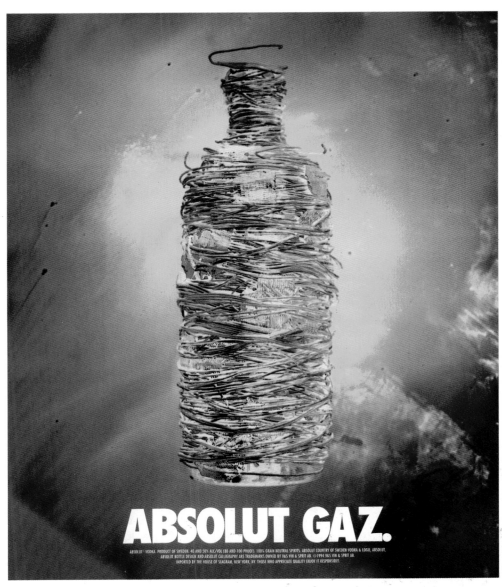

WIRED

ABSOLUT GAZ.

JACQUELINE DEDELL

Inc

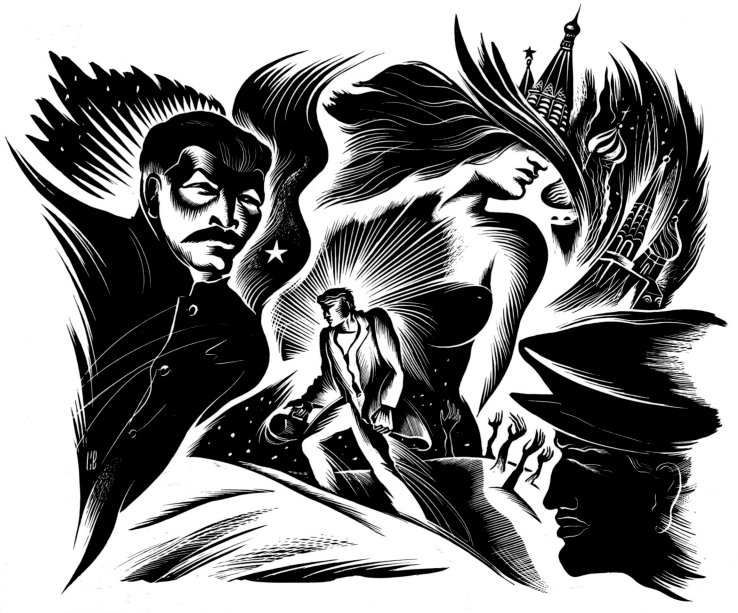

THE WASHINGTON POST

THE NEW YORK TIMES

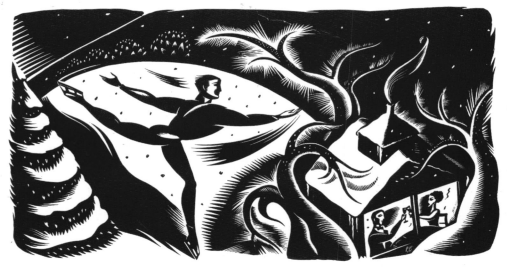

SAVAGE DESIGN

THE WASHINGTON POST

JACQUELINE DEDELL Inc

JACQUELINE DEDELL *Inc* 58 WEST 15TH STREET, NEW YORK, NEW YORK, 10011 **TEL:** (212) 741-2539 **FAX:** (212) 741-4660

ST. MARTIN'S PRESS

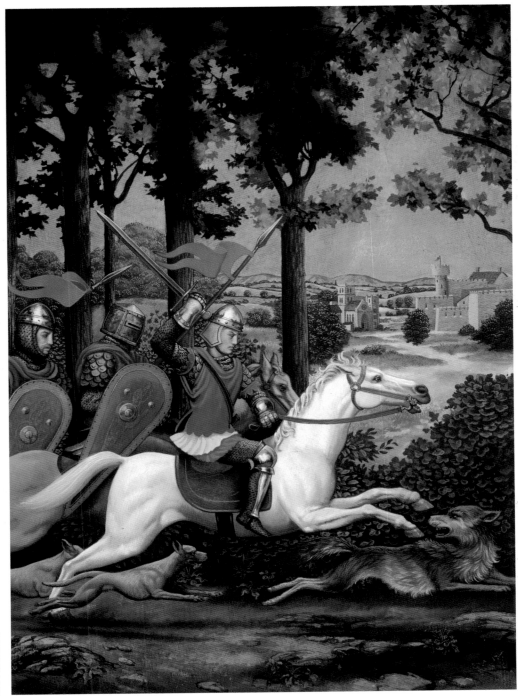

BALLANTINE BOOKS

JACQUELINE DEDELL Inc

DEK COMMUNICATION/BREAST CARE GUIDE

BLOOMBERG MAGAZINE

Chez Nous

HARPER COLLINS

RODALE PRESS

SHISEIDO/JAPAN

JACQUELINE DEDELL Inc.

JOSELINE DOBELL Inc 58 WEST 15TH STREET, NEW YORK, NEW YORK 10011 TEL: (212) 741-2528 FAX: (212) 741-4660

SCHERING PLOUGH ANNUAL REPORT

JACQUELINE DEDELL *Inc*

MONA MEYER McGRATH & GAVIN / LIVING SMARTER MAGAZINE

la maison

le bateau

le coq

la fleur

JACQUELINE DEDELL Inc. 58 WEST 15TH STREET, NEW YORK, NEW YORK, 10011 **TEL:** (212) 741-2539 **FAX:** (212) 741-4660

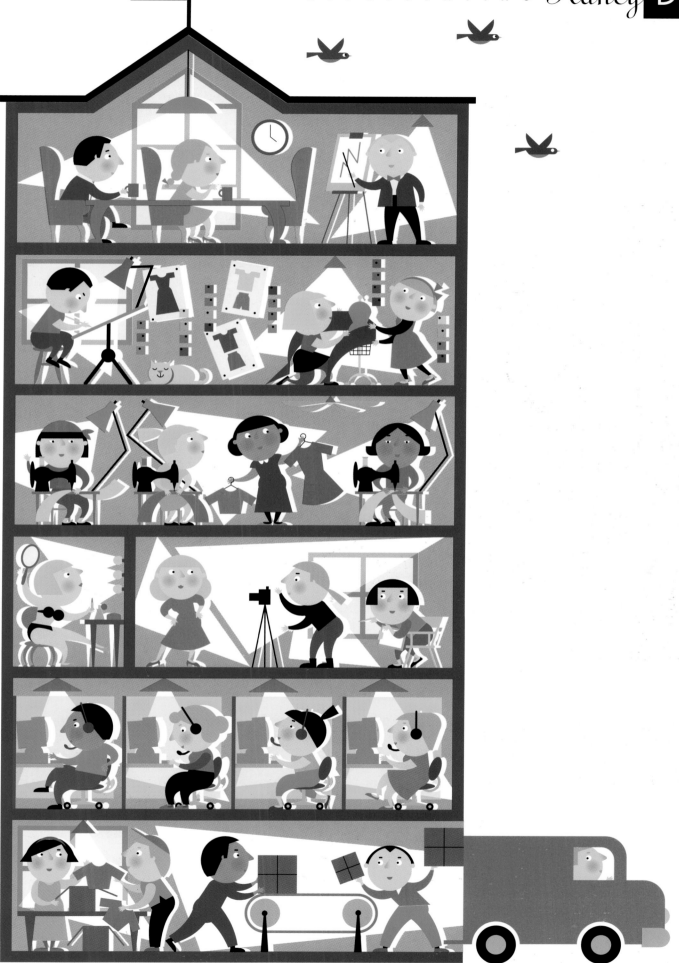

JACQUELINE DeDELL Inc

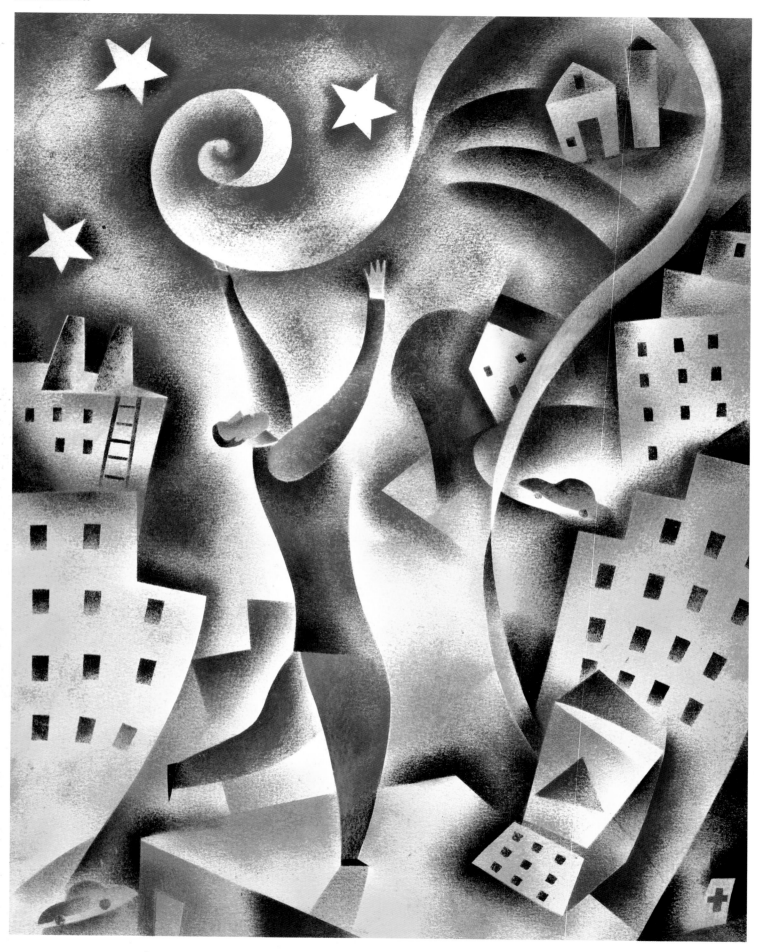

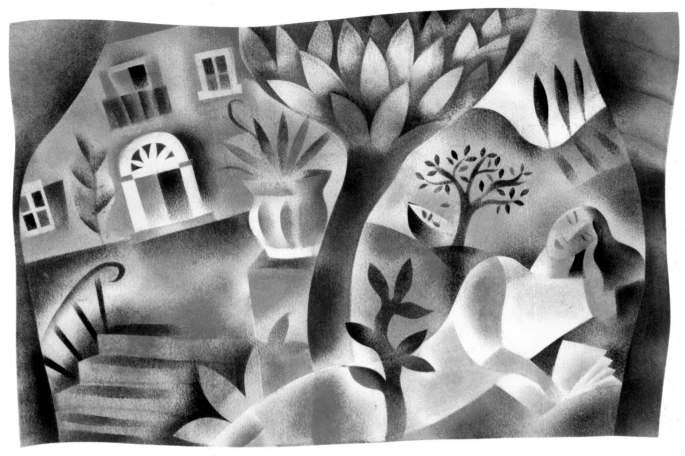

HOUSE BEAUTIFUL MAGAZINE

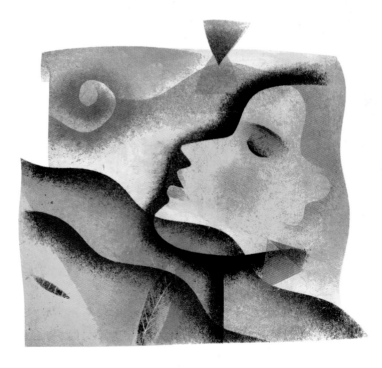

NEW AGE JOURNAL

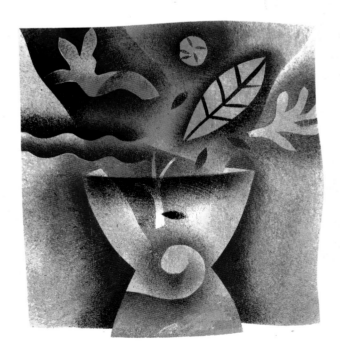

JACQUELINE DEDELL *Inc.*

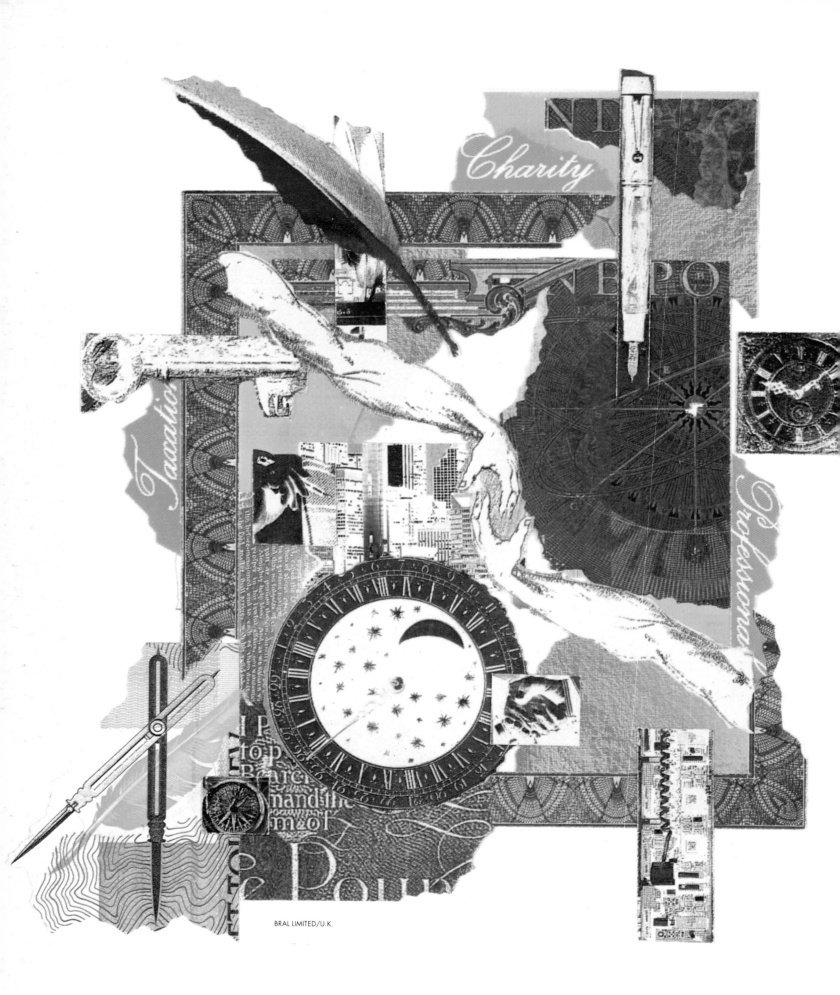

BRAL LIMITED/U.K.

JACQUELINE DeDELL *Inc* 58 WEST 15TH STREET, NEW YORK, NEW YORK, 10011 **TEL:** (212) 741-2539 **FAX:** (212) 741-4660

REPRESENTING *David* **LOFTUS**

BRAL LIMITED/U.K.

PHILIPS ELECTRONICS/HOLLAND

JACQUELINE DEDELL *Inc*

AVON

AVON

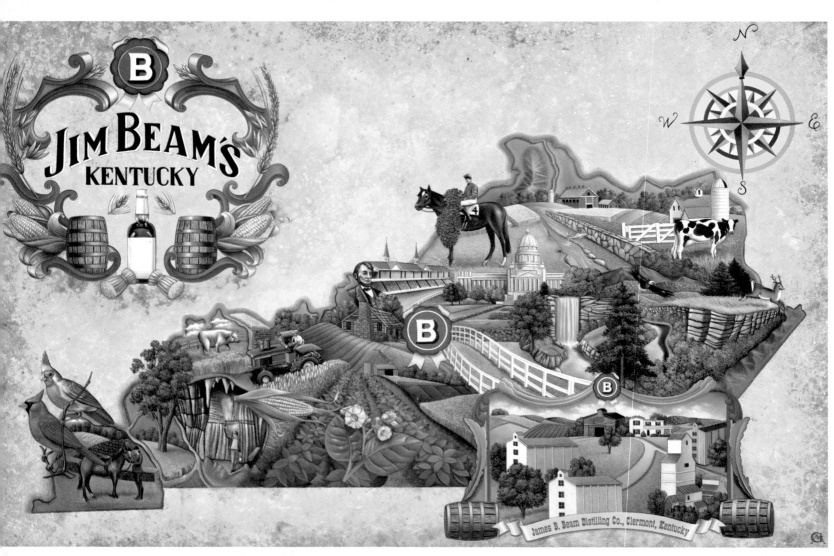

MURAL FOR JIM BEAM DISTILLERY CENTER

JACQUELINE DELL

Inc

ARISMENDI KNOX/HUDSON RIVER PARK CONSERVANCY

TIME MAGAZINE CORPORATE CHRISTMAS CARD

THE HARTFORD COURANT

JACQUELINE DEDELL Inc.

W.H. SMITH/U.K.

THE DESIGN COUNCIL

ONE DAY TRAVELCARD USER
ALL THIS COULD BE YOURS.

UNDERGROUND

NETWORK SOUTHEAST RAILWAYS/U.

JACQUELINE DEDELL Inc 58 WEST 15TH STREET, NEW YORK, NEW YORK, 10011 **TEL:** (212) 741-2539 **FAX:** (212) 741-4660

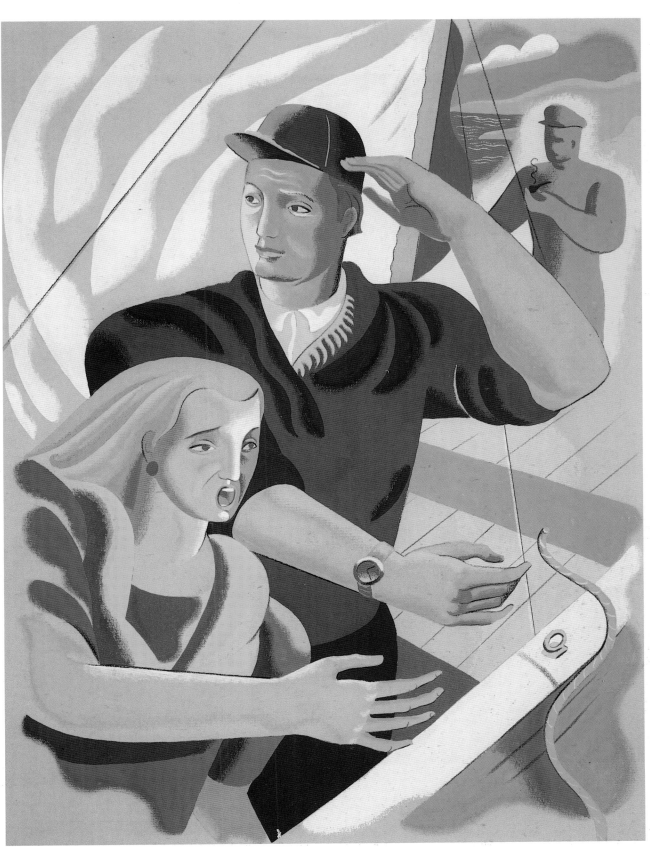

JACQUELINE DeDELL Inc.

DORLING KINDERSLEY

HUTAMAKI / FINLAND

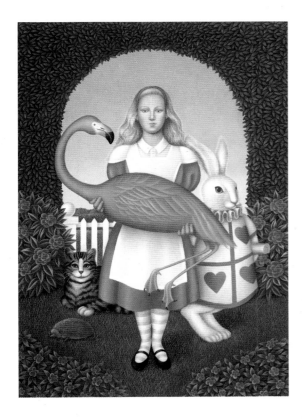

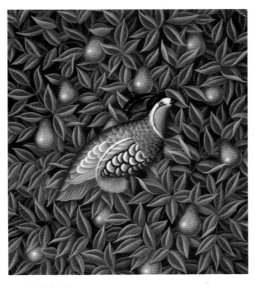

GLITTERWRAP INC.

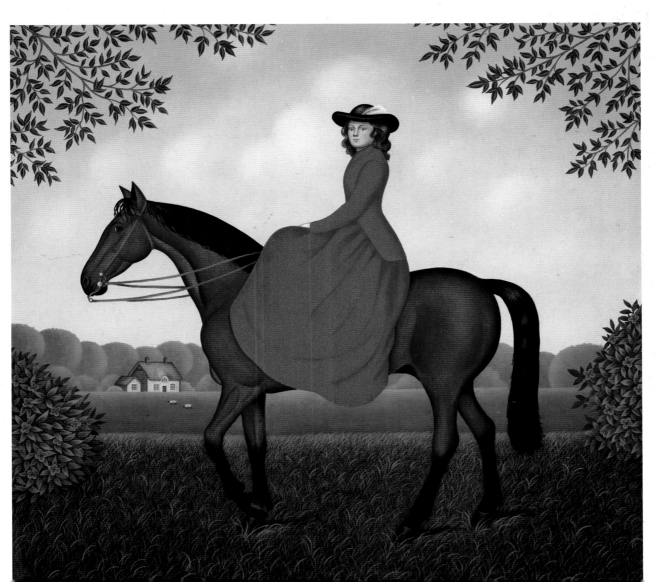

JACQUELINE DEDELL *Inc.*

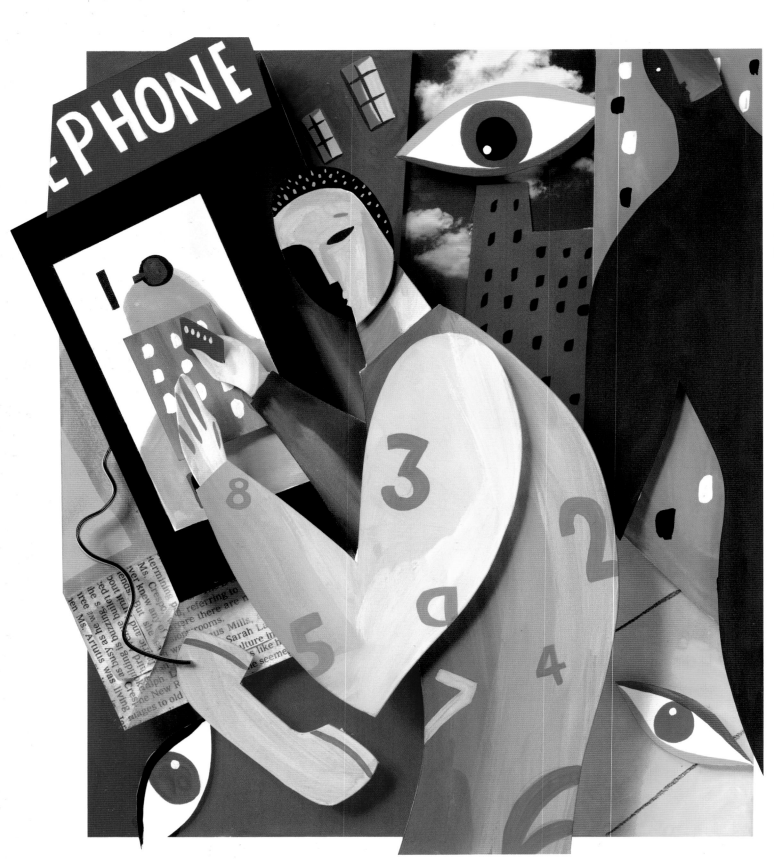

BUSINESS WEEK

JACQUELINE DeDELL *Inc* 58 WEST 15TH STREET, NEW YORK, NEW YORK, 10011 **TEL:** (212) 741-2539 **FAX:** (212) 741-4660

DELICIOUS MAGAZINE

DONOVAN DESIGN

JACQUELINE DEDELL Inc.

SMASHING PLATES

DOWNEAST DESIGN

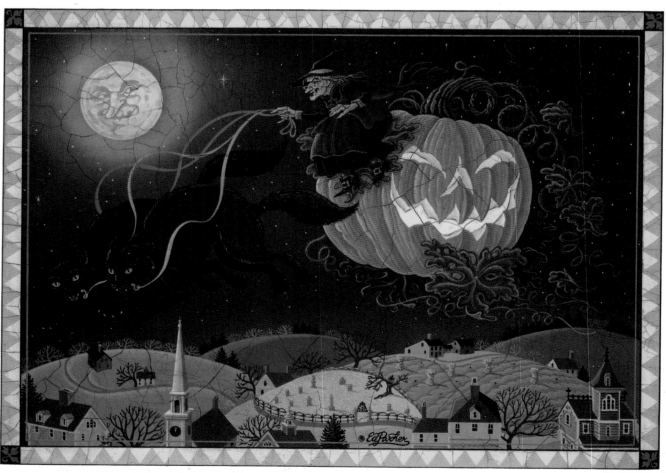

JACQUELINE DEDELL Inc 58 WEST 15TH STREET, NEW YORK, NEW YORK, 10011 **TEL:** (212) 741-2539 **FAX:** (212) 741-4660

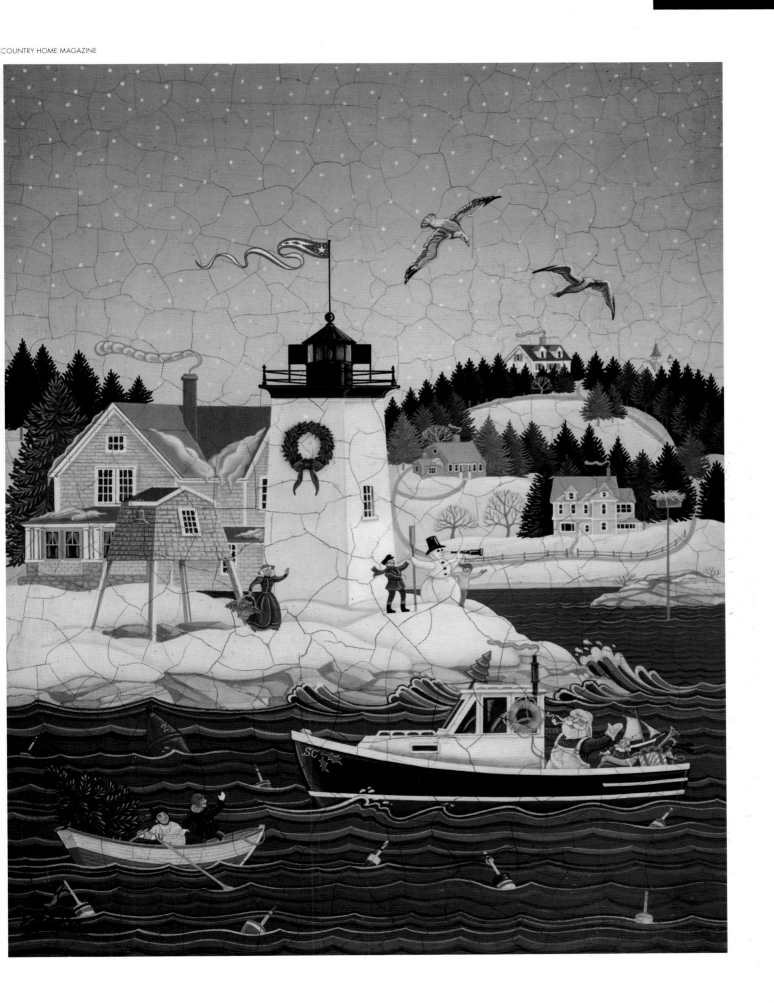

COUNTRY HOME MAGAZINE

JACQUELINE DEDELL Inc

108 East 35 St.
New York 10016
Phone: (212) 889-3337
Fax: (212) 889-3341

GERALD & CULLEN RAPP, INC.

Philip
Anderson

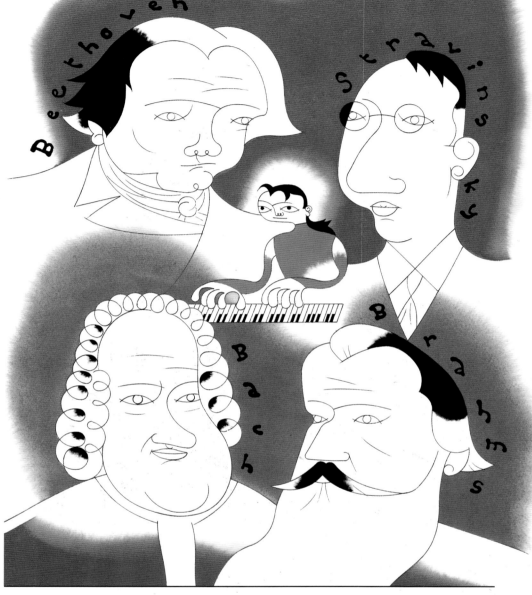

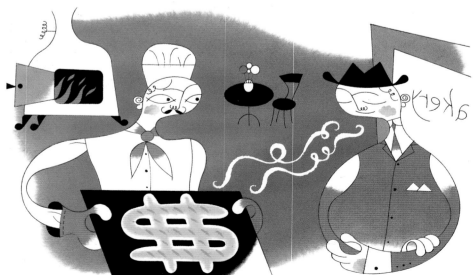

GERALD & CULLEN RAPP, INC.
Phone: (212) 889 3337

Philip
Anderson

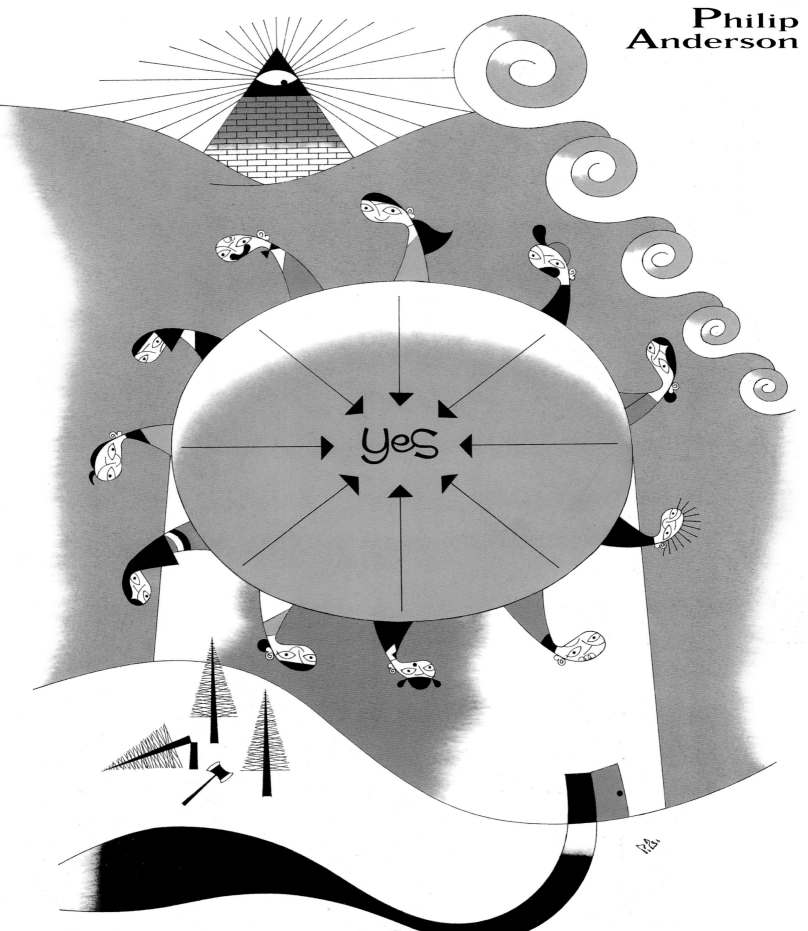

108 East 35 St.
New York 10016
Phone: (212) 889-3337
Fax: (212) 889-3341

GERALD & CULLEN RAPP, INC.

Nanette Biers

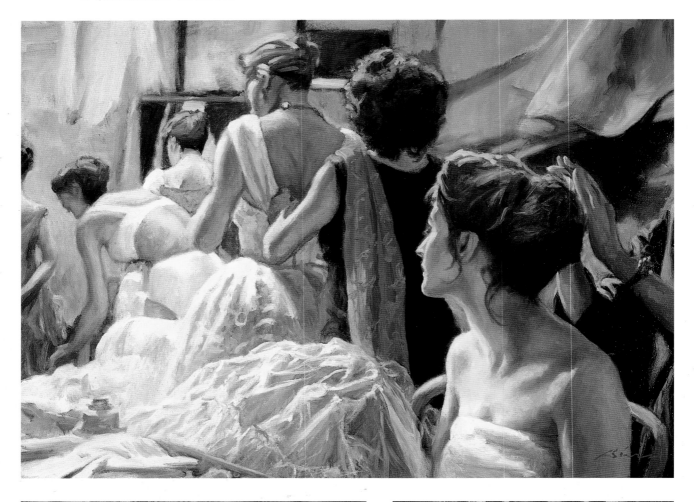

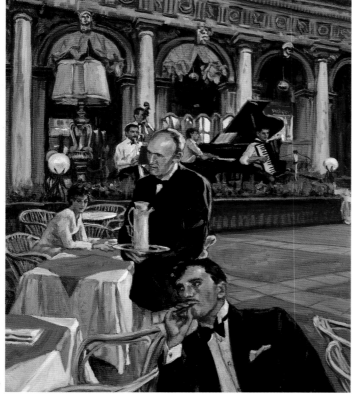

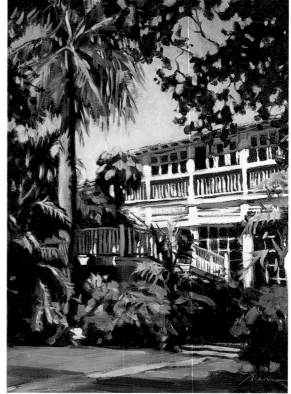

Nanette Biers

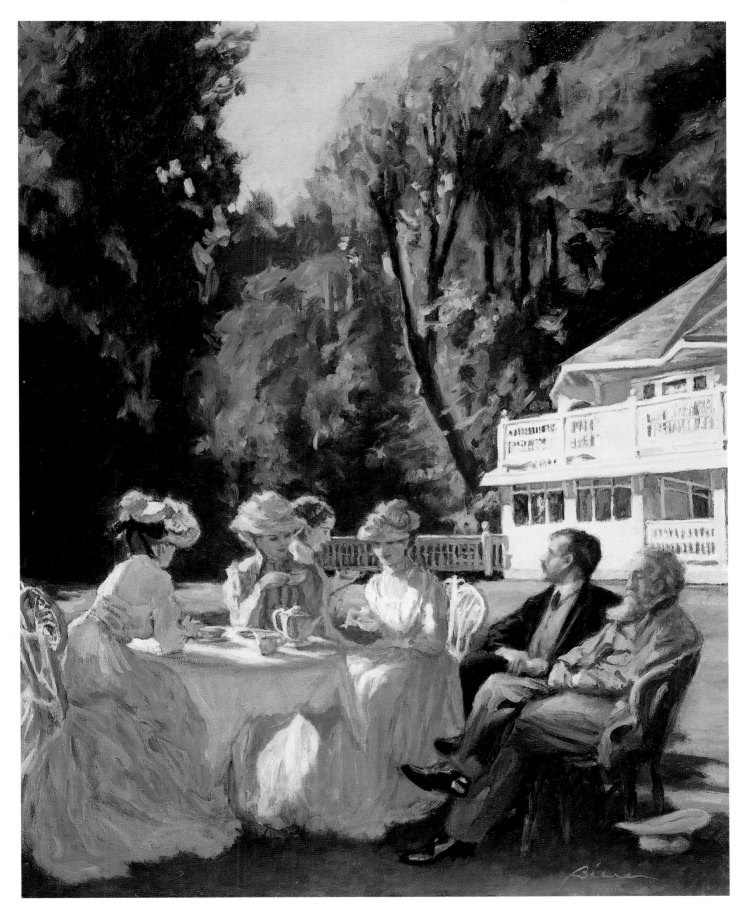

108 East 35 St.
New York 10016
Phone: (212) 889-3337
Fax: (212) 889-3341

GERALD & CULLEN RAPP, INC.

Stuart Briers

deMichiell

GERALD & CULLEN RAPP, INC
Phone: (212) 889 3337

GERALD & CULLEN RAPP, INC. (212) 889-3337 Fax: (212) 889-3341

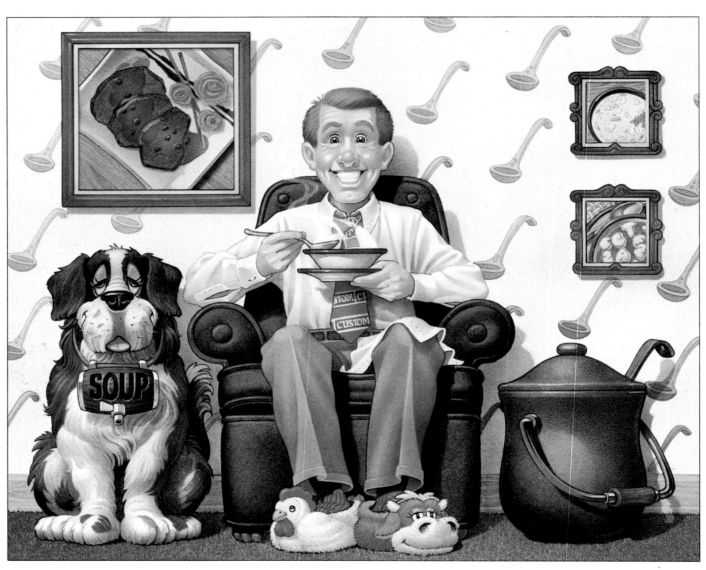

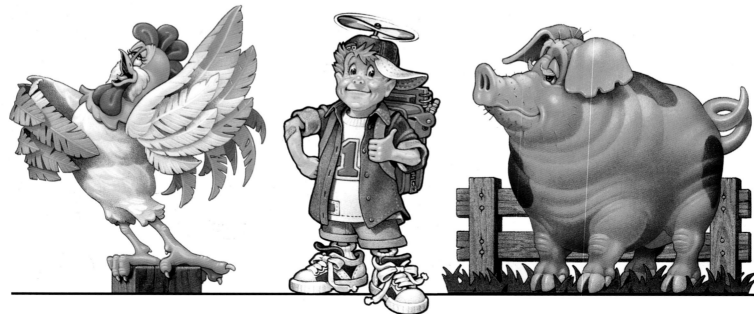

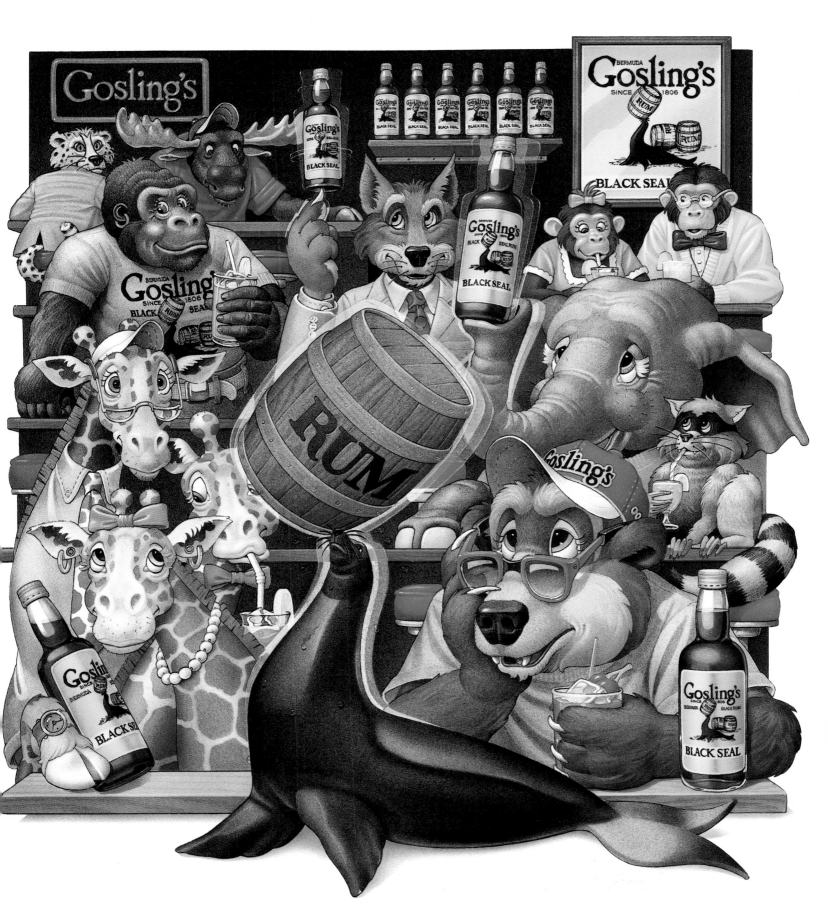

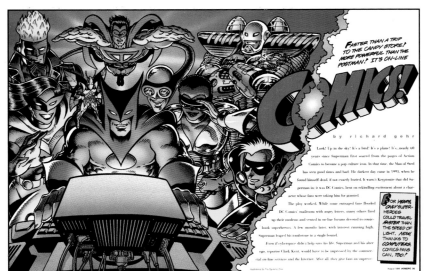

FASTER THAN A TRIP TO THE CANDY STORE! MORE POWERFUL THAN THE POSTMAN! IT'S ON-LINE

Comics!

by richard gehr

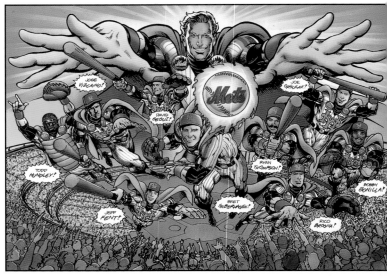

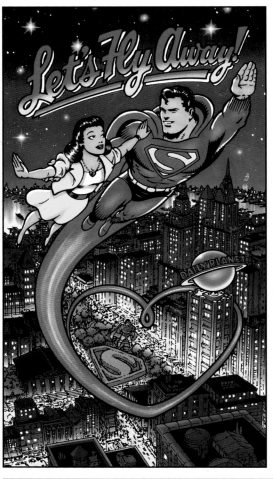

Let's Fly Away!

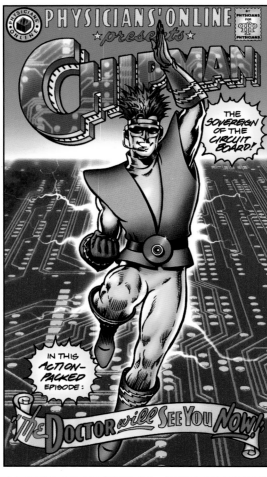

PHYSICIANS'ONLINE presents

CHIPMAN

THE SOVEREIGN OF THE CIRCUIT BOARD!

IN THIS ACTION-PACKED EPISODE:

The Doctor will SEE YOU NOW!

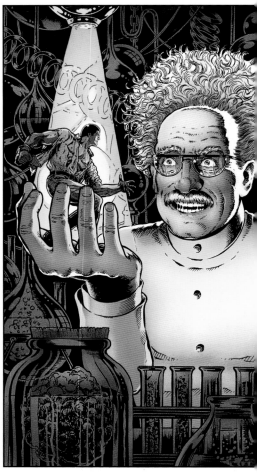

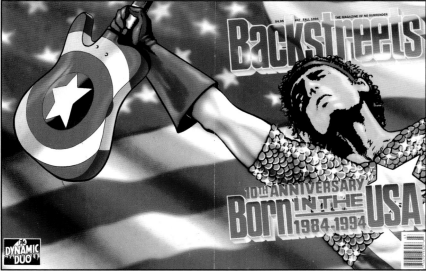

Backstreets

$4.95 #47 FALL 1994 THE MAGAZINE OF NO SURRENDER

10TH ANNIVERSARY Born IN THE USA 1984·1994

DYNAMIC DUO

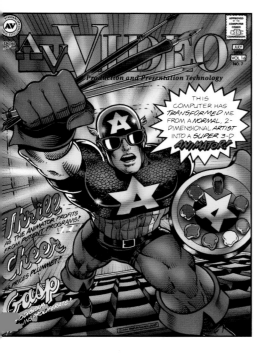

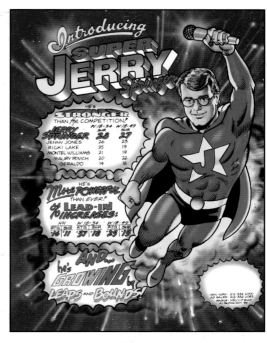

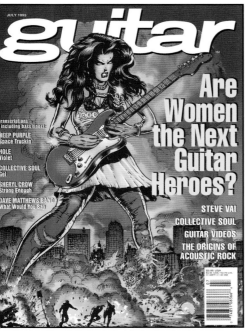

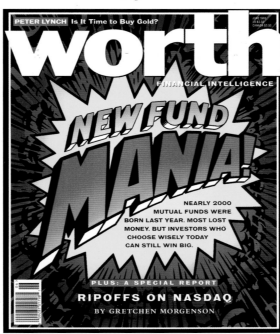

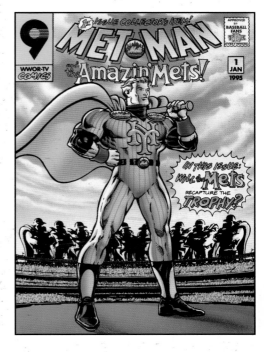

ARLEN SCHUMER & SHERRI WOLFGANG

REPRESENTED BY

GERALD & CULLEN
RAPP, INC.

108 East 35 St.
New York 10016
Phone: (212) 889-3337
Fax: (212) 889-3341

108 East 35 St.
New York 10016
Phone: (212) 889-3337
Fax: (212) 889-3341

GERALD & CULLEN RAPP, INC.

the
warm
and
witty
jacki
GELB

☆

jacki selb

GERALD & CULLEN RAPP, INC.
Phone: (212) 889 3337

TRUTH, SELF-fulfillment, and THE SEARCH FOR THE PERFECT ICED TEA.

FiRST came iced tea in cans.

Then boTTLes.

Then fruity flavors wiTH funny names like Pink Passion ♡ Palooka. ♡

And soon the WORLD Knew that iced tea could be MORE than what AUNT MatiLda served on Sundays.

And they looked anew upon The Iced Tea PoT ™ and said, "EUReKA! I can make this stuff at home.

And have it just the way I want it.

WHenever I want it.

Try new flavors. And only add what I want.

And leave ouT what I don't.

And serve it to my friends ... OR noT."

And that's how it came to pass.

It's YOUR taste. Why noT make it YOUR tea?

167

GERALD RAPP
GERALD & CULLEN RAPP INC.
108 E. 35 St. NY, NY. 10016
212-889-3337

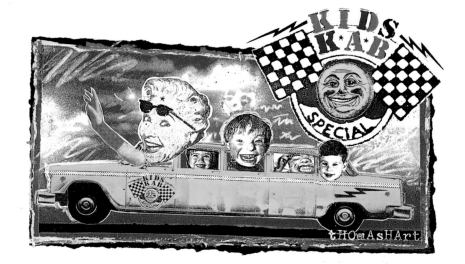

KIDS KAB SPECIAL

tHOmAsHArt

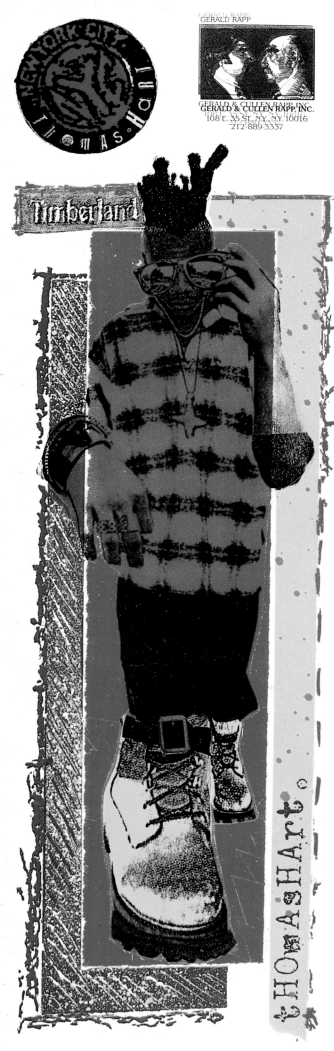

Timberland

tHOmAsHArt©

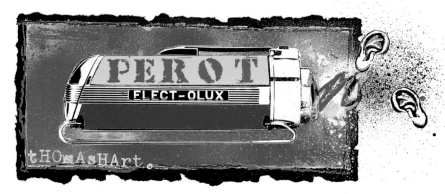

PEROT
ELECT-OLUX

tHOmAsHArt.

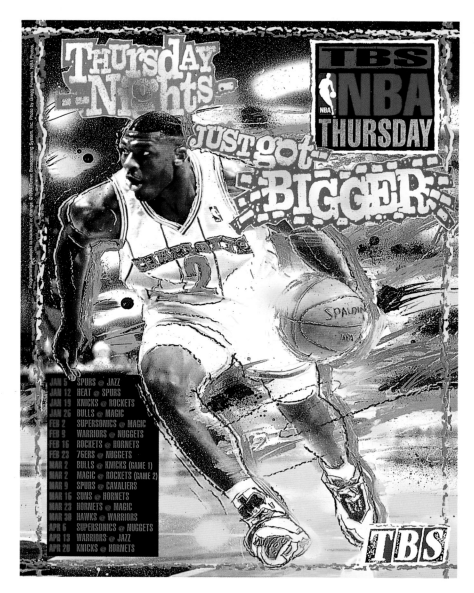

Thursday Nights

TBS NBA THURSDAY

JUST got BIGGER

JAN 5	SPURS @ JAZZ	
JAN 12	HEAT @ SPURS	
JAN 19	KNICKS @ ROCKETS	
JAN 26	BULLS @ MAGIC	
FEB 2	SUPERSONICS @ MAGIC	
FEB 9	WARRIORS @ NUGGETS	
FEB 16	ROCKETS @ HORNETS	
FEB 23	76ERS @ NUGGETS	
MAR 2	BULLS @ KNICKS (GAME 1)	
MAR 2	MAGIC @ ROCKETS (GAME 2)	
MAR 9	SPURS @ CAVALIERS	
MAR 16	SUNS @ HORNETS	
MAR 23	HORNETS @ MAGIC	
MAR 30	HAWKS @ WARRIORS	
APR 6	SUPERSONICS @ NUGGETS	
APR 13	WARRIORS @ JAZZ	
APR 20	KNICKS @ HORNETS	

SPALDING NBA

TBS

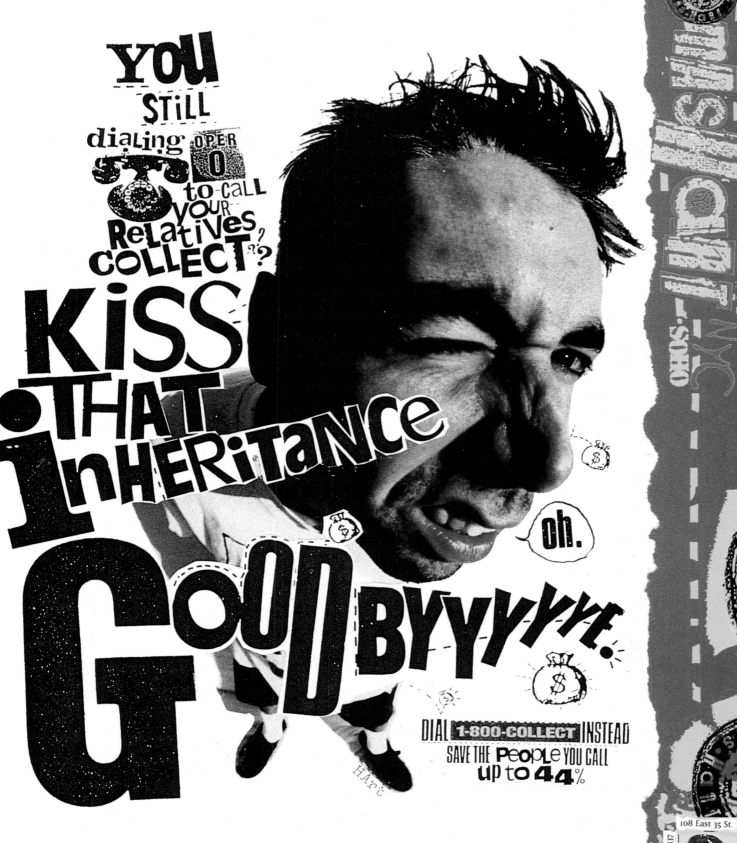

GERALD & CULLEN RAPP INC.

108 E. 35TH ST.
N.Y. N.Y. 10016

phone:
212. 889. 3337

fax:
212. 889. 3341

CLAP
CLAP

Le Cirque D'Automates

Peter Hoey

ILLUSTRATOR–RINGLEADER

represented by: **Gerald & Cullen Rapp, Inc.** phone: **212. 889. 3337**

108 East 35 St.
New York 10016
Phone: (212) 889-3337
Fax: (212) 889-3341

GERALD & CULLEN RAPP, INC.

Celia Johnson

Celia Johnson

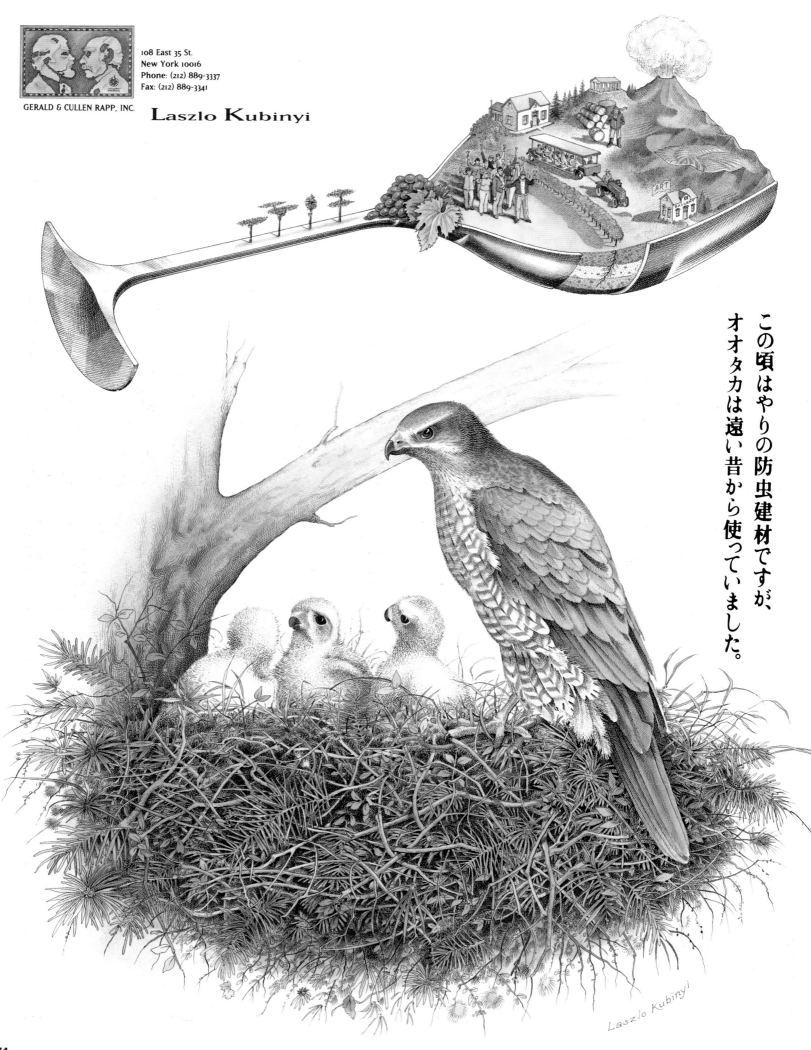

108 East 35 St.
New York 10016
Phone: (212) 889-3337
Fax: (212) 889-3341

GERALD & CULLEN RAPP, INC.

Laszlo Kubinyi

この頃はやりの防虫建材ですが、オオタカは遠い昔から使っていました。

Laszlo Kubinyi

GERALD & CULLEN RAPP, INC.
Phone: (212) 889 3337

Laszlo Kubinyi

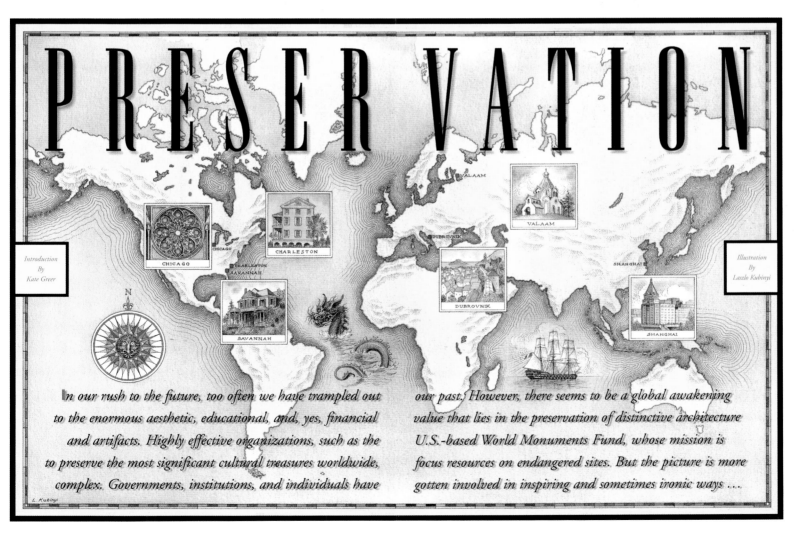

PRESERVATION

Introduction By Kate Greer

Illustration By Laszlo Kubinyi

In our rush to the future, too often we have trampled out to the enormous aesthetic, educational, and, yes, financial and artifacts. Highly effective organizations, such as the to preserve the most significant cultural treasures worldwide, complex. Governments, institutions, and individuals have

our past. However, there seems to be a global awakening value that lies in the preservation of distinctive architecture U.S.-based World Monuments Fund, whose mission is focus resources on endangered sites. But the picture is more gotten involved in inspiring and sometimes ironic ways ...

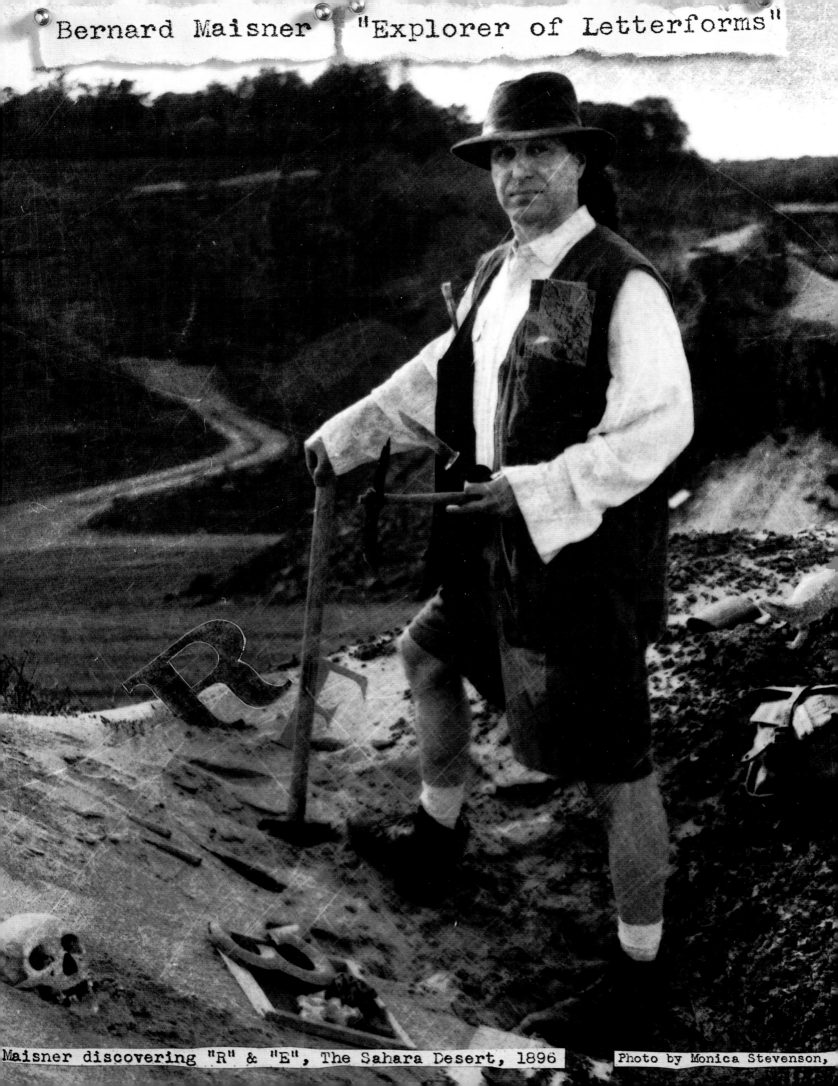

Bernard Maisner "Explorer of Letterforms"

Maisner discovering "R" & "E", The Sahara Desert, 1896 Photo by Monica Stevenson,

e the People

The Captain was here

Barry Manilow

Violence

ON THE JOB SITE

"AUTOMOBILE OF THE YEAR"
—AUTOMOBILE MAGAZINE
PLYMOUTH neon

Part II
OWER

REVLON Revolutionary

Paint
in

Clapton

DINE OUT LOS ANGELES
"At Mimi's
we
An

DINE OUT CALIFORNIA
"I'm a Californian,
but I'm French too.
So I believe in fulfilling
every expectation,
& then going one step
beyond American Express
helps me do that."

BERNARD MAISNER HAND-LETTERING
Represented by: Gerald & Cullen Rapp
108 East 35th Street, N.Y., N.Y. 10016
Ph: (212)889-3337 ✳ Fax: (212)889-3341

"Virtue lies
in moderation."

MICK JAGGER

PSYCHO TRAINING by
CONVERSE

Richie Sambora
STRANGER IN THIS TOWN

BSOLUT PROV

inatra

Spiegel

Who
esn't like a

Snow Ivory Snow Snow
Ivory Snow Ivory Snow Ivory
Ivory Snow
Ivory Snow Ivory
Snow Ivory Snow
Ivory Snow Ivory
Snow Ivory Snow
Snow Snow
Ivory Snow

All My Children

AFRICA

OIL OF OLAY

Whitney

A lifetime of beautiful skin.

GERALD & CULLEN RAPP, INC.

108 E. 35TH ST.
NEW YORK, 10016
PHONE: 212·889·3337
FAX: 212·889·3341

Hal Mayforth

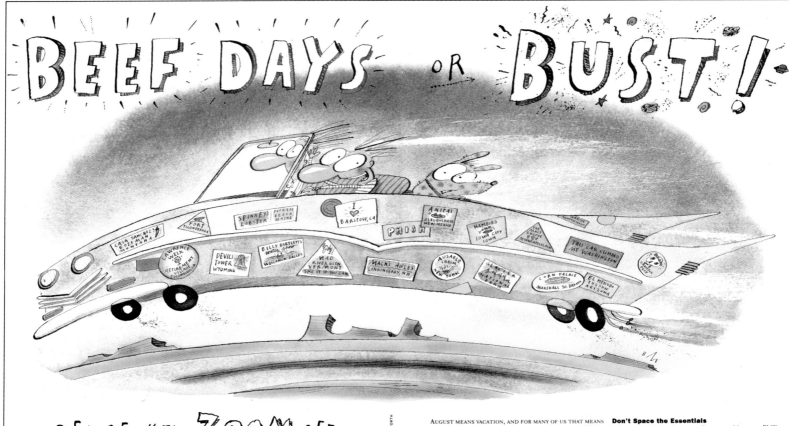

BEEF DAYS OR BUST!

BEFORE you ZOOM OFF ON THAT SUMMER ROAD TRIP, A few SUGGESTIONS →

ILLUSTRATIONS BY HAL MAYFORTH

AUGUST MEANS VACATION, AND FOR MANY OF US THAT MEANS road trip. Time to fish out the drive tunes and the musty old Igloo and head off for parts unknown. I've driven across America countless times, and if I've learned one thing, it's that this country is bigger than it looks on a map. Maps are rarely more than three or four feet across. Coast to coast, it's several times that.

Fortunately, I've learned more than one thing.

By Pete Nelson

Don't Space the Essentials

■ In your tool kit, stock one medium screwdriver, one Phillipshead, an adjustable wrench, a flashlight, extra fan belts and fuses, brake fluid, a quart of oil, and a couple hundred rolls of duct tape.
■ Get a magnetic holder and hide an extra set of keys someplace where thieves won't think to look. I'd tell you where, but they might read this.
■ Bring SPF 700 sunblock for your left arm, which after five days

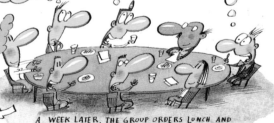

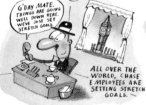
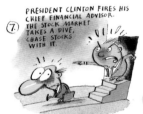

GERALD & CULLEN RAPP, INC.

108 East 35 St.
New York 10016
Phone: (212) 889-3337
Fax: (212) 889-3341

Rick Meyerowitz

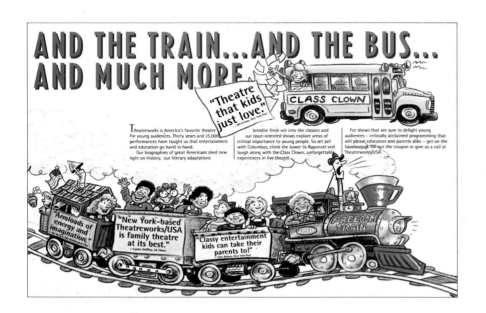

AND THE TRAIN...AND THE BUS... AND MUCH MORE.

"Theatre that kids just love."
— Bill Ernsher, *New York Post*

CLASS CLOWN

Theatreworks is America's favorite theatre for young audiences. Thirty years and 25,000 performances have taught us that entertainment and education go hand in hand.
Our biographies of great Americans shed new light on history, our literary adaptations

breathe fresh wit into the classics and our issue-oriented shows explore areas of critical importance to young people. So set sail with: Columbus, climb the tower to Rapunzel and laugh along with the Class Clown...unforgettable experiences in live theatre.

For shows that are sure to delight young audiences – critically acclaimed programming that will please, educators and parents alike – get on the bandwagon. Fill out the coupon or give us a call at Theatreworks/USA.

"Armloads of energy and imagination."

"New York-based Theatreworks/USA is family theatre at its best."
— Lynne Heffley, *LA Times*

"Classy entertainment kids can take their parents to!"
— Clive Barnes, *New York Post*

FREEDOM TRAIN

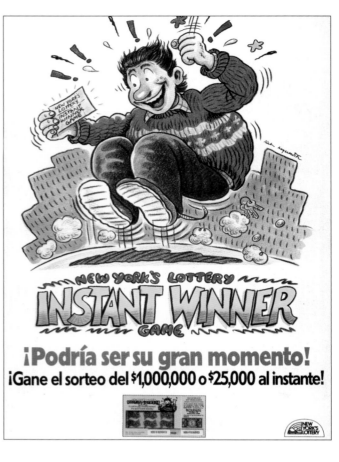

NEW YORK'S LOTTERY INSTANT WINNER GAME

¡Podría ser su gran momento!
¡Gane el sorteo del $1,000,000 o $25,000 al instante!

WE'LL ONLY GO SO FAR TO GET YOU TO SELL OUR NEW EUROPEAN TOURS.

Of course, we're not quite sure how far that is yet.
So we're offering 12% commission on all our new tours. That's 12% on ground packages. Plus 12% on airfare.*
And you can book both by making just one convenient call.
We're also offering great European tour packages to travelers. Bargain packages. First class packages. And a decidedly first class airline, Virgin Atlantic. All for less than they'd expect to pay.
So when you get a chance, call us at (212) 242-1330 or (201) 623-0500. In Florida call (305) 871-3554. And we'll send you a Virgin Holidays brochure.
Of course, if you don't want one, we're not going to beg.
Well...maybe just this once.

VIRGIN HOLIDAYS
You deserve it.

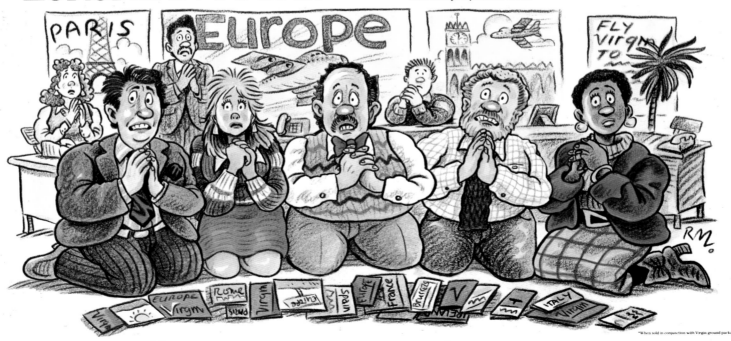

*When sold in conjunction with Virgin ground packages.

180

GERALD & CULLEN RAPP, INC.

Phone: (212) 889 3337

Rick Meyerowitz

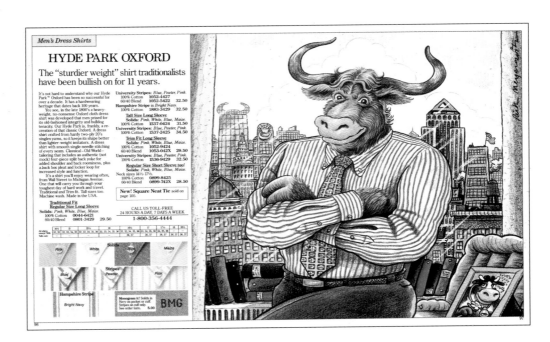

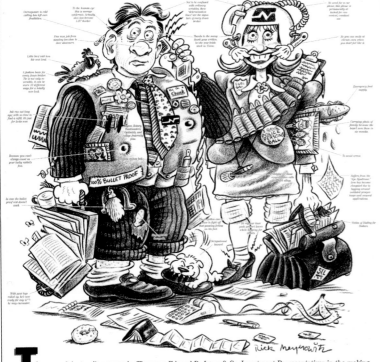

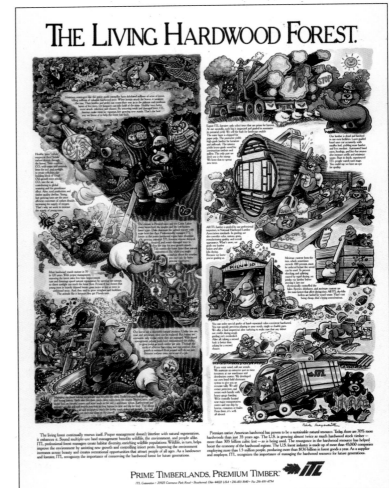

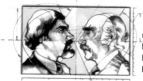

108 East 35 St.
New York 10016
Phone: (212) 889-3337
Fax: (212) 889-3341

GERALD & CULLEN RAPP, INC.

Bruce Morser

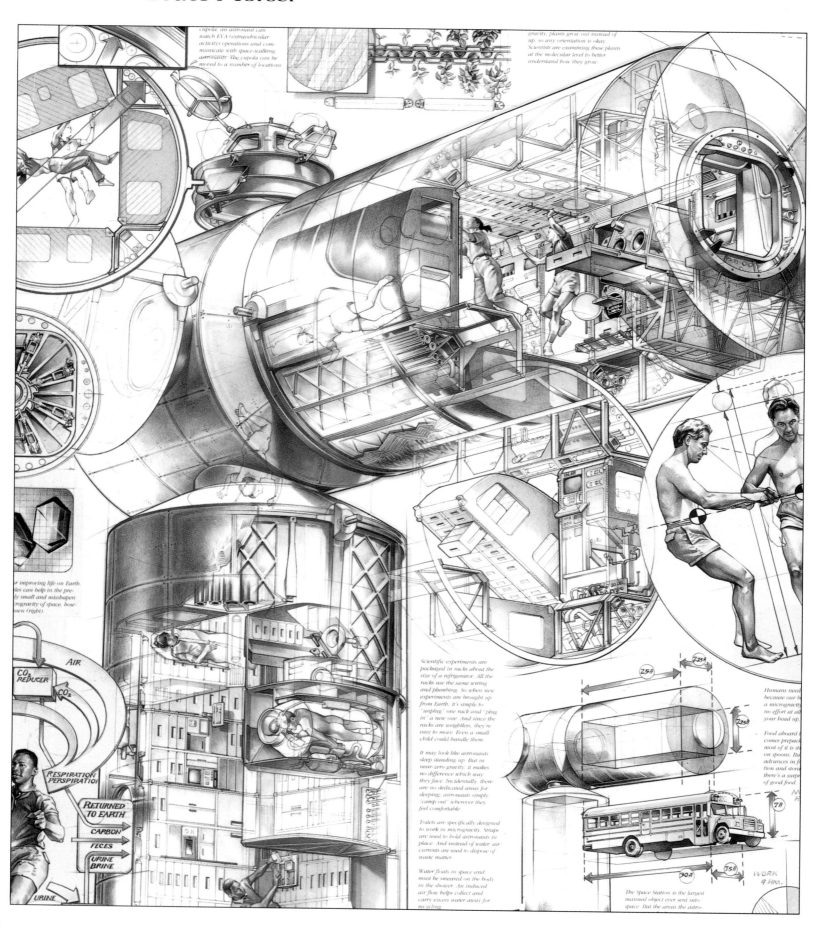

cupola, an astronaut can watch EVA (extravehicular activity) operations and communicate with space-walking astronauts. The cupola can be moved to a number of locations

gravity, plants grow out instead of up, so any orientation is okay. Scientists are examining these plants at the molecular level to better understand how they grow.

r improving life on Earth.
les can help in the pre-
ly small and misshapen
rogravity of space, how-
wn (right).

CO₂ REDUCER
AIR
CO₂
RESPIRATION
PERSPIRATION
RETURNED TO EARTH
CARBON
FECES
URINE BRINE
URINE

Scientific experiments are packaged in racks about the size of a refrigerator. All the racks use the same wiring and plumbing. So when new experiments are brought up from Earth, it's simple to "unplug" one rack and "plug in" a new one. And since the racks are weightless, they're easy to move. Even a small child could handle them.

It may look like astronauts sleep standing up. But in near-zero gravity, it makes no difference which way they face. Incidentally, there are no dedicated areas for sleeping; astronauts simply "camp out" wherever they feel comfortable.

Toilets are specifically designed to work in microgravity. Straps are used to hold astronauts in place. And instead of water, air currents are used to dispose of waste matter.

Water floats in space and must be smeared on the body in the shower. An induced air flow helps collect and carry excess water away for recycling

Humans need
because our b
a microgravit
no effort at all
your head up.

Food aboard
comes prepa
most of it is st
on spoons. Bu
advances in f
tion and stor
there's a surp
of good food.

The Space Station is the largest manned object ever sent into space. But the areas the astro-

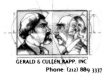

GERALD & CULLEN RAPP, INC
Phone: (212) 889 3337

Bruce Morser

height for your Apple system. Because the positions of the elements of your desk and computer are closely interrelated, we suggest that you read all of the relevant parts of this booklet before setting up or modifying your work area.

23"–28"

SCIENTIFIC AMERICAN

FEBRUARY 1995
$3.95

Bubbles turn sound into light.

Debunking The Bell Curve.

Microchips: How much smaller?

Building strong muscles is only one of the uses tried for anabolic steroids.

108 East 35 St.
New York 10016
Phone: (212) 889-3337
Fax: (212) 889-3341

GERALD & CULLEN RAPP, INC.

Alex Murawski

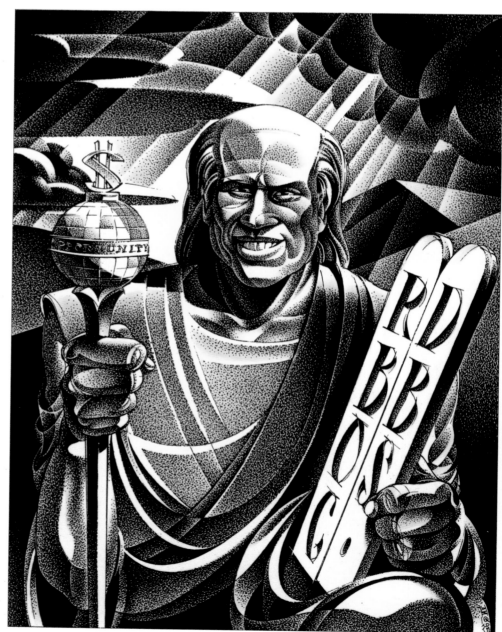

GERALD & CULLEN RAPP, INC.
Phone: (212) 889 3337

Alex Murawski

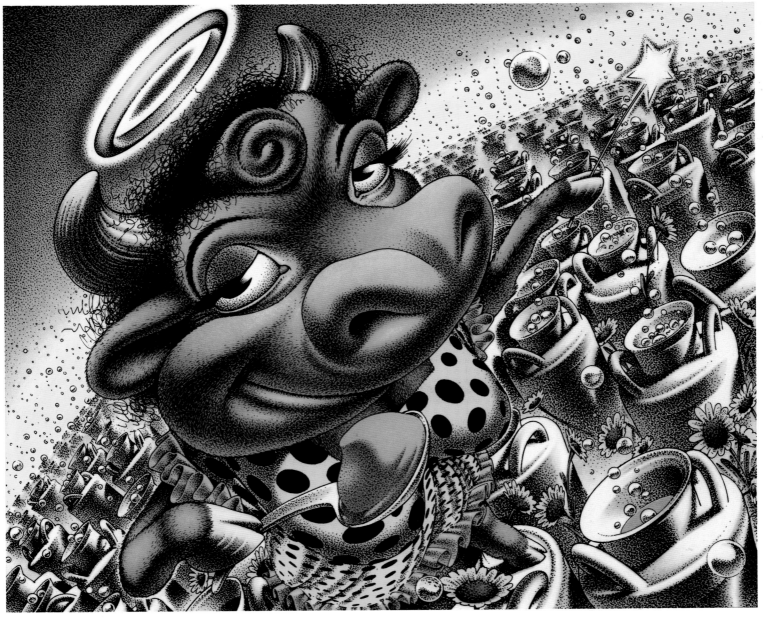

108 East 35 St.
New York 10016
Phone: (212) 889-3337
Fax: (212) 889-3341

GERALD & CULLEN RAPP, INC.

Marlies Merk Najaka

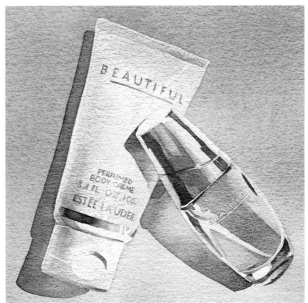

Marlies Merk Najaka

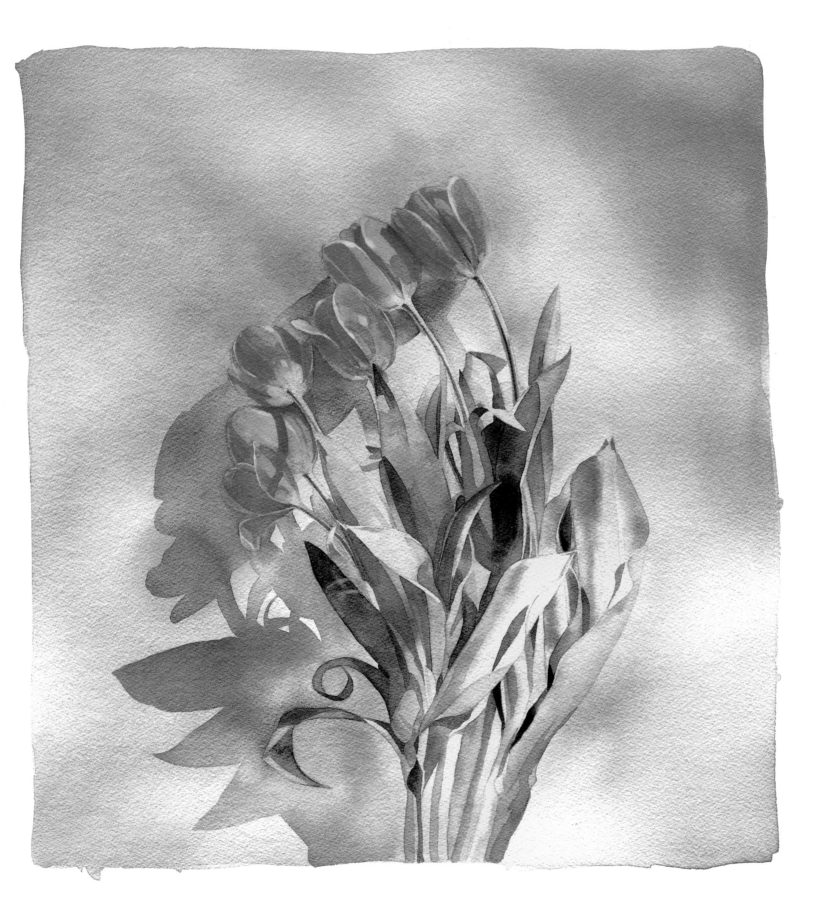

108 East 35 St.
New York 10016
Phone: (212) 889-3337
Fax: (212) 889-3341

GERALD & CULLEN RAPP, INC.

Camille Przewodek

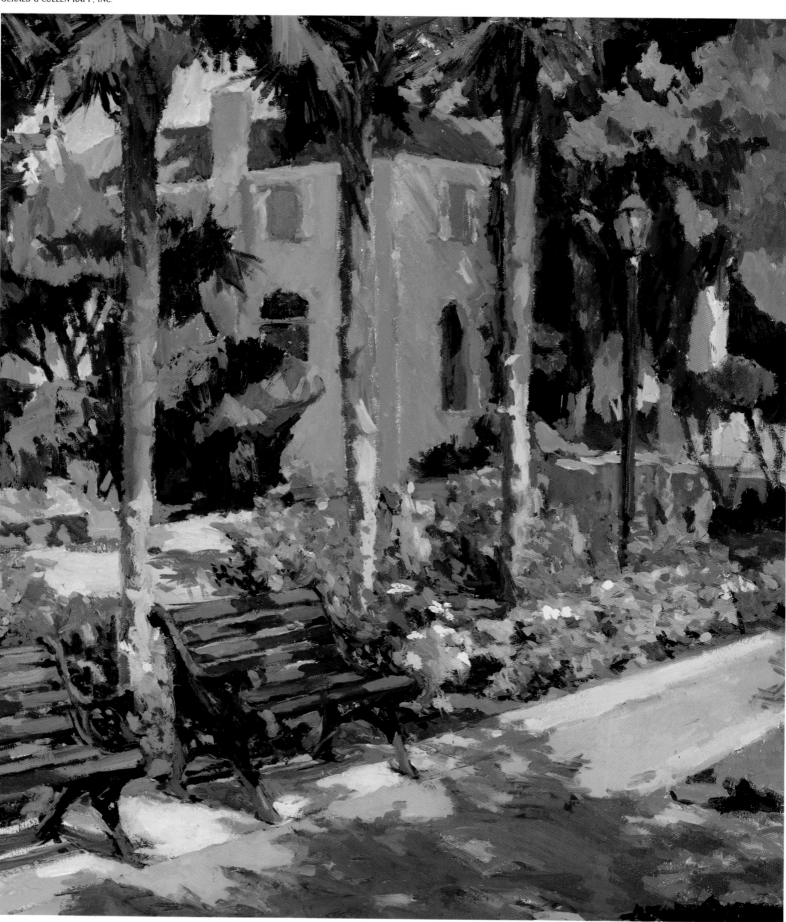

Camille Przewodek

GERALD & CULLEN RAPP, INC

Phone: (212) 889 3337

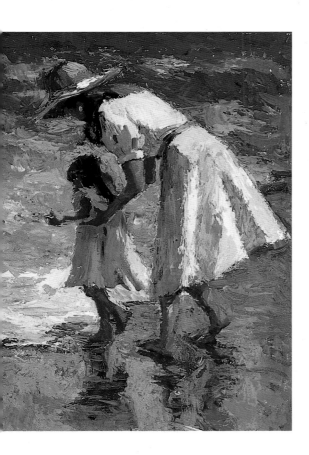

ROSENTHAL

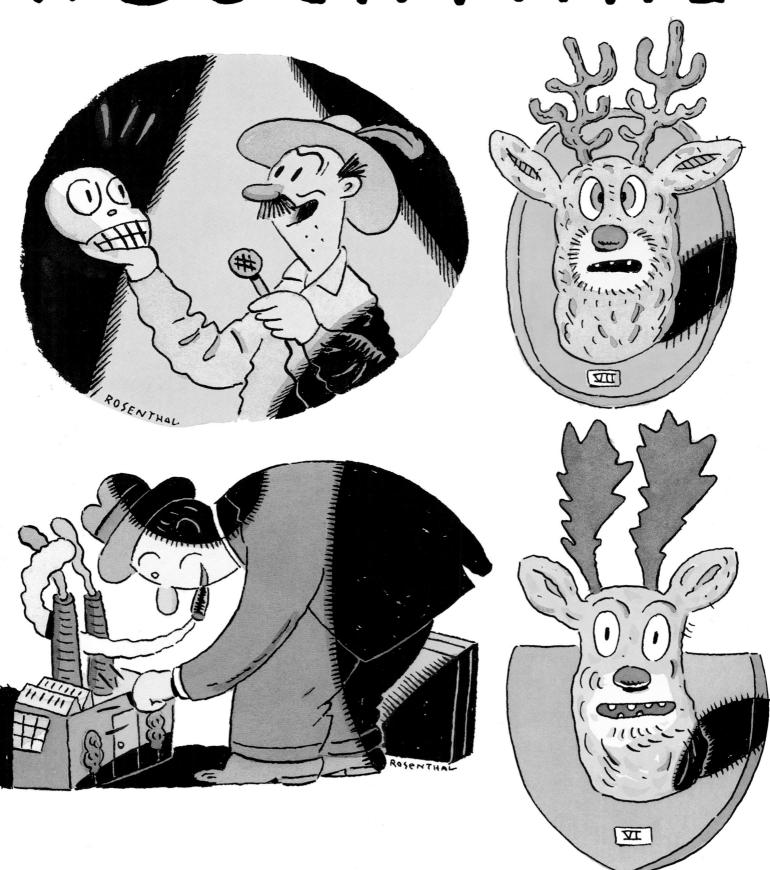

MARC ROSENTHAL REPRESENTED BY GERALD & CULLEN RAPP, PHONE (212) 889-3337, FAX (212) 889-3341

ROSENTHAL

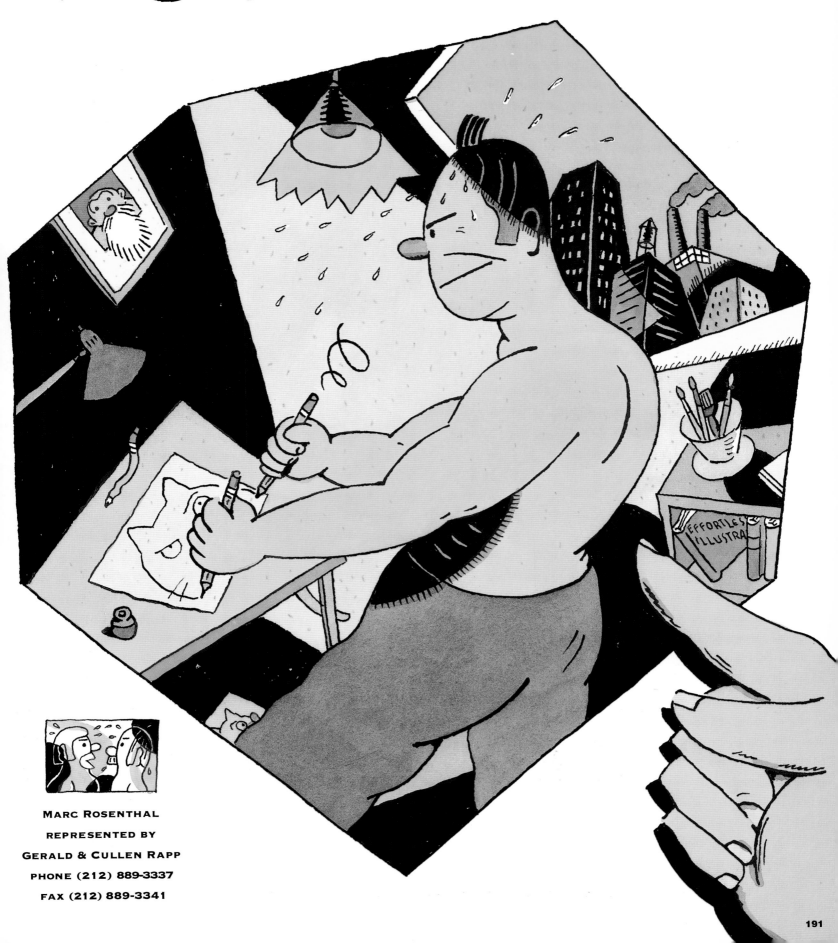

MARC ROSENTHAL

REPRESENTED BY

GERALD & CULLEN RAPP

PHONE (212) 889-3337

FAX (212) 889-3341

108 East 35 St.
New York 10016
Phone: (212) 889-3337
Fax: (212) 889-3341

GERALD & CULLEN RAPP, INC.

JAMES STEINBERG

GERALD & CULLEN RAPP, INC
Phone: (212) 889 3337

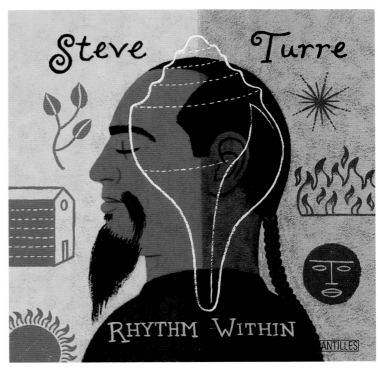

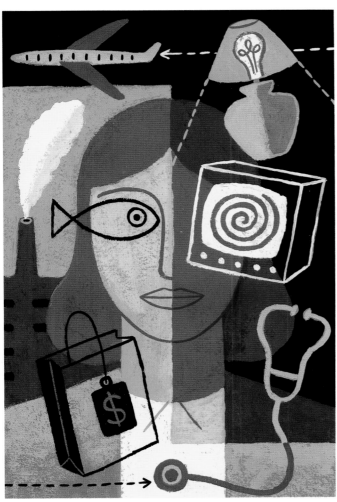

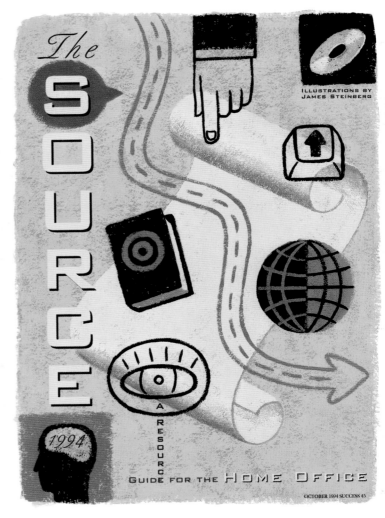

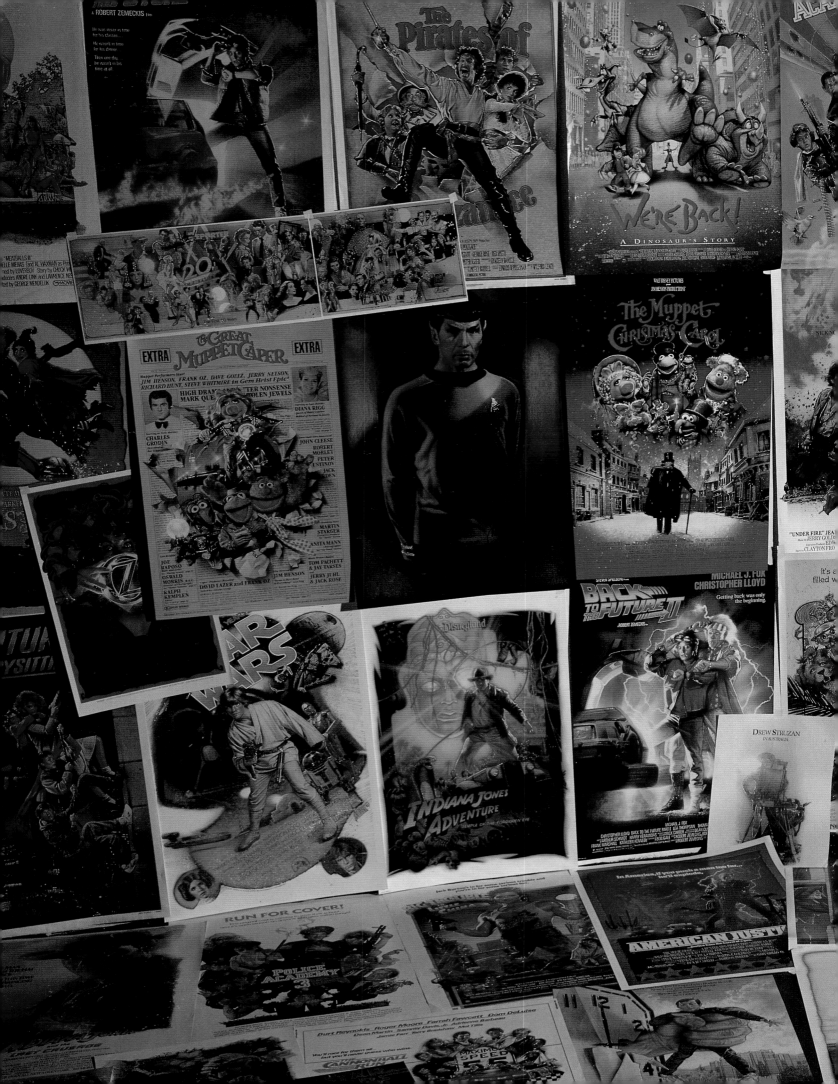

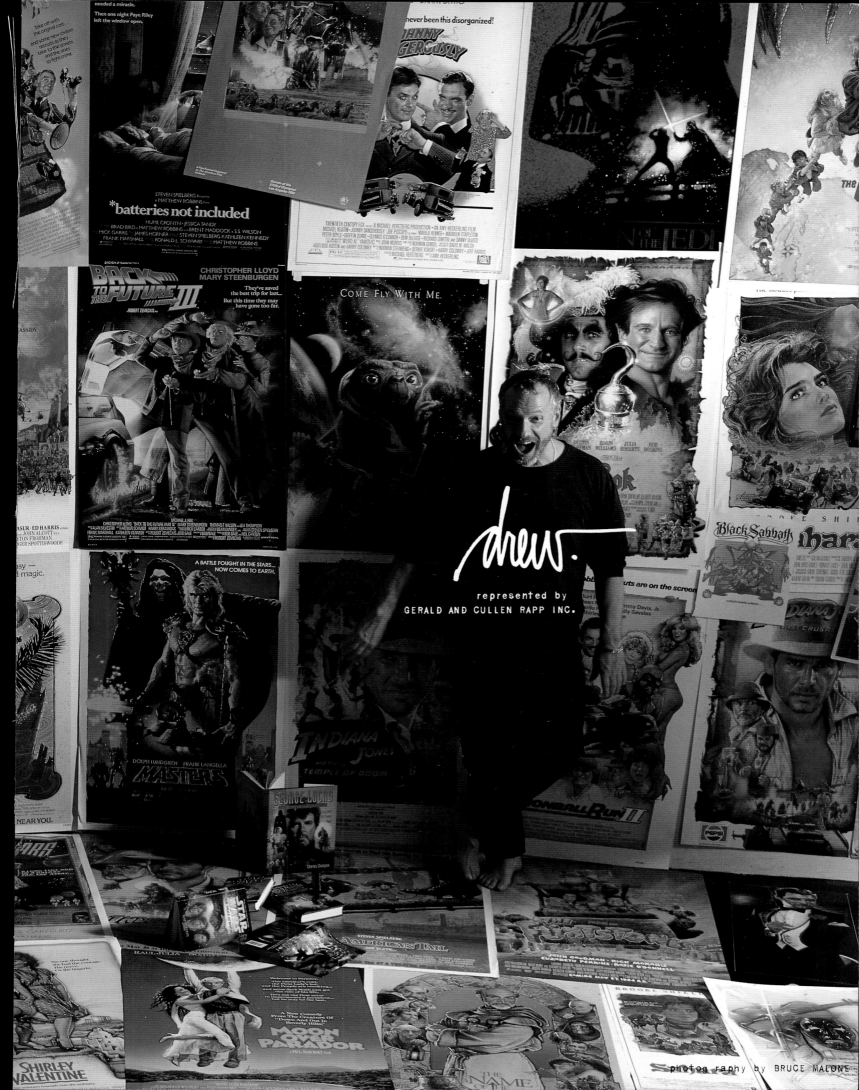

GERALD & CULLEN RAPP, INC.

108 East 35 St.
New York 10016
Phone: (212) 889-3337
Fax: (212) 889-3341

Andrea Ventura

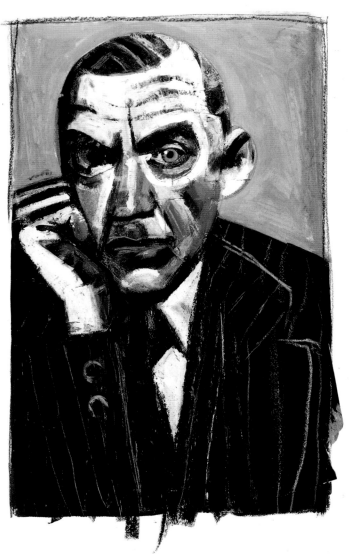

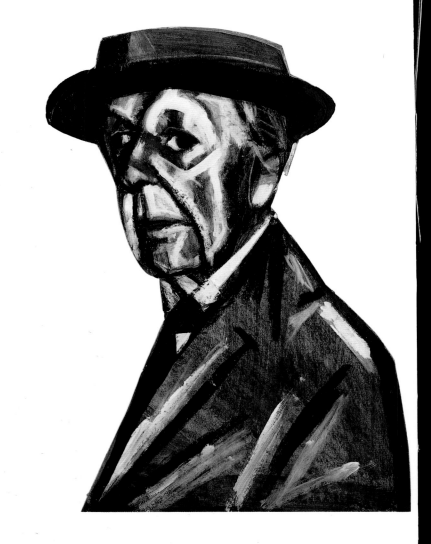

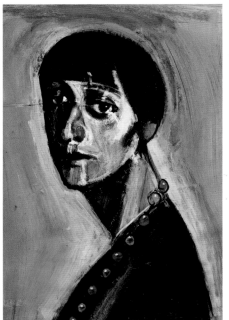

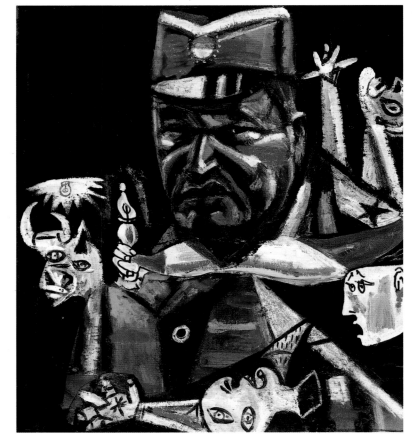

Andrea Ventura

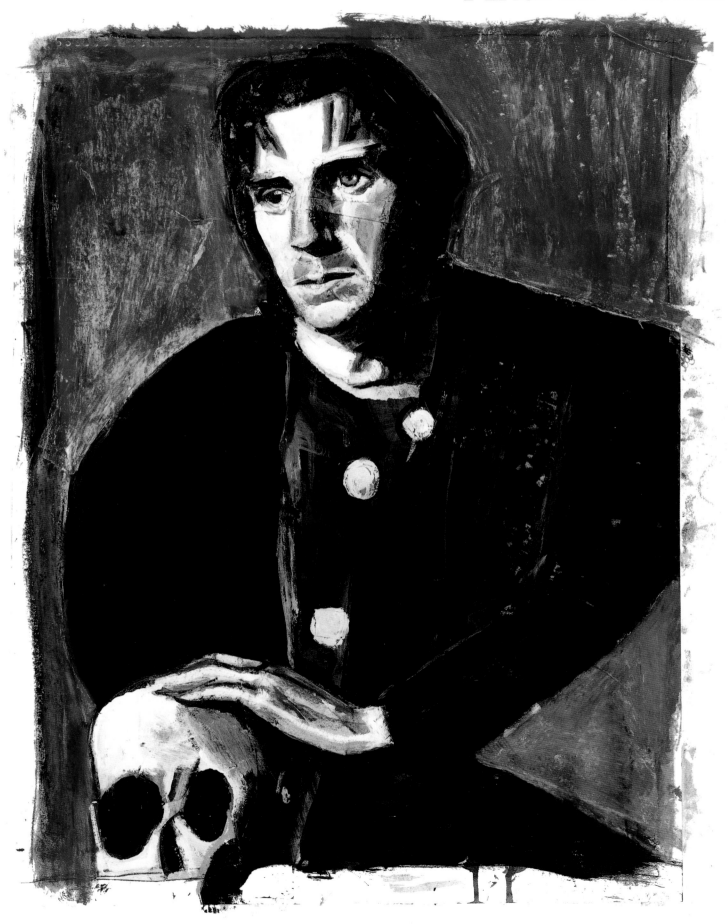

108 East 35 St.
New York 10016
Phone: (212) 889-3337
Fax: (212) 889-3341

GERALD & CULLEN RAPP, INC.

Michael Witte

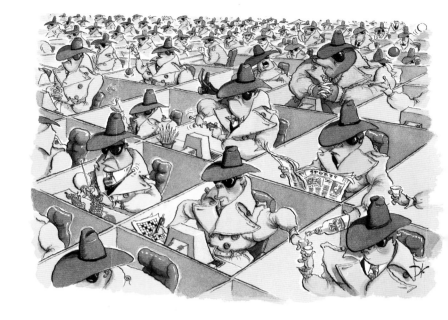

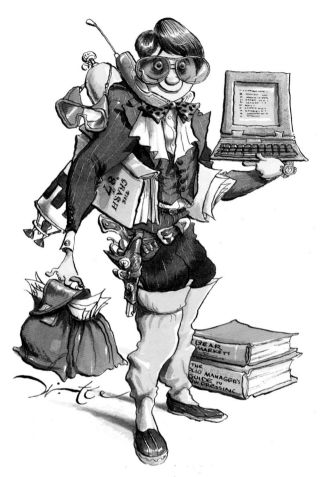

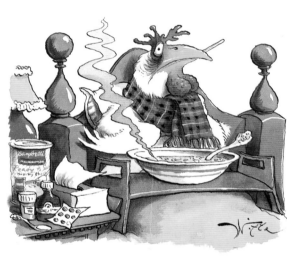

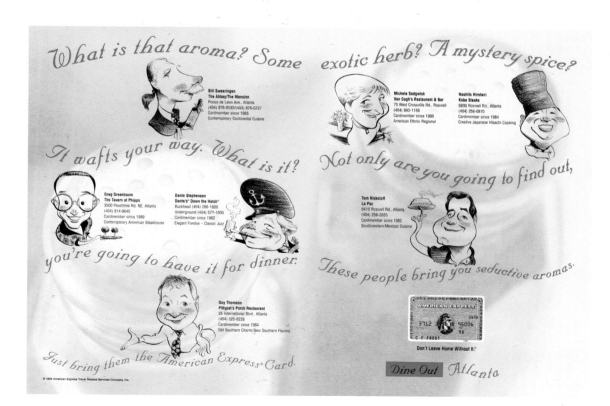

GERALD & CULLEN RAPP, INC.
Phone: (212) 889 3337

Michael Witte

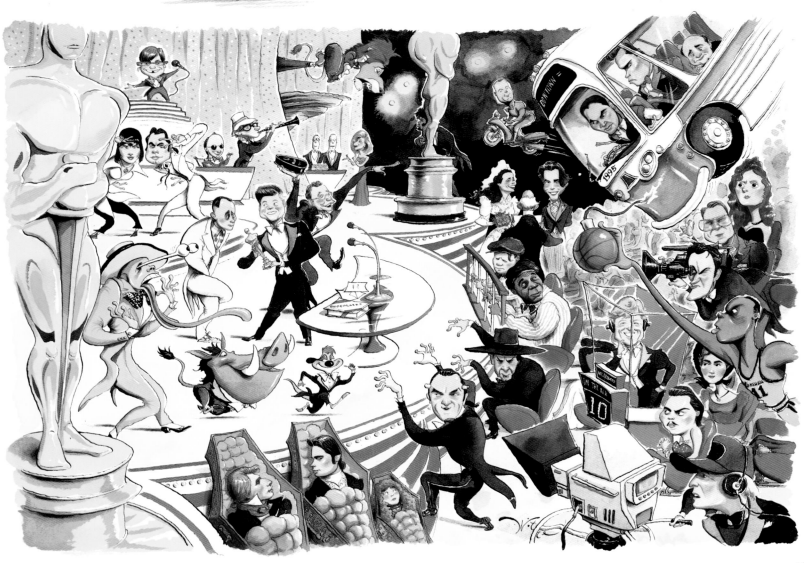

GERALD & CULLEN RAPP, INC.

108 East 35 St.
New York 10016
Phone: (212) 889-3337
Fax: (212) 889-3341

Bob Ziering

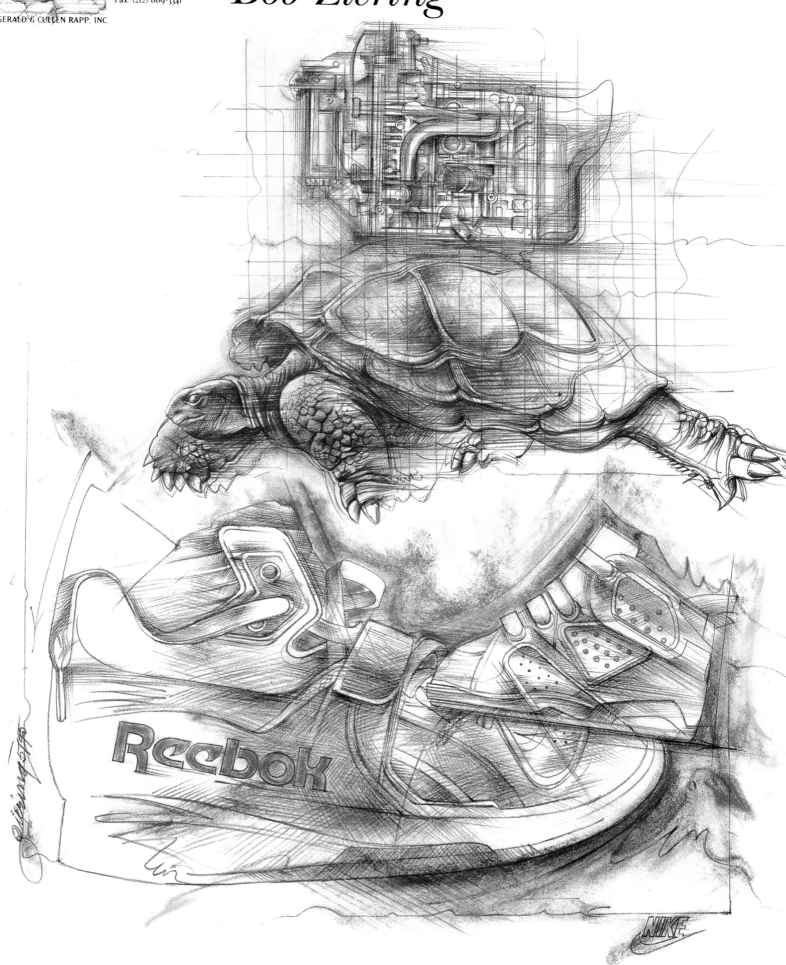

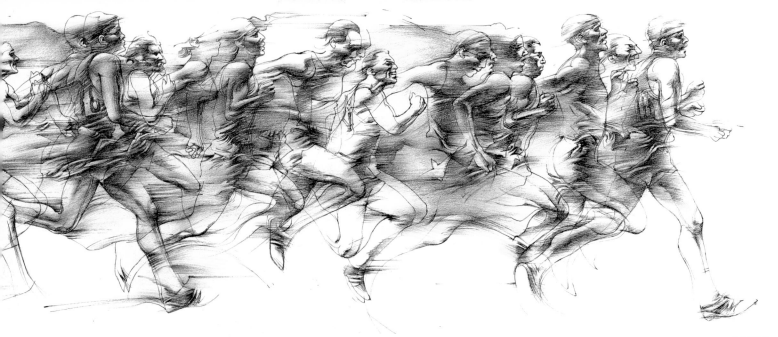

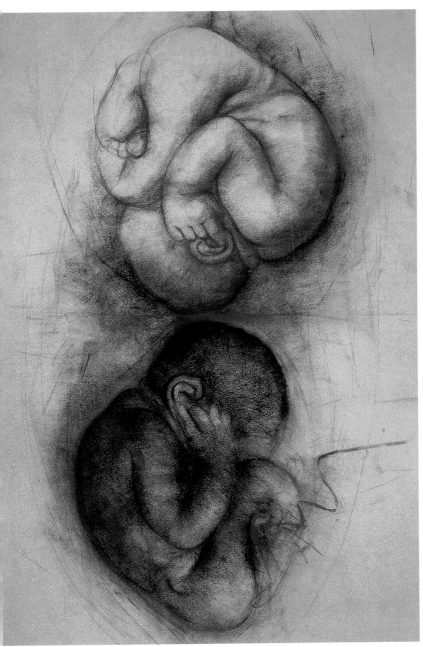

NOK LIPS

Bob Ziering

108 East 35 St.
New York 10016
Phone: (212) 889-3337
Fax: (212) 889-3341

GERALD & CULLEN RAPP, INC.

108 East 35 St.
New York 10016
Phone: (212) 889-3337
Fax: (212) 889-3341

GERALD & CULLEN RAPP, INC.

Lon Busch

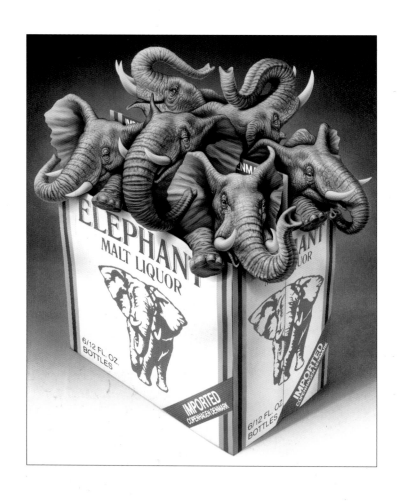

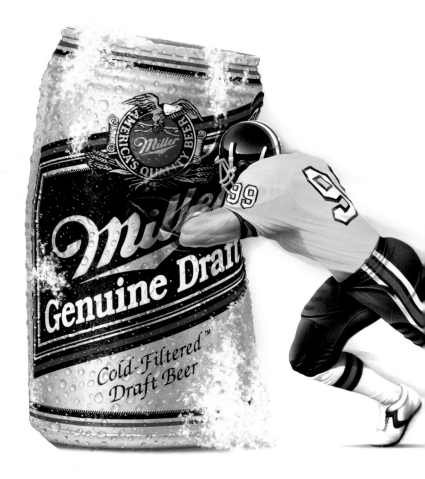

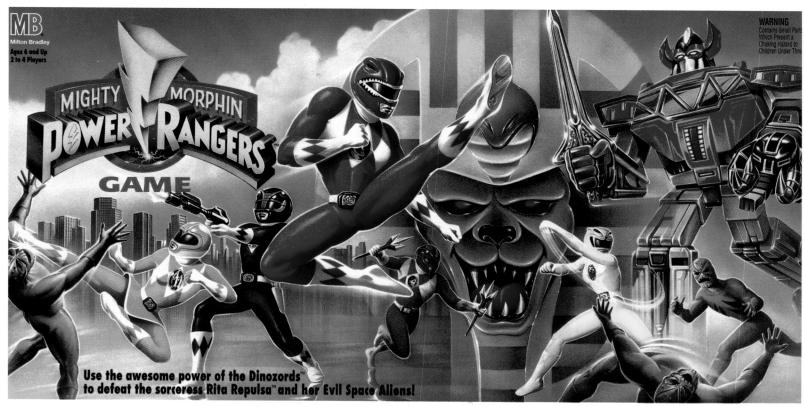

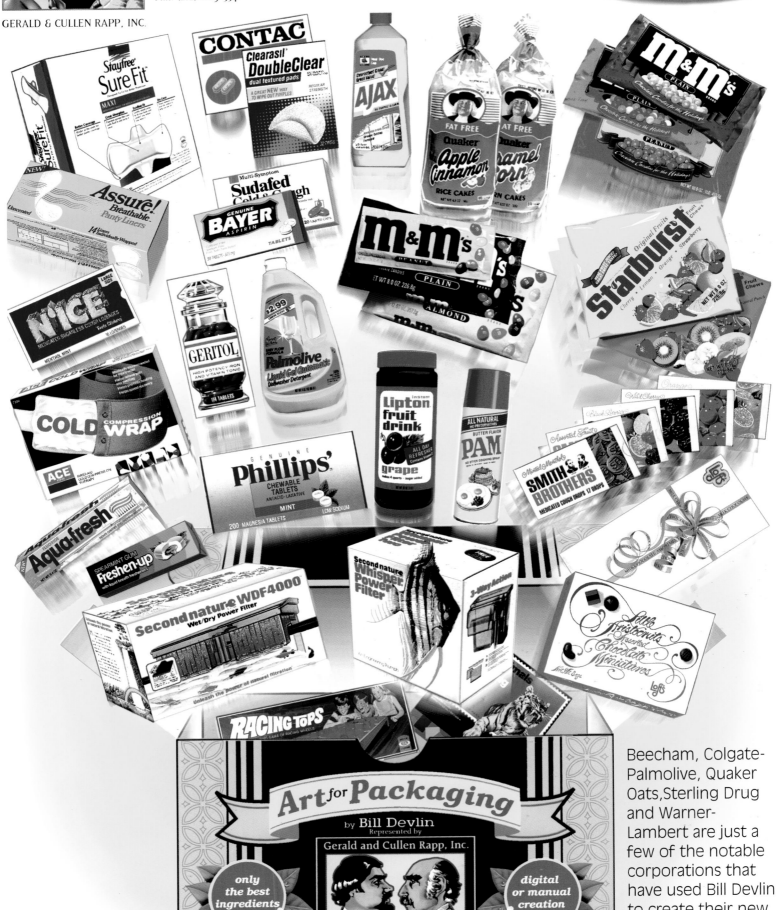

Beecham, Colgate-Palmolive, Quaker Oats, Sterling Drug and Warner-Lambert are just a few of the notable corporations that have used Bill Devlin to create their new packaging art.

Randy Glass

Okay, Grill Us.

Beef.
Real Food For Real People.

**Domino's Knows
You'll Love Our
Pepperoni
Pizza
Feast**

NOBODY
KNOWS
LIKE
DOMINO'S

How You Like Pizza At Home.

3-D COMPUTER ILLUSTRATION, INTERACTIVE PRODUCTION

STEVE KELLER

108 E. 35th St.
New York 10016
Phone (212) 889-3337
Fax (212) 889-3341

GERALD & CULLEN RAPP, INC.

Visit the Keller Productions web site:
http://www.earthlink.net/~kelprod
or
Call for the Keller Productions

Cool Graphics, Animation,
& Interactive Stuff --it's FREE

108 East 35 St.
New York 10016
Phone: (212) 889-3337
Fax: (212) 889-3341

GERALD & CULLEN RAPP, INC.

Sigmund Pifko

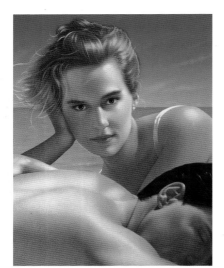

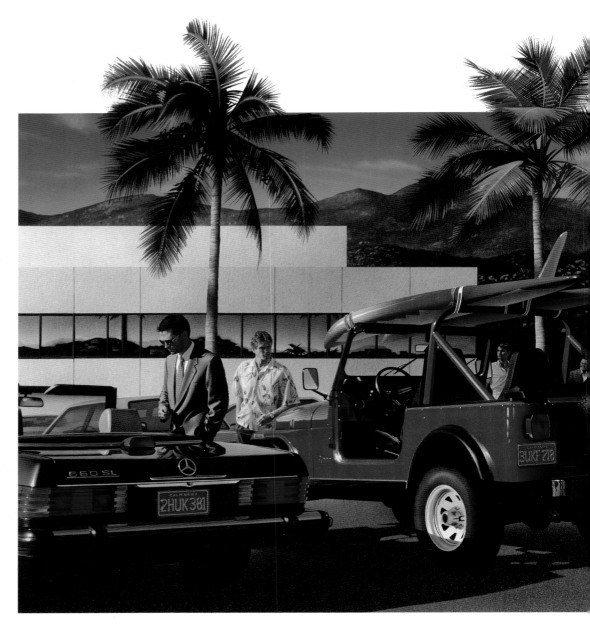

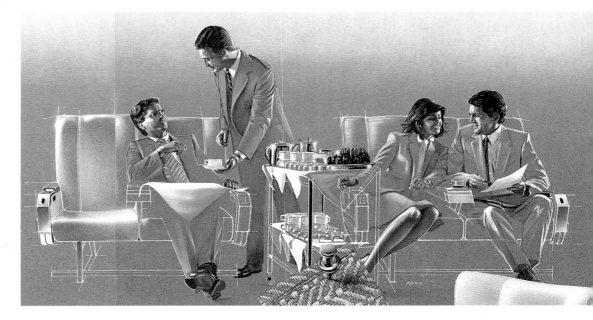

JeRrY Leff
ASSOCIATES

(212) 697-8525
Fax (212) 949-1843

LINGTA KUNG

H.B.
Lewis

RIK OLSON

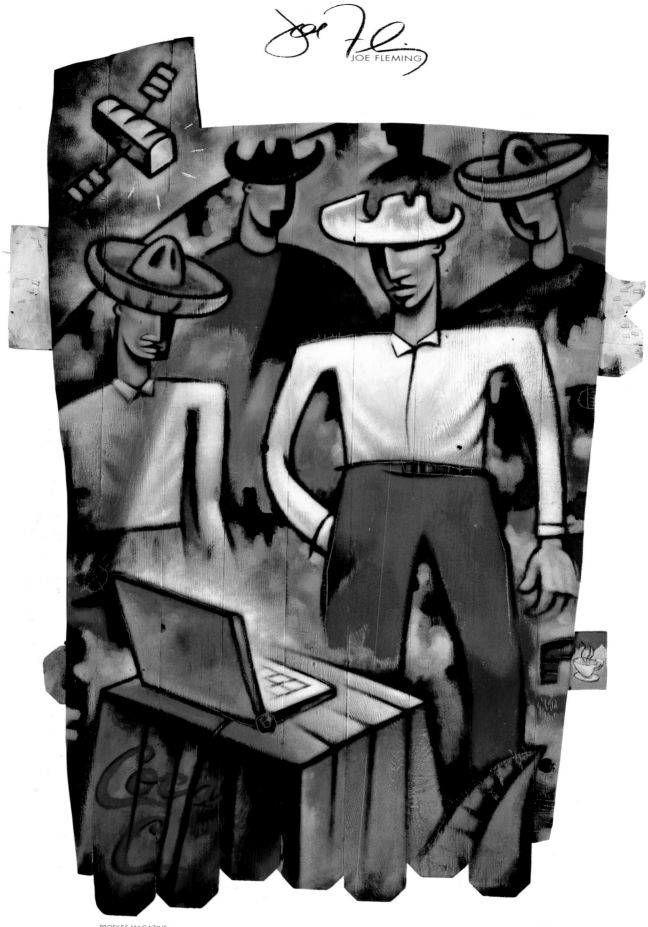

PROFILES MAGAZINE

JOE FLEMING

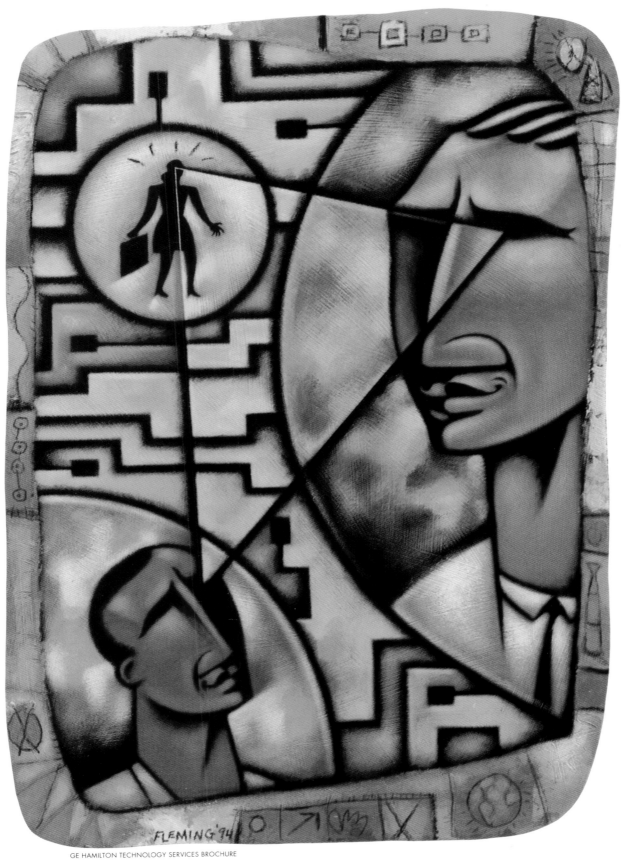

FLEMING '94

GE HAMILTON TECHNOLOGY SERVICES BROCHURE

(212) 697-8525 Fax (212) 949-1843

FRANCIS LIVINGSTON

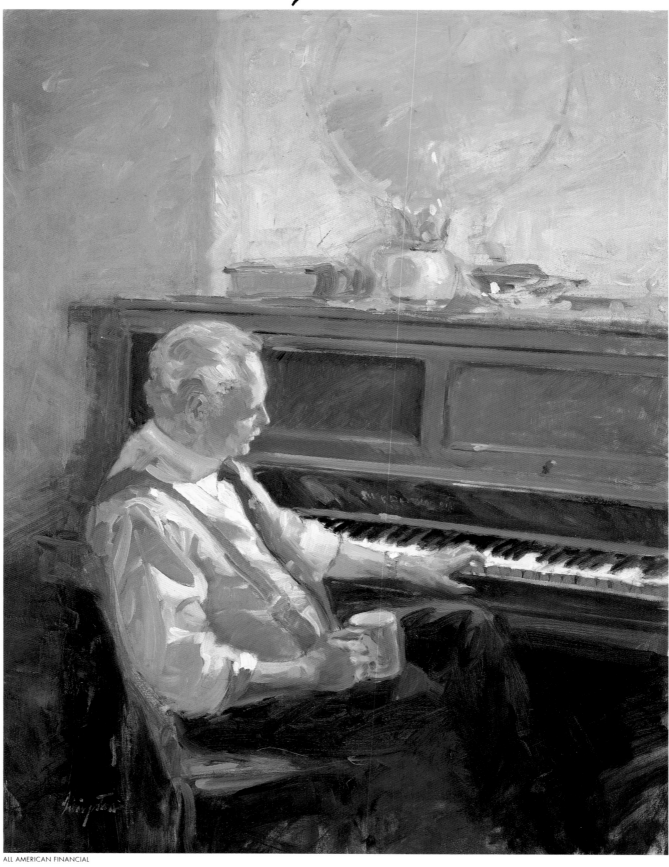

ALL AMERICAN FINANCIAL

West Coast
Freda Scott
(415) 621-2992
Fax (415) 621-5202

(212) 697-8525 Fax (212) 949-1843

FRANCIS LIVINGSTON

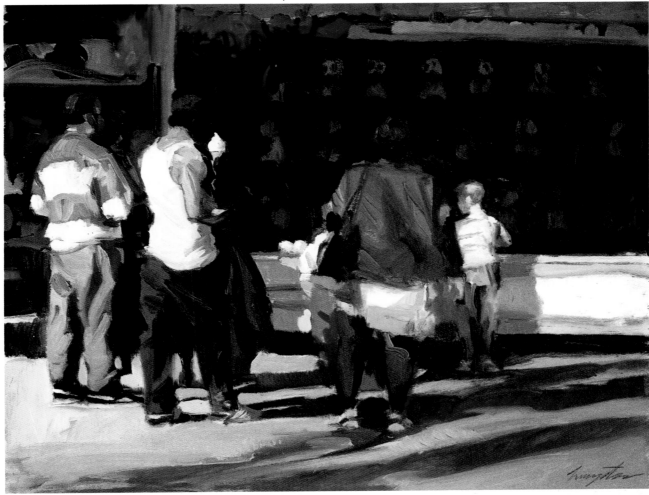

VANILLA ICE CREAM

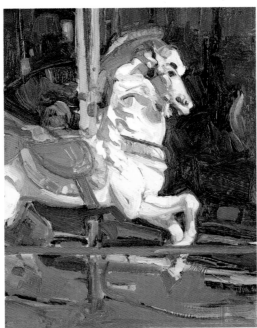

CAROUSEL

CAPITOLA

 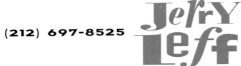

RIK·OLSON

RIK OLSON

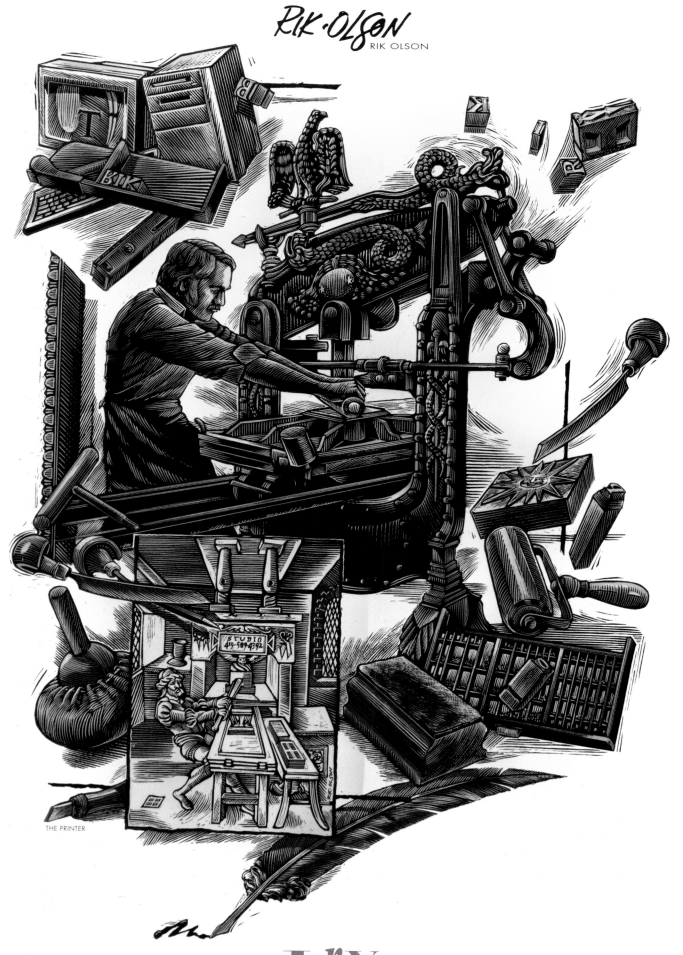

THE PRINTER

Chicago: Tom Maloney
(312) 704-0500

(212) 697-8525 Fax (212) 949-1843

Jerry Leff
ASSOCIATES

San Francisco: Missy Pepper
(415) 543-6881

Los Angeles: Ann Koeffler
(213) 957-2327

GREG BEECHAM

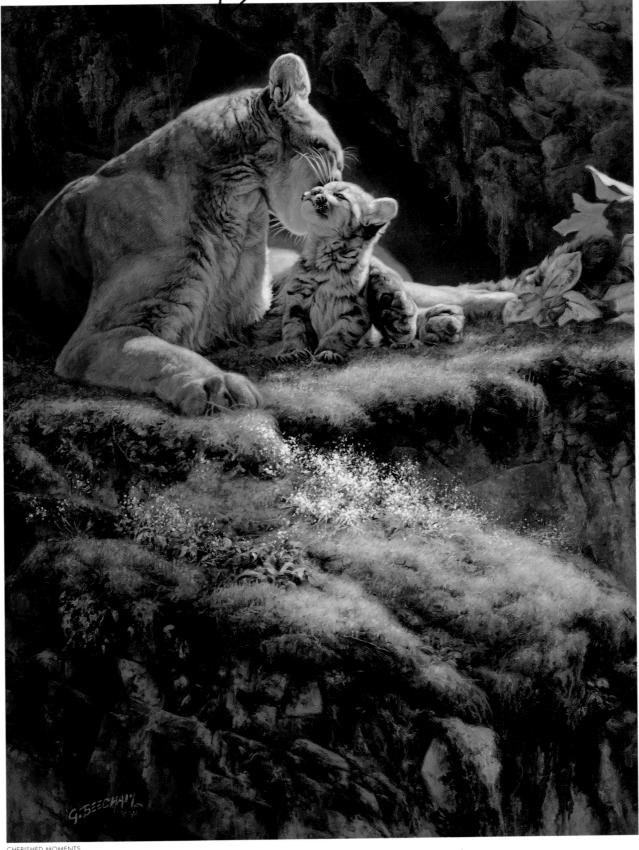

CHERISHED MOMENTS

(212) 697-8525 Jerry Leff ASSOCIATES Fax (212) 949-1843

MARY THELEN

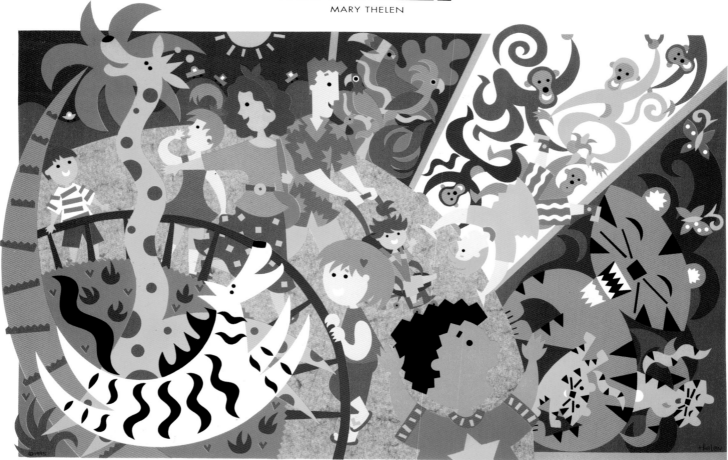

THE ZOO

DFS GROUP LTD.

MARY THELEN

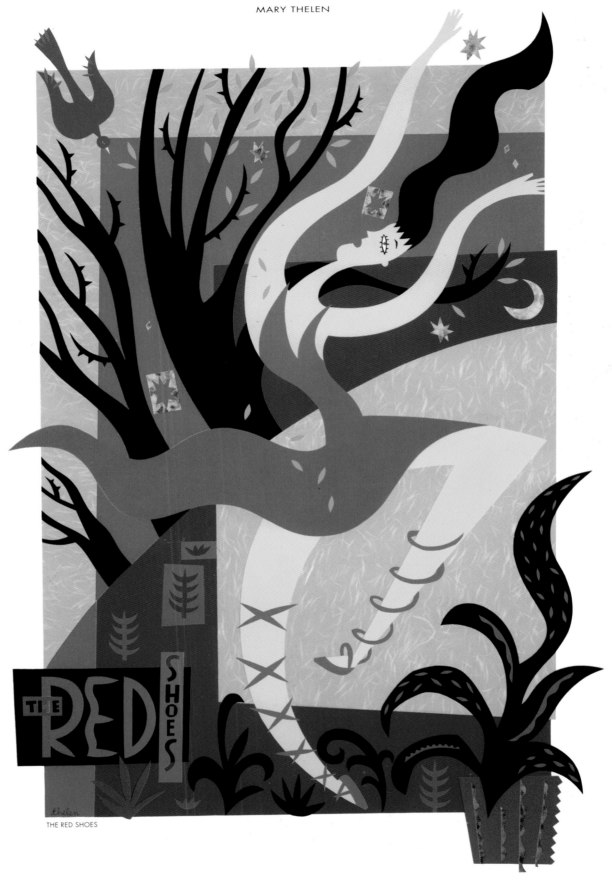

THE RED SHOES

THE JAMES MARKS COLLECTION

PINNACLE BOOKS

(212) 697-8525 Jerry Leff ASSOCIATES Fax (212) 949-1843

DANIEL ADEL

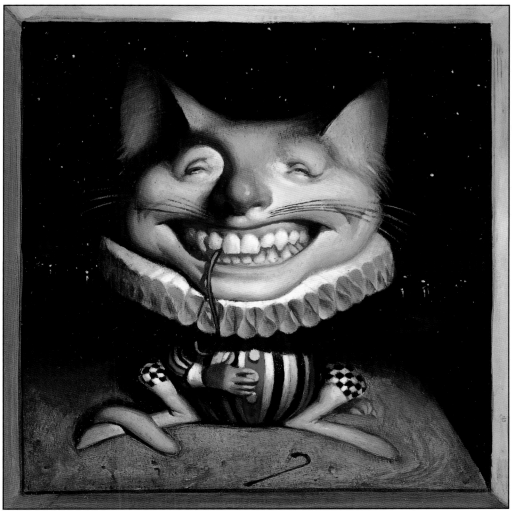

THE BOOK THAT JACK WROTE

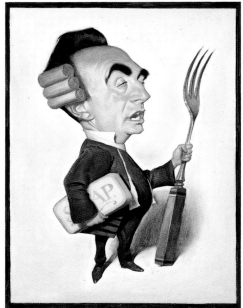

ROBERT SHAPIRO

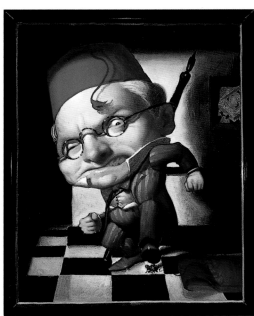

THE BOOK THAT JACK WROTE

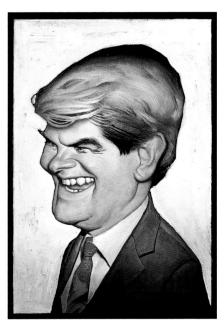

NEWT GINGRICH

Manuel Geerinck

MANUEL GEERINCK

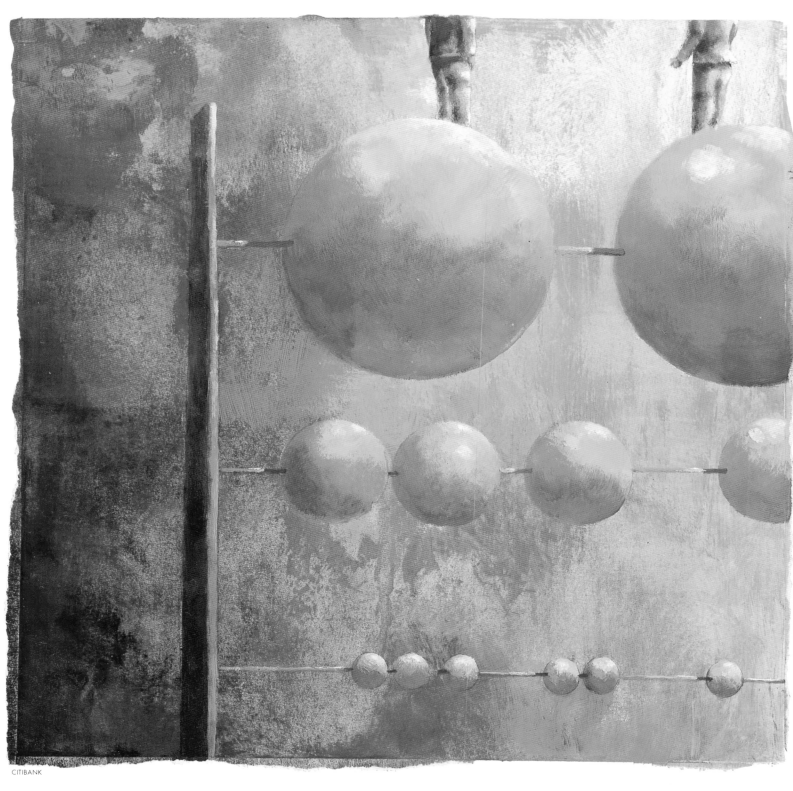

CITIBANK

Manuel Geerinck

MANUEL GEERINCK

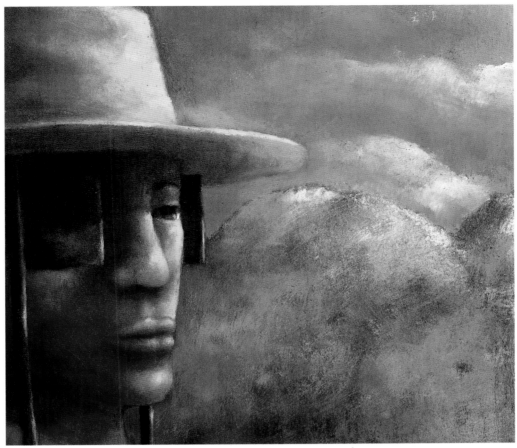

WEST MAGAZINE

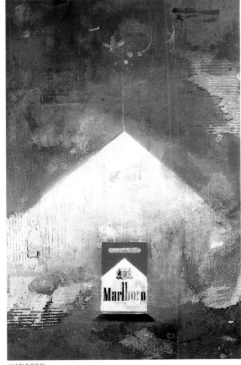

MARLBORO

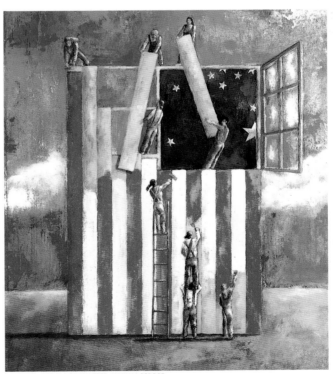

POLITICAL ACTION COMMITTEE ANNUAL REPORT

(212) 697-8525

JerrY Leff
ASSOCIATES

Fax (212) 949-1843

219

SUE ROTHER

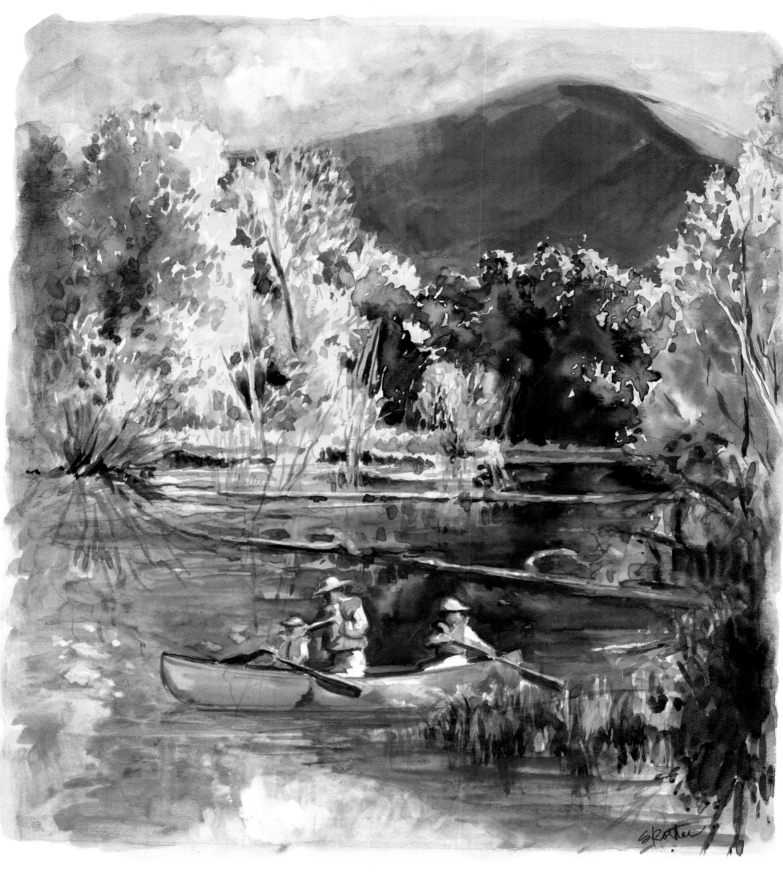

West Coast
Freda Scott
(415) 621-2992
Fax (415) 621-5202

(212) 697-8525

Jerry
Leff
ASSOCIATES

Fax (212) 949-1843

SUE ROTHER

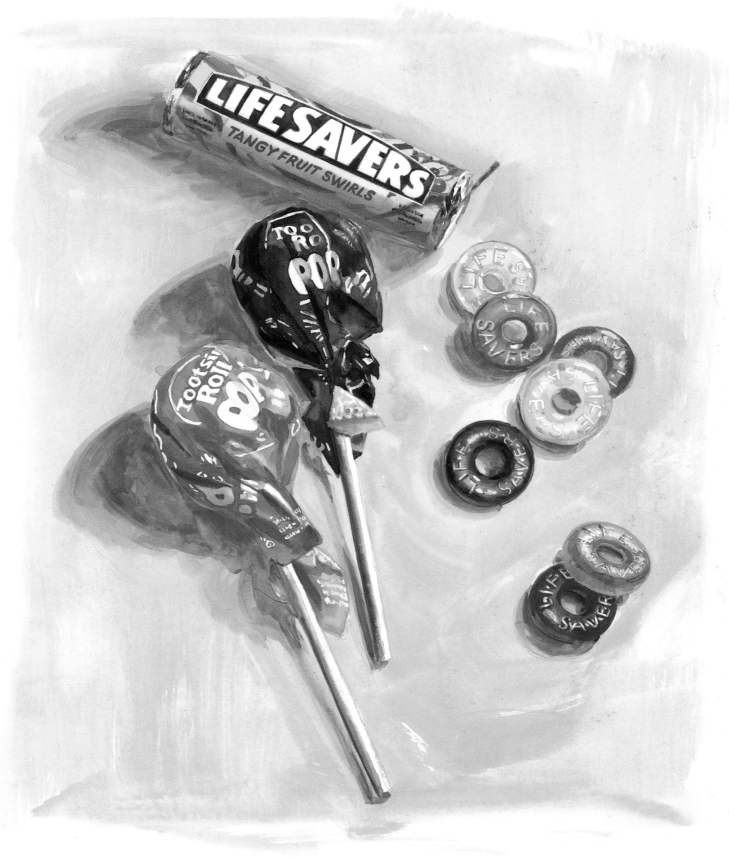

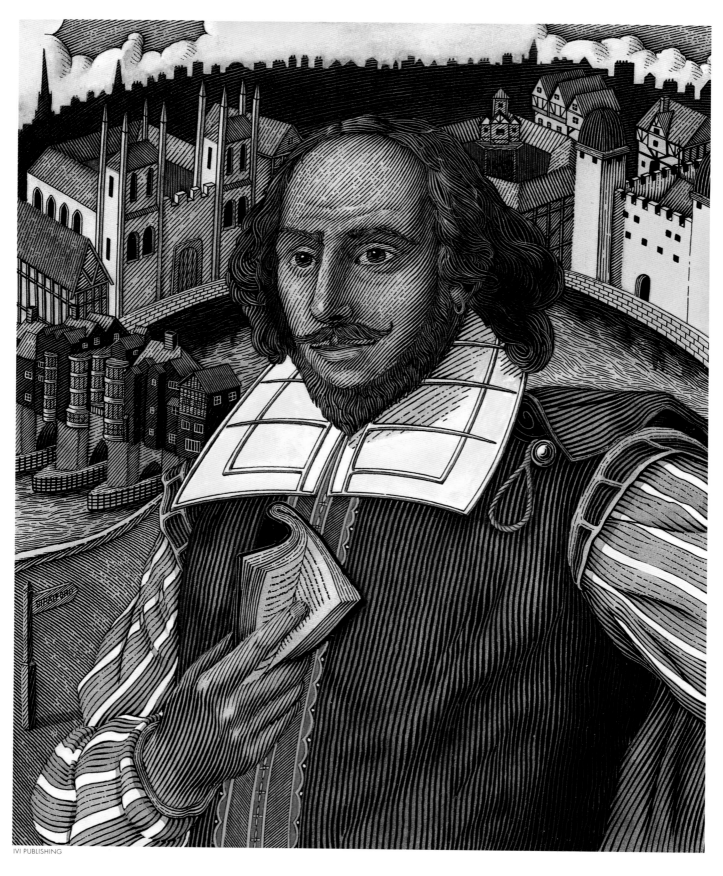

IVI PUBLISHING

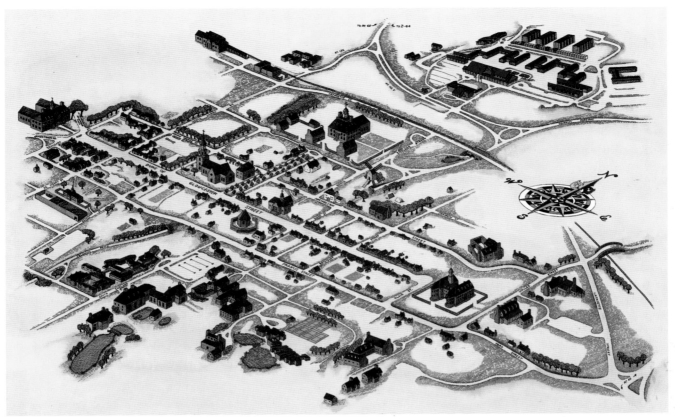

COLONIAL WILLIAMSBURG

UTAH SYMPHONY

AT & T

223

TERRY HOFF

CONSOLIDATED FREIGHTWAYS

FRIGIDAIRE

PRIVATE COLLECTION

West Coast
Freda Scott
(415) 621-2992
Fax (415) 621-5202

(212) 697-8525 Fax (212) 949-1843

Jerry
Leff
ASSOCIATES

Fred Hilliard

FRED HILLIARD

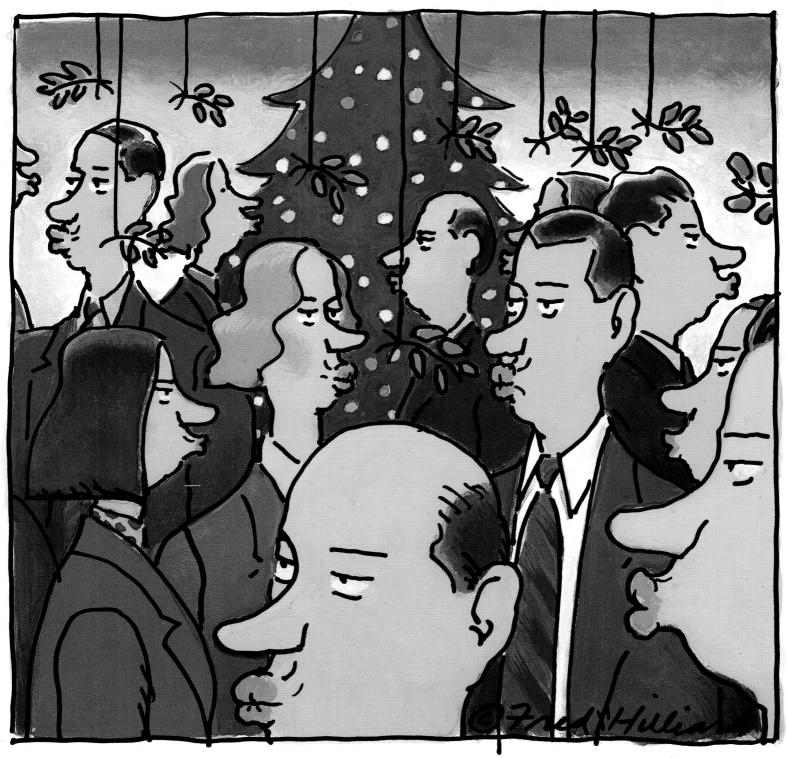

Optimism reigns at the XYZ Company this Holiday Season.

AgnesARU
AGNES ARU

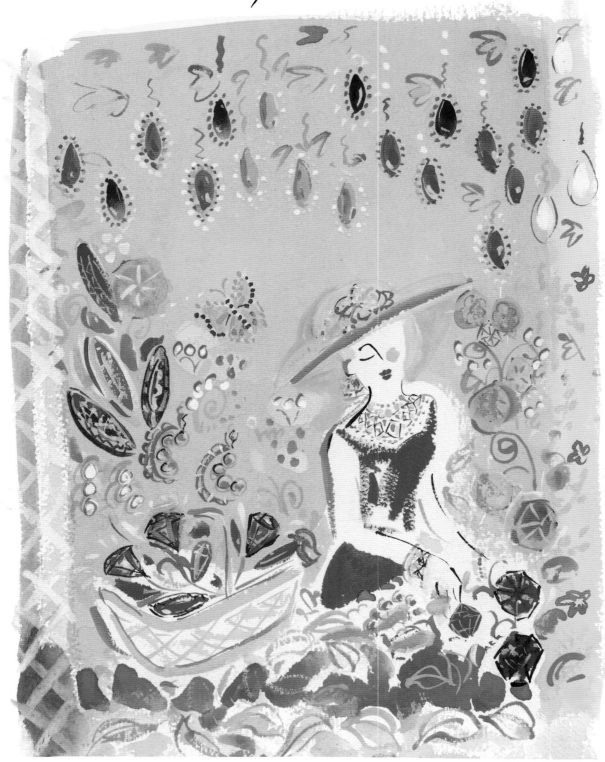

MACLEAN HUNTER PUB. LTD.

NANCY STENTZ

DŌTY

Gazebo Blend. The perfect summer escape.

ODAY
GEM
GALLERY

*When Dining at Ryan's, We
Ask You to Please Dress Formally.
Wear A Shirt.*

Mexico's Colonial Heartland

San Juan

Natural

SEATTLE CHOCOLATES

ILLUSTRATION
WORKS

*Holiday
Wrappings*

(212) 697-8525

JerrY
Jeff
ASSOCIATES

Fax (212) 949-1843

North West
Jorgensen/Barrett
(206) 634-1880
Fax (206) 632-2024

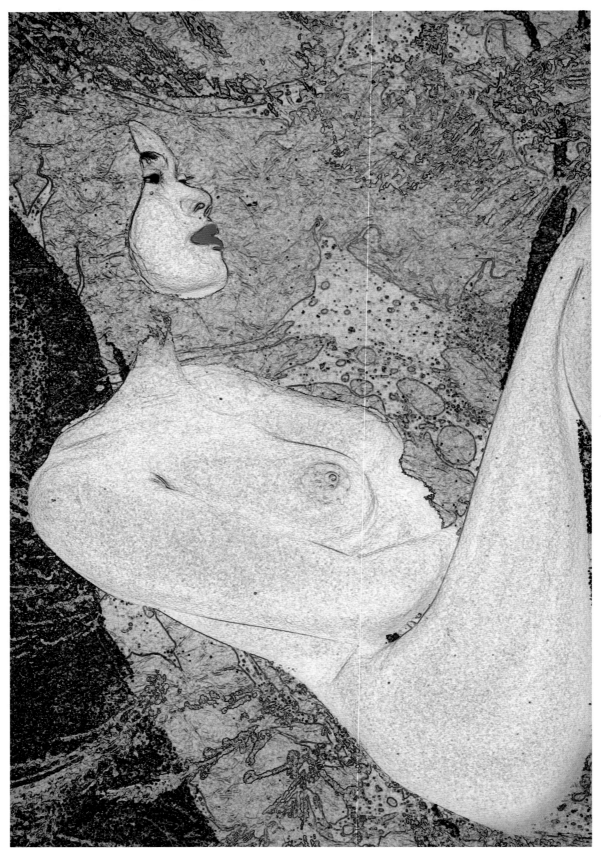

FRANCO ACCORNERO

(212) 697-8525 Fax (212) 949-1843

MARYJANE BEGIN

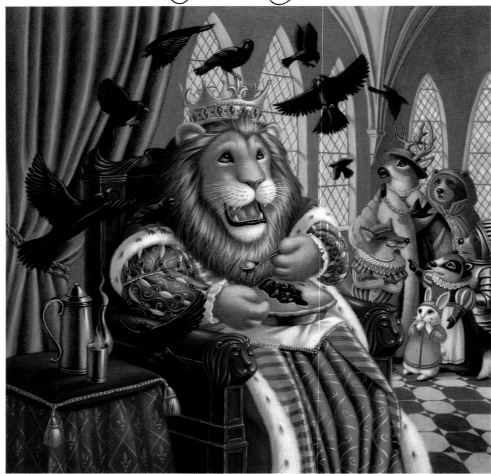

THE DANBURY MINT

PROCTOR & GAMBLE

JOHNSON & JOHNSON PRIVATE COLLECTION

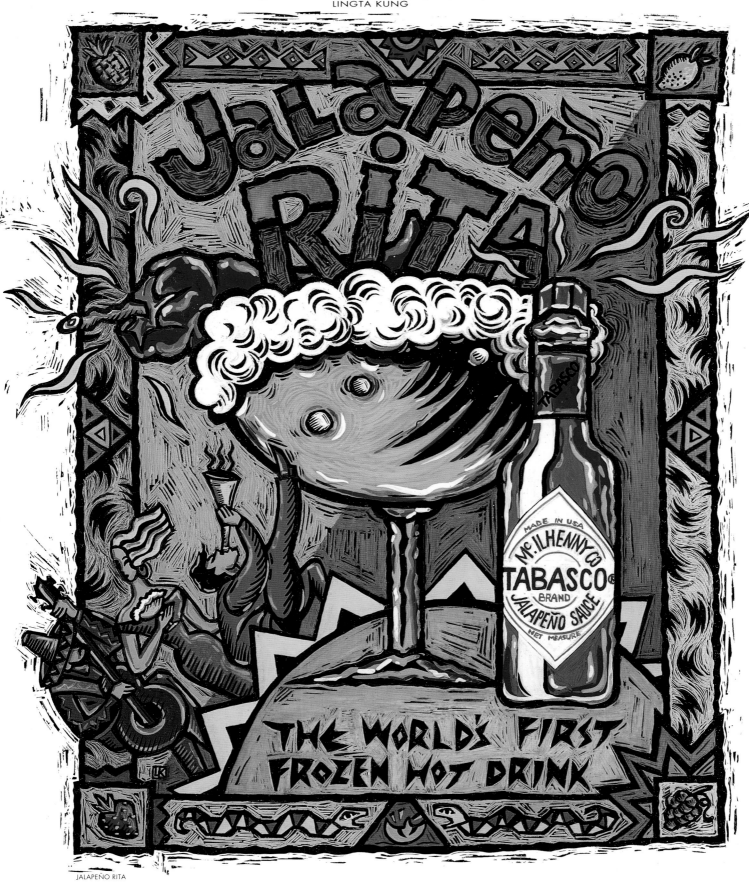

JALAPEÑO RITA

(212) 697-8525 Jerry Leff ASSOCIATES Fax (212) 949-1843

DENISE CRAWFORD

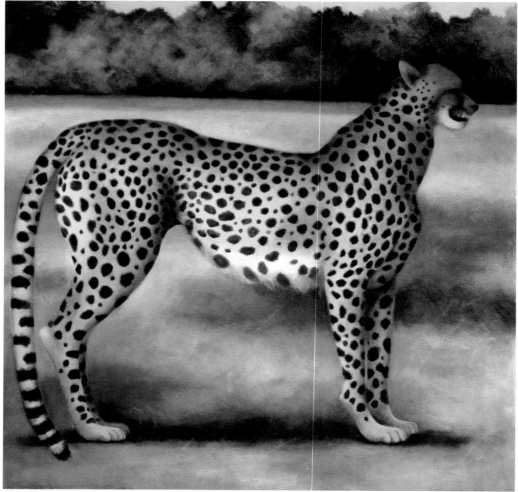

PRIVATE COMMISSION

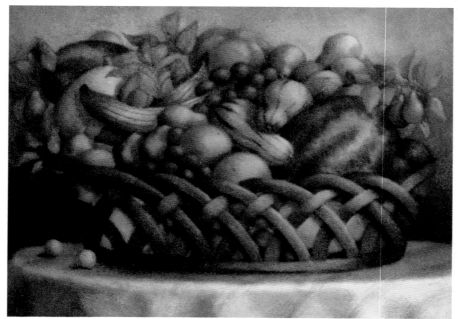

PRIVATE COLLECTION

YANKEE MAGAZINE

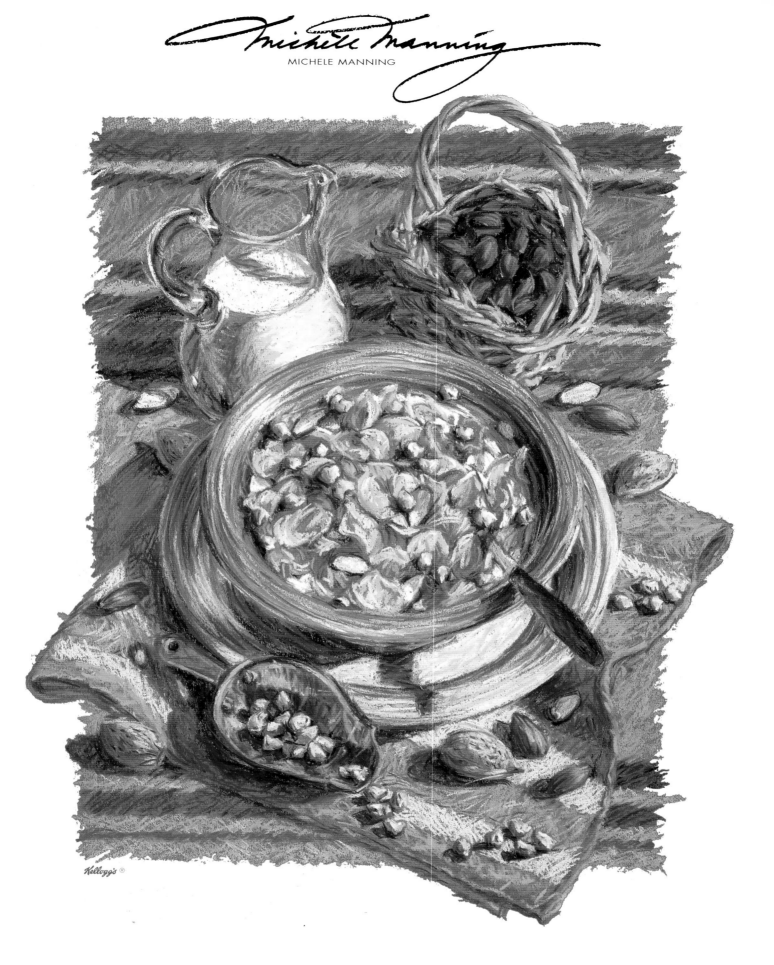

Michele Manning

MICHELE MANNING

West Coast
Jan Collier
(415) 383-9026
Fax (415) 383-9037

(212) 697-8525

Fax (212) 949-1843

Jerry Leff
ASSOCIATES

Michele Manning

MICHELE MANNING

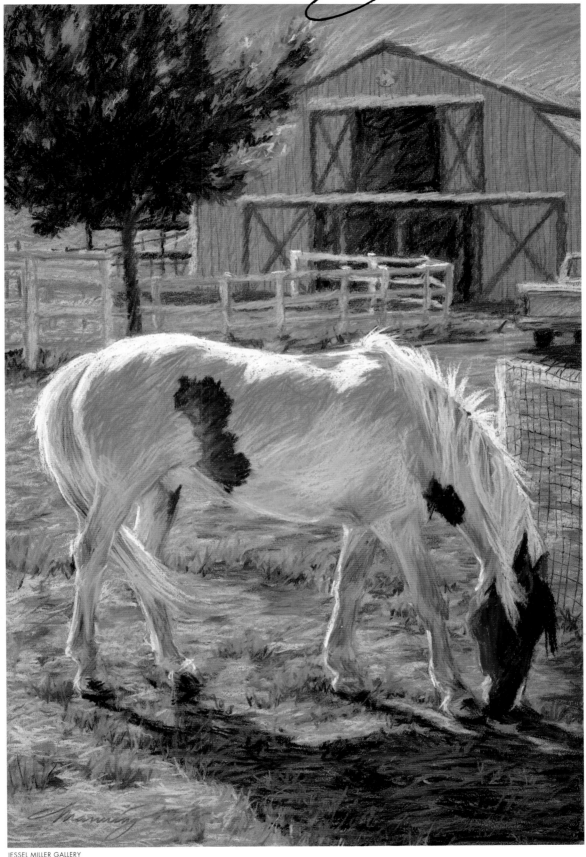

JESSEL MILLER GALLERY

(212) 697-8525 Fax (212) 949-1843

West Coast
Jan Collier
(415) 383-9026
Fax (415) 383-9037

KENT BARTON

RICHARD CLINE

PAUL COX

DAVID JOHNSON

RICHARD

GREGORY MANCHESS

BILL NELSON

DOUGLAS SMITH

MARK SUMMERS

JAMES BENNETT

JOHN COLLIER

JACK E. DAVIS

GARY KELLEY

SOLOMON

LORENZO MATTOTTI

C. F. PAYNE

GENNADY SPIRIN

121 MADISON AVE NYC 10016 (212) 683-1362 FAX: (212) 683-1919

KENT BARTON

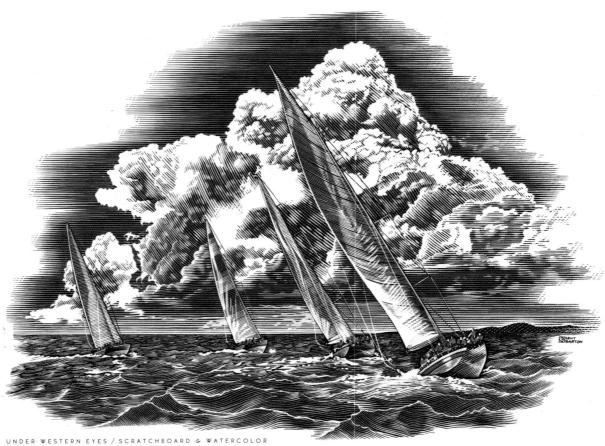

UNDER WESTERN EYES / SCRATCHBOARD & WATERCOLOR

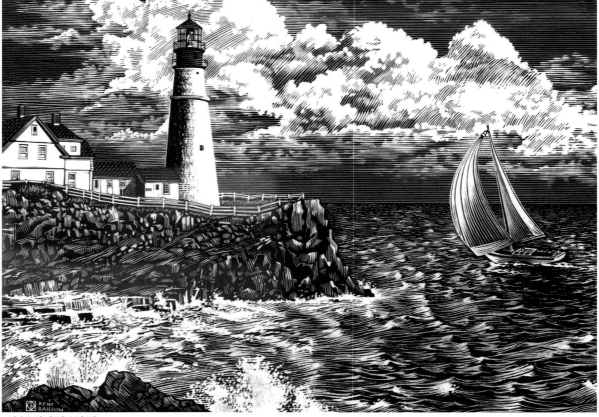

AROUND THE LIGHT

RICHARD SOLOMON
ARTIST REPRESENTATIVE

121 MADISON AVE NYC 10016 (212) 683-1362 FAX: (212) 683-191

KENT BARTON

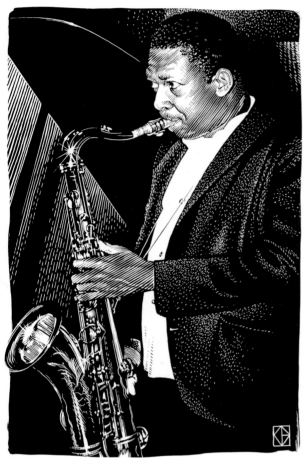

JOHN COLTRANE / SCRATCHBOARD

THE BERGDORF GOODMAN LOOK

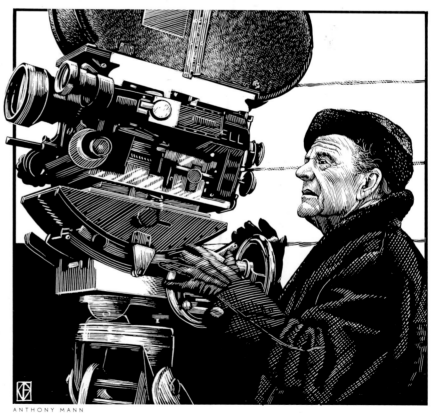

ANTHONY MANN

RICHARD SOLOMON
ARTIST REPRESENTATIVE

21 MADISON AVE NYC 10016 (212) 683-1362 FAX: (212) 683-1919

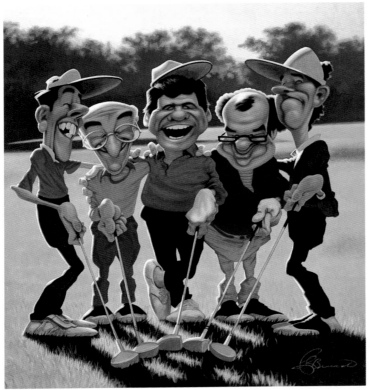

LEE TREVINO AND FRIENDS / OIL

DON'T HANG THIS MAN! ALAN GREENSPAN

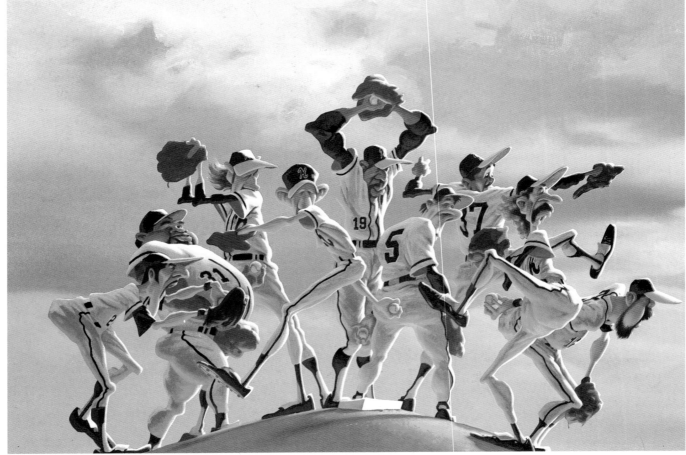

HERE'S THE PITCH

R I C H A R D S O L O M O N
A R T I S T R E P R E S E N T A T I V E

1 2 1 M A D I S O N A V E N Y C 1 0 0 1 6 (2 1 2) 6 8 3 - 1 3 6 2 F A X : (2 1 2) 6 8 3 - 1 9 1

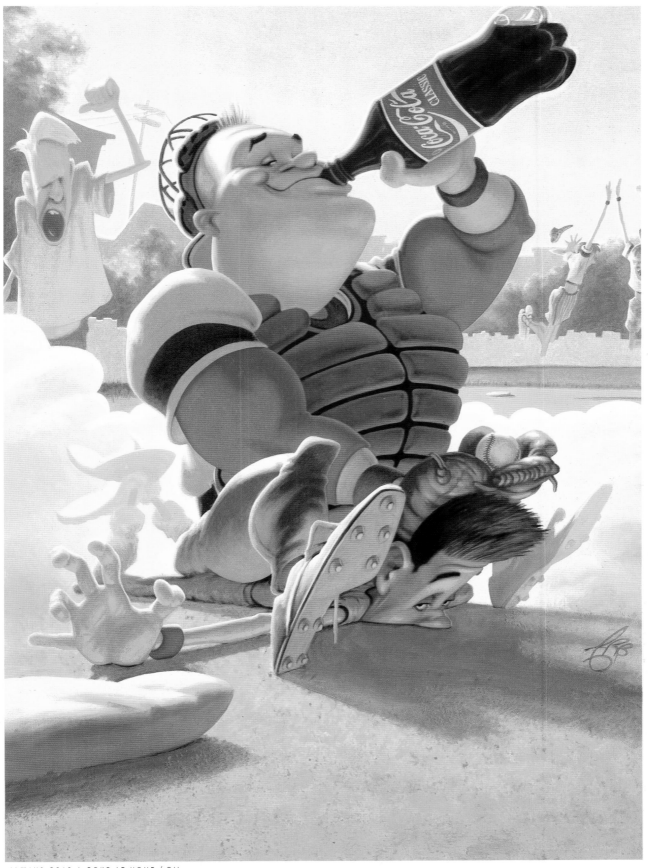

ALWAYS GRAB A COKE AT HOME / OIL

RICHARD SOLOMON
ARTIST REPRESENTATIVE

21 MADISON AVE NYC 10016 (212) 683-1362 FAX: (212) 683-1919

RICHARD CLINE

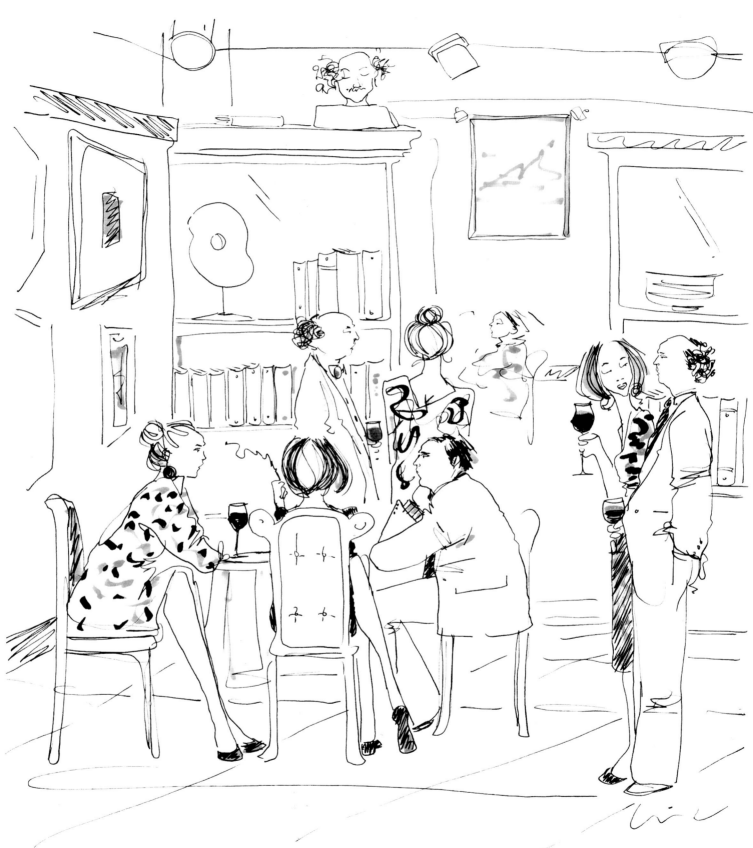

I'M NOT SEEING ANYONE AT THE MOMENT. THE ONLY LONG TERM RELATIONSHIP I HAVE IS WITH MY FERRARI/ INK & TONE

RICHARD SOLOMON
ARTIST REPRESENTATIVE

121 MADISON AVE NYC 10016 (212) 683-1362 FAX: (212) 683-191

RICHARD CLINE

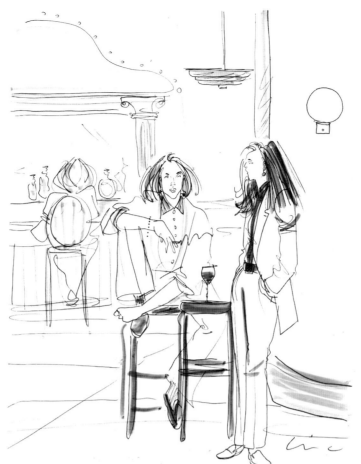

I NEED A MONSTER IN MY LIFE / INK & TONE.

I'VE SEEN ALL HIS SHORT FILMS ABOUT THE RAINFOREST. NOW WHAT?

RICHARD SOLOMON
ARTIST REPRESENTATIVE

21 MADISON AVE NYC 10016 (212) 683-1362 FAX: (212) 683-1919

JOHN COLLIER

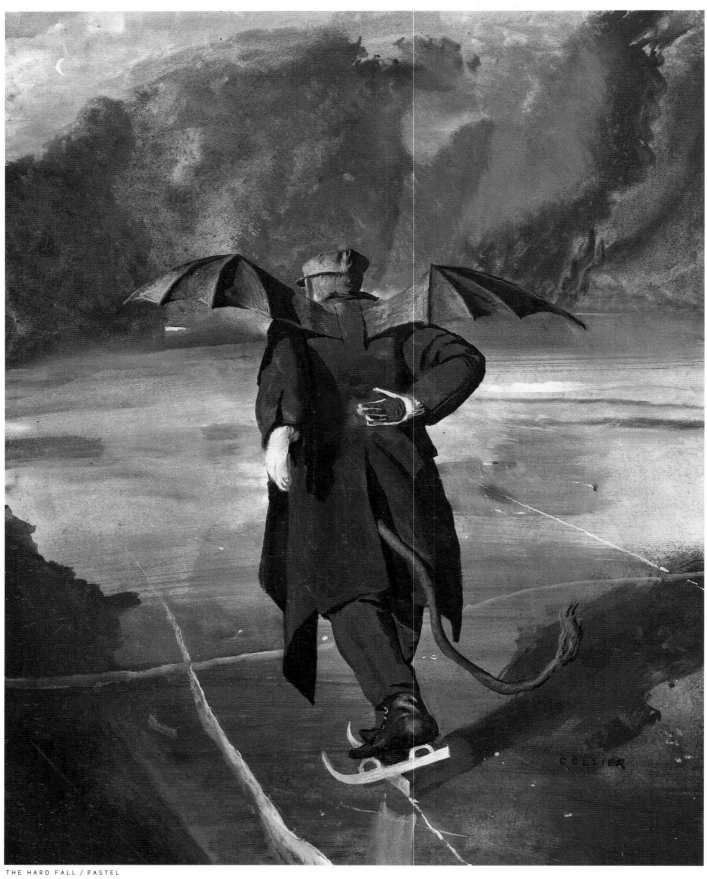

THE HARD FALL / PASTEL

JOHN COLLIER

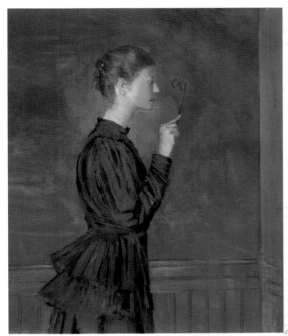

THE AGE OF INNOCENCE / EDITH WHARTON / PASTEL THE MASTER OF PETERSBURG

THE AGE OF INNOCENCE / EDITH WHARTON

RICHARD SOLOMON
ARTIST REPRESENTATIVE

21 MADISON AVE NYC 10016 (212) 683-1362 FAX: (212) 683-1919

PAUL COX

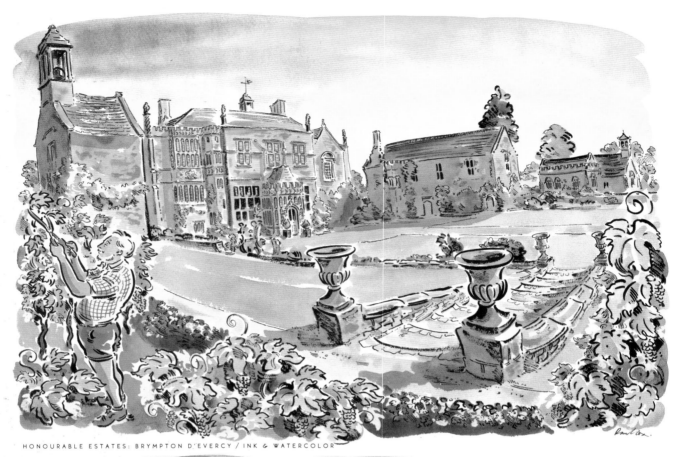

HONOURABLE ESTATES: BRYMPTON D'EVERCY / INK & WATERCOLOR

HONOURABLE ESTATES: BEAULIEU

RICHARD SOLOMON
ARTIST REPRESENTATIVE

121 MADISON AVE NYC 10016 (212) 683-1362 FAX: (212) 683-191

RELATIONSHIPS

RELATIONSHIPS

JUST ONE UNINVITED GUEST CAN SPOIL THE WHOLE PARTY

SHA-BOOM / COLORED PENCIL

RICHARD SOLOMON
ARTIST REPRESENTATIVE

121 MADISON AVE NYC 10016 (212) 683-1362 FAX: (212) 683-191

PATE' POOTOIS' RED HOT PARLOUR JAZZ ENSEMBLE / PASTEL

RICHARD SOLOMON
ARTIST REPRESENTATIVE

121 MADISON AVE NYC 10016 (212) 683-1362 FAX: (212) 683-1919

DAVID JOHNSON

A GIRL GROWING UP IN CHINA / INK & WATERCOLOR

HONORE DE BALZAC

THOMAS PAINE

RICHARD SOLOMON
ARTIST REPRESENTATIVE

121 MADISON AVE NYC 10016 (212) 683-1362 FAX: (212) 683-191

DAVID JOHNSON

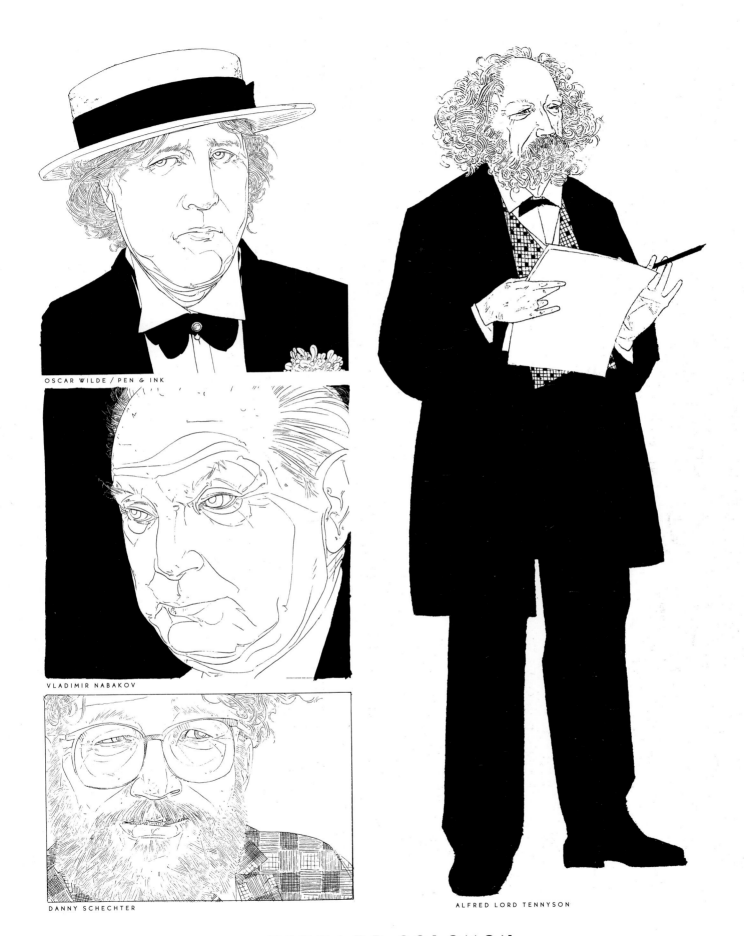

OSCAR WILDE / PEN & INK

VLADIMIR NABAKOV

DANNY SCHECHTER

ALFRED LORD TENNYSON

RICHARD SOLOMON
ARTIST REPRESENTATIVE

1 2 1 M A D I S O N A V E N Y C 1 0 0 1 6 (2 1 2) 6 8 3 - 1 3 6 2 F A X : (2 1 2) 6 8 3 - 1 9 1 9

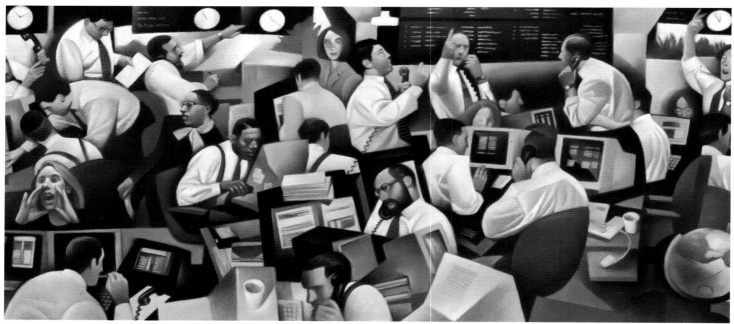

GLOBAL TRADING / PASTEL

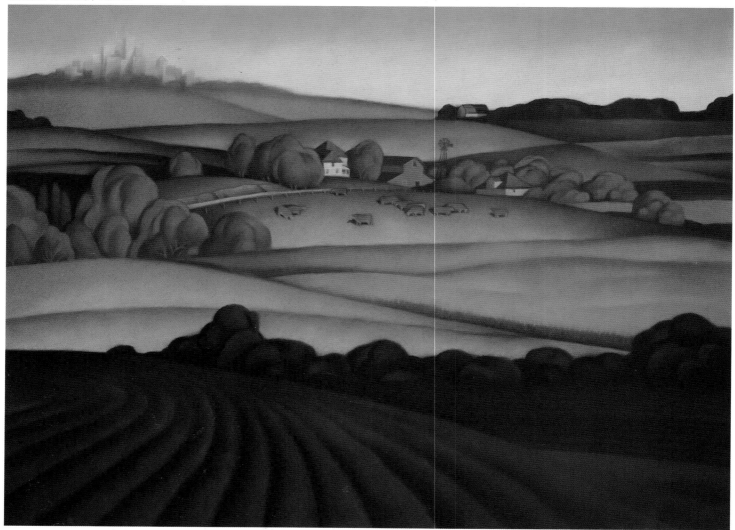

THERE'S A PLACE BETWEEN CALIFORNIA AND WALL STREET, WHERE YOU ARE ALWAYS WELCOME

RICHARD SOLOMON
ARTIST REPRESENTATIVE

1 2 1 M A D I S O N A V E N Y C 1 0 0 1 6 (2 1 2) 6 8 3 - 1 3 6 2 F A X : (2 1 2) 6 8 3 - 1 9 1 9

GARY KELLEY

RICHARD SOLOMON
ARTIST REPRESENTATIVE

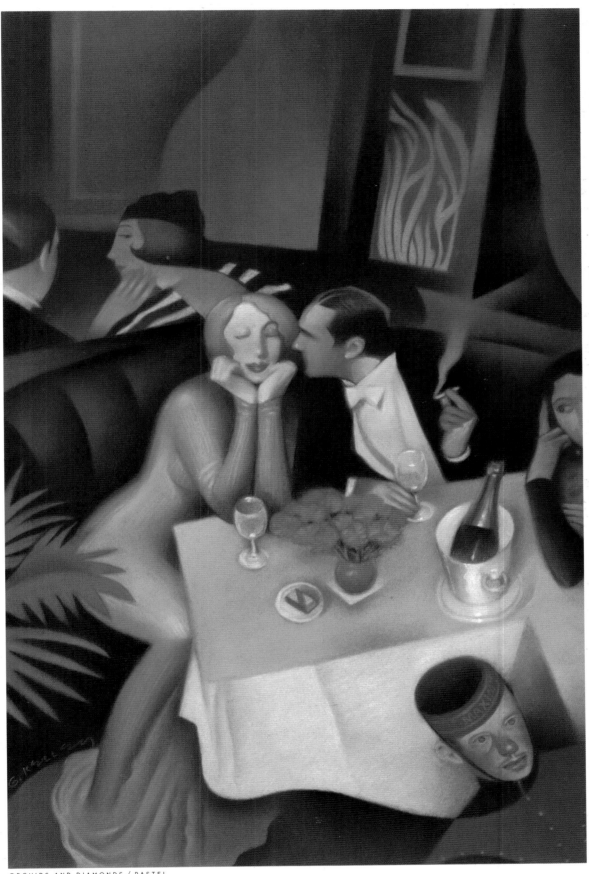

ORCHIDS AND DIAMONDS / PASTEL

121 MADISON AVE NYC 10016 (212) 683-1362 FAX: (212) 683-1919

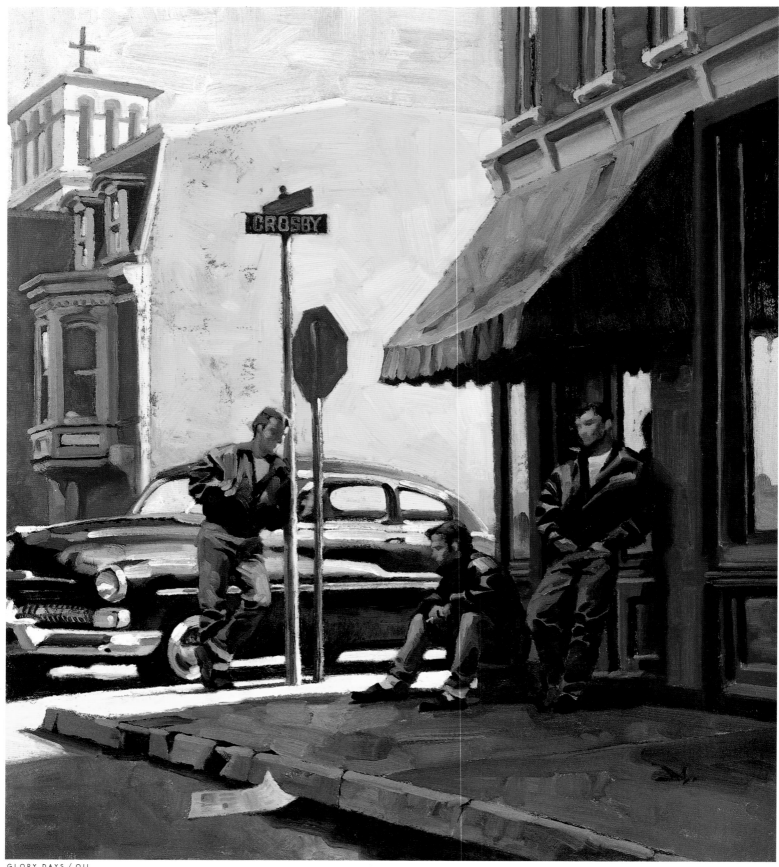

GLORY DAYS / OIL

254

GREGORY MANCHESS

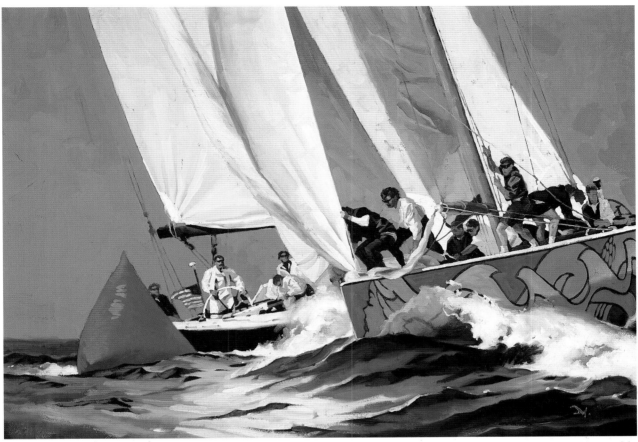

"YOUNG AMERICA" / OIL

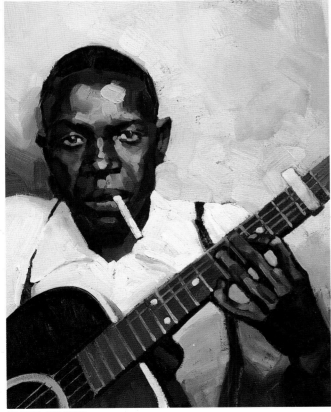

ROBERT JOHNSON

SELF PORTRAIT

RICHARD SOLOMON
ARTIST REPRESENTATIVE

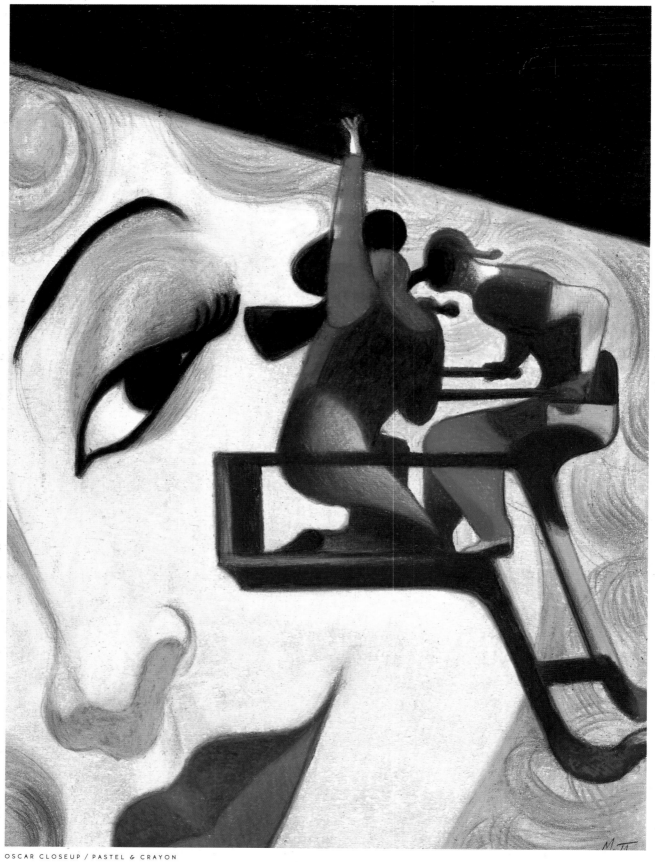

OSCAR CLOSEUP / PASTEL & CRAYON

LORENZO MATTOTTI

SOLITUDINE COPERTINA / PASTEL & CRAYON

LOVE MODERNE

VOYAGER

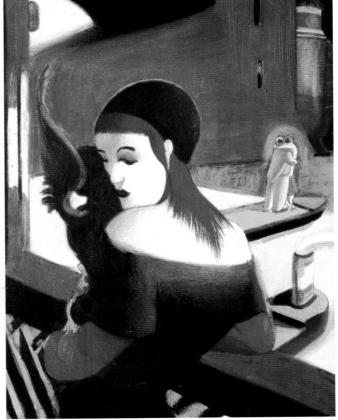

AWAY FAR AWAY

RICHARD SOLOMON
ARTIST REPRESENTATIVE

21 MADISON AVE NYC 10016 (212) 683-1362 FAX: (212) 683-1919

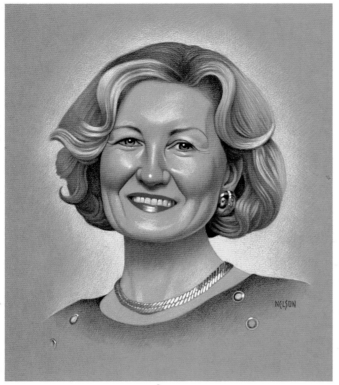

SENATOR KAY BAILEY HUTCHINSON / COLORED PENCIL

WINGED FIGURE

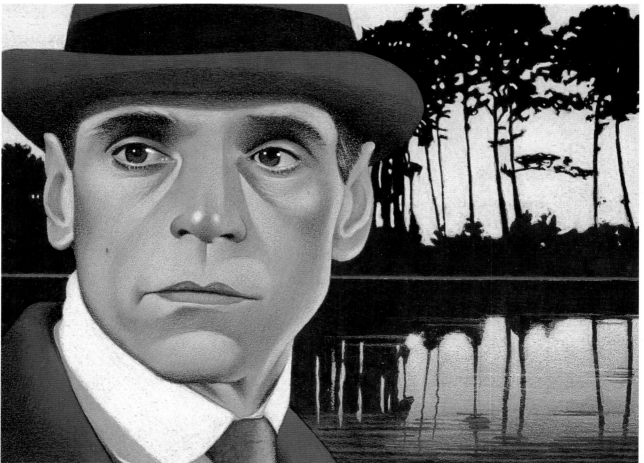

JEREMY IRONS

BILL NELSON

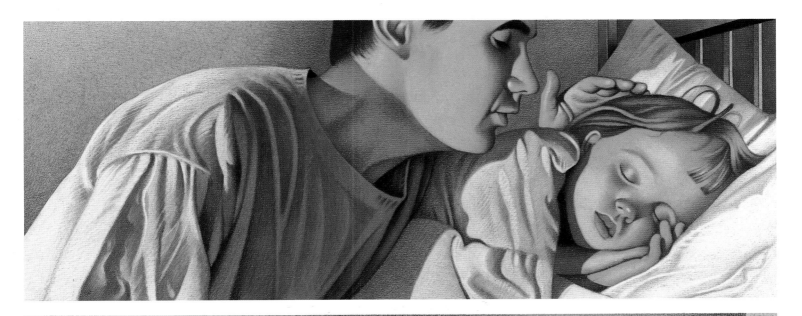

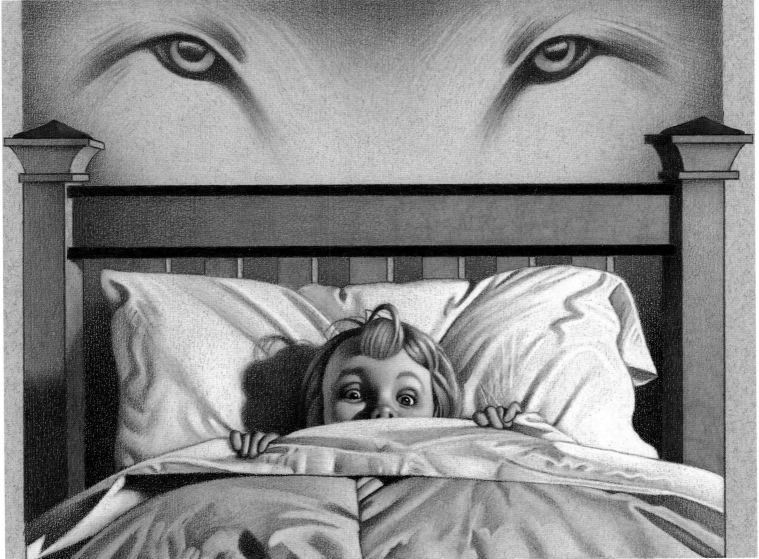

PAUL AND THE WOLF / COLORED PENCIL

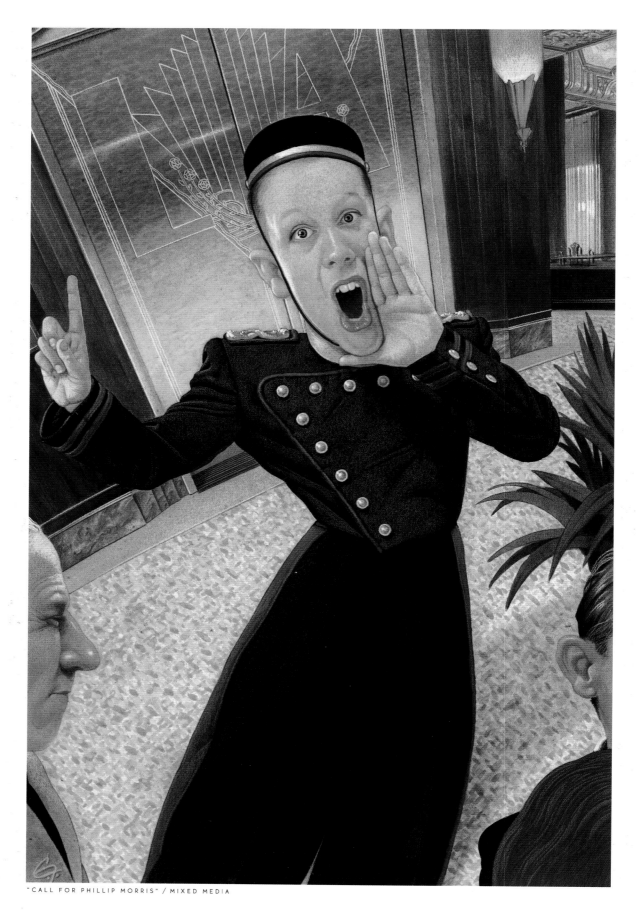

"CALL FOR PHILLIP MORRIS" / MIXED MEDIA

RICHARD SOLOMON
ARTIST REPRESENTATIVE

STEE-RIKE! / MIXED MEDIA

LATE NIGHT WITH DAVID LETTERMAN

STILL THE BEST SHOW IN TOWN: LE CIRQUE

RICHARD SOLOMON

ARTIST REPRESENTATIVE

121 MADISON AVE NYC 10016 (212) 683-1362 FAX: (212) 683-1919

PROFESSOR DILLAMOND OF CRAGE HALL / SCRATCHBOARD

RICHARD SOLOMON
ARTIST REPRESENTATIVE

121 MADISON AVE NYC 10016 (212) 683-1362 FAX: (212) 683-191

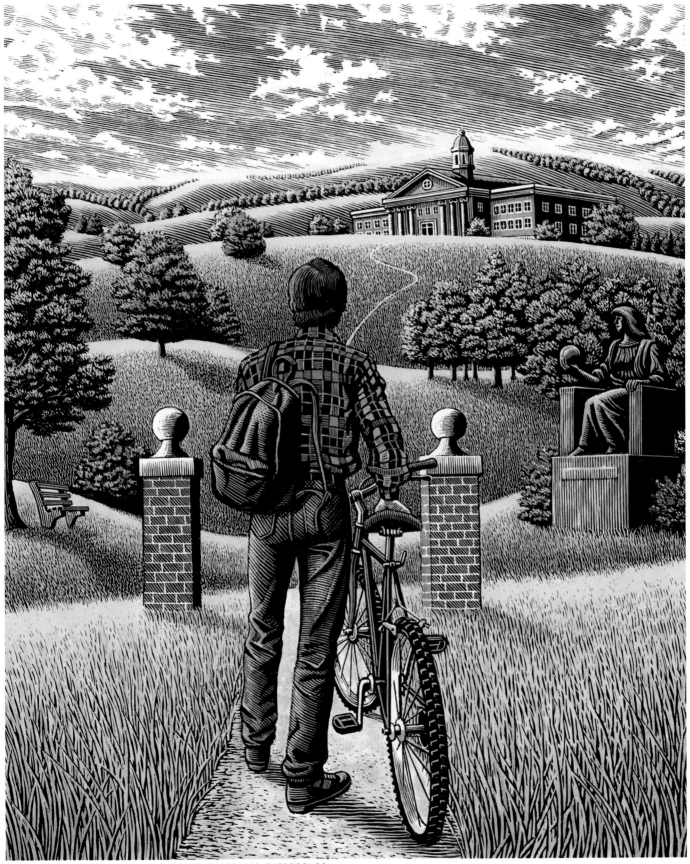

A NEW WORLD OF INFORMATION / SCRATCHBOARD AND WATERCOLOR

RICHARD SOLOMON

ARTIST REPRESENTATIVE

21 MADISON AVE NYC 10016 (212) 683-1362 FAX: (212) 683-1919

GENNADY SPIRIN

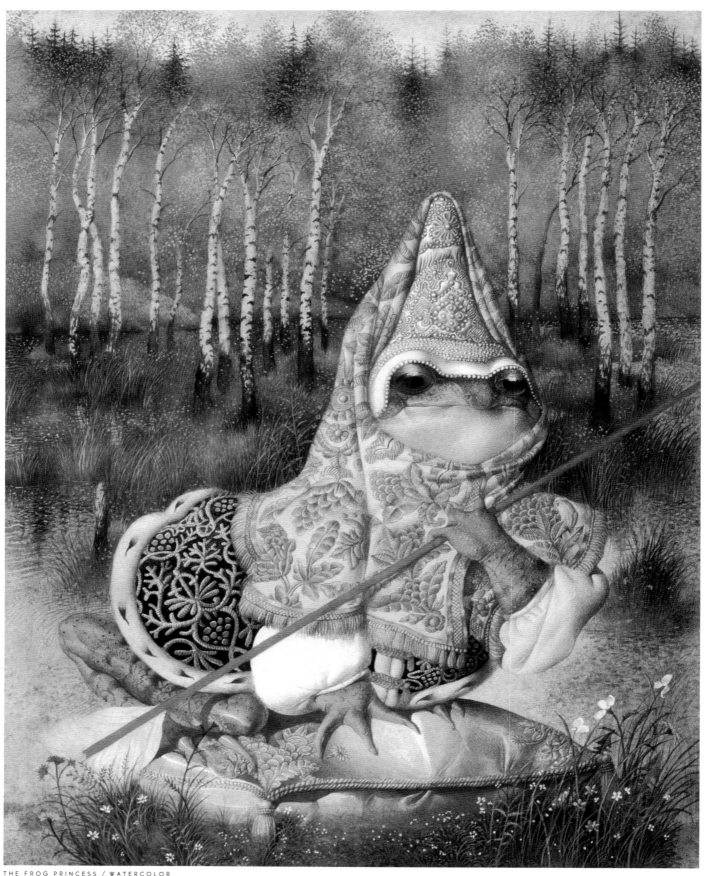

THE FROG PRINCESS / WATERCOLOR

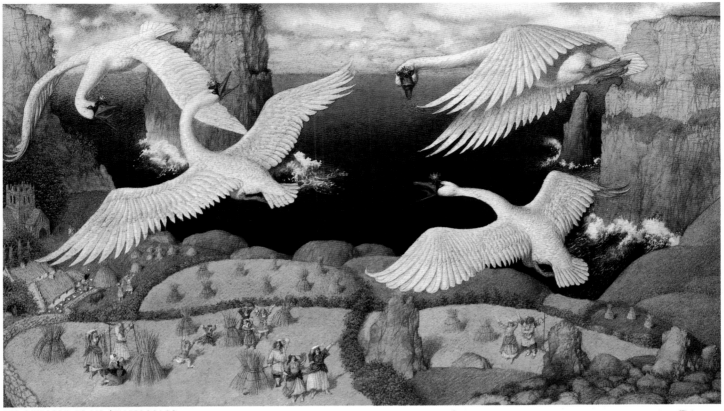

THE CHILDREN OF LIR / WATERCOLOR

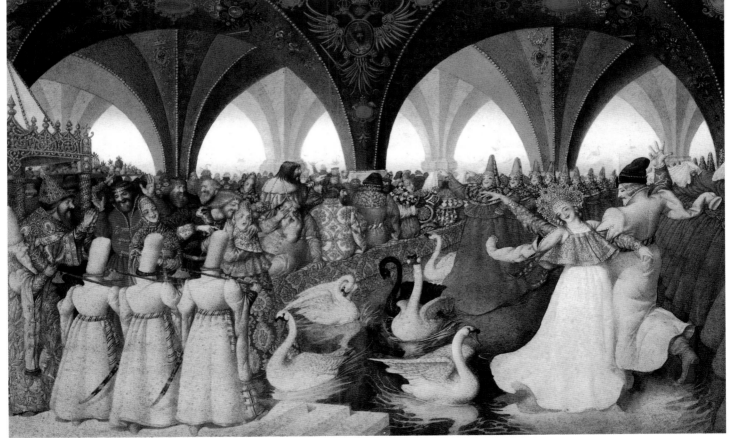

PRICE IVAN AND VASILISA THE WISE BEGAN TO DANCE

RICHARD SOLOMON
ARTIST REPRESENTATIVE

MARK SUMMERS

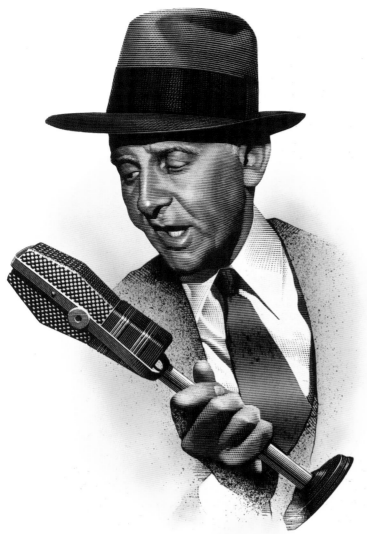

WALTER WINCHELL / SCRATCHBOARD & WATERCOLOR

"TALL SPOUTS WERE SEEN TO LEEWARD. . ."

SOMETHING BIG IS COMING: FORD CONTOUR, MERCURY MYSTIQUE

RICHARD SOLOMON
ARTIST REPRESENTATIVE

121 MADISON AVE NYC 10016 (212) 683-1362 FAX: (212) 683-191

JONATHAN SWIFT / SCRATCHBOARD

RICHARD SOLOMON

ARTIST REPRESENTATIVE

21 MADISON AVE NYC 10016 (212) 683-1362 FAX: (212) 683-1919

Mike Wimmer

As the creative needs of our clients evolve, so too does the portfolio and services of Mendola Artists. In the past year Mendola has added special effects photography and 3-D animation, both requiring the most sophisticated software and equipment. We have also added interesting conceptual and decorative styles executed with a simple paintbrush. And Mendola continues to represent the finest realistic painters in the industry. Mendola Artists has a staff of expert sales consultants to recommend the right talent for your project. On the west coast, we have a new office to service your needs. You can see the full range of our talent by reviewing the Mendola sections in the major sourcebooks or by requesting our latest promotion book.

MENDOLA LTD.
ARTISTS REPRESENTATIVES
212 **986-5680** FAX 212 818-1246
420 LEXINGTON AVE. NEW YORK N.Y. 10170
WEST COAST 503 236-2645

Send me the 1996 Mendola Artists Promotion Book
(send or fax us a copy of this ad)
Send to:
MENDOLA ARTISTS
420 Lexington Ave.
Penthouse
New York, New York 10170
(212) 986-5680
ATTN: Tim Mendola

My address:

Name_____

Title_____

Company_____

Street_____

Address_____

Phone_____

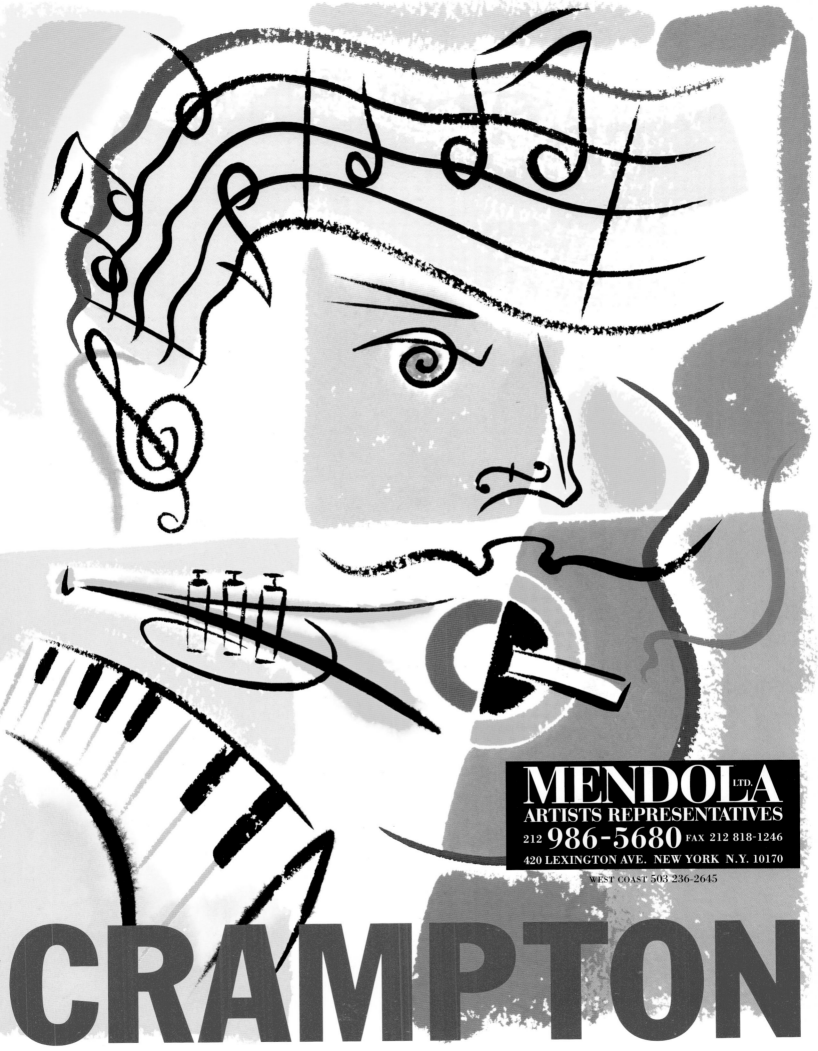

CRAMPTON

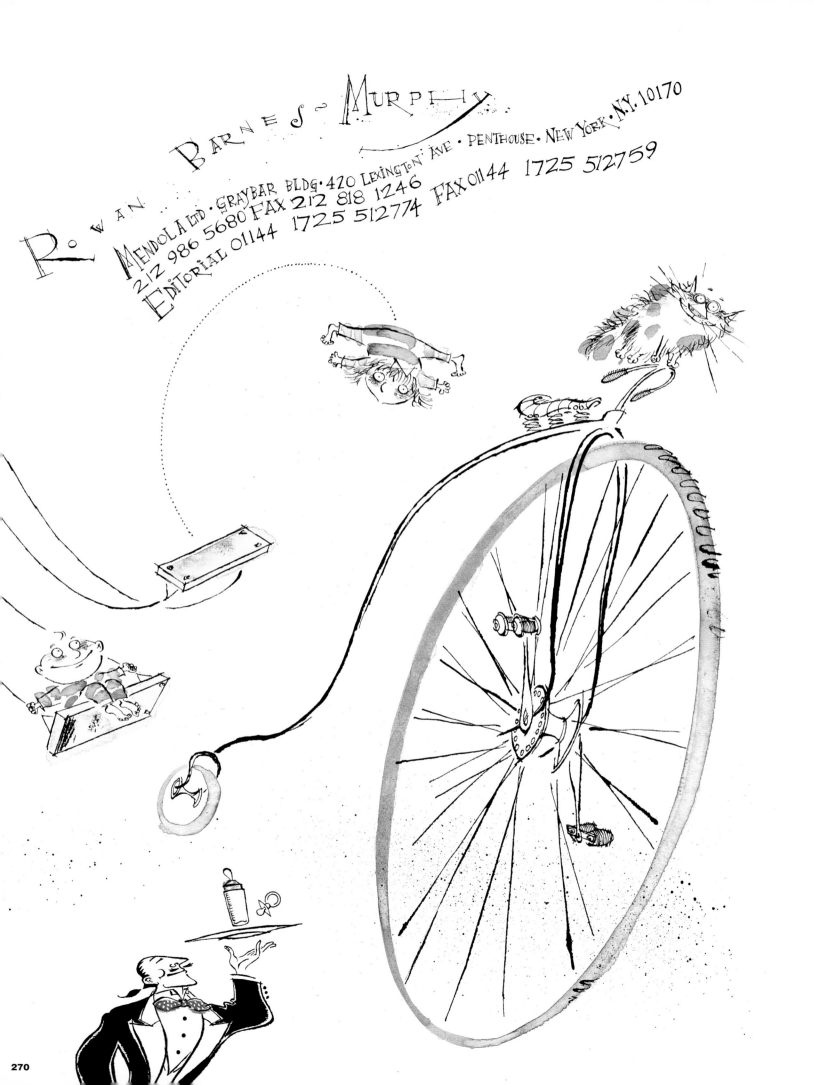

Rowan BARNES~MURPHY
Mendola Ltd · Graybar Bldg · 420 Lexington Ave · Penthouse · New York · N.Y. 10170
212 986 5680 FAX 212 818 1246
Editorial 01144 1725 512774 FAX 01144 1725 512759

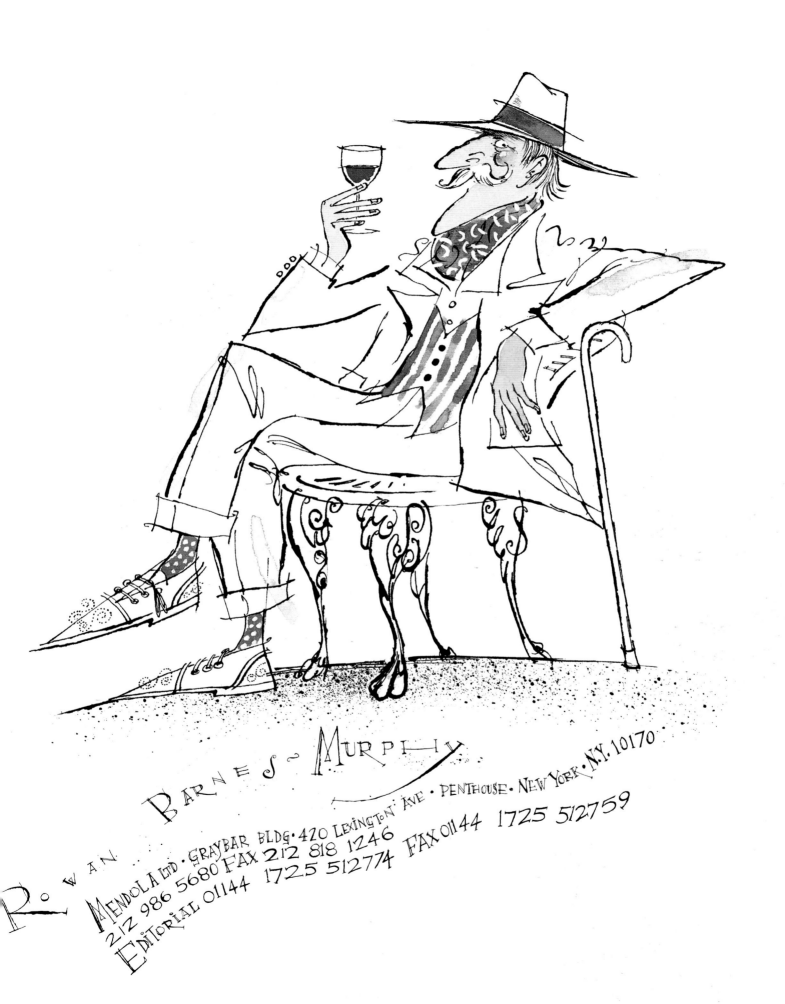

BARNES~MURPHY

Rowan

MENDOLA LTD · GRAYBAR BLDG · 420 LEXINGTON AVE · PENTHOUSE · NEW YORK · N.Y. 10170
212 986 5680 FAX 212 818 1246
EDITORIAL 01144 1725 512774 FAX 01144 1725 512759

WAYNE VINCENT

MENDOLA LTD.
212-986-5680

EDITORIAL
703-532-8551

WAYNE VINCENT

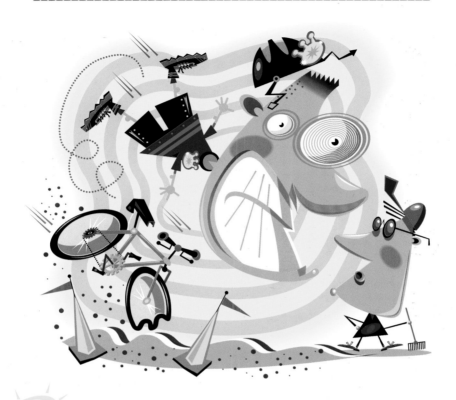

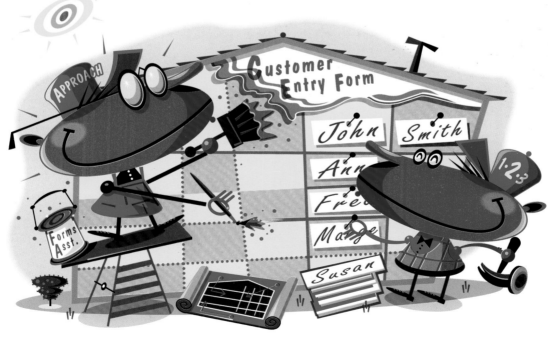

© 1995 Wayne Vincent & Associates Linotronic Imaging by VIP Systems Inc., Alexandria, VA

MOTOWN®
ANIMATION

graphics
CONTEMPORARY ILLUSTRATION and COMIC BOOK ART
for ADVERTISING and BEYOND

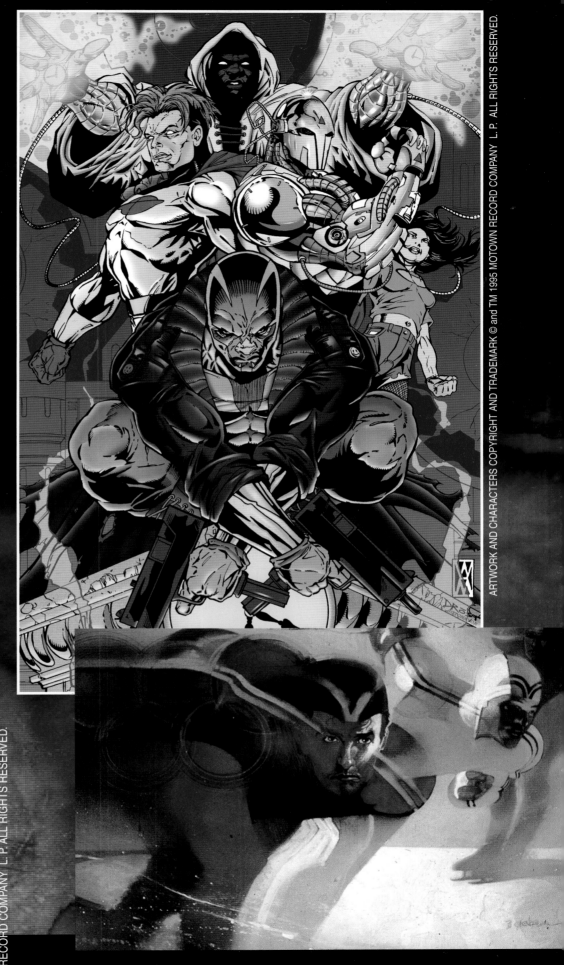

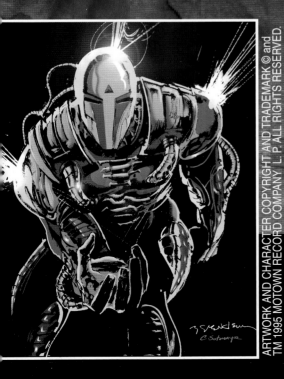

MENDOLA LTD.
ARTISTS REPRESENTIVES
212 **986-5680** FAX 212 818-1246
420 LEXINGTON AVE. NEW YORK N. Y. 10170

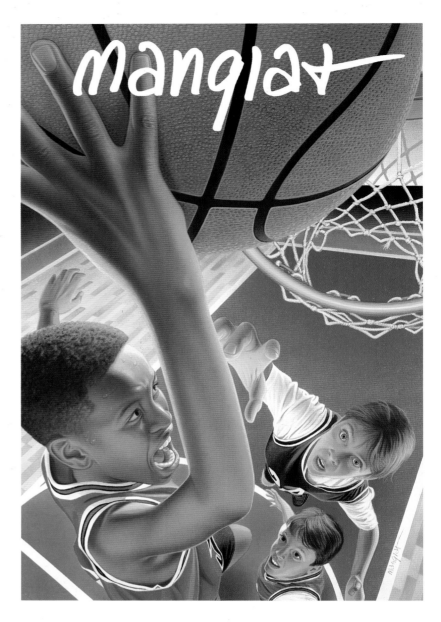

MICHAEL HALBERT

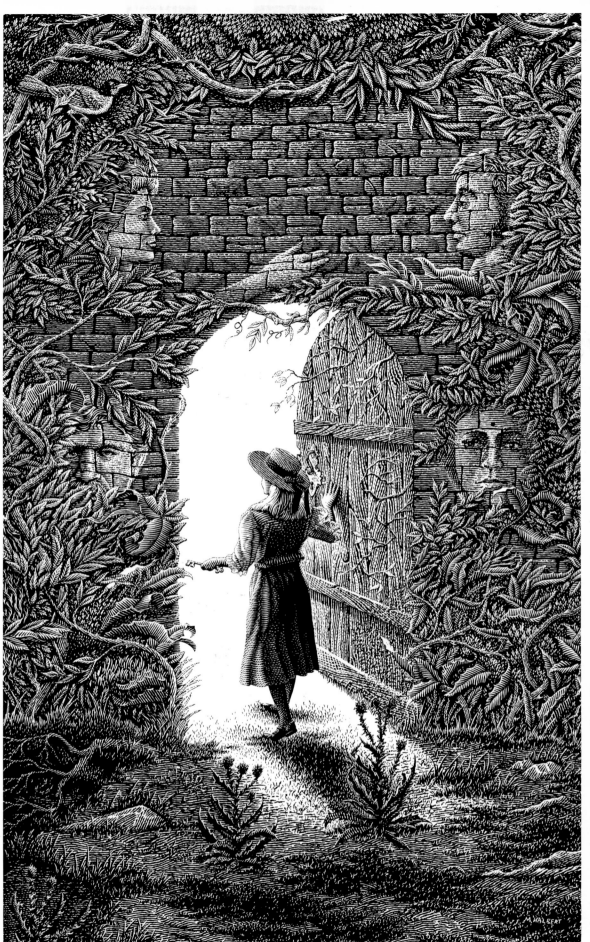

MICHAEL HALBERT

KITCHELL

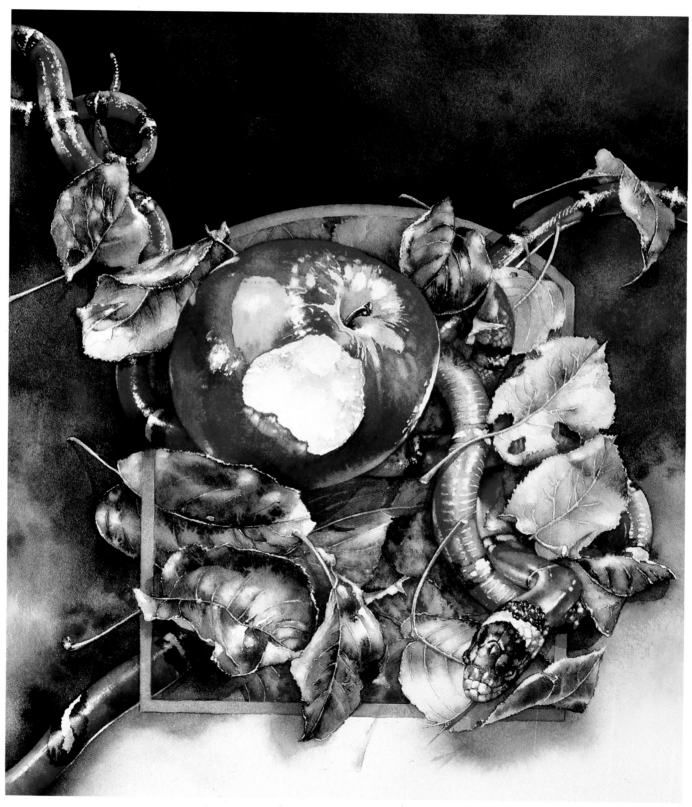

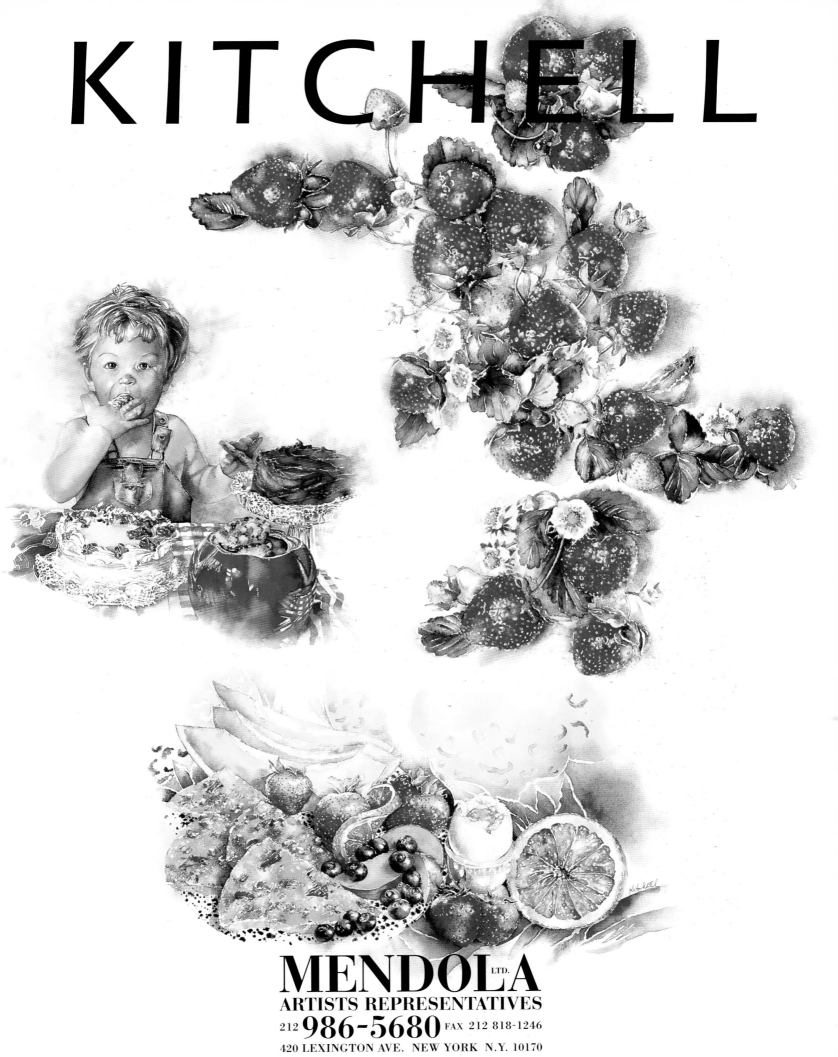

KITCHELL

BILL JAMES

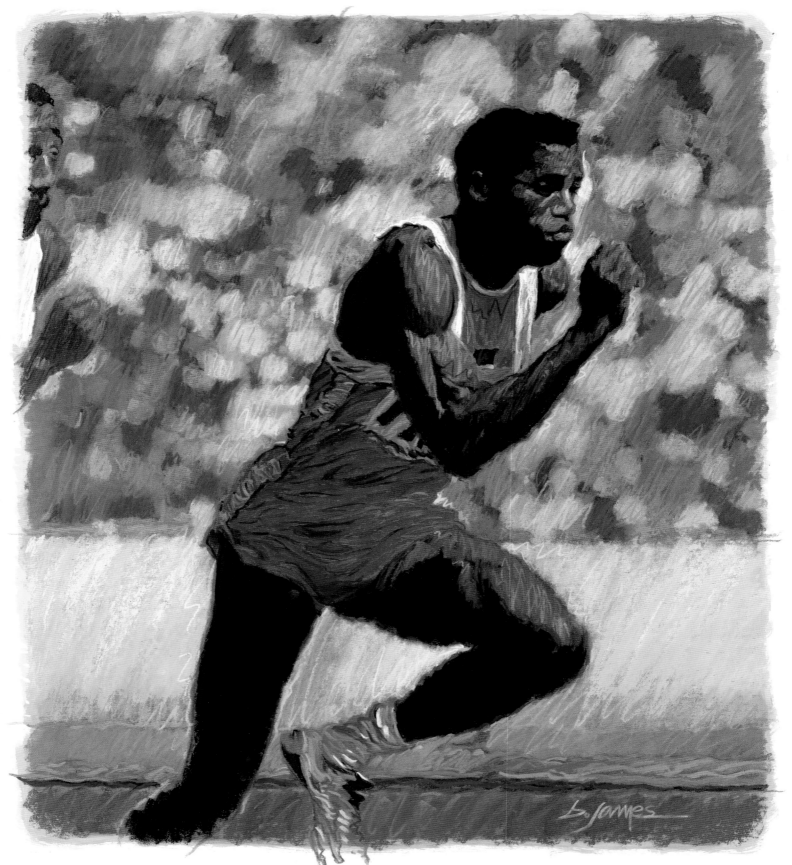

BILL JAMES

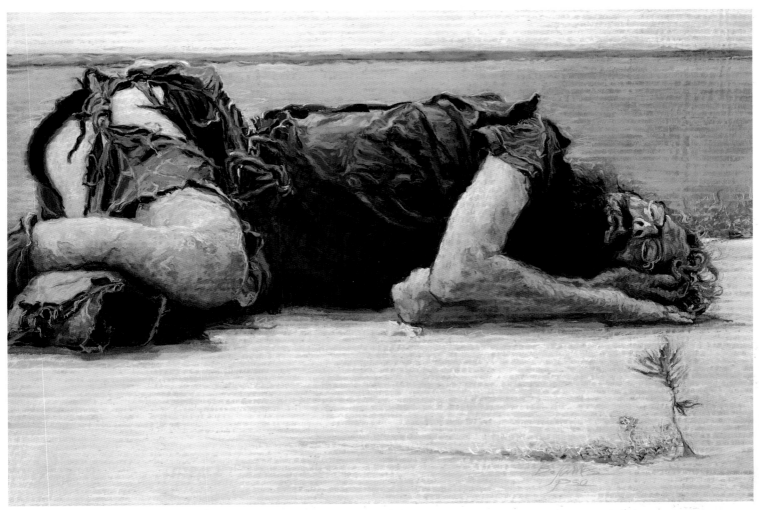

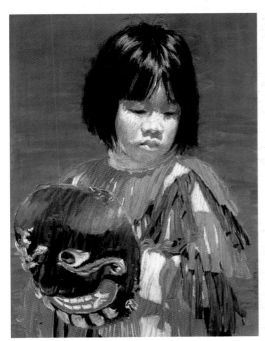

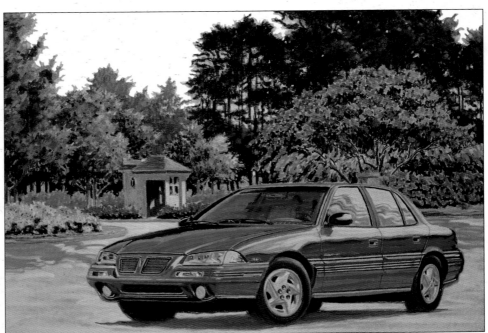

283

BORIS
ZLOTSKY

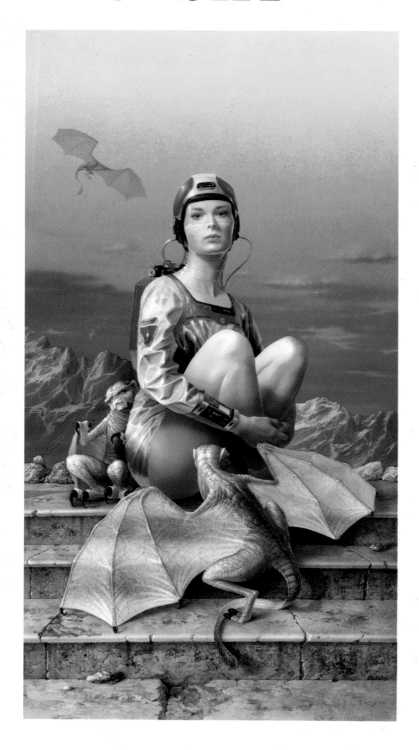

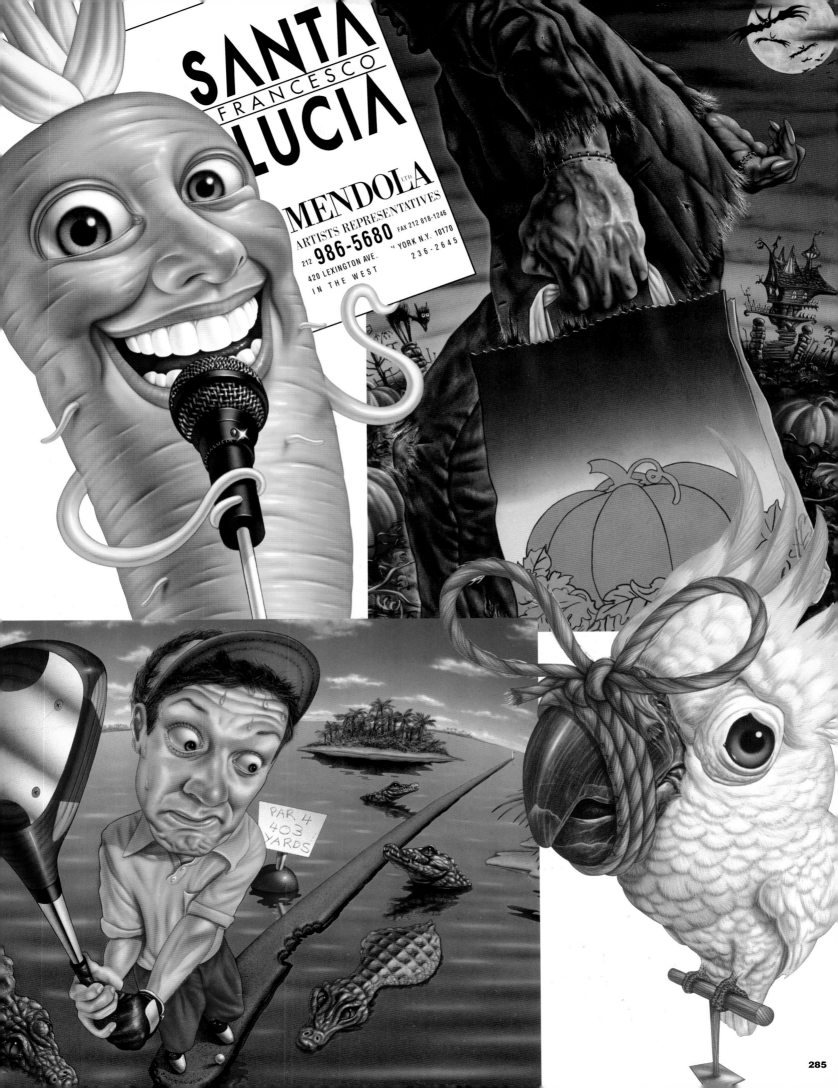

PAR 4
403
YARDS

TOM NEWSOM

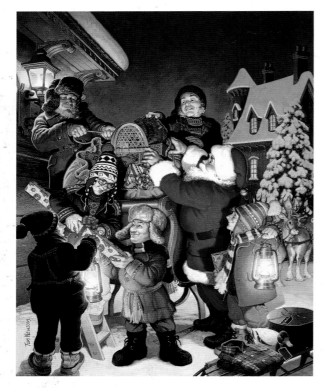

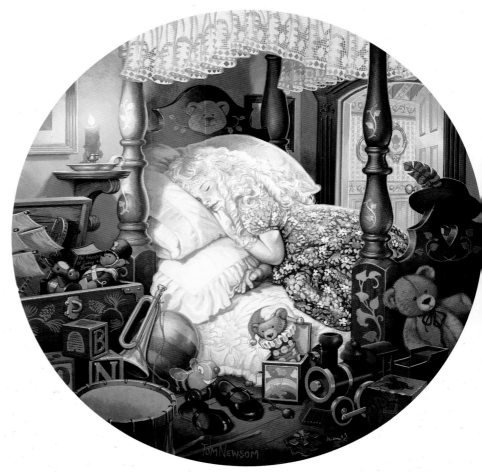

286

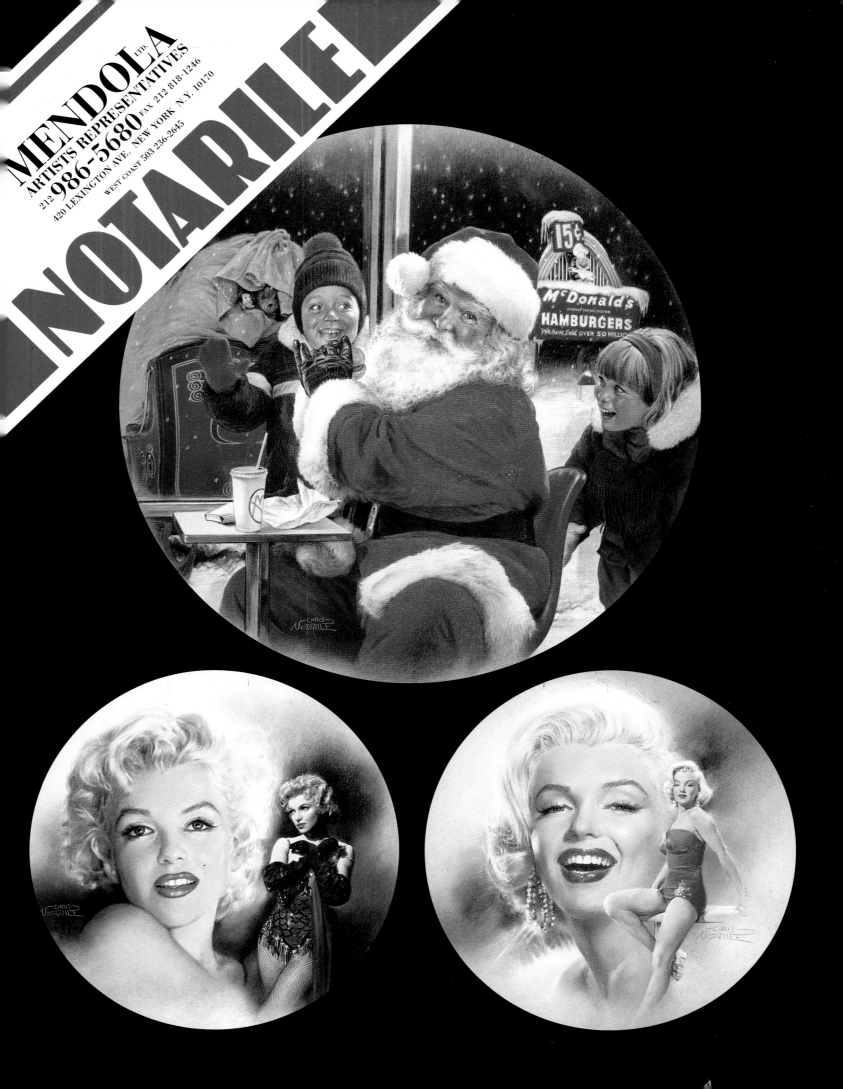

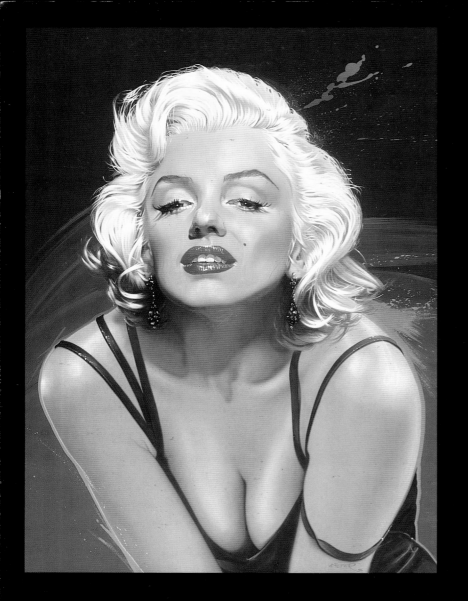

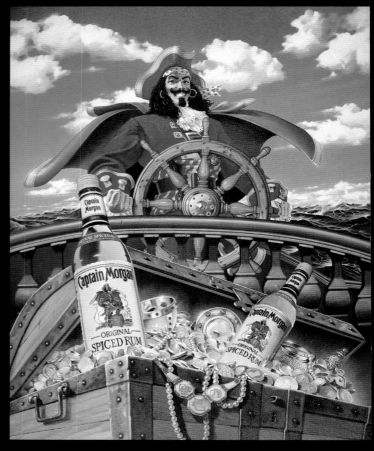

ALFONS KIEFER

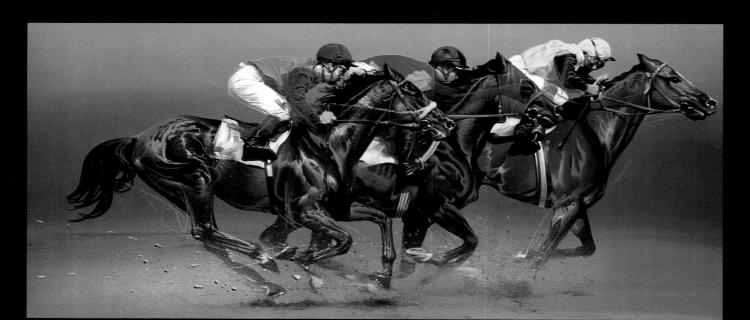

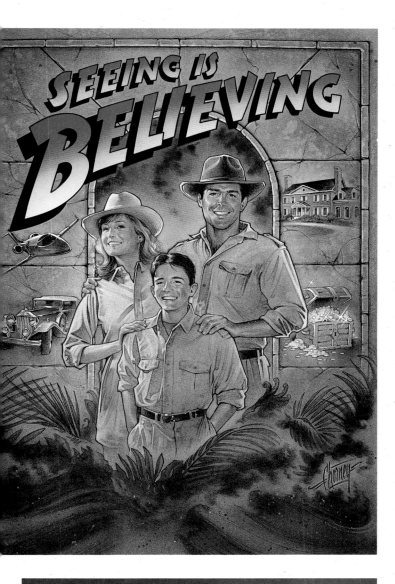

STEVEN
CHORNEY
ILLUSTRATION

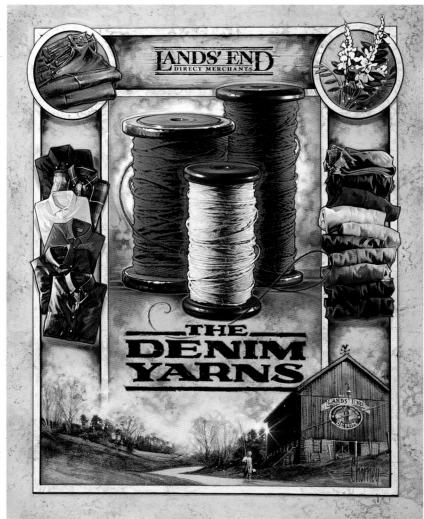

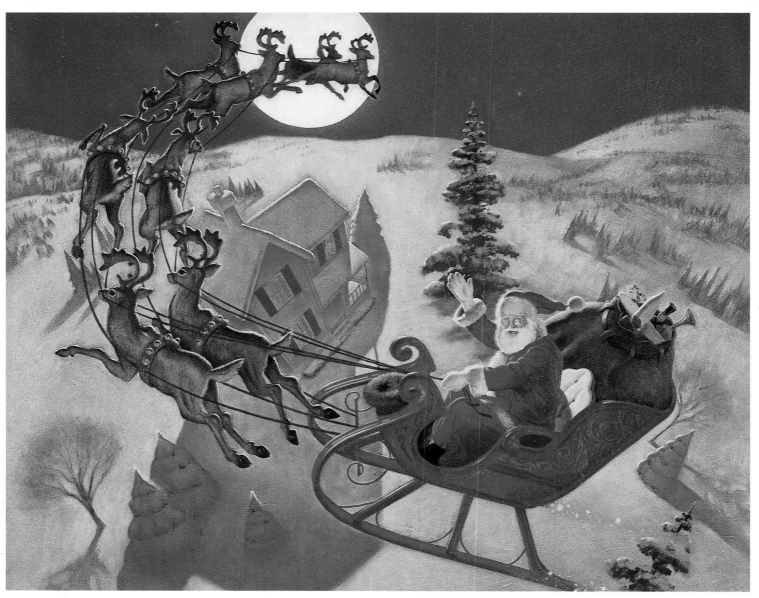

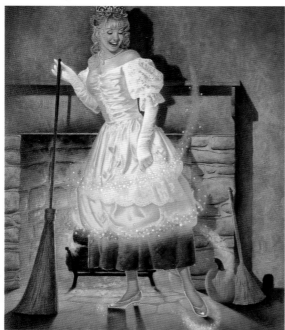

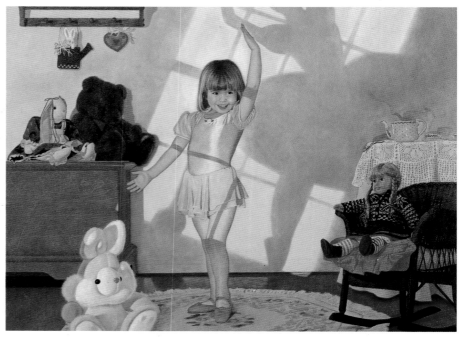

JASON DOWD

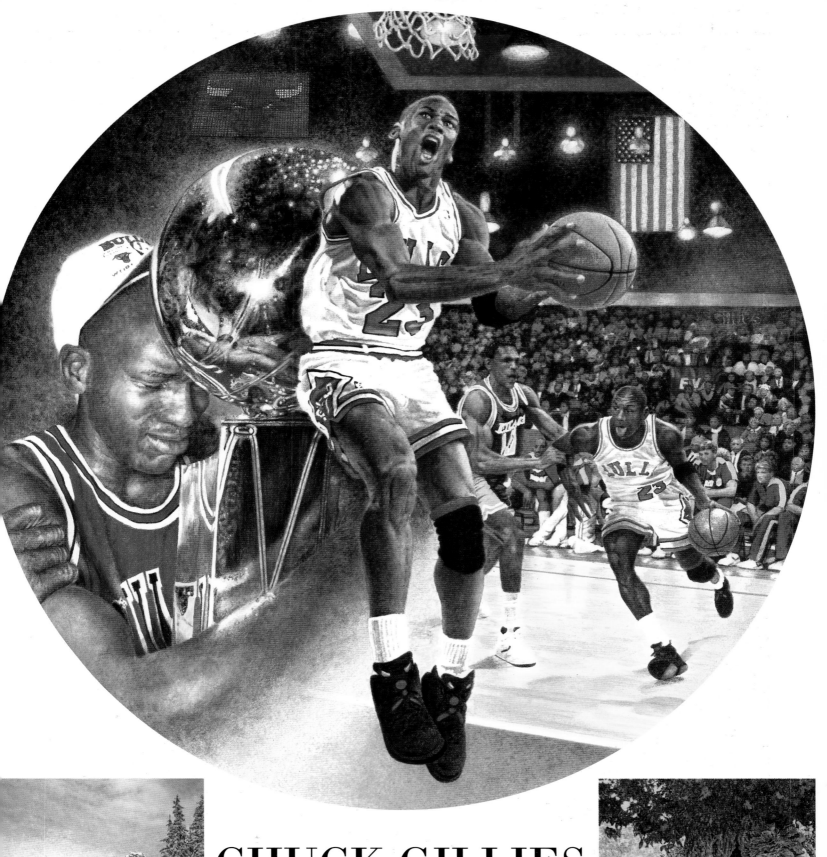

CHUCK GILLIES

MENDOLA LTD.
ARTISTS REPRESENTATIVES
212 **986-5680** FAX 212 818-1246
420 LEXINGTON AVE. NEW YORK N.Y. 10170

WEST COAST 503 236-2645

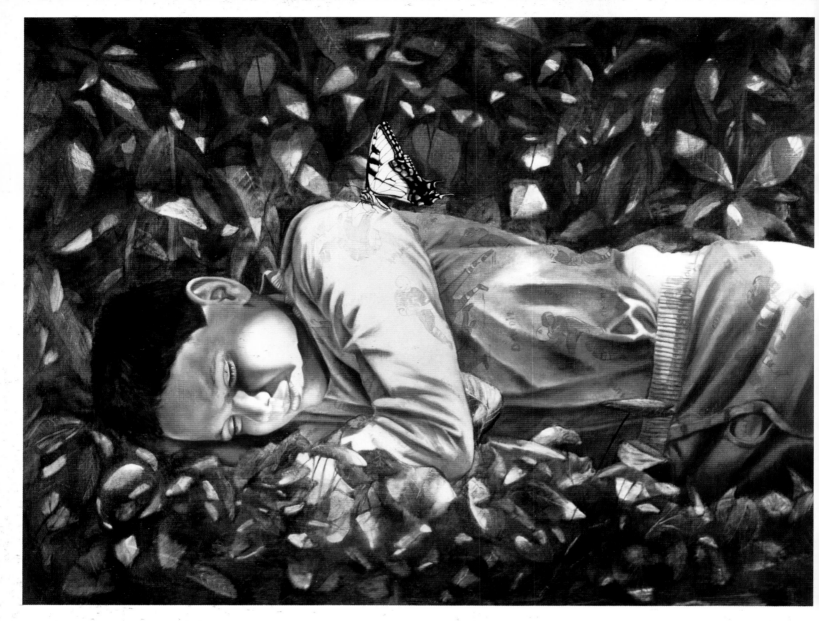

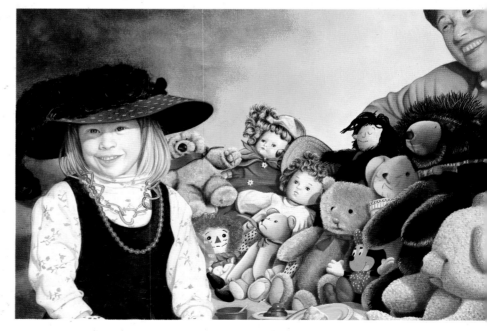

OBERT TANENBAUM

BILL SILVERS

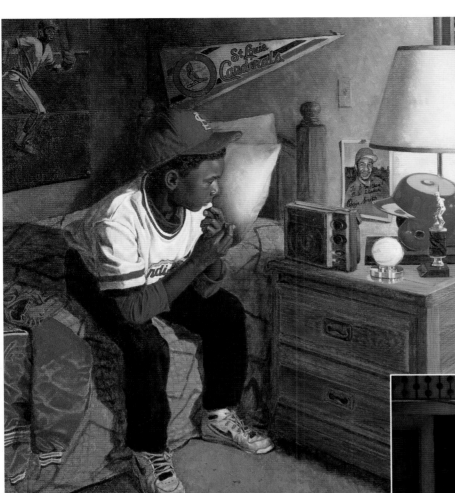

BRENT BENGER

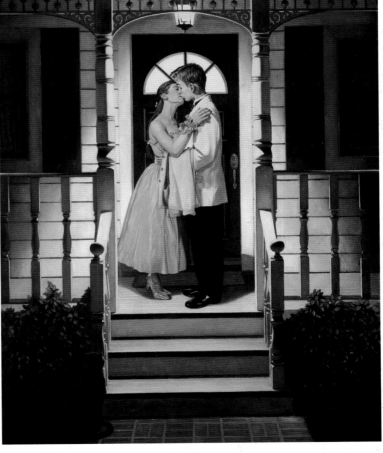

295

GeoSTORM

PARTY ANIMAL

PAUL MANZ

SCREAMER

ALL-STAR Racing TEAM

296

Geoffrey McCormack

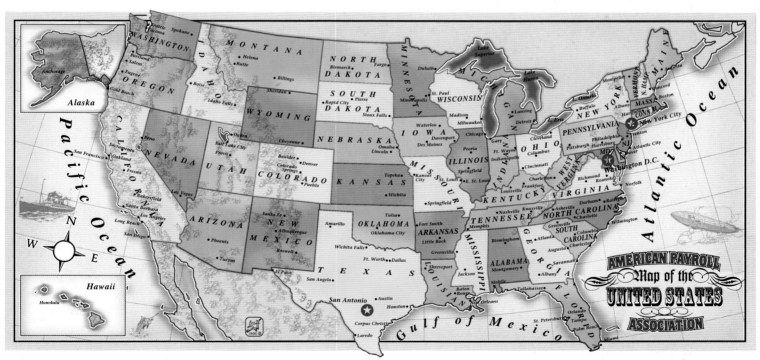

BILL VANN
SPORTS, ILLUSTRATED

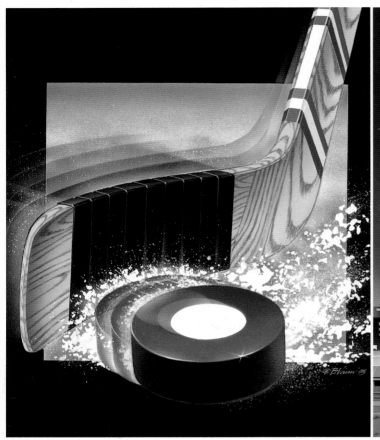

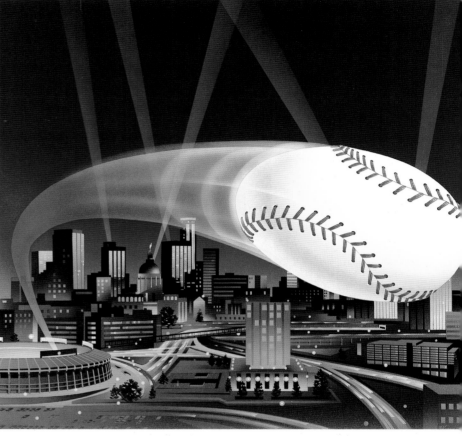

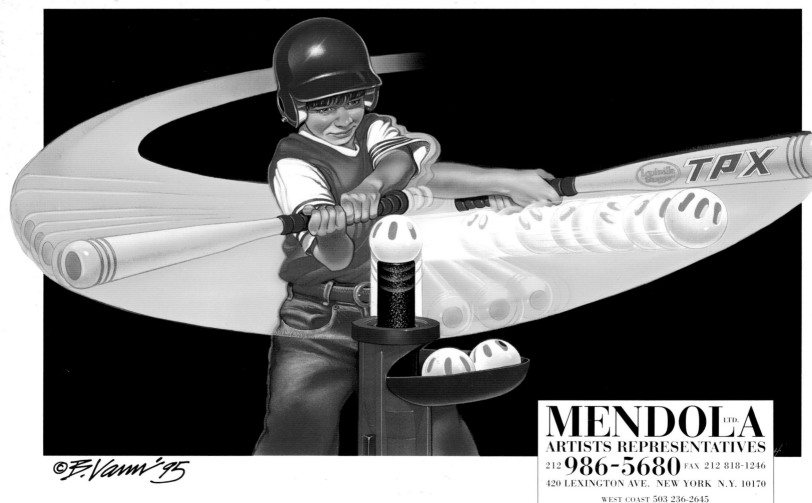

©B. Vann '95

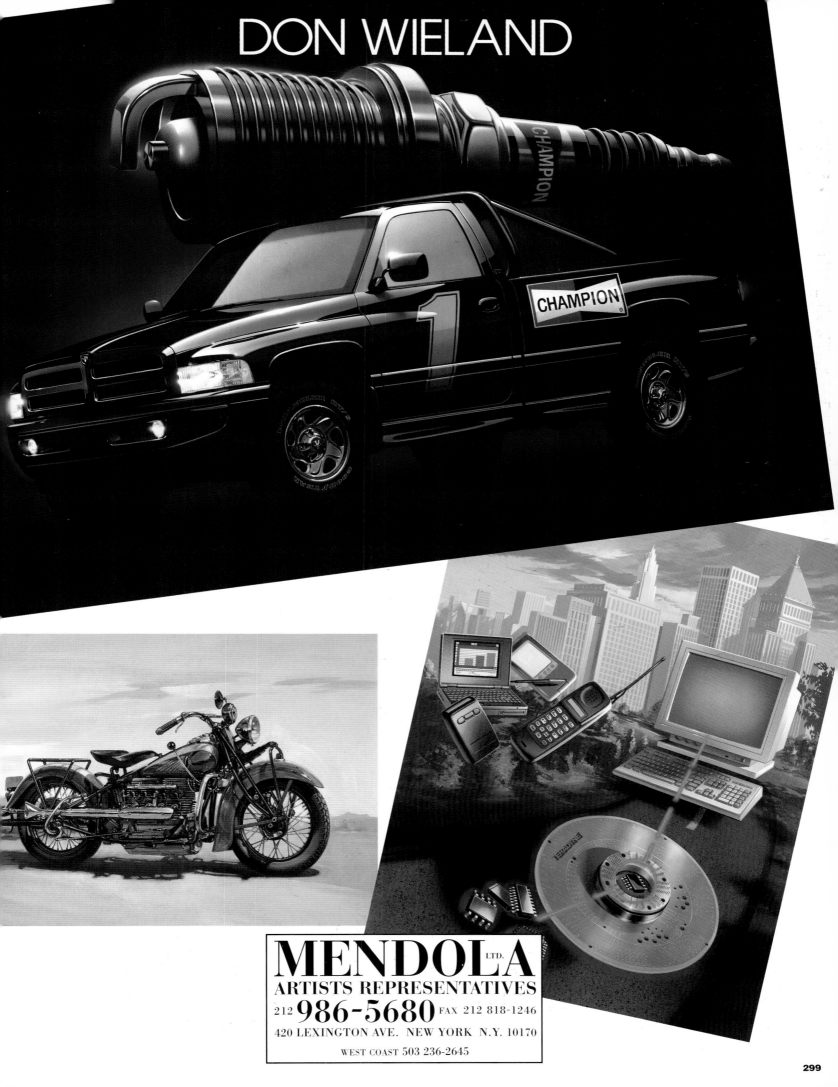

DON WIELAND

ROBERT KROGLE

MENDOLA LTD.
ARTISTS REPRESENTATIVES
212 **986-5680** FAX 212 818-1246
420 LEXINGTON AVE. NEW YORK N.Y. 10170
WEST COAST 503 236-2645

DAVID SCHLEINKOFER

MENDOLA LTD.

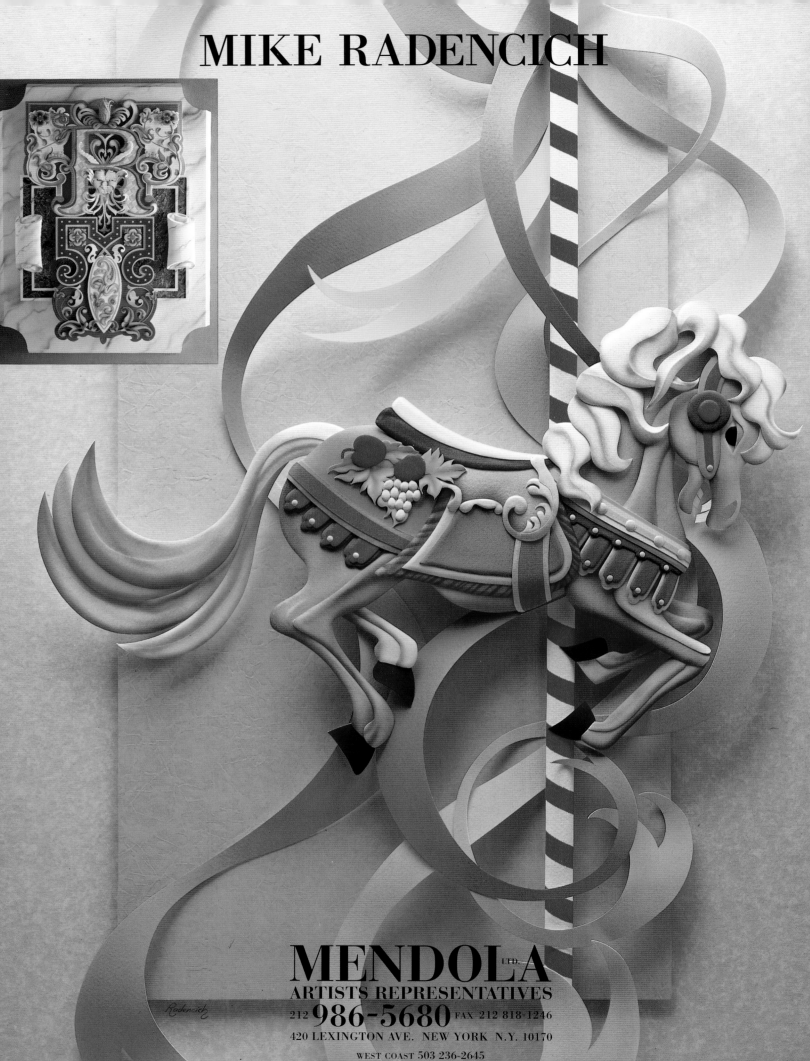

MIKE RADENCICH

MENDOLA LTD.
ARTISTS REPRESENTATIVES
212 **986-5680** FAX 212 818-1246
420 LEXINGTON AVE. NEW YORK N.Y. 10170
WEST COAST 503 236-2645

THE NEWCOMERS CHALLENGE TELMEX

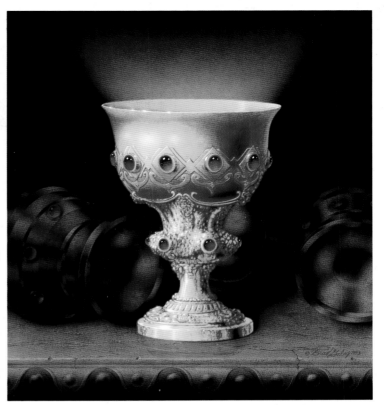

FINDING THE GRAIL OF FUEL ADDITIVES

SCRIBNERS' TRADE BOOK COVER: *MASS EXTINCTIONS*

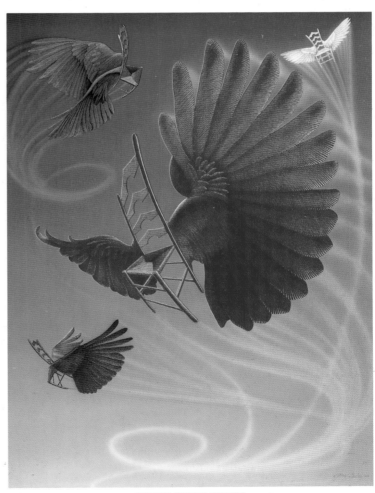

DIFFA'S FLYING CHAIRS

BRAD GABER
Conceptual Solutions That Are Outside of the Box.

MENDOLA LTD.
ARTISTS REPRESENTATIVES
212 **986-5680** FAX 212 818-1246
420 LEXINGTON AVE. NEW YORK N.Y. 10170

WEST COAST 503 236-2645

303

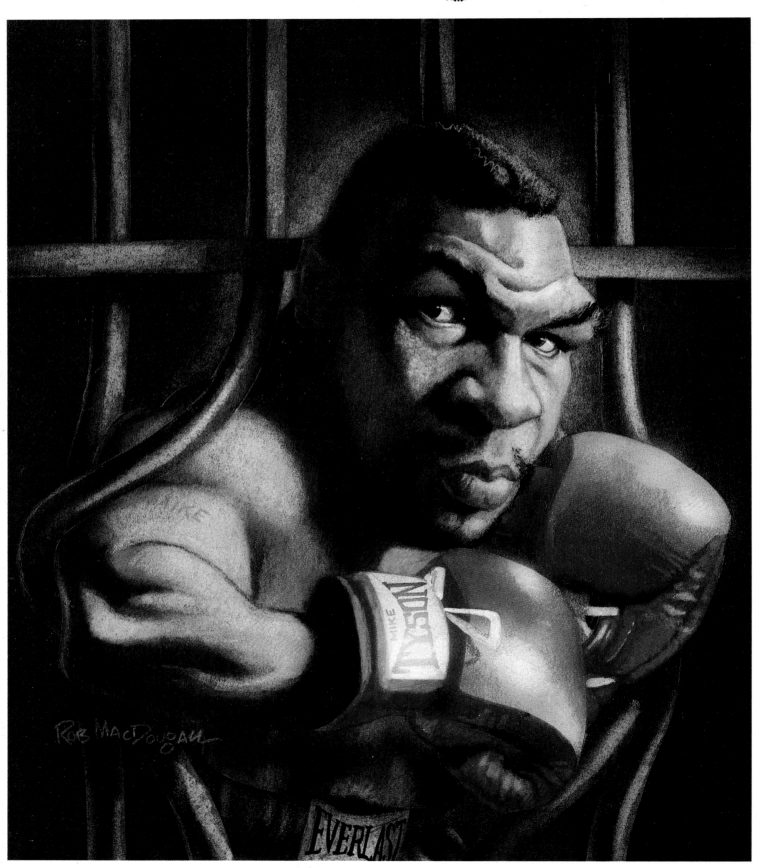

Rob McDougall

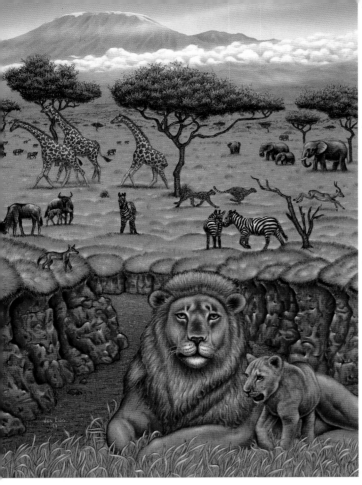

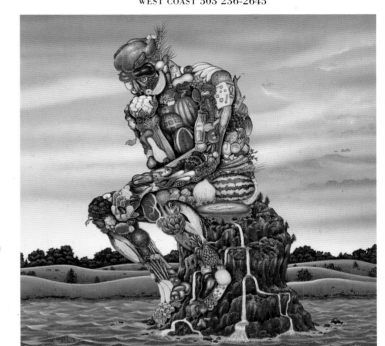

J O N E L L I S

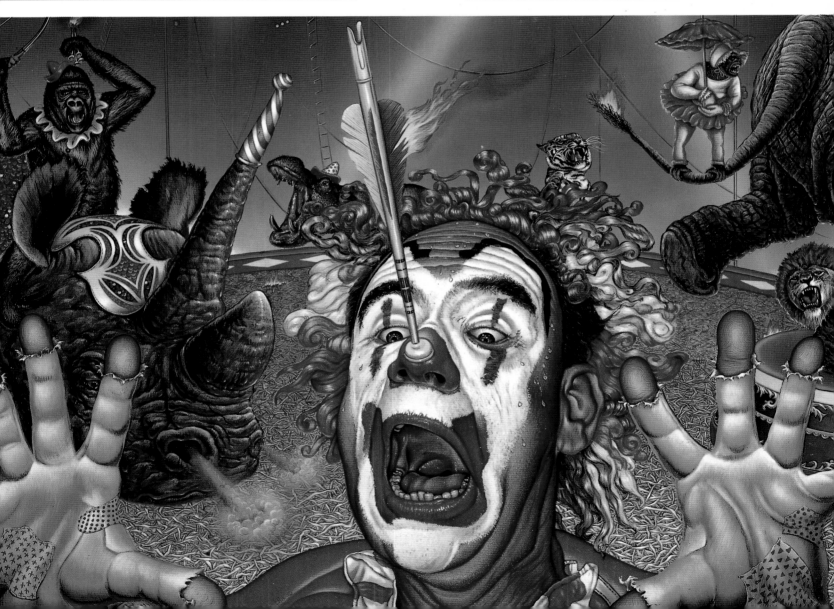

MITCH GREENBLATT

DIMENSIONAL ILLUSTRATION

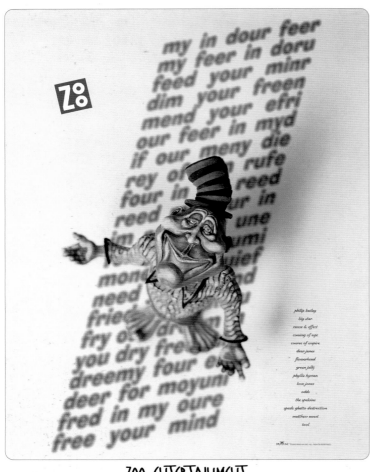

ZOO ENTERTAINMENT

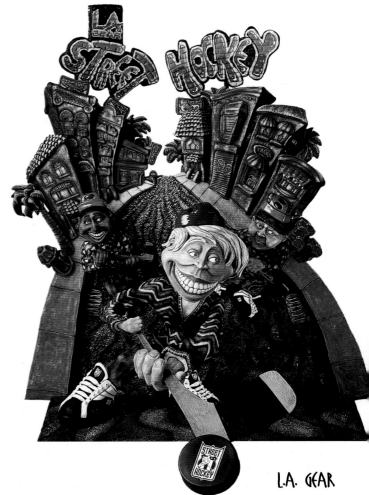

L.A. GEAR

ZOO ENTERTAINMENT CD - "FLOWERHEAD"

NBC - "THE TONIGHT SHOW WITH JAY LENO"

"GO WEST YOUNG MOON"

JONATHAN MILNE • PAPER SCULPTURE

ED MARTINEZ

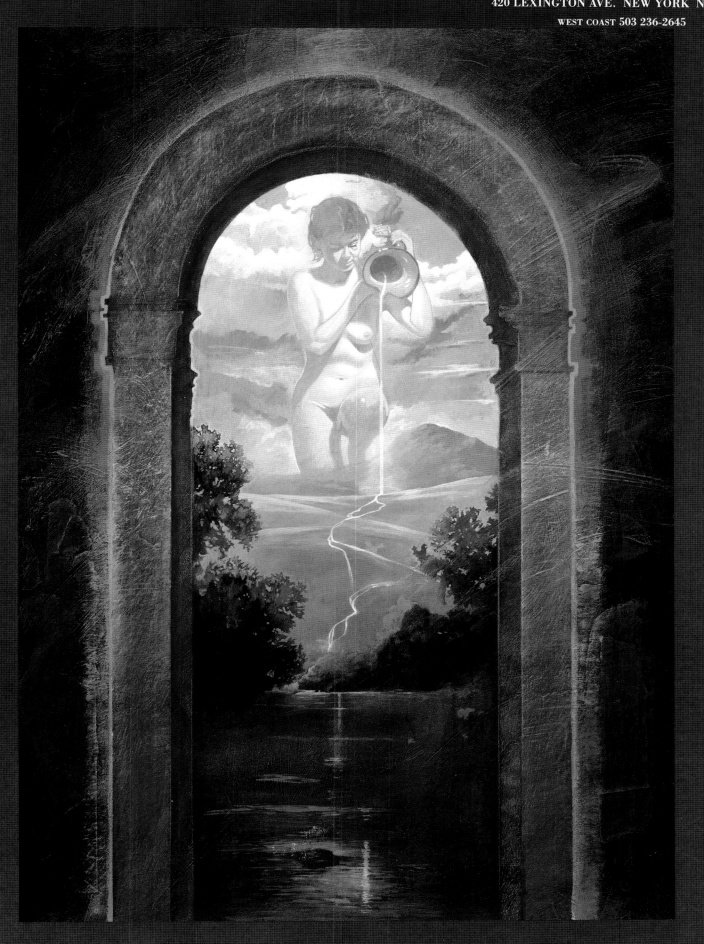

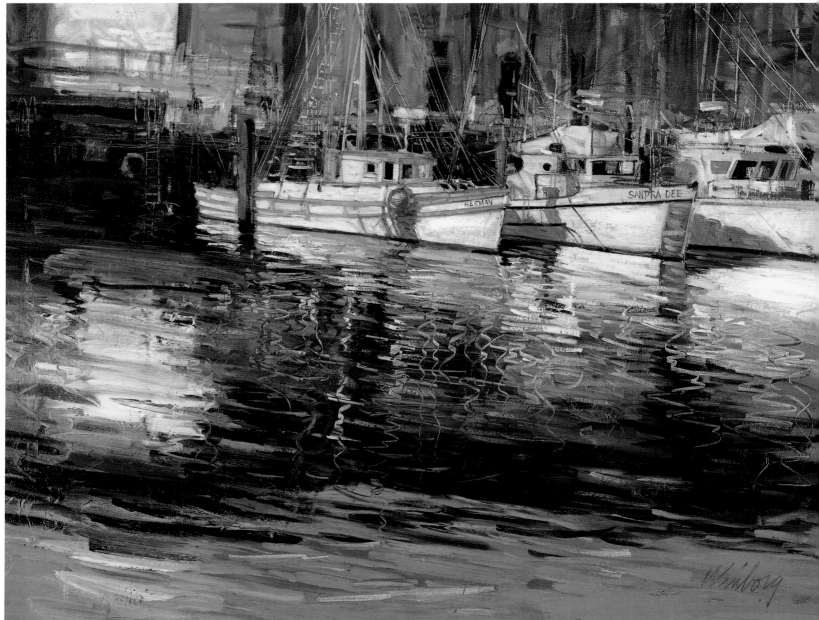

LARRY WINBORG

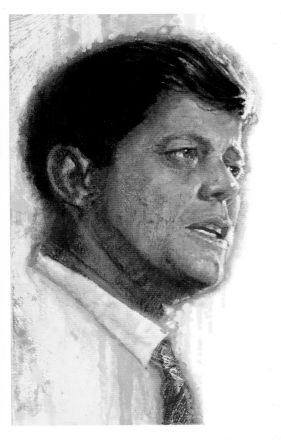

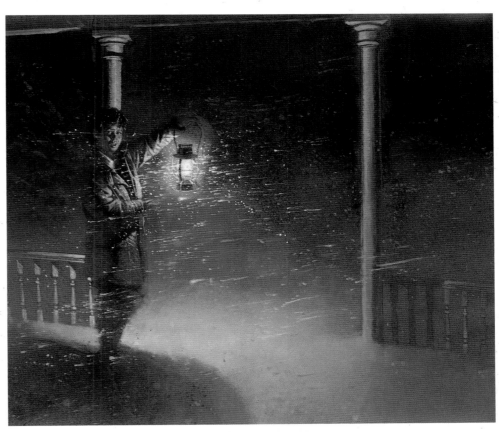

JEFFREY TERRESON

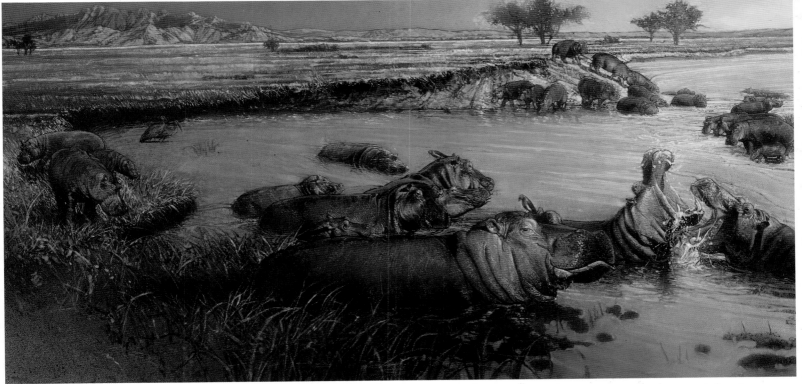

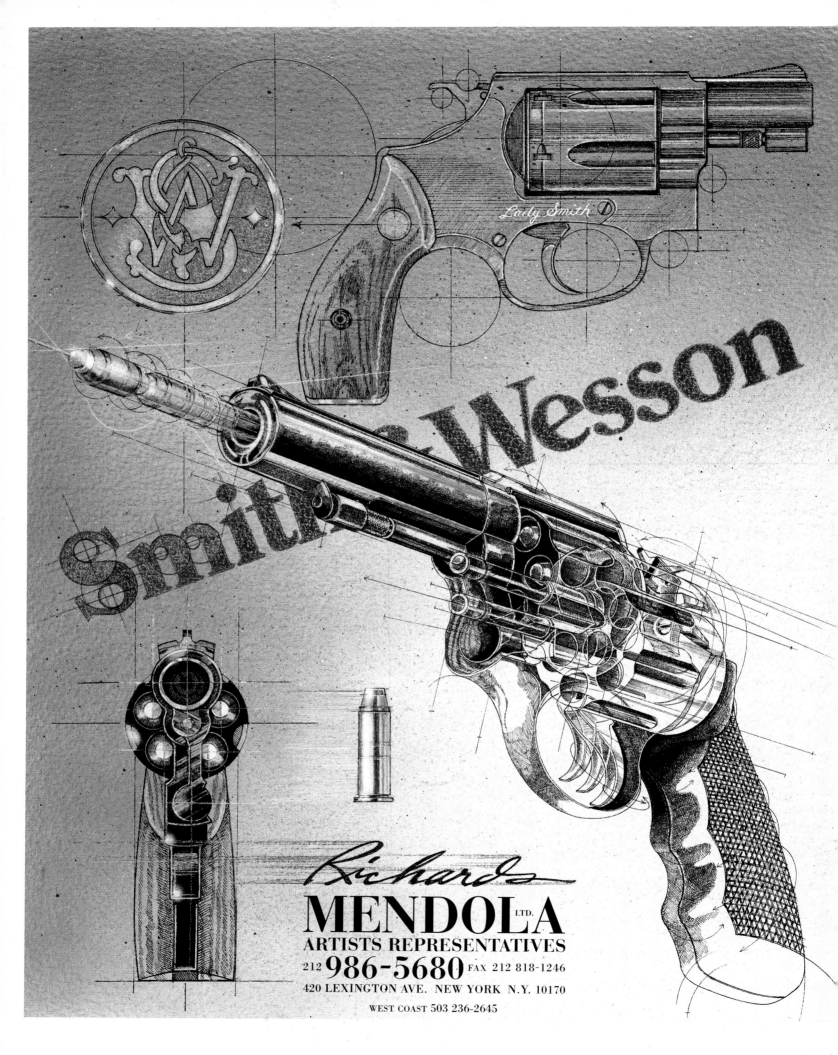

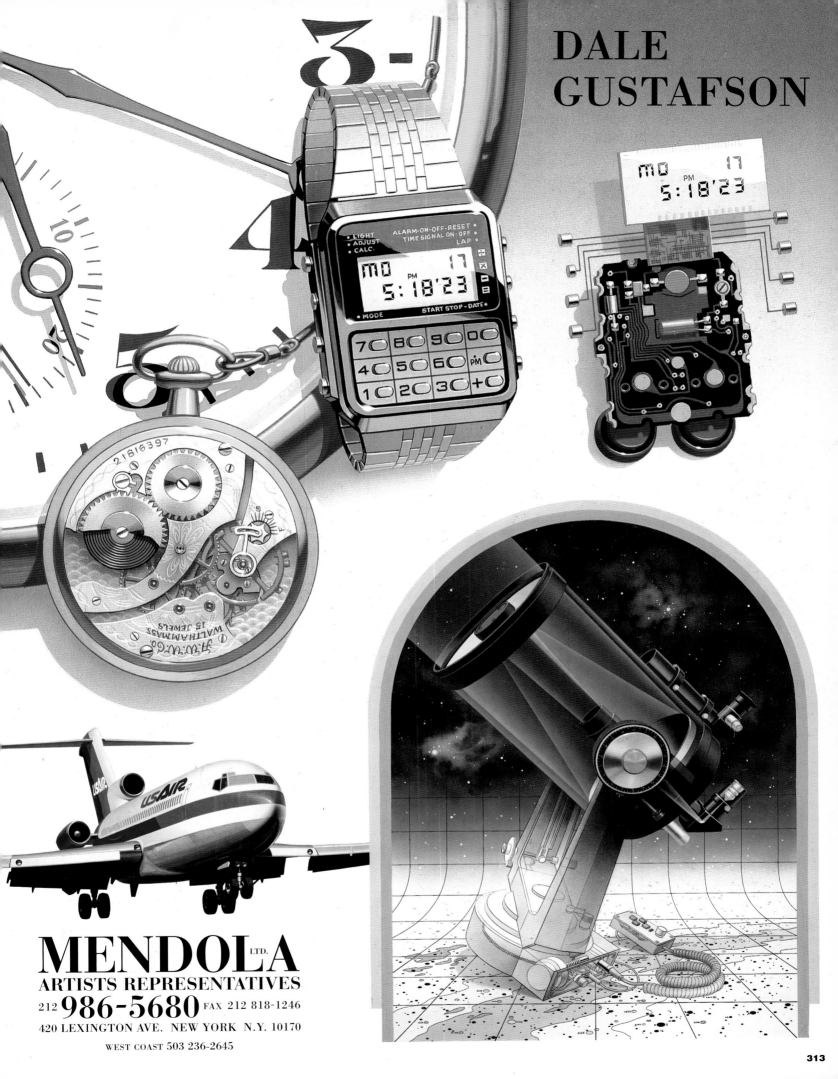

DALE GUSTAFSON

D.MᶜGowan

CHRIS

MENDOLA LTD.
ARTISTS REPRESENTATIVES
212 **986-5680** FAX 212 818-1246
420 LEXINGTON AVE. NEW YORK N.Y. 10170
WEST COAST 503 236-2645

DELLORCO

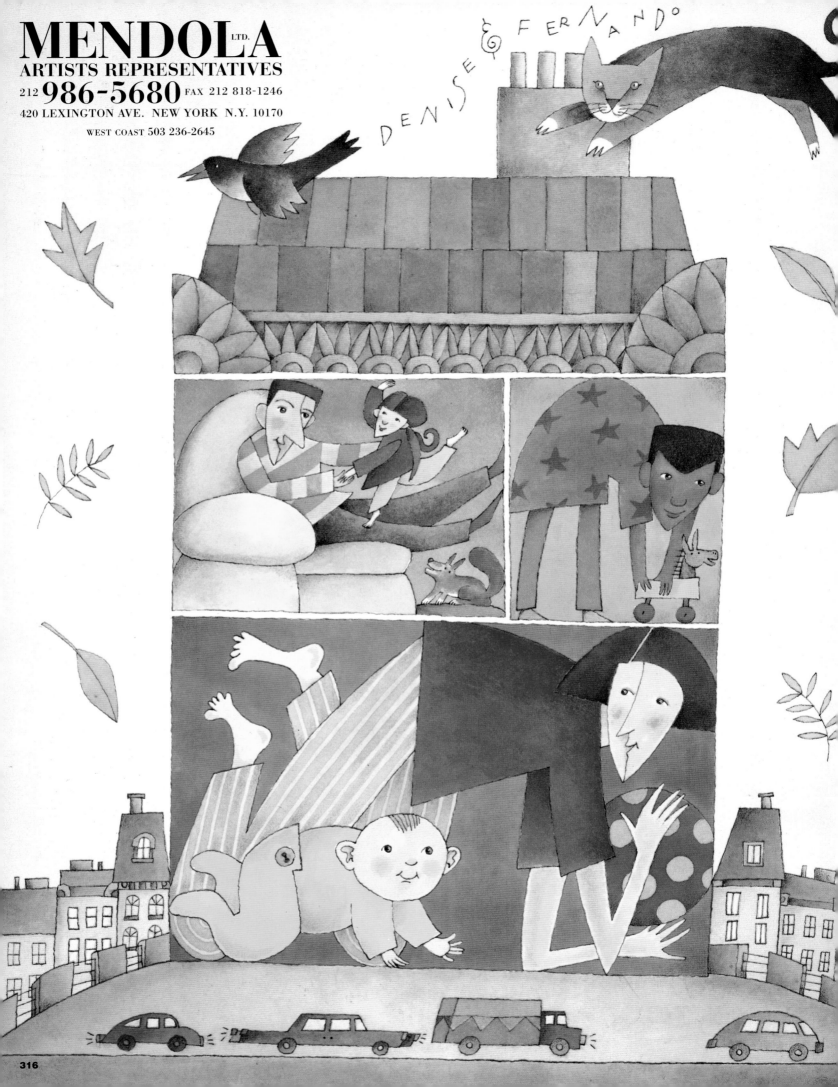

DENISE & FERNANDO

Liisa Chauncy Guida

Fort Whipper Snapper
Thunder Cat Cave
Bear Cave
Jackrabbit Joe's Lookout
Indian Burial Grounds
Gold Mine
JAIL
Tombstone Territory
Matawin Teepee Village
Gitchegumee Gulch
Dragons Breath Mine
Magic Forest
Summer Camp

©1994 Liisa Chauncy Guida

SUPER STARS

Liisa Chauncy Guida ©1994

MOGUL MICE

Liisa Chauncy Guida ©1994

RON BERG

Represented by

MENDOLA LTD.
ARTISTS REPRESENTATIVES
212 **986-5680** FAX 212 818-1246
420 LEXINGTON AVE. NEW YORK N.Y. 10170

WEST COAST 503 236-2645

Frank Riccio

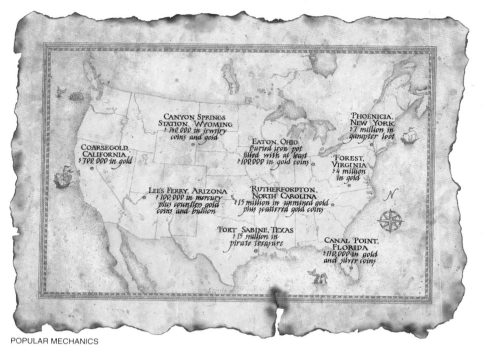

POPULAR MECHANICS

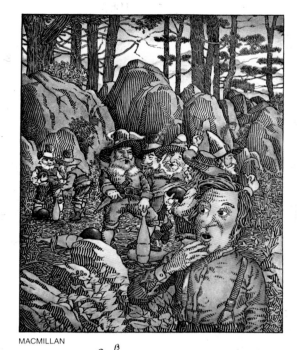

MACMILLAN

Elephant
LOXODONTA AFRICANA

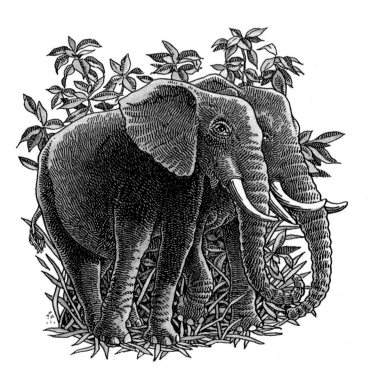

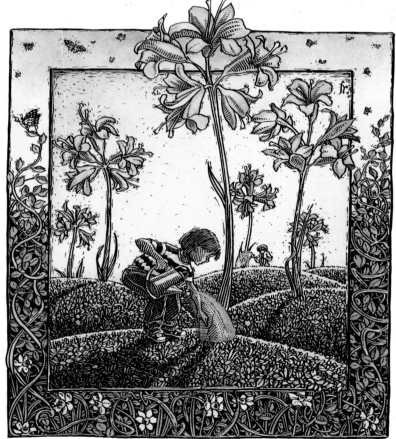

GRACE PUBLISHING AND COMMUNICATIONS

ROBERT HYNES

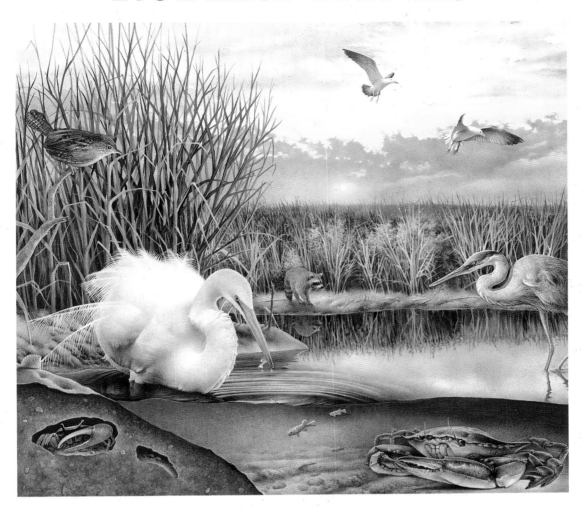

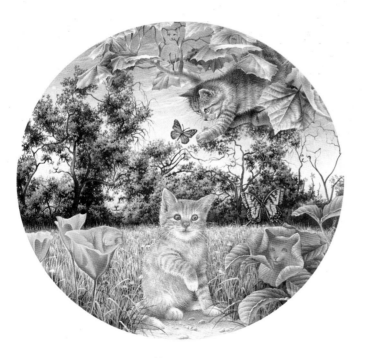

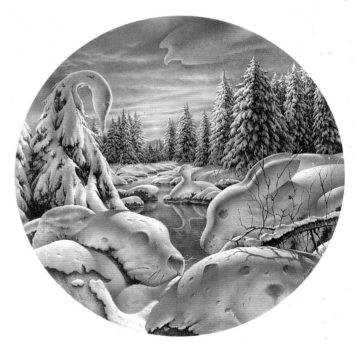

BILL MAUGHAN

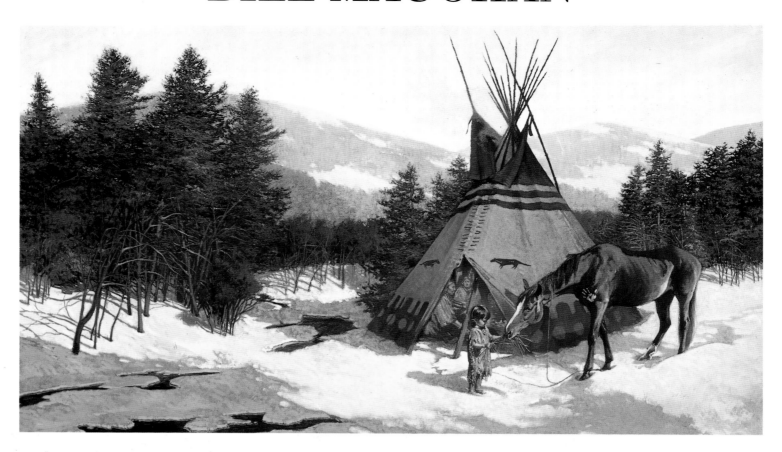

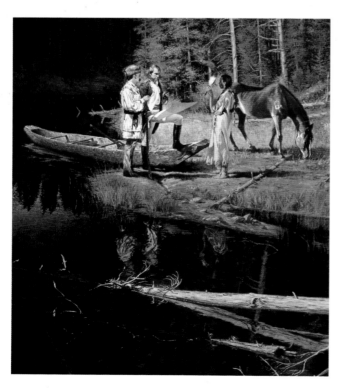

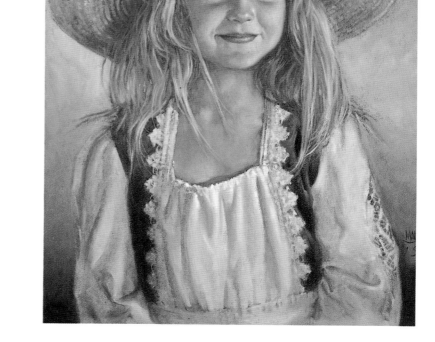

322

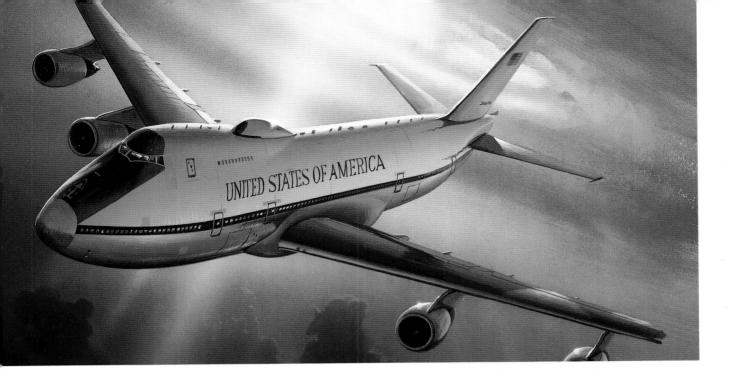

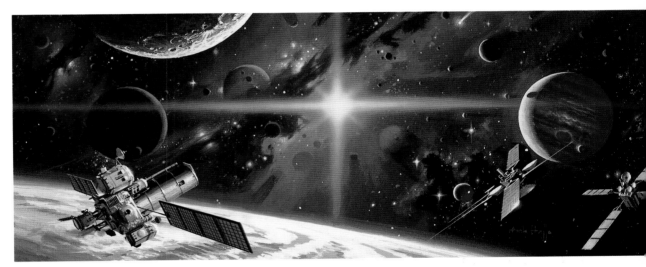

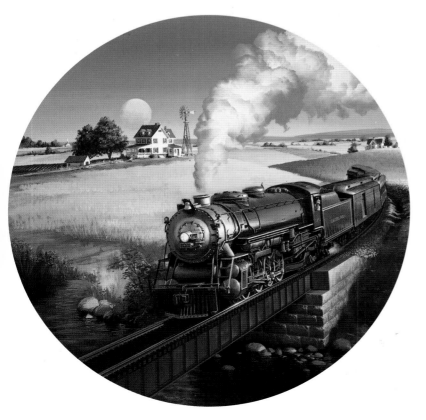

ATTILA
HEJJA

MENDOL_{LTD.}A
ARTISTS REPRESENTATIVES
212 **986-5680** FAX 212 818-1246
420 LEXINGTON AVE. NEW YORK N.Y. 10170
WEST COAST 503 236-2645

JONATHAN COMBS

HOLLAND AMERICA
WORLD CRUISE

PANAMA CANAL · SRI LANKA · PHILIPPINES · AUSTRALIA · TONGA · INDONESIA · HAWAII · MEXICO · CHIN · · DIA · AMOA · COLOMBIA · NEW ZEALAND · GREECE · YPT · ISREAL ·

REFRESH OUR WILDLIFE

PHIL FRANKE

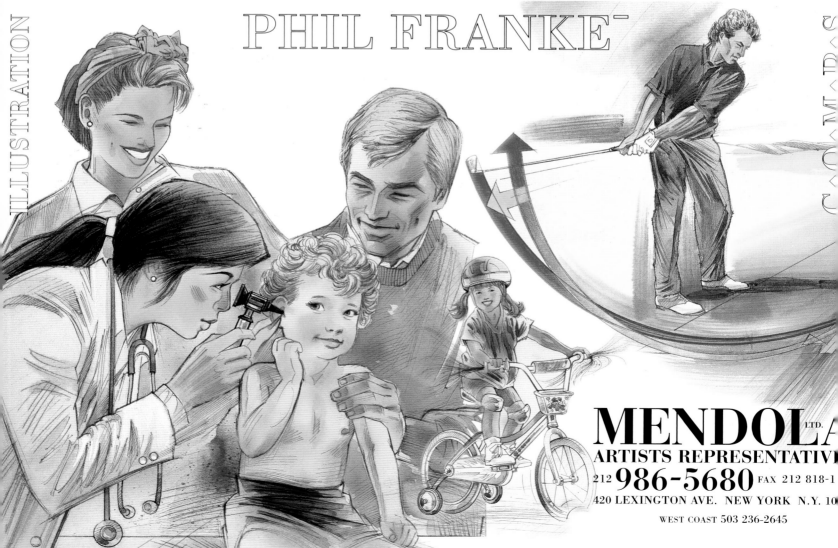

ILLUSTRATION

COMADAS

CARL CASSLER

325

THIERRY THOMPSON

ARTIST STUDIO: 1-800-643-0029

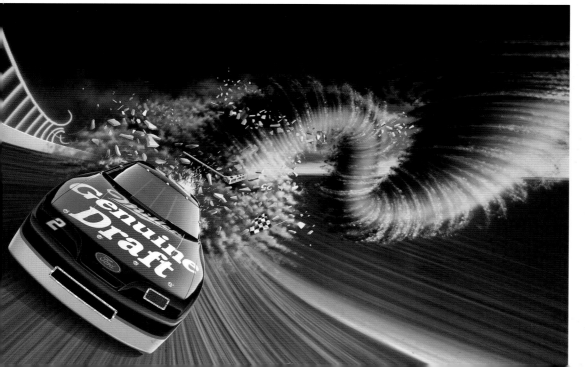

MENDOLA LTD.
ARTISTS REPRESENTATIVE
212 **986-5680** FAX 212 818-1
420 LEXINGTON AVE. NEW YORK N.Y. 10
WEST COAST 503 236-2645

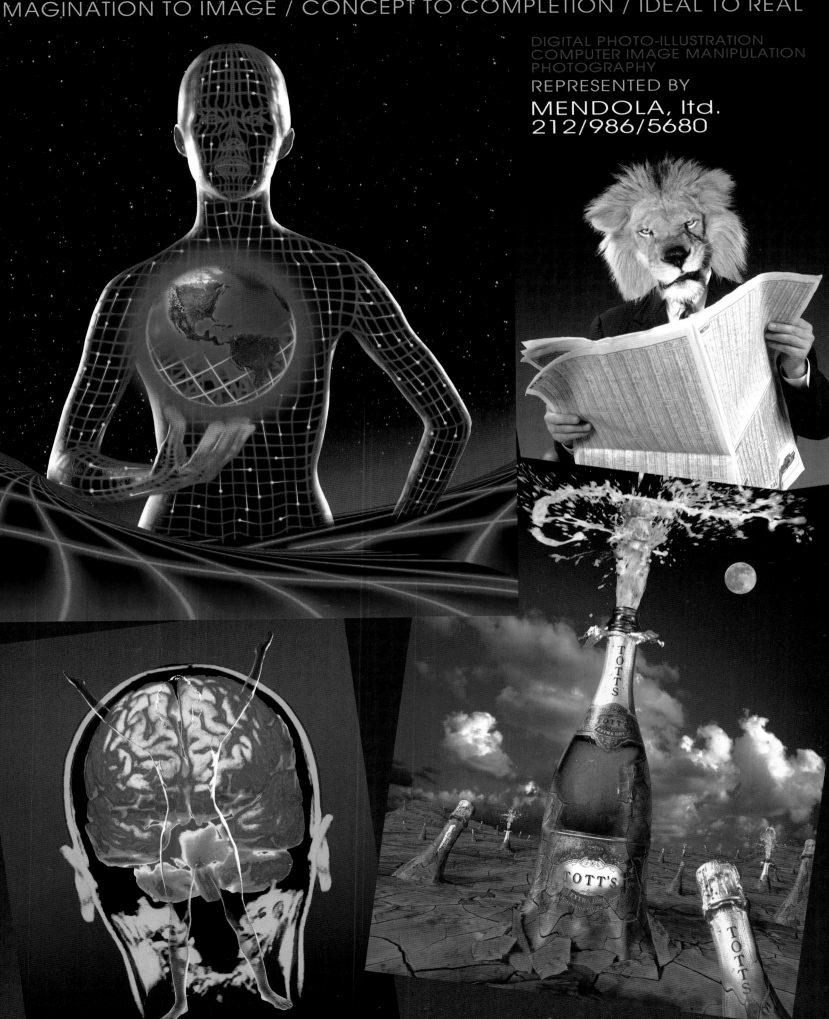

BARRY BLACKMAN STUDIO, INC.

MAGINATION TO IMAGE / CONCEPT TO COMPLETION / IDEAL TO REAL

DIGITAL PHOTO-ILLUSTRATION
COMPUTER IMAGE MANIPULATION
PHOTOGRAPHY

REPRESENTED BY

MENDOLA, ltd.
212/986/5680

RENARD

REPRESENTS

TEL: 212-490-2450 • FAX: 212-697-6828
501 FIFTH AVENUE, NEW YORK, NY 10017

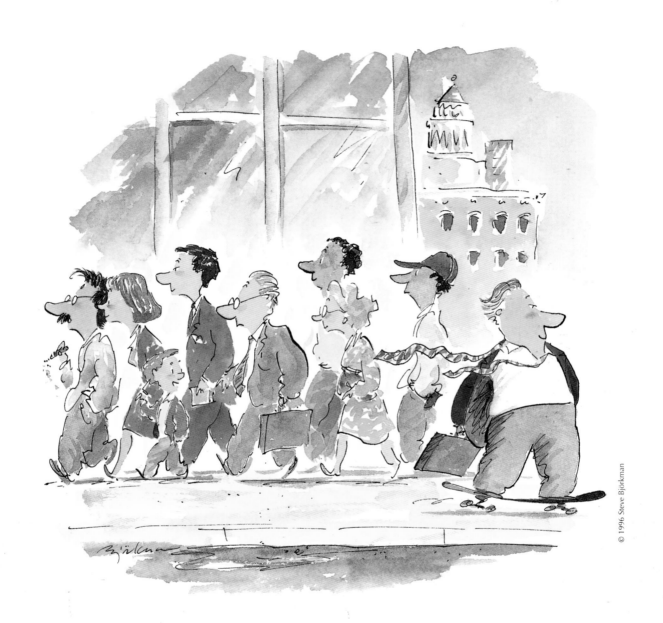

STEVE BJÖRKMAN

 RENARD REPRESENTS TEL: 212-490-2450 • FAX: 212-697-6828

RENARD

REPRESENTS

RENE
MILOT

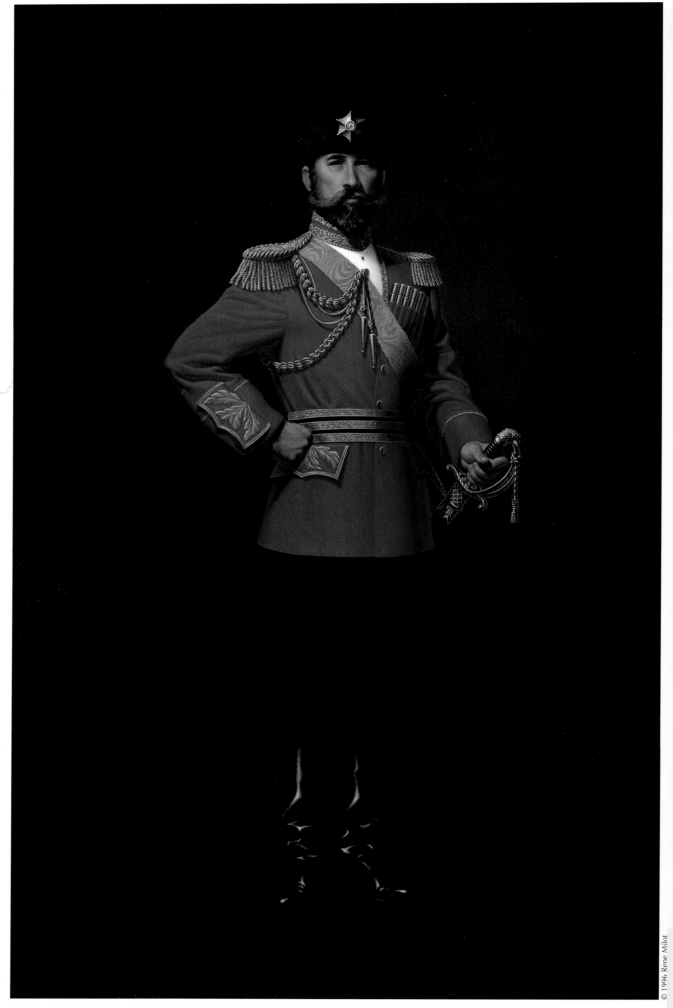

RENARD REPRESENTS

■

TEL: 212•490•2450
FAX: 212•697•6828

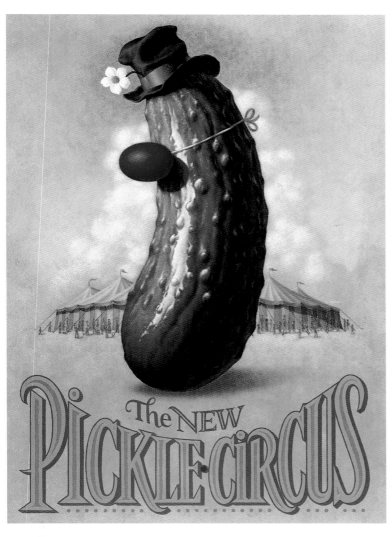

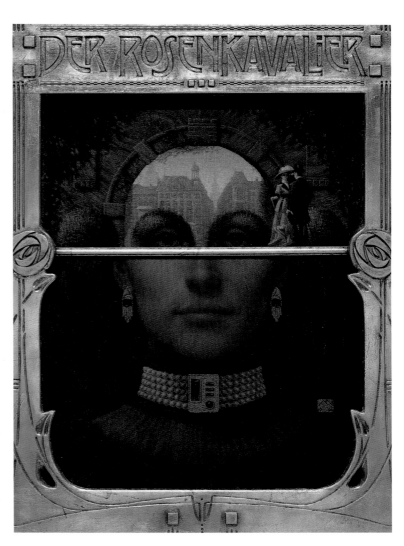

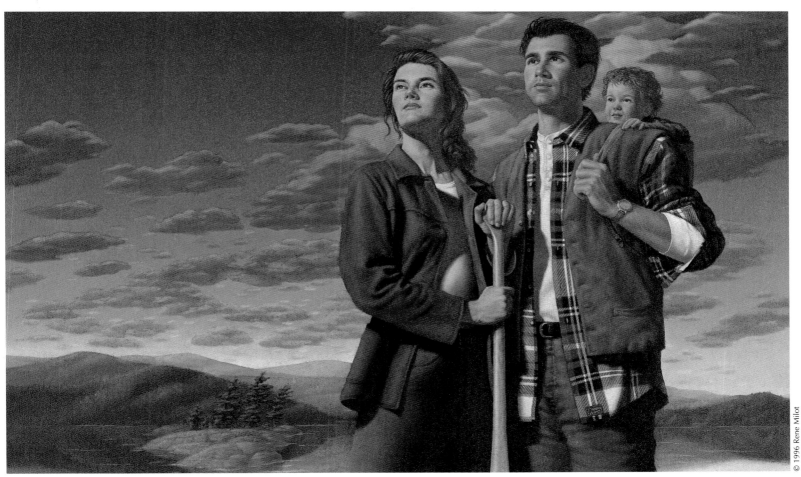

RENARD
REPRESENTS

MATSU

COMPUTER
ILLUSTRATION

RENARD REPRESENTS
■

TEL: 212•490•2450
FAX: 212•697•6828

333

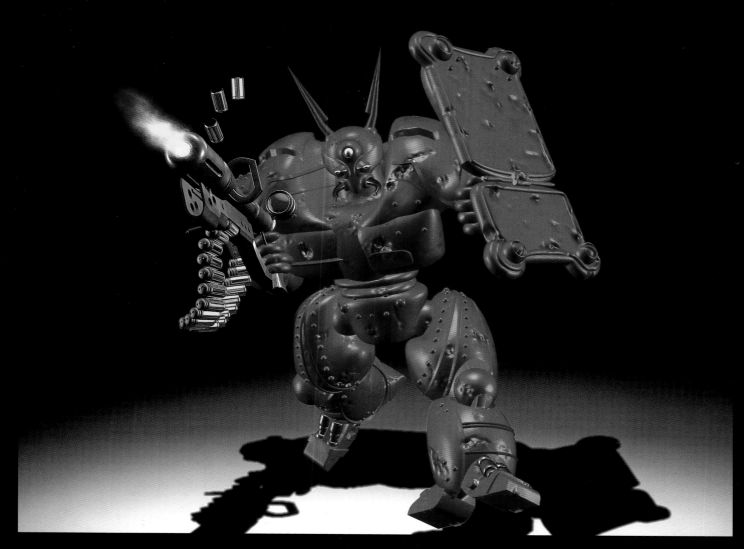

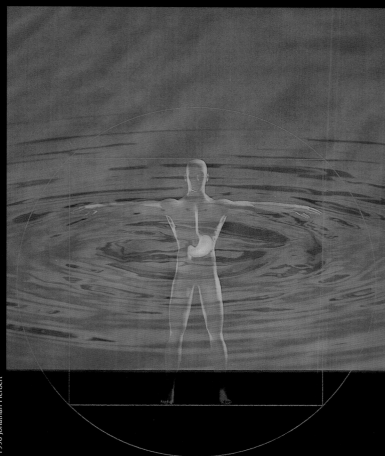

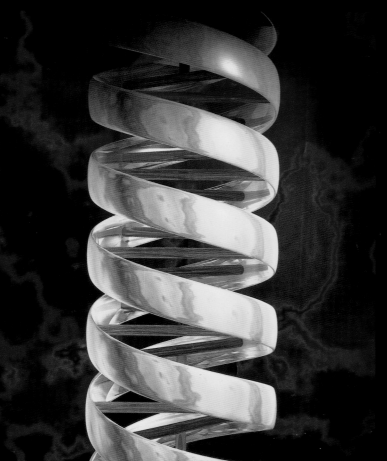

ROGER
HILL

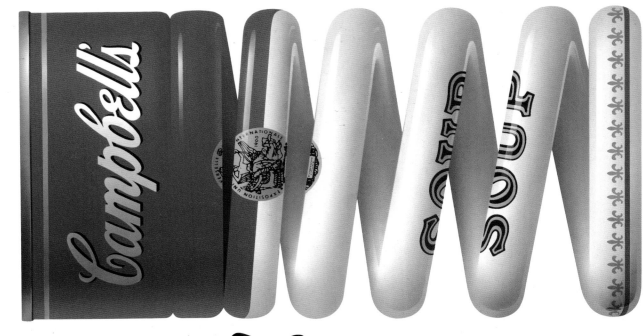

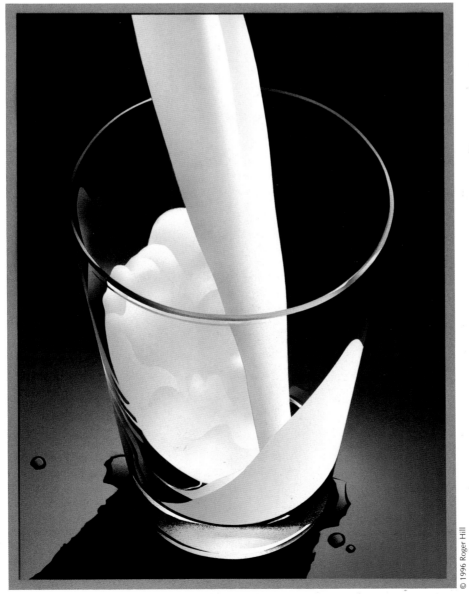

VALERIE
SINCLAIR

© 1996 Valerie Sinclair

THEO
RUDNAK

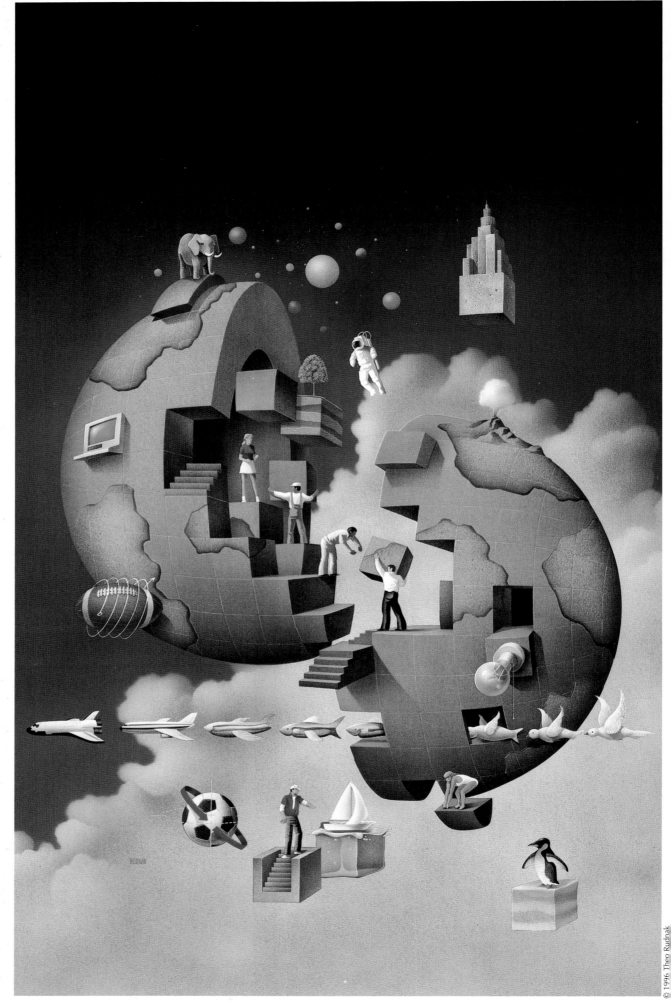

RENARD REPRESENTS

■

TEL: 212•490•2450
FAX: 212•697•6828

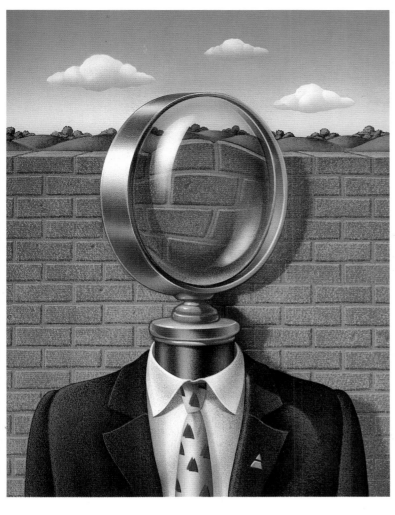

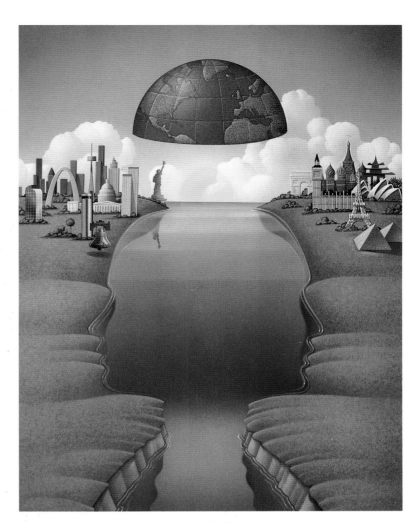

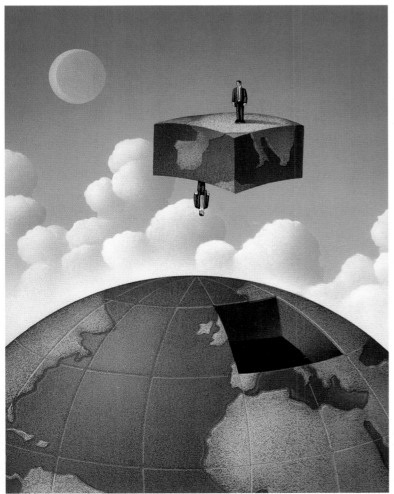

RENARD
REPRESENTS

JOHN
MARTIN

RENARD
REPRESENTS

KIM
WHITESIDES

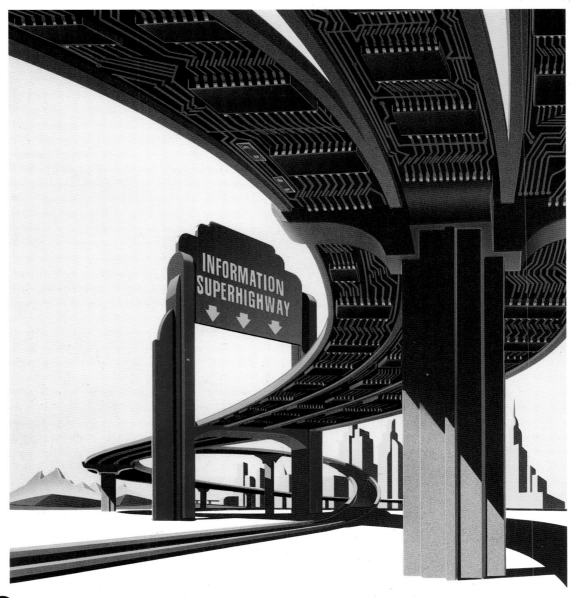

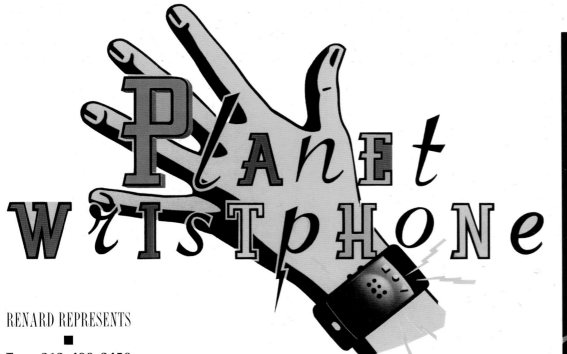

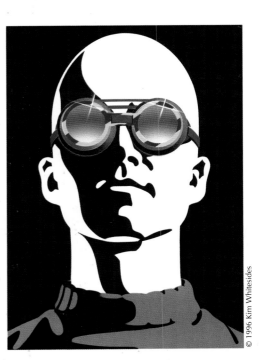

RENARD REPRESENTS
■

TEL: 212•490•2450
FAX: 212•697•6828

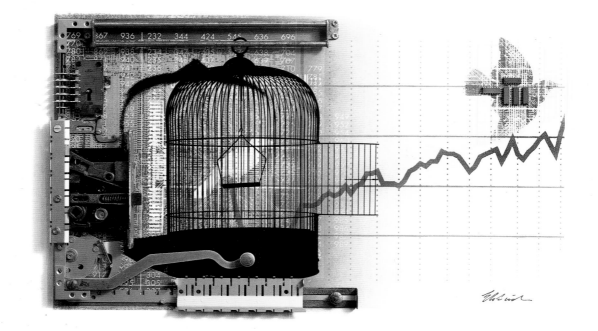

GARY
ELDRIDGE

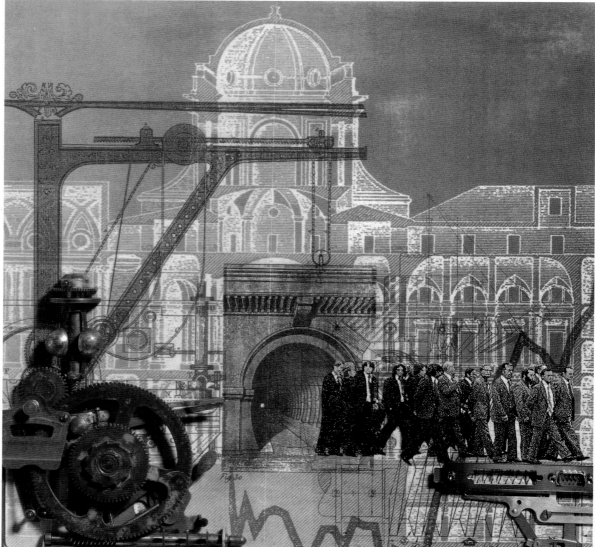

© 1996 Gary Eldridge

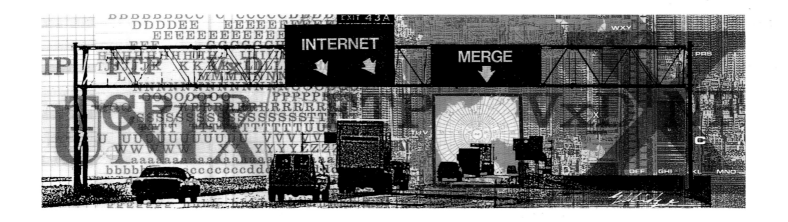

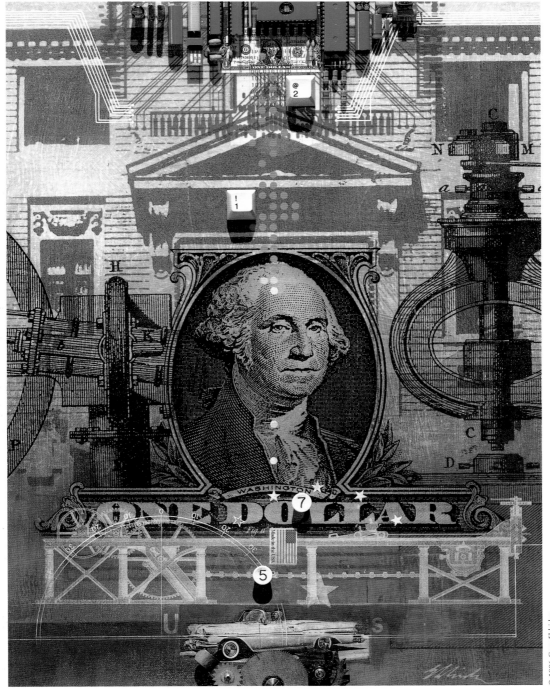

R E N A R D

REPRESENTS

BILL
CIGLIANO

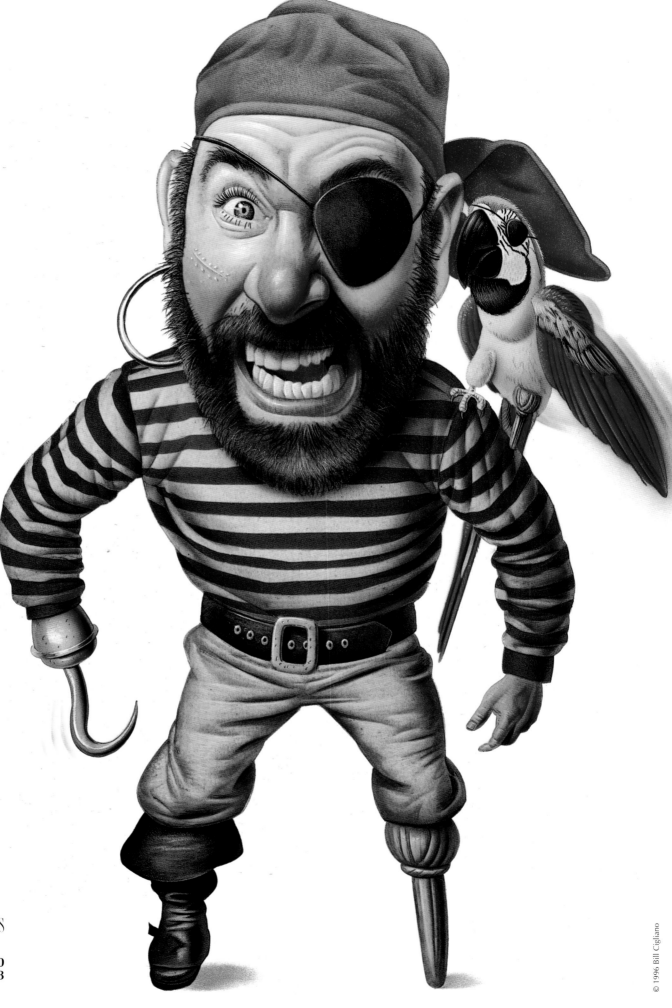

RENARD REPRESENTS

■

Tel: 212•490•2450
Fax: 212•697•6828

© 1996 Bill Cigliano

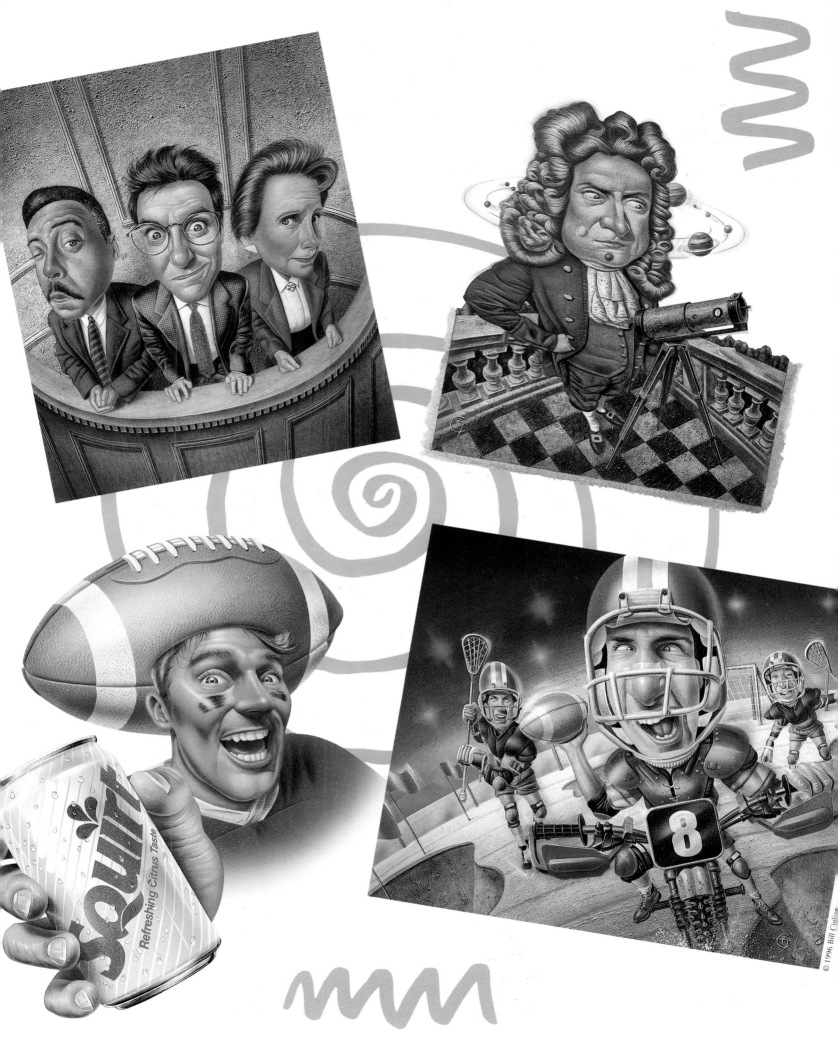

RENARD

REPRESENTS

WAYNE
McLOUGHLIN

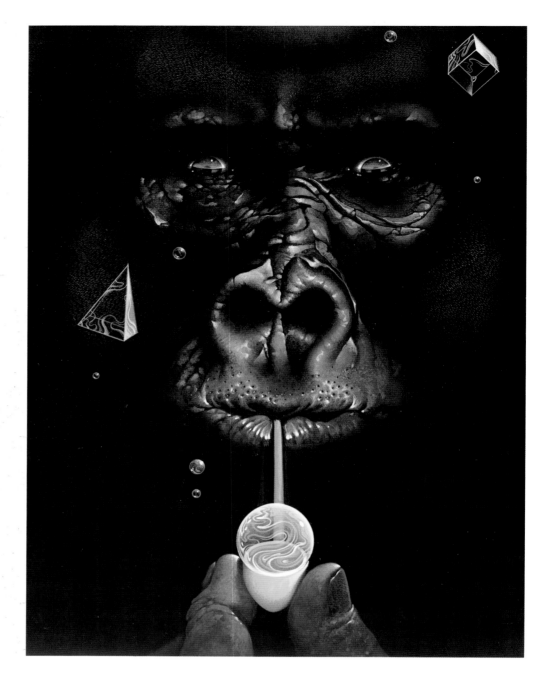

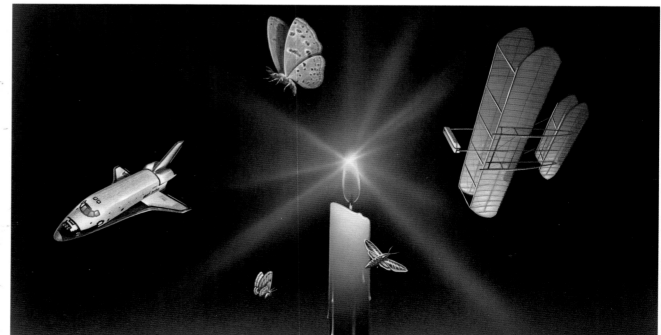

RENARD REPRESENTS

■

Tel: 212•490•2450
Fax: 212•697•6828

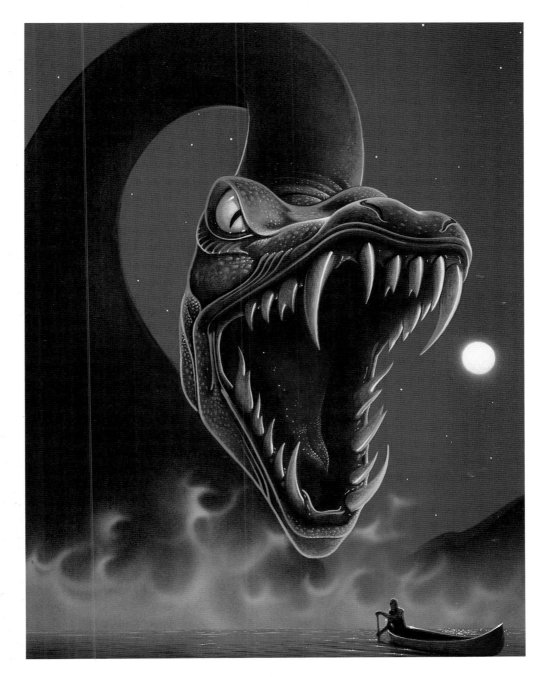

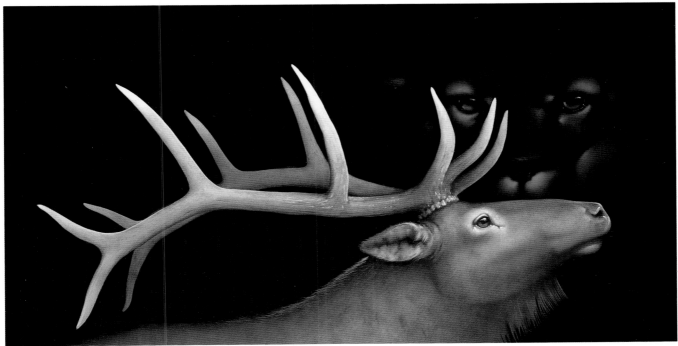

ROBERT
RODRIGUEZ

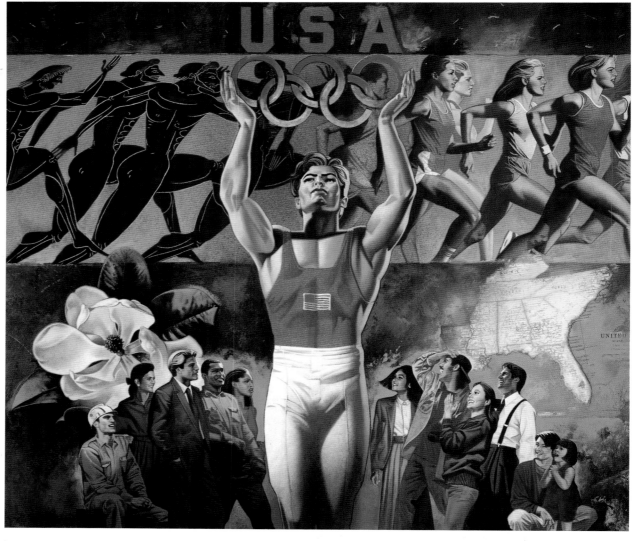

© 1996 Robert Rodriguez

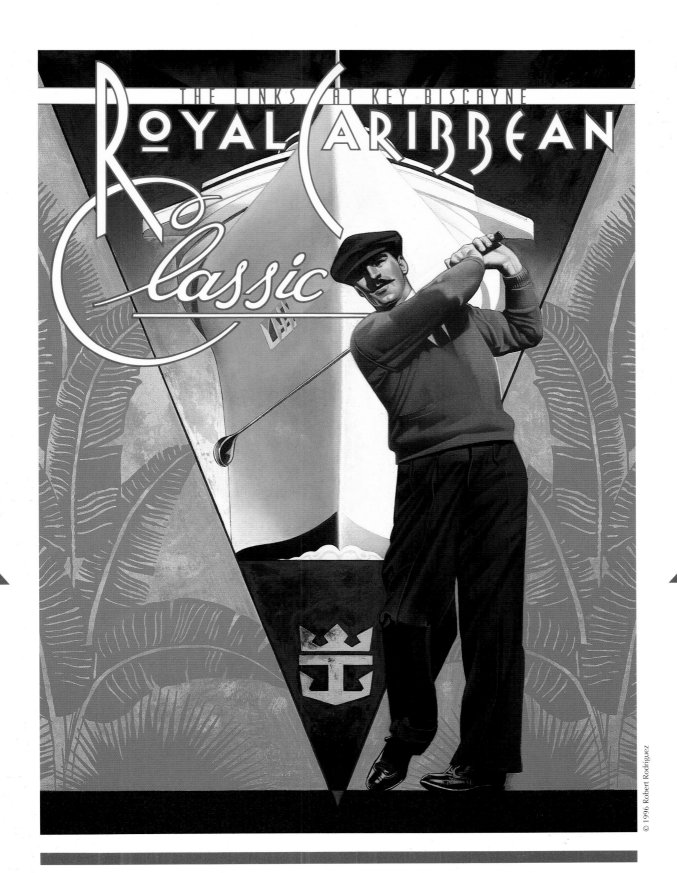

RODRIGUEZ

JAMES
BOZZINI

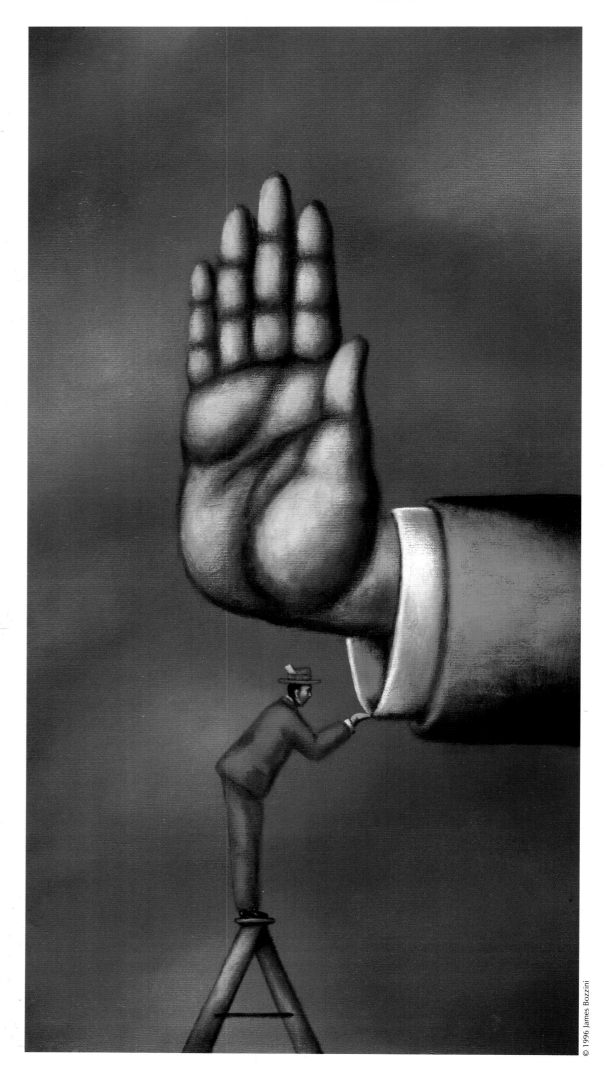

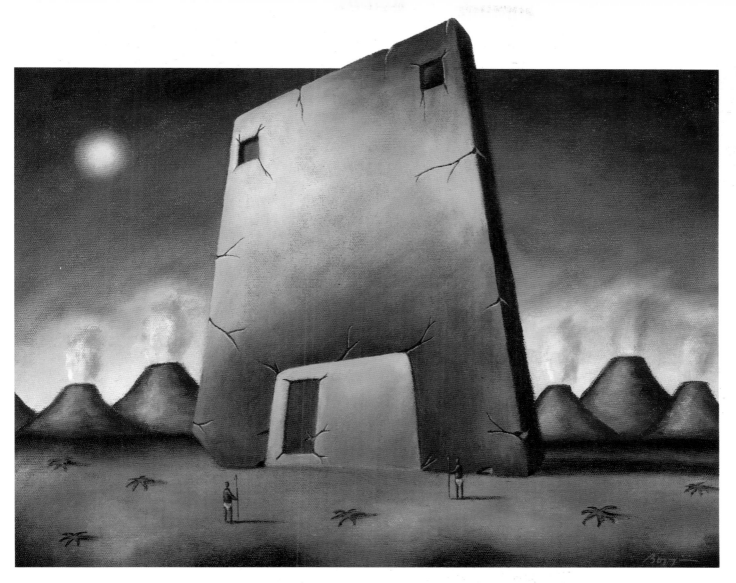

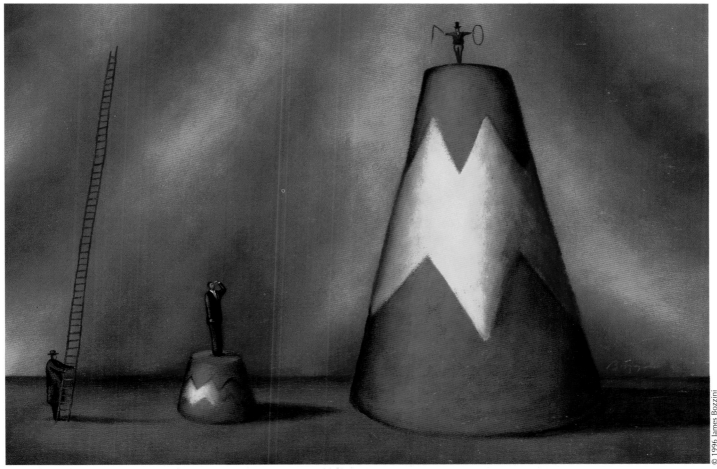

R E N A R D

REPRESENTS

JEFFREY PELO

COMPUTER
ILLUSTRATION

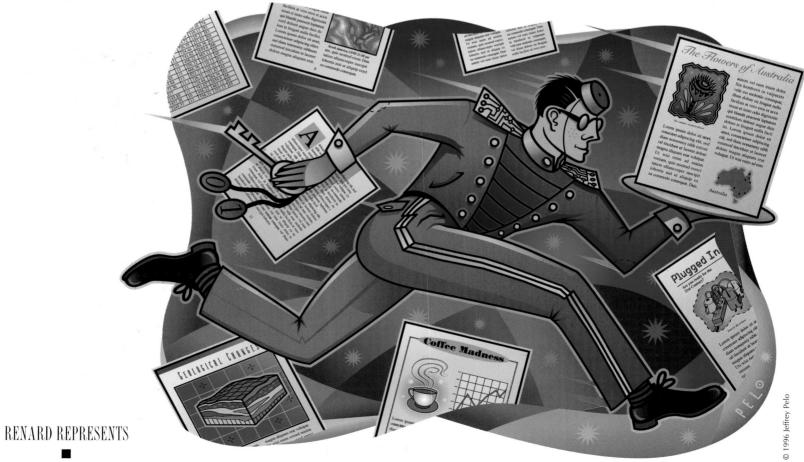

RENARD REPRESENTS
■
TEL: 212•490•2450
FAX: 212•697•6828

DAN
GARROW

RENARD
REPRESENTS

MICHAEL
McGURL

RENARD REPRESENTS

■

Tel: 212•490•2450
Fax: 212•697•6828

MATTHEW
HOLMES

© 1996 Matthew

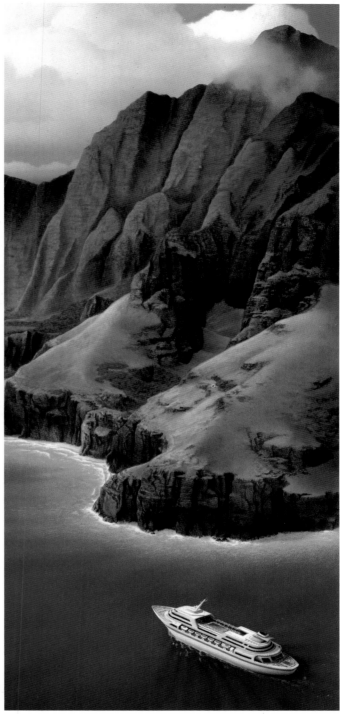
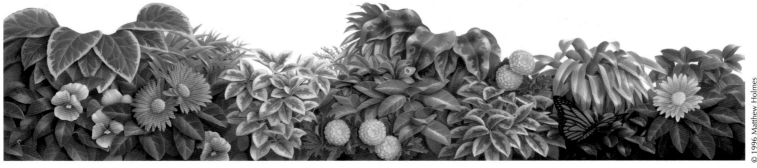

ROB
BROOKS

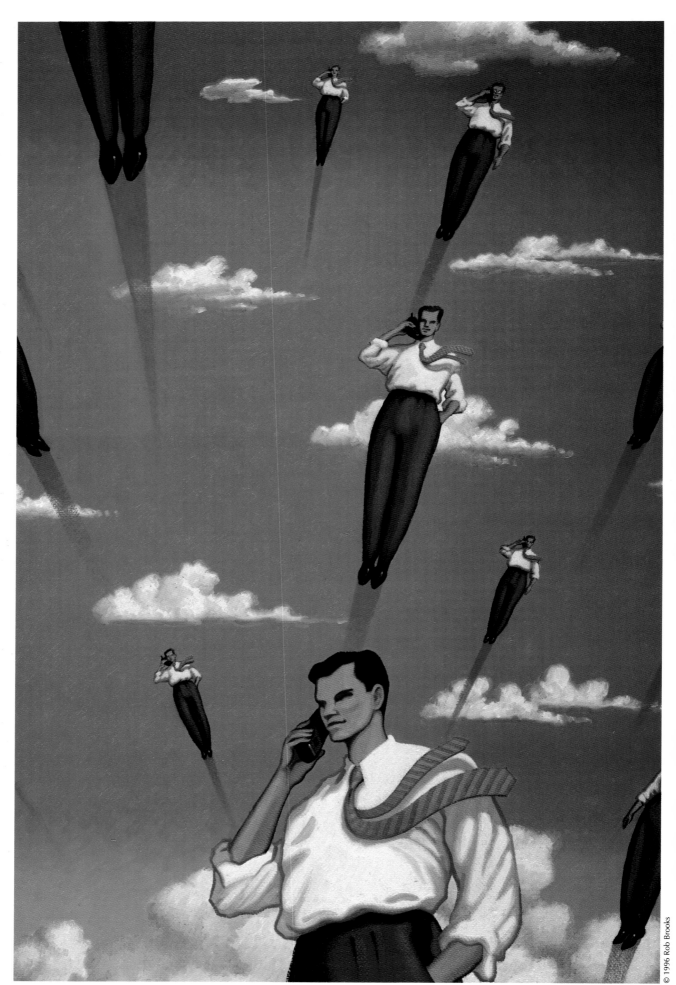

© 1996 Rob Brooks

362

RENARD
REPRESENTS

JUD
GUITTEAU

RENARD REPRESENTS

∎

TEL: 212•490•2450
FAX: 212•697•6828

RENARD
REPRESENTS

STU
SUCHIT

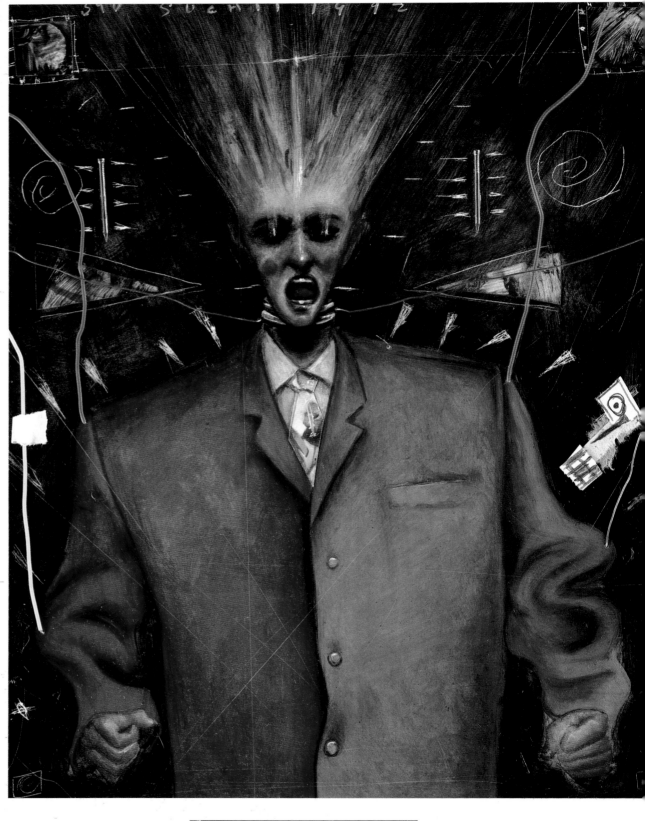

RENARD REPRESENTS
■

Tel: 212•490•2450
Fax: 212•697•6828

RENARD
REPRESENTS

STÉPHAN
DAIGLE

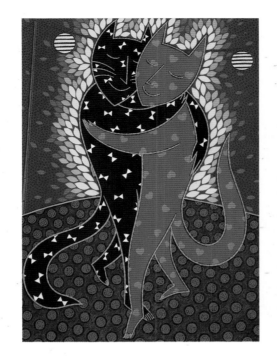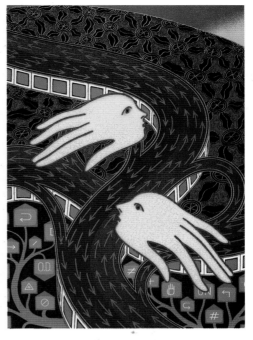

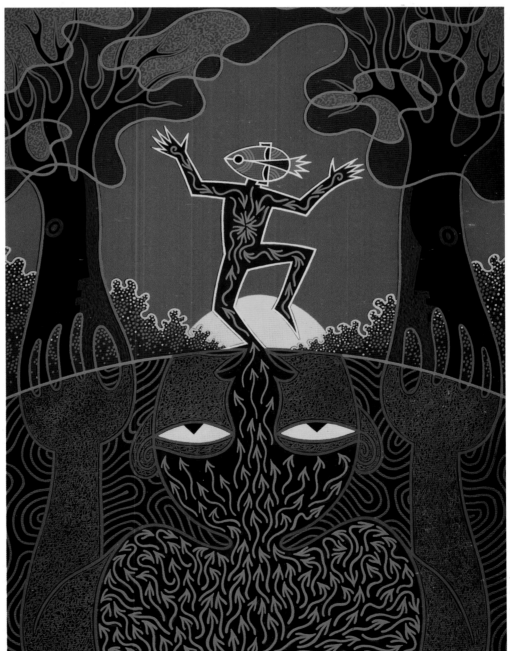

RENARD REPRESENTS
■

Tel: 212•490•2450
Fax: 212•697•6828

RENARD

REPRESENTS

WILLIAM
HARRISON

MEAT

MEAT-
HEAD

MEETING

RENARD REPRESENTS
■
TEL: 212•490•2450
FAX: 212•697•6828

WILLIAM
HARRISON

THESE ARE MY KIDS... I PROMISED THEM
THEY COULD BE IN MY AD. -W.H.

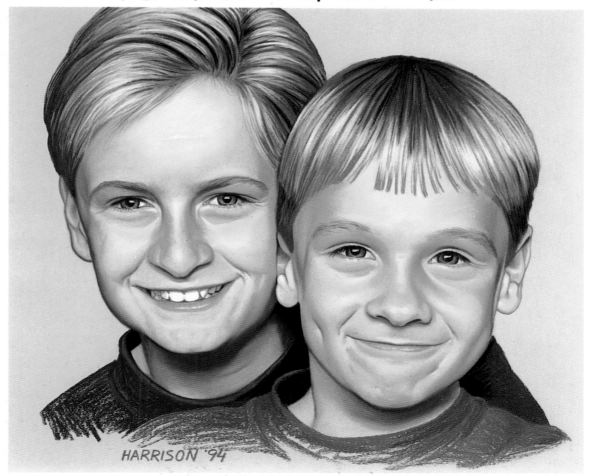

HARRISON '94

© 1996 William Harrison

RICHARD
NEWTON

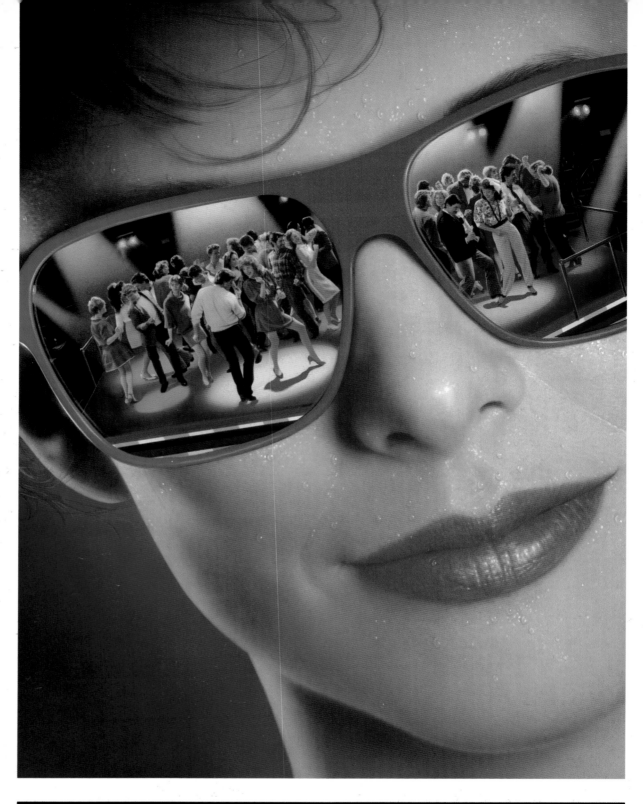

RENARD REPRESENTS

■

TEL: 212•490•2450
FAX: 212•697•6828

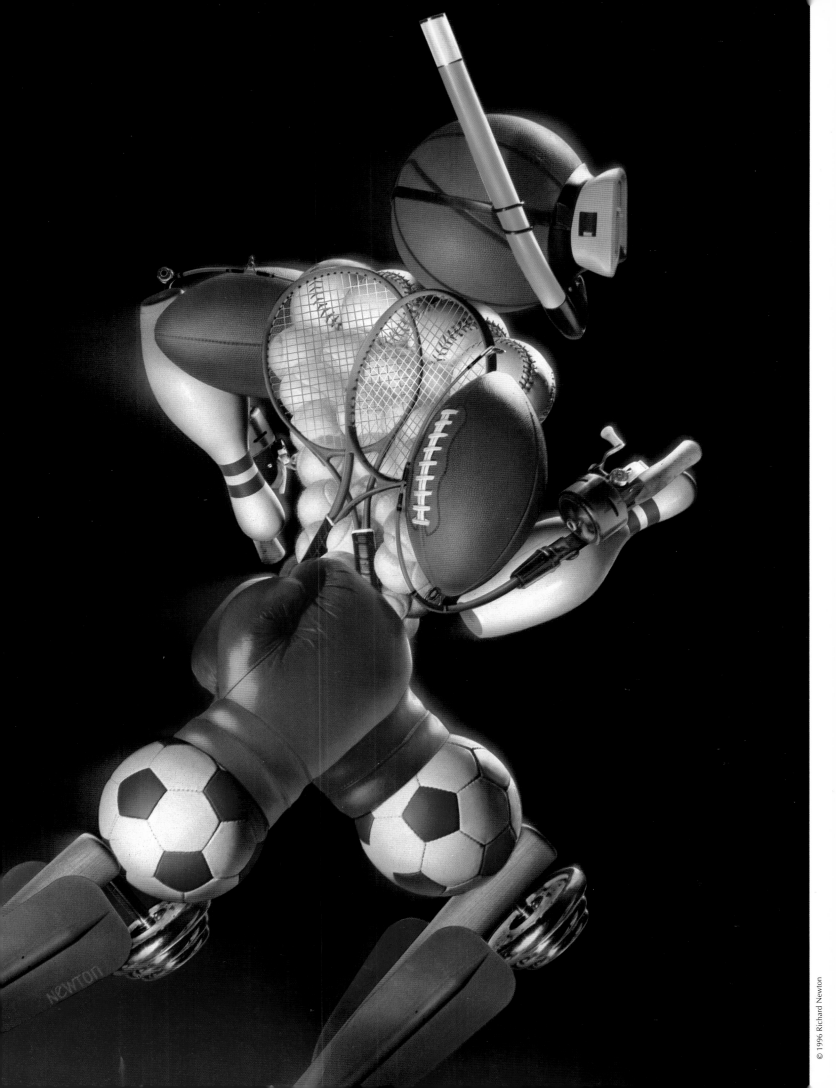

JÖZEF
SUMICHRAST

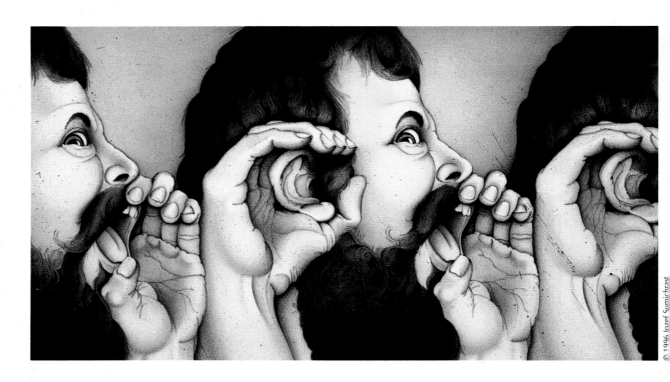

© 1996 Jözef Sumichrast

jözef

RENARD
REPRESENTS

AUDRA
GERAS

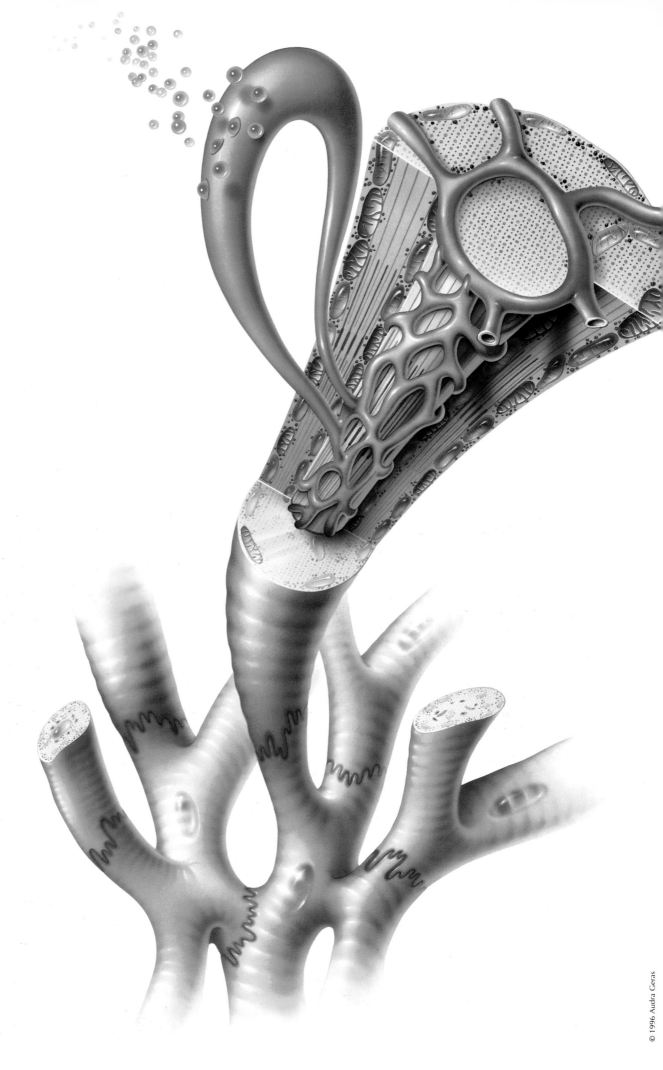

RENARD REPRESENTS

■

TEL: 212•490•2450
FAX: 212•697•6828

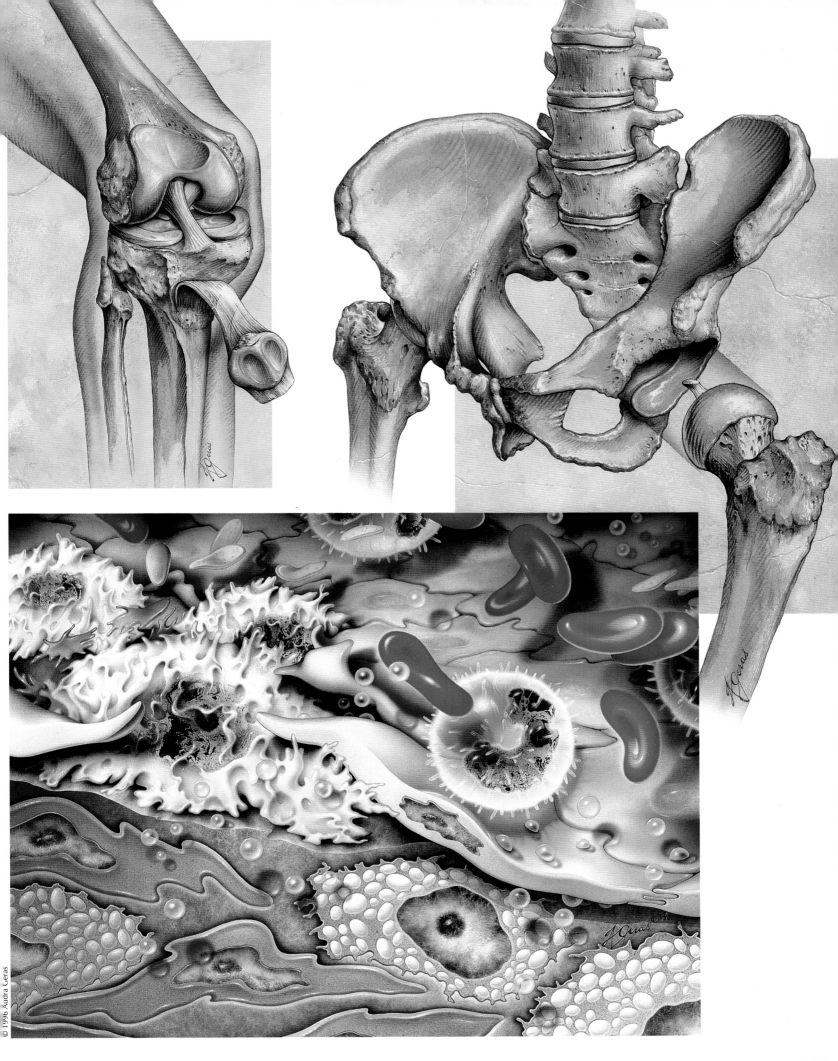

MICHAEL SCHWAB

RENARD REPRESENTS
212 / 490 - 2450
FAX 697 - 6828

POLO RALPH LAUREN AT YOUNG QUINLAN
SIXTH ANNUAL
POLO CLASSIC
SUNDAY AUGUST 6, 1995
FOR CHILDREN'S HOME SOCIETY OF MINNESOTA

MICHAEL SCHWAB
415/331-7621
FAX 331-7623

Tim Girvin Design, Inc.
Seattle Phone: 206.623.7808
Seattle Fax: 206.340.1837
Los Angeles Phone: 310.458.2675
Los Angeles Fax: 310.458.1494
Represented in New York by
Renard Represents: 212.490.2450

TIM GIRVIN DESIGN

brands

CRIMSON TIDE

Nintendo

GAME BOY

ASYMETRIX
Entertainment ™

Vanilla
GARDENS

SUPERTERMINAL ™

VIRTUAL BOY

ChipsAhoy!

Jefferson in Paris

AIRDATA
AT&T McCAW WIRELESS GROUP

**Wheat
Thins**

Paul Newman
Nobody's Fool

VISIO

LEGENDS

I M A G E S C U L P T U R E

juba
new, fresh beverages

ts include: Creative Services: Tim Girvin Design, Inc.
e Computer MCA/Universal Paramount Pictures BrandQuesting™ Seattle Phone: 206.623.7808
-Cola McCaw Cellular Planet Hollywood Visual Brand Management and Assessment Seattle Fax: 206.340.1837
su/Tokyo Microsoft Shiseido/Tokyo Corporate and Product Identification Los Angeles Phone: 310.458.2675
e Lauder Nabisco Suntory/Tokyo Name and Brand Development Los Angeles Fax: 310.458.1494
 Nintendo The Pepsi Company Retail and Restaurant Design Represented in New York by
General Foods Nordstrom The Walt Disney Company Exhibit and Conference Design Renard Represents: 212.490.2450
 Olin Skis Warner Brothers Multimedia Interactive Design
 Total Packaging
 TransparentDesign™

CONSTELLATION FILMS
HOLLYWOOD, CA

MEL·GIBSON
BRAVEHEART

LIGHTOWL LLC.
STRATEGIES FOR BUSINESS AND MARKETING

MOCIOGARDEN
TOKYO

Midisoft

SUPER NINTENDO
ENTERTAINMENT SYSTEM

of the FALL

NINTENDO
ULTRA
64

BRAND ILLUSTRATION

CLIENT: TIMES SQUARE
BUSINESS IMPROVEMENT
DISTRICT

PH: (212) 475-0440 FX: (212) 353-8538
VICKI
MORGAN
ASSOCIATES
194 THIRD AVE NYC 10003

381

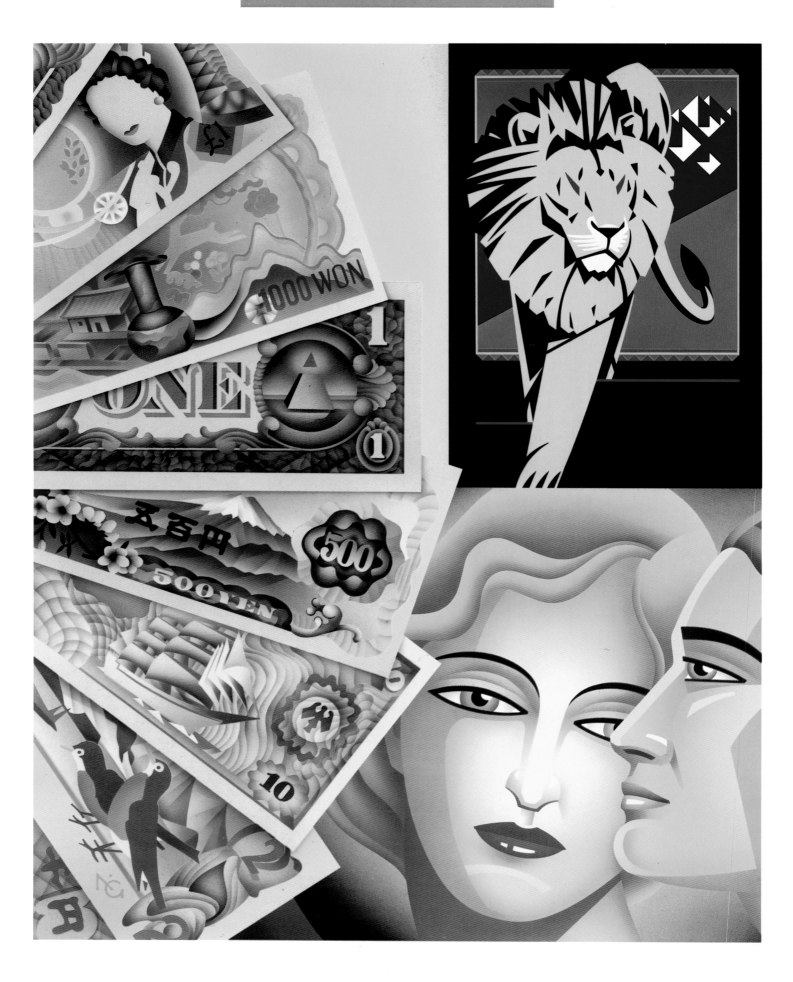

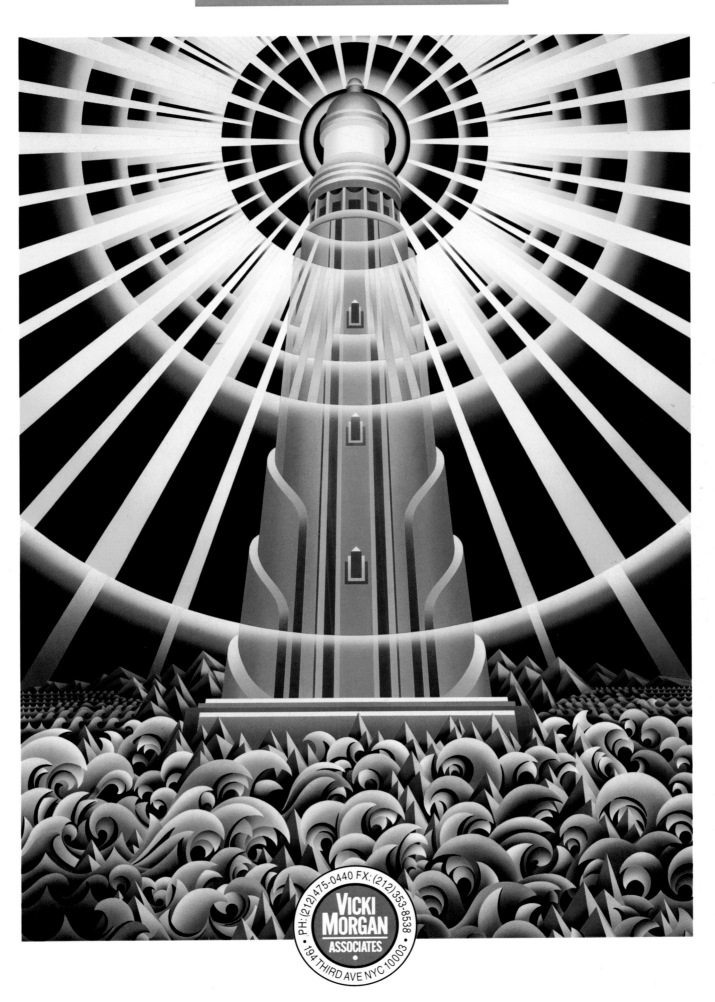

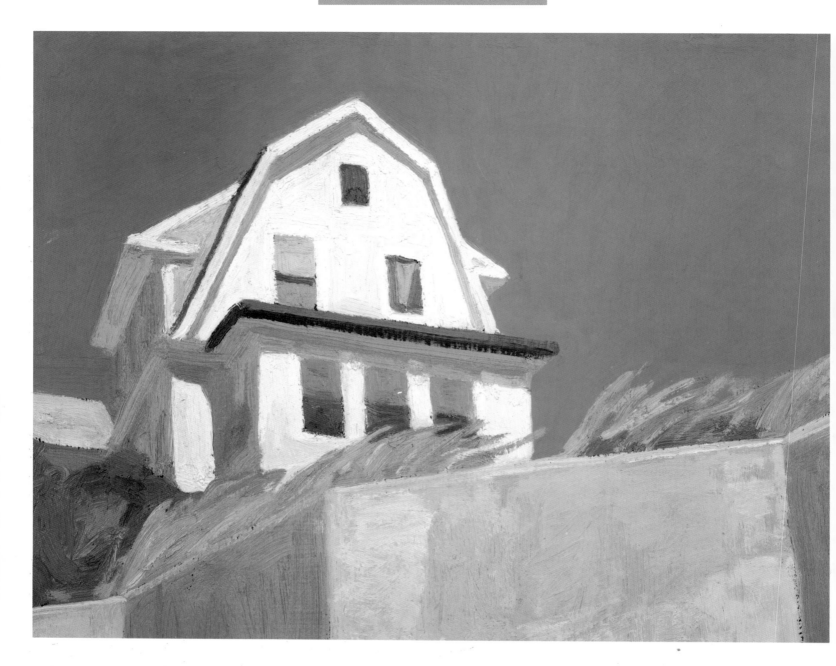

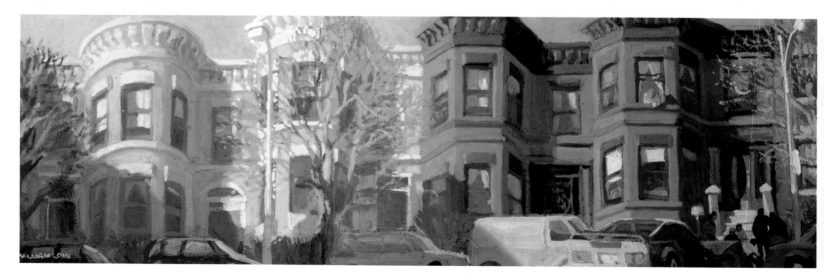

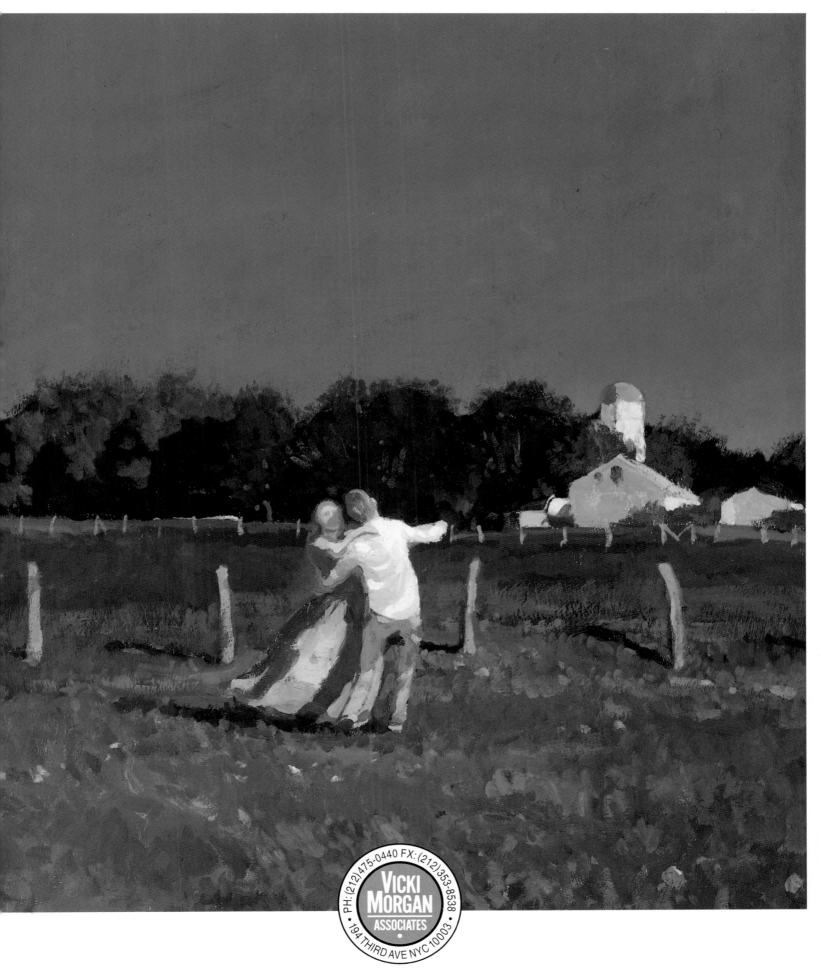

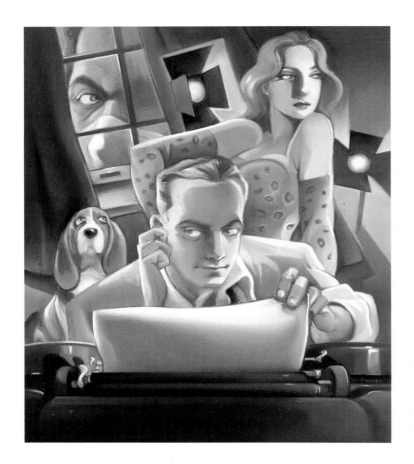

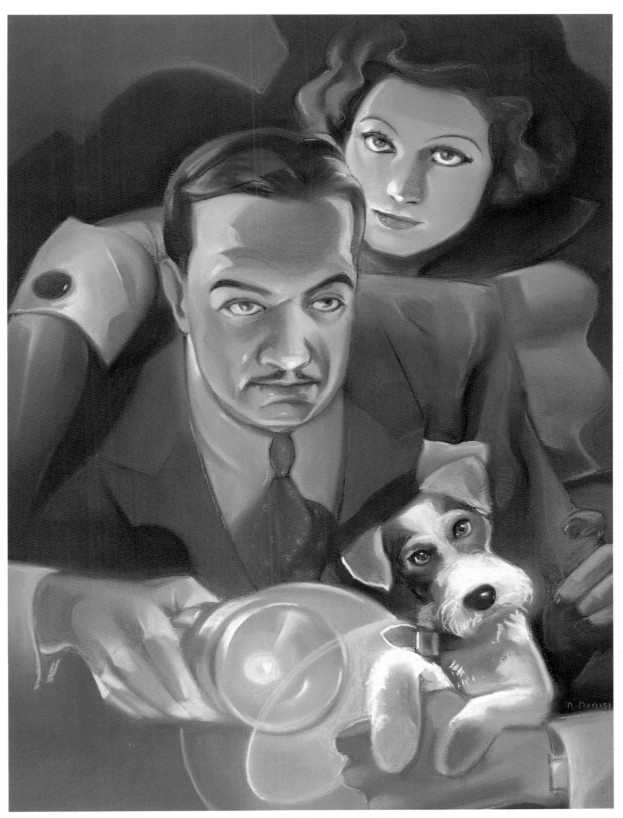

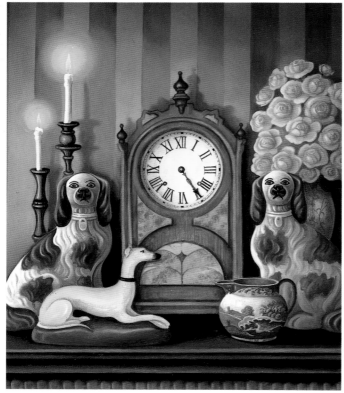

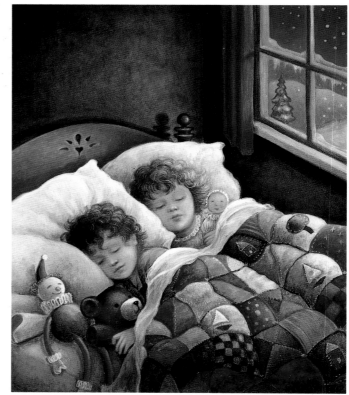

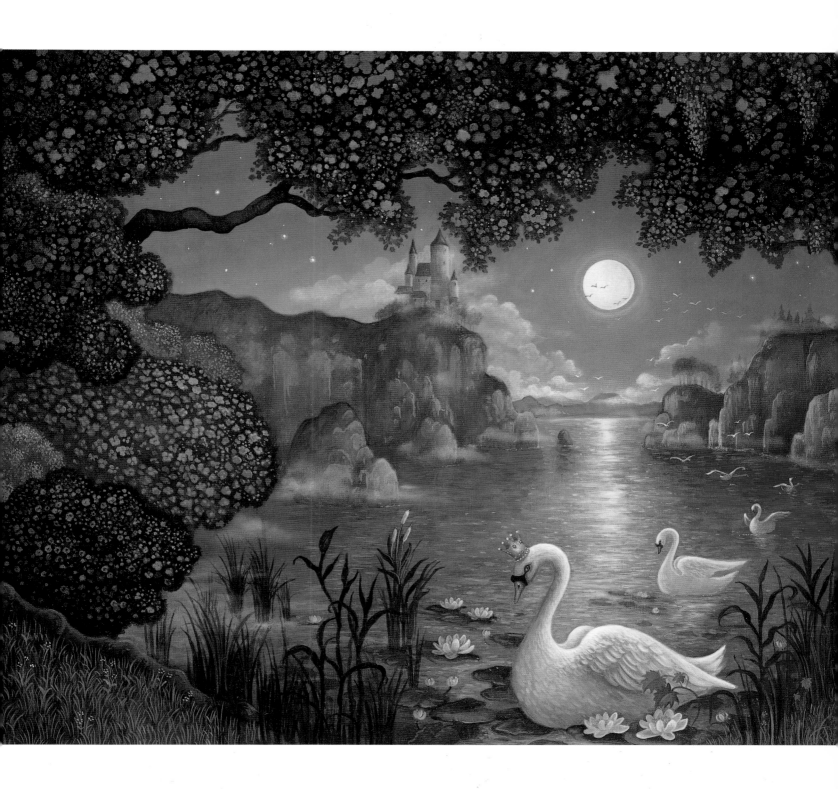

PH: (212) 475-0440 FX: (212) 353-8538

VICKI MORGAN ASSOCIATES

194 THIRD AVE NYC 10003

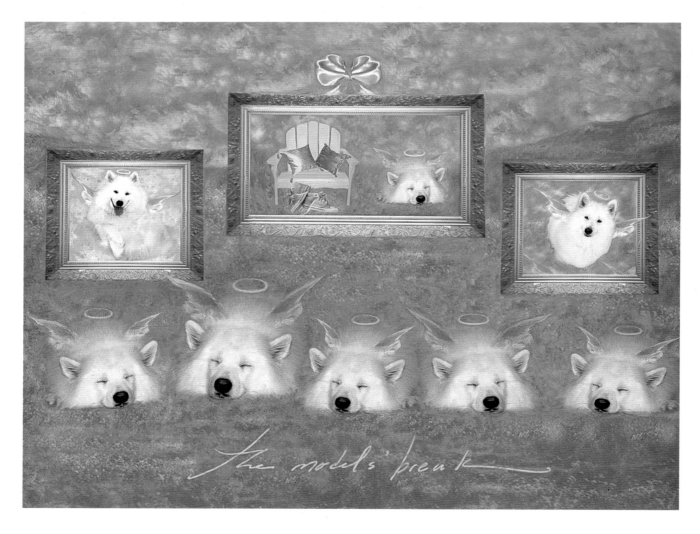

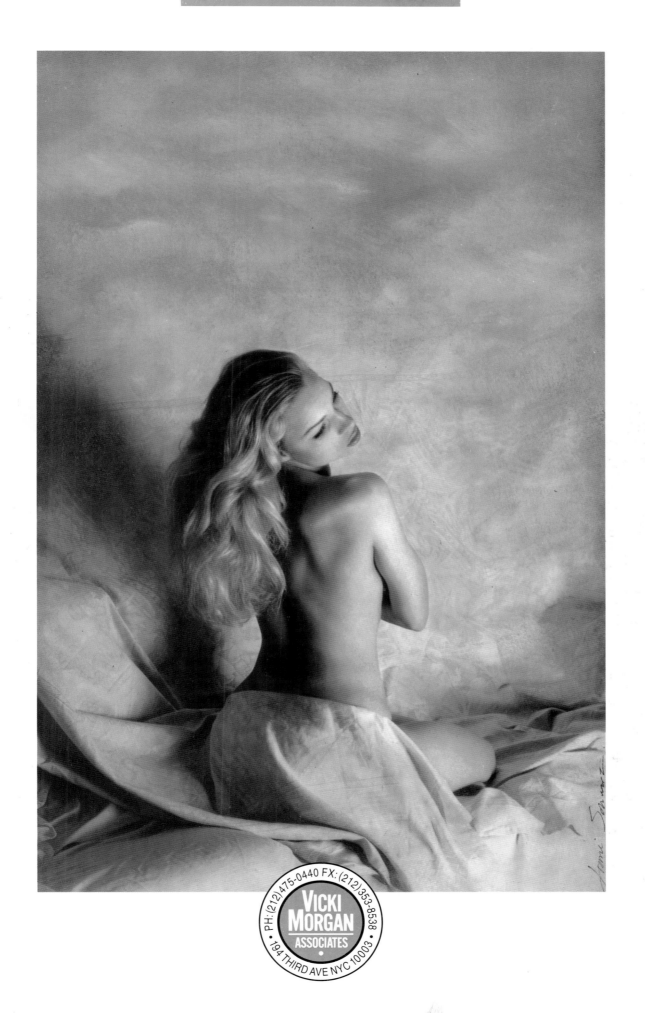

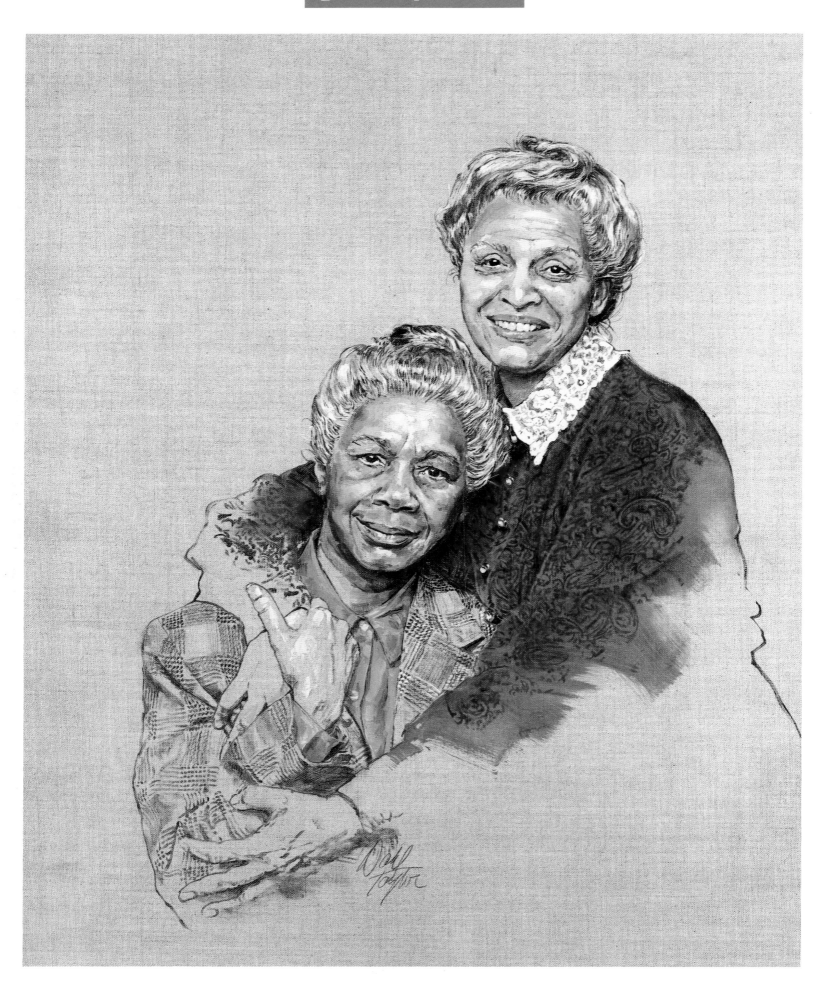

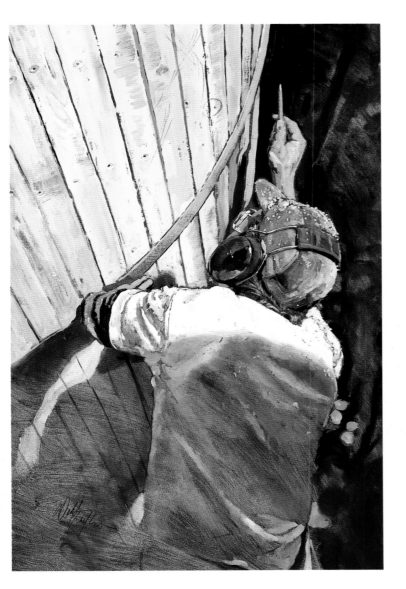

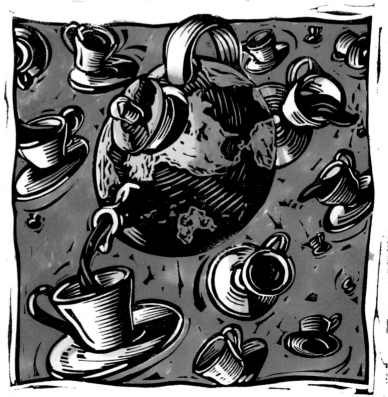

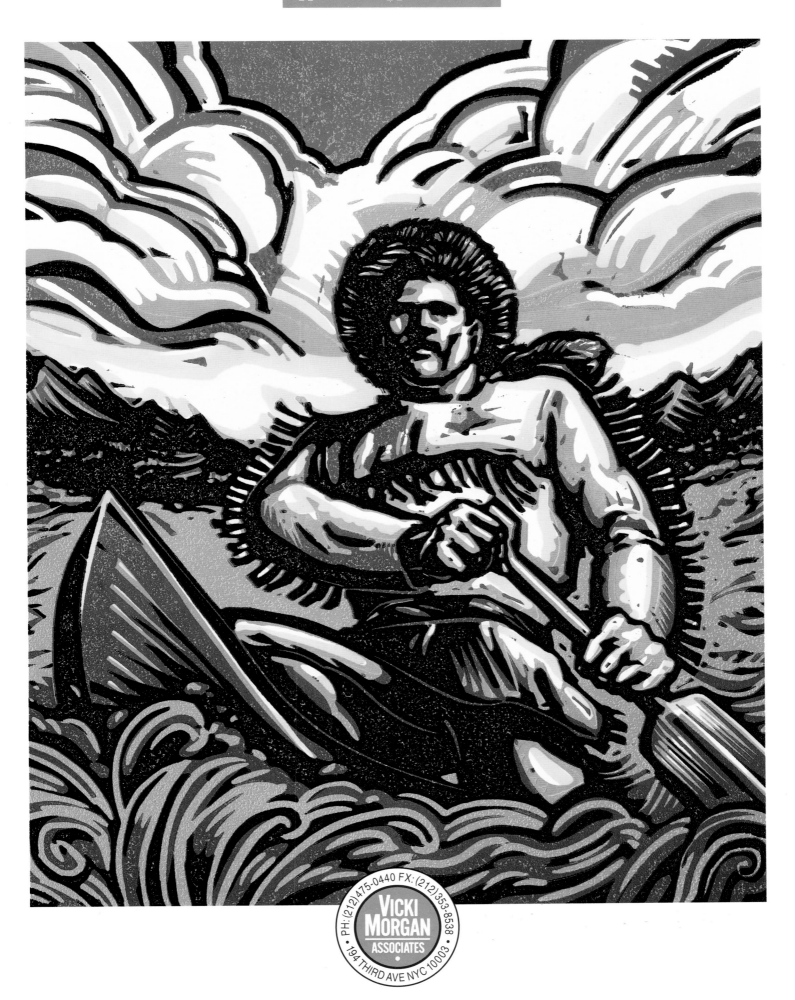

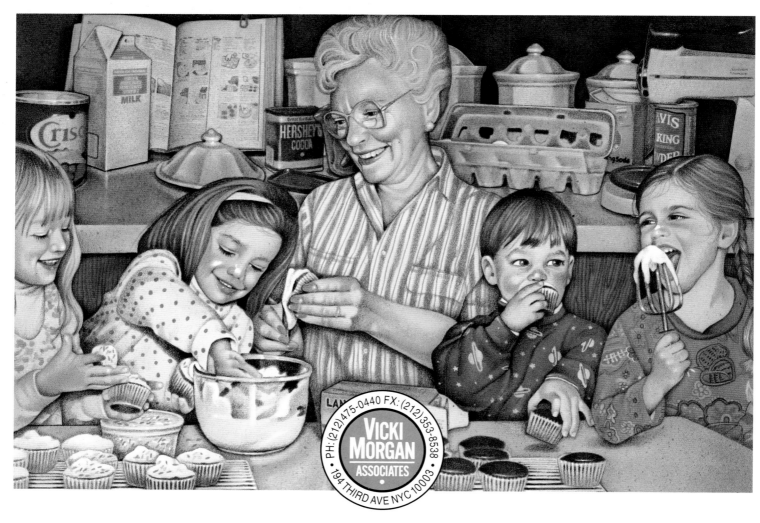

PH: (212) 475-0440 FX: (212) 353-8538
VICKI MORGAN ASSOCIATES
194 THIRD AVE NYC 10003

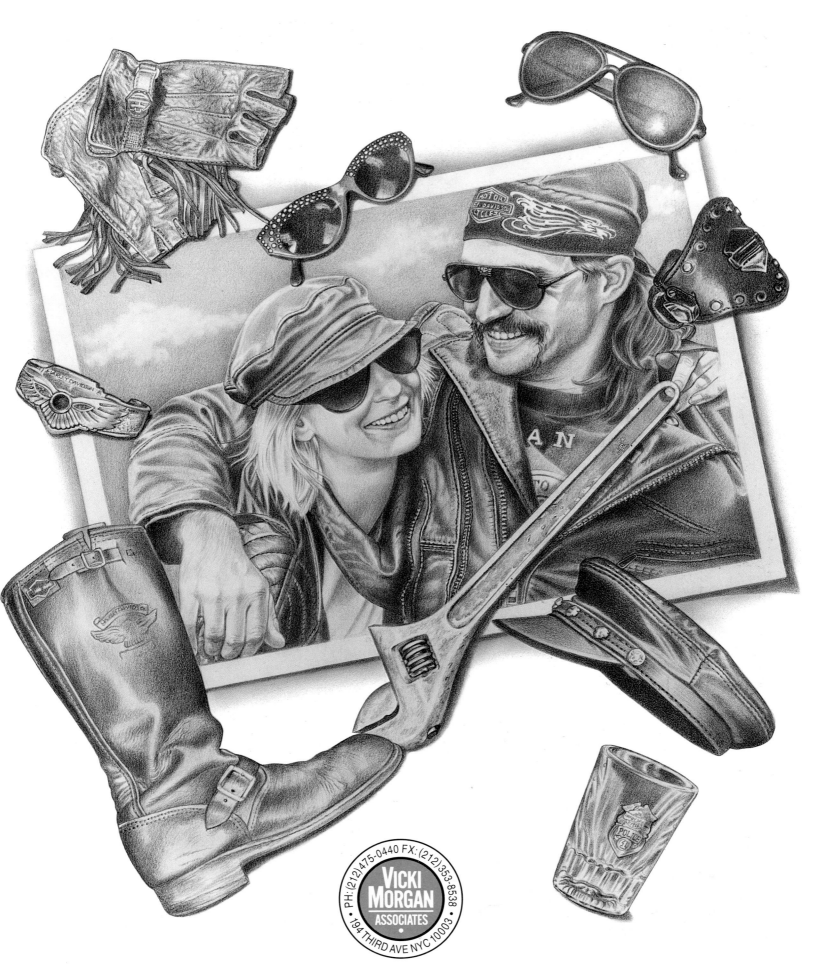

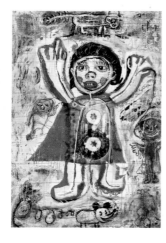

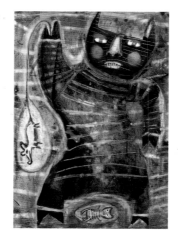

PH: (212) 475-0440 FX: (212) 353-8538
VICKI MORGAN ASSOCIATES
194 THIRD AVE NYC 10003

MODERN

AMERICAN
 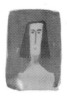
MEMOIRS

EDITED BY
Annie Dillard and Cort Conley

PH: (212) 475-0440 FX: (212) 353-8538

VICKI
MORGAN
ASSOCIATES

194 THIRD AVE NYC 10003

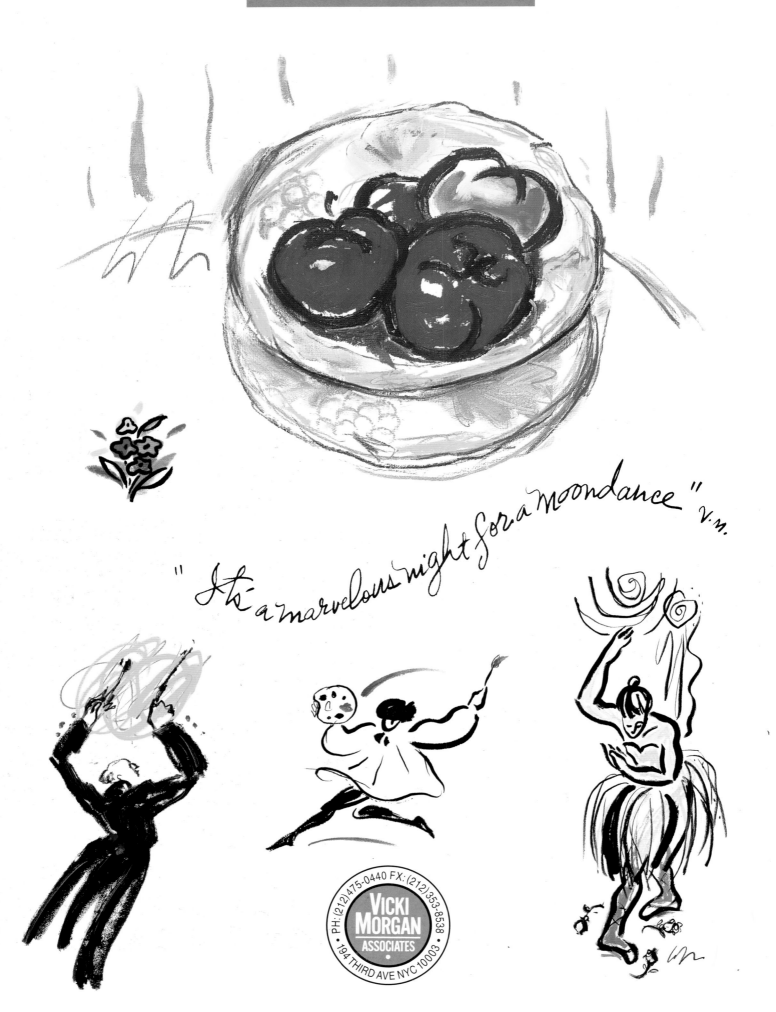

LAURIE LAFRANCE

"It's a marvelous night for a moondance" v.m.

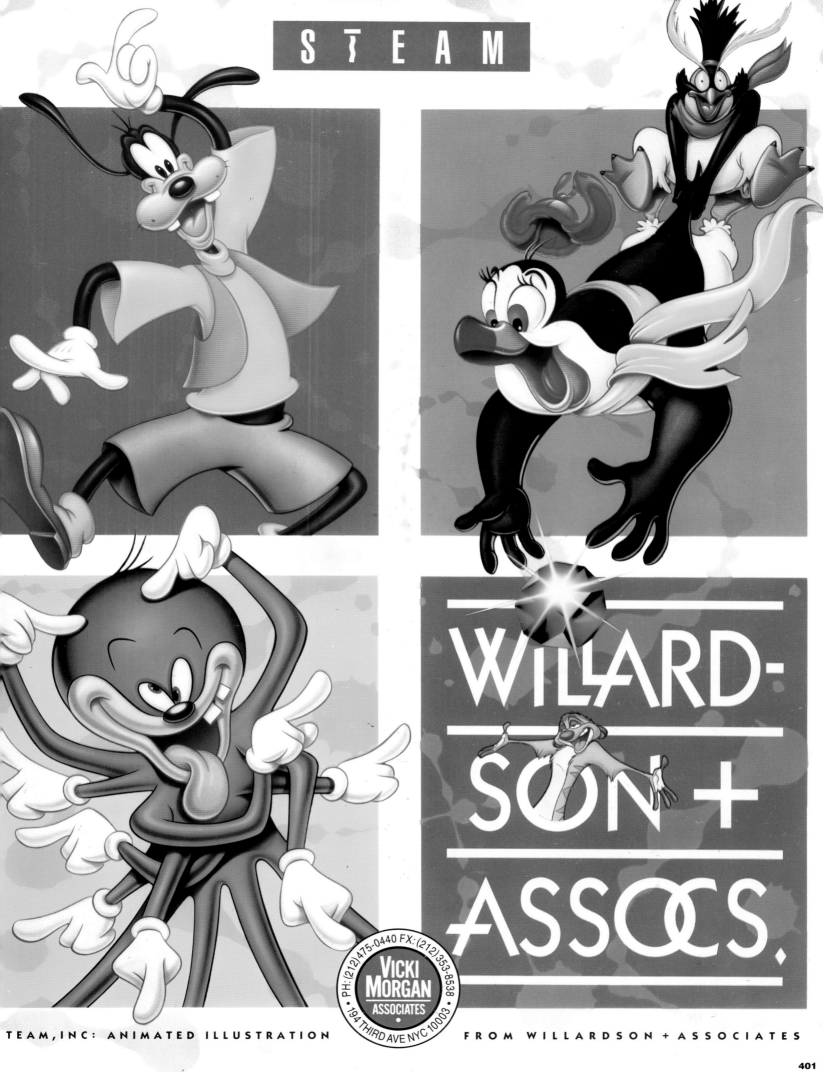

STEAM

WILLARD-SON + ASSOCS.

TEAM, INC: ANIMATED ILLUSTRATION FROM WILLARDSON + ASSOCIATES

GARY BASEMAN

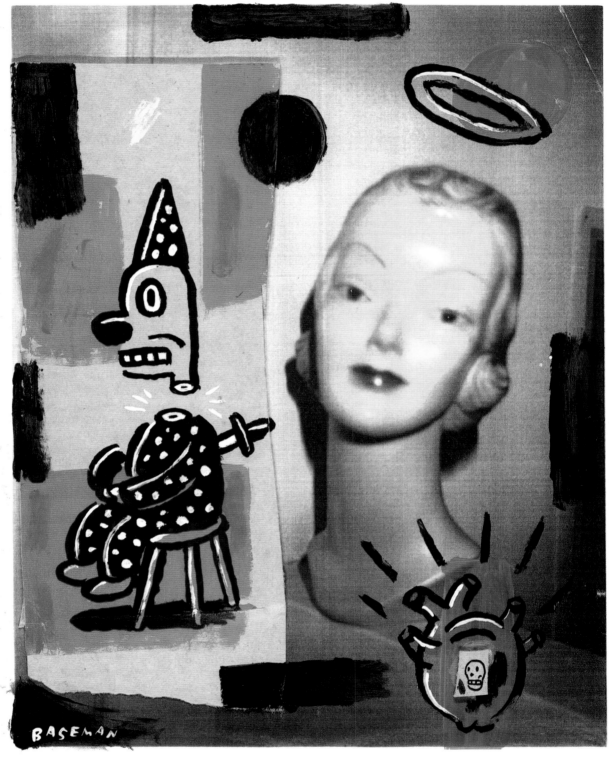

RAY GUN

BASEMAN

GARY BASEMAN

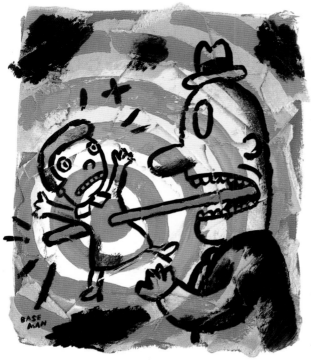

NEW YORK TIMES MAGAZINE

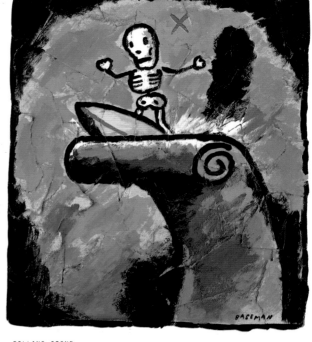

ROLLING STONE

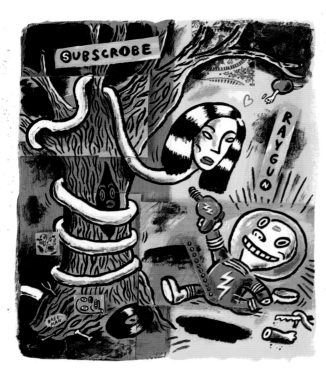

RAY GUN

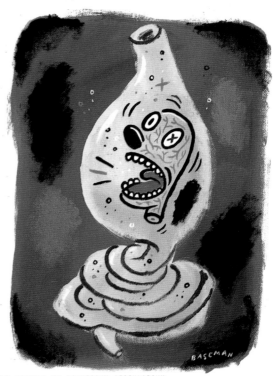

THE JOURNAL OF COLLEGIUM AESCULAPIUM

NICHOLAS WILTON

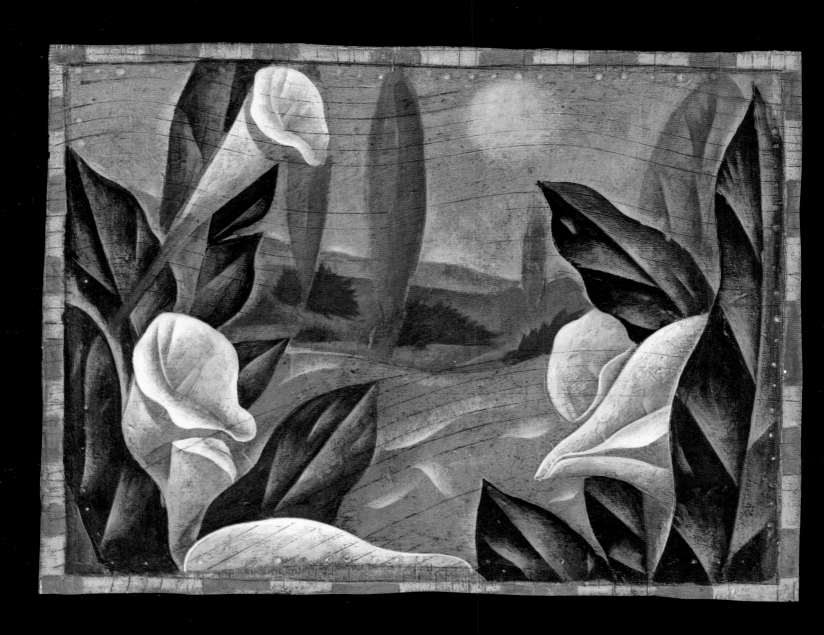

Jan Collier
415.383.9026

Jan Collier

Studio
415.488.4710

NICHOLAS WILTON

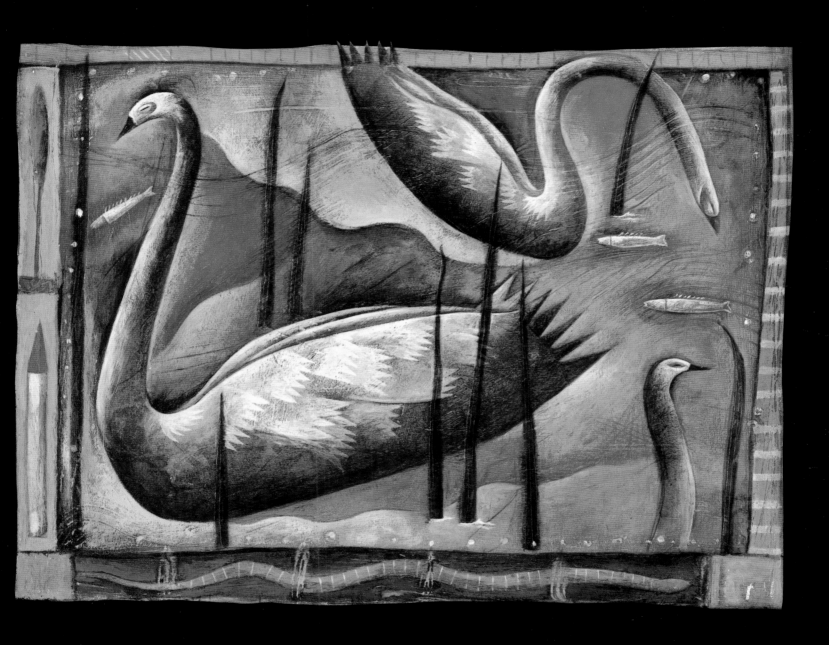

JAN COLLIER
415.383.9026

STUDIO
415.488.4710

Jan Collier

GARY BASEMAN

KIDSOFT

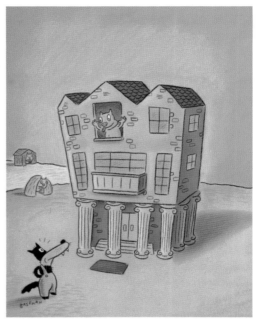

IBM

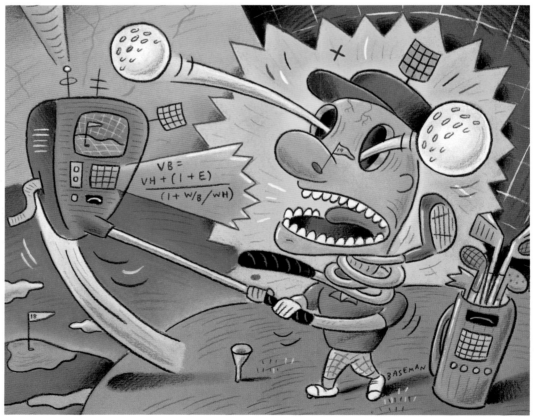

SPORTS ILLUSTRATED

COCO MASUDA

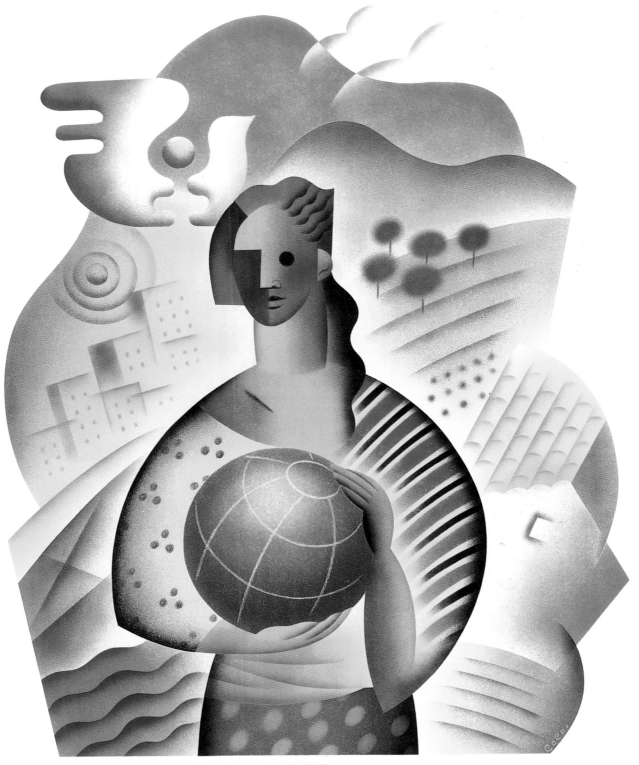

UNITED NATIONS: FOURTH WORLD CONFERENCE ON WOMEN

Jan Collier

Jan Collier
415.383.9026

Northeast + Editorial
Call Studio
212.753.9331

GREG CLARKE

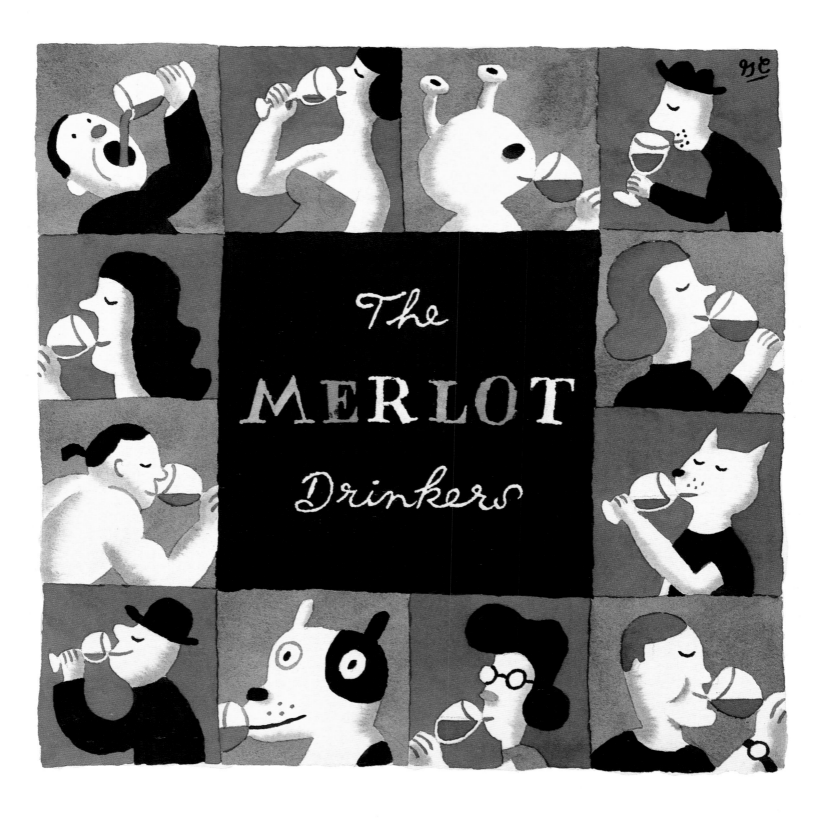

The MERLOT Drinkers

Jan Collier
415.383.9026

Jan Collier

Editorial
310.395.7958

RAE ECKLUND

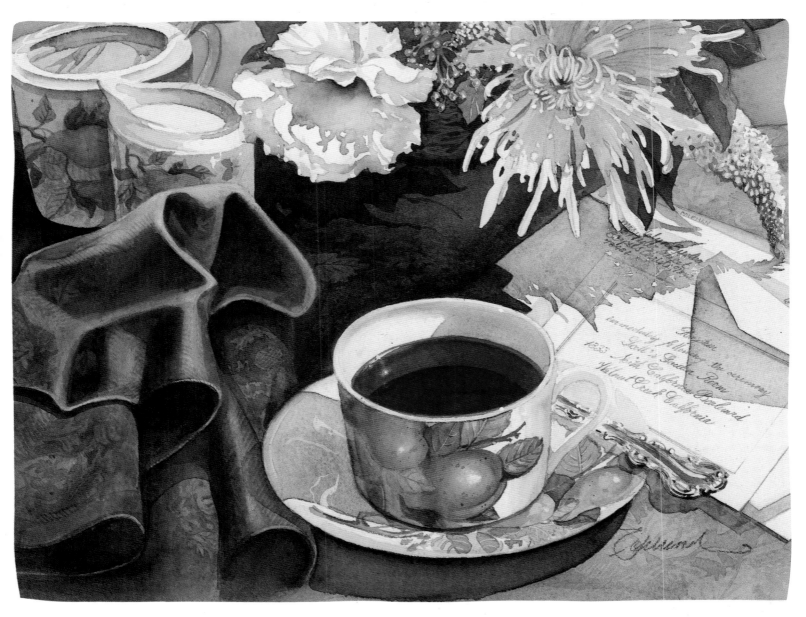

S&W CORPORATION
GOURMET MAGAZINE

RICH BORGE

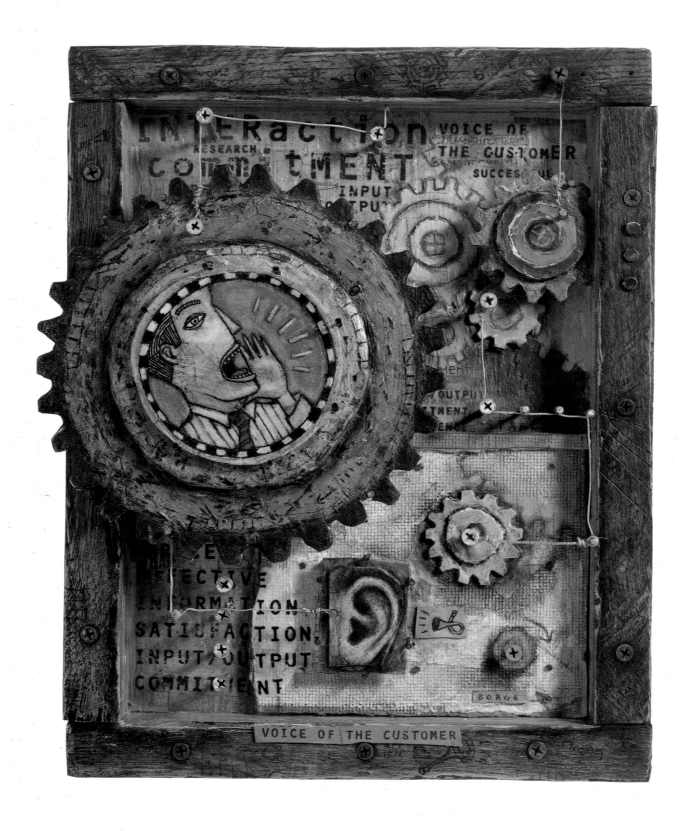

KATE MUELLER

J O H N P A T R I C K

M A R Y G R A N D P R E ´

F R A N K L I N H A M M O N D

415

YOUNG SOOK CHO

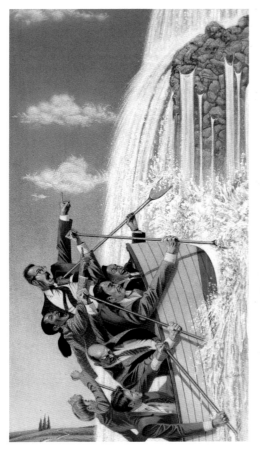

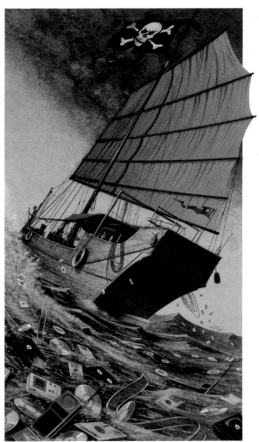

DAVID BECK

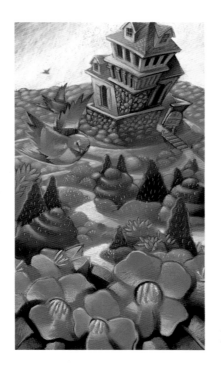

M A R K B R A U G H T

GREG LAFEVER

D A V E L A F L E U R

D A V E L A F L E U R

E V A N G E L I A P H I L L I P P I D I S

BOB JAMES

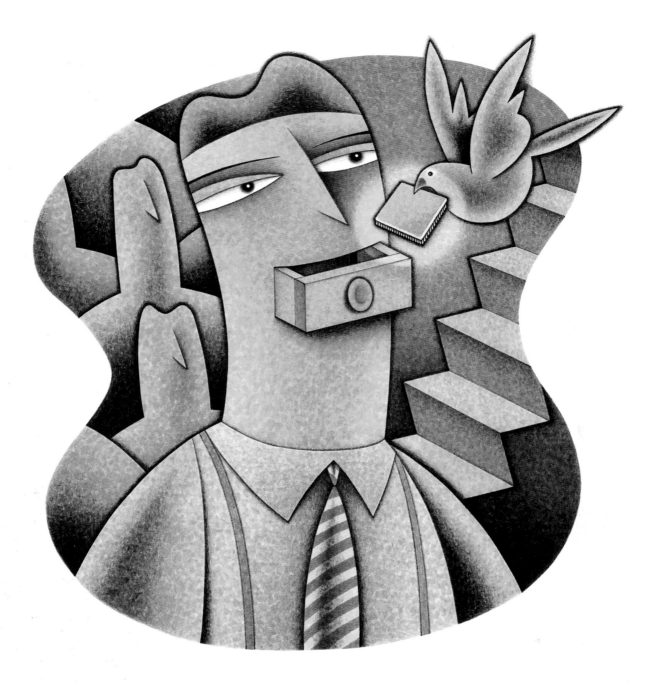

JOSEF GAST

C U R T I S P A R K E R

SCOTT HULL ASSOCIATES 513.433.8383 **NYC** 212.966.3604 **FAX** 513.433.0434

ANDY BUTTRAM

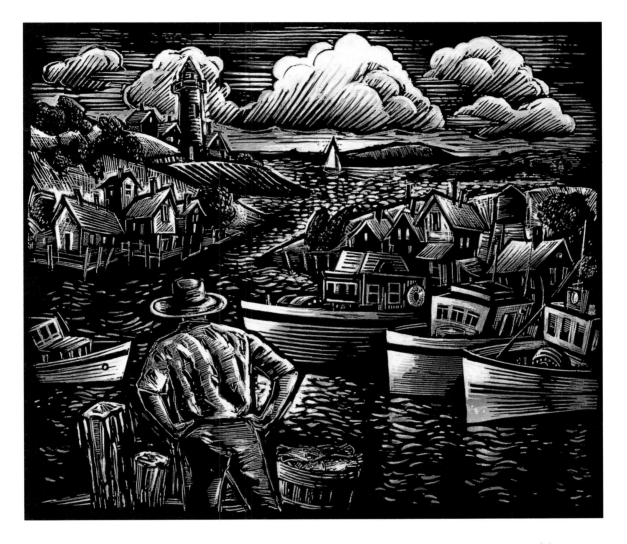

PETE HARRITOS

L A R R Y M A R T I N

T E D P I T T S

G R E G D E A R T H

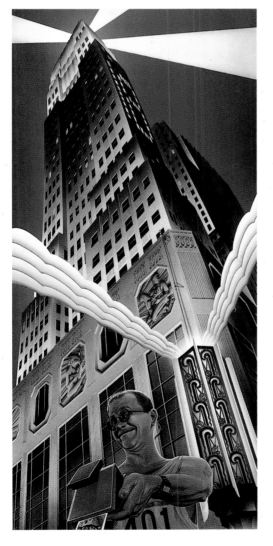

J O H N M A G G A R D

J O H N C E B A L L O S

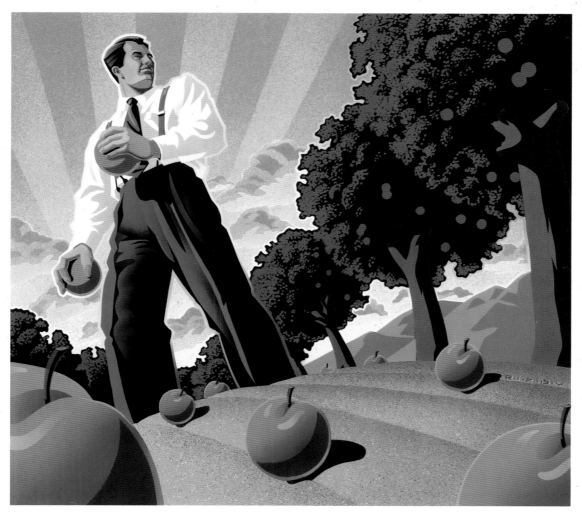

M A R K R I E D Y

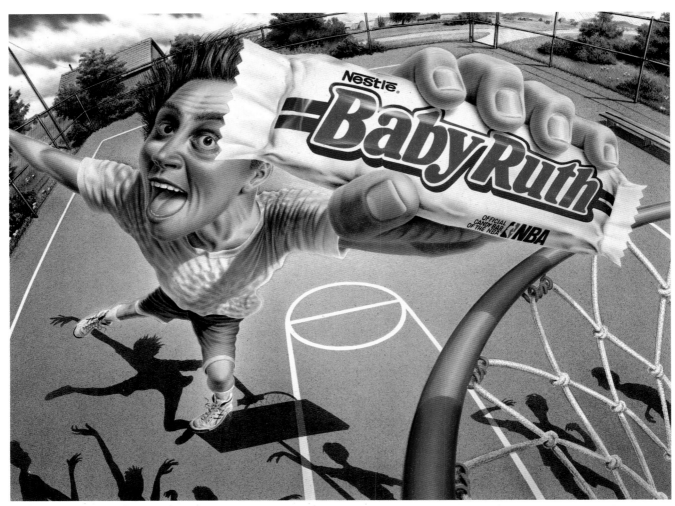

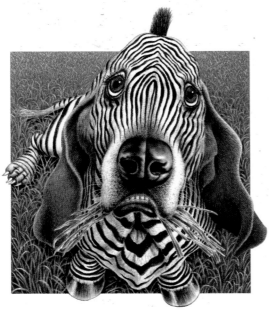

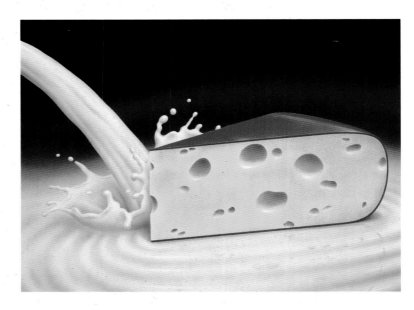

TRACY BRITT

SCOTT HULL ASSOCIATES 513.433.8383 NYC 212.966.3604 FAX 513.433.0434

J E F F B R I C E

KOLEA BAKER

Artists Representative Inc

GREG RAGLAND

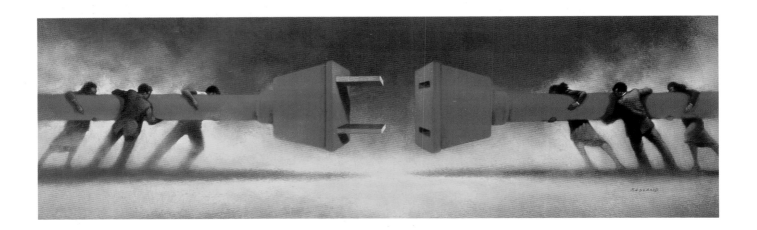

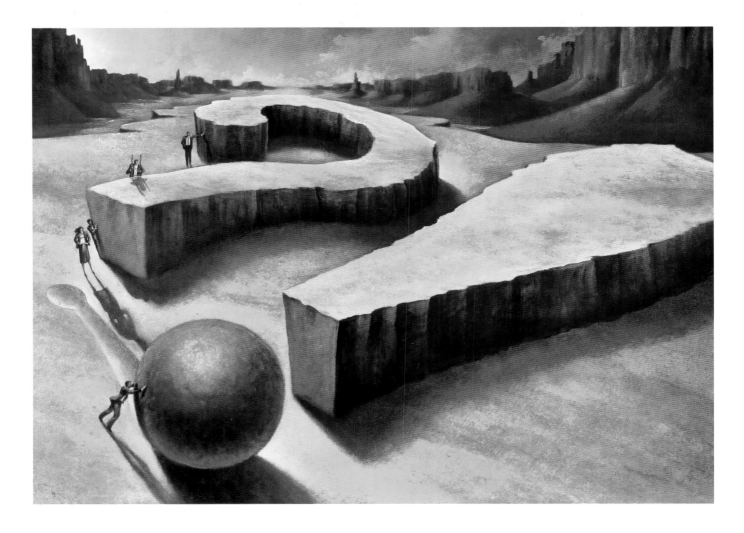

KOLEA BAKER
Artists Representative Inc

2814 - NW 72nd Street Seattle WA 98117 206.784.1136 fax 206.784.1171
email: BakerKolea@aol.com Call for our current promo.

JERE SMITH

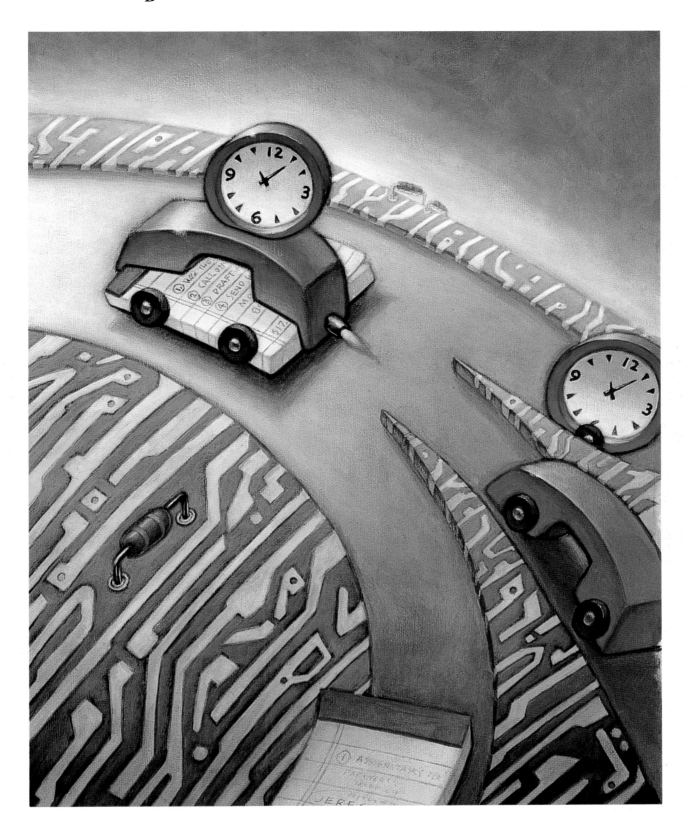

MARGARET CHODOS-IRVINE

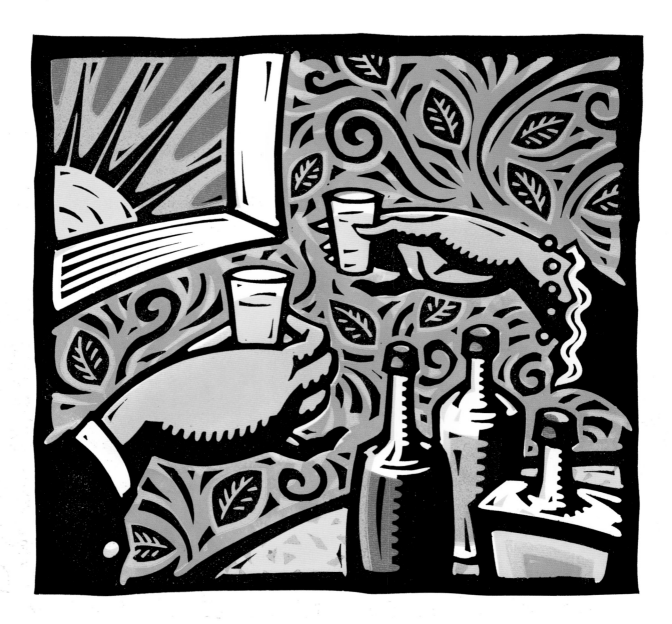

KOLEA BAKER
Artists Representative Inc

2814 - NW 72nd Street Seattle WA 98117 206.784.1136 fax 206.784.1171
email: BakerKolea@aol.com Call for our current promo.

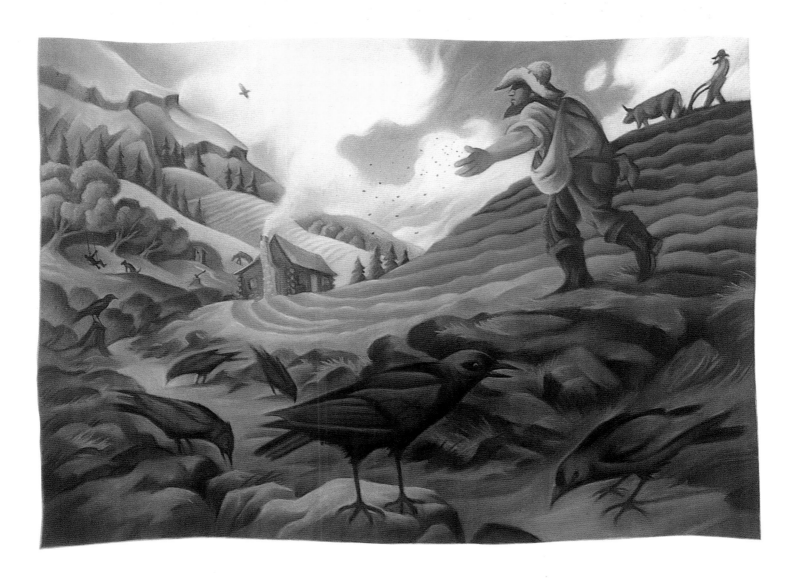

GEORGE ABE

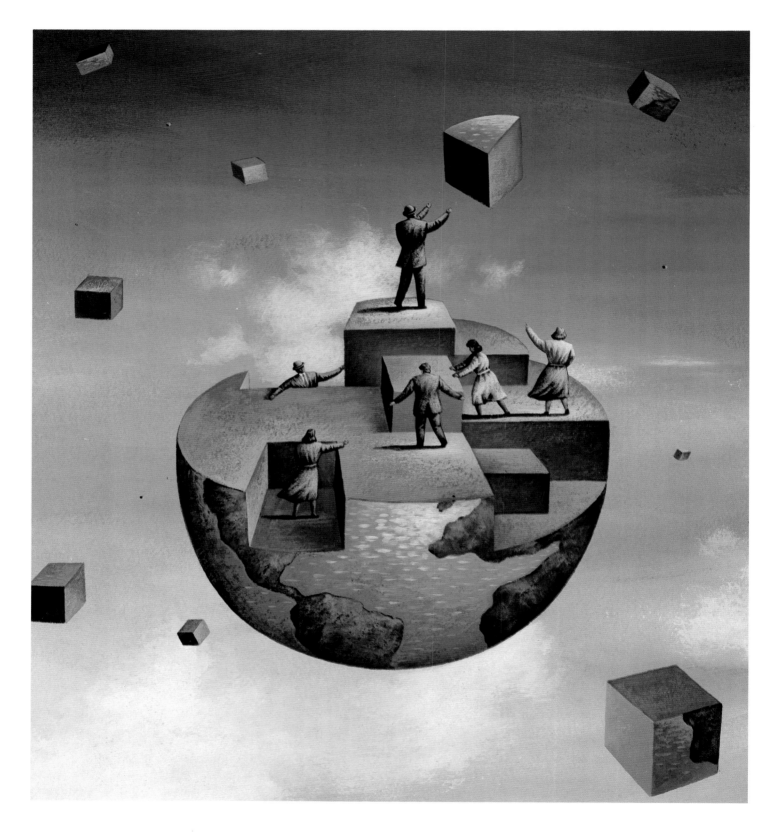

440

GEORGE ABE

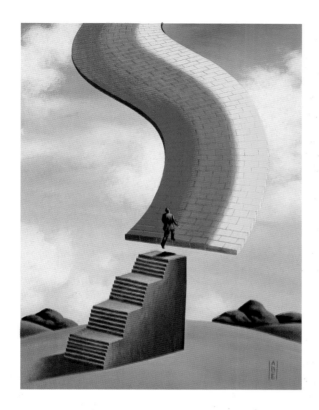 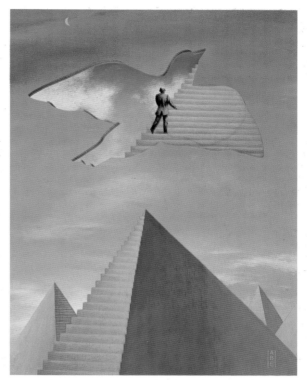

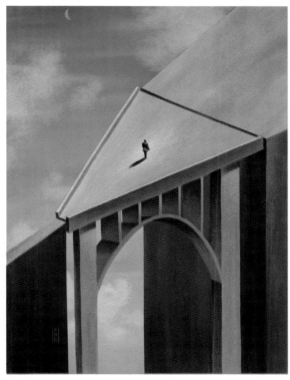 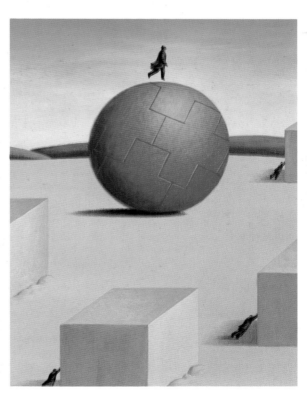

441

DON BAKER

KOLEA BAKER
Artists Representative Inc

2814 - NW 72nd Street Seattle WA 98117 206.784.1136 fax 206.784.1171
email: BakerKolea@aol.com Call for our current promo.

DON BAKER

KOLEA BAKER

Artists Representative Inc

2814 - NW 72nd Street Seattle WA 98117 206.784.1136 fax 206.784.1171
email: BakerKolea@aol.com Call for our current promo.

CHRISTINA DE MUSEE

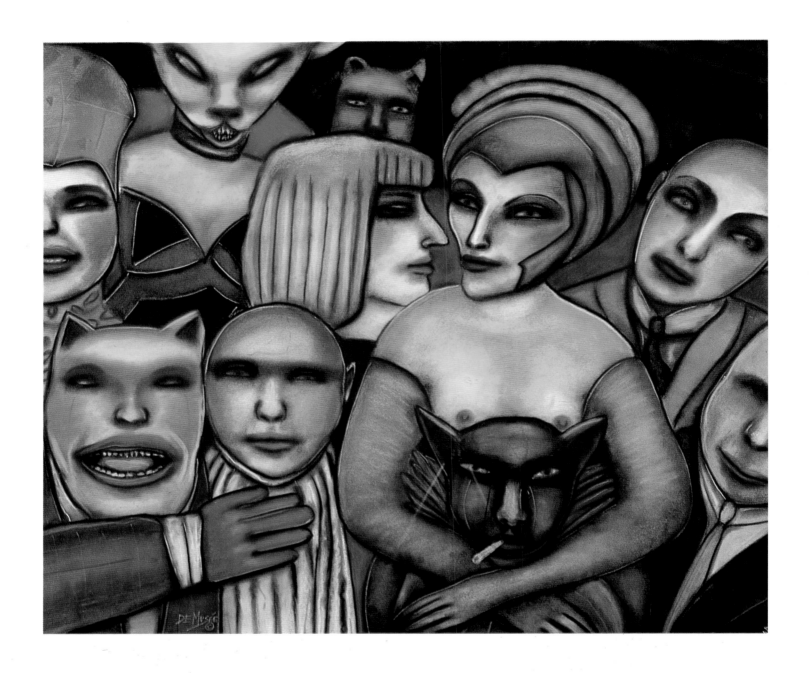

KOLEA BAKER
Artists Representative Inc

2814 - NW 72nd Street Seattle WA 98117 206.784.1136 fax 206.784.1171
email: BakerKolea@aol.com Call for our current promo.

CHRISTINA DE MUSEE

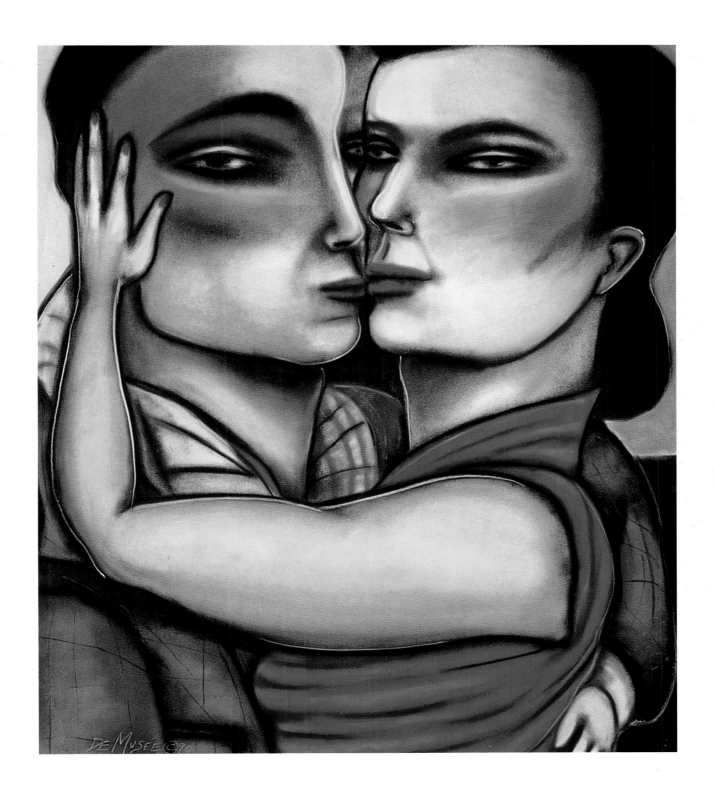

KOLEA BAKER
Artists Representative Inc

2814 - NW 72nd Street Seattle WA 98117 206.784.1136 fax 206.784.1171
email: BakerKolea@aol.com Call for our current promo.

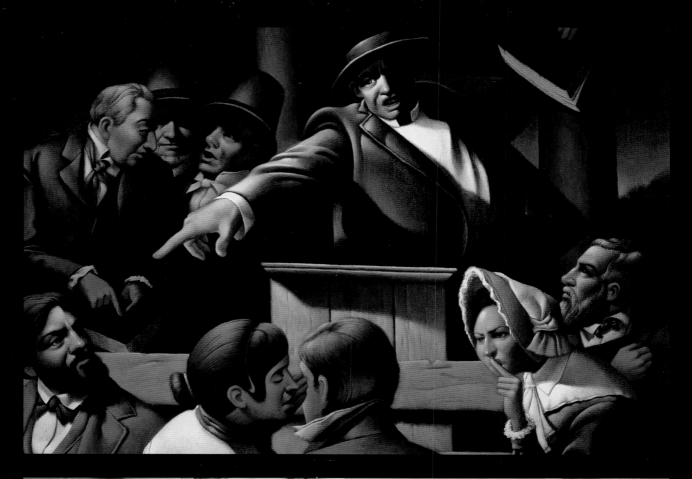

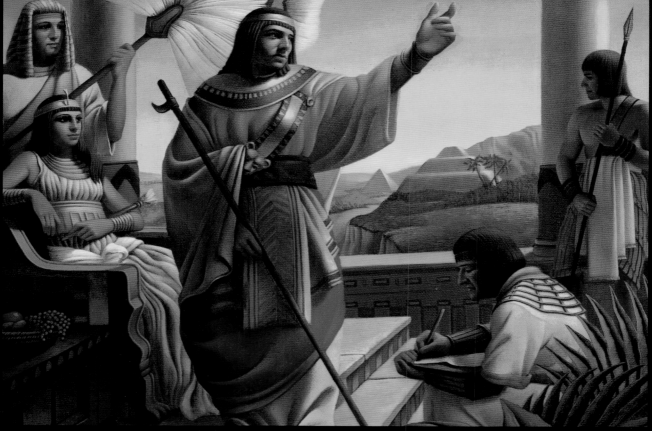

CARY AUSTIN

SHANNON · ASSOCIATES 327 East 89th Street, Suite 3E • New York, NY 10128-5075 • Tel (212) 831-5650 • Fax (212) 831-62

CARY AUSTIN

SHANNON·ASSOCIATES 327 East 89th Street, Suite 3E • New York, NY 10128-5075 • Tel (212) 831-5650 • Fax (212) 831-6241

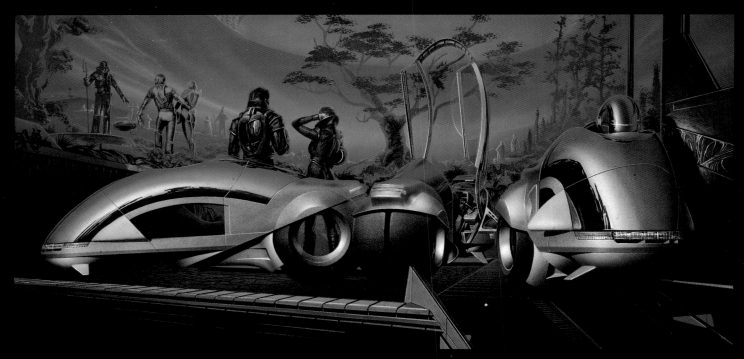

PETER BOLLINGER

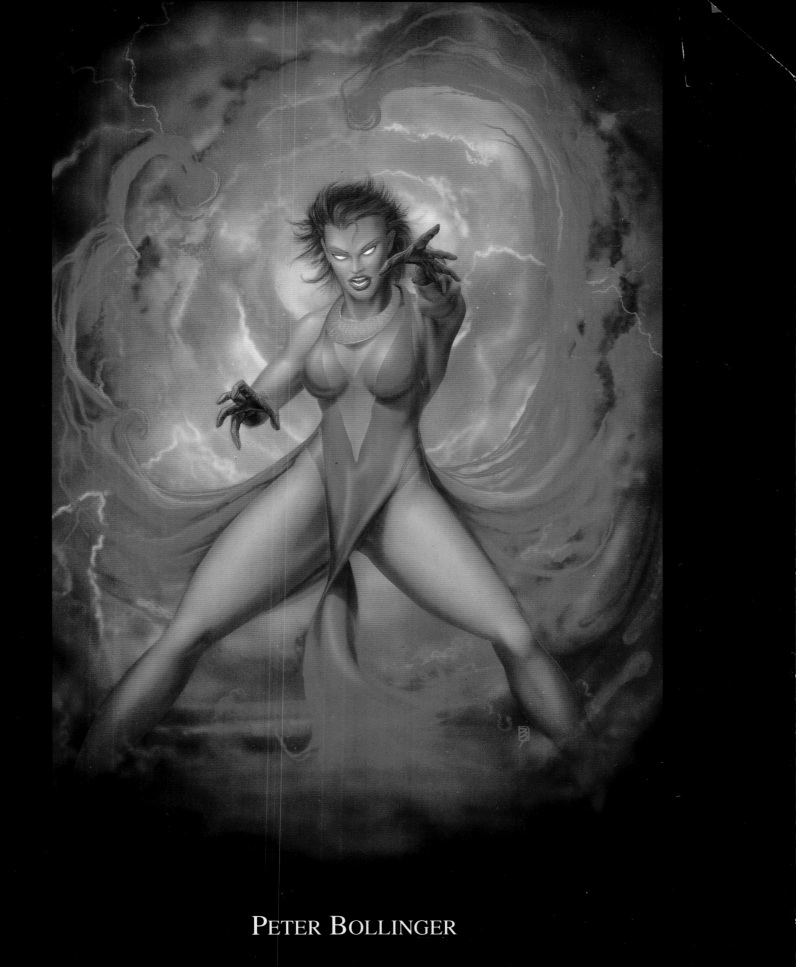

PETER BOLLINGER

HANNON·ASSOCIATES 327 East 89th Street, Suite 3E • New York, NY 10128-5075 • Tel (212) 831-5650 • Fax (212) 831-6241

PETER BOLLINGER
DIGITAL ILLUSTRATION

SHANNON·ASSOCIATES 327 East 89th Street, Suite 3E • New York, NY 10128-5075 • Tel (212) 831-5650 • Fax (212) 831-62

PETER BOLLINGER
DIGITAL ILLUSTRATION

HANNON·ASSOCIATES 327 East 89th Street, Suite 3E • New York, NY 10128-5075 • Tel (212) 831-5650 • Fax (212) 831-6241

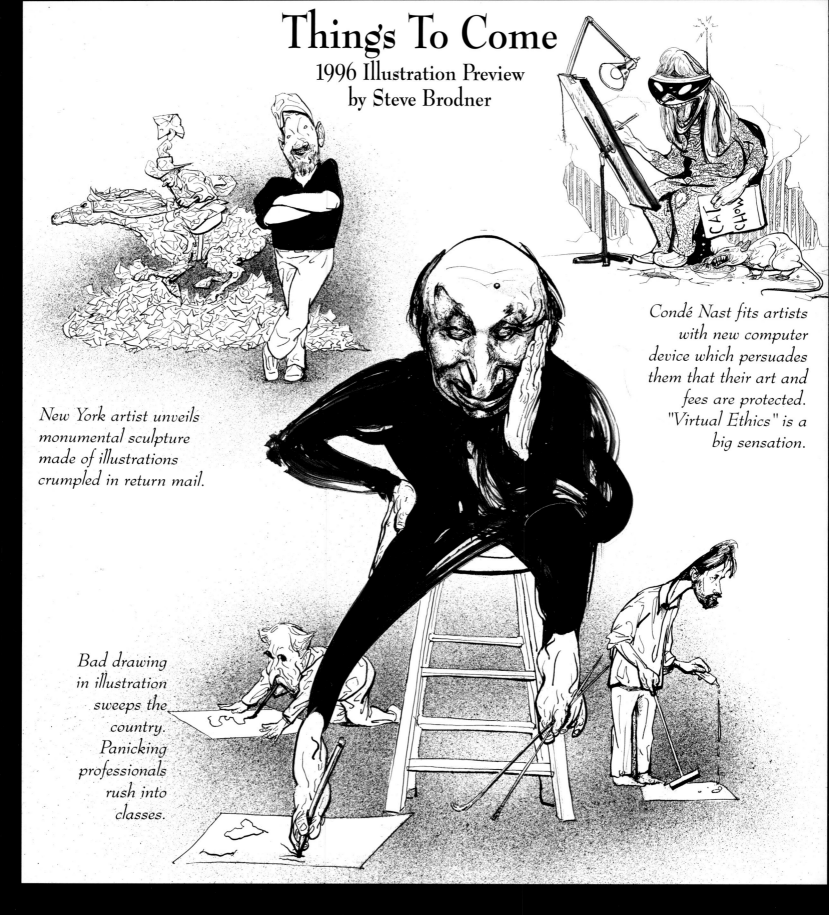

Things To Come

1996 Illustration Preview
by Steve Brodner

New York artist unveils monumental sculpture made of illustrations crumpled in return mail.

Condé Nast fits artists with new computer device which persuades them that their art and fees are protected. "Virtual Ethics" is a big sensation.

Bad drawing in illustration sweeps the country. Panicking professionals rush into classes.

STEVE BRODNER

SHANNON · ASSOCIATES 327 East 89th Street, Suite 3E • New York, NY 10128-5075 • Tel (212) 831-5650 • Fax (212) 831-62

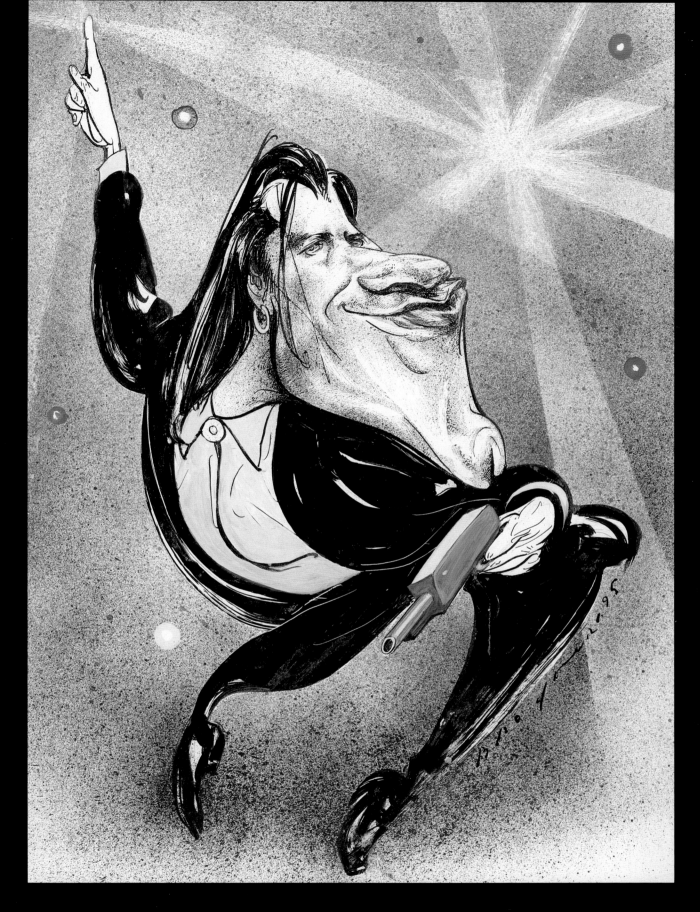

STEVE BRODNER

HANNON·ASSOCIATES 327 East 89th Street, Suite 3E • New York, NY 10128-5075 • Tel (212) 831-5650 • Fax (212) 831-6241

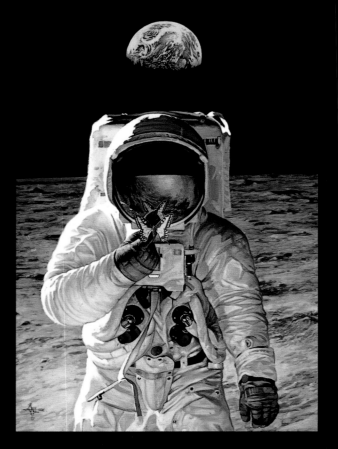

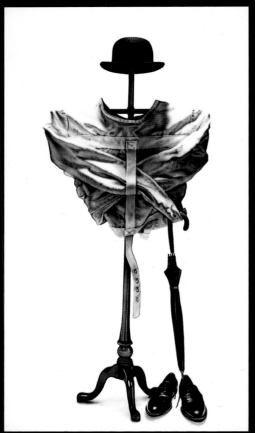

GREG CALL

SHANNON · ASSOCIATES 327 East 89th Street, Suite 3E • New York, NY 10128-5075 • Tel (212) 831-5650 • Fax (212) 831-62

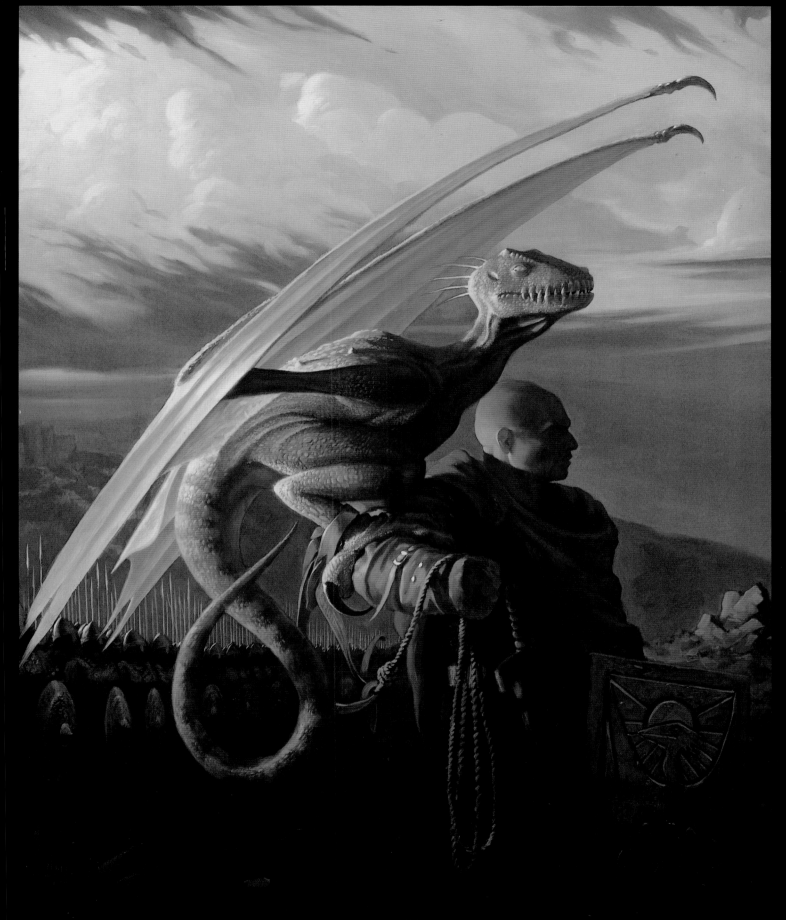

GREG CALL

HANNON · ASSOCIATES 327 East 89th Street, Suite 3E • New York, NY 10128-5075 • Tel (212) 831-5650 • Fax (212) 831-6241

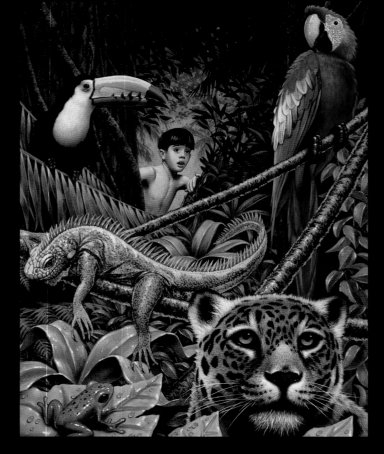
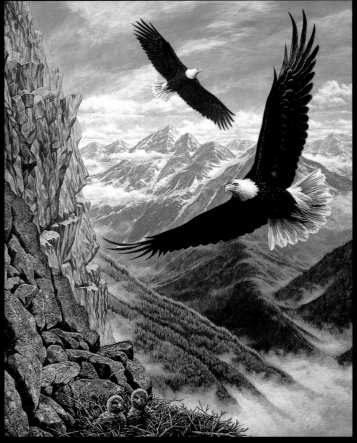
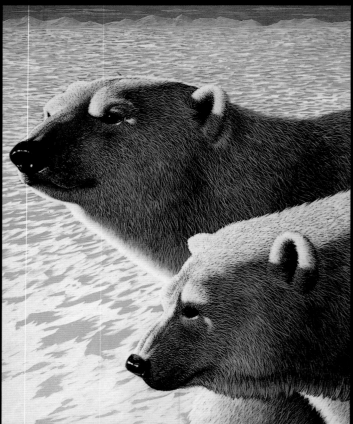

Protect our endangered species.

RICHARD COWDREY

RICHARD COWDREY

HANNON · ASSOCIATES 327 East 89th Street, Suite 3E • New York, NY 10128-5075 • Tel (212) 831-5650 • Fax (212) 831-6241

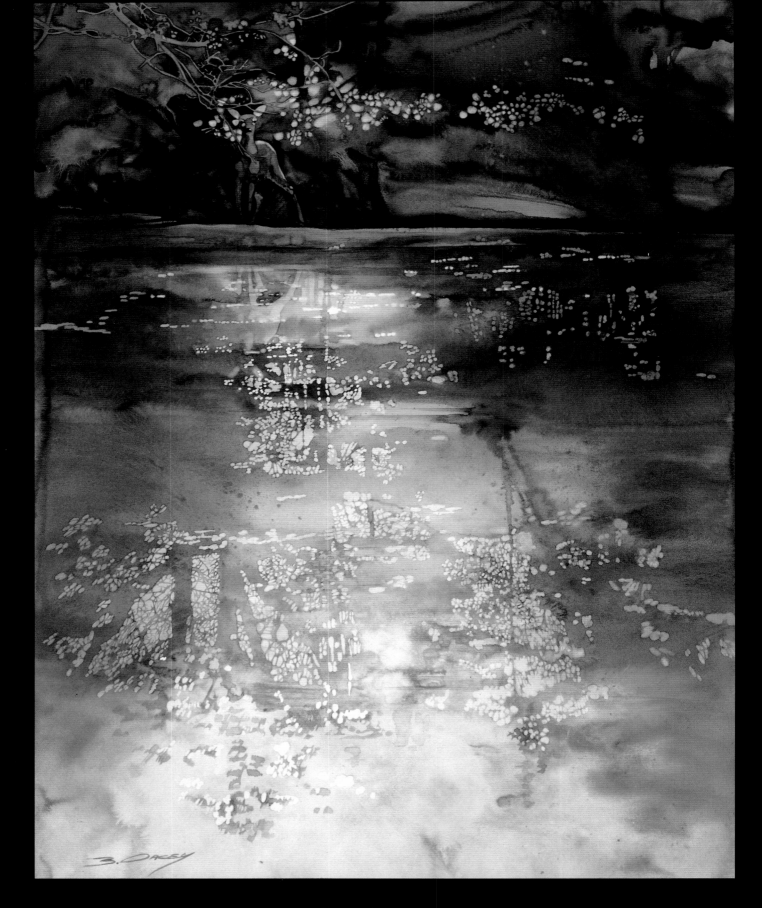

BOB DACEY

SHANNON · ASSOCIATES 327 East 89th Street, Suite 3E • New York, NY 10128-5075 • Tel (212) 831-5650 • Fax (212) 831-62

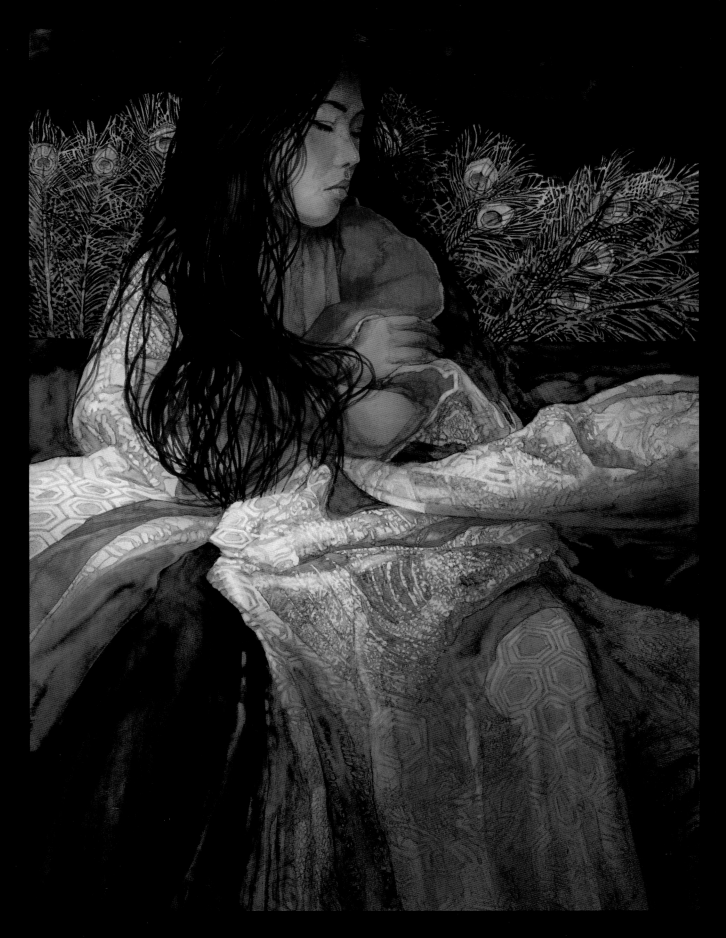

BOB DACEY

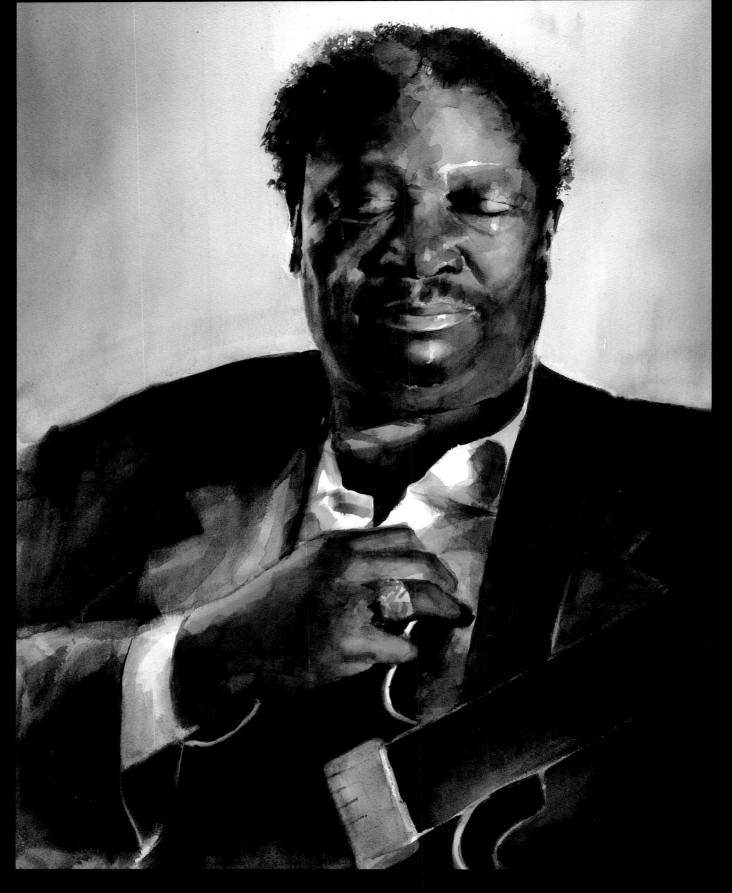

JOHN DeGRACE

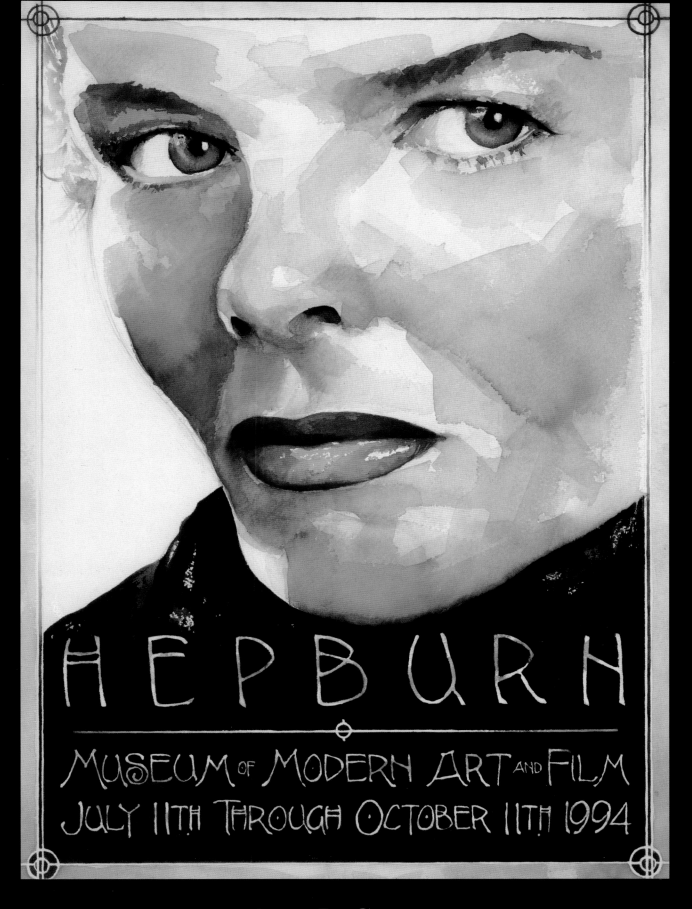

HEPBURH

MUSEUM of MODERN ART and FILM
JULY 11TH THROUGH OCTOBER 11TH 1994

JOHN DeGRACE

HANNON·ASSOCIATES 327 East 89th Street, Suite 3E • New York, NY 10128-5075 • Tel (212) 831-5650 • Fax (212) 831-6241

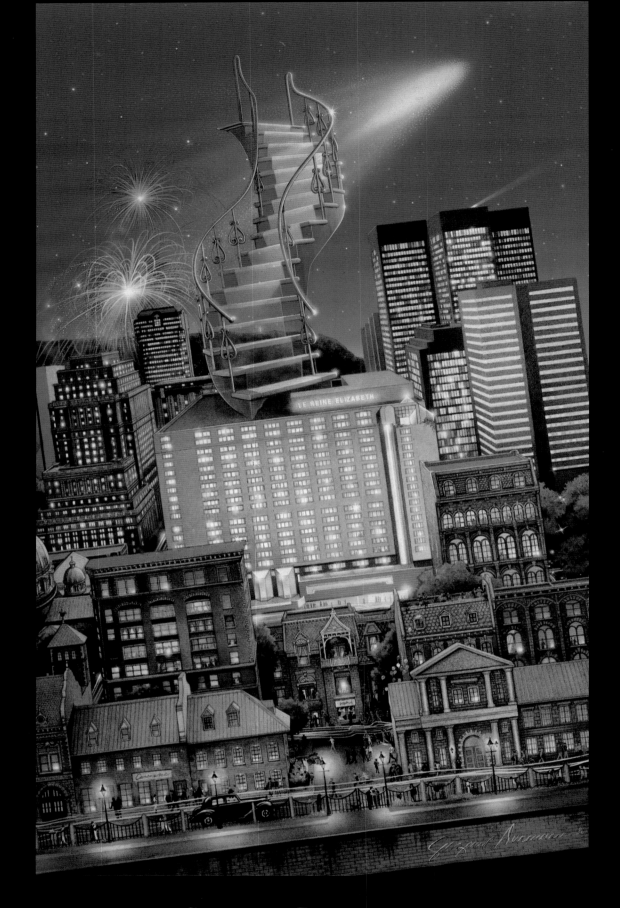

SUZANNE DURANCEAU

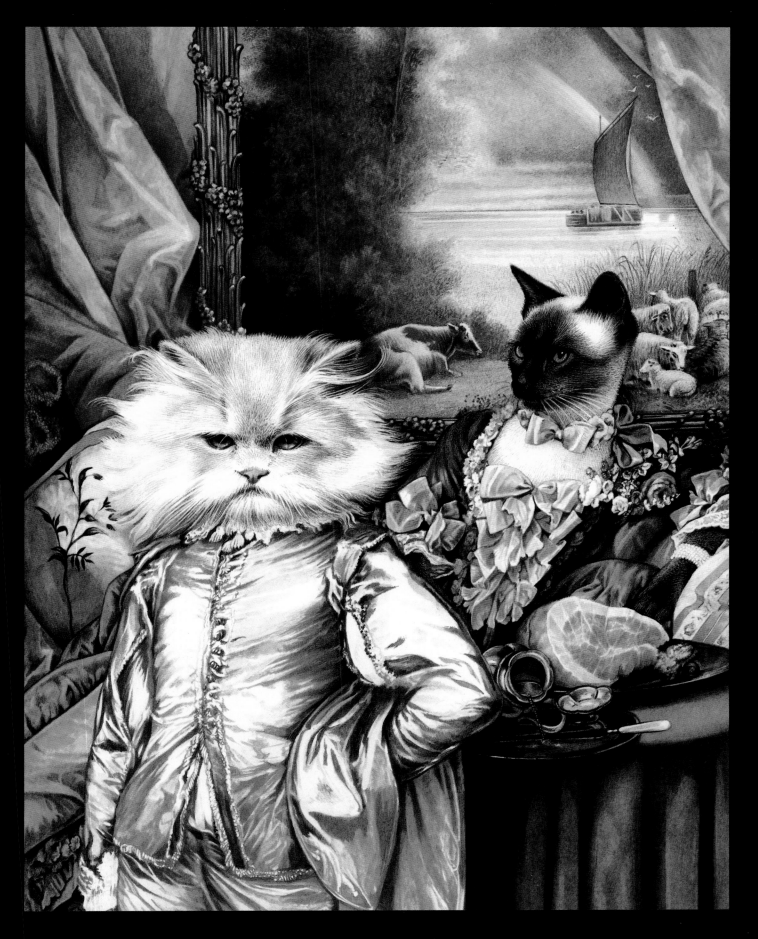

SUZANNE DURANCEAU

HANNON · ASSOCIATES 327 East 89th Street, Suite 3E • New York, NY 10128-5075 • Tel (212) 831-5650 • Fax (212) 831-6241

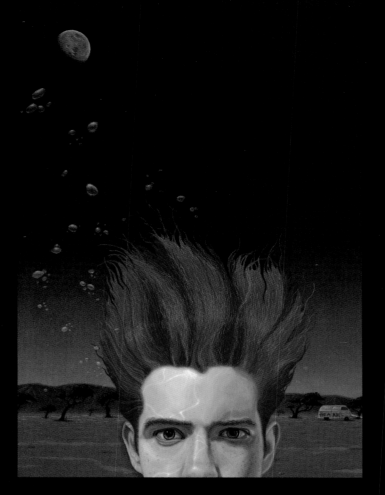

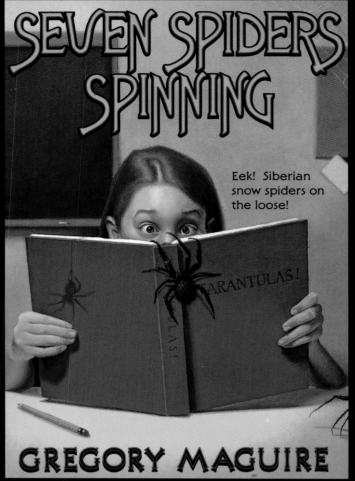

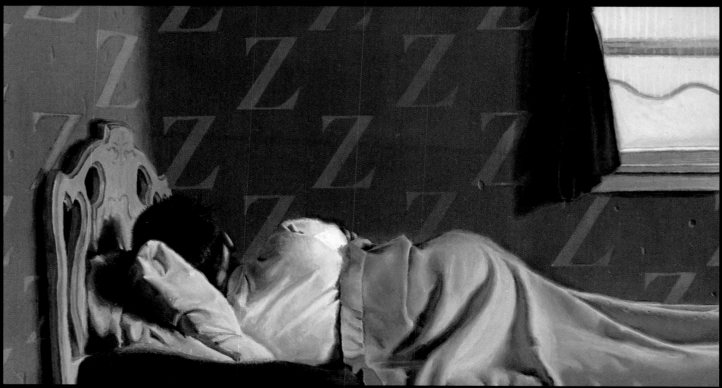

MARK ELLIOTT

SHANNON · ASSOCIATES 327 East 89th Street, Suite 3E • New York, NY 10128-5075 • Tel (212) 831-5650 • Fax (212) 831-62

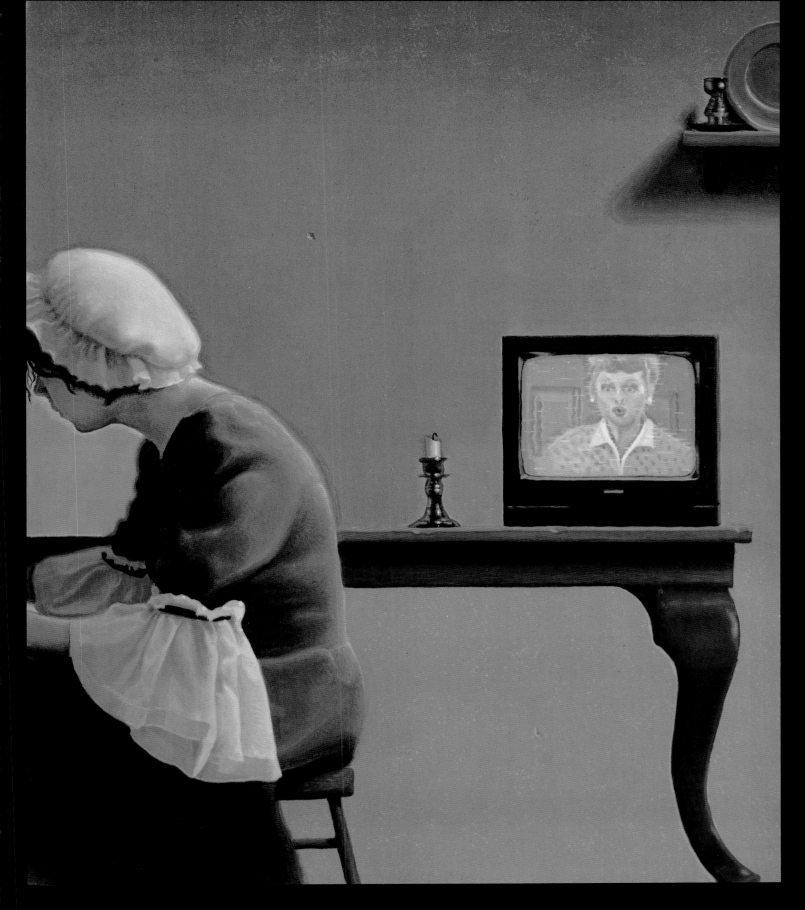

MARK ELLIOTT

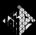

HANNON · ASSOCIATES 327 East 89th Street, Suite 3E • New York, NY 10128-5075 • Tel (212) 831-5650 • Fax (212) 831-6241

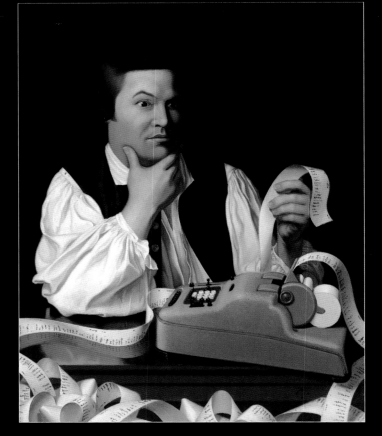

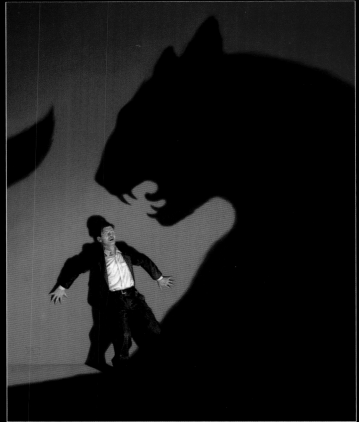

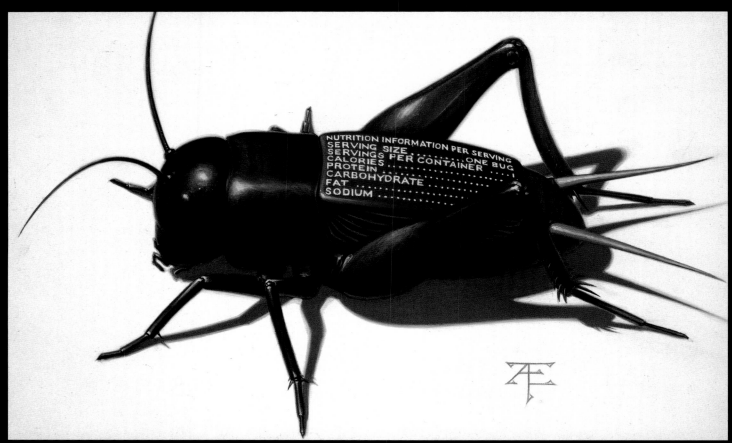

TRISTAN ELWELL

SHANNON · ASSOCIATES 327 East 89th Street, Suite 3E • New York, NY 10128-5075 • Tel (212) 831-5650 • Fax (212) 831-62

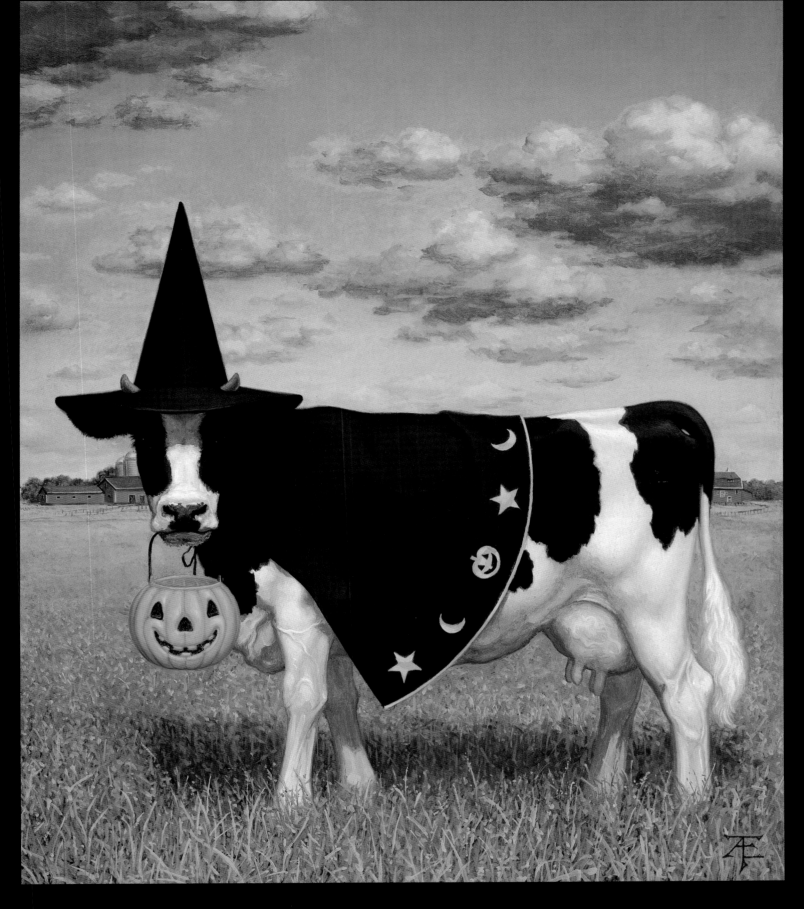

TRISTAN ELWELL

HANNON · ASSOCIATES 327 East 89th Street, Suite 3E • New York, NY 10128-5075 • Tel (212) 831-5650 • Fax (212) 831-6241

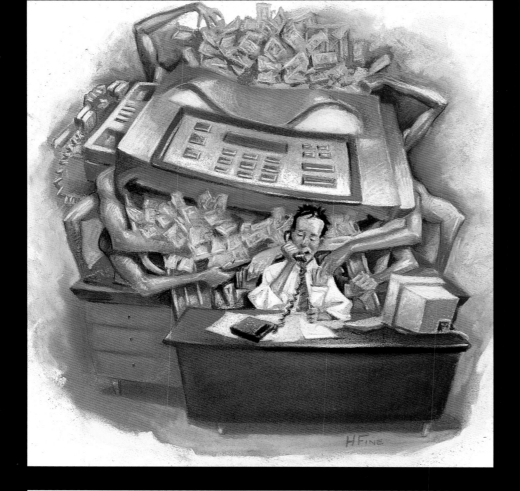

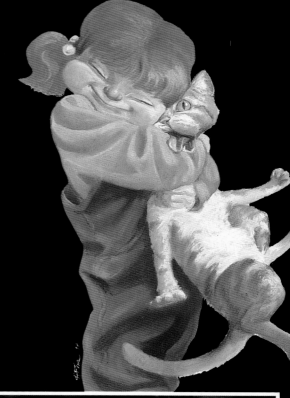

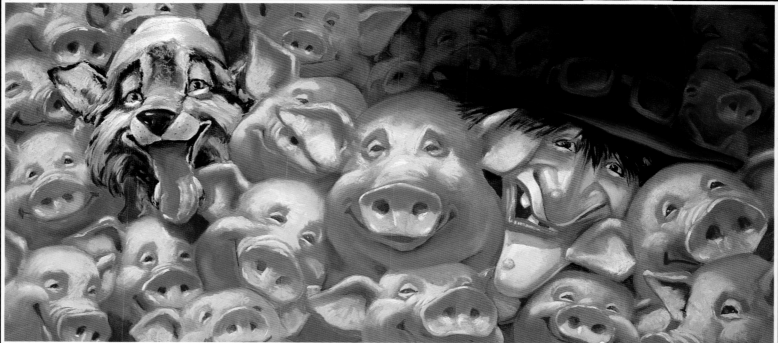

HOWARD FINE

SHANNON · ASSOCIATES 327 East 89th Street, Suite 3E • New York, NY 10128-5075 • Tel (212) 831-5650 • Fax (212) 831-62

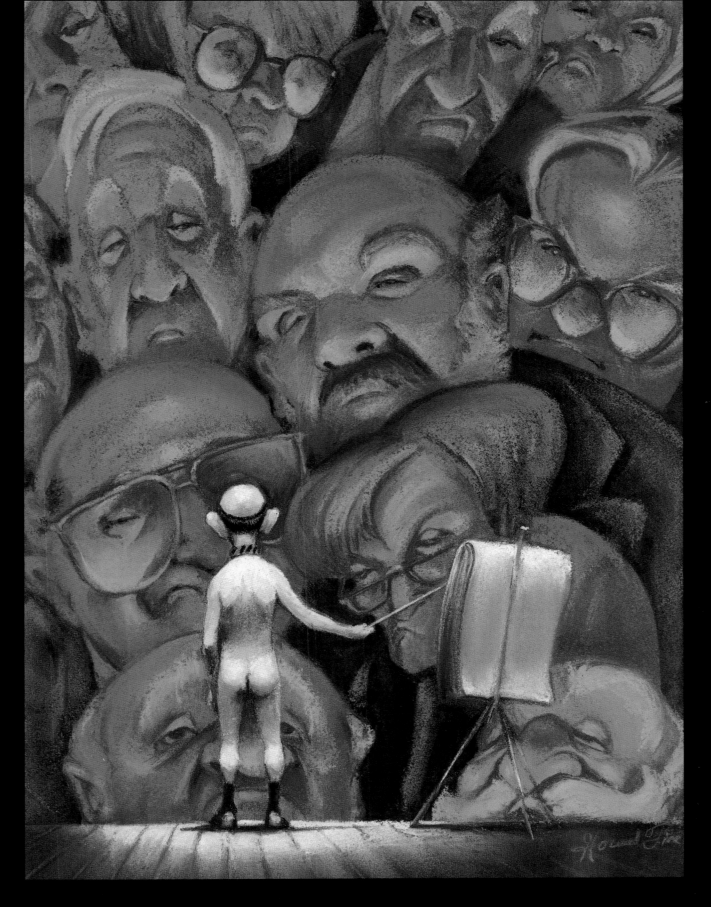

HOWARD FINE

HANNON · ASSOCIATES 327 East 89th Street, Suite 3E • New York, NY 10128-5075 • Tel (212) 831-5650 • Fax (212) 831-6241

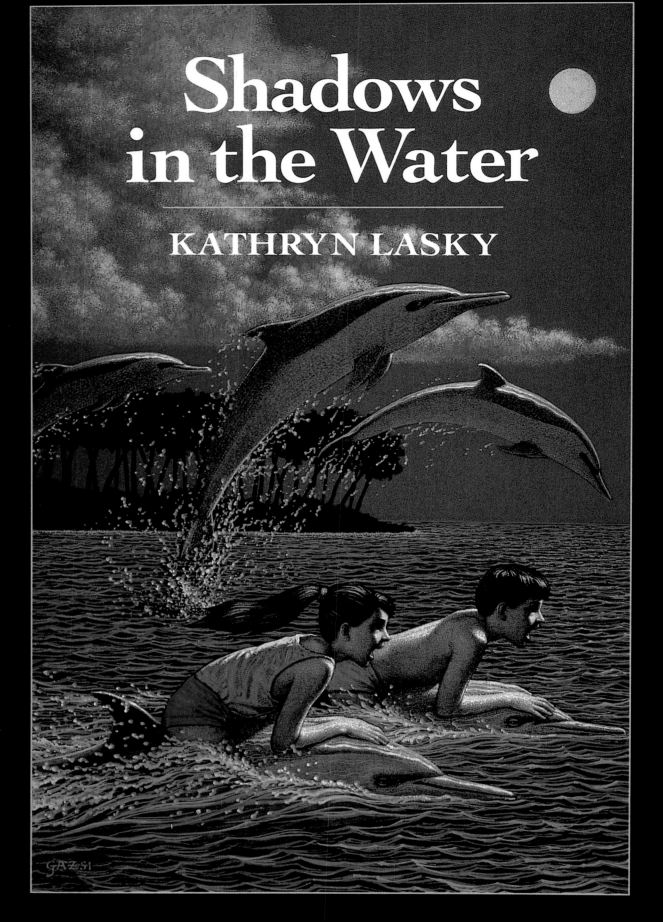

Shadows
in the Water

KATHRYN LASKY

ED GAZSI

SHANNON · ASSOCIATES 327 East 89th Street, Suite 3E • New York, NY 10128-5075 • Tel (212) 831-5650 • Fax (212) 831-62

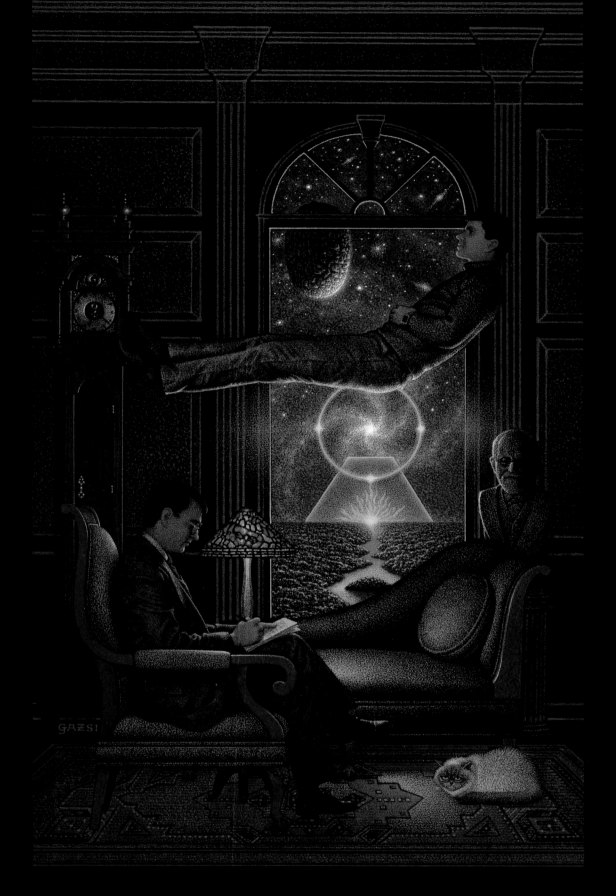

ED GAZSI

HANNON·ASSOCIATES 327 East 89th Street, Suite 3E • New York, NY 10128-5075 • Tel (212) 831-5650 • Fax (212) 831-6241

JANET HAMLIN

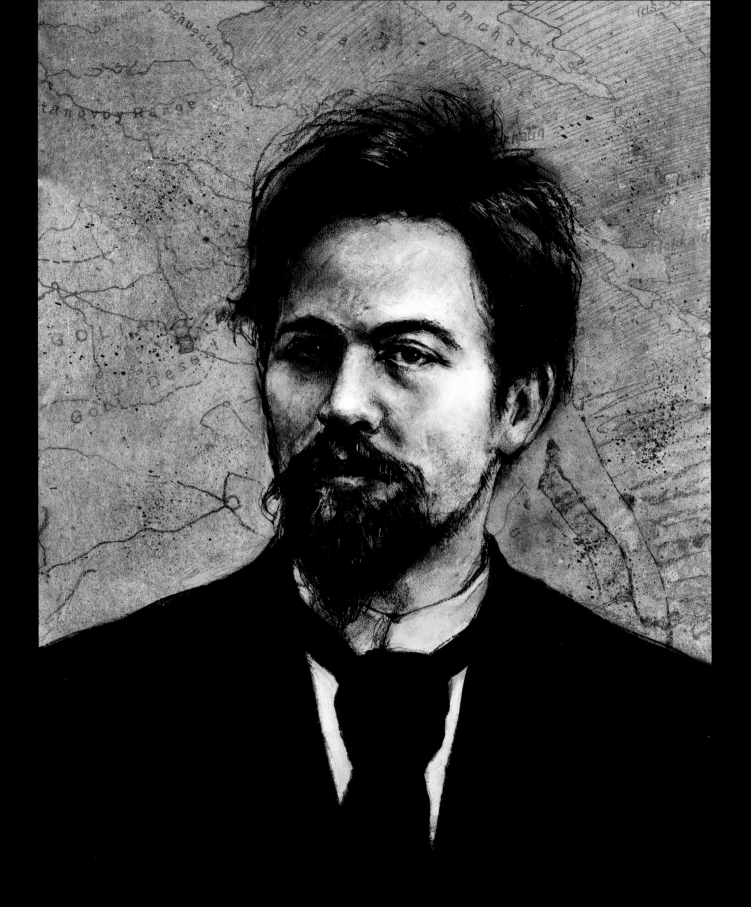

JANET HAMLIN

HANNON·ASSOCIATES 327 East 89th Street, Suite 3E • New York, NY 10128-5075 • Tel (212) 831-5650 • Fax (212) 831-6241

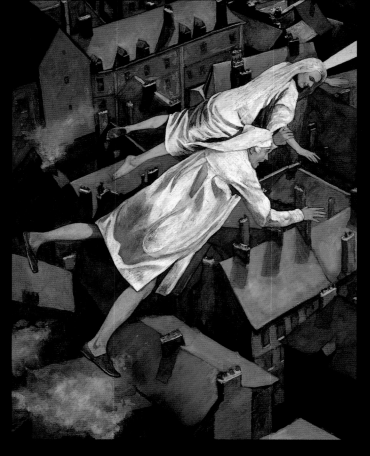
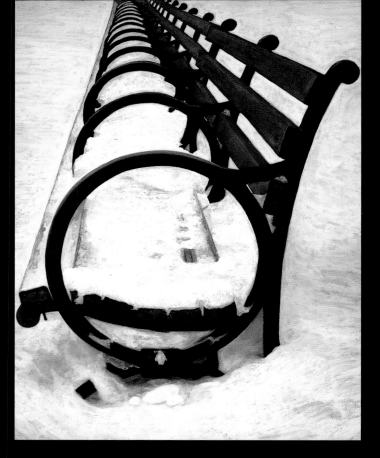
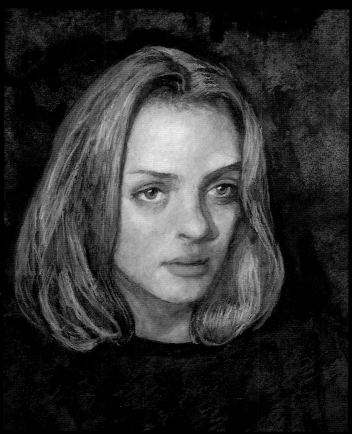
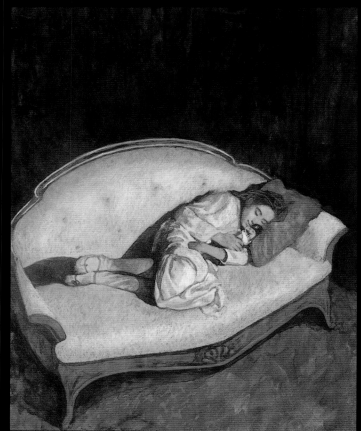

STEPHEN T. JOHNSON

SHANNON · ASSOCIATES 327 East 89th Street, Suite 3E • New York, NY 10128-5075 • Tel (212) 831-5650 • Fax (212) 831-62

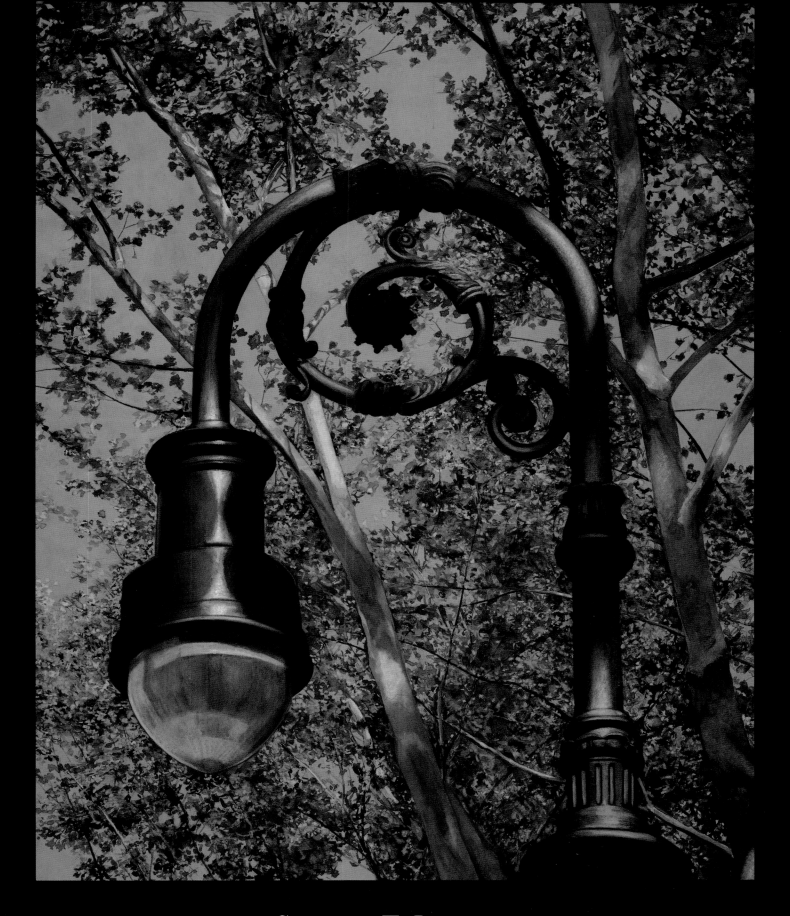

STEPHEN T. JOHNSON

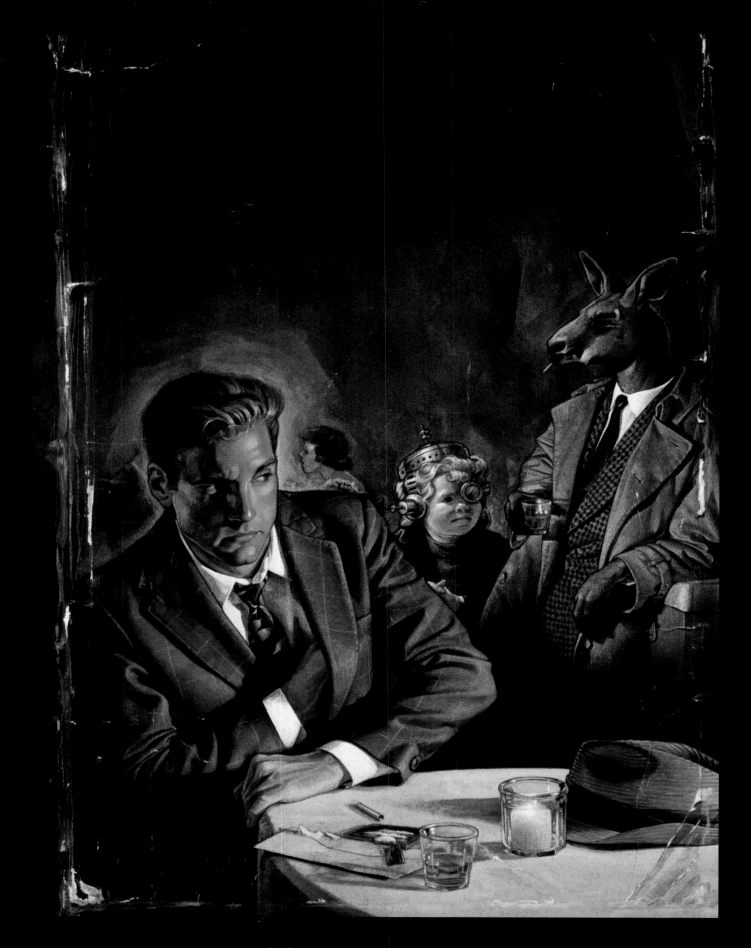

MICHAEL KOELSCH

SHANNON · ASSOCIATES 327 East 89th Street, Suite 3E • New York, NY 10128-5075 • Tel (212) 831-5650 • Fax (212) 831-62

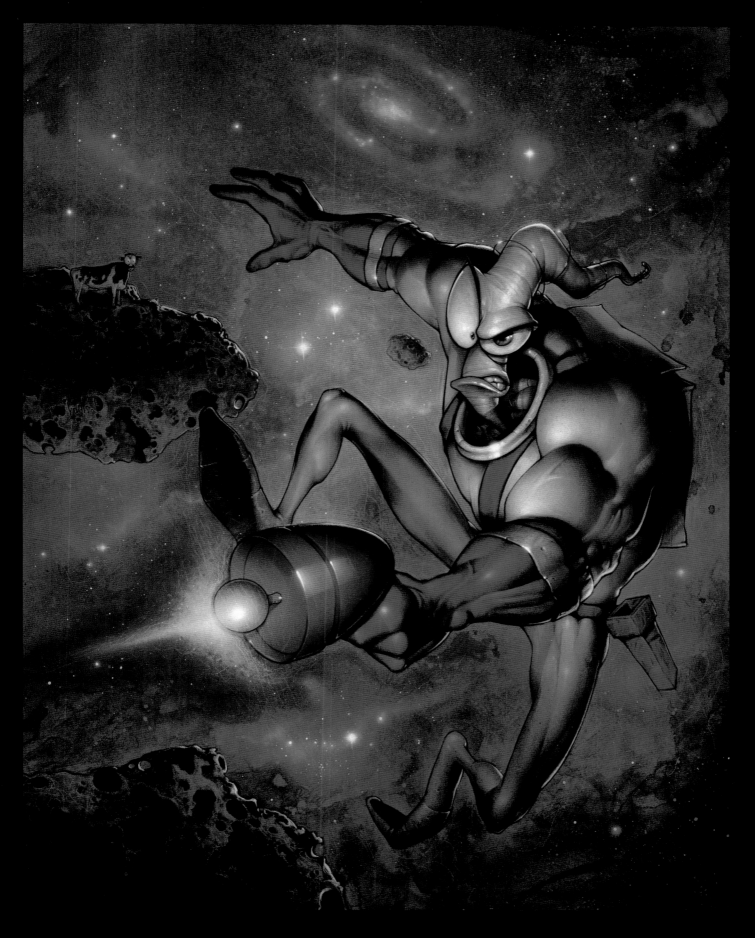

MICHAEL KOELSCH

HANNON · ASSOCIATES 327 East 89th Street, Suite 3E • New York, NY 10128-5075 • Tel (212) 831-5650 • Fax (212) 831-6241

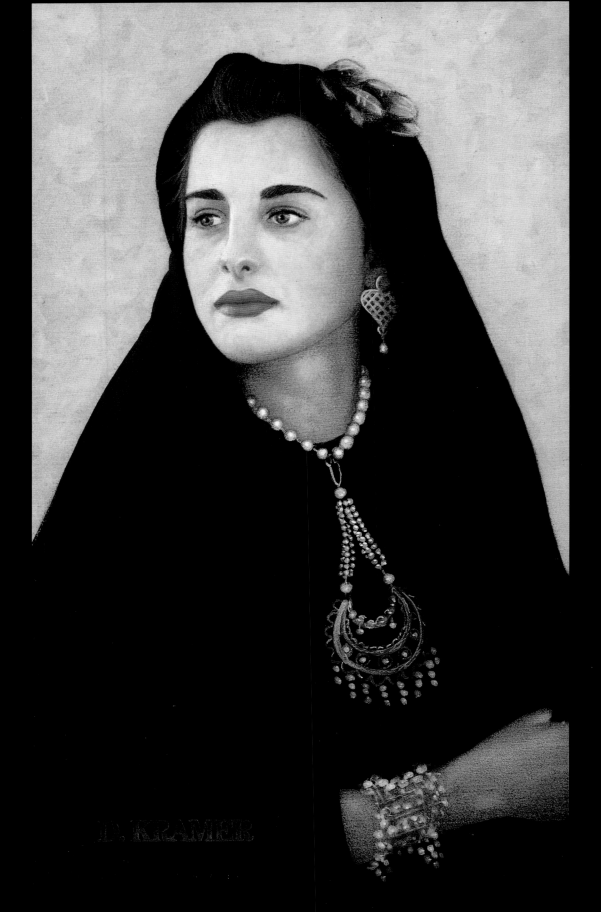

DAVE KRAMER

SHANNON · ASSOCIATES 327 East 89th Street, Suite 3E • New York, NY 10128-5075 • Tel (212) 831-5650 • Fax (212) 831-62

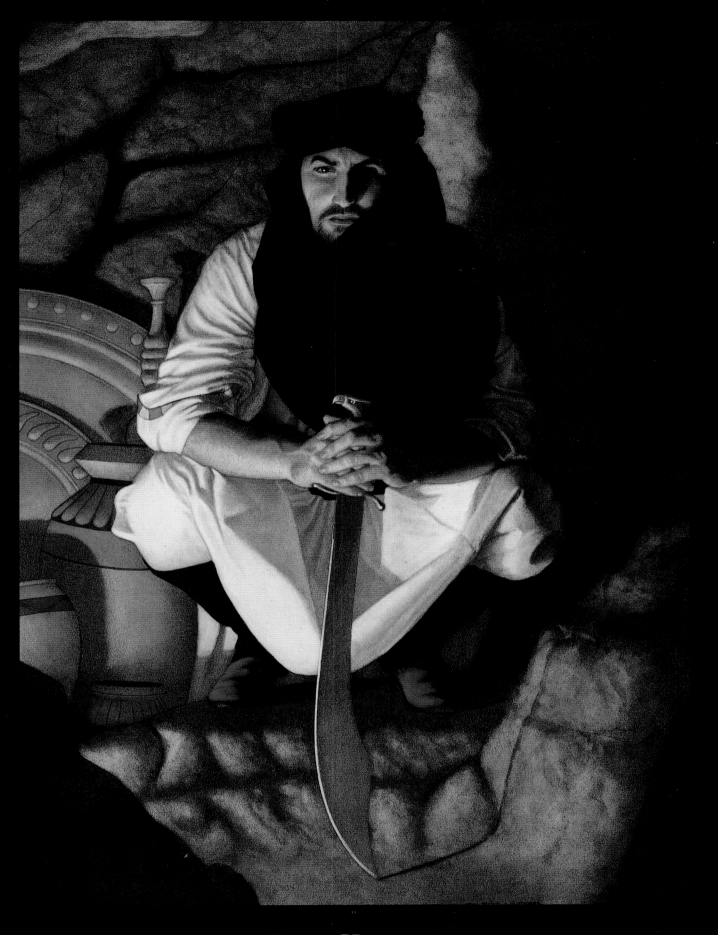

DAVE KRAMER

IANNON · ASSOCIATES 327 East 89th Street, Suite 3E • New York, NY 10128-5075 • Tel (212) 831-5650 • Fax (212) 831-6241

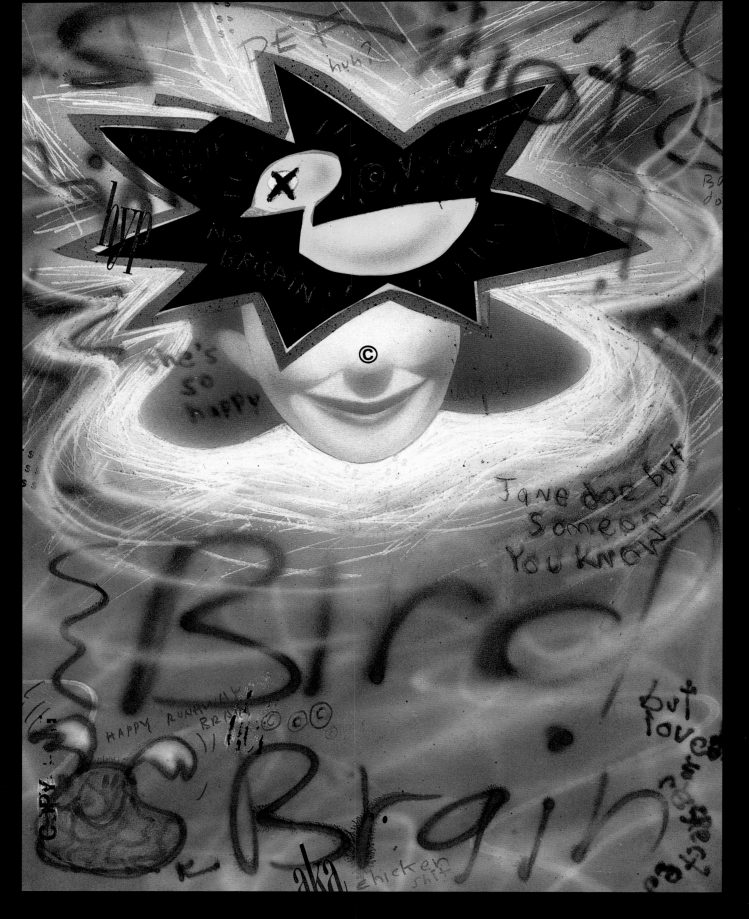

VINCENT LaCava

SHANNON·ASSOCIATES 327 East 89th Street, Suite 3E • New York, NY 10128-5075 • Tel (212) 831-5650 • Fax (212) 831-62

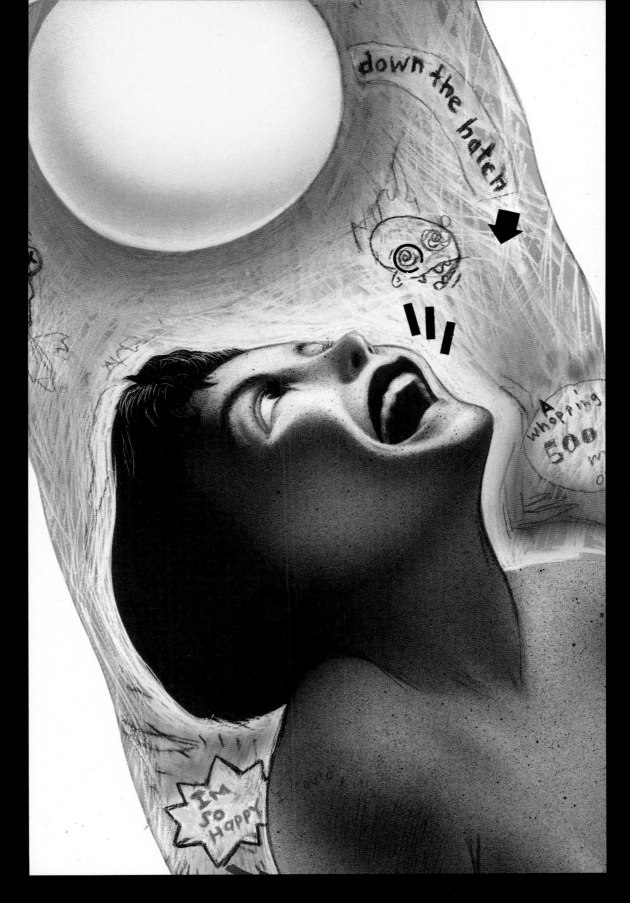

VINCENT LaCava

HANNON · ASSOCIATES 327 East 89th Street, Suite 3E • New York, NY 10128-5075 • Tel (212) 831-5650 • Fax (212) 831-6241

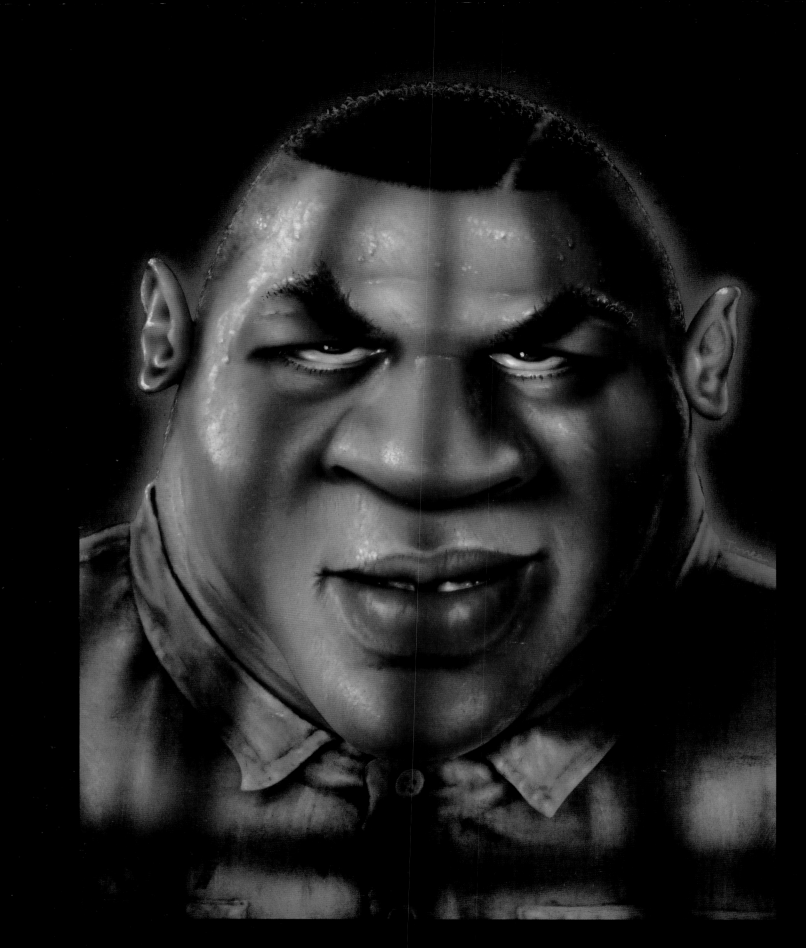

CARLOS TORRES

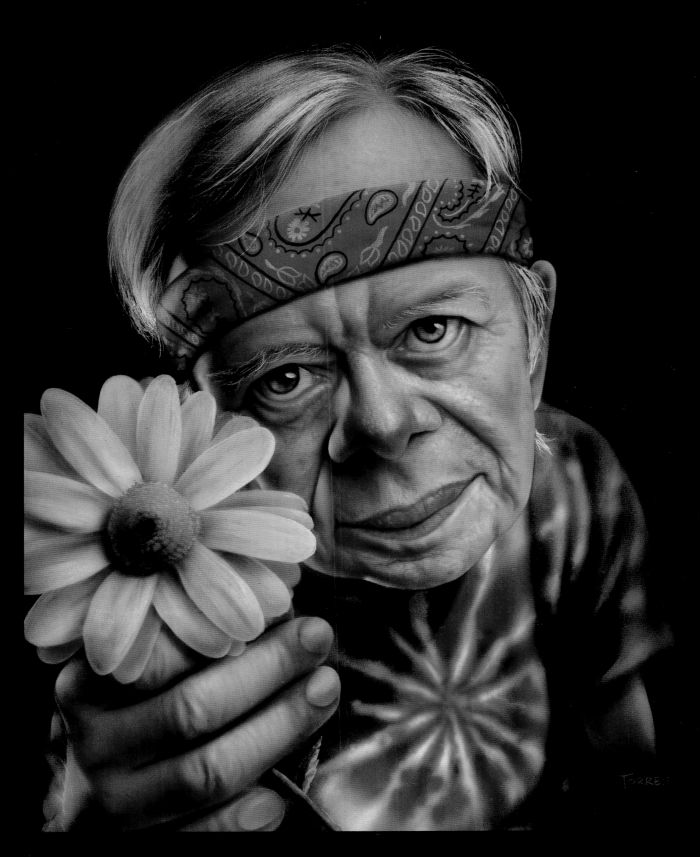

CARLOS TORRES

ANNON · ASSOCIATES 327 East 89th Street, Suite 3E • New York, NY 10128-5075 • Tel (212) 831-5650 • Fax (212) 831-6241

GARY CICCARELLI

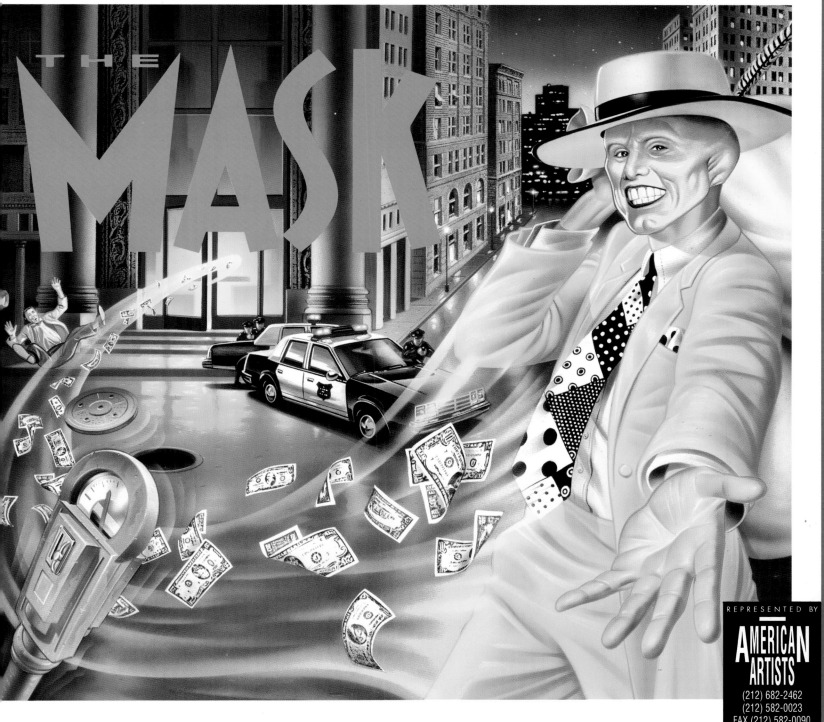

REPRESENTED BY

AMERICAN ARTISTS

(212) 682-2462
(212) 582-0023
FAX (212) 582-0090

BOT RODA

Artwork created in
Adobe Illustrator™

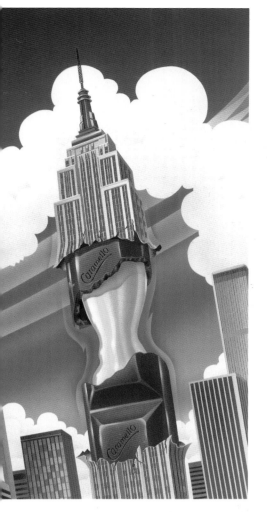

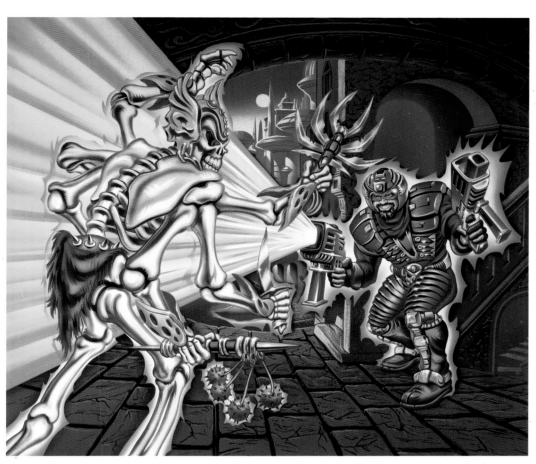

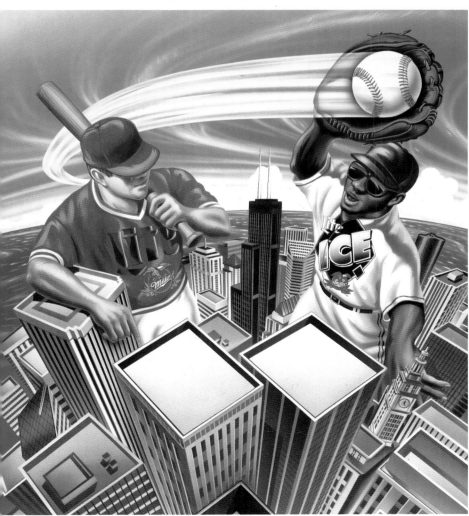

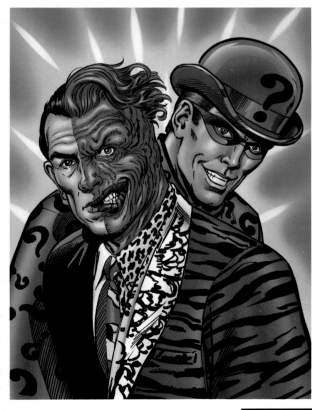

DEPEW STUDIOS

Depew Studios have successfully brought their years of conventional illustration experience into the realm of high resolutions bit mapped painting. So what does this mean for you? Well for starters since these CMYK images were created in Photoshop they are by definition pre press ready, look Mom no scanning. How about E mail up dates of your image in progress. Changes are fast, just a phone call away that's understood, but remember these images are created in a pre press environment. Manipulations that could be difficult if not impossible to do conventionally are handled with ease and by the very artist how has created your painting. Call for a portfolio showing soon.

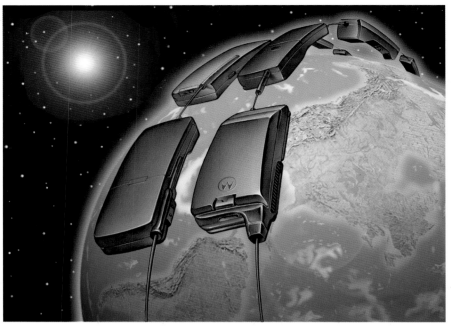

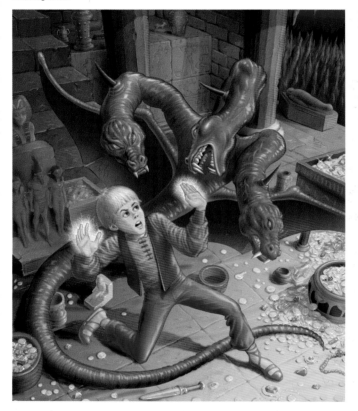

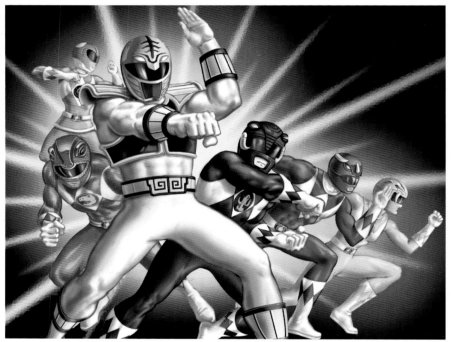

© Disney

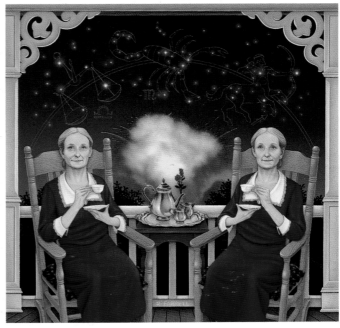

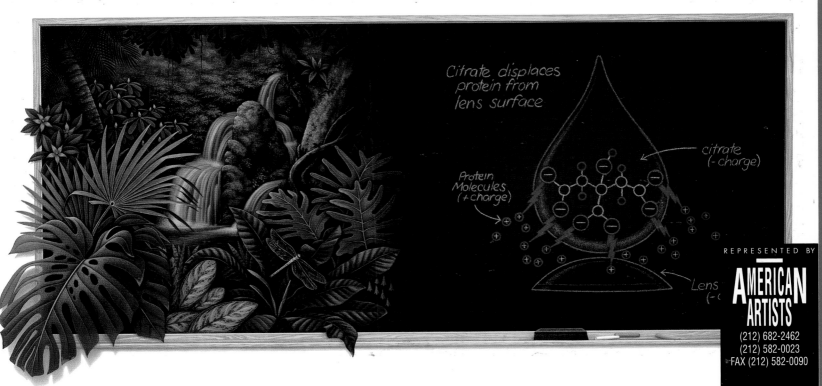

Citrate displaces protein from lens surface

citrate
(– charge)

Protein Molecules
(+charge)

Lens
(–c

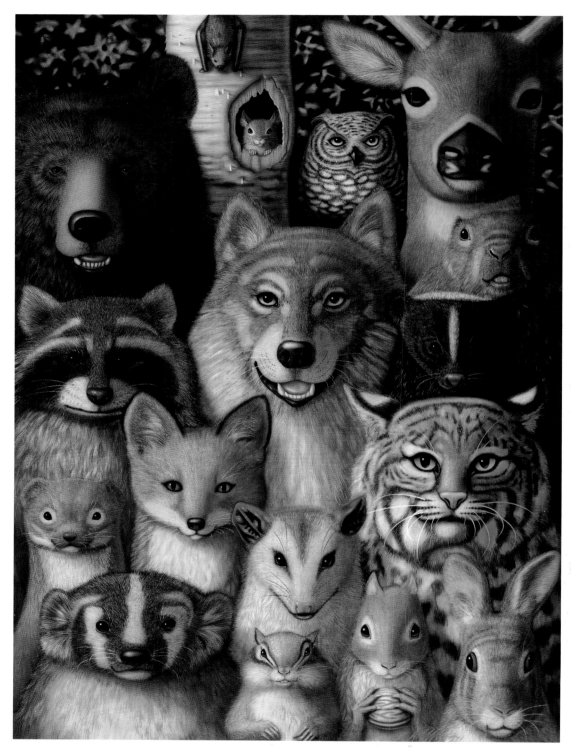

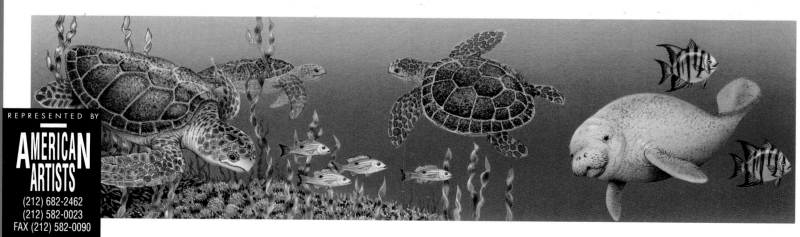

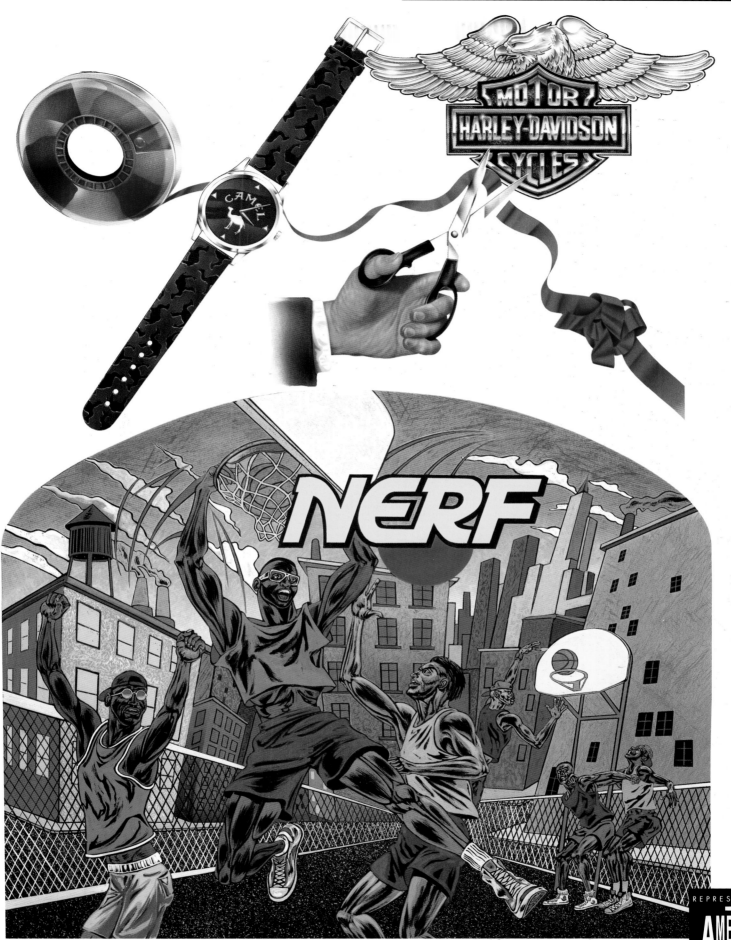

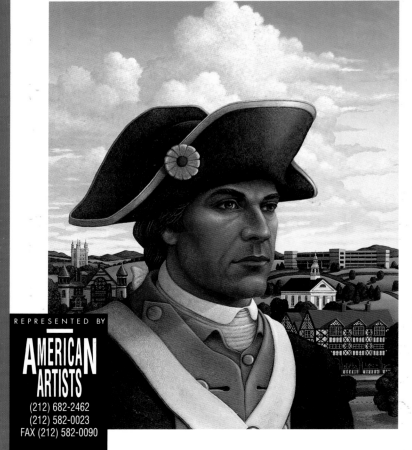

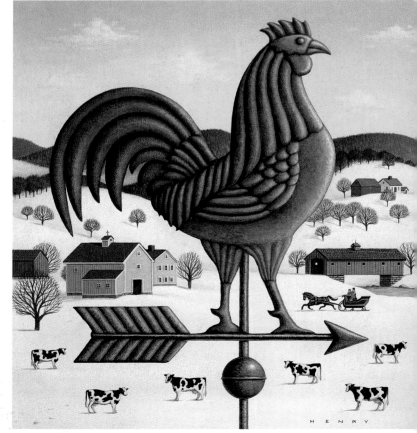

REPRESENTED BY

AMERICAN ARTISTS

(212) 682-2462
(212) 582-0023
FAX (212) 582-0090

RY & COMPANY

4) 296·9666

X 296·1537

Studio:

(310) 432-8122

REPRESENTED BY

AMERICAN ARTISTS

(212) 682-2462
(212) 582-0023
FAX (212) 582-0090

PAMELA HAMILTON

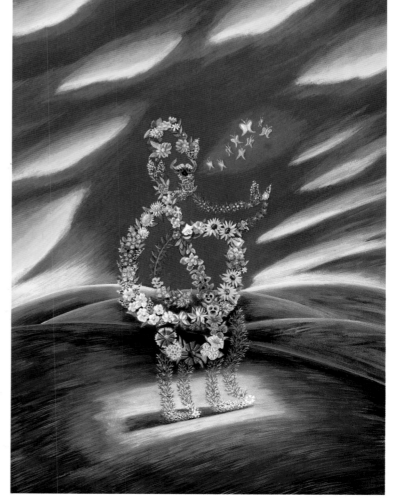

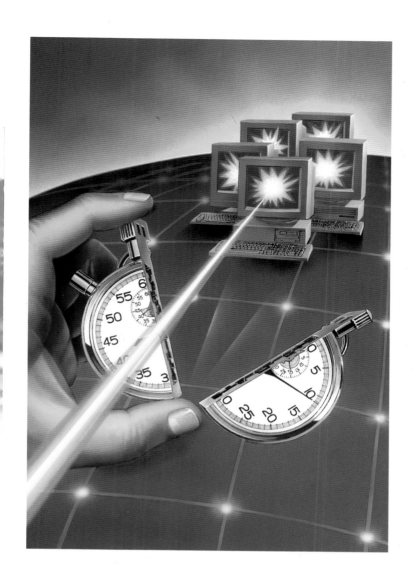

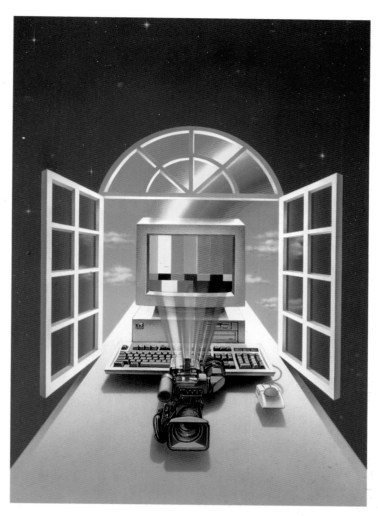

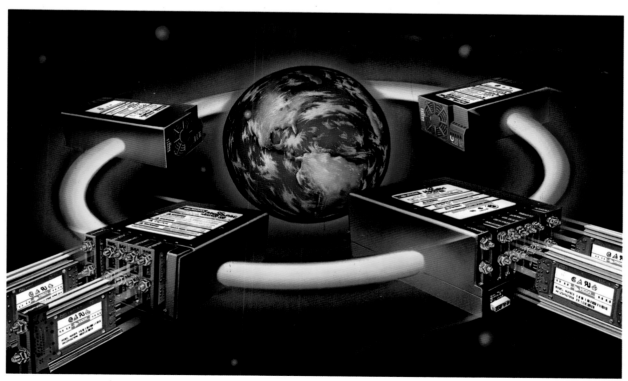

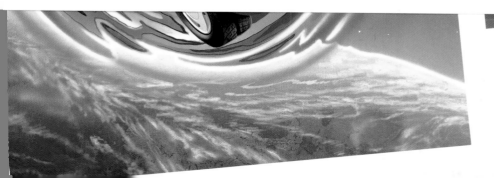

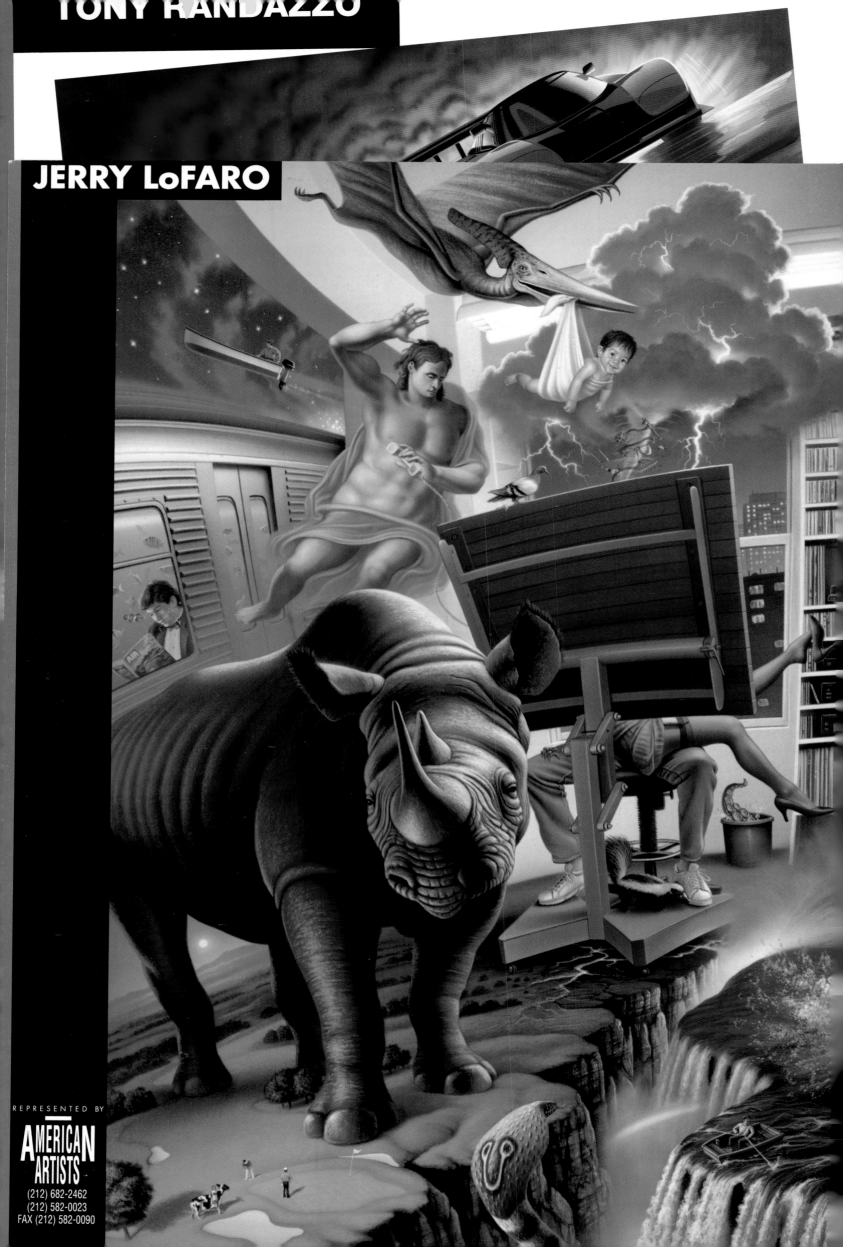

TONY RANDAZZO

JERRY LoFARO

REPRESENTED BY

AMERICAN
ARTISTS

(212) 682-2462
(212) 582-0023
FAX (212) 582-0090

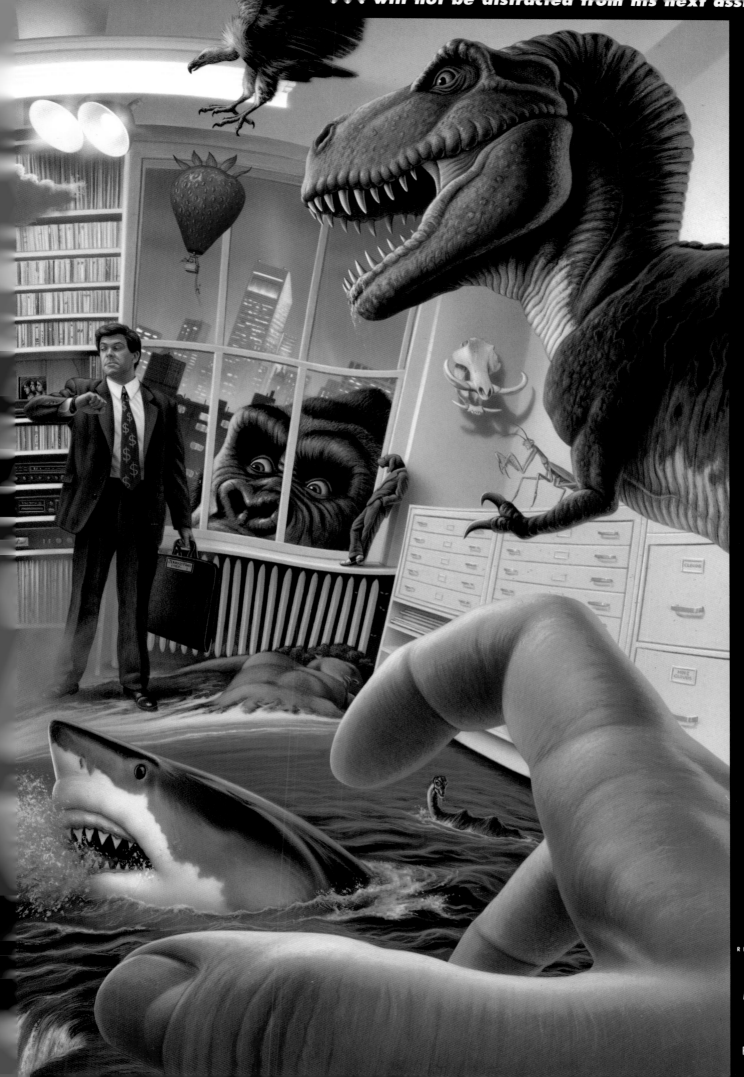

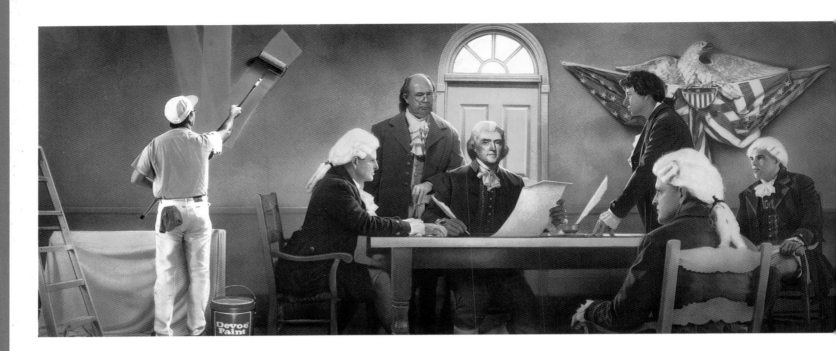

In Chicago Call: Munro/Goodman (312) 321-1336

eddie young

Builds good characters

STUDIO

one:
0) 429-2513

x:
0) 429-1400

NEW YORK:
American Artist
(212) 582-0023

LOS ANGELES:
Carole Newman
(310) 394-5031

© 1995 Fox Kids Video

© 1995 Walt Disney

503

MALCOLM FARLEY

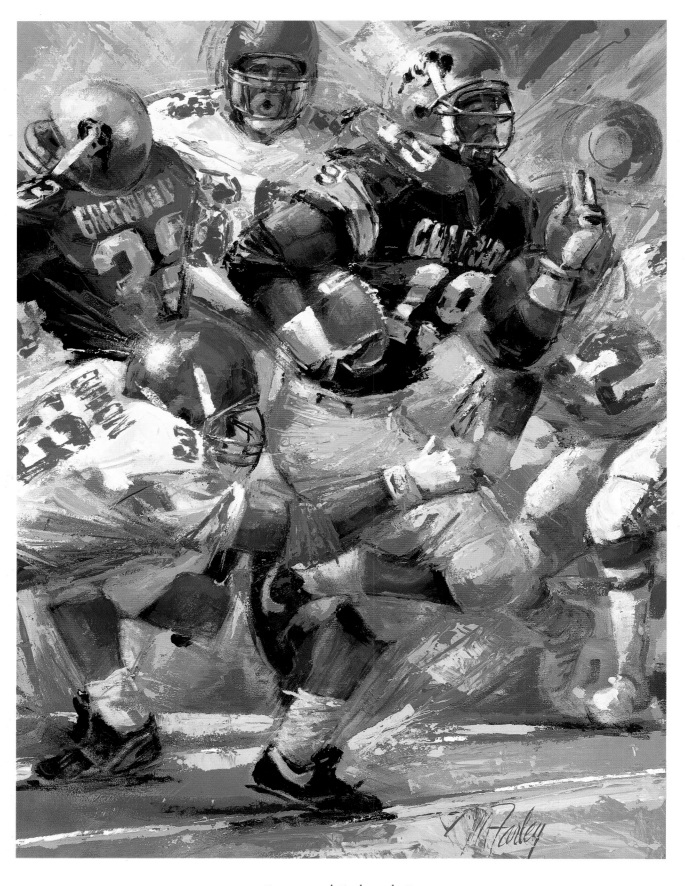

MALCOLM FARLEY

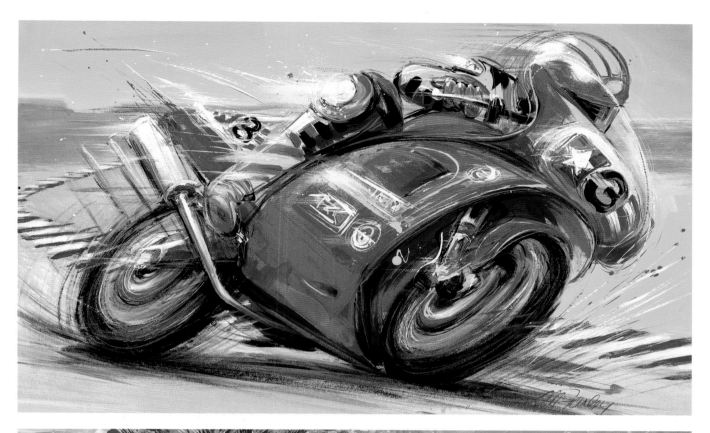

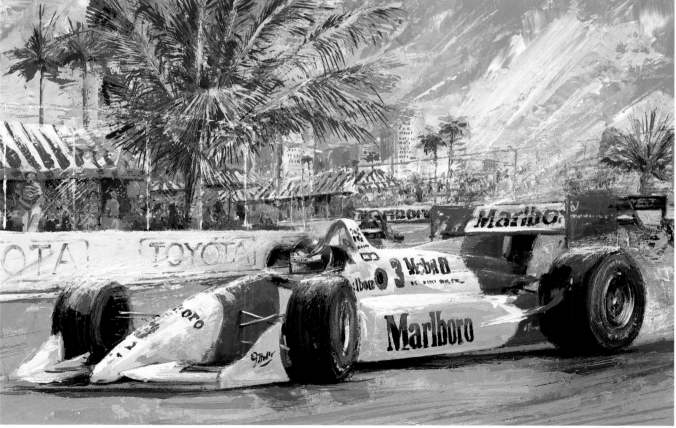

Represented Exclusively By

MALCOLM FARLEY STUDIO

Ph: (303) 420-9135
Fx: (303) 425-5984

CELEBRITY SPORTS INTERNATIONAL, INC.

PH: (702) 873-3333
FX: (702) 873-1664

NEW YORK AMERICAN ARTISTS

Ph: (212) 682-2462
Fx: (212) 582-0090

Official 1996 Olympic Coin Artist

ETHAN SUMMERS ILLUSTRATION

STUDIO TELEPHONE (704) 365-4554

STUDIO FAX (704) 365-9101

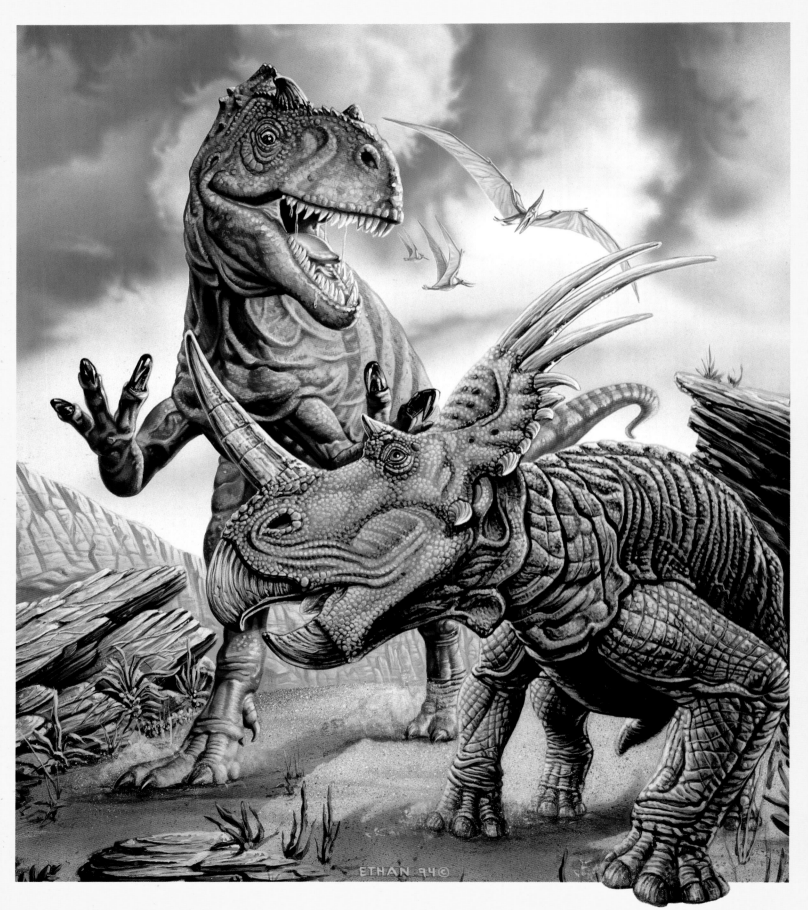

REPRESENTED BY AMERICAN ARTISTS (212) 682-2462 (212) 582-0023

506

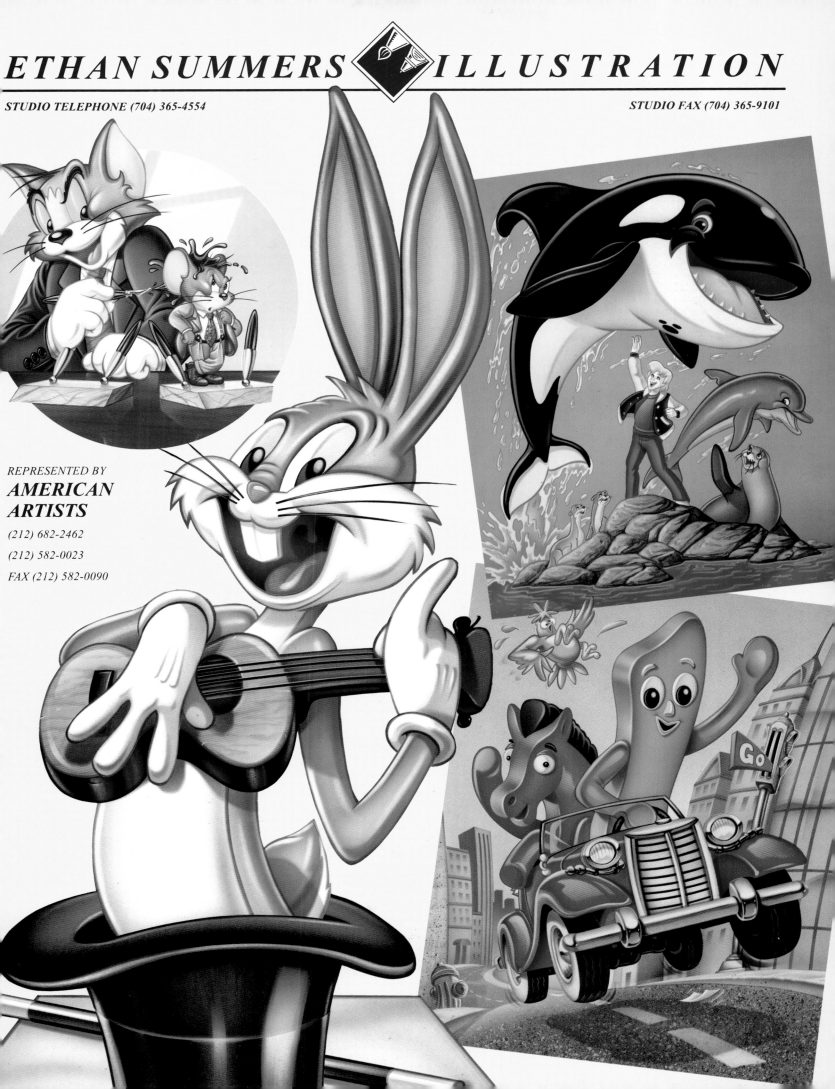

ETHAN SUMMERS ILLUSTRATION

STUDIO TELEPHONE (704) 365-4554

STUDIO FAX (704) 365-9101

REPRESENTED BY

AMERICAN ARTISTS

(212) 682-2462

(212) 582-0023

FAX (212) 582-0090

BRALDT BRALDS

ROY CARRUTHERS

TERESA FASOLINO

ROBERT GIUSTI

ROBERT GOLDSTROM

MARK HESS

JOHN H HOWARD

VICTOR JUHASZ

WILSON McLEAN

SIMMS TABACK

DAVID WILCOX

THE NEWBORN GROUP

REPRESENTATIVE

JOAN SIGMAN

270 PARK AVE SOUTH
SUITE 8E NYC 10010
TEL 212•260•6700
FAX 212•260•9600

ROY CARRUTHERS

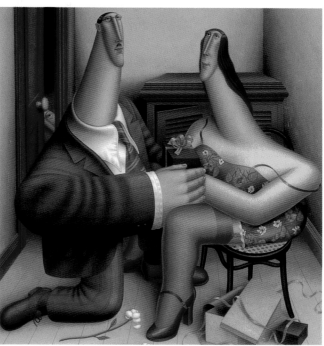

THE NEWBORN GROUP

REPRESENTATIVE

JOAN SIGMAN

270 PARK AVE SOUTH
SUITE 8E NYC 10010
TEL 212•260•6700
FAX 212•260•9600

JOHN H HOWARD

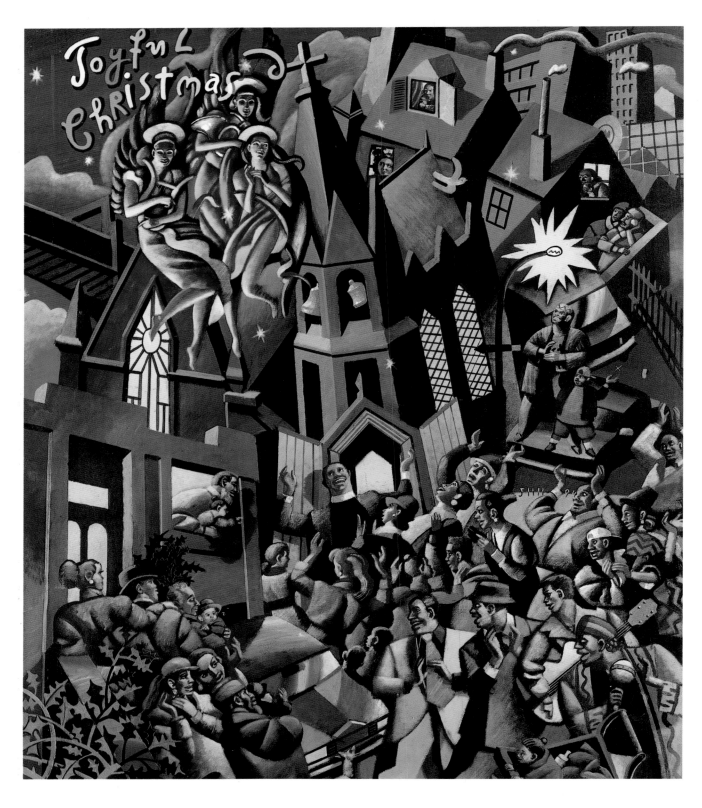

THE NEWBORN GROUP

REPRESENTATIVE

JOAN SIGMAN

270 PARK AVE SOUTH
SUITE 8E NYC 10010
TEL 212•260•6700
FAX 212•260•9600

JOHN H HOWARD

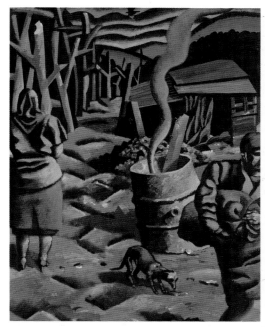

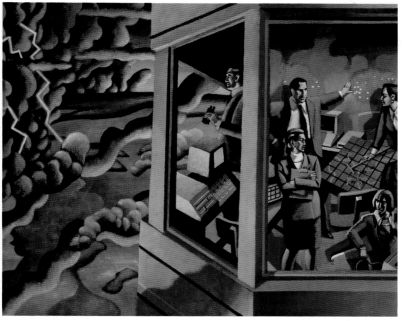

THE NEWBORN GROUP

REPRESENTATIVE

JOAN SIGMAN

270 PARK AVE SOUTH
SUITE 8E NYC 10010
TEL 212·260·6700
FAX 212·260·9600

ROBERT GOLDSTROM

THE NEWBORN GROUP

REPRESENTATIVE

JOAN SIGMAN

270 PARK AVE SOUTH
SUITE 8E NYC 10010
TEL 212•260•6700
FAX 212•260•9600

ROBERT GOLDSTROM

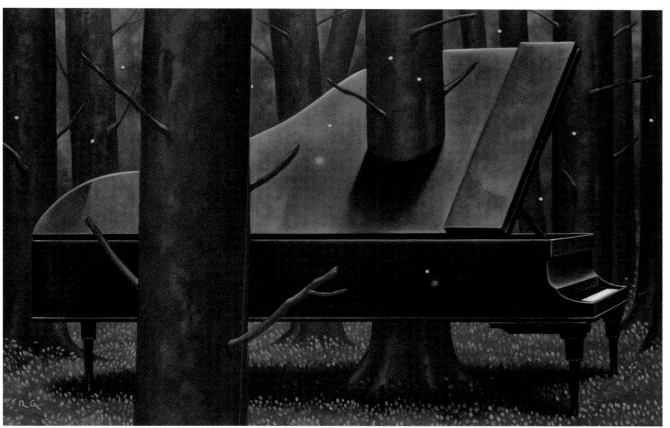

THE NEWBORN GROUP

REPRESENTATIVE

JOAN SIGMAN

270 PARK AVE SOUTH
SUITE 8E NYC 10010
TEL 212·260·6700
FAX 212·260·9600

513

DAVID WILCOX

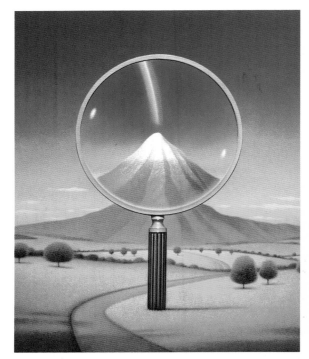

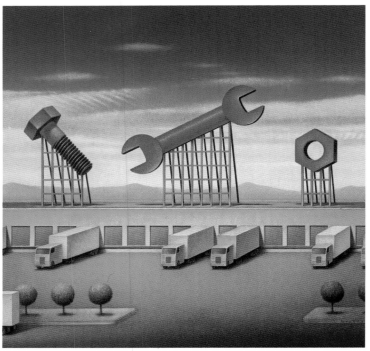

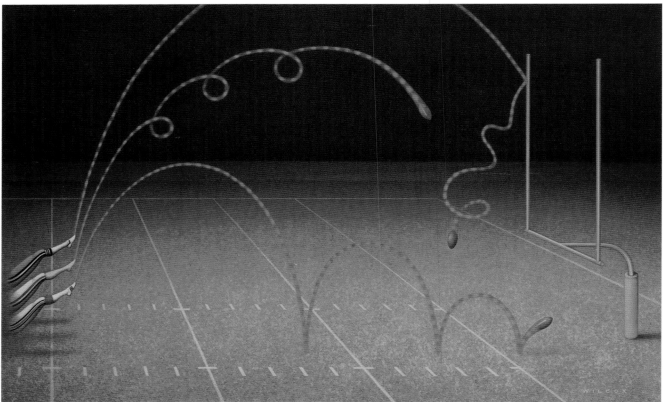

THE NEWBORN GROUP

REPRESENTATIVE

JOAN SIGMAN

270 PARK AVE SOUTH
SUITE 8E NYC 10010
TEL 212•260•6700
FAX 212•260•9600

DAVID WILCOX

THE NEWBORN GROUP

REPRESENTATIVE

JOAN SIGMAN

270 PARK AVE SOUTH
SUITE 8E NYC 10010
TEL 212•260•6700
FAX 212•260•9600

TERESA FASOLINO

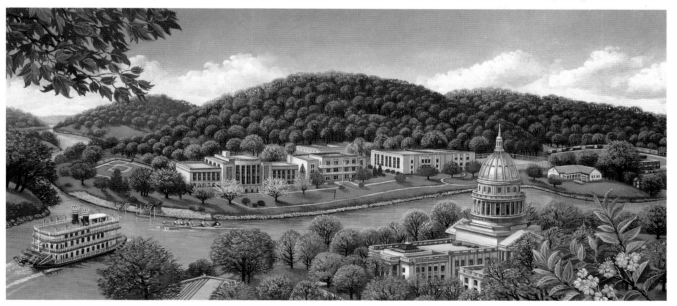

THE NEWBORN GROUP

REPRESENTATIVE

JOAN SIGMAN

270 PARK AVE SOUTH
SUITE 8E NYC 10010
TEL 212·260·6700
FAX 212·260·9600

WILSON McLEAN

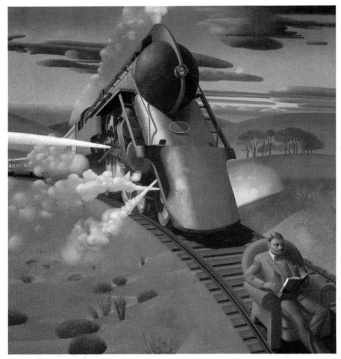
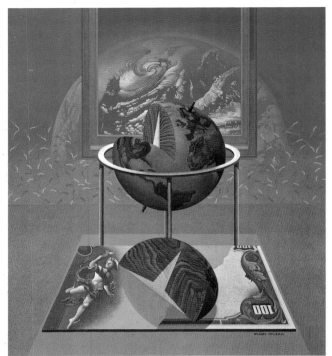
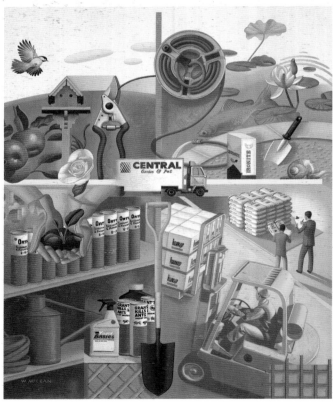
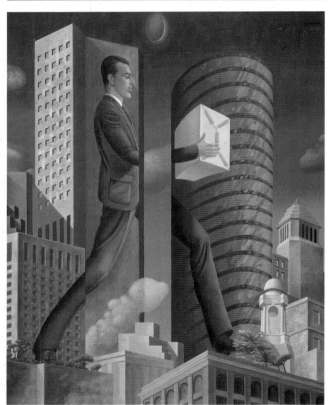

THE NEWBORN GROUP

REPRESENTATIVE

JOAN SIGMAN

270 PARK AVE SOUTH
SUITE 8E NYC 10010
TEL 212·260·6700
FAX 212·260·9600

WILSON McLEAN

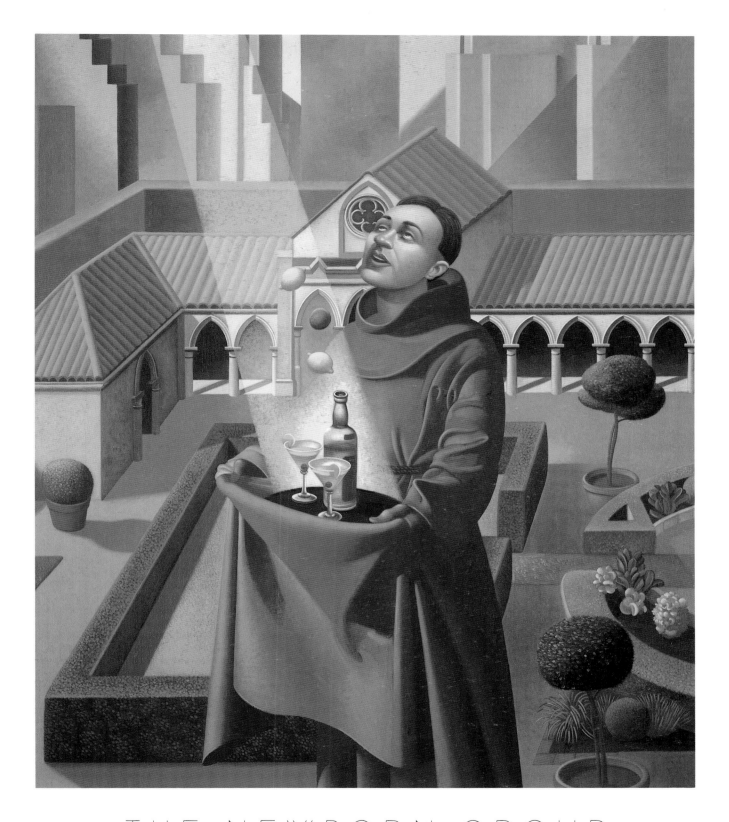

THE NEWBORN GROUP

REPRESENTATIVE

JOAN SIGMAN

270 PARK AVE SOUTH
SUITE 8E NYC 10010
TEL 212·260·6700
FAX 212·260·9600

THE NEWBORN GROUP

REPRESENTATIVE

JOAN SIGMAN

270 PARK AVE SOUTH
SUITE 8E NYC 10010
TEL 212·260·6700
FAX 212·260·9600

VICTOR JUHASZ

THE NEWBORN GROUP

REPRESENTATIVE
JOAN SIGMAN
270 PARK AVE SOUTH
SUITE 8E NYC 10010
TEL 212·260·6700
FAX 212·260·9600

ROBERT GIUSTI

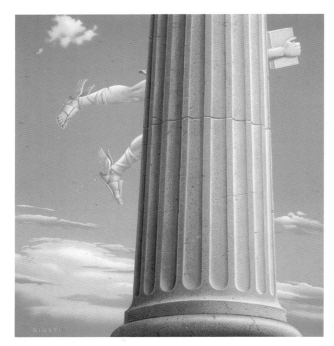
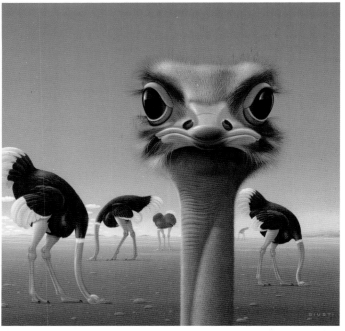
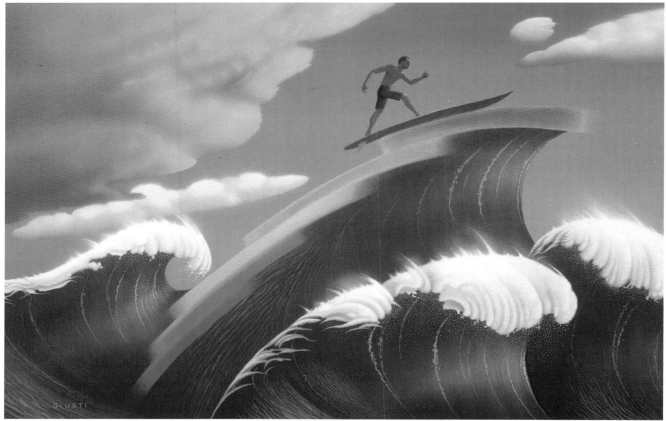

THE NEWBORN GROUP

REPRESENTATIVE

JOAN SIGMAN

270 PARK AVE SOUTH
SUITE 8E NYC 10010
TEL 212•260•6700
FAX 212•260•9600

ROBERT GIUSTI

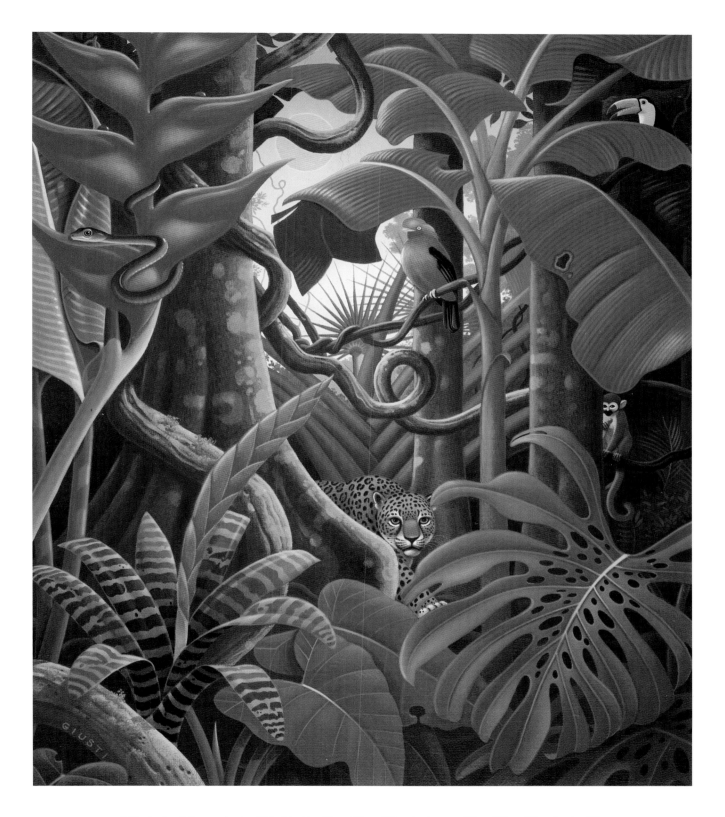

GIUSTI

THE NEWBORN GROUP

REPRESENTATIVE

JOAN SIGMAN

270 PARK AVE SOUTH
SUITE 8E NYC 10010
TEL 212·260·6700
FAX 212·260·9600

MARK HESS

THE NEWBORN GROUP

REPRESENTATIVE

JOAN SIGMAN

270 PARK AVE SOUTH
SUITE 8E NYC 10010
TEL 212·260·6700
FAX 212·260·9600

MARK HESS

MOBIL MASTERPIECE THEATRE PRESENTS

DANDELION
DEAD

Could He Blow Them Away?

Mobil

THE NEWBORN GROUP

REPRESENTATIVE

JOAN SIGMAN

270 PARK AVE SOUTH
SUITE 8E NYC 10010
TEL 212·260·6700
FAX 212·260·9600

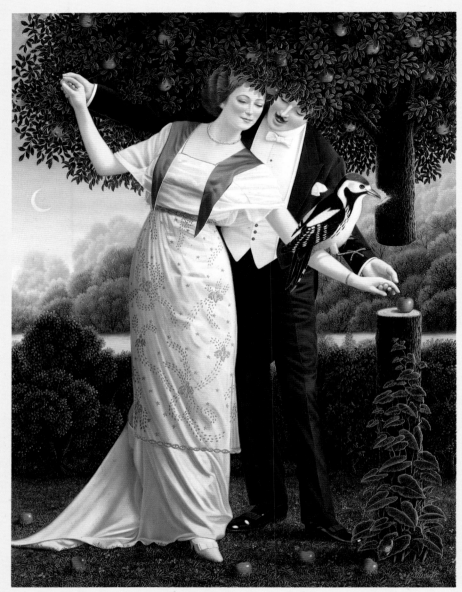

Gervasio Gallardo

L A V A T Y

(212) 427-5632

L

FRANK & JEFF LAVATY

(212) 427-5632 Fax: (212) 427-6372
Associates:
Steven Kenny & Ebba Lavaty

Representing
NEAL HUGHES

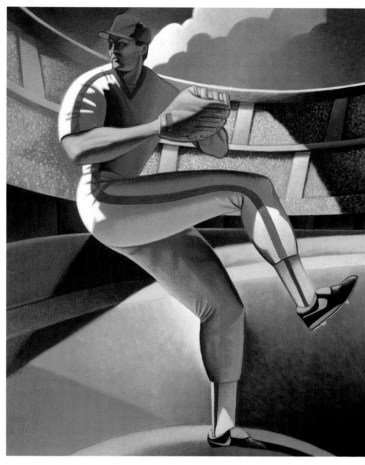

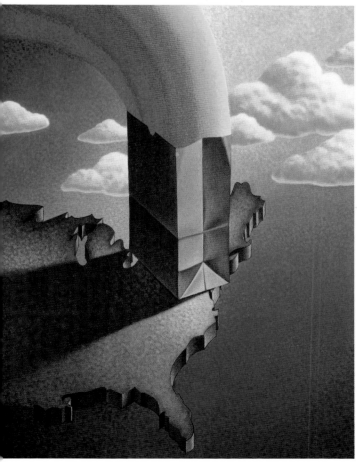

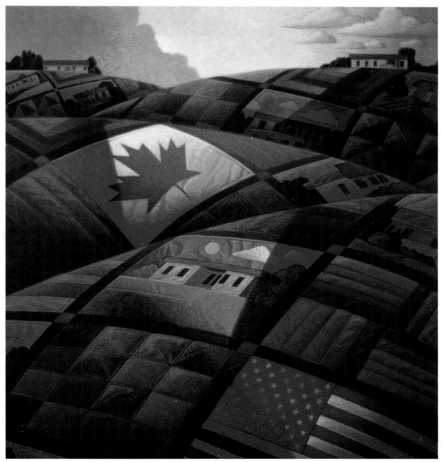

L

FRANK & JEFF LAVATY
(212) 427-5632 Fax: (212) 427-6372
Associates:
Steven Kenny & Ebba Lavaty

Representing
BEN VERKAAIK

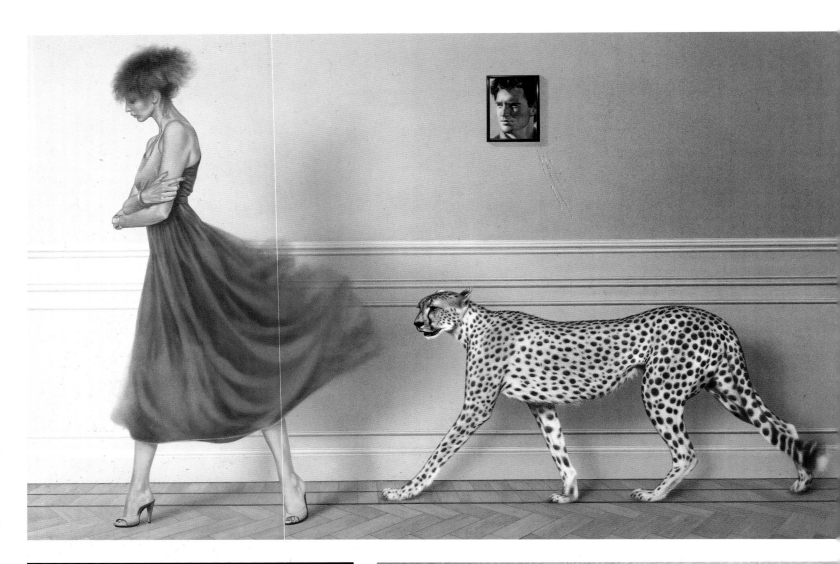

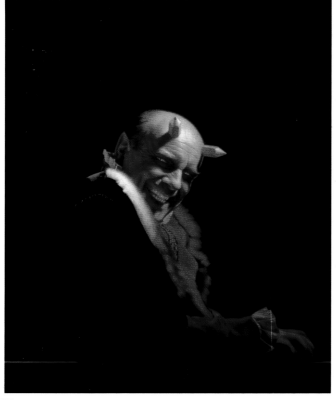

L

FRANK & JEFF LAVATY

(212) 427-5632 Fax: (212) 427-6372
Associates:
Steven Kenny & Ebba Lavaty

Representing
BEN VERKAAIK

FRANK & JEFF LAVATY
(212) 427-5632 Fax: (212) 427-6372
Associates:
Steven Kenny & Ebba Lavaty

Representing
CHRIS DUKE

Inga playing flute

chris Duke

530

L

FRANK & JEFF LAVATY
(212) 427-5632 Fax: (212) 427-6372
Associates:
Steven Kenny & Ebba Lavaty

Representing

CHRIS DUKE

L

FRANK & JEFF LAVATY
(212) 427-5632 Fax: (212) 427-6372
Associates:
Steven Kenny & Ebba Lavaty

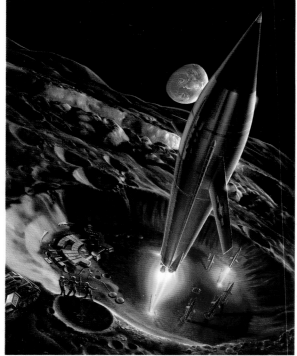

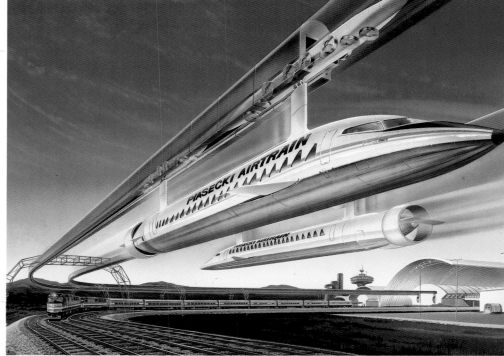

L

fRANK & JEff LAVATY
(212) 427-5632 Fax: (212) 427-6372
Associates:
Steven Kenny & Ebba Lavaty

Representing
CARLOS OCHAGAVIA

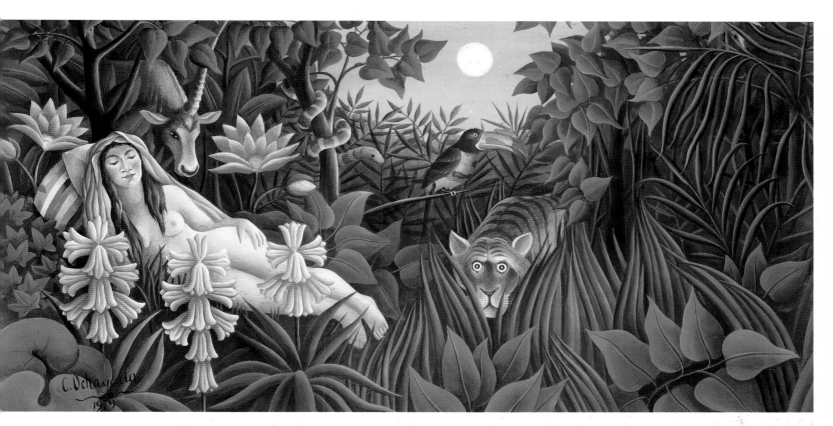

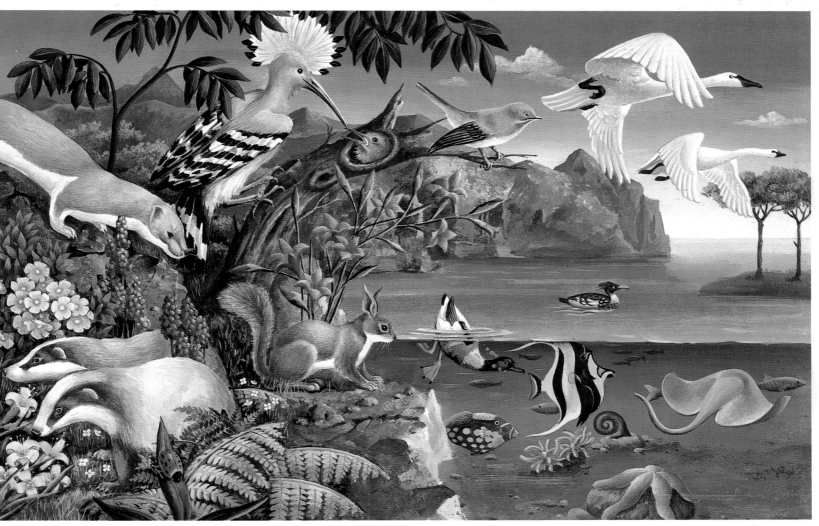

L

FRANK & JEFF LAVATY
(212) 427-5632 Fax: (212) 427-6372
Associates:
Steven Kenny & Ebba Lavaty

Representing
LORI ANZALONE

FRANK & JEFF LAVATY
(212) 427-5632 Fax: (212) 427-6372
Associates:
Steven Kenny & Ebba Lavaty

Representing
LORI ANZALONE

L

FRANK & JEFF LAVATY
(212) 427-5632 Fax: (212) 427-6372
Associates:
Steven Kenny & Ebba Lavaty

Representing
DAVID CHEN

L

FRANK & JEFF LAVATY
(212) 427-5632 Fax: (212) 427-6372
Associates:
Steven Kenny & Ebba Lavaty

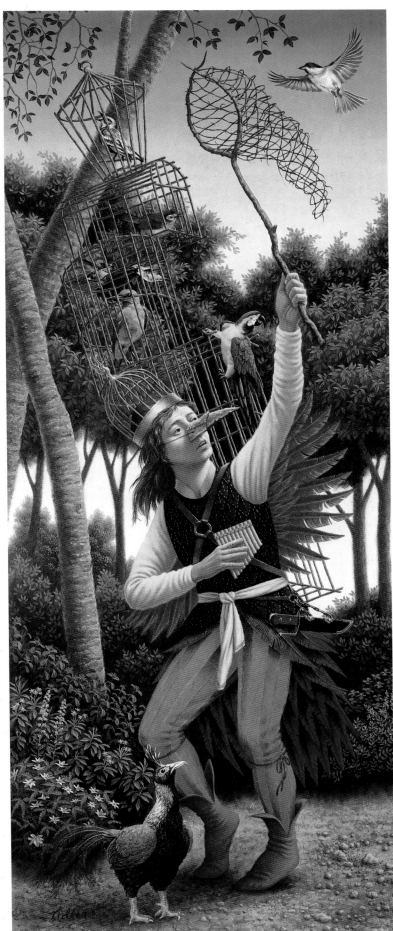

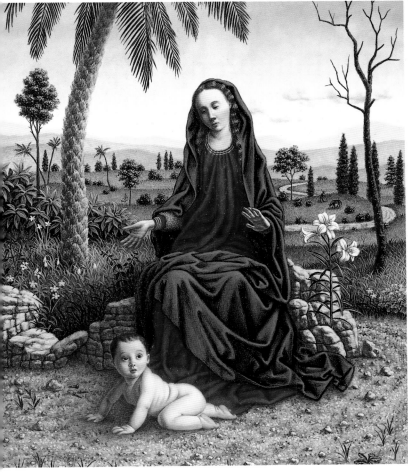

L

FRANK & JEFF LAVATY
(212) 427-5632 Fax: (212) 427-6372
Associates:
Steven Kenny & Ebba Lavaty

Representing
ROBERT LOGRIPPO

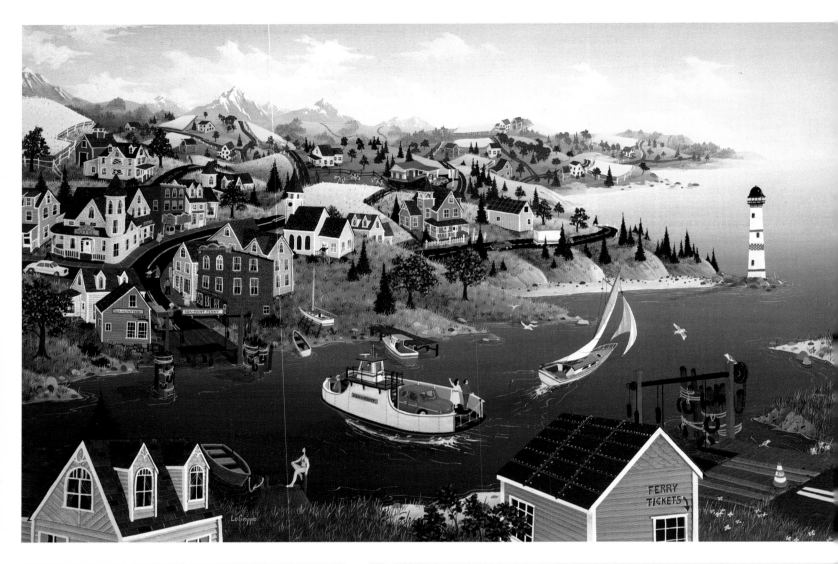

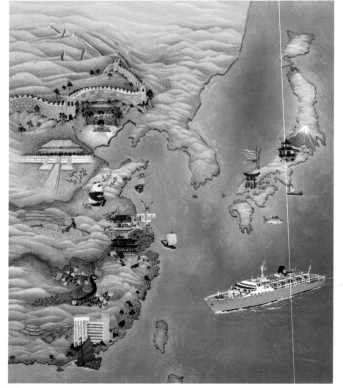

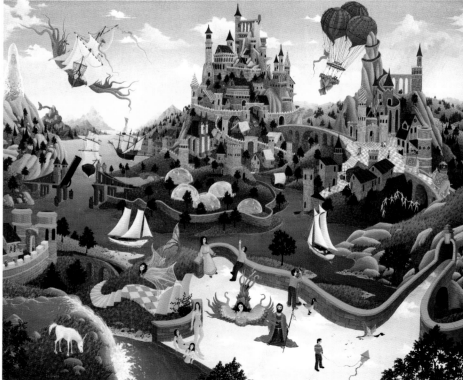

FRANK & JEFF LAVATY

(212) 427-5632 Fax: (212) 427-6372
Associates:
Steven Kenny & Ebba Lavaty

Representing
P E T E R S C A N L A N

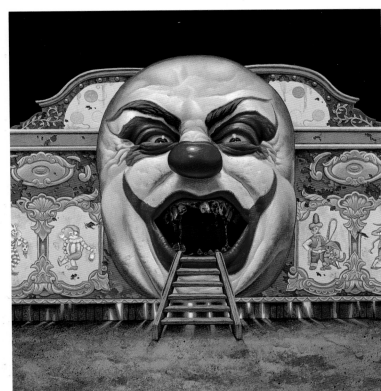

L
FRANK & JEFF LAVATY
(212) 427-5632 Fax: (212) 427-6372
Associates:
Steven Kenny & Ebba Lavaty

Representing
S T A N H U N T E R

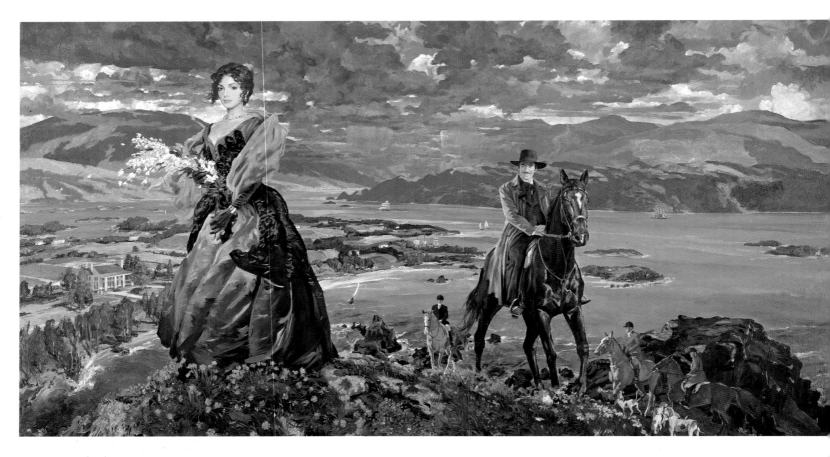

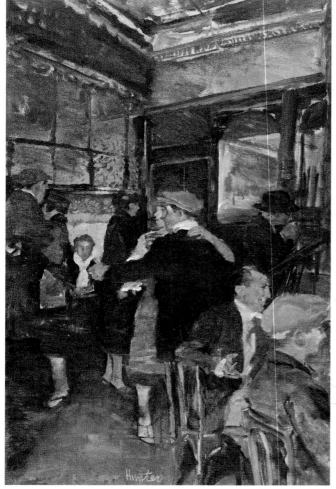

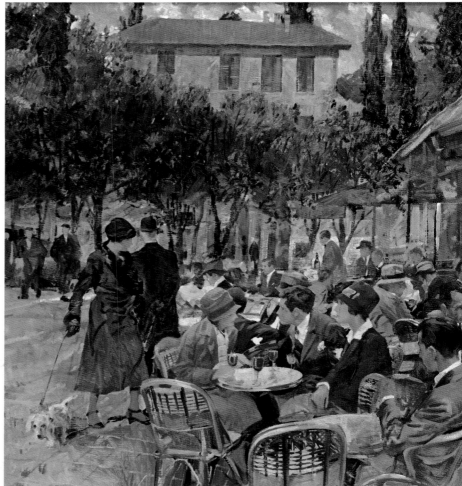

L

FRANK & JEFF LAVATY
(212) 427-5632 Fax: (212) 427-6372
Associates:
Steven Kenny & Ebba Lavaty

Representing

R I C H A R D C . B A E H R ,
A . I . A .

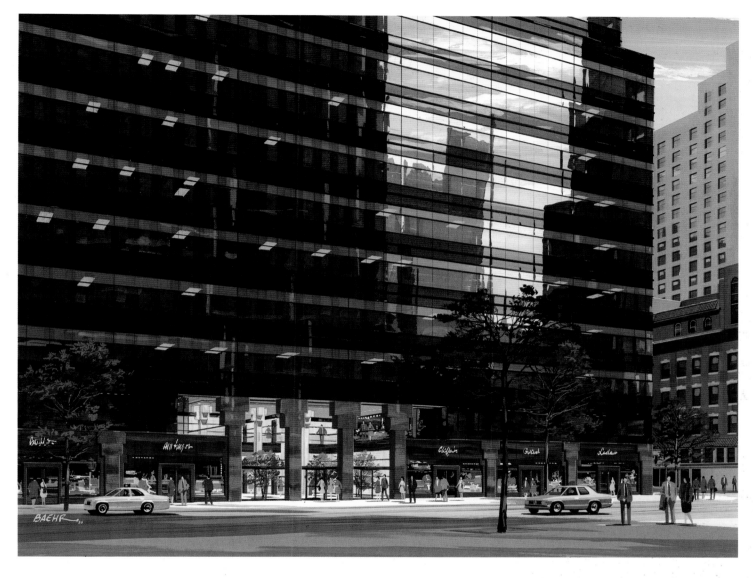

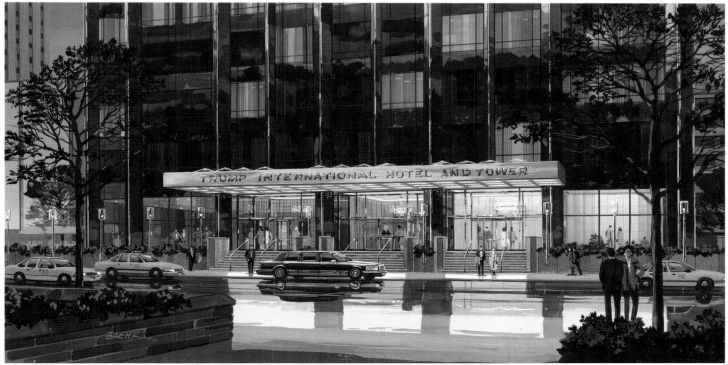

fRANK & JEff LAVATY
(212) 427-5632 Fax: (212) 427-6372
Associates:
Steven Kenny & Ebba Lavaty

Representing
CRAIG ATTEBERY

L

FRANK & JEFF LAVATY
(212) 427-5632 Fax: (212) 427-6372
Associates:
Steven Kenny & Ebba Lavaty

Representing
DON DEMERS

L

FRANK & JEFF LAVATY
(212) 427-5632 Fax: (212) 427-6372
Associates:
Steven Kenny & Ebba Lavaty

Representing
DOMENICK D'ANDREA

L

FRANK & JEFF LAVATY
(212) 427-5632 Fax: (212) 427-6372
Associates:
Steven Kenny & Ebba Lavaty

Representing
S T U D I O L I D D E L L

CLARE JETT AND ASSOCIATES ✈ 502-228-9427 ✈ FAX 502-228-8857

JENNIFER BOLTEN

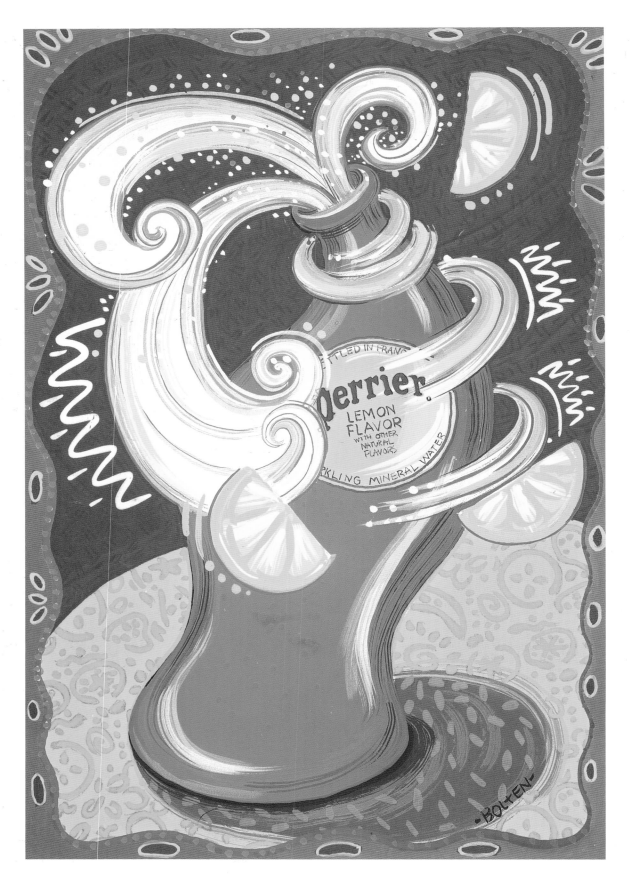

CLARE JETT AND ASSOCIATES ✈ 502-228-9427 ✈ FAX 502-228-8857

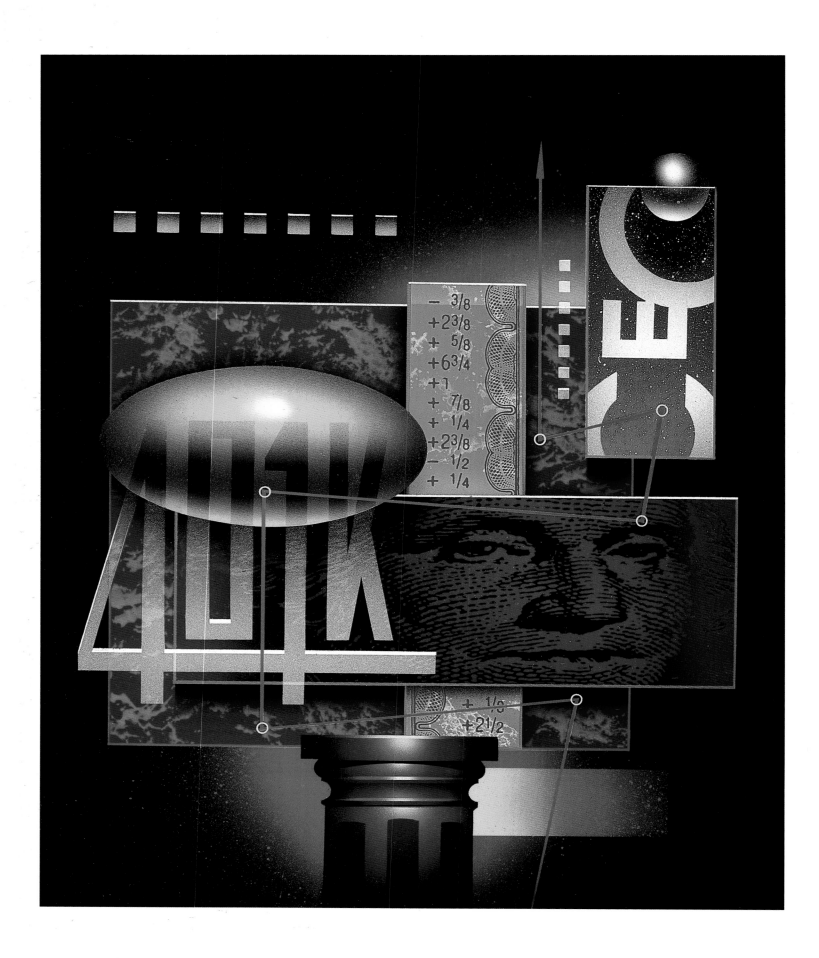

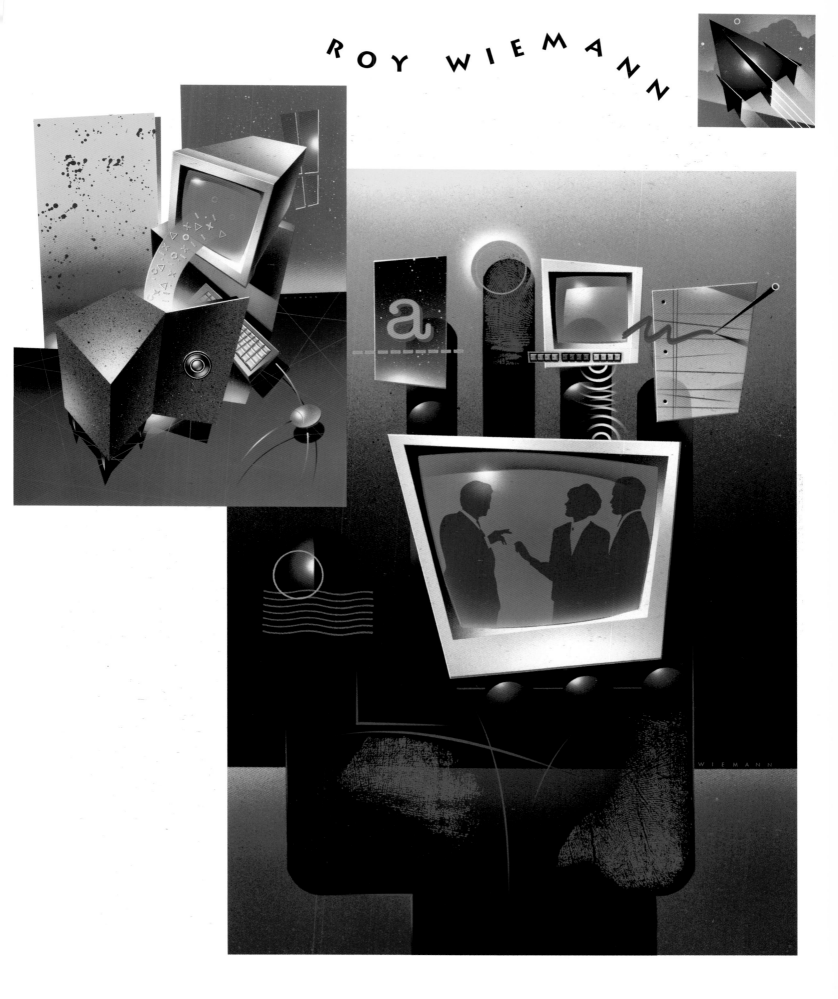

ANNETTE CABLE

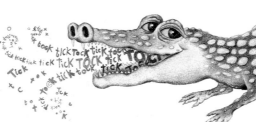

CLARE JETT AND ASSOCIATES ✈ 502-228-9427 ✈ FAX 502-228-8857

DAN BRAWNER

CLARE JETT AND ASSOCIATES ✈ 502-228-9427 ✈ FAX 502-228-8857

CLAUDIA HAMMER

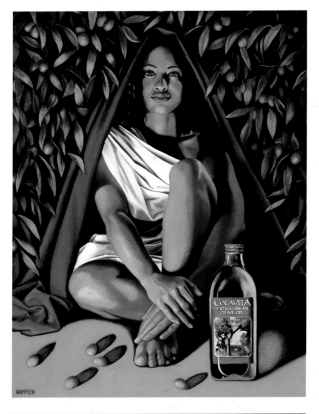

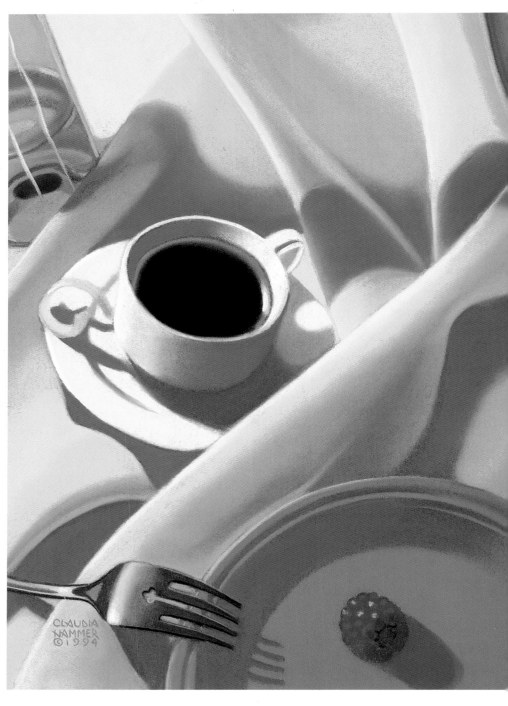

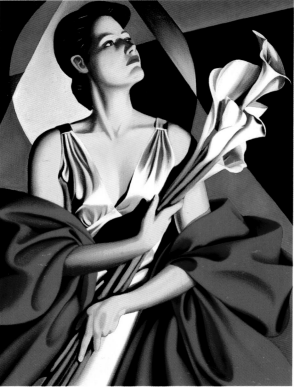

RON BELL

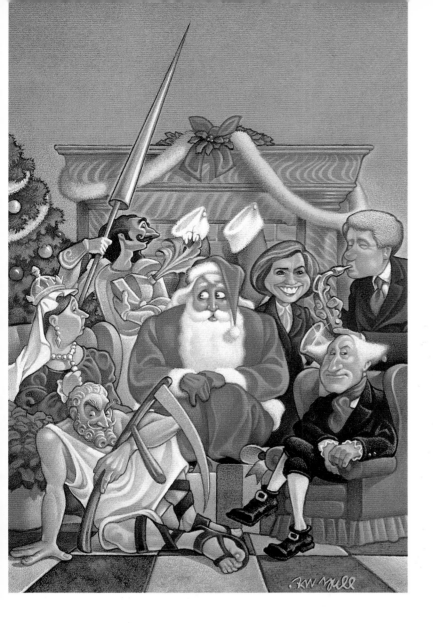

CLARE JETT AND ASSOCIATES ✈ **502-228-9427** ✈ **FAX 502-228-8857**

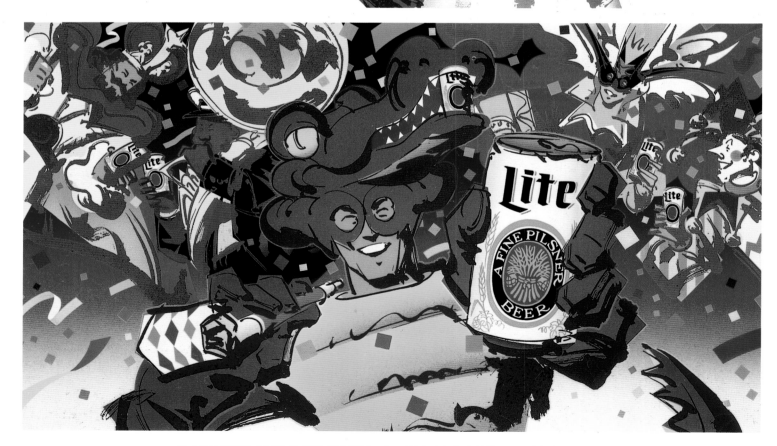

CLARE JETT AND ASSOCIATES ✈ 502-228-9427 ✈ FAX 502-228-8857

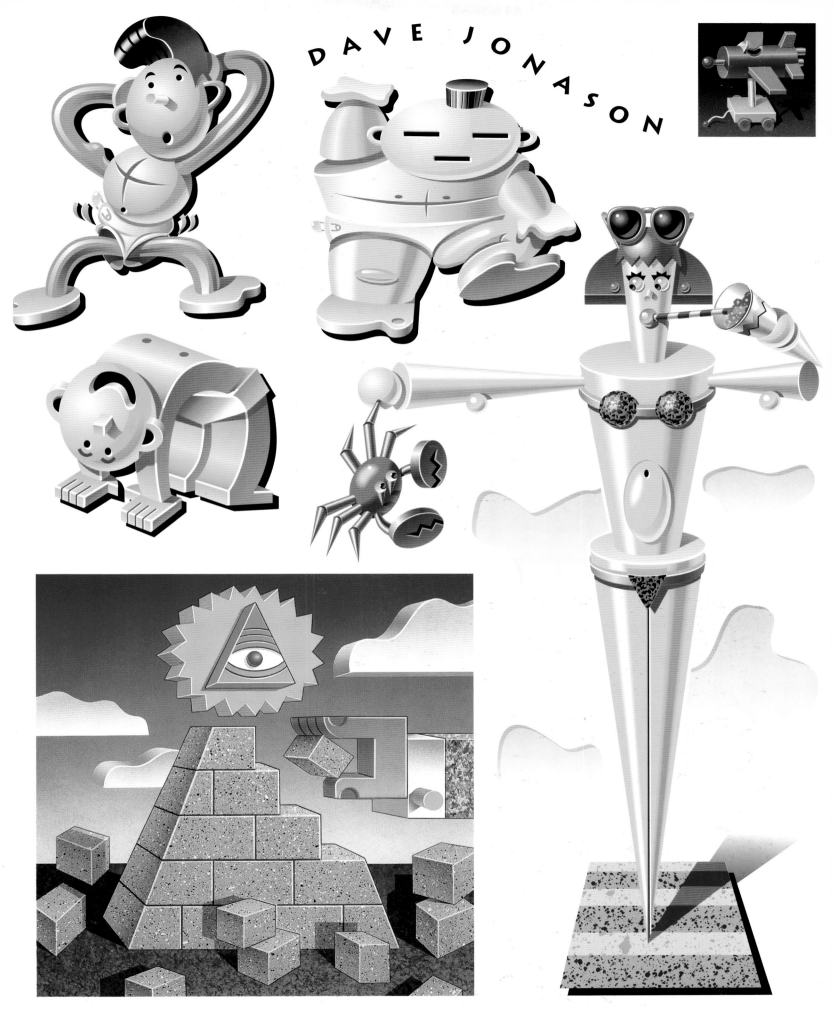

DAVE JONASON

MARIO NOCHE

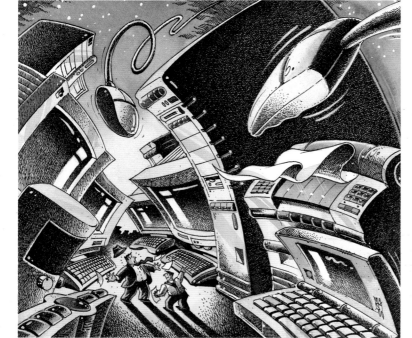

CLARE JETT AND ASSOCIATES ✈ **502-228-9427** ✈ **FAX 502-228-8857**

CYNTHIA TORP

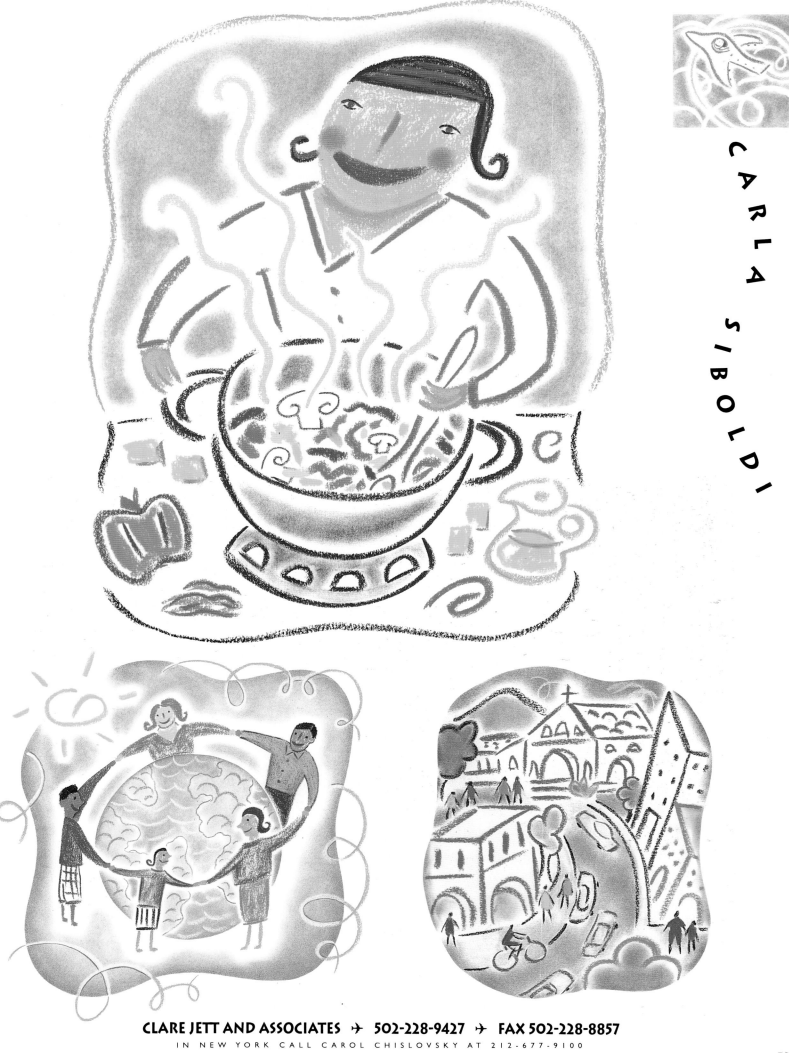

CARLA SIBOLDI

PAUL WOLF

DAVID WARINER

CHASE MANHATTAN BANK

CHASE MANHATTAN BANK

SUSAN AND CO

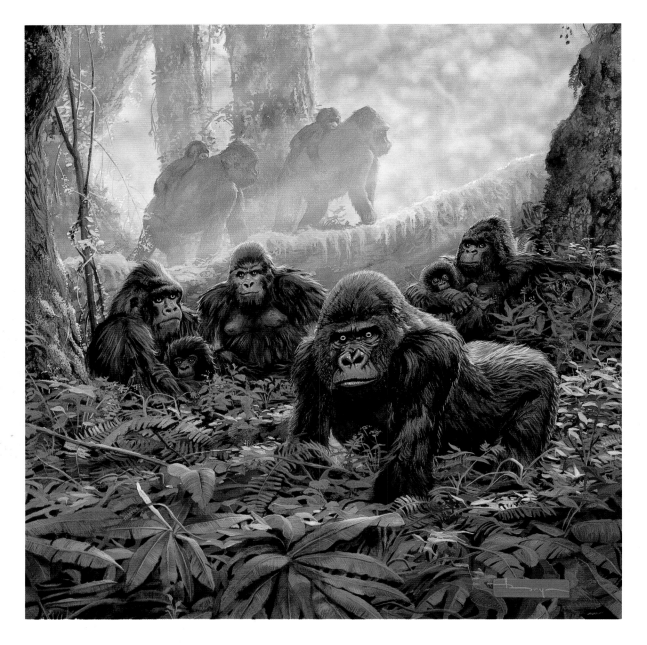

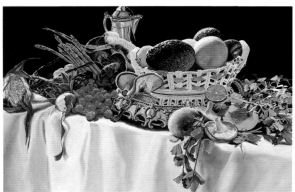

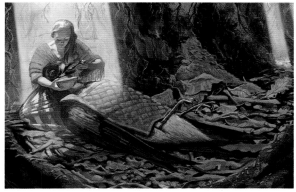

SUSAN AND CO

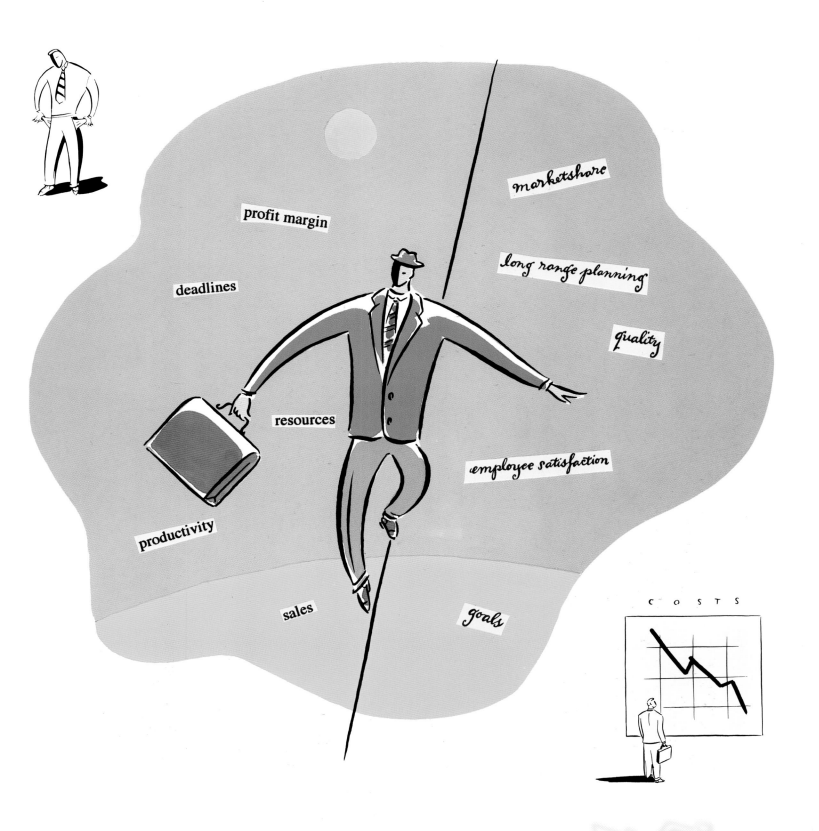

profit margin

marketshare

deadlines

long range planning

quality

resources

employee satisfaction

productivity

sales

goals

COSTS

SUSAN AND CO

ARTIST REPRESENTATIVE / PHONE 206 728 1300 / FAX 206 728 7522

567

MOSS BAY ALES

FRESH LOCAL ALES

HALE'S ALES
BREWERY

SUSAN AND Co

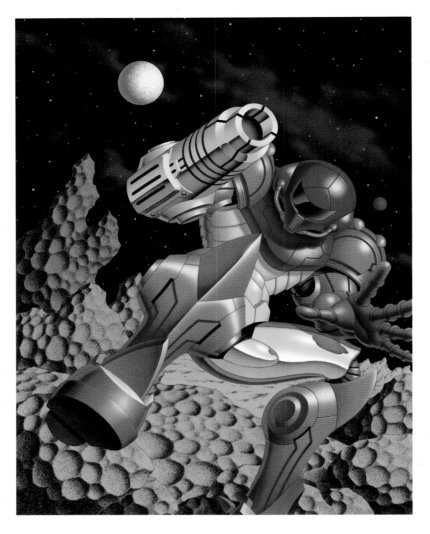
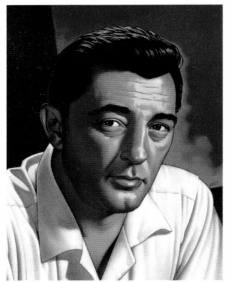
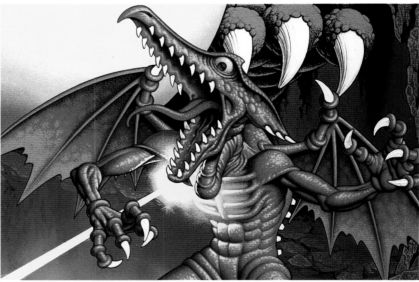

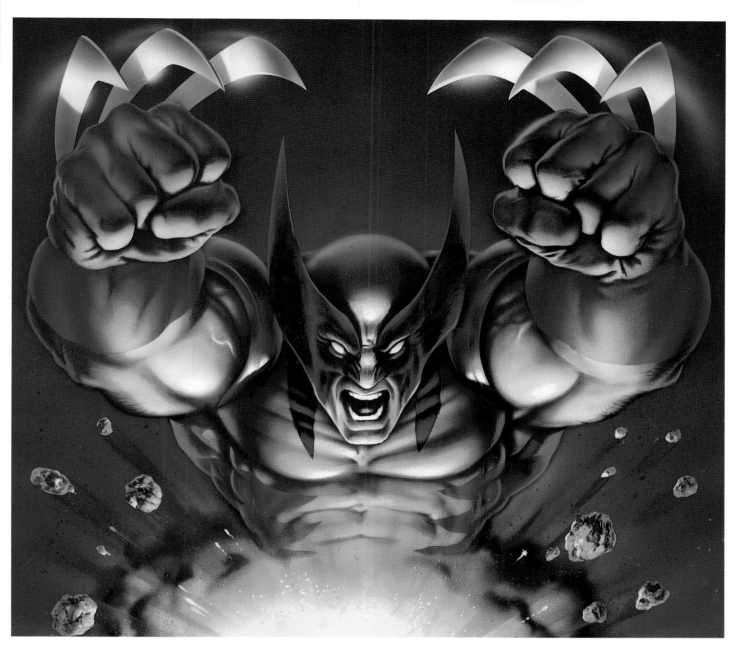

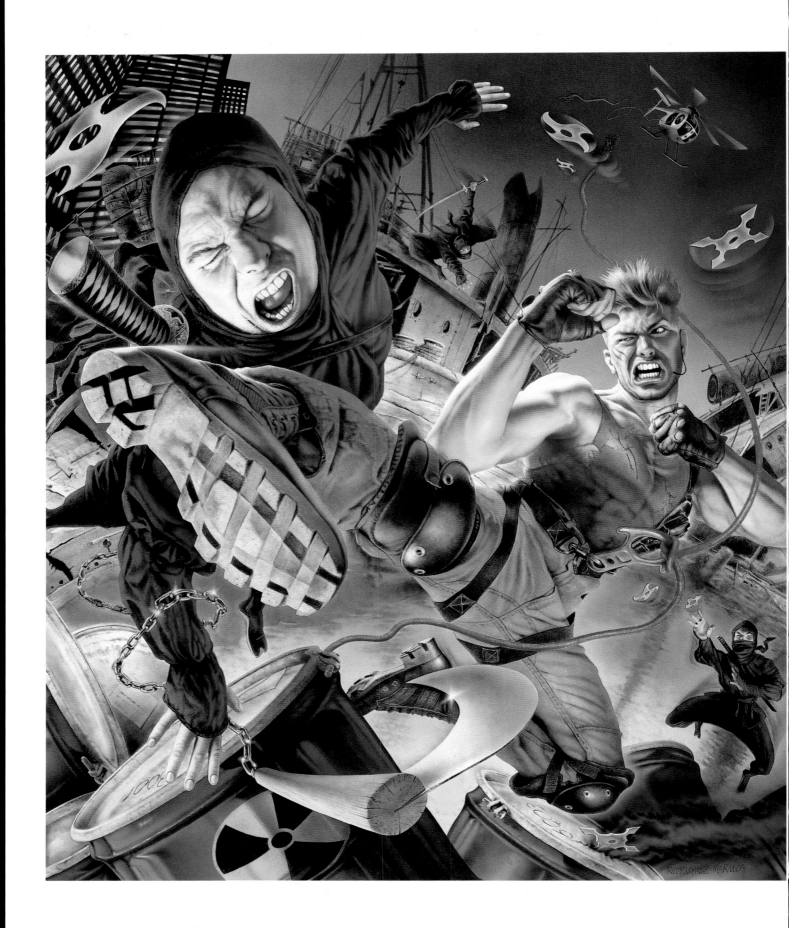

CHI 312·786·1560 NY 212·912·1877 CECI BARTELS ASSOCIATES STL 314·781·7377 FAX 781·8017
AGENTS FOR ARTISTS

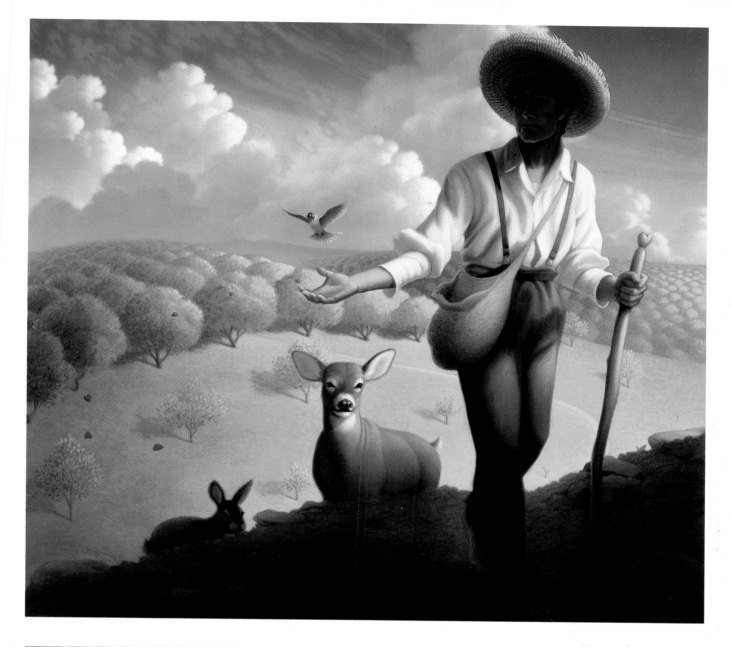

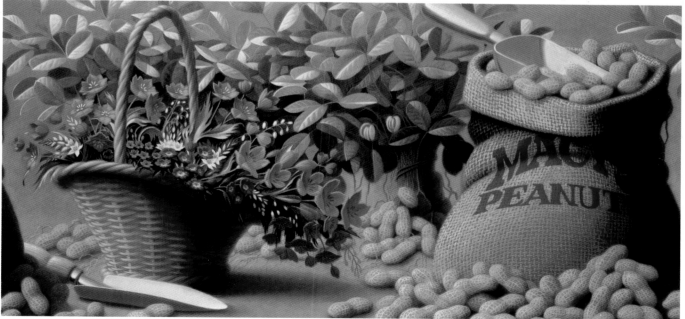

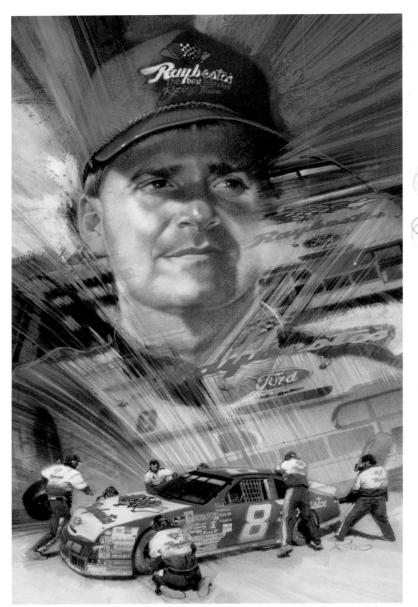

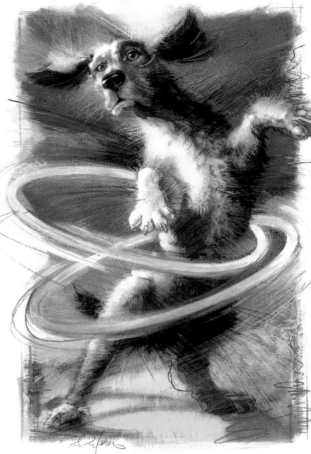

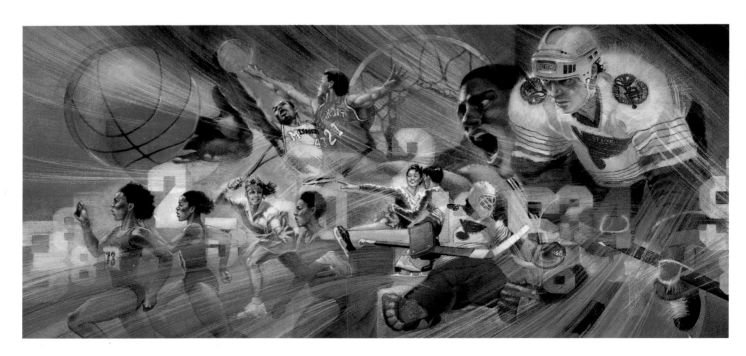

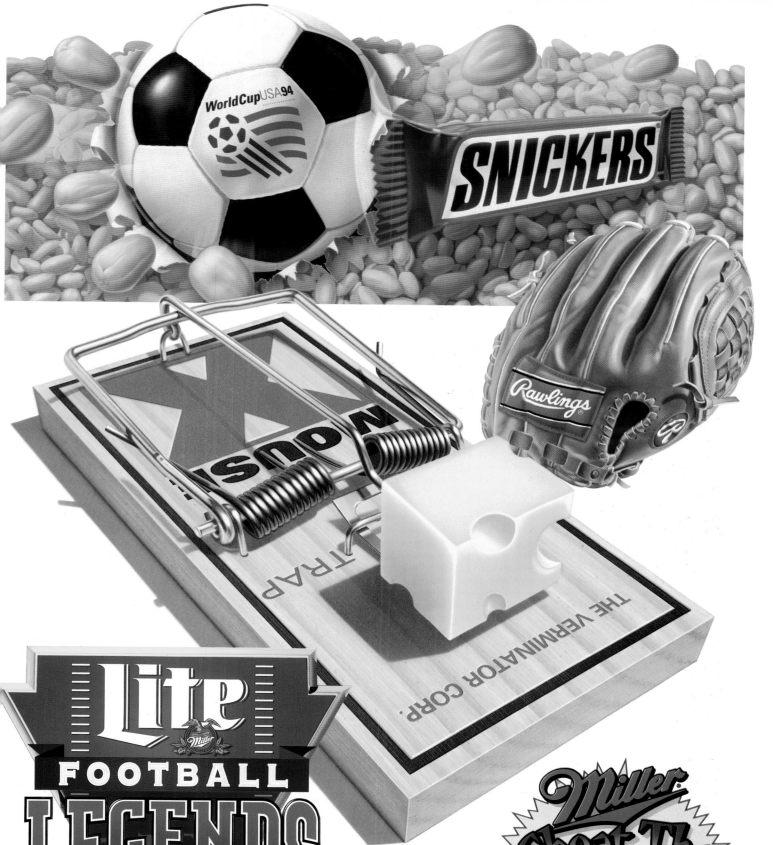

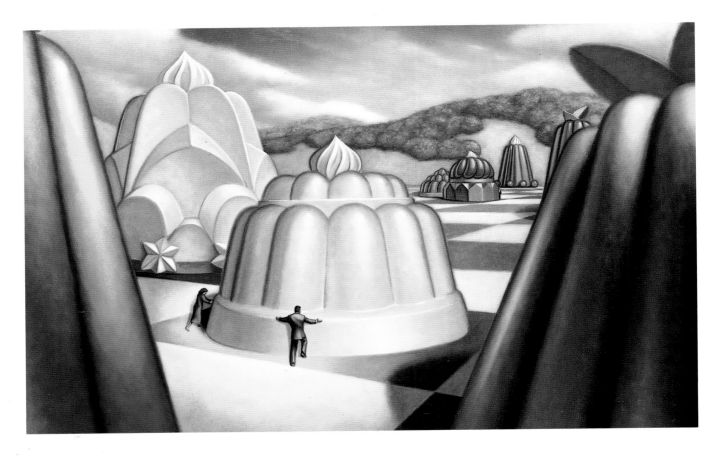

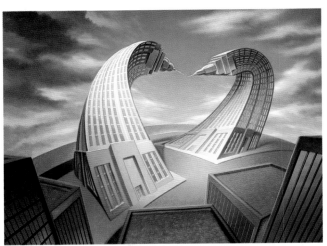
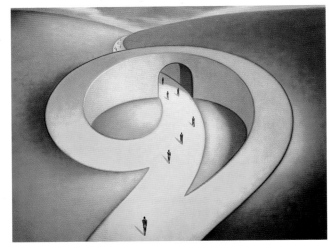

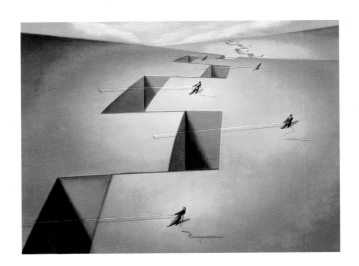
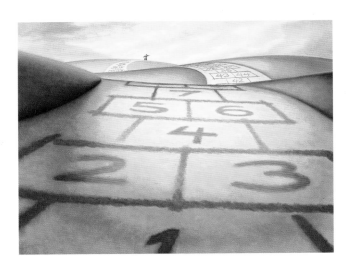

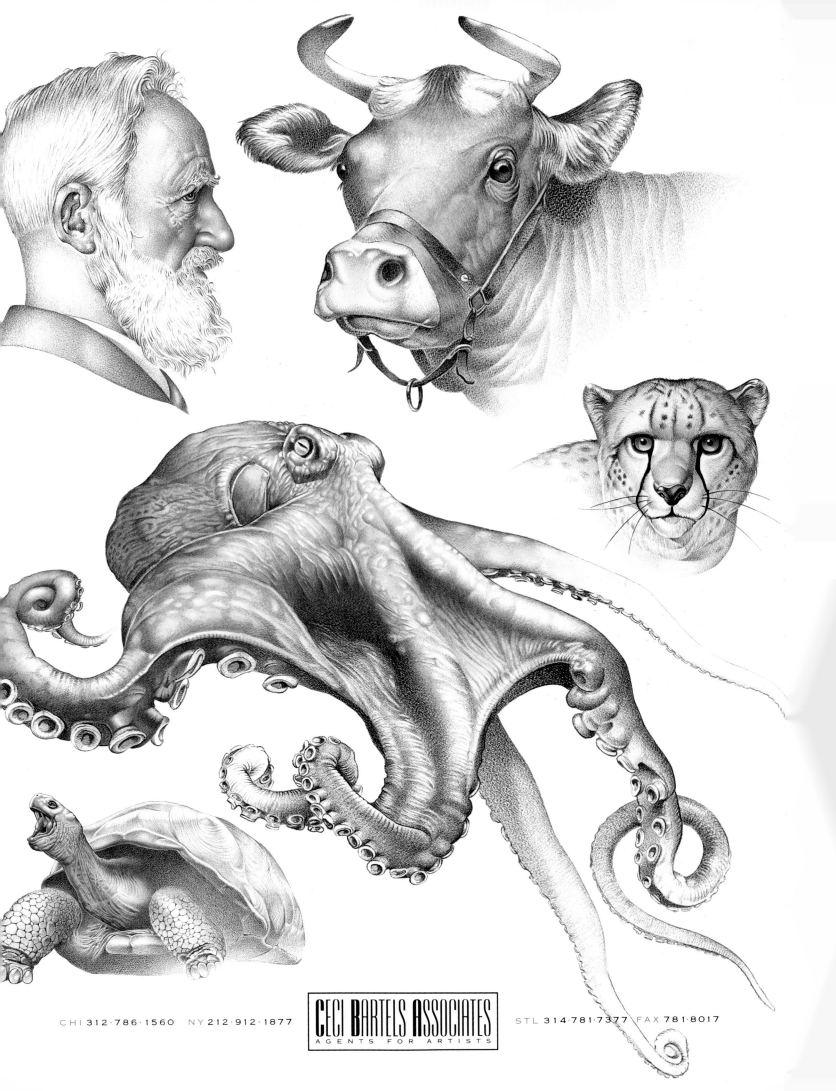

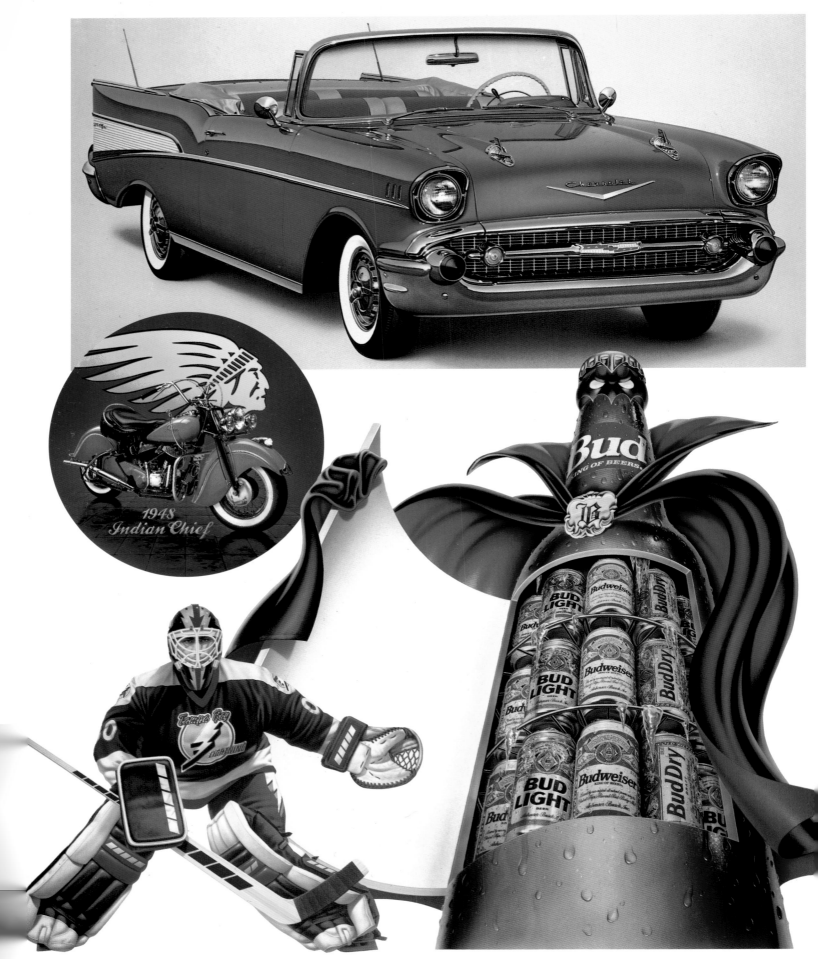

SPEEDO

S

SHOOTERS

POLO

33

OLYMPICS

ATLANTA
USA

CHI 312·786·1560 NY 212·912·1877 CECI BARTELS ASSOCIATES STL 314·781·7377 FAX 781·8017

AGENTS FOR ARTISTS

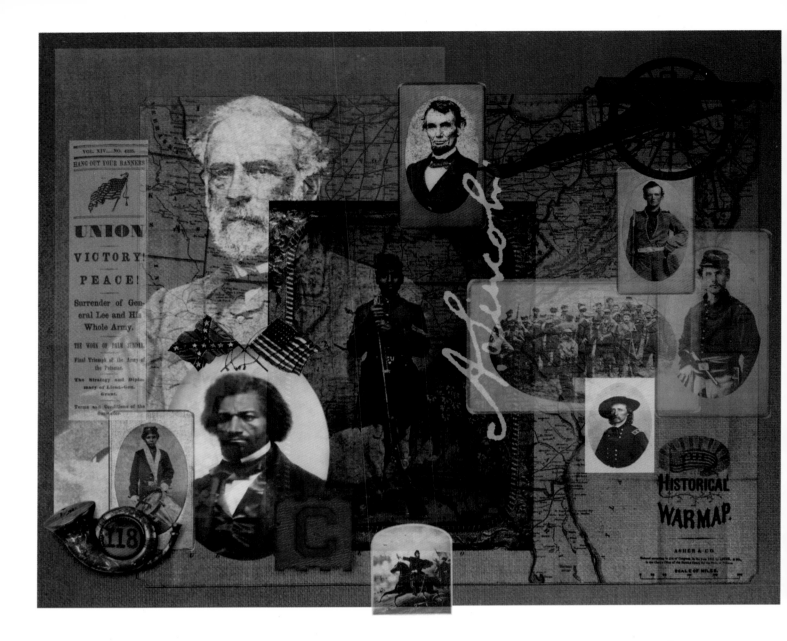

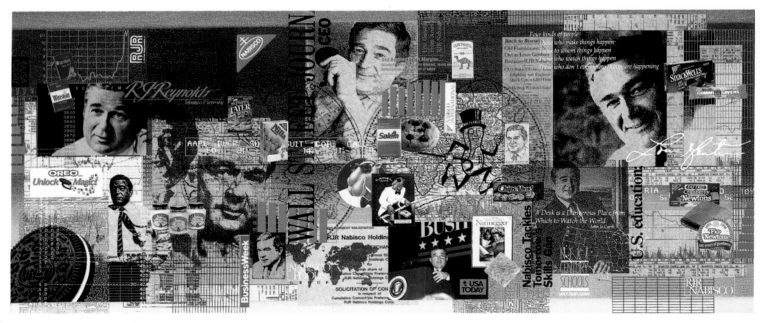

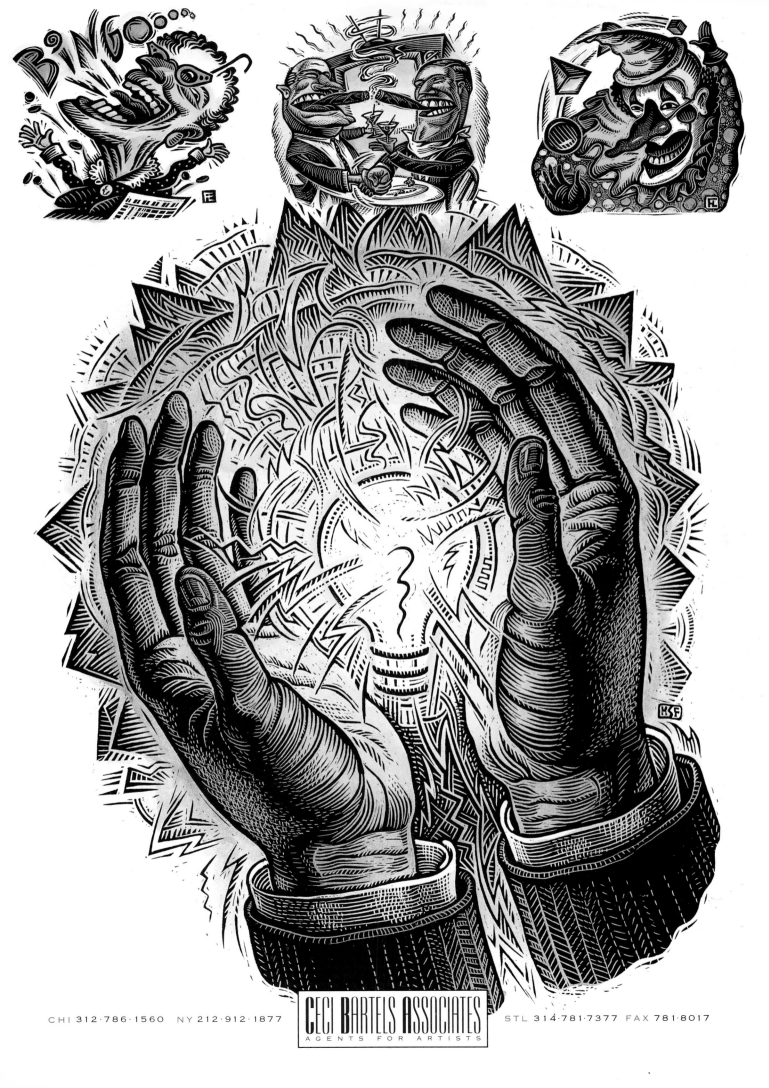

CHI 312·786·1560 NY 212·912·1877 CECI BARTELS ASSOCIATES STL 314·781·7377 FAX 781·8017
AGENTS FOR ARTISTS

Fred Saunders

S t e p h e n K o n z

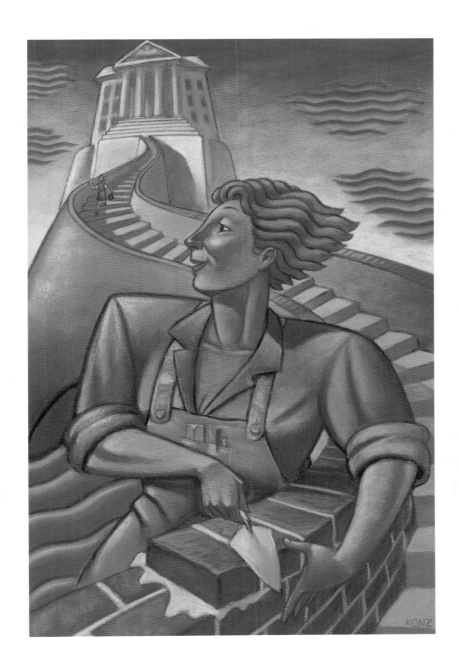

Kate Eggleston-Wirtz

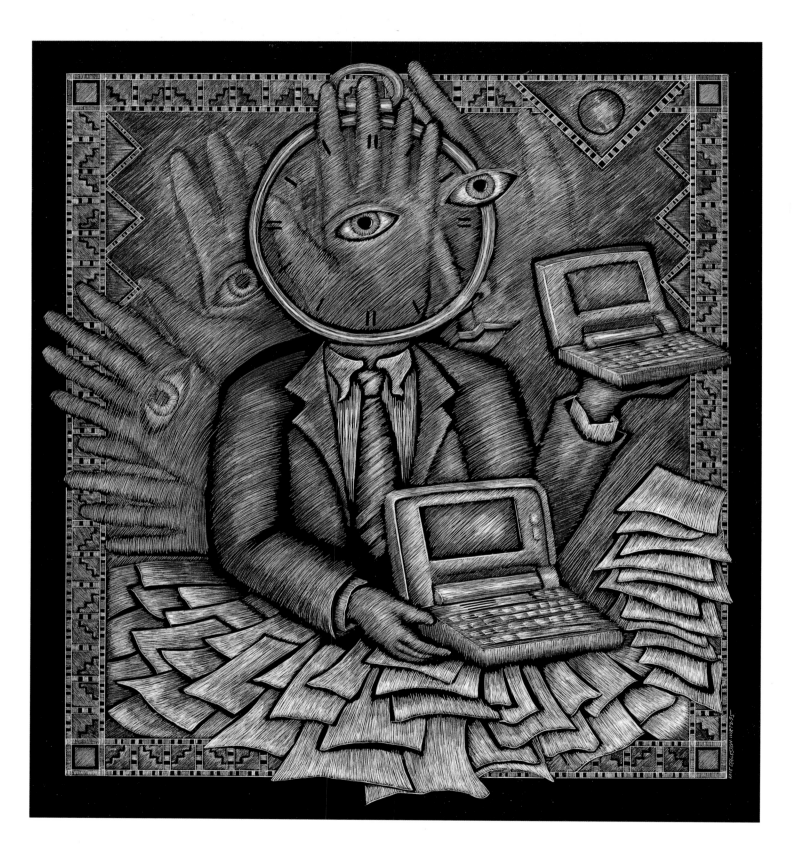

Represented by Jaz & Jaz 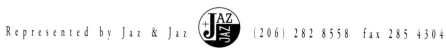 (206) 282 8558 fax 285 4304

fax for our CD and home page address

Larry Milam

Artist's studio & fax (503) 236 9121

Represented by Jaz & Jaz (206) 282 8558 fax 285 4304

Bonnie Rieser

CORPORATE

fax for our CD and home page address

Bonnie Rieser

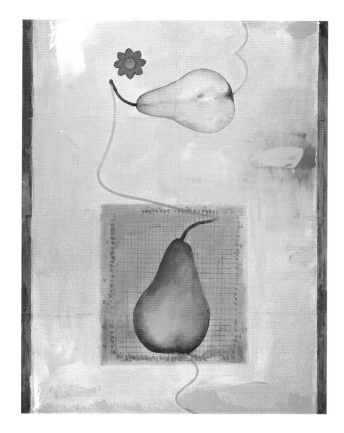
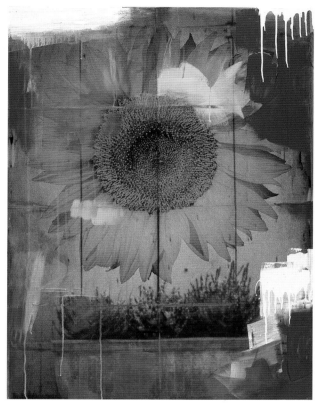
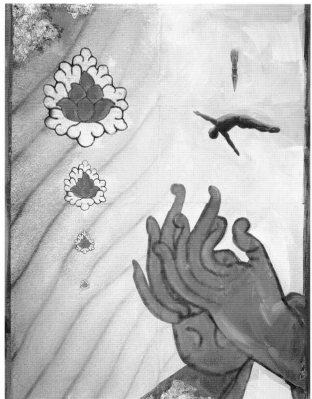

PUBLISHING

Represented by Jaz & Jaz (206) 282 8558 fax 285 4304

fax for our CD and home page address

John Fretz

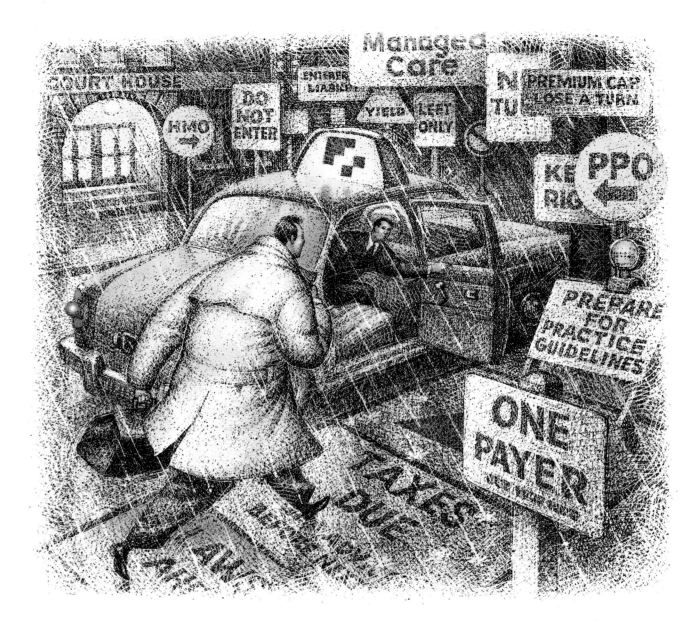

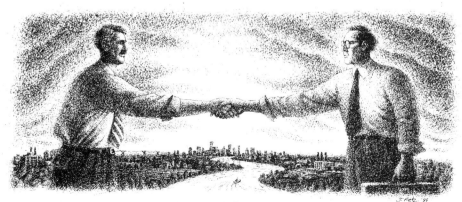

Artist's studio & fax (206) 623 1931

Represented by Jaz & Jaz (206) 282 8558 fax 285 4304

see '94 & '95 Creative Illustration - fax for our CD and home page address

Jim Chow

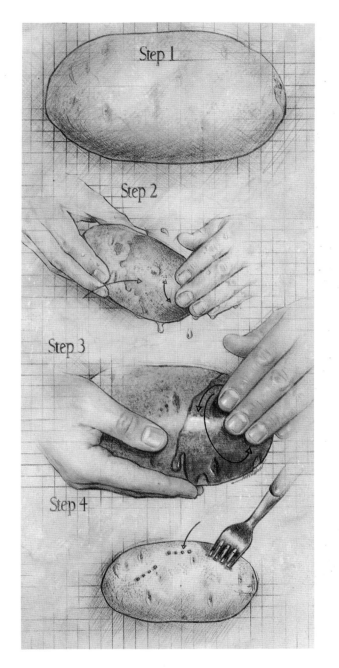

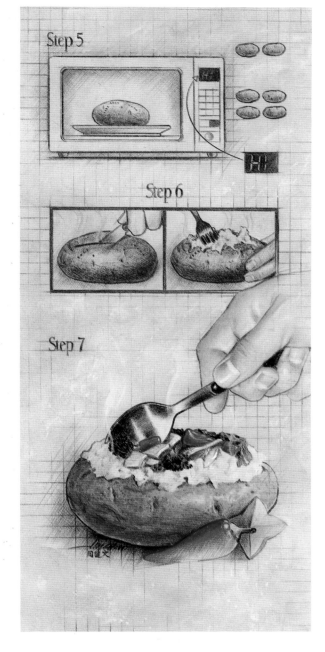

Represented by Jaz & Jaz (206) 282 8558 fax 285 4304

Vaughn Aldredge

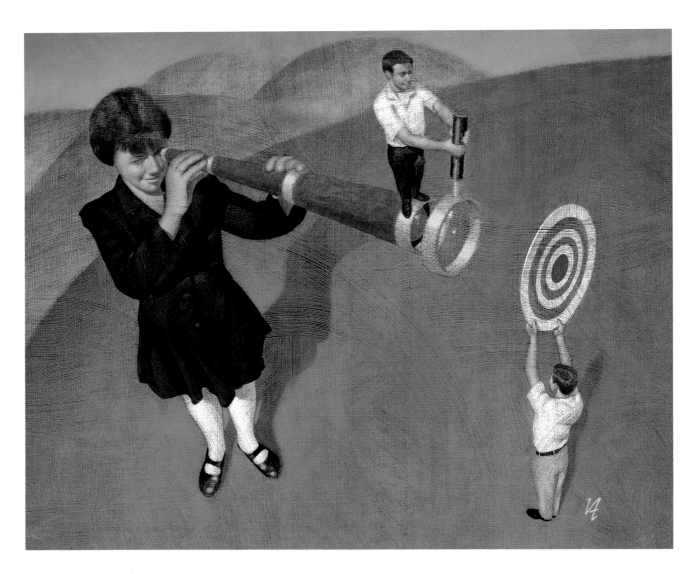

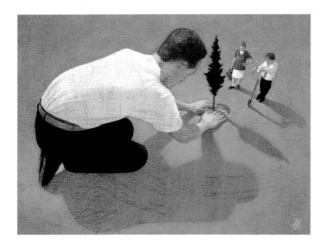

Kim Drew

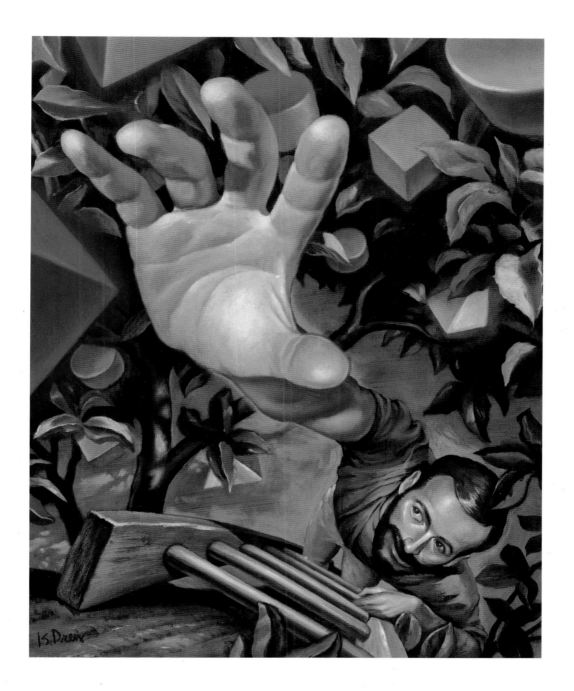

Represented by Jaz & Jaz (206) 282 8558 fax 285 4304

Todd Nordling

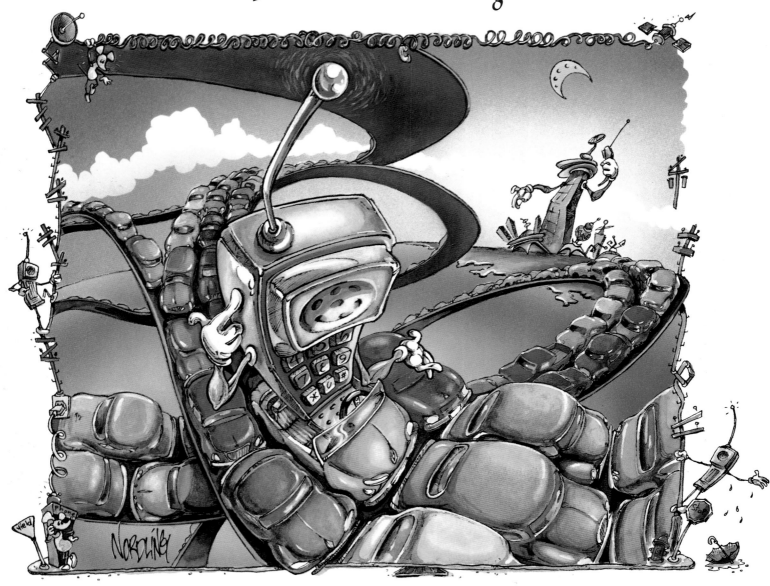

Represented by Jaz & Jaz (206) 282 8558 fax 285 4304

see '95 Creative Illustration - fax for our CD and home page address

Jim Frisino

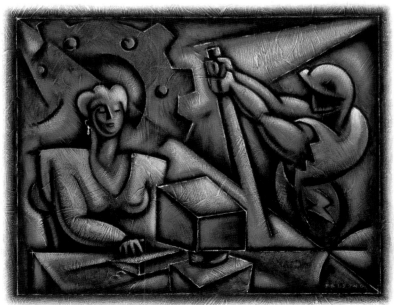

Artist's studio & fax (206) 523 9593

see '95 Creative Illustration & Creative Options - fax for our CD and home page address

Christopher Baldwin

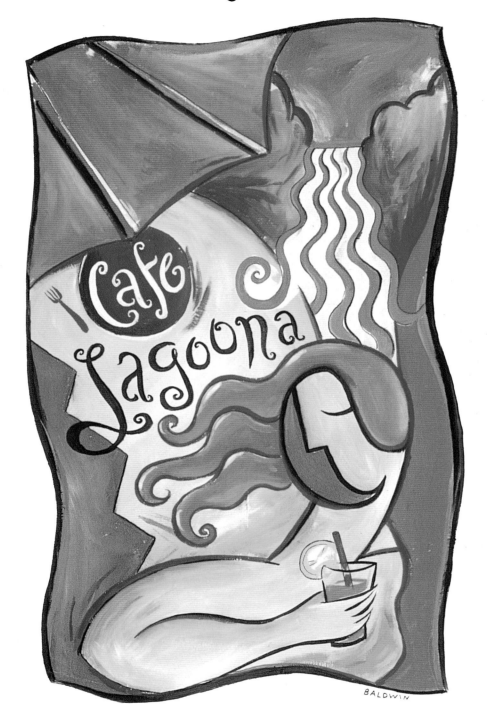

Represented by Jaz & Jaz **Jaz Jaz** (206) 282 8558 fax 285 4304

see '94 & '95 Creative Illustration & Creative Options - fax for our CD and home page address

Julie Paschkis

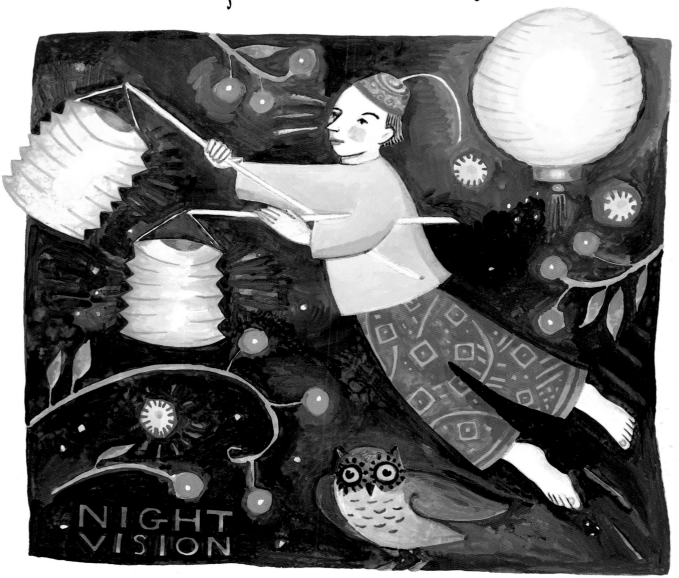

NIGHT
VISION

Artist's studio (206) 525 5205 fax 525 0831

Represented by Jaz & Jaz (206) 282 8558 fax 285 4304

see '94 & '95 Creative Illustration - fax for our CD and home page address

Peter Fiore

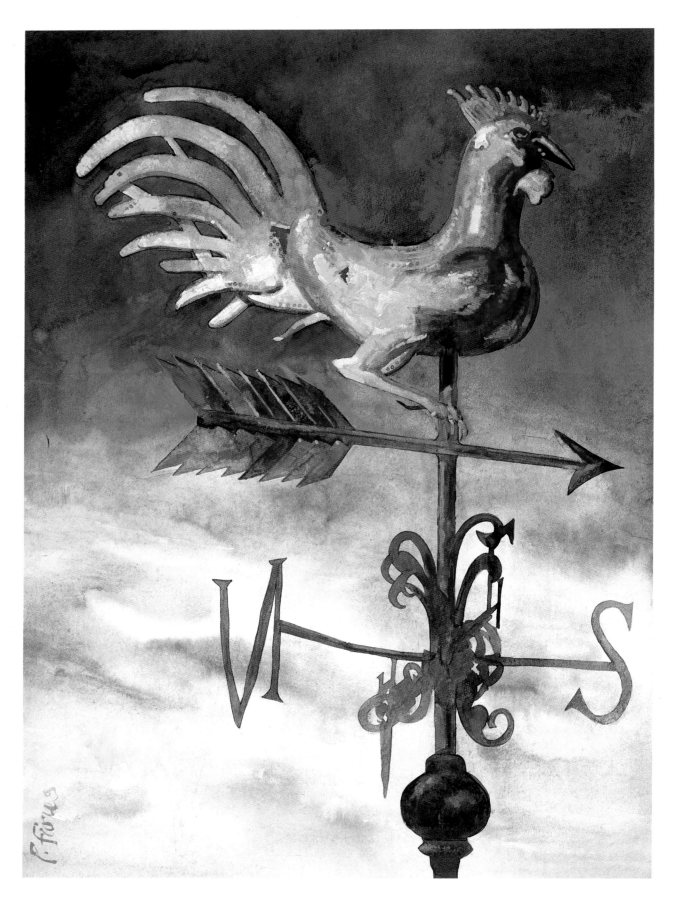

Artists	89	New York	212	Contact:
Representative	Fifth Avenue	New York	627-1554	Betty Krichman
	Suite 901	10003	627-1719 Fax	Ron Puhalski

Peter Fiore

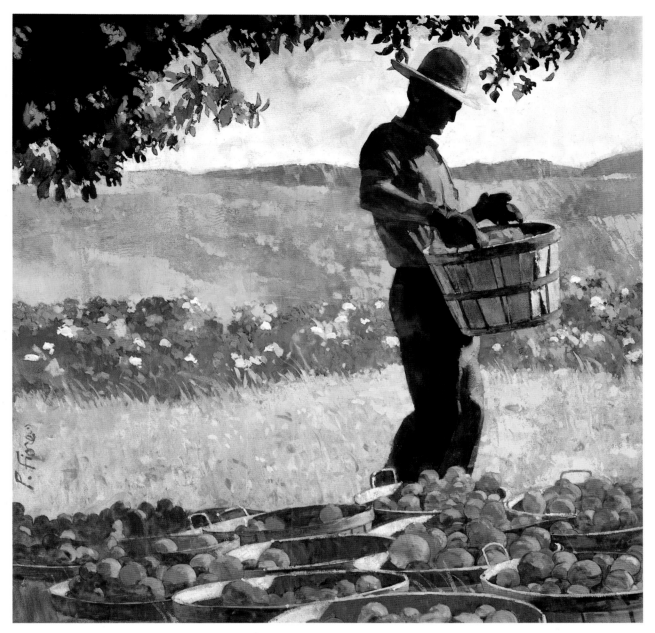

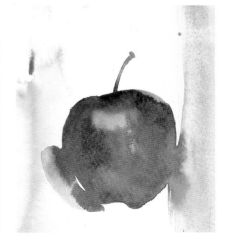

Artists 89 New York 212 Contact:
Representative Fifth Avenue New York 627-1554 Betty Krichman
 Suite 901 10003 627-1719 Fax Ron Puhalski

Matthew Rotunda

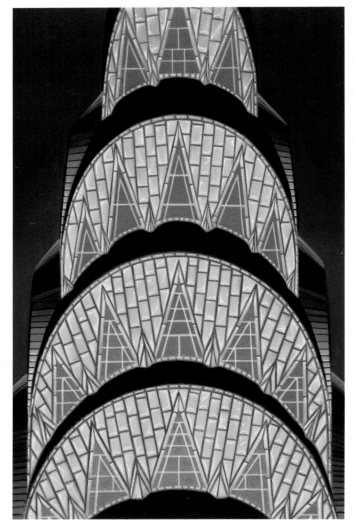

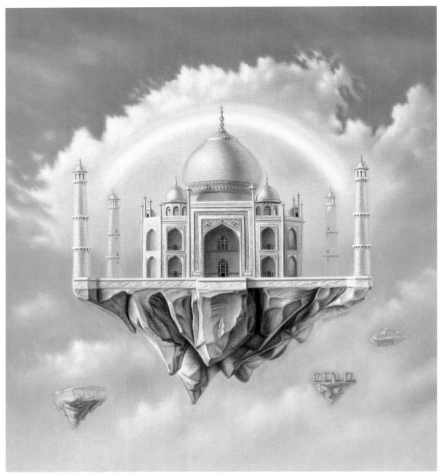

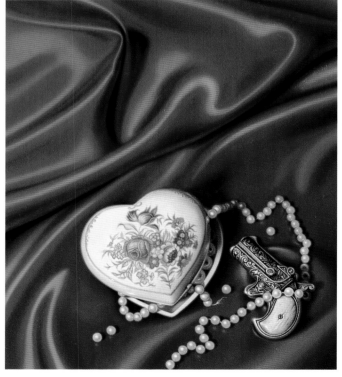

| Artists Representative | 89 Fifth Avenue Suite 901 | New York New York 10003 | 212 627-1554 627-1719 Fax | Contact: Betty Krichman Ron Puhalski |

Linda Benson

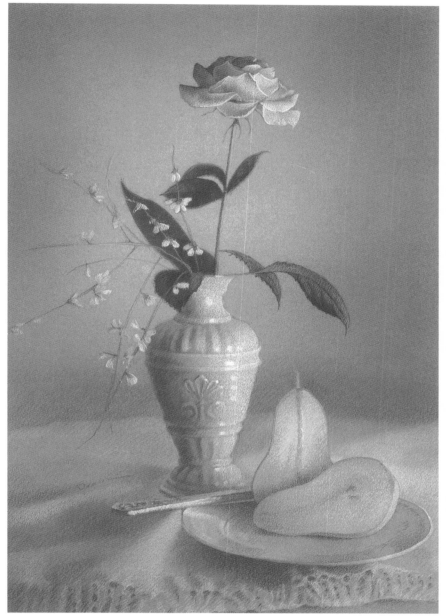

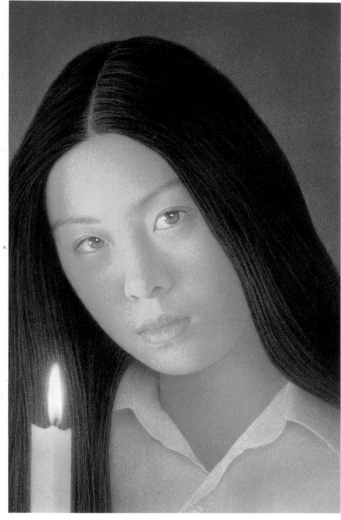

Artists	89	New York	212	Contact:
Representative	Fifth Avenue	New York	627-1554	Betty Krichman
	Suite 901	10003	627-1719 Fax	Ron Puhalski

Paul Bachem

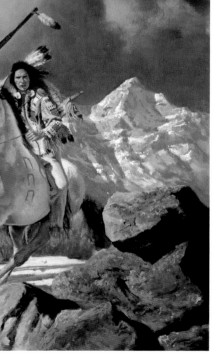

Artists Representative	89 Fifth Avenue Suite 901	New York New York 10003	212 627-1554 627-1719 Fax	Contact: Betty Krichman Ron Puhalski

Daniel O'Leary

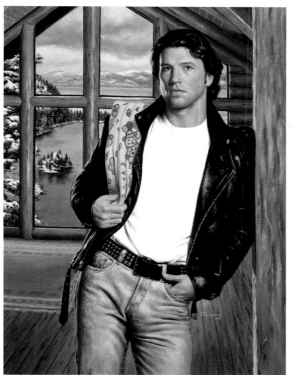

Brad Teare

Artists	89	New York	212	Contact:
Representative	Fifth Avenue	New York	627-1554	Betty Krichman
	Suite 901	10003	627-1719 Fax	Ron Puhalski

Mitchell Hooks

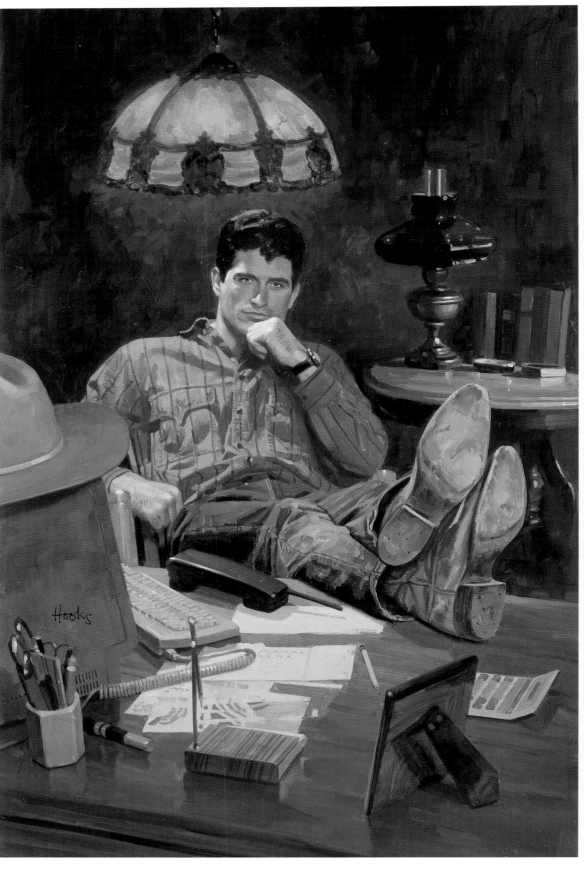

Artists
Representative

89
Fifth Avenue
Suite 901

New York
New York
10003

212
627-1554
627-1719 Fax

Contact:
Betty Krichman
Ron Puhalski

Adrian Chesterman

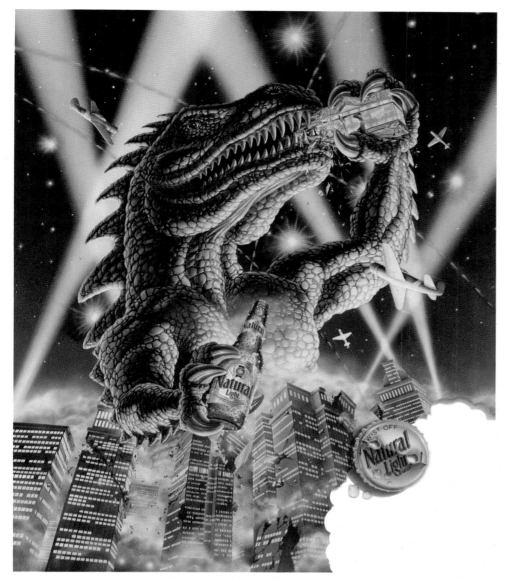

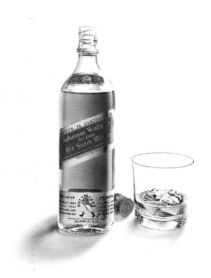

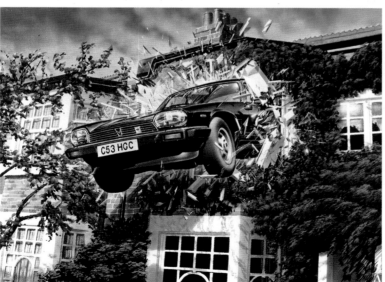

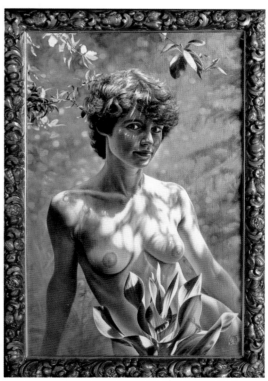

Artists	89	New York	212	Contact:
Representative	Fifth Avenue	New York	627-1554	Betty Krichman
	Suite 901	10003	627-1719 Fax	Ron Puhalski

607

Broeck Steadman

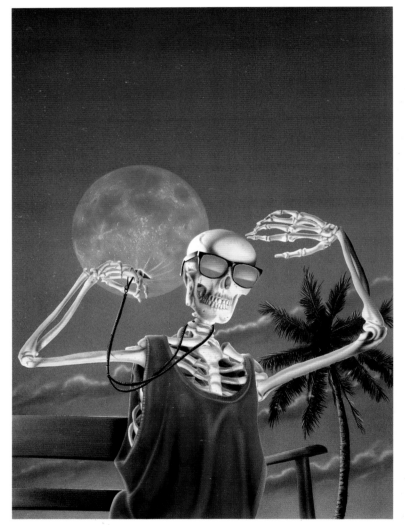

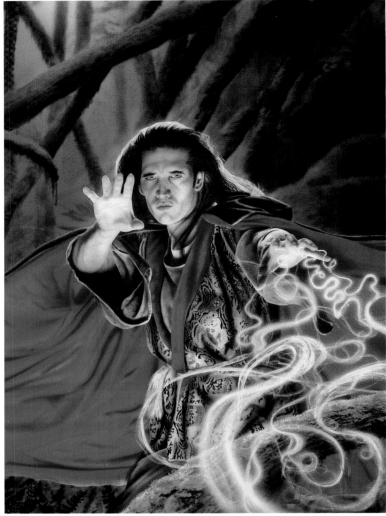

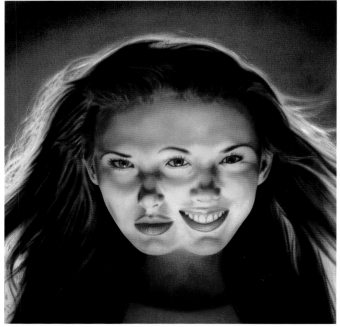

| Artists Representative | 89 Fifth Avenue Suite 901 | New York New York 10003 | 212 627-1554 627-1719 Fax | Contact: Betty Krichman Ron Puhalski |

Rudy Laslo

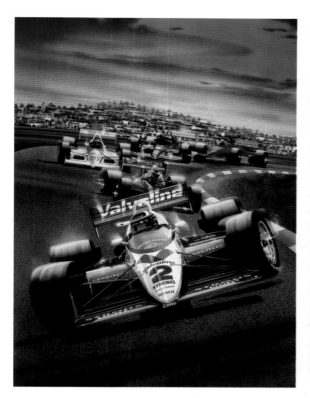
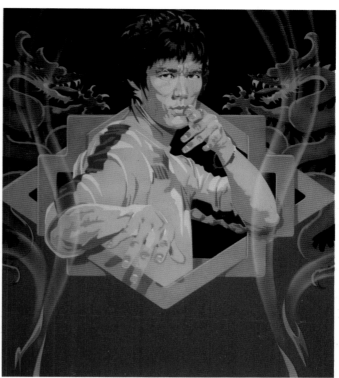

Marcia Pyner

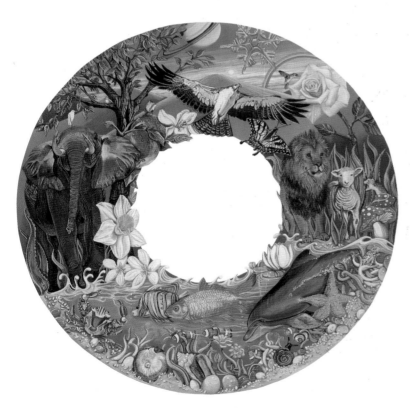
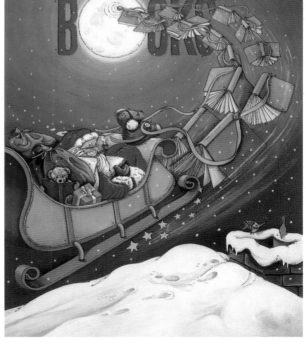

Rudy Laslo

Art*works*

Artists
Representative

89
Fifth Avenue
Suite 901

New York
New York
10003

212
627-1554
627-1719 Fax

Contact:
Betty Krichman
Ron Puhalski

Steve Brennan

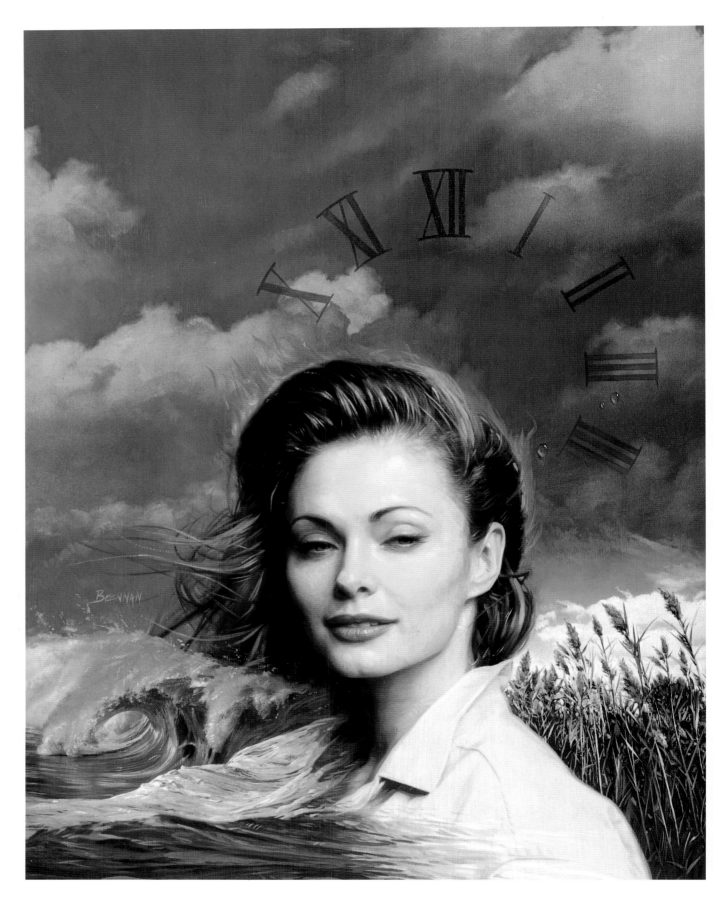

Artists
Representative

89
Fifth Avenue
Suite 901

New York
New York
10003

212
627-1554
627-1719 Fax

Contact:
Betty Krichman
Ron Puhalski

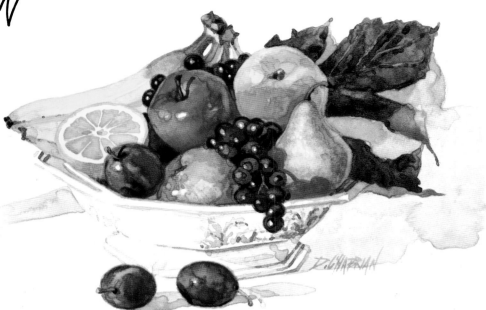

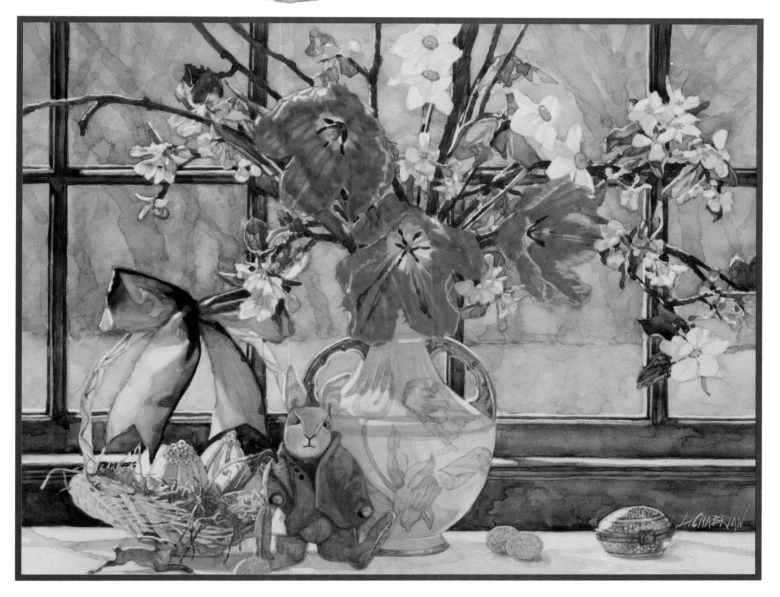

Artists	89	New York	212	Contact:
Representative	Fifth Avenue	New York	627-1554	Betty Krichman
	Suite 901	10003	627-1719 Fax	Ron Puhalski

Bob Jones

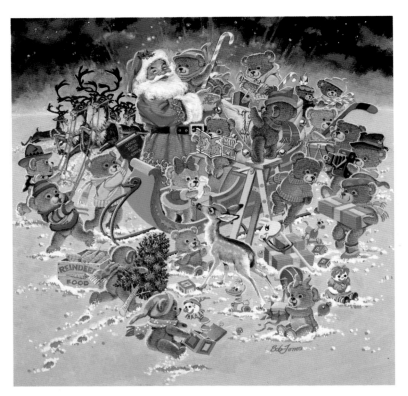

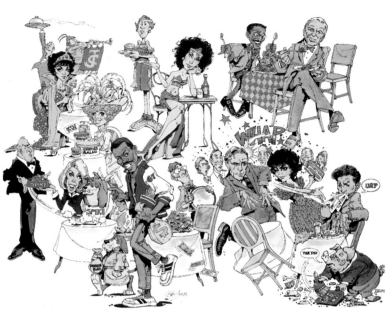

Kim Barnes

Artists 89 New York 212 Contact:
Representative Fifth Avenue New York 627-1554 Betty Krichman
Suite 901 10003 627-1719 Fax Ron Puhalski

Dan Brown

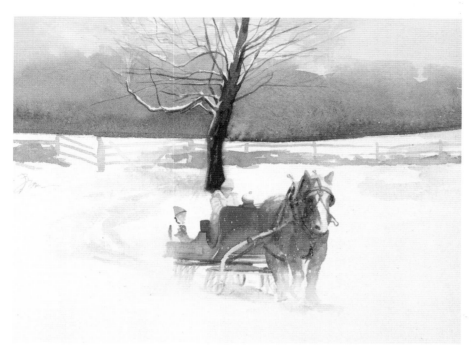

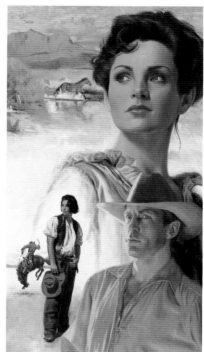

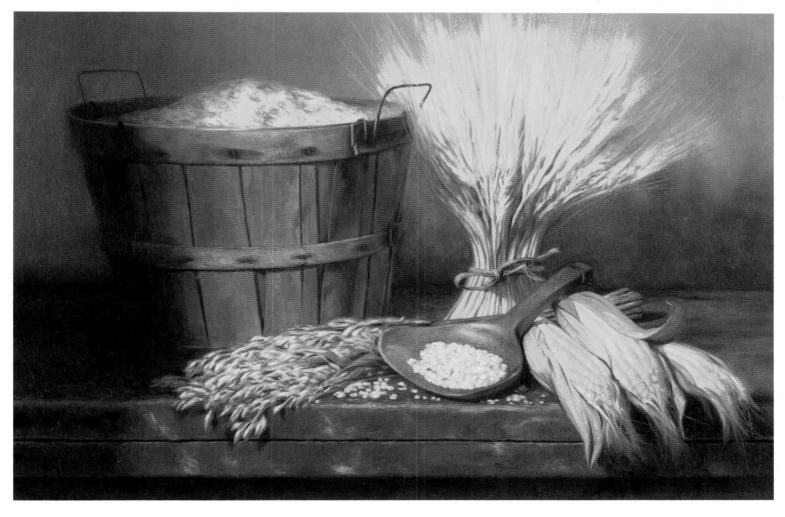

Artists
Representative

89
Fifth Avenue
Suite 901

New York
New York
10003

212
627-1554
627-1719 Fax

Contact:
Betty Krichman
Ron Puhalski

Peter Siu

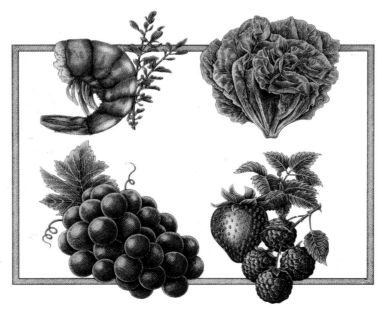

KANGAROO

| Artists Representative | 89 Fifth Avenue Suite 901 | New York New York 10003 | 212 627-1554 627-1719 Fax | Contact: Betty Krichman Ron Puhalski |

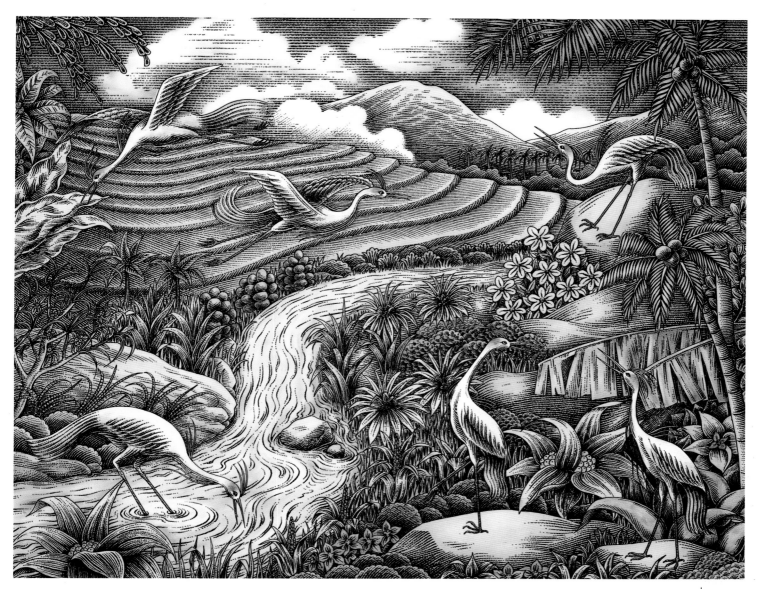

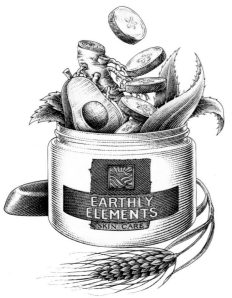

Artists	*89*	*New York*	*212*	*Contact:*
Representative	*Fifth Avenue*	*New York*	*627-1554*	*Betty Krichman*
	Suite 901	*10003*	*627-1719 Fax*	*Ron Puhalski*

ROB MAGIERA

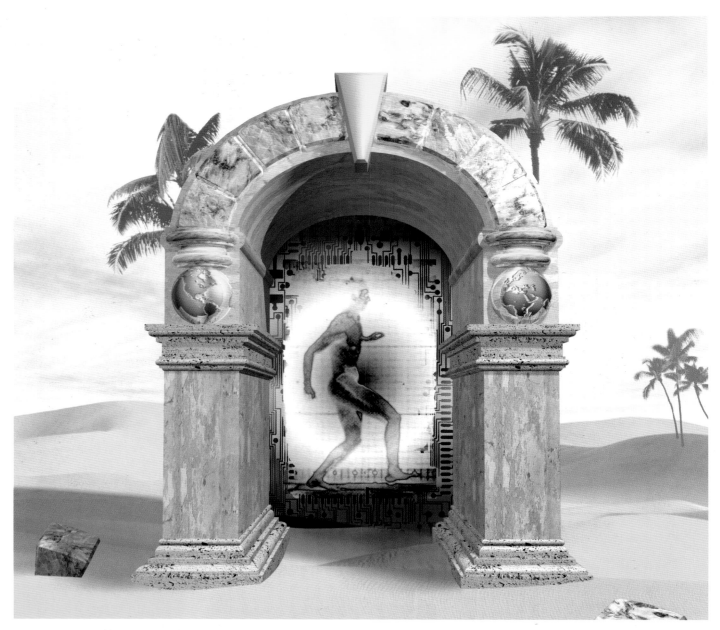

616

LEONID MYSAKOV

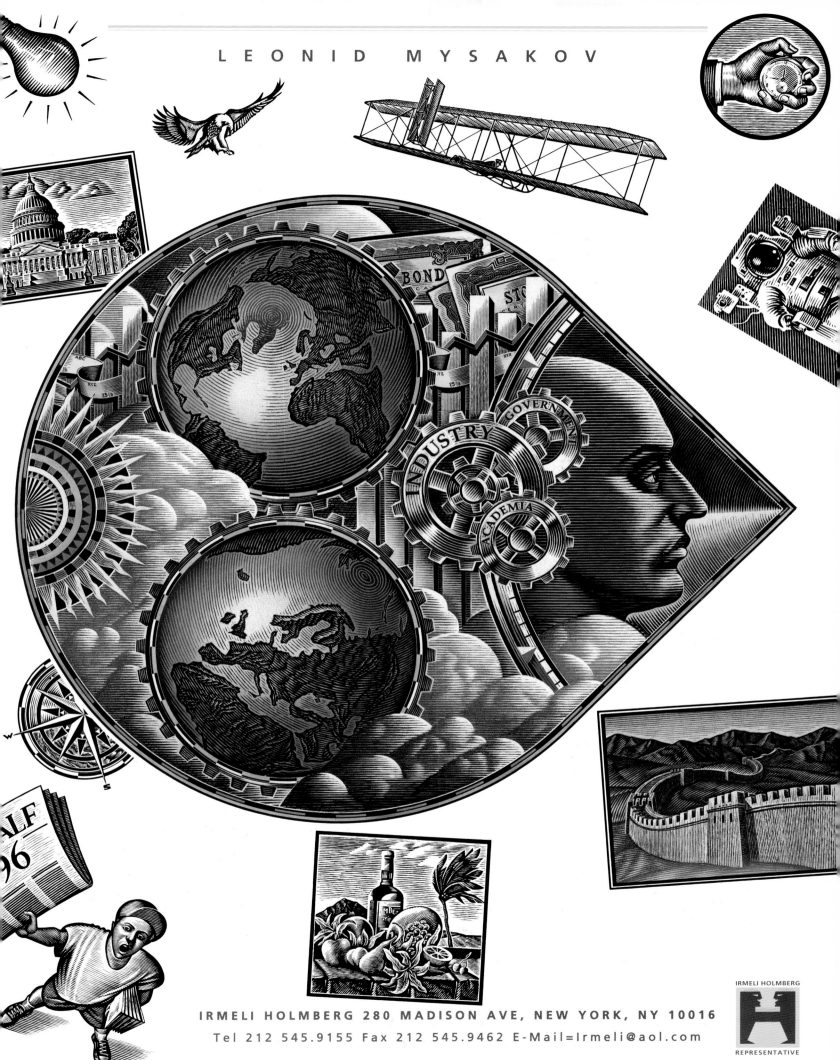

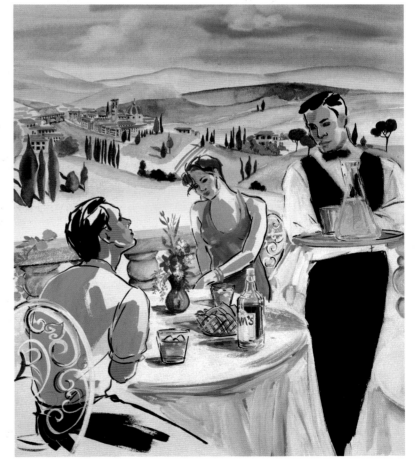

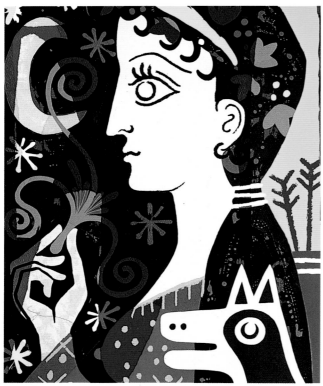

Artemis

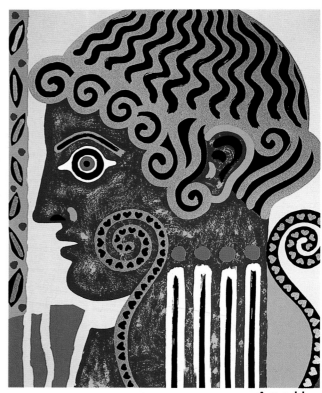

Apollo

45 meter mural for swimming pool

MELISSA SWEET

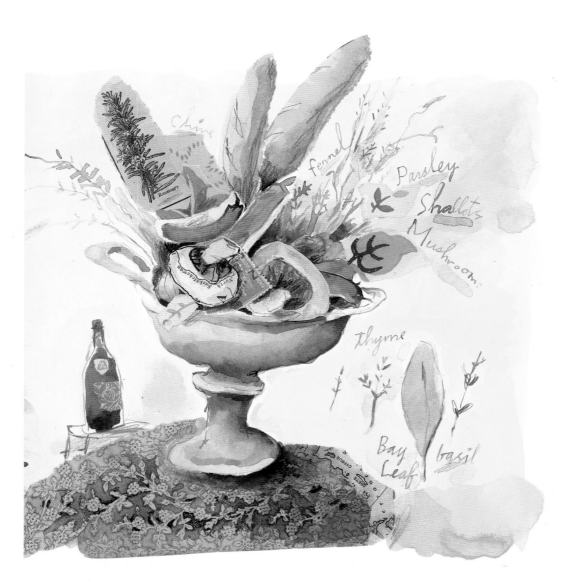

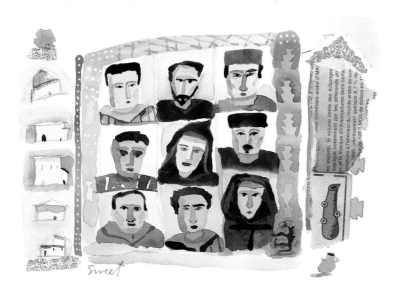

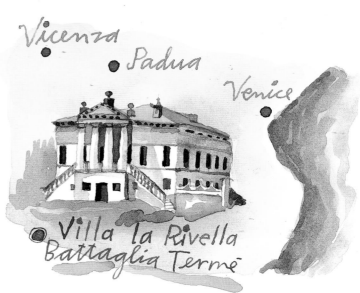

ROSANNE KALOUSTIAN

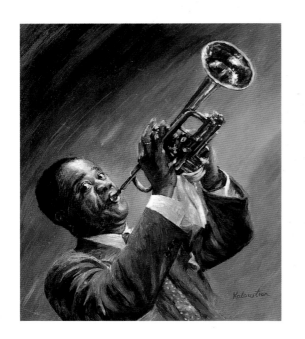

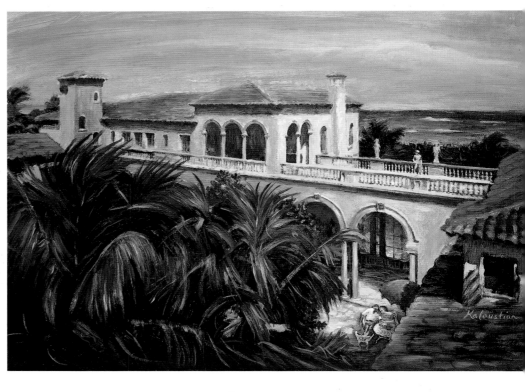

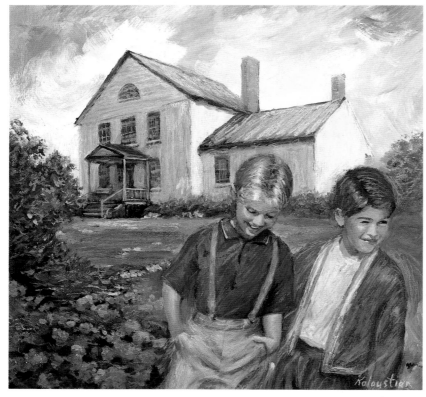

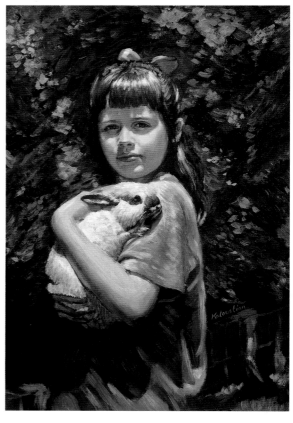

KAZ AIZAWA

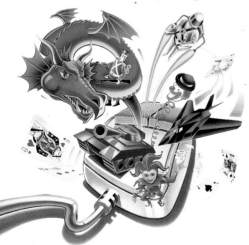

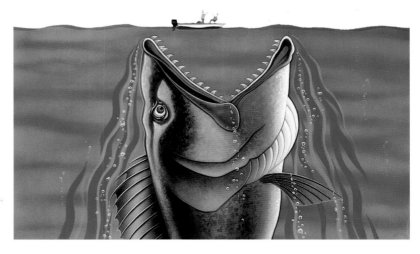

626

TIVADAR BOTE

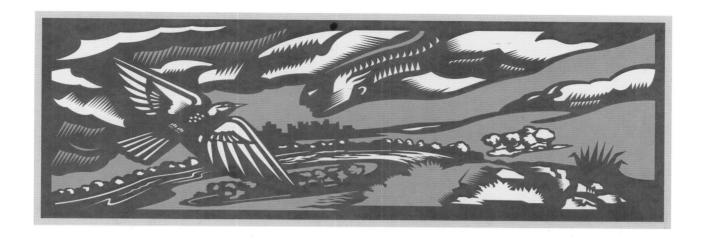

Riccardo Stampatori

Antonio Cangemi

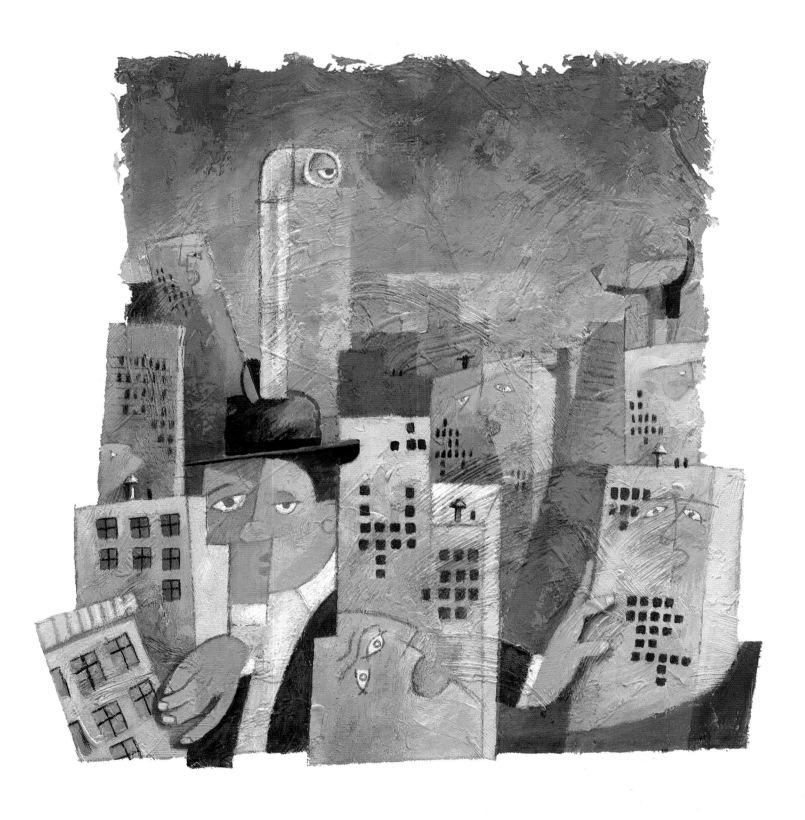

Pierre-Paul Pariseau

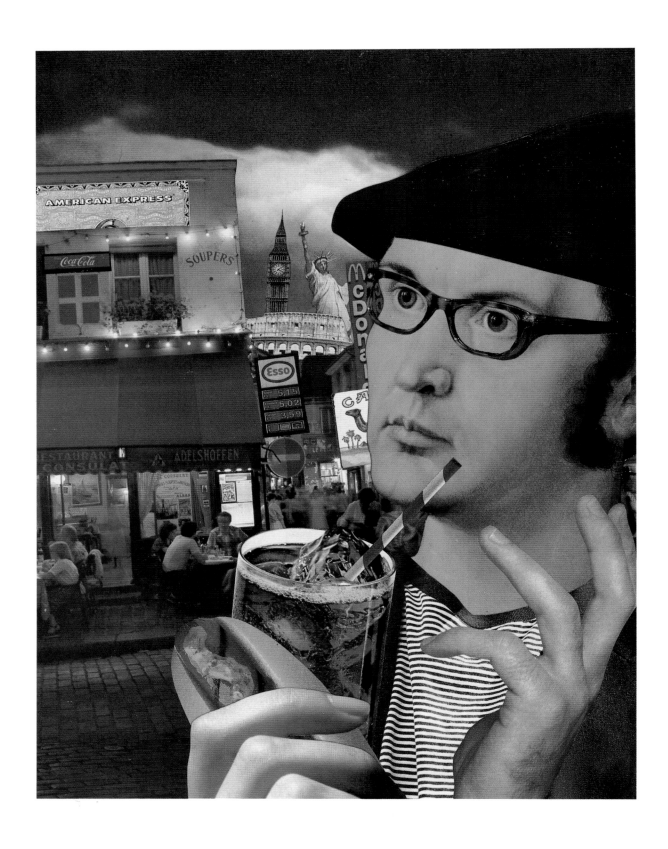

Susan Todd

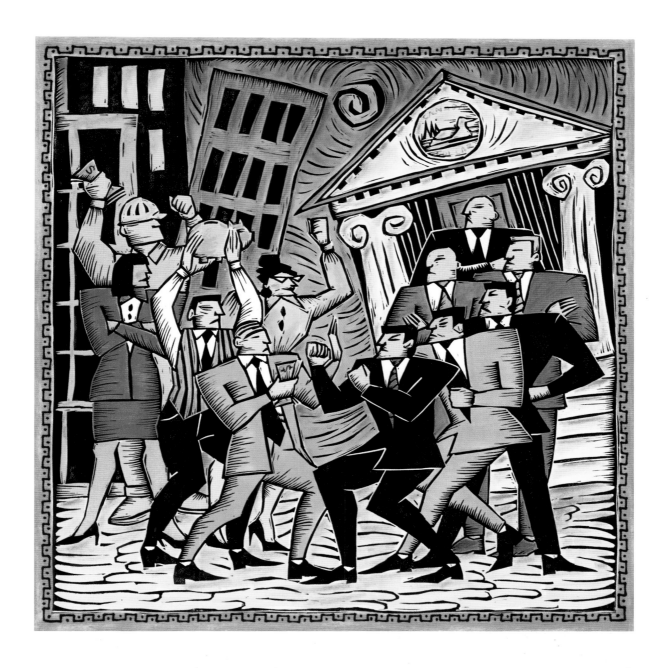

Dave Whamond

toronto 416-367-2446
new york 212-643-0896

312-663-5506 chicago
213-688-7428 los angeles

artist representatives - call for portfolios

Rose Zgodzinski

T.V. SURVEY

WHAT STUDENTS WATCH

SITUATION COMEDIES

75 % 93 % 76 % 74 %

GRADE 9th 10th 11th 12th

INTERVIEW / VARIETY

55 % 45 % 33 % 35 %

GRADE 9th 10th 11th 12th

ANIMATION

70 % 43 % 39 % 61 %

9th 10th 11th 12th GRADE

NEWS

45 % 61 % 42 % 61 %

GRADE 9th 10th 11th 12th

CONTINUING EDUCATION

Should it be mandatory for pharmacists?

81.4 % Strongly agree

11.1 % Neutral

7.5 % Disagree

TOTAL RESPONDENTS: CHAIN/INDEPENDENT COMBINED, 955

Nutritive components

High Carbohydrates Foods 8%

Minerals 4%

Fat/Oil 15%

High Protein Foods 13%

Water 60%

toronto 416-367-2446
new york 212-643-0896

IN A BOX 3

312-663-5506 chicago
213-688-7428 los angeles

artist representatives - call for portfolios

Anne Stanley

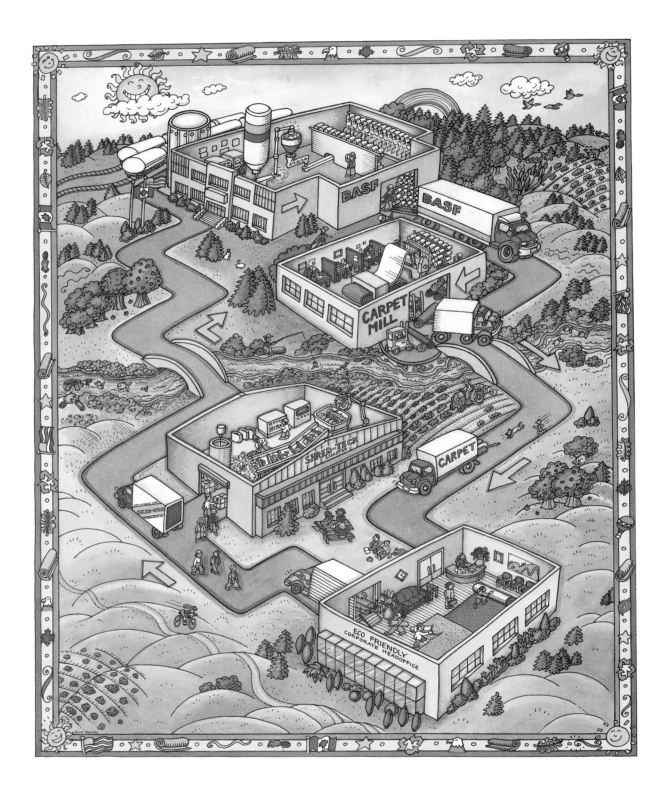

toronto 416-367-2446 312-663-5506 chicago
new york 212-643-0896 213-688-7428 los angeles

artist representatives - call for portfolios

Scot Ritchie

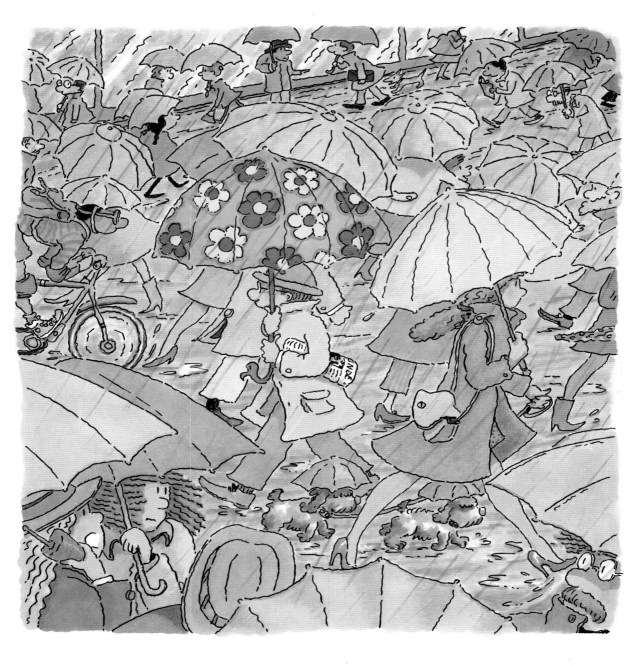

Glen Hanson

636

Kathryn Adams

Jimminy

David Chestnutt

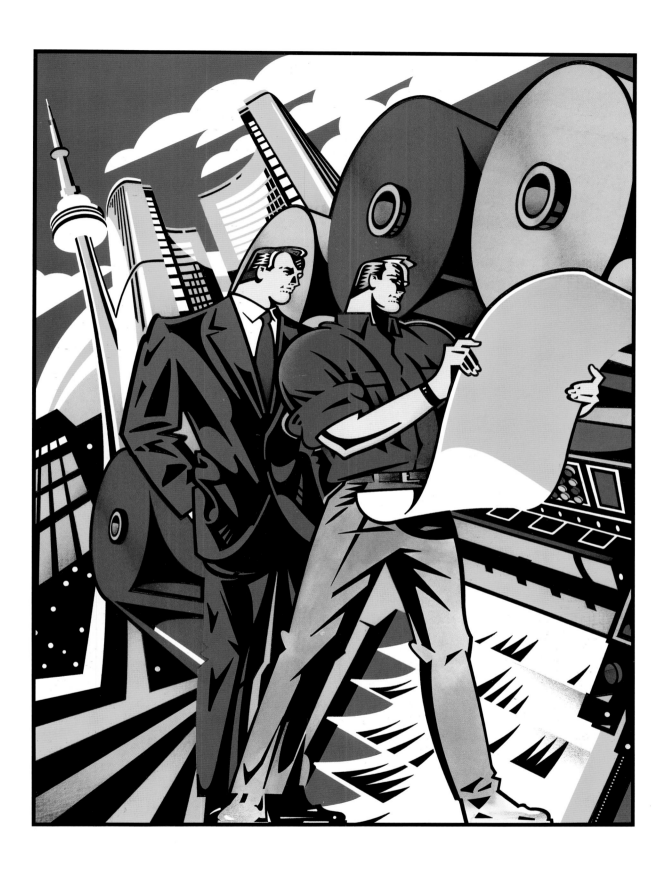

Paul Watson

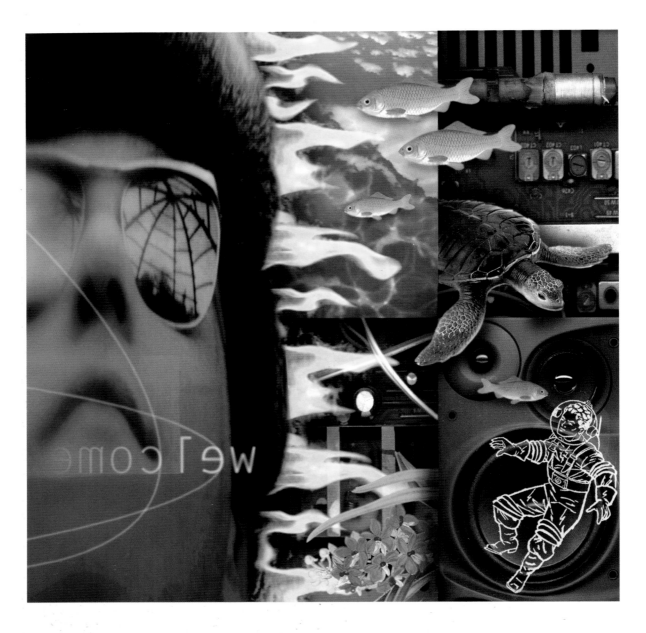

Eric Colquhoun

toronto 416-367-2446 312-663-5506 chicago
new york 212-643-0896 213-688-7428 los angeles

artist representatives - call for portfolios

DAVID TILLINGHAST

PHONE : 818-403-0991 1003 DIAMOND AVENUE • SUITE 200 • SOUTH PASADENA • 91030 FAX: 818-403-0993

REPRESENTED ON THE WEST COAST BY COREY GRAHAM REPRESENTS 415-956-4750

DAVID TILLINGHAST

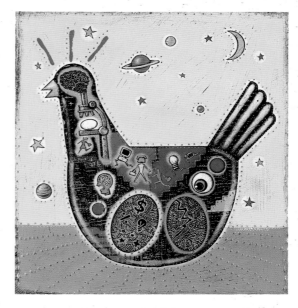

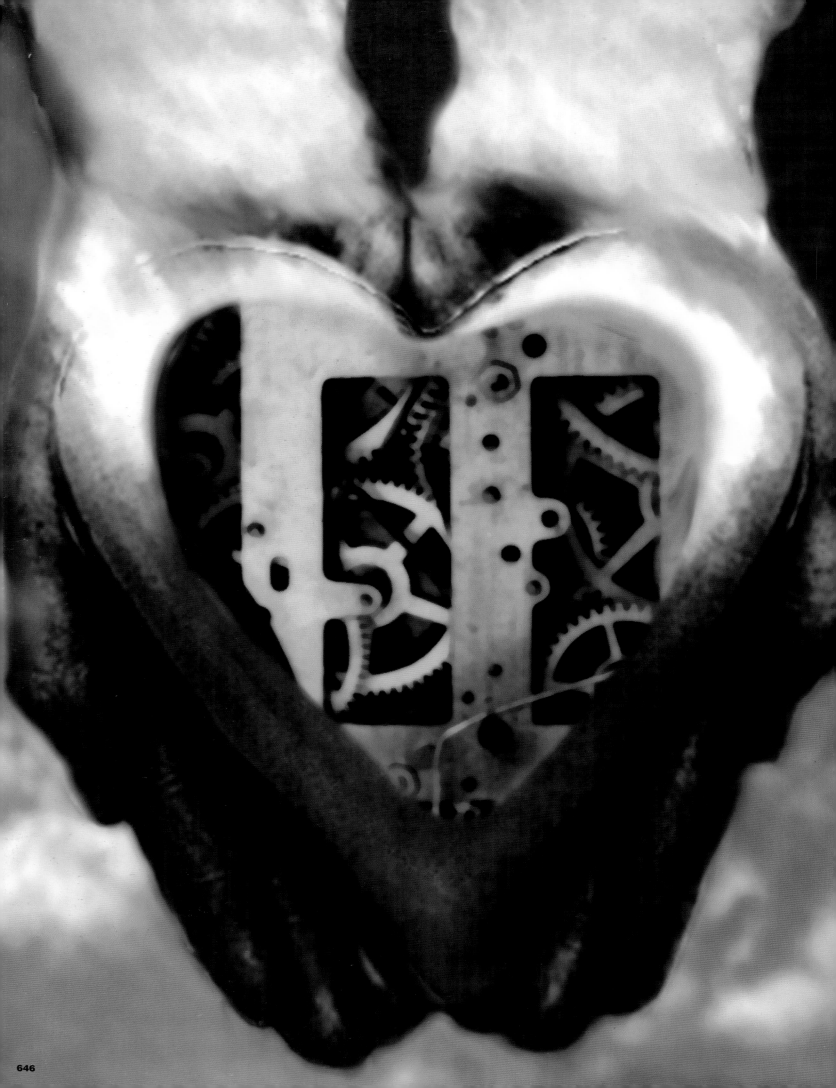

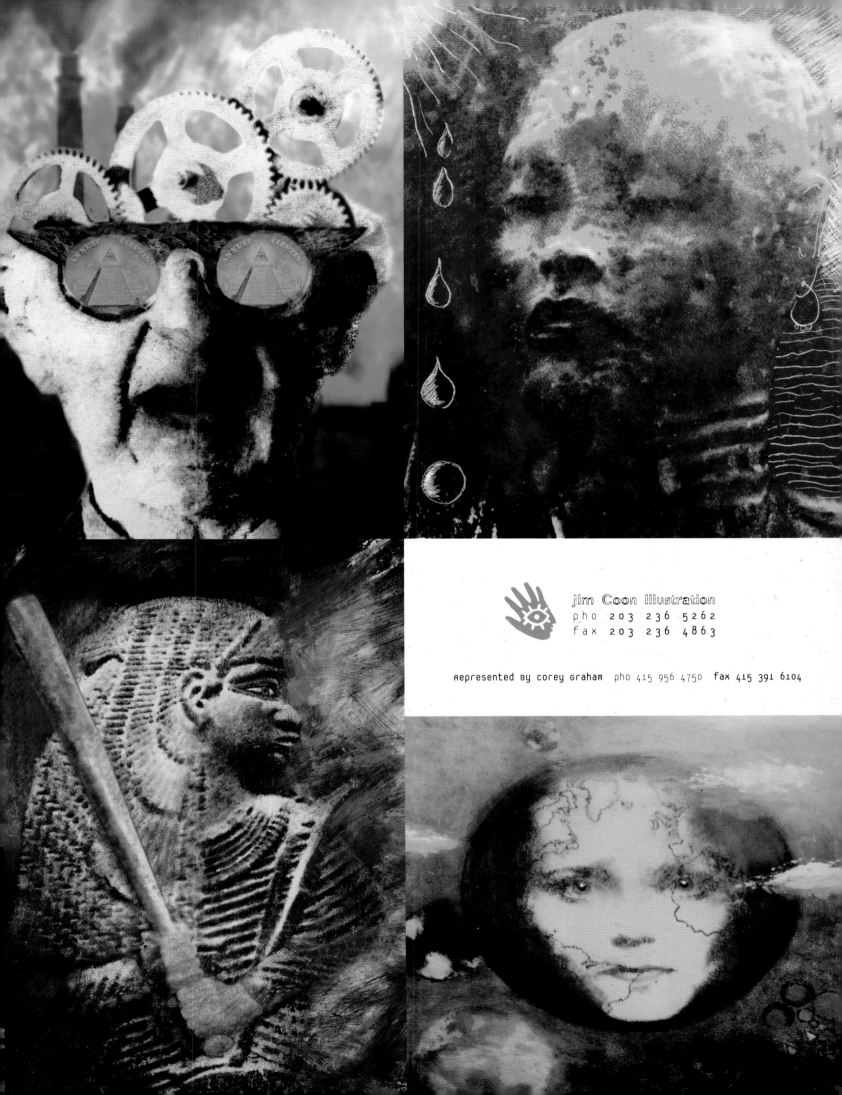

Jim Coon Illustration
pho 203 236 5262
fax 203 236 4863

Represented by corey graham pho 415 956 4750 fax 415 391 6104

FRANK ANSLEY

415.989.9614
fax 415.989.9630

Charles Schwab

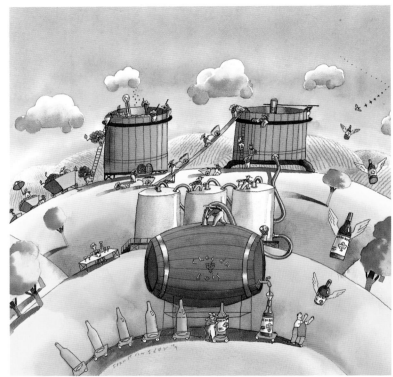

Clos du Bois

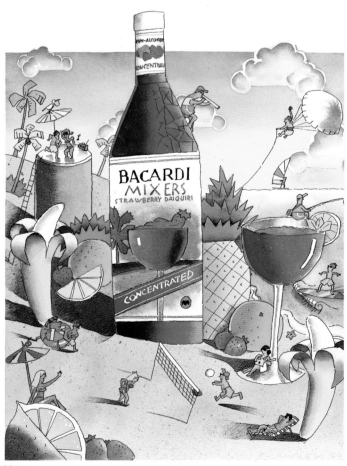

Lintas

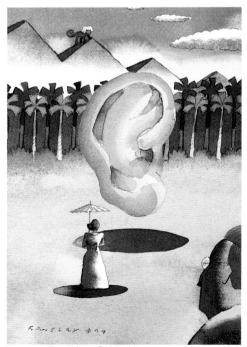

Firewater Films/Metro Publishing

COREY GRAHAM REPRESENTS
PIER 33 NORTH
SAN FRANCISCO CA 94111
415-956-4750
FAX 415-391-6104

648

FRANK ANSLEY

415.989.9614
fax 415.989.9630

Charles Schwab

Health Progress Magazine

Nuclear Energy Institute

Outlook Magazine

J.P. Morgan

Animation Reel Available.

COREY GRAHAM REPRESENTS
PIER 33 NORTH
SAN FRANCISCO CA 94111
415-956-4750
FAX 415-391-6104

COREY GRAHAM
REPRESENTS
PIER 33 NORTH
SAN FRANCISCO
9 4 1 1 1
415 956 4750
FAX 391 6104

ROGER BOEHM

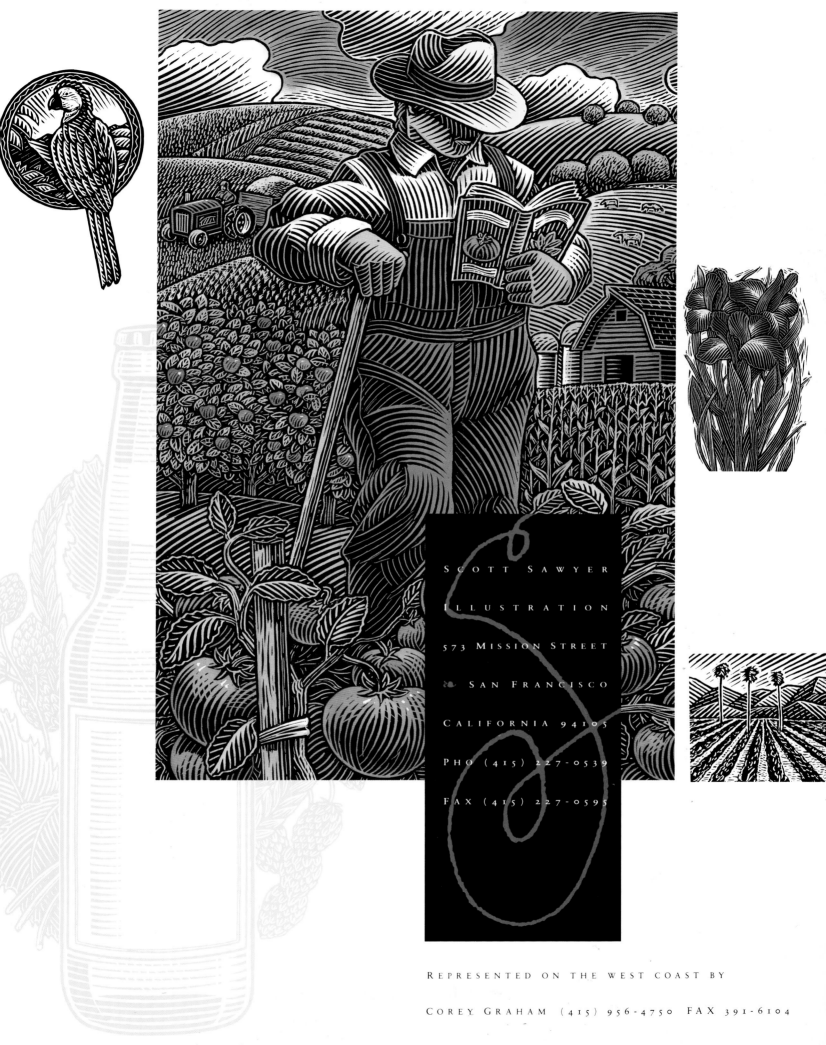

SCOTT SAWYER

ILLUSTRATION

573 MISSION STREET

SAN FRANCISCO

CALIFORNIA 94105

PHO (415) 227-0539

FAX (415) 227-0595

REPRESENTED ON THE WEST COAST BY

COREY GRAHAM (415) 956-4750 FAX 391-6104

651

PEG MAGOVERN

510.648.1444

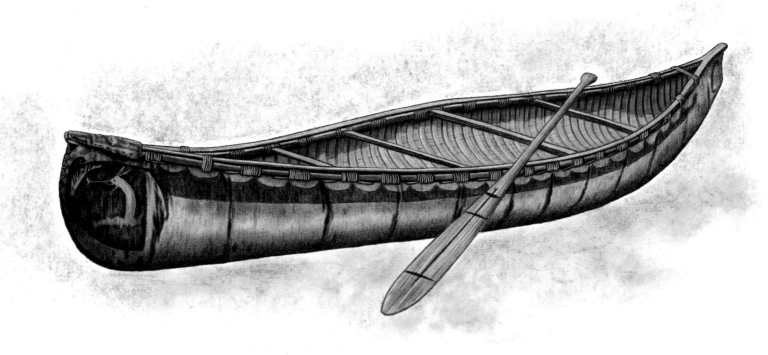

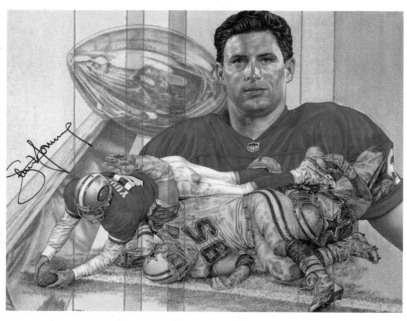

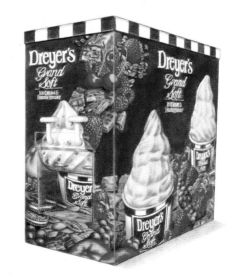

COREY GRAHAM REPRESENTS
PIER 33 NORTH
SAN FRANCISCO CA 94111
415-956-4750
FAX 415-391-6104

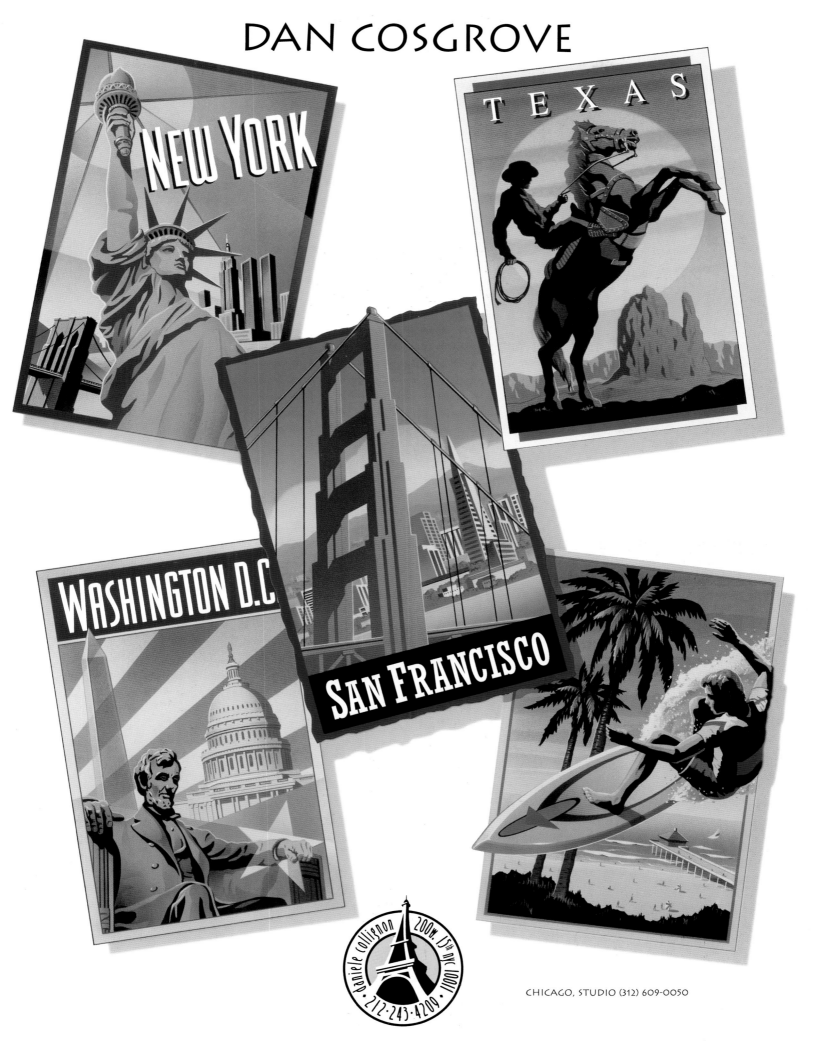

DAN COSGROVE

NEW YORK

TEXAS

WASHINGTON D.C.

SAN FRANCISCO

daniele collignon 200 w. 15th nyc 10011 · 212·243·4209

CHICAGO, STUDIO (312) 609-0050

HARVEY CHAN

daniele collignon 200 w. 15th nyc 10011
212·243·4209

HARVEY CHAN

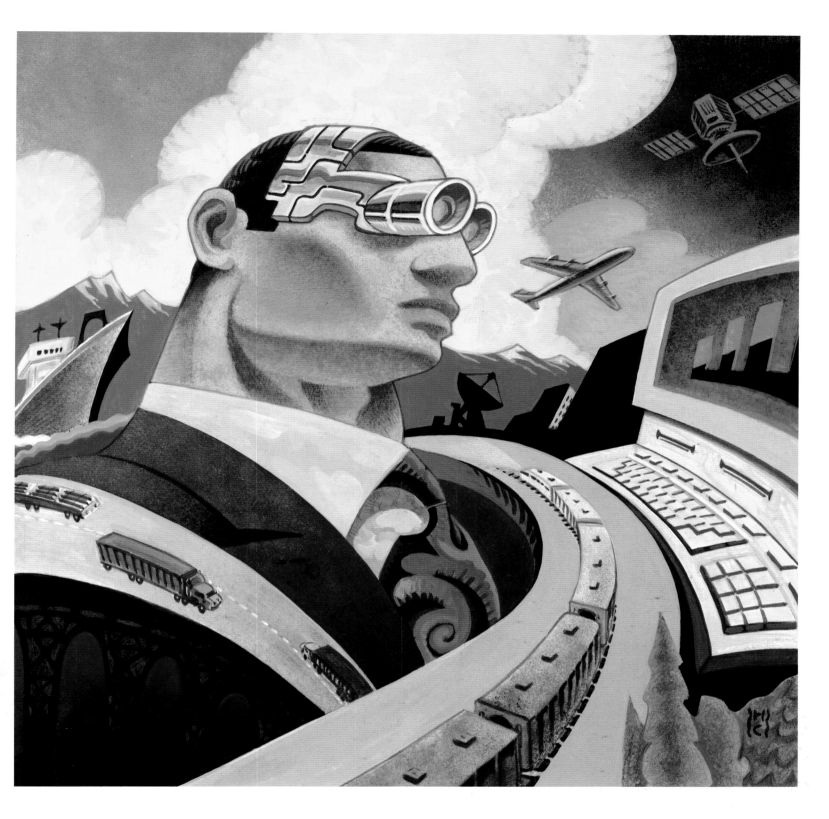

DENNIS ZIEMIENSKI

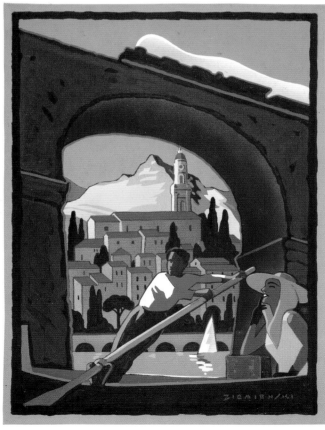

VICKI YIANNIAS

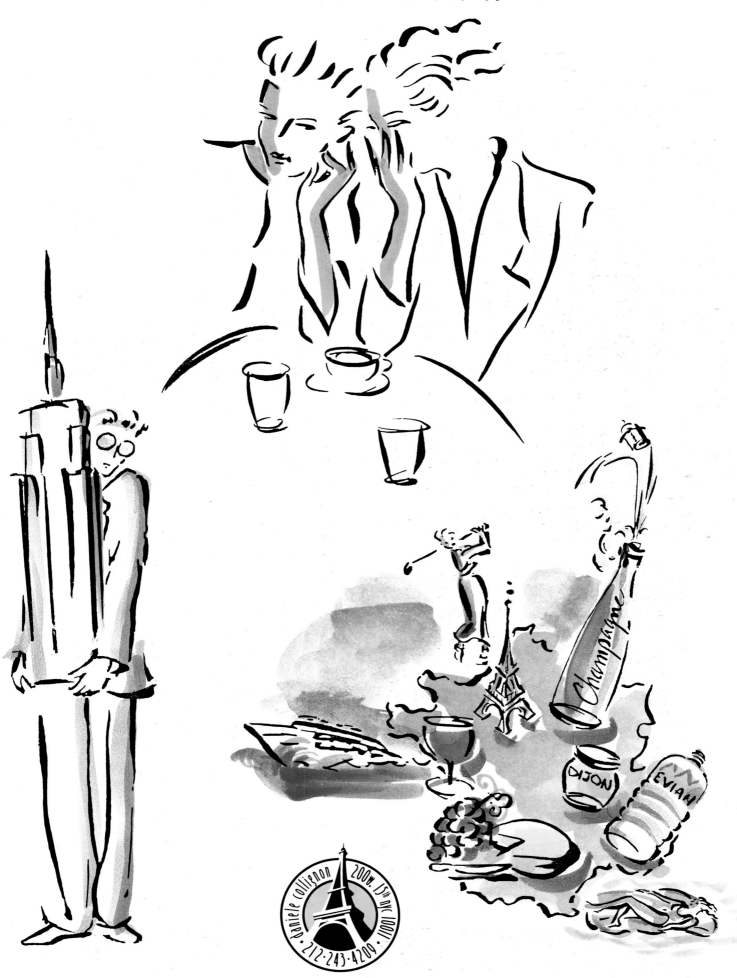

DIANNE BENNETT

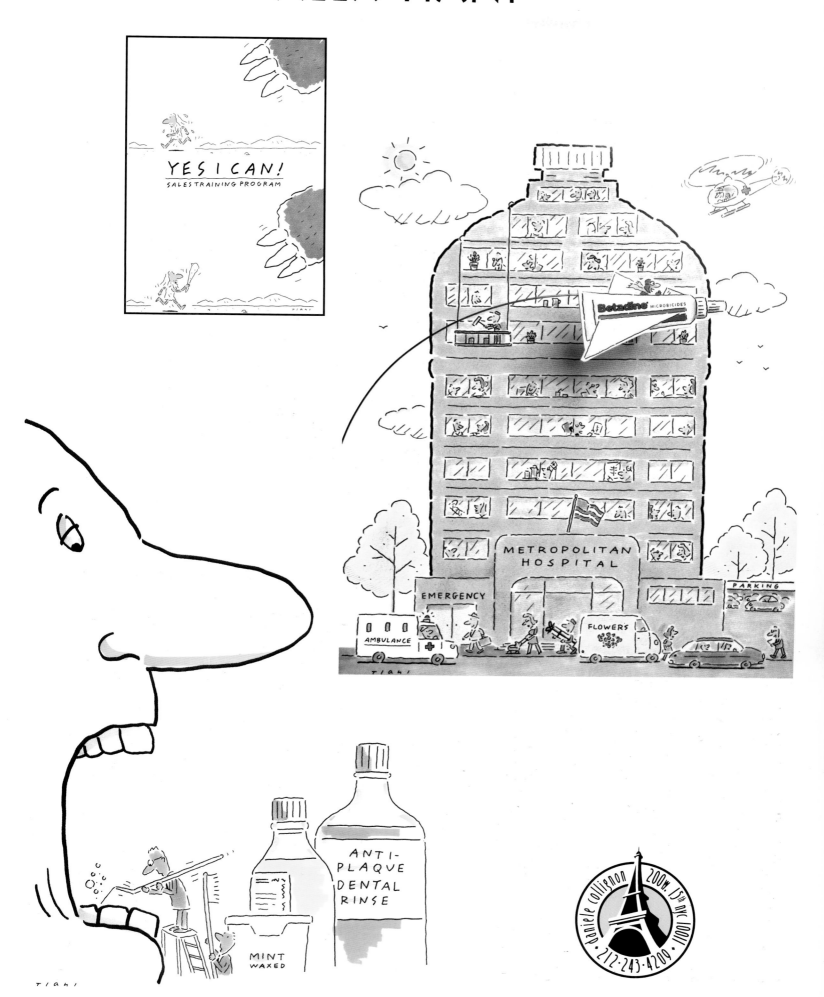

BF

·
BILL
FRAM
PTON
·

daniele collignon 200 w. 15th nyc 10011
212·243·4209

DON WELLER

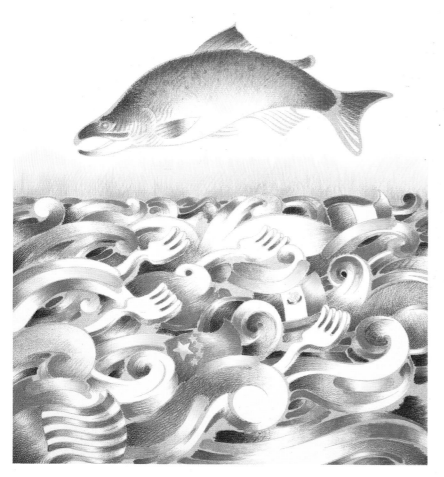

NAN BROOKS

♥ Represented by ♥

WENDE CAPORALE

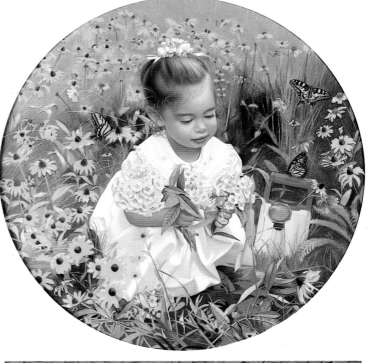

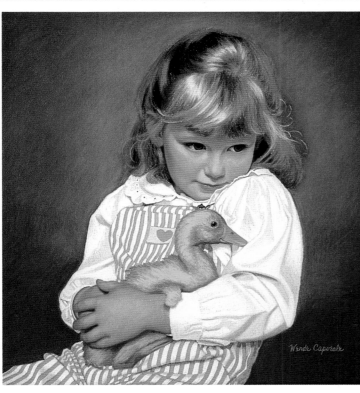

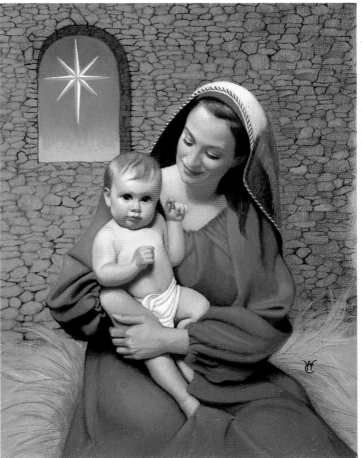

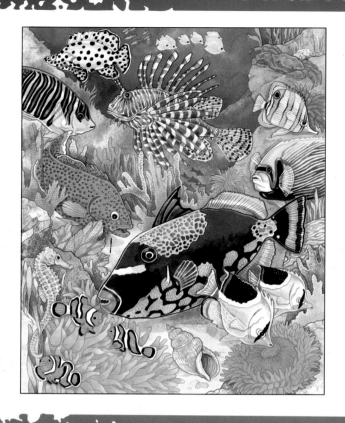

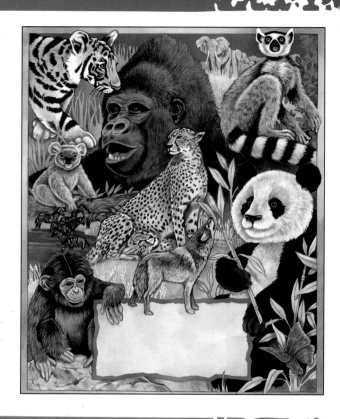
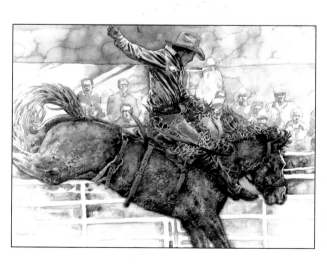
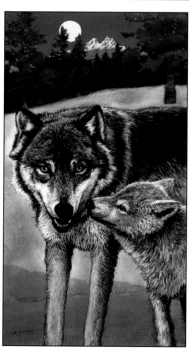
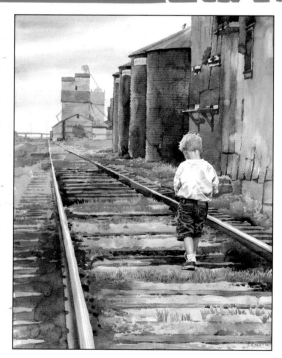

ROBERT EVANS

Computer and Traditional Illustration 415·397·5322

Photoshop

Photoshop

3-D Modeling

Photoshop

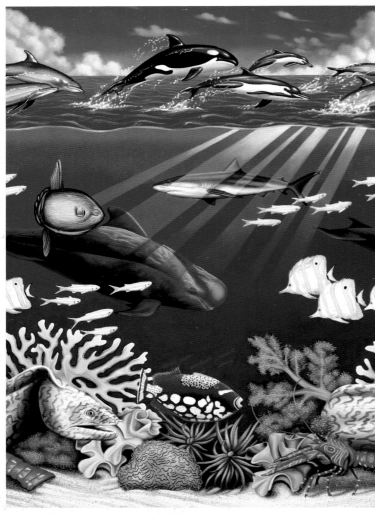

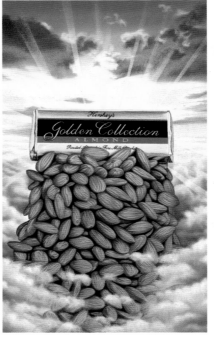
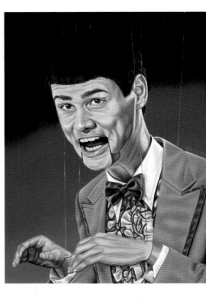
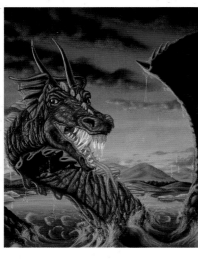
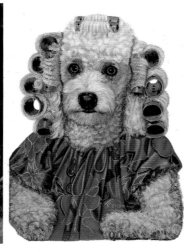
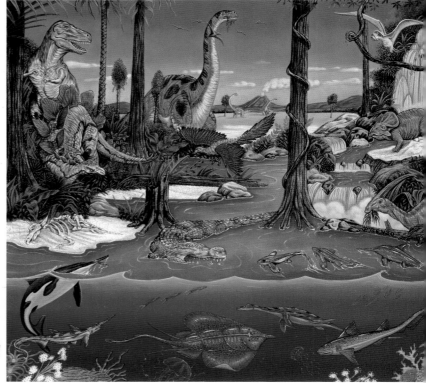

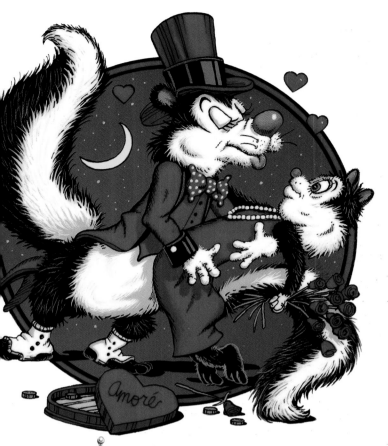

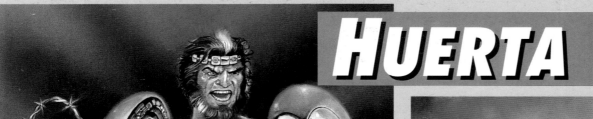
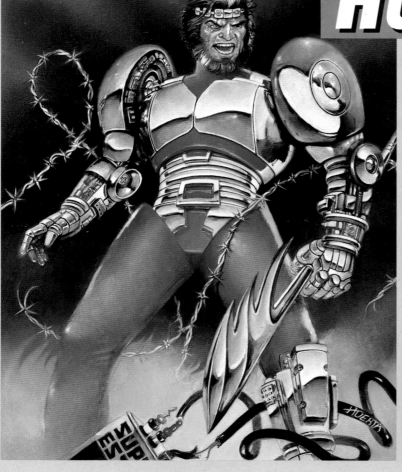
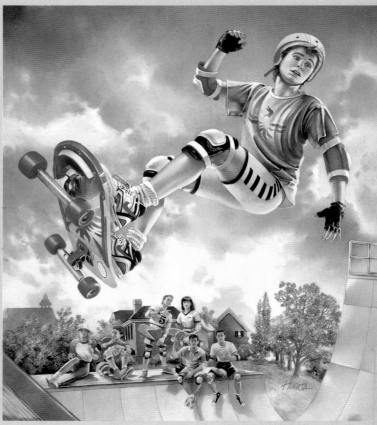
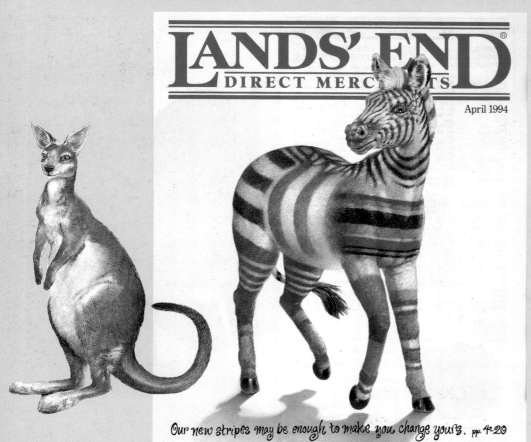

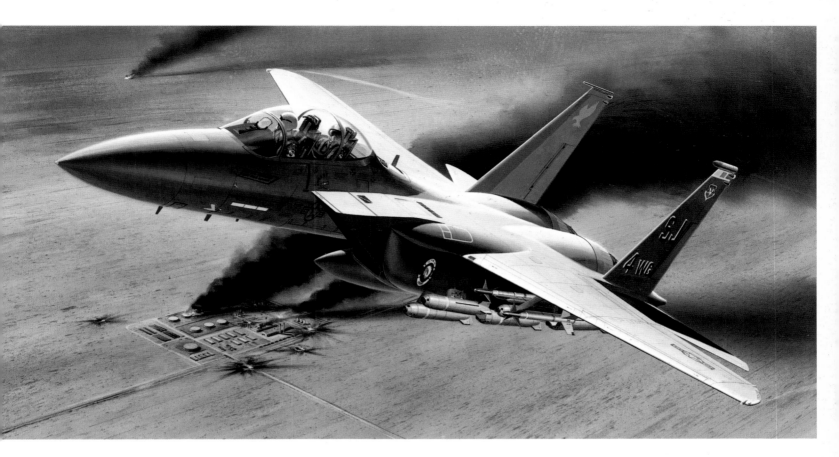
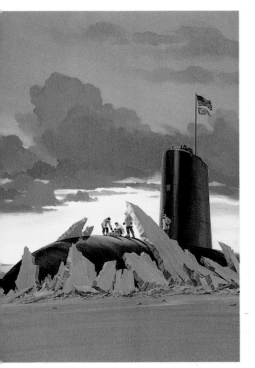
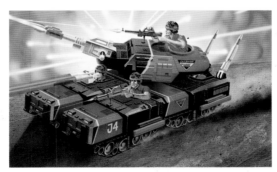
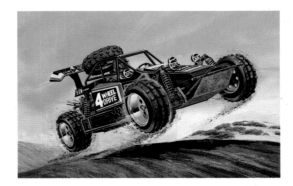

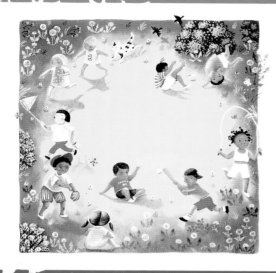
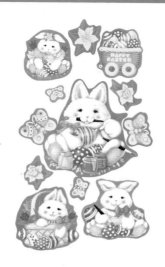
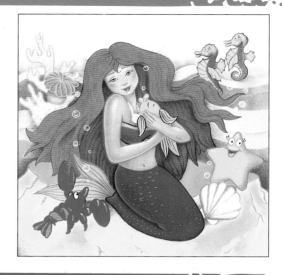

KIMBERLY KNOLL

KATHLEEN DUNNE

Rosenthal **RR** Represents

• 3850 EDDINGHAM AVE. • CALABASAS, CA 91302 •
• (818) • 222 • 5445 • FAX • (818) • 222 • 5650 •

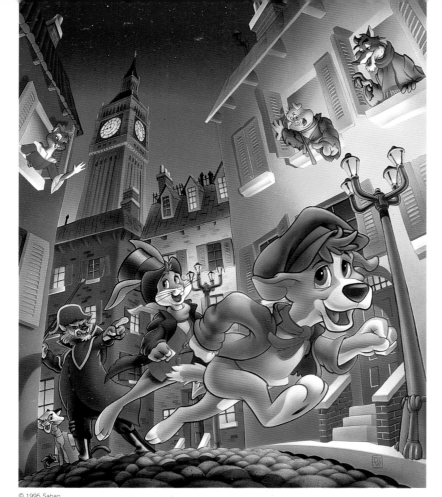

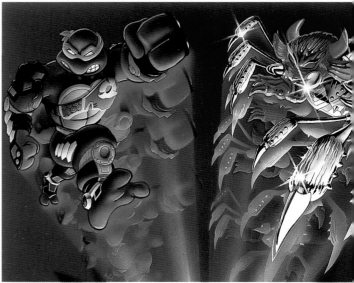

Dirk J. Wunderlich

818 . 763 . 4848

Fax 818 . 752 . 9977

Rosenthal Represents

3850 Eddingham Avenue

Calabasas, CA 91302

818 . 222 . 5445

Fax 818 . 222 . 5650

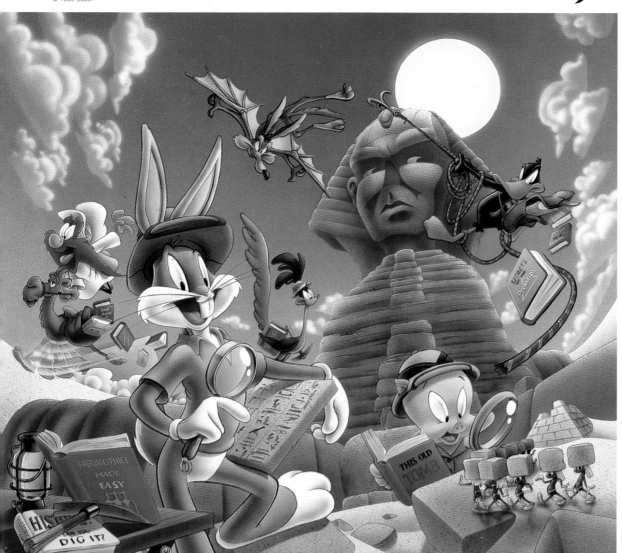

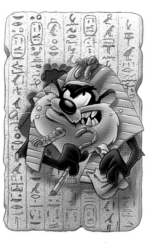

MARY ROSS

SUCCESS

NEW PARADIGMS

The only way to have a friend is to be one

A true friend is the best possession

DON DUDLEY

RON PETERSON

ELIZABETH TRAYNOR

RITA GATLIN REPRESENTS

USA 800.924.7881 SF 415.924.7881 FAX 415.924.7891

TOM HENNESSY

RITA GATLIN REPRESENTS

USA 800.924.7881 **SF** 415.924.7881 **FAX** 415.924.7891

REPRESENTED BY TRICIA WEBER

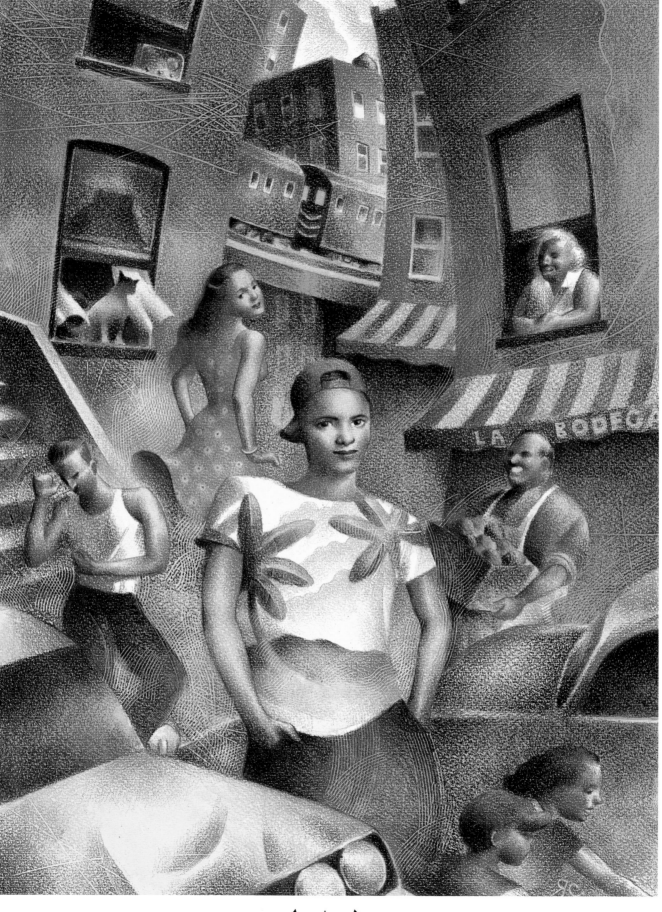

125 W. 77TH ST. N.Y.C. 10024

http://www.interport.net/WeberGroup

THE WEBER GROUP

P: 212-799-6532 F: 212-769-8833

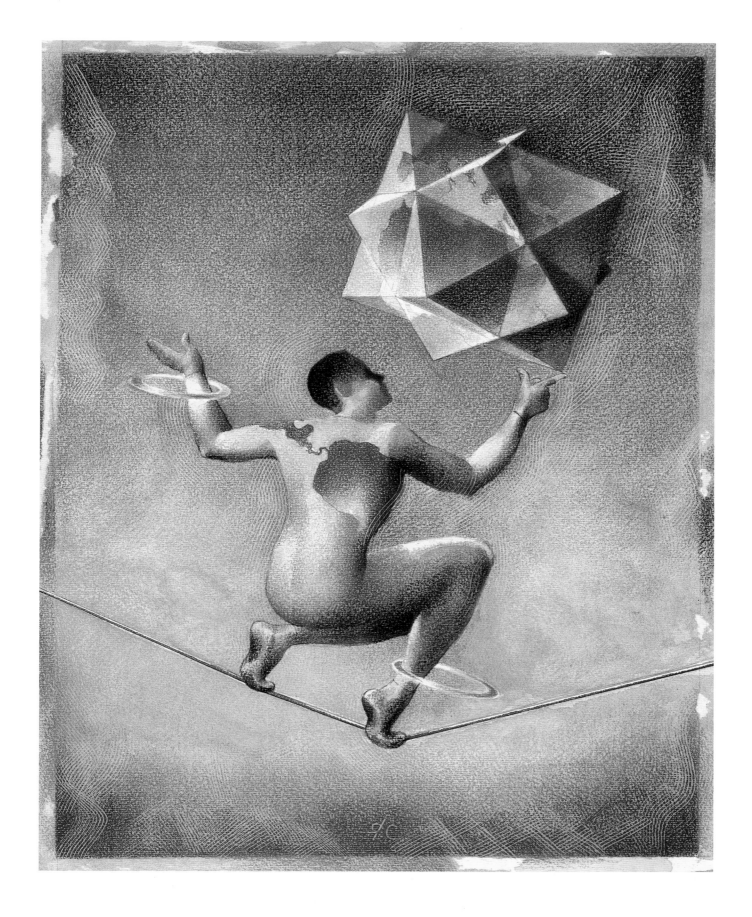

THE WEBER GROUP

P: 212-799-6532 F: 212-769-8833

REPRESENTED BY TRICIA WEBER

125 W. 77TH ST. N.Y.C. 10024

http://www.interport.net/WeberGroup

THE WEBER GROUP

P: 212-799-6532 F: 212-769-8833

P: 212-799-6532 F: 212-769-8833

THE WEBER GROUP

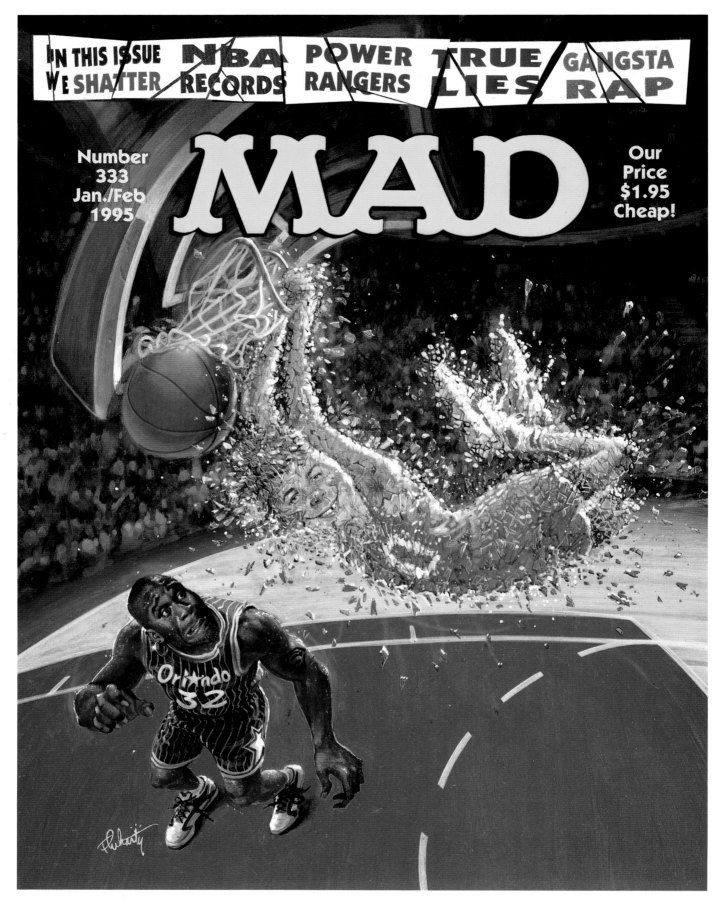

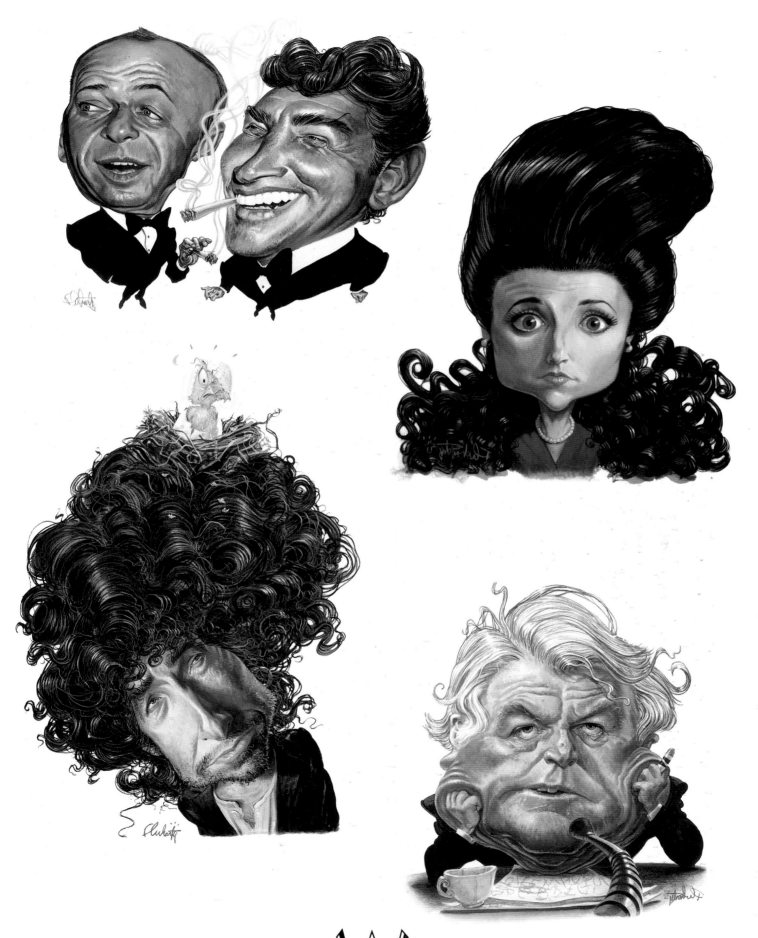

125 W. 77TH ST. N.Y.C. 10024

http://www.interport.net/WeberGroup

P: 212-799-6532 F: 212-769-8833

THE WEBER GROUP

REPRESENTED BY TRICIA WEBER

http://www.interport.net/WeberGroup

125 W. 77TH ST. N.Y.C. 10024

THE WEBER GROUP

P: 212-799-6532 F: 212-769-8833

125 W. 77TH ST. N.Y.C. 10024

THE WEBER GROUP

P: 212-799-6532 F: 212-769-8833

ELLEN WEINSTEIN

REPRESENTED BY TRICIA WEBER

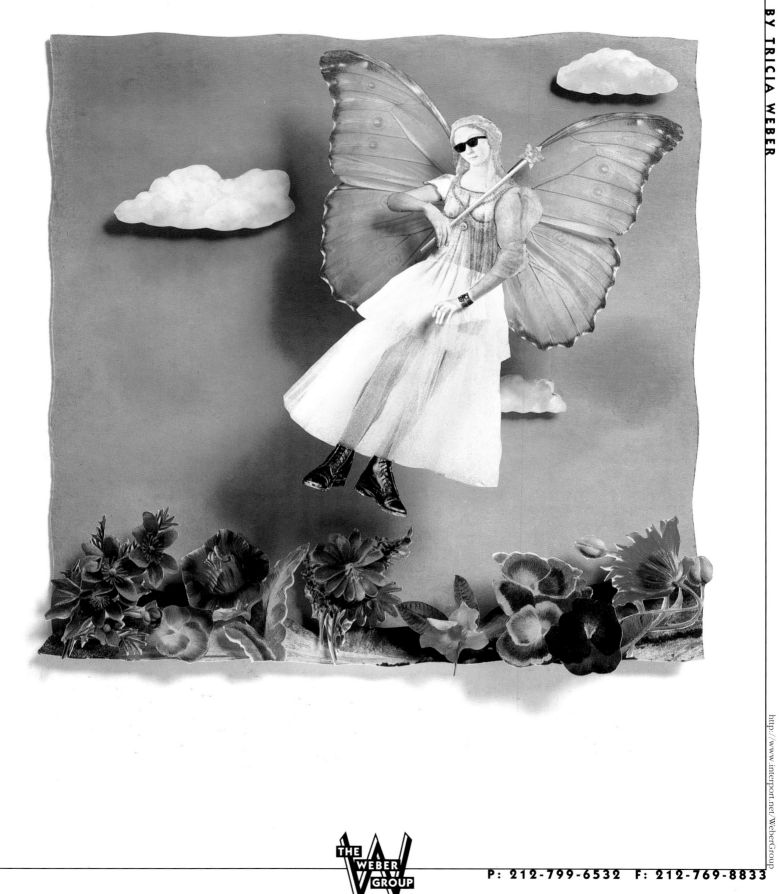

125 W. 77TH ST. N.Y.C. 10024

http://www.interport.net/WeberGroup

THE
WEBER
GROUP

P: 212-799-6532 F: 212-769-8833

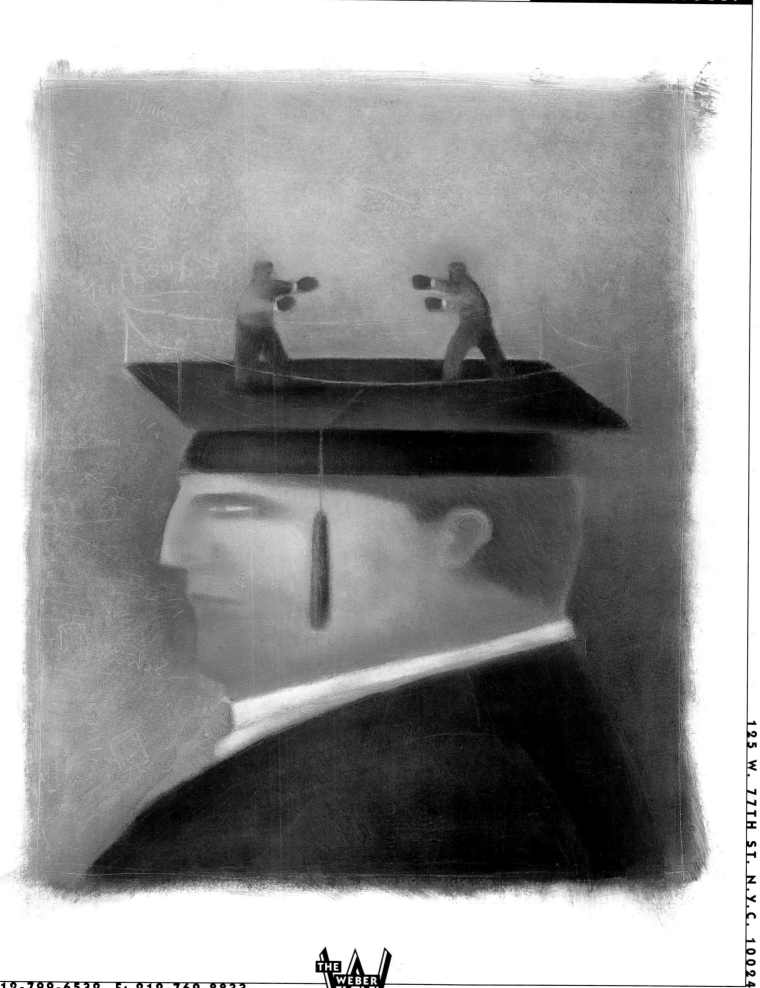

P: 212-799-6532 F: 212-769-8833

125 W. 77TH ST. N.Y.C. 10024

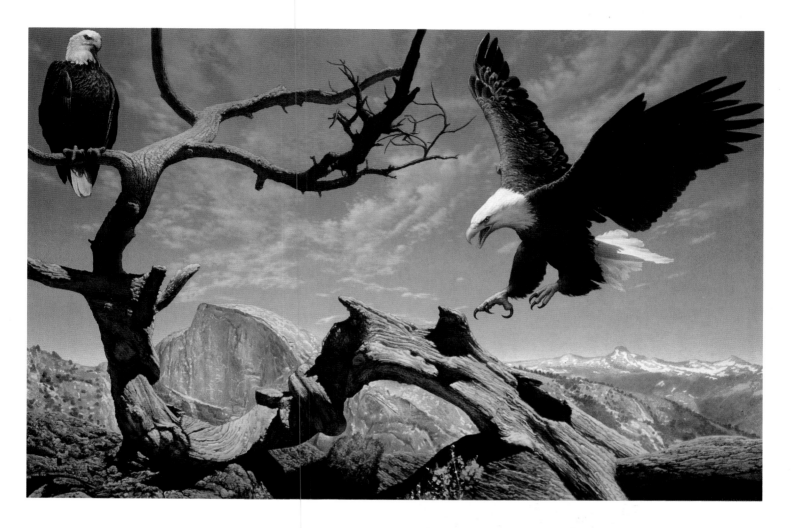
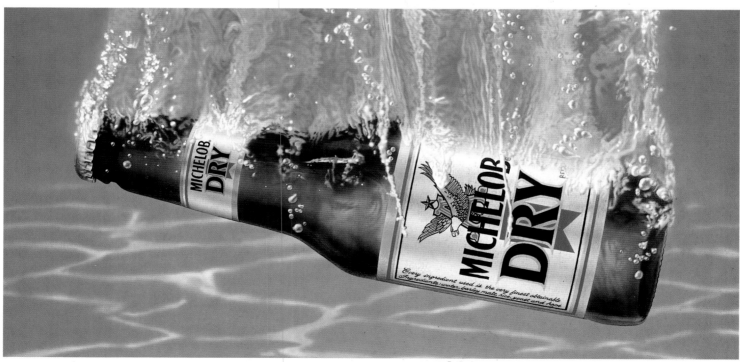

PAUL ROGERS

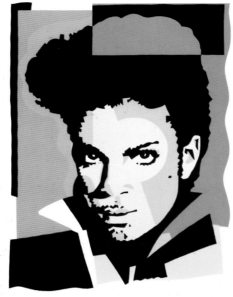
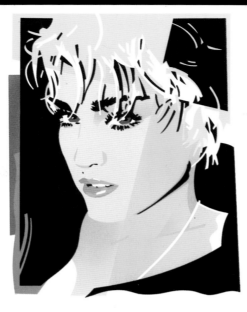
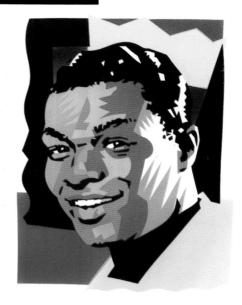

PAUL ROGERS

RITA MARIE
RODNEY RAY

los angeles (213)934-3395 fax (213)936-2757
chicago (312)222-0337 fax (312)883-0375

WILLIAM RIESER

WILLIAM RIESER

RICK FARRELL

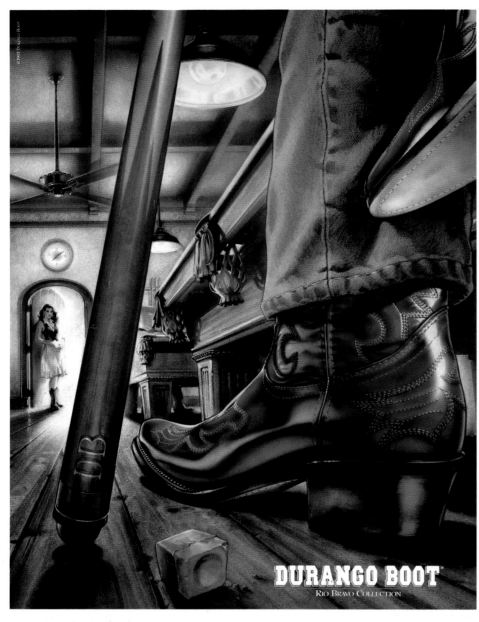

DURANGO BOOT
Rio Bravo Collection

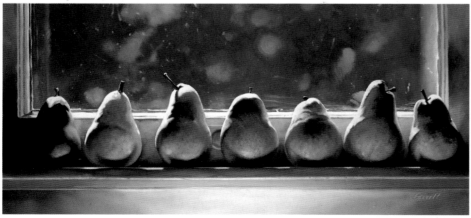

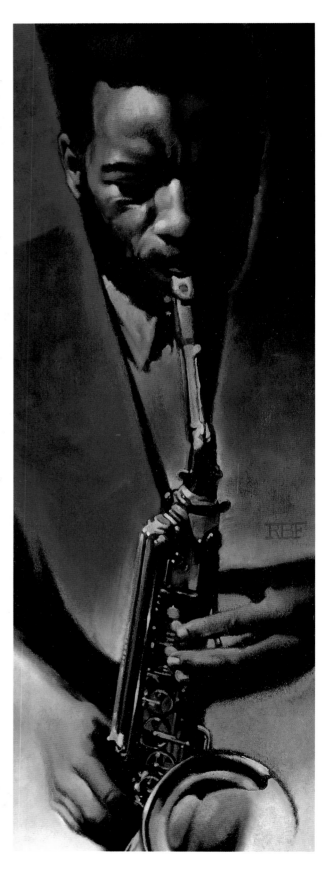

694

DANNY SMYTHE

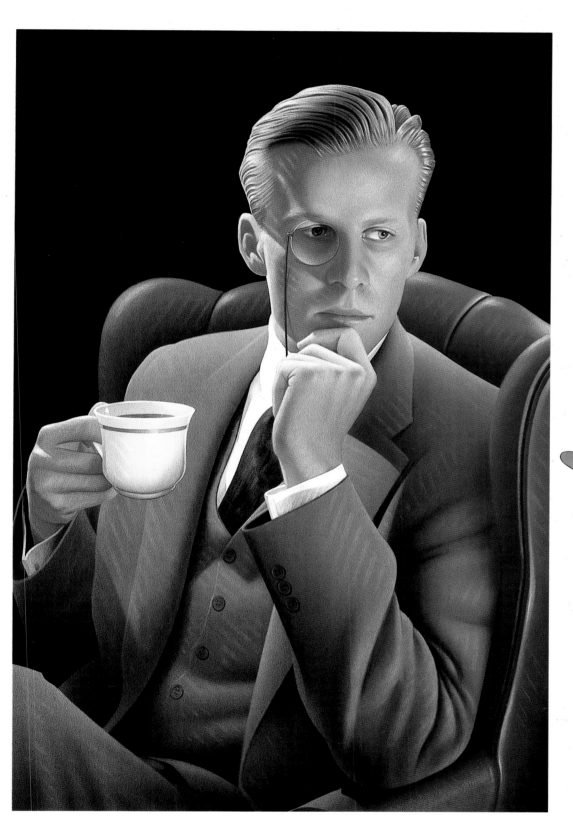

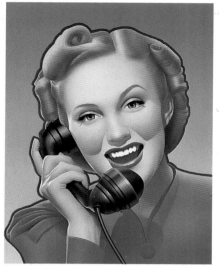

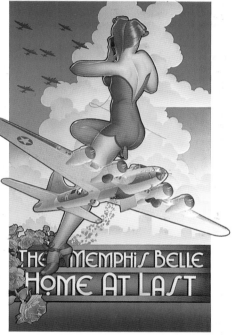

THE MEMPHIS BELLE
HOME AT LAST

CREATIVE FREELANCERS

REPRESENTING

CLIFFORD FAUST

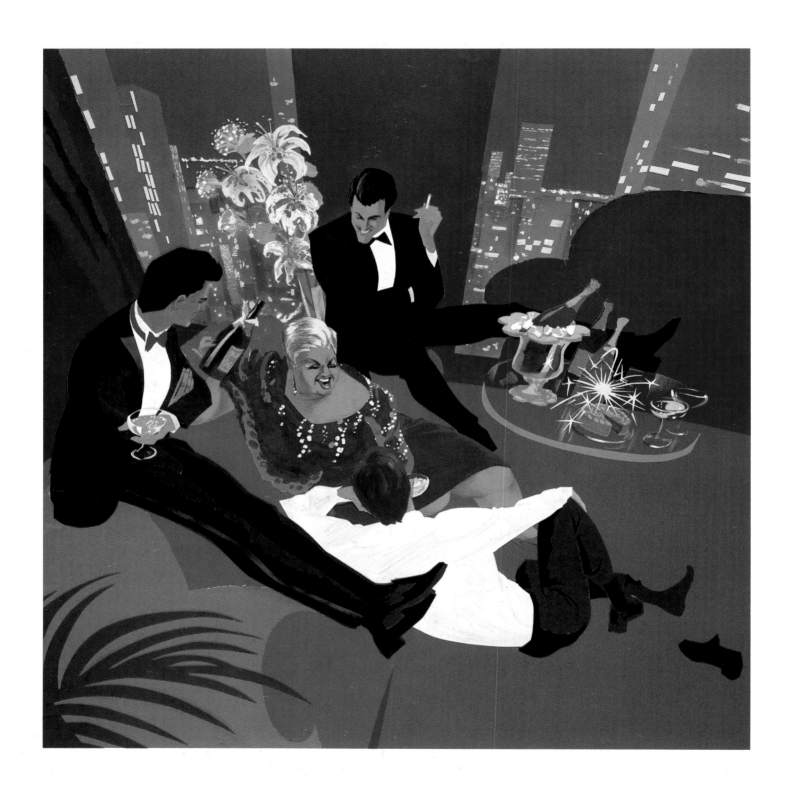

REPRESENTING

CHRIS CELUSNIAK

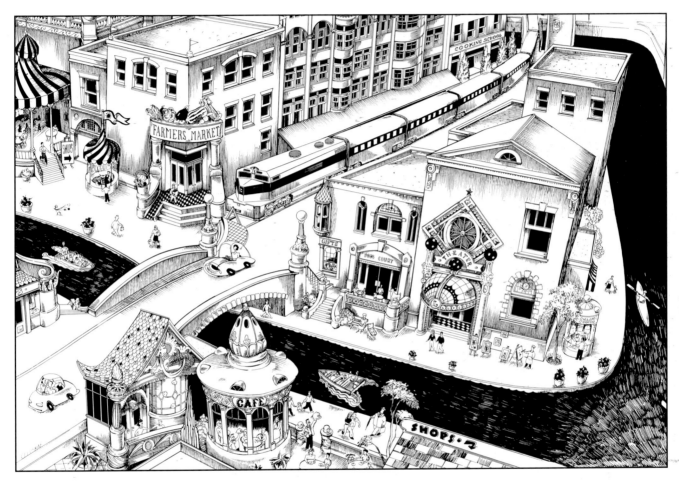

FOR MORE SAMPLES OF THIS ARTIST, PLEASE SEE VOLUME #17-PG 469 & #18-PG 533.
THE ILLUSTRATION GROUP (800) 398-9544 25 WEST 45TH ST., NEW YORK, N.Y. 10036 FAX (212) 398-9547

REPRESENTING
RICK GEARY JIM OWENS
LOU VACCARO QUENTIN WEBB

QUENTIN WEBB

JIM OWENS
See Vol. #15 Pg. 460, Vol. #17 Pg. 468 & Vol. #18 Pg. 526.

LOU VACCARO

RICK GEARY See Vol. #16 Pg. 472, Vol. #17 Pg. 473 & Vol. #18 Pg. 526.

REPRESENTING
GEO SIPP

REPRESENTING

KEITH LARSON MERKLEY
DAVID TAMURA WINSTON TRANG

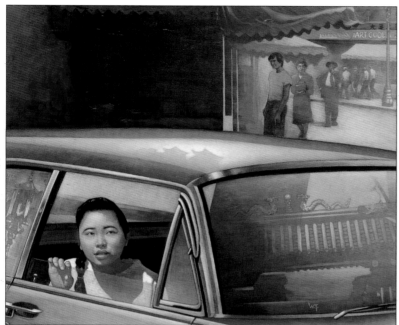

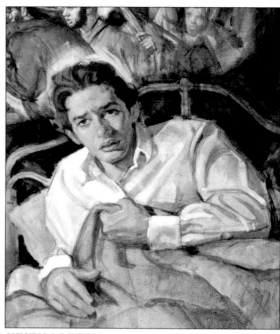

WINSTON TRANG

KEITH LARSON

MERKLEY

DAVID TAMURA

REPRESENTING

GREG NEWBOLD

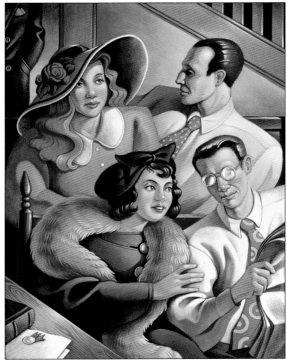

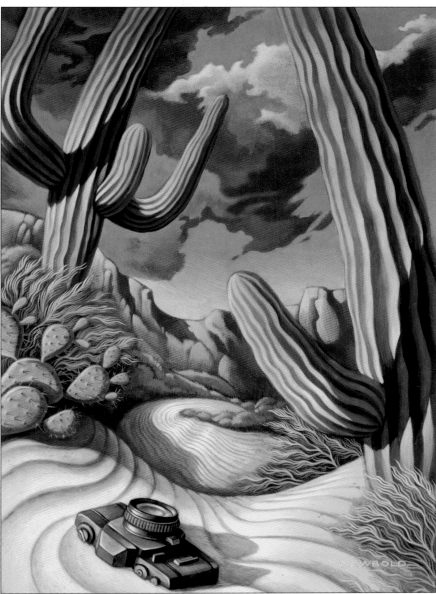

CREATIVE FREELANCERS

MARCEL BORDEI CAROLYN CARPENTER
JAMES COOPER, M.D. A.J. MILLER

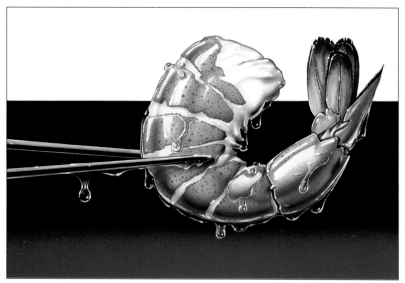

A.J. MILLER
See Vol. #14 Pg. 280.

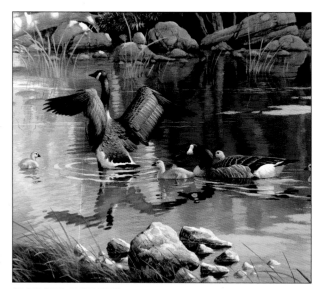

MARCEL BORDEI

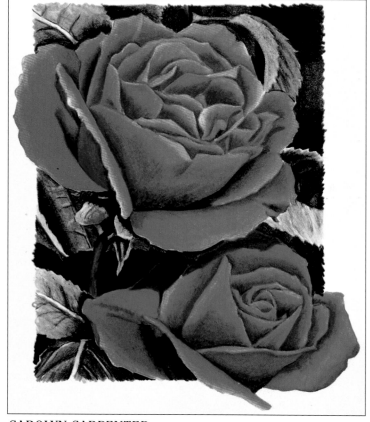

CAROLYN CARPENTER

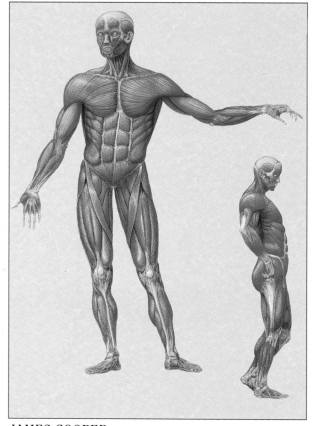

JAMES COOPER
See Vol. #17 Pg. 476.

FOR MORE SAMPLES, PLEASE SEE VOLUME AND PAGE NOTED OR CALL FOR A PRESENTATION.
THE ILLUSTRATION GROUP (800) 398-9544 25 WEST 45TH ST., NEW YORK, N.Y. 10036 FAX (212) 398-9547

CREATIVE FREELANCERS

REPRESENTING

JOHN EDENS CHET JEZIERSKI
ROB LAWSON GLEN TARNOWSKI

JOHN EDENS
See Vol. #12 Pg. 365.

GLEN TARNOWSKI
See Vol. #14 Pg. 297.

ROB LAWSON See Vol. #16 Pg. 471,
Vol. #17 Pg. 471 & Vol. #18 Pg. 534.

CHET JEZIERSKI See Vol. #15 Pg. 279,
Vol. #16 Pg. 471 & Vol #17 Pg. 476.

FOR MORE SAMPLES, PLEASE SEE VOLUME AND PAGE NOTED OR CALL FOR A PRESENTATION.
THE ILLUSTRATION GROUP (800) 398-9544 25 WEST 45TH ST., NEW YORK, N.Y. 10036 FAX (212) 398-9547

CREATIVE FREELANCERS

REPRESENTING

STEPHEN BORNSTEIN ROGER CHANDLER
JIM DELAPINE STEVE SULLIVAN

COMPUTER ARTISTS

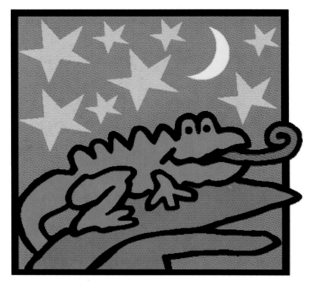

STEVE SULLIVAN
See Vol. #16 Pg. 464 & Vol. #17 Pg. 476.

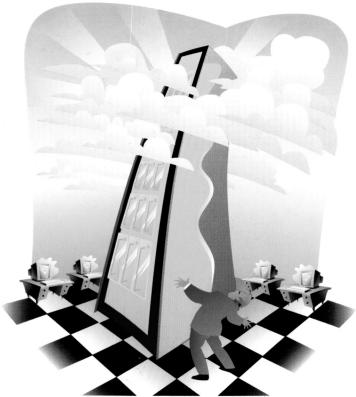

ROGER CHANDLER
See Vol. #17 Pg. 467 & Vol. #18 Pg. 532.

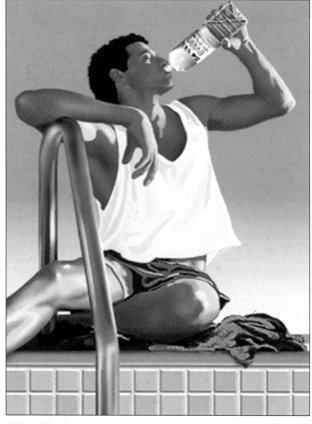

JIM DELAPINE
See Vol. #18 Pg.530.

STEPHEN BORNSTEIN

FOR MORE SAMPLES, PLEASE SEE VOLUME AND PAGE NOTED OR CALL FOR A PRESENTATION.
THE ILLUSTRATION GROUP (800) 398-9544 25 WEST 45TH ST., NEW YORK, N.Y. 10036 FAX (212) 398-9547

REPRESENTING
YEMI
COMPUTER & TRADITIONAL ILLUSTRATION

USA [206] 467 . 9156 FAX [206] 467 . 8730

CANADA [604] 684 . 6826 FAX [604] 733 . 4422

J O H N B O L E S K Y

REP•ART

ARTISTS' REPRESENTATIVES

USA [206] 467 . 9156 FAX [206] 467 . 8730

CANADA [604] 684 . 6826 FAX [604] 733 . 4422

Also in Showcase 18, page 763

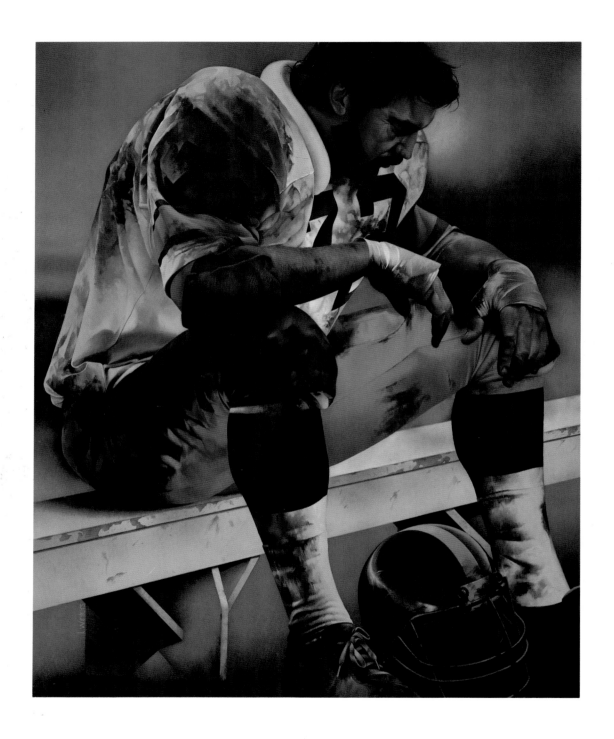

USA [206] 467 . 9156 FAX [206] 467 . 8730
CANADA [604] 684 . 6826 FAX [604] 733 . 4422

M ICHAEL T AKAGI

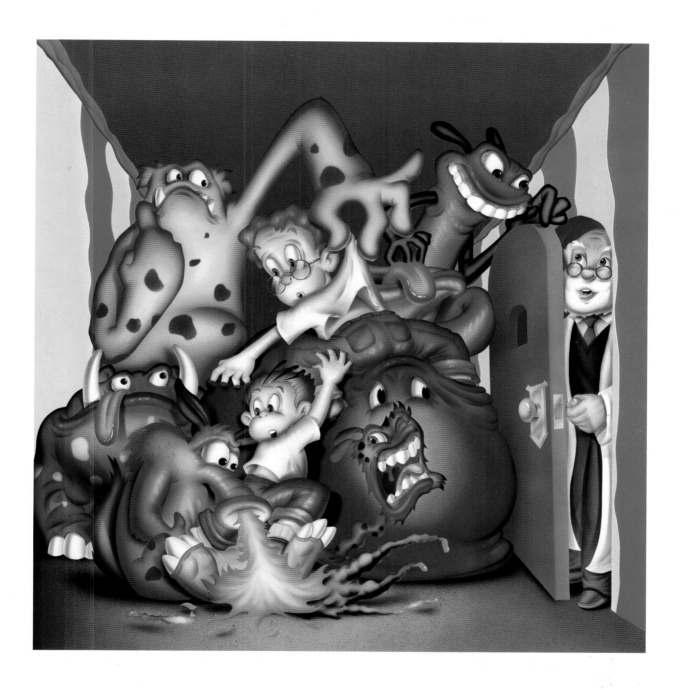

USA [206] 467 . 9156 FAX [206] 467 . 8730

CANADA [604] 684 . 6826 FAX [604] 733 . 4422

A lso in Showcase 18, page 1298 and Creative Illustration 7, page 412

MICHAEL McKINNELL

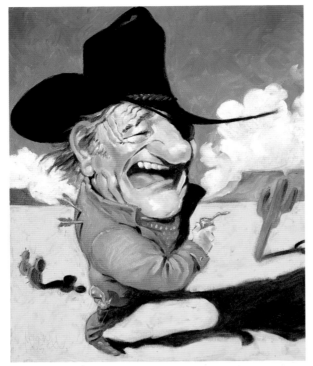

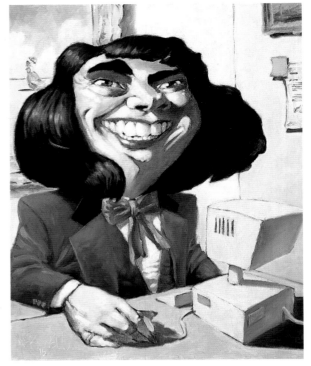

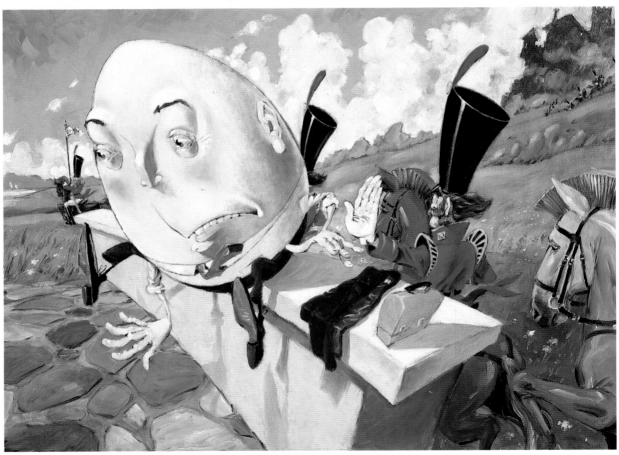

USA [206] 467 . 9156 FAX [206] 467 . 8730

CANADA [604] 684 . 6826 FAX [604] 733 . 4422

STEPHANIE CARTER

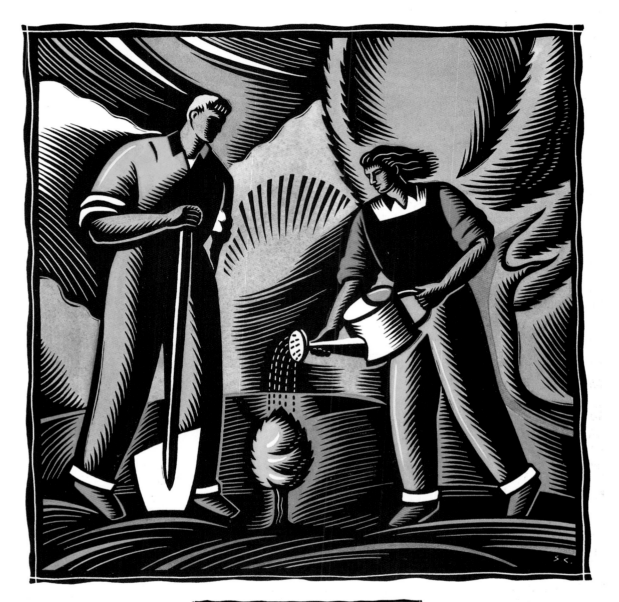

USA [206] 467 . 9156 FAX [206] 467 . 8730

CANADA [604] 684 . 6826 FAX [604] 733 . 4422

Also in Showcase 18, page 765

WENDY WORTSMAN

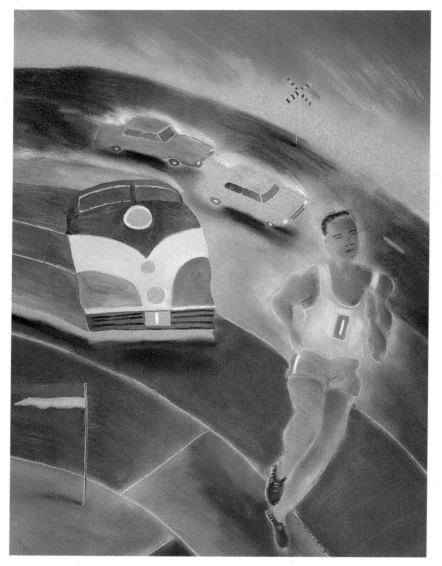

REP·ART
ARTISTS' REPRESENTATIVES

USA [206] 467 . 9156 FAX [206] 467 . 8730
CANADA [604] 684 . 6826 FAX [604] 733 . 4422

USA [206] 467 . 9156 FAX [206] 467 . 8730

CANADA [604] 684 . 6826 FAX [604] 733 . 4422

Also in Showcase 18, page 763

ⒶD A M ⓇO G E R S

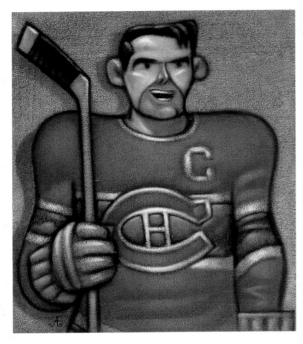
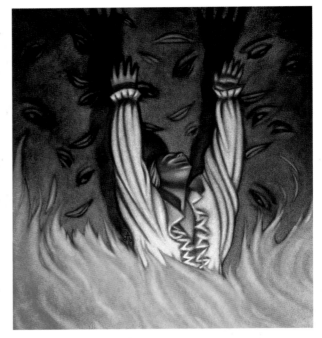
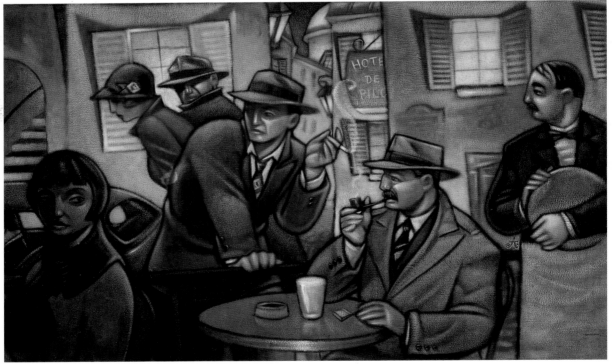

USA [206] 467 . 9156 FAX [206] 467 . 8730
CANADA [604] 684 . 6826 FAX [604] 733 . 4422

Also in Showcase 18, page 767

rep
res
ented by

513
861
1400

FAX
513
861
6420

Berendsen

A N D A S S O C I A T E S , I N C .

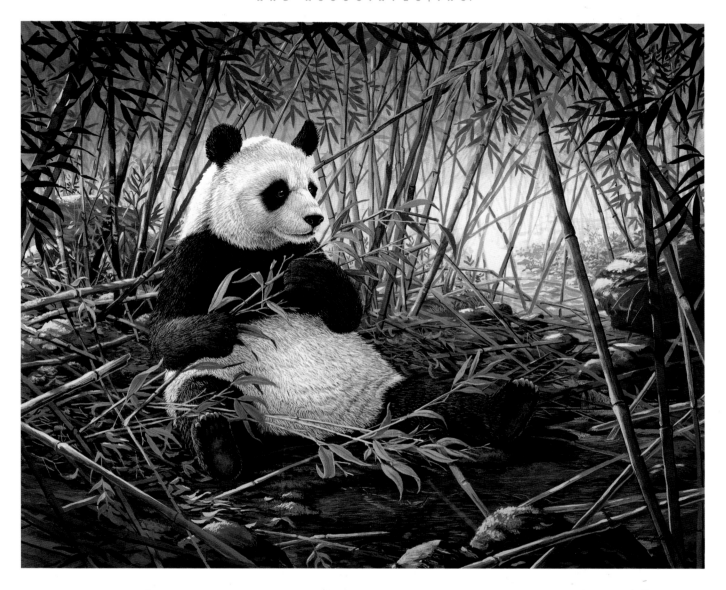

Kevin **Torline**

2233 Kemper Lane · Cincinnati, OH · 45206

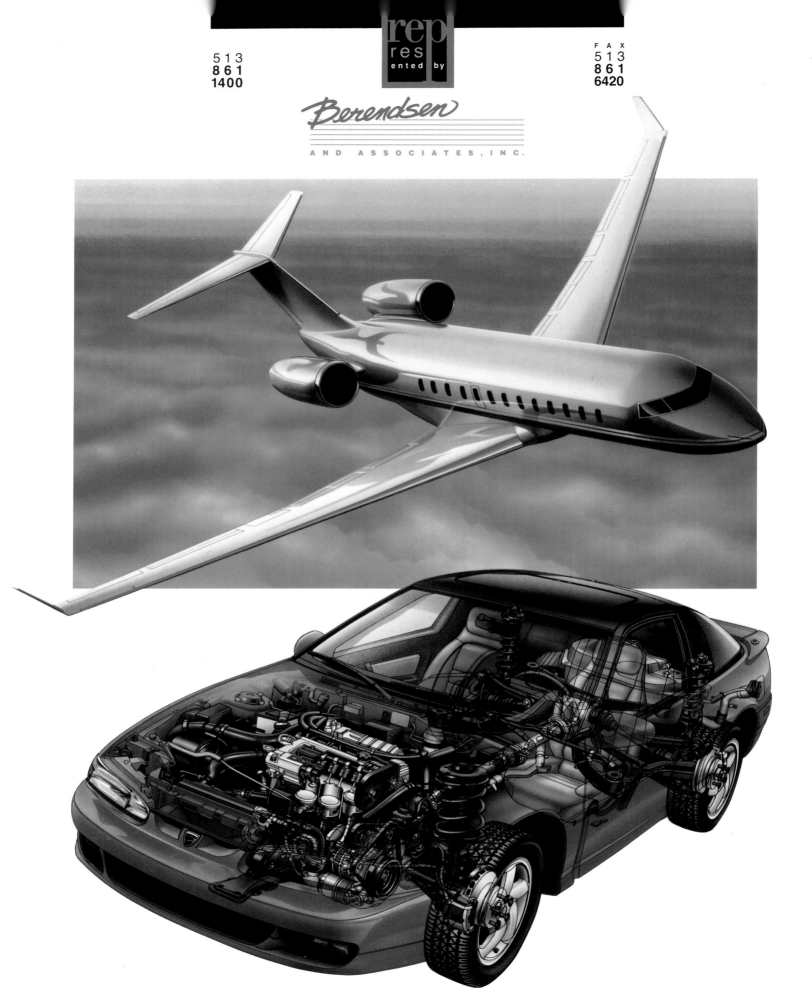

rep
res
ented by

Berendsen

A N D A S S O C I A T E S , I N C .

513
861
1400

FAX
513
861
6420

Gary **Richardson**

2233 Kemper Lane · Cincinnati, OH · 45206

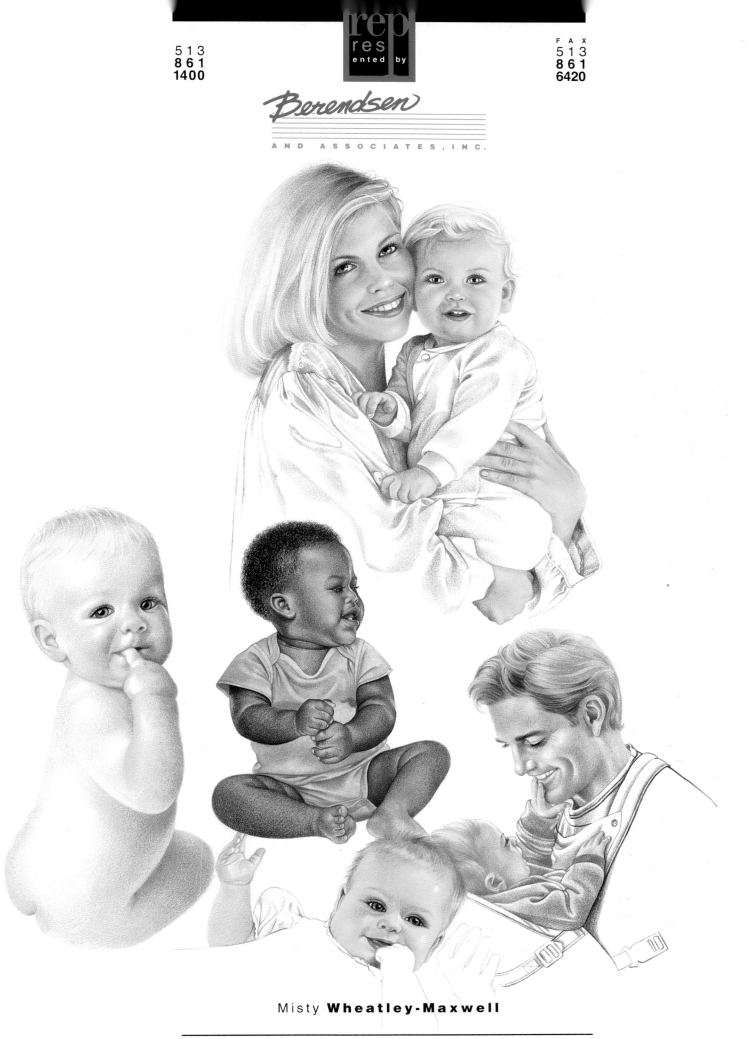

rep
res
ented by

5 1 3
8 6 1
1400

F A X
5 1 3
8 6 1
6420

Berendsen

A N D A S S O C I A T E S , I N C.

Misty **Wheatley-Maxwell**

2233 Kemper Lane · Cincinnati, OH · 45206

rep
res
ented by

513
8 6 1
1400

F A X
5 1 3
8 6 1
6420

Berendsen
AND ASSOCIATES, INC.

Jake **Ellison**

Garry **Nichols**

Dave **Reed**

2233 Kemper Lane · Cincinnati, OH · 45206

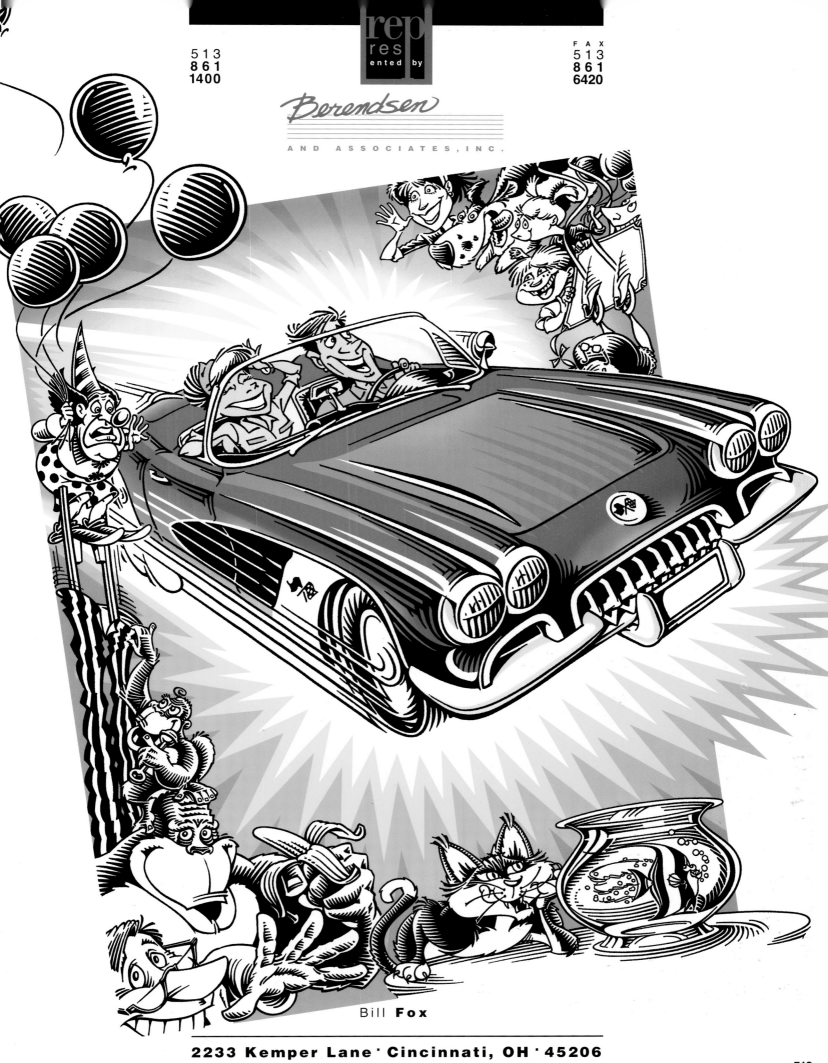

rep res ented by

Berendsen

AND ASSOCIATES, INC.

513
861
1400

FAX
513
861
6420

Bill **Fox**

2233 Kemper Lane · Cincinnati, OH · 45206

JULIA NOONAN
The Penny & Stemer Group • Call: Carol Lee Stemer • Phone: 212·505·9342 • Fax: 212·505·1844

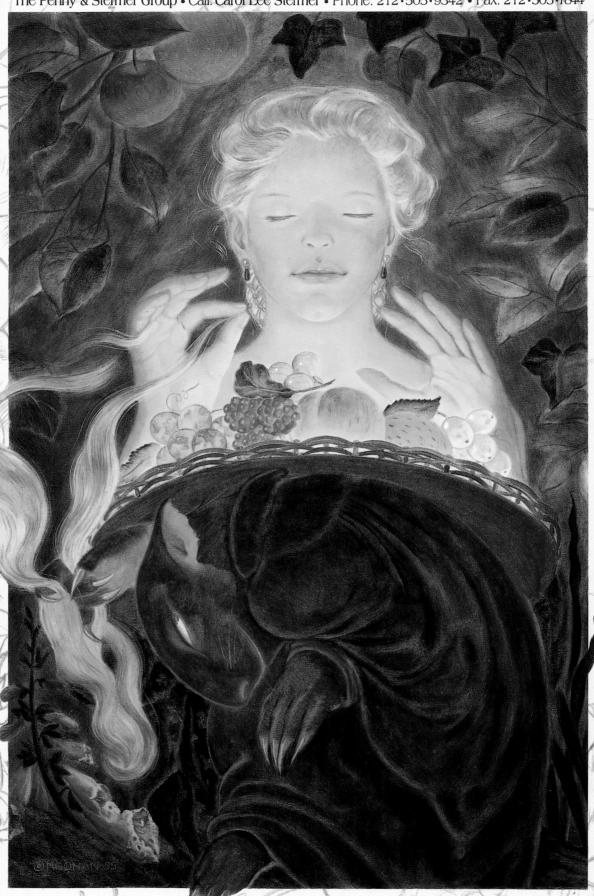

Goblin Market ~ "Men sell not such fruit in any town." Christina Rossetti

Julia Noonan

Represented By: The Penny & Stermer Group • Call: Carol Lee Stermer
Phone: 212•505•9342 • Fax: 212•505•1844

GLYNNIS OSHER
REPRESENTED BY:
THE PENNY & STERMER GROUP
CALL: CAROL LEE STERMER
PHONE 212 505-9342
FAX 212 505-1844

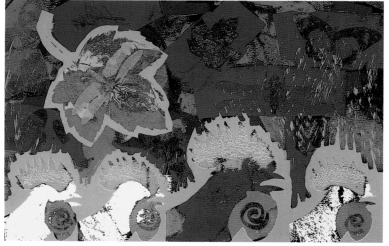

West of the Mississippi
Christine Prapas
Tel 503•658•7070 – Fax 503•658•3960

East of the Mississippi
Penny & Stermer Group
Tel 212•505•9342 – Fax 212•505•1844

S T E V E *Ellis*

I L L U S T R A T I O N

Studio Tel 310•792•1888 – Fax 310•374•7558

RICK STROMOSKI

Represented by the Penny Stermer Group

For samples and rates call Carol Lee at (212) 505-9342 or fax (212) 505-1844

SCOTT GORDLEY

ILLUSTRATOR

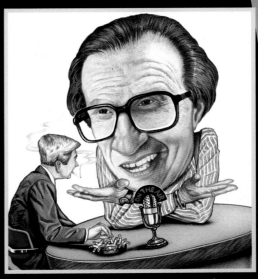

GREGORY A. BUSKE

Represented by: The Penny & Stermer Group

Call Carol Lee Stermer 212-505-9342 Fax 212-505-1844

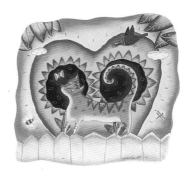

Mercedes McDonald

Clients:

Neiman Marcus

Orchard Books

Bank of America

Sun Microsystems

Amdah

Ligature

Houghton Mifflin

Sears

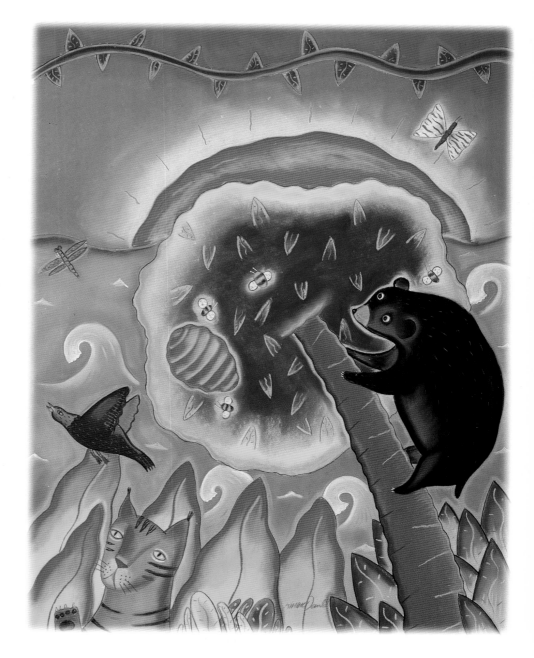

Represented by | FRIEND & JOHNSON:

NEW YORK 212.808.0022 Fax 212.808.0269

CHICAGO 312.943.7885 Fax 312.943.4975

DALLAS 214.559.0055 Fax 214.559.0724

NADINE HUNTER:

N. CALIFORNIA 415.456.7711 Fax 415.454.9162

LAURIE PRIBBLE:

S. CALIFORNIA 818.574.0288 Fax 818.574.3940

James Noel Smith

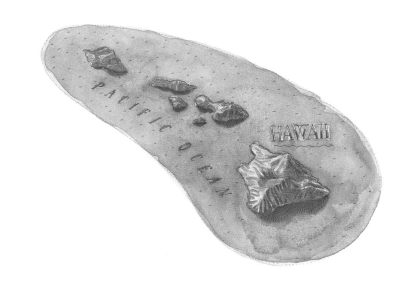

Clients:

Lexus

Nordstrom

Healthy Choice

Lands End

U.S. News & World Report

Murata/Muratec

American Airlines

Levi Strauss

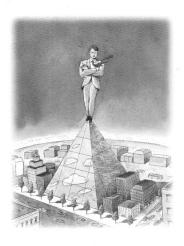

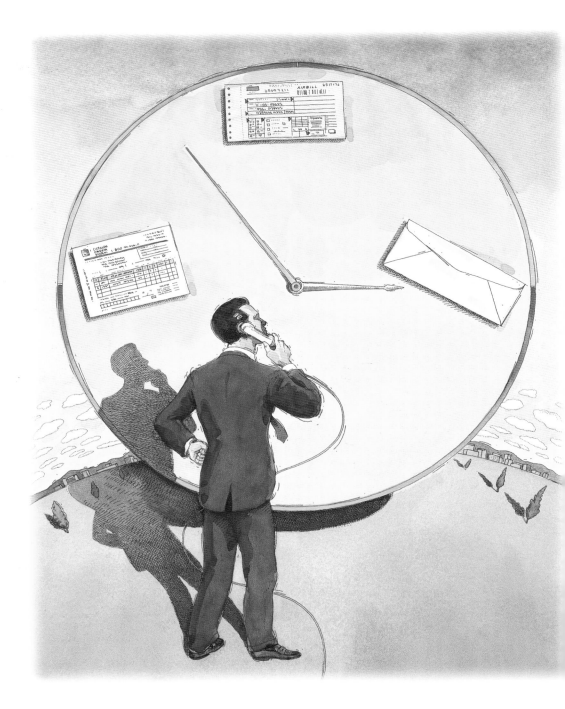

Represented by | FRIEND & JOHNSON:

NEW YORK 212.808.0022 Fax 212.808.0269 CHICAGO 312.943.7885 Fax 312.943.4975 DALLAS 214.559.0055 Fax 214.559.0724 SAN FRANCISCO 415.927.4500 Fax 415.927.450

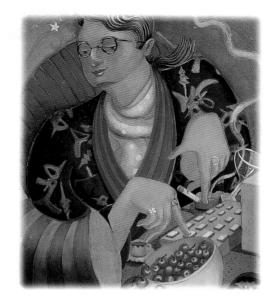

Barbara Lambase

Clients:

Harcourt Brace

Simon & Schuster

Sears

Harper Collins

The Bon Marche

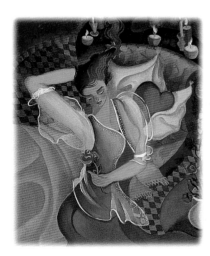

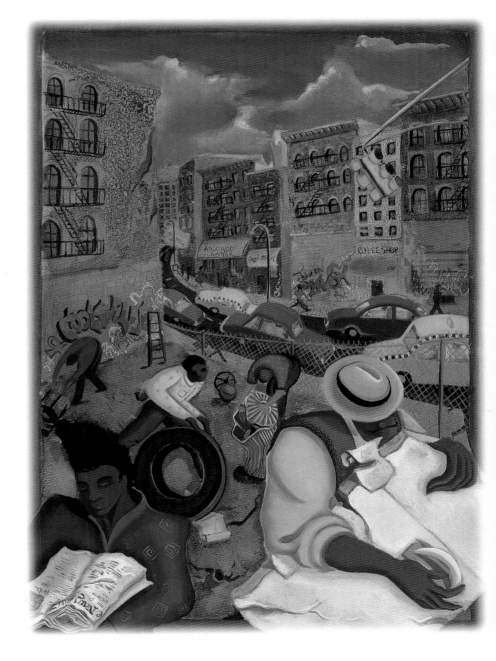

Represented by | FRIEND & JOHNSON:

NEW YORK 212.808.0022 Fax 212.808.0269 CHICAGO 312.943.7885 Fax 312.943.4975 DALLAS 214.559.0055 Fax 214.559.0724 SAN FRANCISCO 415.927.4500 Fax 415.927.4507

729

Hilary Mosberg

Clients:

Toyota

Marlboro/Phillip Morris

Sebastiani Vineyards

Farrar, Strauss & Giroux

Estee Lauder

Eddie Bauer

Williams Sonoma

Represented by | FRIEND & JOHNSON:

NEW YORK 212.808.0022 Fax 212.808.0269 CHICAGO 312.943.7885 Fax 312.943.4975 DALLAS 214.559.0055 Fax 214.559.0724 SAN FRANCISCO 415.927.4500 Fax 415.927.4507

John English

Clients:

Chrysler Corporation

Newsweek

Boeing

Knoll Furniture Group

Hitachi

American Airlines

Miller Beer

Atlantic Records

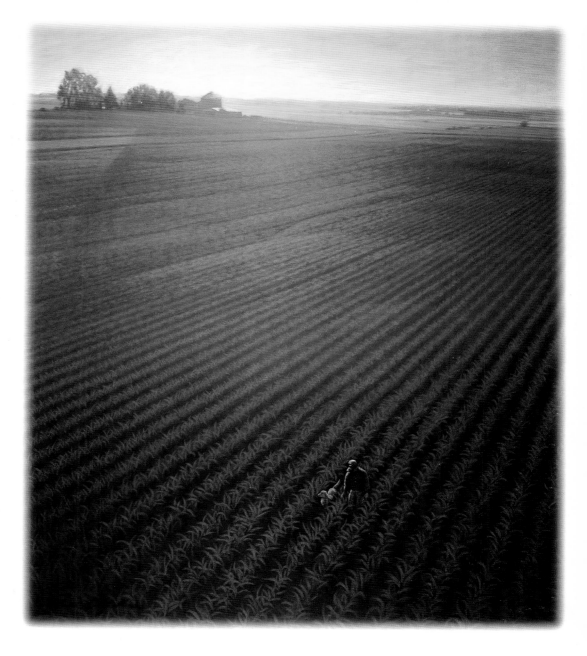

Represented by | FRIEND & JOHNSON:

NEW YORK 212.808.0022 Fax 212.808.0269 CHICAGO 312.943.7885 Fax 312.943.4975 DALLAS 214.559.0055 Fax 214.559.0724 SAN FRANCISCO 415.927.4500 Fax 415.927.4507

DIANE BIGDA

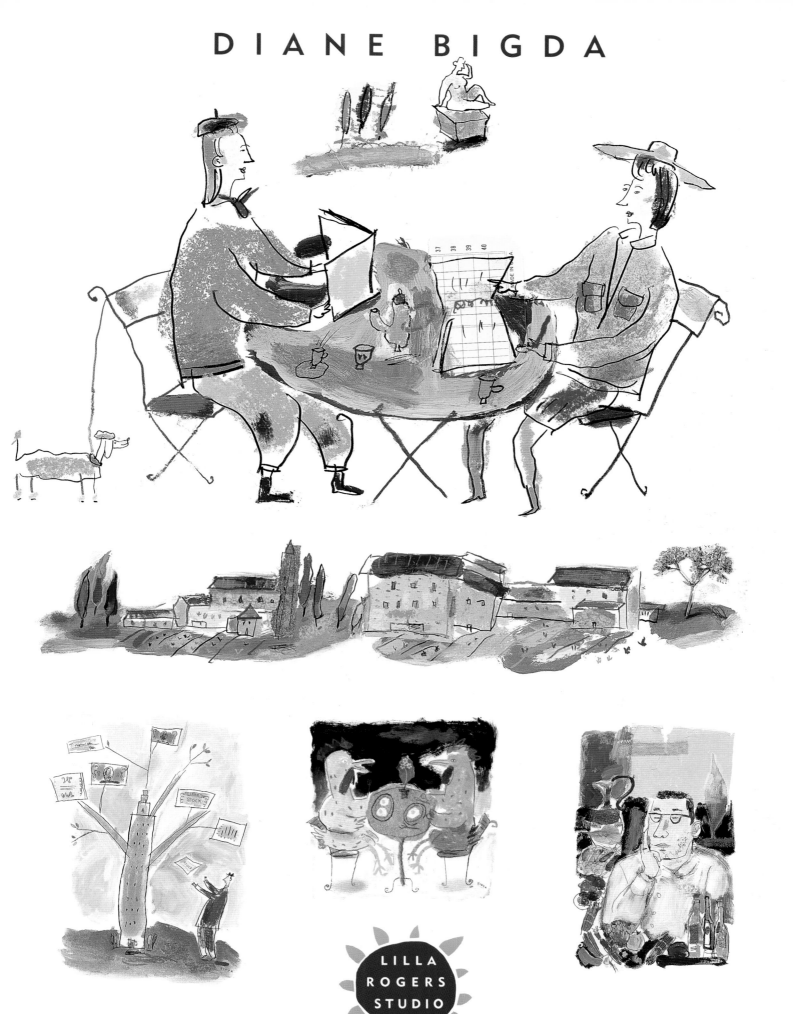

SUSAN FARRINGTON

DONNA INGEMANSON

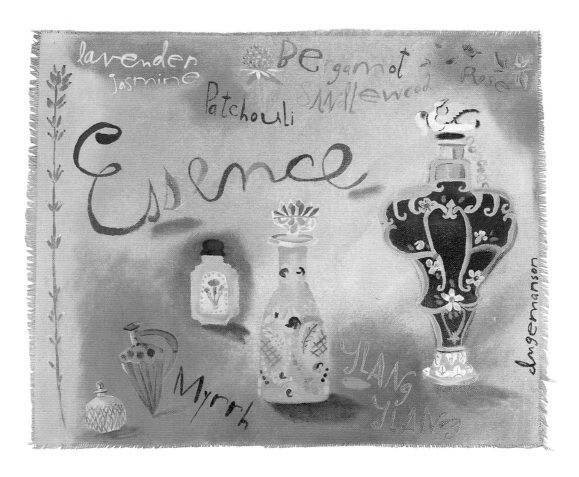

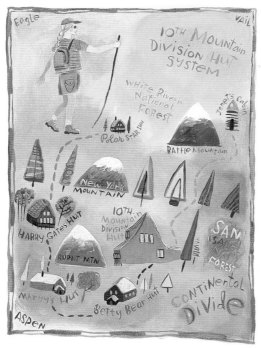

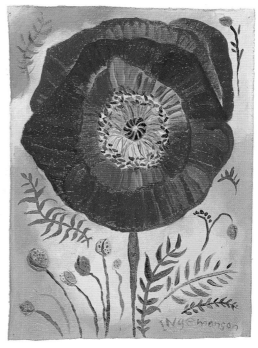

ANN BOYAJIAN

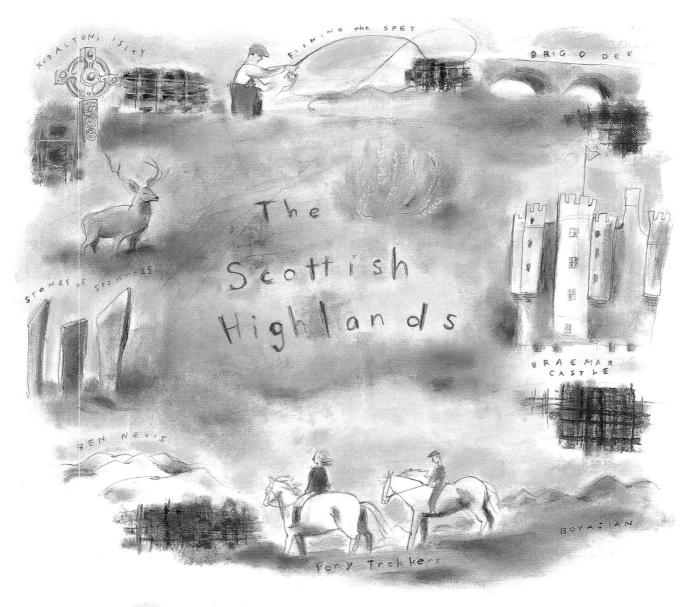

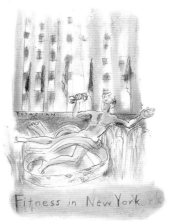

ALIONA KATZ

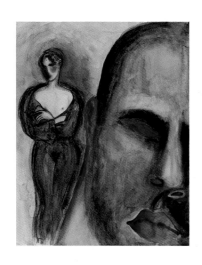

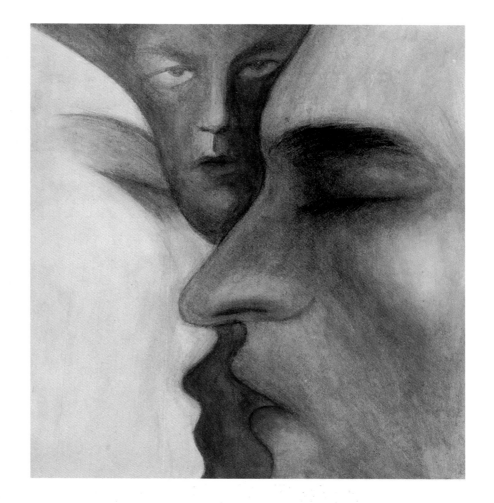

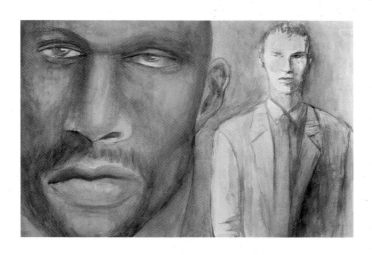

LILLA ROGERS STUDIO

TEL 617 641 2787 FAX 617 641 2244 6 PARKER ROAD ARLINGTON MA 02174

ALAN WITSCHONKE

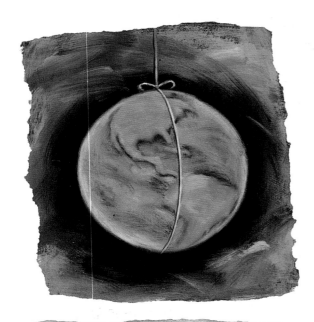

top dog

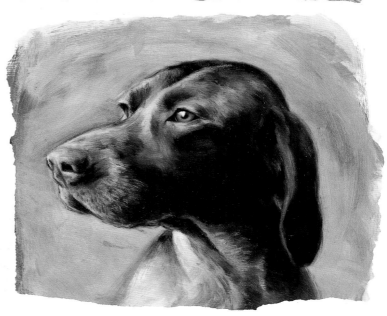

the world
on a string

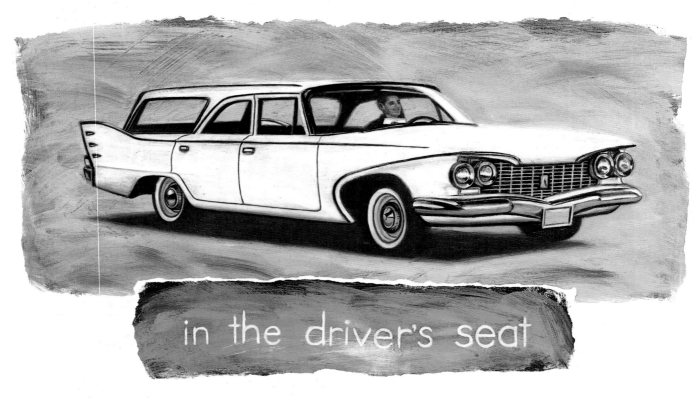

in the driver's seat

LILLA
ROGERS
STUDIO

TEL 617 641 2787 FAX 617 641 2244 6 PARKER ROAD ARLINGTON MA 02174

Phill Singer

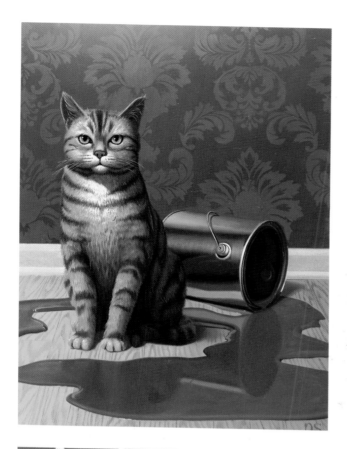

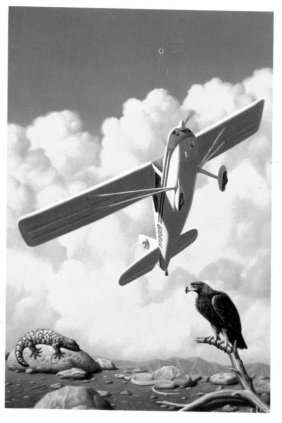

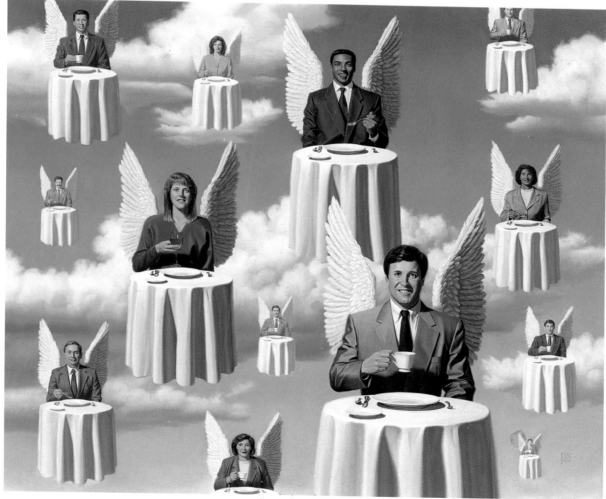

Judy Mattelson/Artists Representative 212-684-2974 / 516-487-1323 **Fax** 516-466-5835

Marvin Mattelson

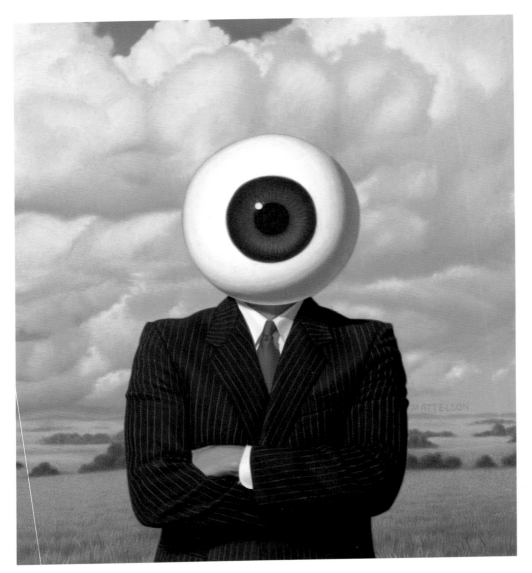

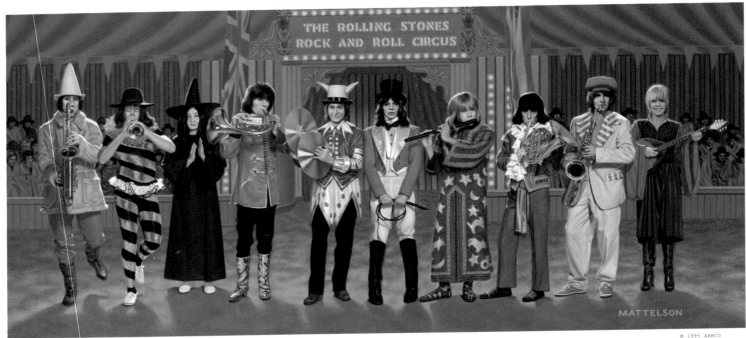

Judy Mattelson/Artists Representative 212-684-2974 / 516-487-1323 **Fax** 516-466-5835

Karen Kluglein

Judy Mattelson/Artists Representative 212-684-2974 / 516-487-1323 **Fax** 516-466-5835

MARK
NAGATA

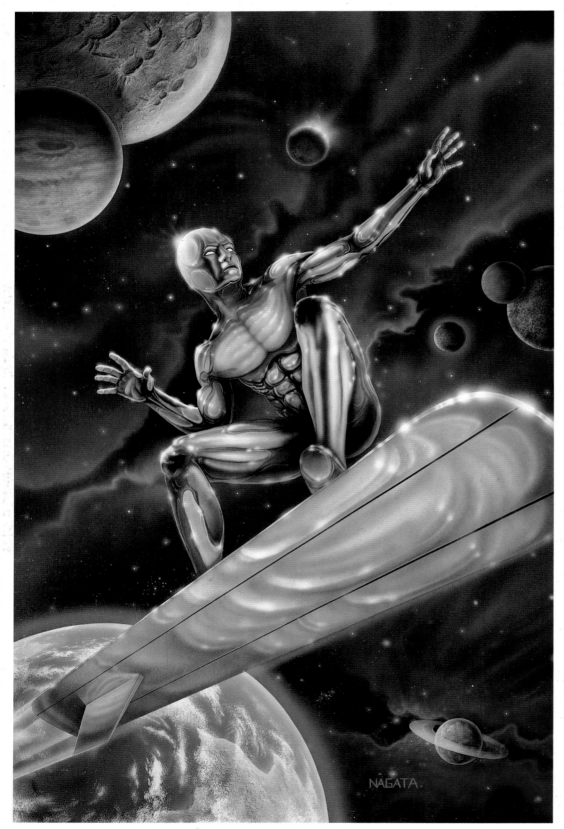

LOTT
REPRESENTATIVES

60 E. 42 ST. #1146 • N.Y., N.Y. 10165 • (212) 953-7088

SEAN
BEAVERS

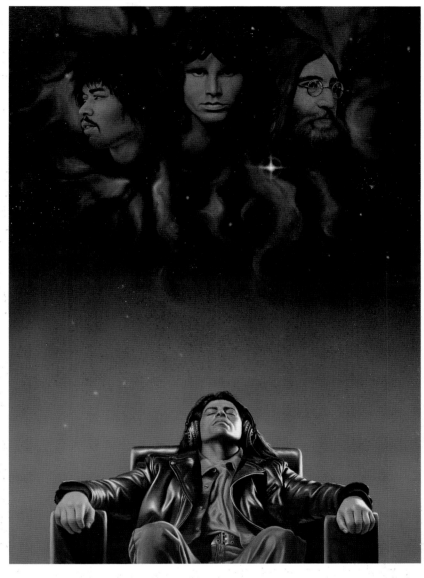

LOTT
REPRESENTATIVES

60 E. 42 ST. #1146 • N.Y., N.Y. 10165 • (212) 953-7088

E D
KURTZMAN

LOTT
REPRESENTATIVES

60 E. 42 ST. #1146 • N.Y., N.Y. 10165 • (212) 953-7088

ERIC J.W.
LEE

LOTT
REPRESENTATIVES

60 E. 42 ST. #1146 • N.Y., N.Y. 10165 • (212) 953-7088

UNIVERSITY OF MINNESOTA

Extension Classes

94/95

Continuing Education and Extension

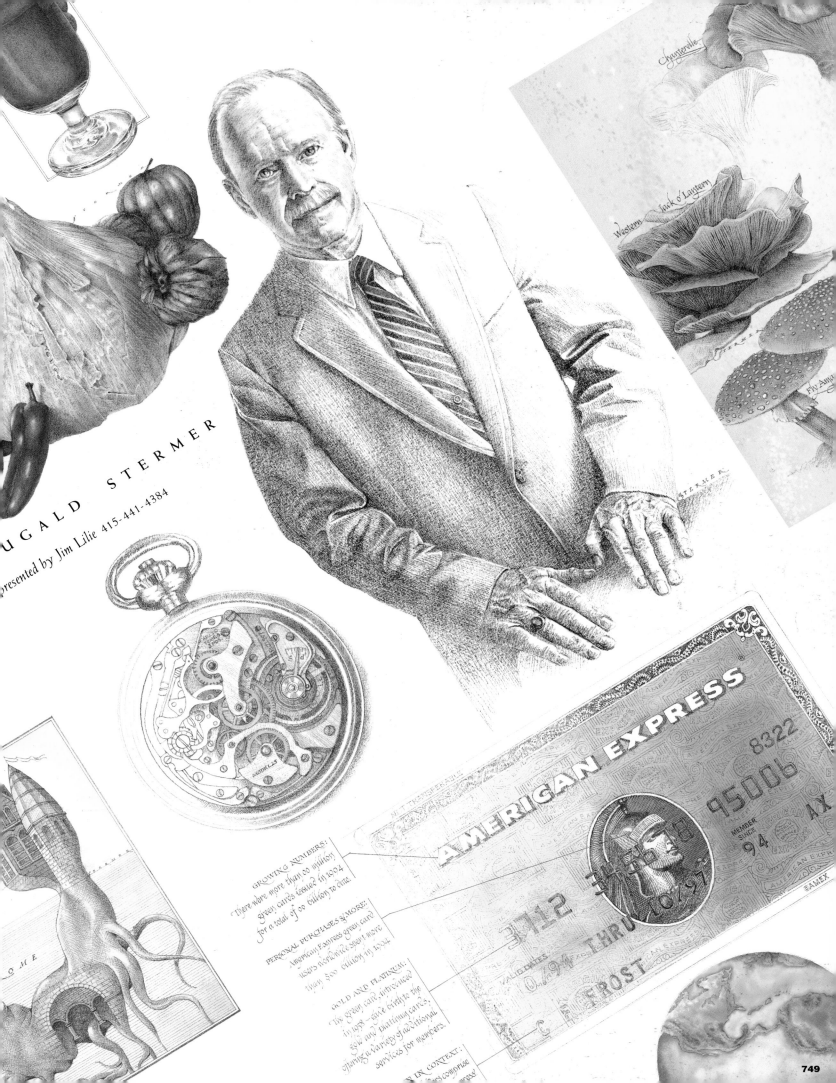

UGALD STERMER

presented by Jim Lilie 415-441-4384

GROWING NUMBERS:
There were more than 60 million
green cards issued in 1994
for a total of 00 billion to date.

PERSONAL PURCHASES & MORE:
American Express green card
users worldwide spent more
than $00 billion in 1994.

GOLD AND PLATINUM:
The green card, introduced
in 1958 — gave birth to the
gold and platinum cards,
offering a variety of additional
services for members.

AMERICAN EXPRESS

8322
95006
AX

MEMBER
SINCE
94

FROST

THRU 10/97
VALIDATES 01/94

EMANUEL SCHONGUT

Represented By

Jim Lilie

415. 441. 4384

fax 415. 395. 9809

ASPEN SNOWMASS

DENNIS ZIEMIENSKI
REPRESENTED BY JIM LILIE
415 441-4384
FAX 415 395-9809

BEACHCOMB
for a Better Tomorrow!

DO YOUR PART! GO TO THE OREGON COAST!

Every time you build a sandcastle or eat a crab at the Oregon coast, you're helping communities cope with Coho salmon-fishing restrictions. For a free Oregon/Pacific NW Coast Travel Guide, call 1-800-547-7842, ext. 10.

CELEBRATING 75 YEARS OF NFL FOOTBALL

Super BOWL

SUPER XXIX BOWL

1920 1995

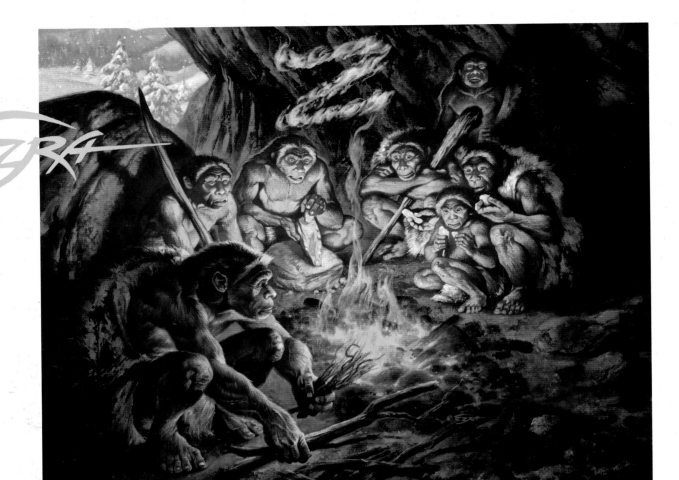

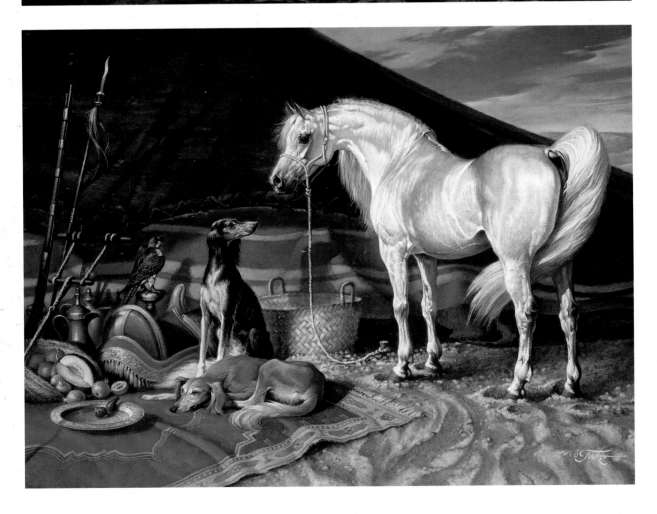

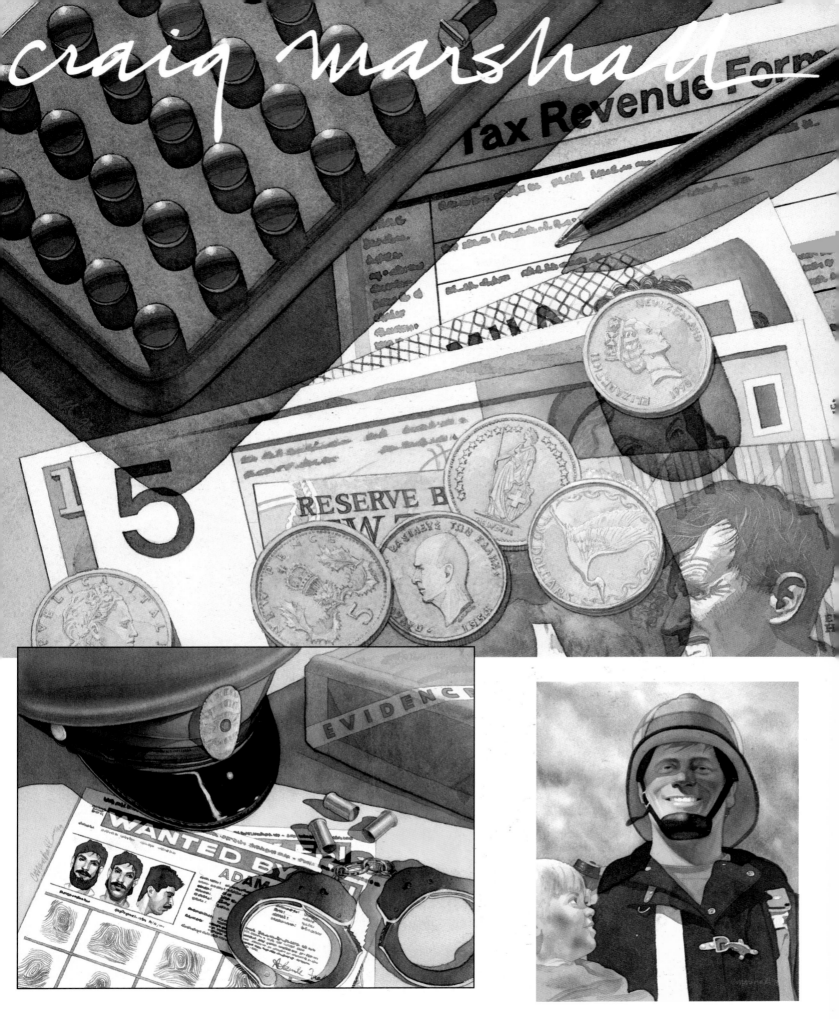

craig marshall

Tax Revenue Form

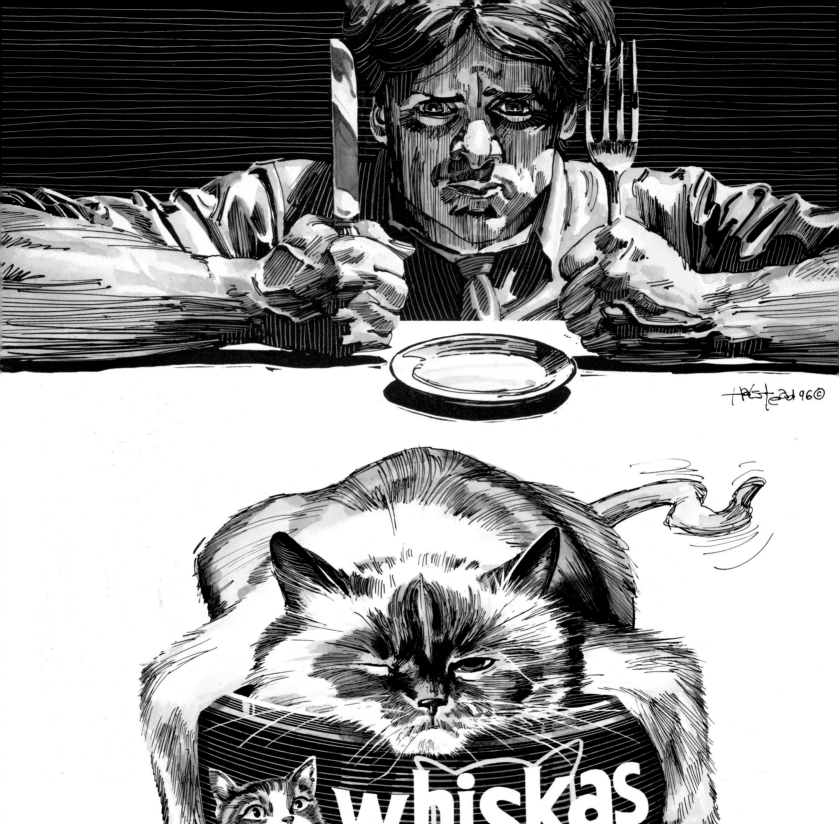

whiskas
KITTY STEW

LOREN LONG

REPRESENTED BY MARY LARKIN 220 E. 57TH ST. NEW YORK, NY 10022 TEL (212) 832-8116 FAX (212) 243-9492

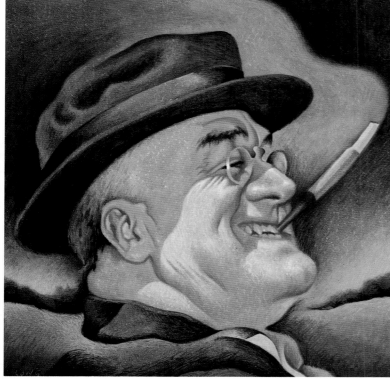

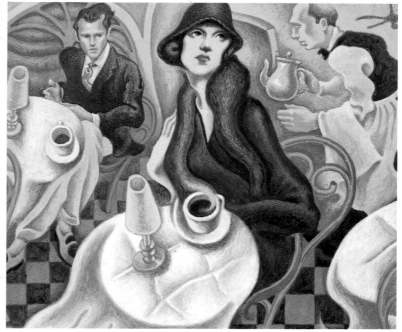

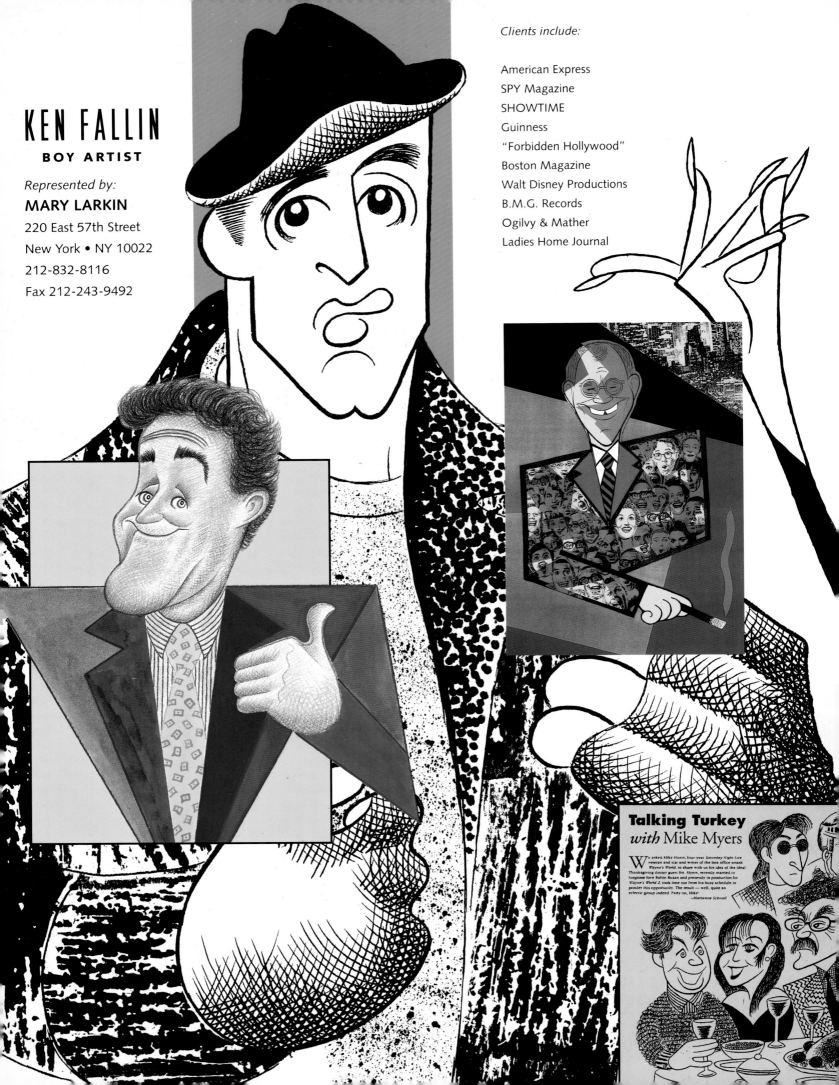

KEN FALLIN
BOY ARTIST

Represented by:
MARY LARKIN

220 East 57th Street
New York • NY 10022

212-832-8116
Fax 212-243-9492

Clients include:

American Express
SPY Magazine
SHOWTIME
Guinness
"Forbidden Hollywood"
Boston Magazine
Walt Disney Productions
B.M.G. Records
Ogilvy & Mather
Ladies Home Journal

Talking Turkey
with Mike Myers

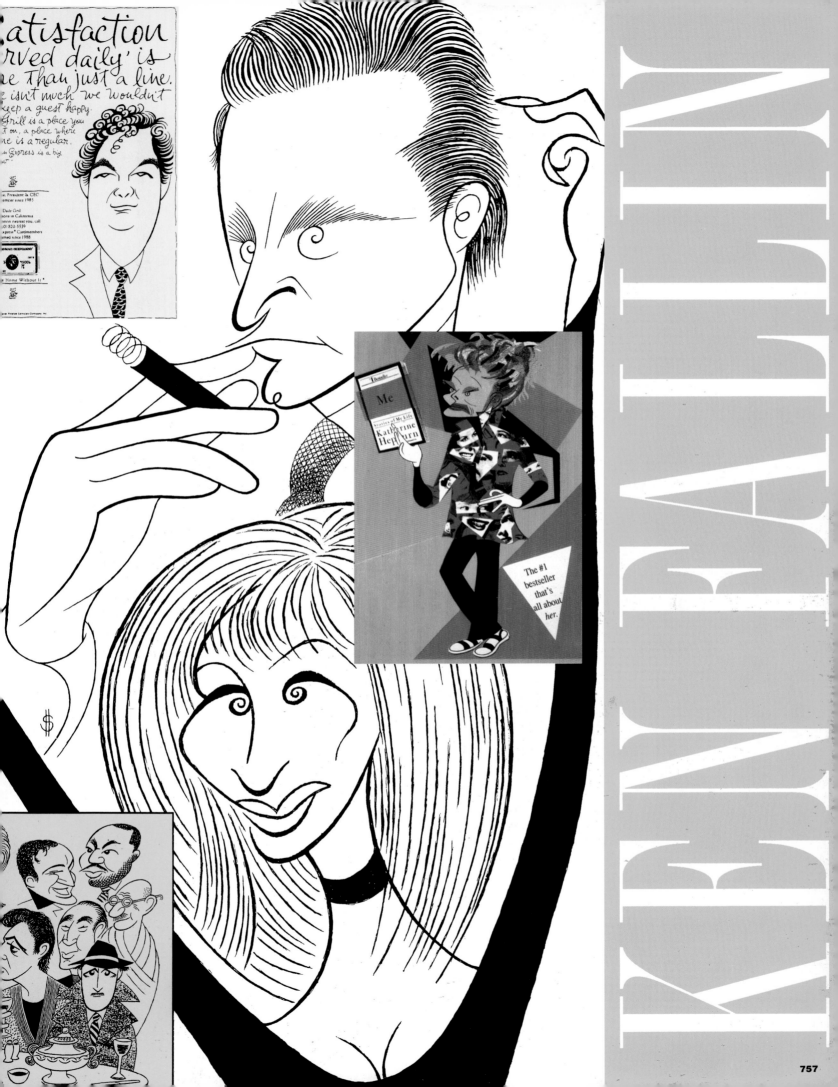

DANUTA JARECKA

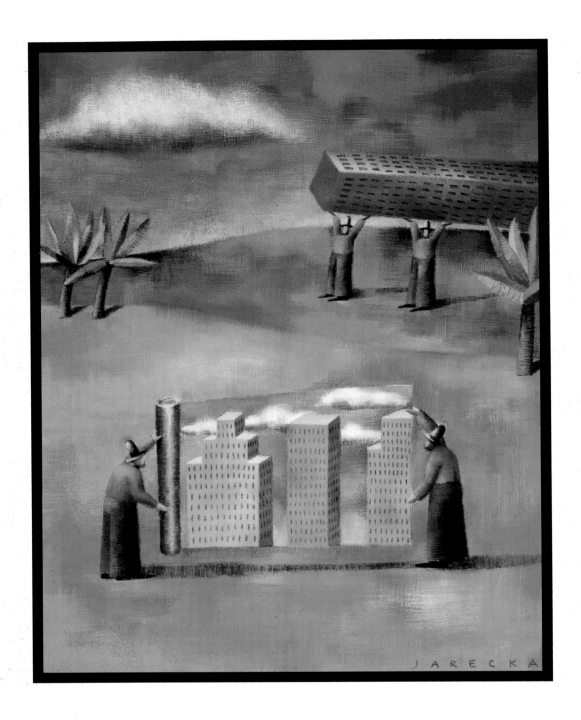

114 EAST 7TH STREET #15
NEW YORK, N.Y. 10009
212 353 3298

REPRESENTED IN NEW ENGLAND BY LEIGHTON & COMPANY 508 921 0887

FRANK FRISARI

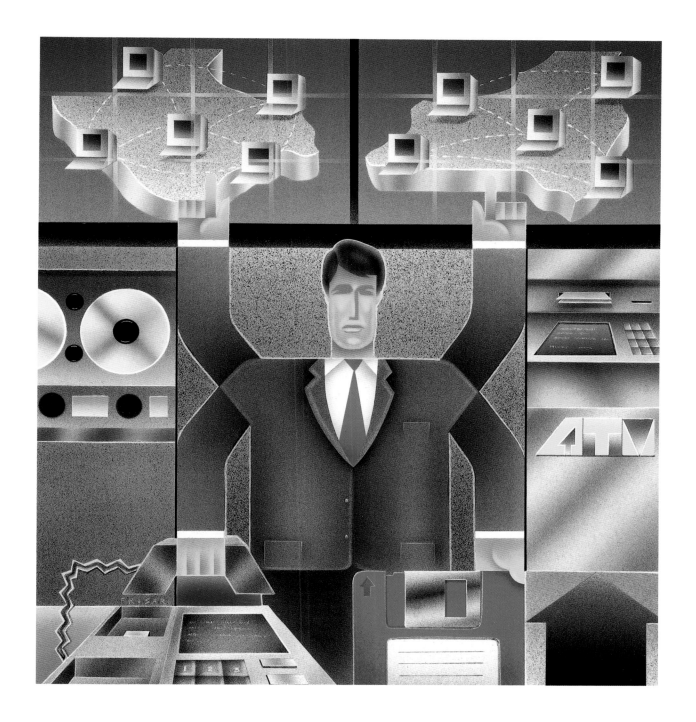

REPRESENTED IN NEW ENGLAND BY LEIGHTON & COMPANY 508 921 0887

JOHN BREAKEY

760

JENNIFER THERMES

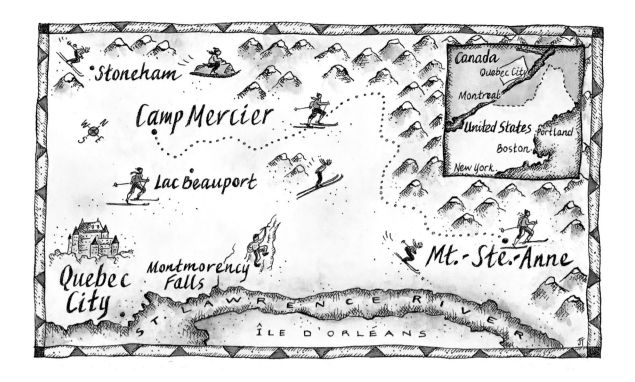

STEVE ATKINSON

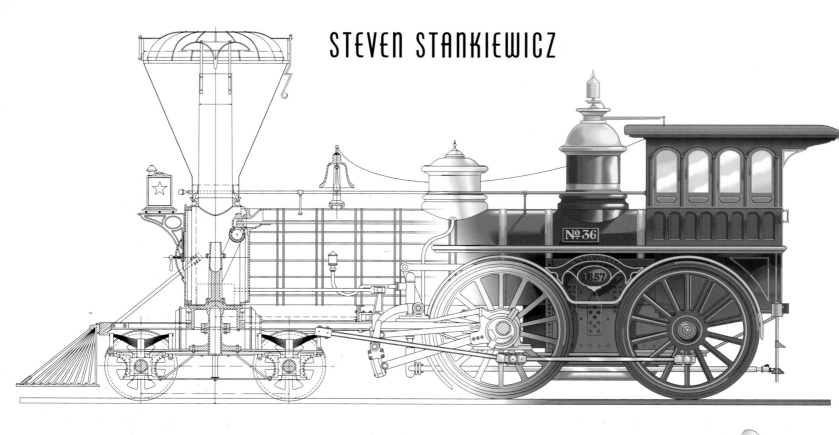

STEVEN STANKIEWICZ

No. 36

1857

How a tsunami is formed:

Rapid movement of the ocean floor displaces a column of water

A series of waves travels outward at heights believed to be less than three feet on the open ocean

As a wave approaches land, its energy compresses into a smaller space, forcing it to gain height

hinge joint

condylar joint

ellipsoid joint

ball-and-socket joint

saddle joint

HOW THE DISABILITY DOLLAR IS SPENT
Including direct costs, hidden costs, and disability management expenses

Workers' compensation **23.5¢**

Long-term disability/ pension **4.8¢**

Short-term disability **19.3¢**

FICA **7¢**

Disability management **9.7¢**

Sick leave **35.6¢**

 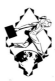

JOAN FARBER

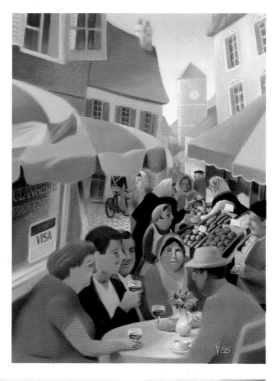

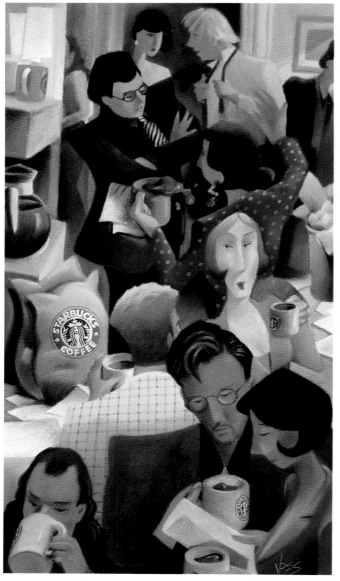

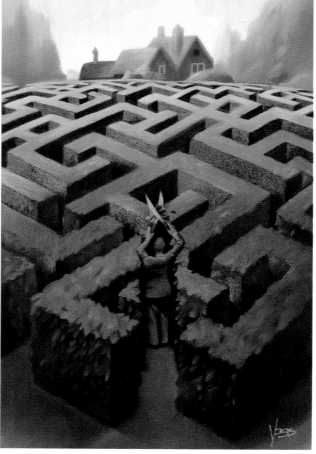

TOM VOSS

MARJORIE E. PESEK

RILEY ILLUSTRATION

ISABELLE DERVAUX

WARREN LINN

TERESA SHELLEY AND LETICIA GERMON NEW YORK CITY (212) 989.8770 FAX (212) 242.6773

RILEY ILLUSTRATION

LIZ PYLE

PHILIPPE WEISBECKER

TERESA SHELLEY AND LETICIA GERMON NEW YORK CITY (212) 989.8770 FAX (212) 242.6773

RILEY ILLUSTRATION

WILLIAM BRAMHALL

GRETCHEN DOW SIMPSON

TERESA SHELLEY AND LETICIA GERMON NEW YORK CITY (212) 989.8770 FAX (212) 242.6773

RILEY ILLUSTRATION

DANNY SHANAHAN

JEFFREY FISHER

TERESA SHELLEY AND LETICIA GERMON NEW YORK CITY (212) 989.8770 FAX (212) 242.6773

Harriet Kasak

TELEPHONE 212•675•5719
FACSIMILE 212•675•6341

Eldon Doty

Theresa Smith

Carolyn Croll

Tungwai Chau

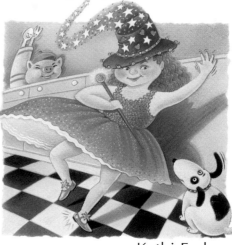

Harriet Kasak

TELEPHONE 212•675•5719
FACSIMILE 212•675•6341

Kathi Ember

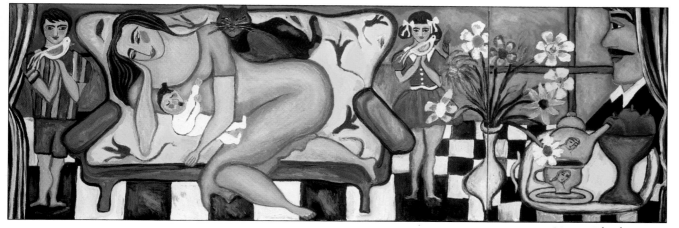

Sina Ghaboussi

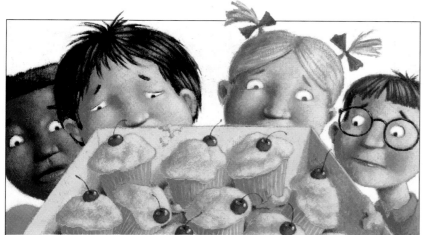

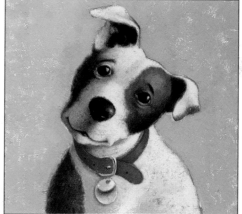

Mike Reed

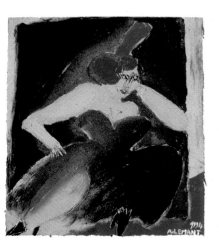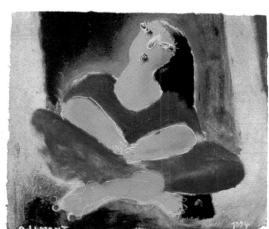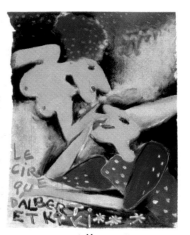

Albert Lemant

Harriet Kasak

TELEPHONE 212•675•5719
FACSIMILE 212•675•6341

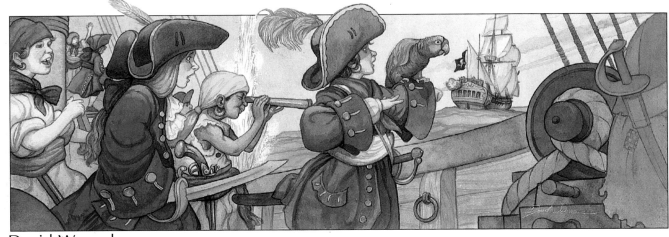

David Wenzel

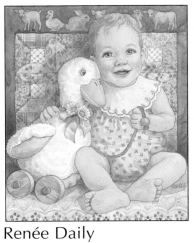

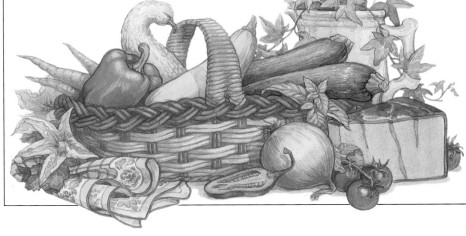

Renée Daily

Jan Palmer

Susan Keeter

Harriet Kasak

TELEPHONE 212•675•5719
FACSIMILE 212•675•6341

Paul Meisel

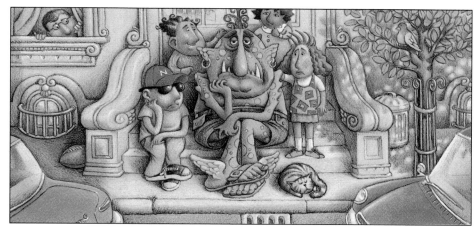

David Austin Clar

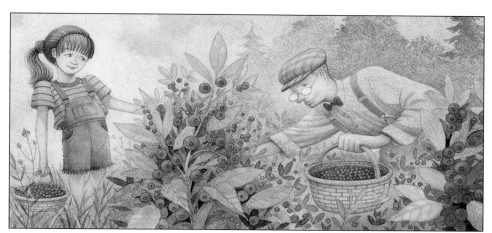

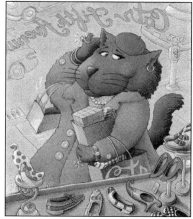

Jack E. Davis

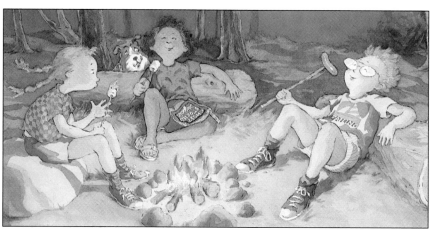

Abby Carter

Harriet Kasak

TELEPHONE 212•675•5719
FACSIMILE•212•675•6341

Randy Verougstraete

Randy Chewning

Nan Brooks

Rémy Simard

Harriet Kasak

TELEPHONE 212•675•5719
FACSIMILE 212•675•6341

George Ulrich

Anne Kennedy

Estelle Carol

Stephanie O'Shaughnessy

Commuter Transportation Services, Inc.

To view more work, see Graphic Artists Guild Directory of Illustration Vol. 8-12.

Fran Seigel 515 Madison Ave., Rm. 2200 New York, NY 10022 (212) 486-9644 Fax (212) 486-9646

Bristol Myers Squibb

U.S. News & World Report

To view more work, see Graphic Artists Guild Directory of Illustration Vol. 8-12.

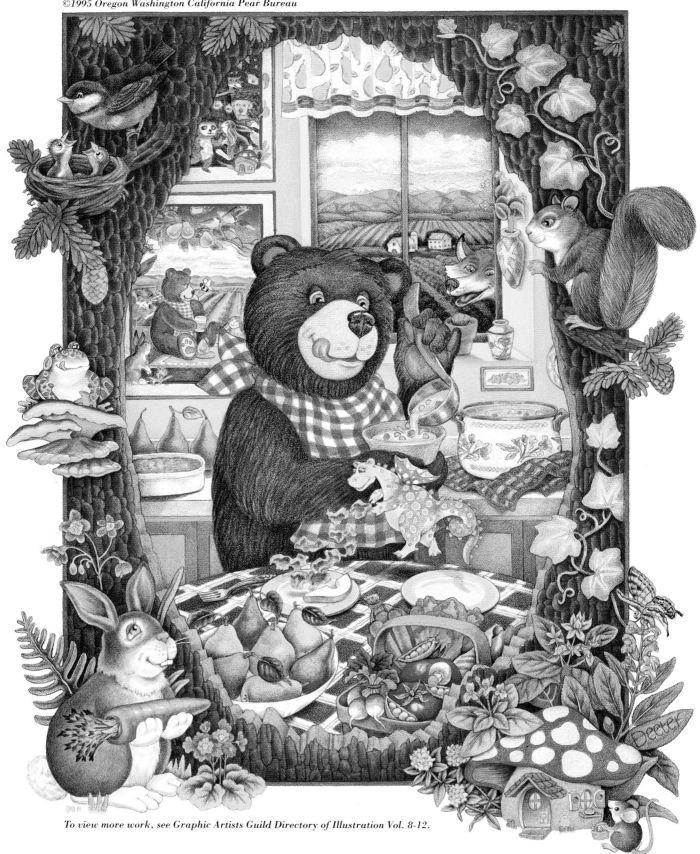

To view more work, see Graphic Artists Guild Directory of Illustration Vol. 8-12.

Fran Seigel 515 Madison Ave., Rm. 2200 New York, NY 10022 (212) 486-9644 Fax (212) 486-9646

To view more work, see Graphic Artists Guild Directory of Illustration Vol. 8-12.

Fran Seigel 515 Madison Ave., Rm. 2200 New York, NY 10022 (212) 486-9644 Fax (212) 486-9646

MIKE
BULL

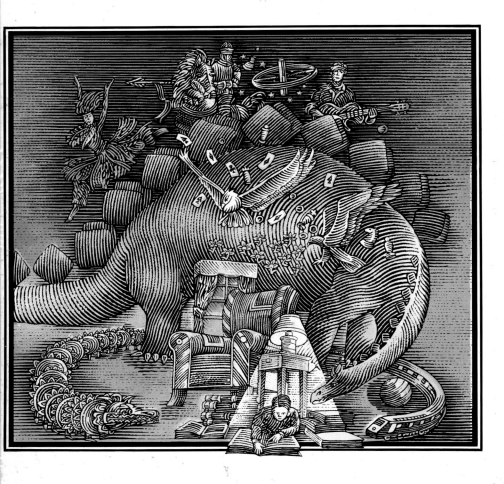

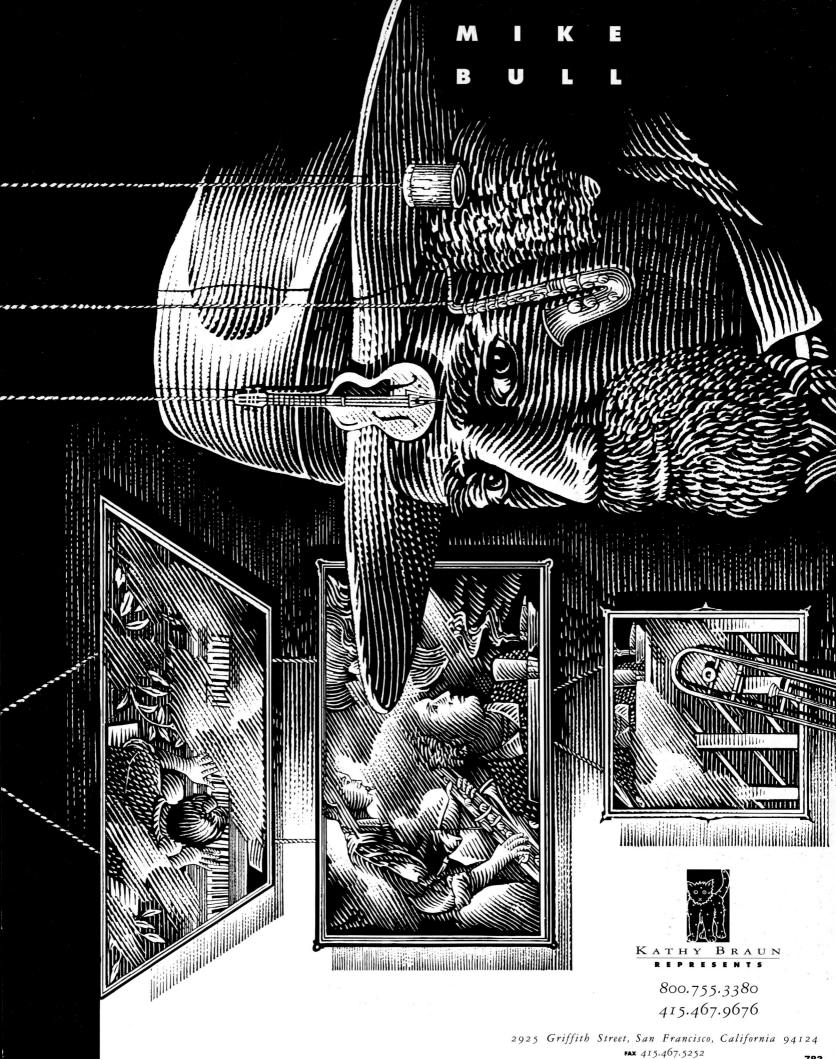

MIKE
BULL

KATHY BRAUN
REPRESENTS

800.755.3380
415.467.9676

2925 Griffith Street, San Francisco, California 94124
FAX 415.467.5252

S U D I
McCOLLUM

Jack-in-the-box.

KATHY BRAUN
R E P R E S E N T S

800.755.3380
415.467.9676

2925 Griffith Street, San Francisco, California 94124
FAX 415.467.5252
ARTIST'S PHONE & FAX 818.243.1345

Rocking Horse.

H E I D I
S C H M I D T

KATHY BRAUN
R E P R E S E N T S

800.755.3380
415.467.9676

2925 Griffith Street, San Francisco, California 94124
FAX 415.467.5252

SCOTT
MATTHEWS

KATHY BRAUN
REPRESENTS

800.755.3380
415.467.9676

2925 Griffith Street, San Francisco, California 94124
FAX 415.467.5252

JENNY CAMPBELL

DEBORAH
WOLFE
LIMITED

731 N. 24TH STREET PHILADELPHIA, PA 19130 215 232 6666 FAX 215 232 6585

MARIANNE HUGHES

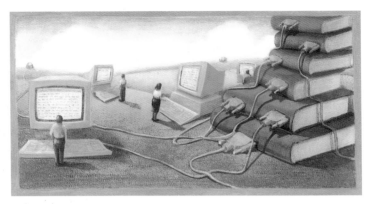

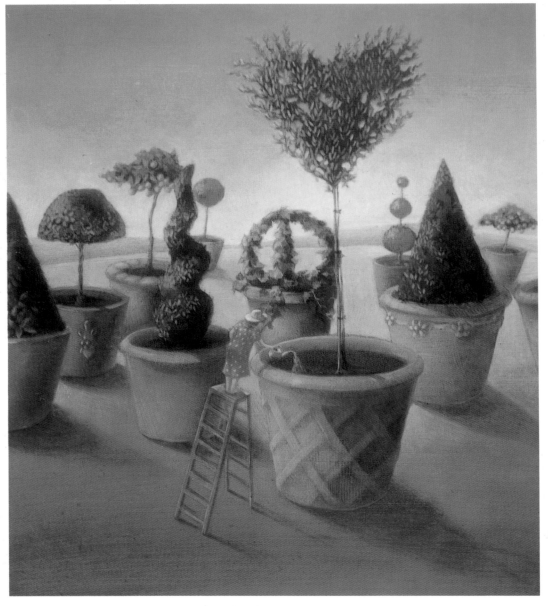

LISA POMERANTZ

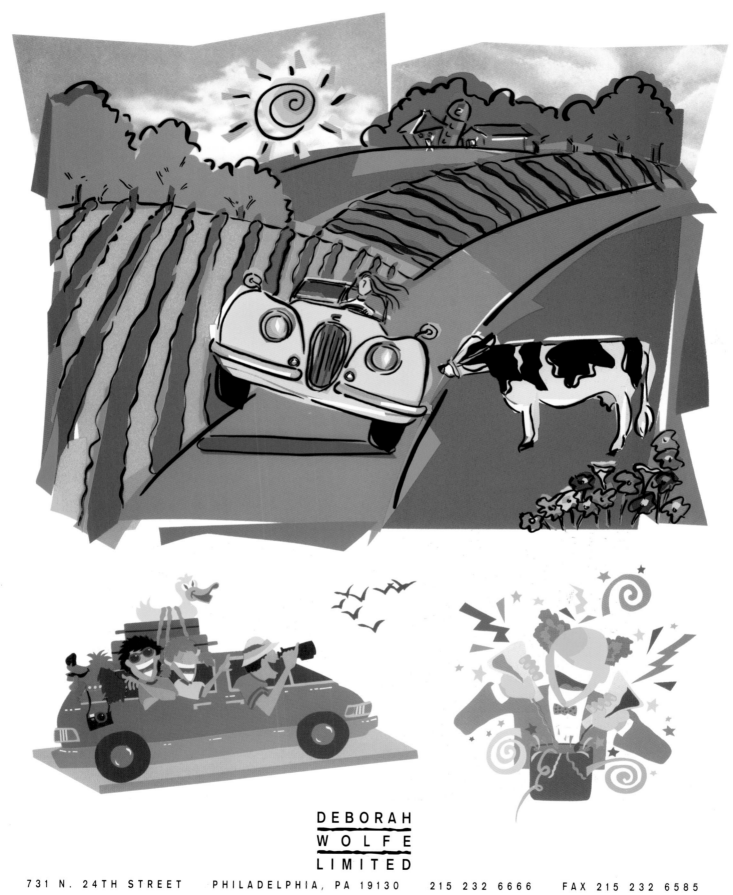

DEBORAH
WOLFE
LIMITED

731 N. 24TH STREET PHILADELPHIA, PA 19130 215 232 6666 FAX 215 232 6585

MUNRO
GOODMAN
ARTIST
REPRESENTATIVES

NEW YORK CITY: 212 691 2667 FAX: 212 633 1844
CHICAGO: 312 321 1336 FAX: 312 321 1350

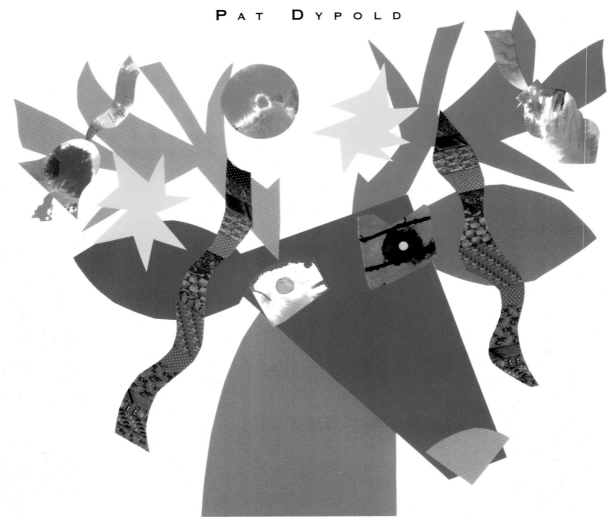

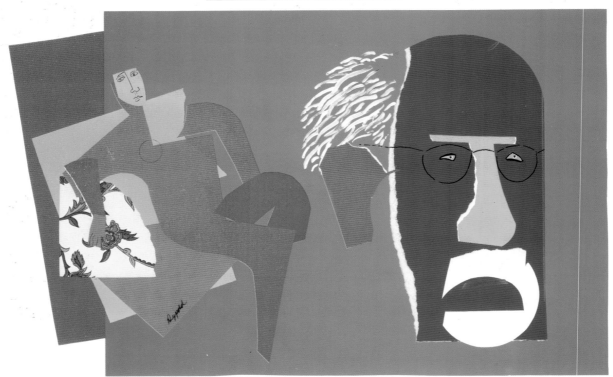

NEW YORK CITY: 212 691 2667 FAX: 212 633 1844

CHICAGO: 312 321 1336 FAX: 312 321 1350

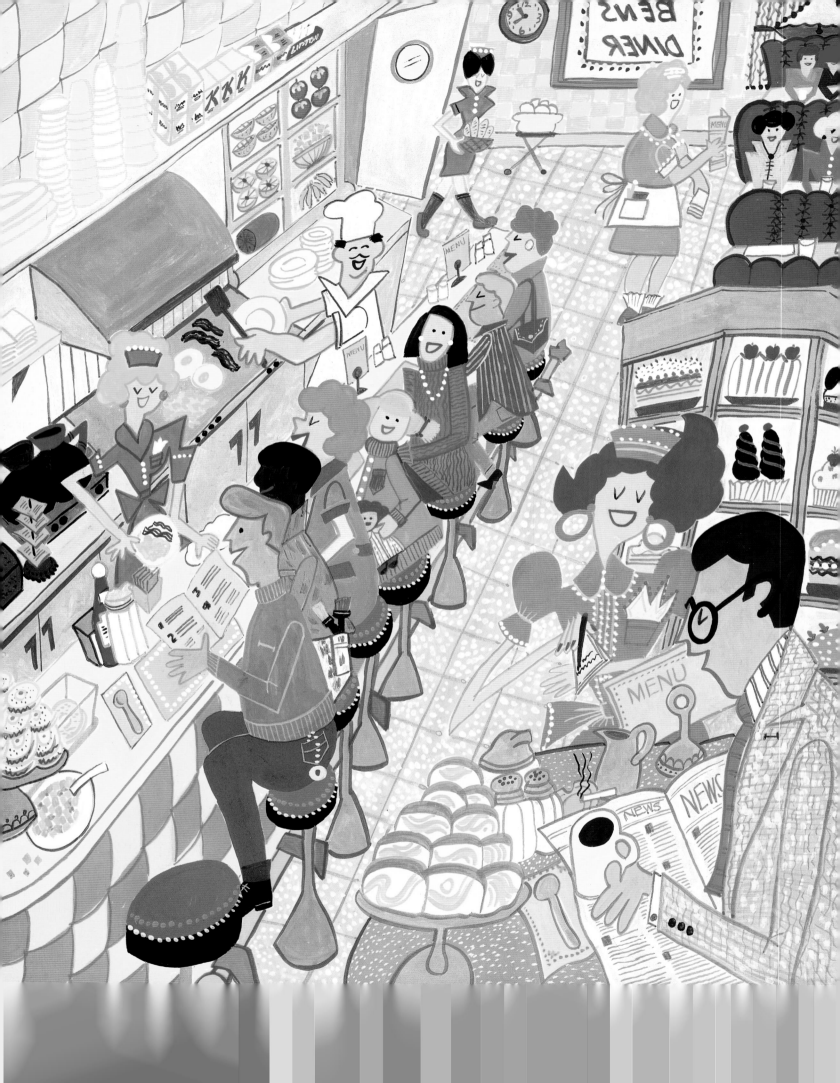

ILLUSTRATION
&
LETTERING

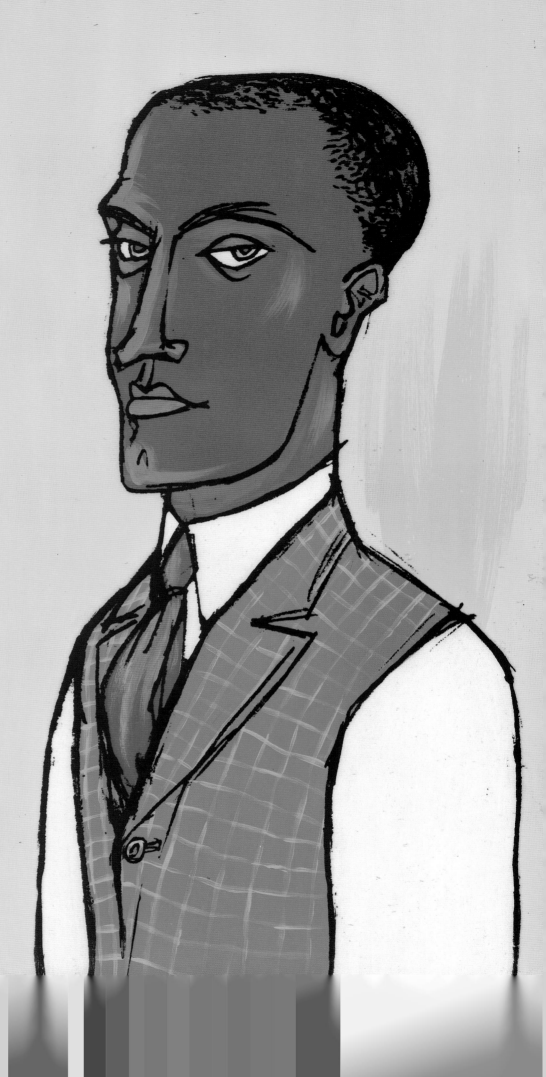

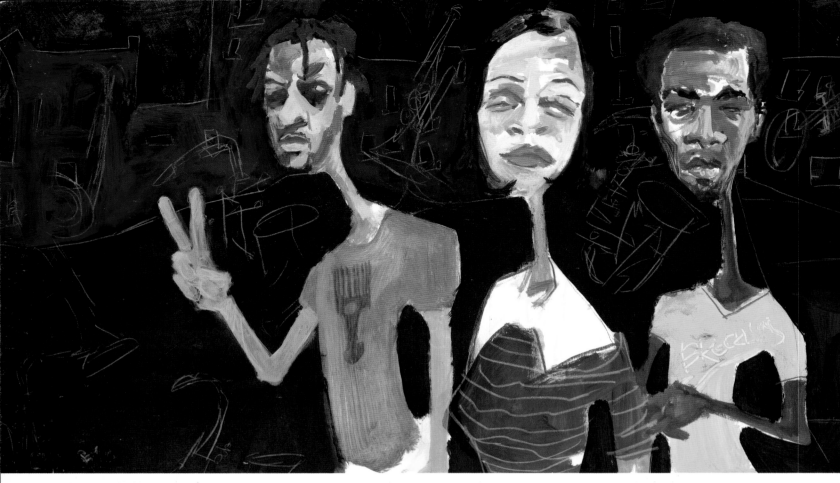

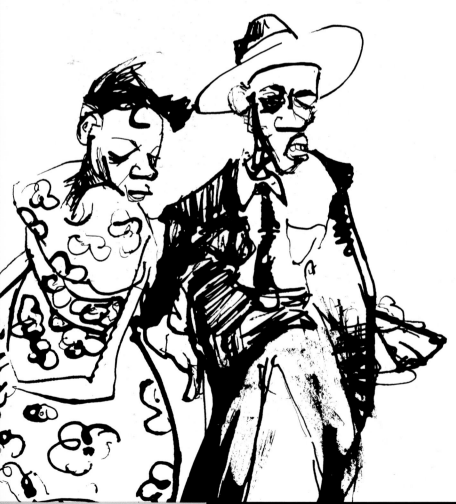

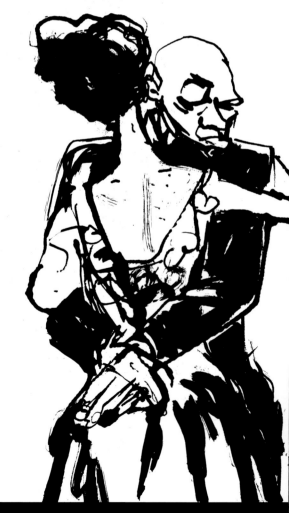

GREG
CHRISTIE

ARTS COUNSEL

212-777-6777

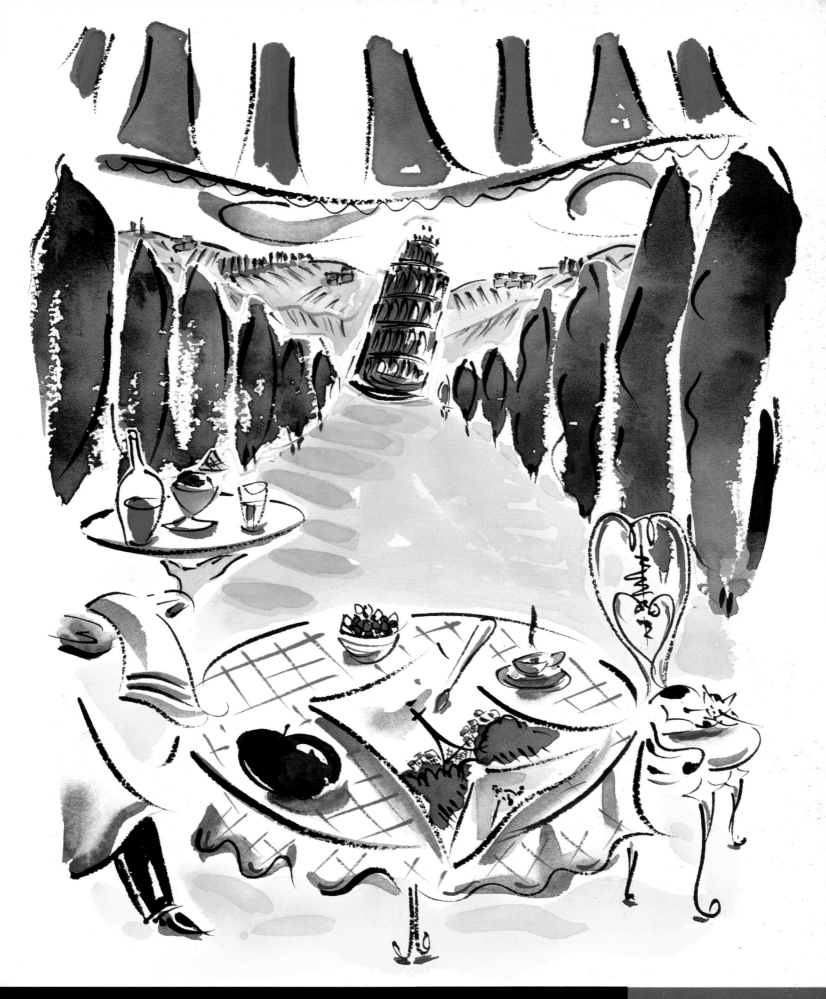

ARTS COUNSEL 212-777-6777

Bob Commander

CONRAD
REPRESENTS

T
415
921.7140

F
415
921.3939

CONRAD REPRESENTS | Art for the brain

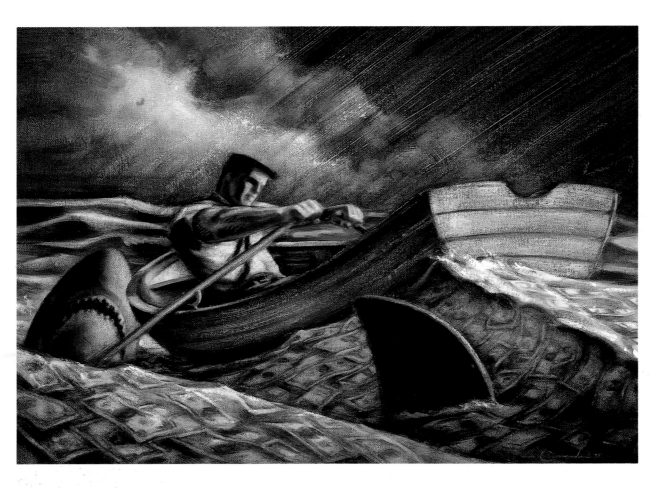

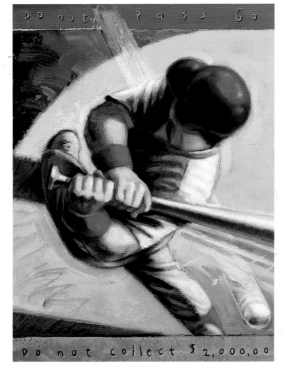

Phil Cheung

CONRAD
REPRESENTS

T
415
921.7140

F
415
921.3939

Art for the brain | CONRAD REPRESENTS

Rafael Lopez

CONRAD
REPRESENTS

T
415
921.7140

F
415
921.3939

CONRAD REPRESENTS | Art for the brain

Phil Foster

CONRAD
REPRESENTS

T
415
921.7140

F
415
921.3939

Art for the brain | CONRAD REPRESENTS

JACKIE URBANOVIC

REPERTORY
REPRESENTS
TEL: 212 486 0177

847A SECOND AVE., SUITE 150, NEW YORK, N.Y. 10017 TEL 212 486 0177

PHILIP KNOWLES

JOHN HANLEY

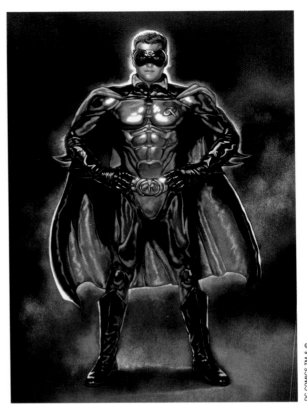

DON STEWART

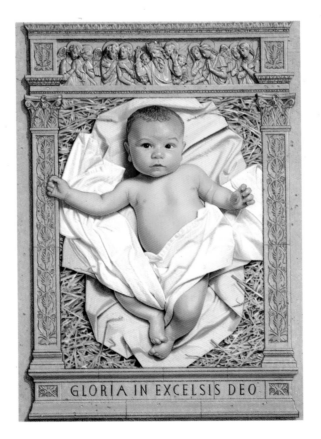

KIRK BOTERO

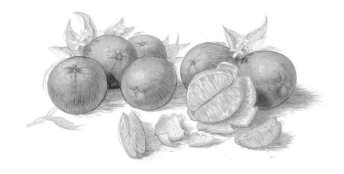

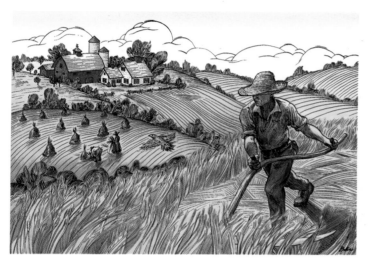

CRISTOS

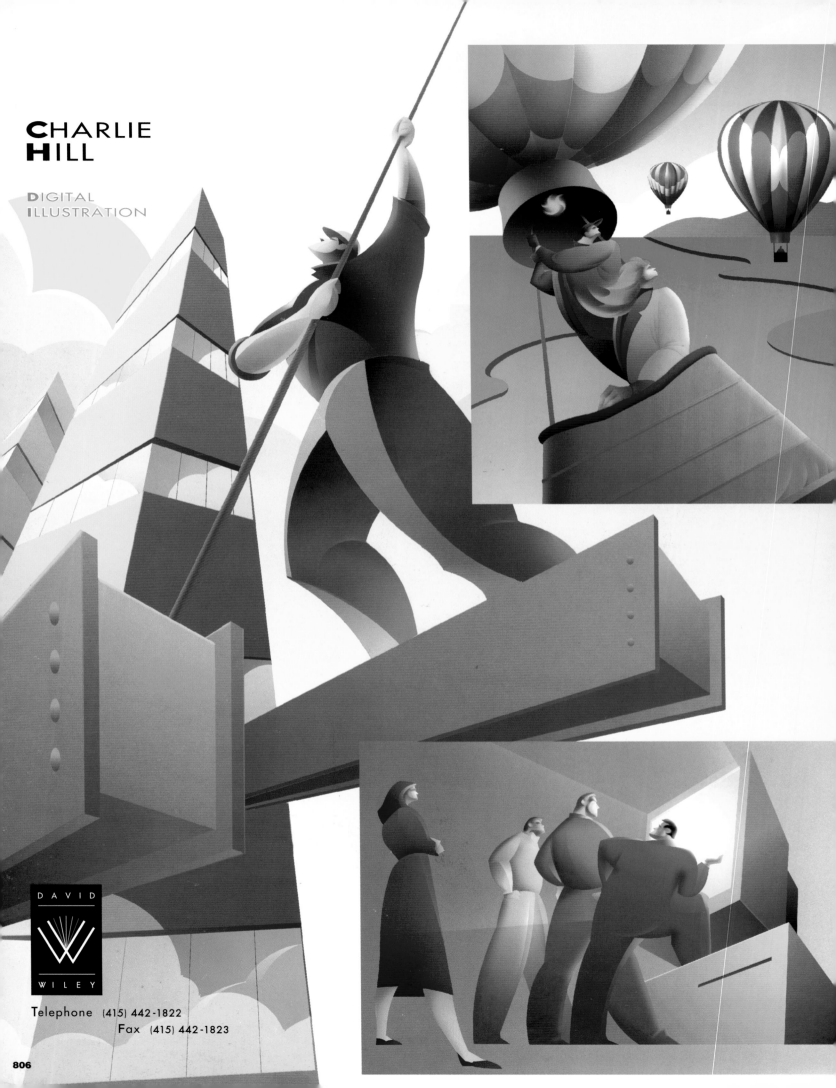

CHARLIE
HILL

DIGITAL
ILLUSTRATION

DAVID
W
WILEY

Telephone (415) 442-1822
Fax (415) 442-1823

806

KEN TOYAMA

DIGITAL
ILLUSTRATION

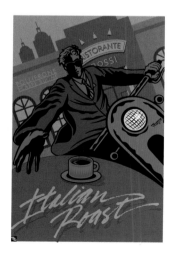

DAVID
WILEY

Telephone **(415) 442-1822**

Fax **(415) 442-1823**

JAMES CHAFFEE

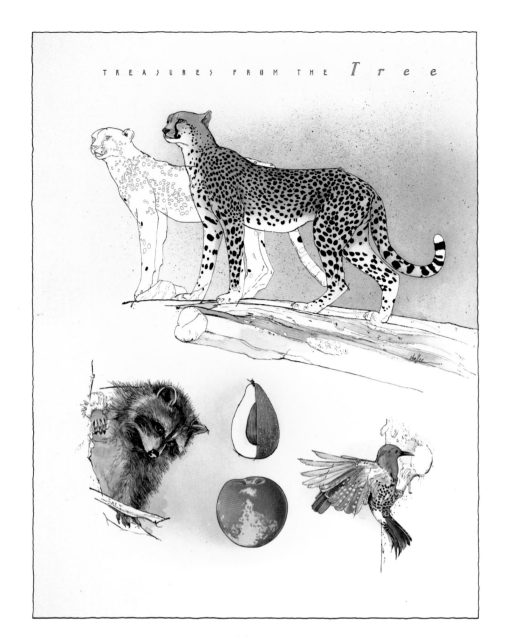

TREASURES FROM THE *Tree*

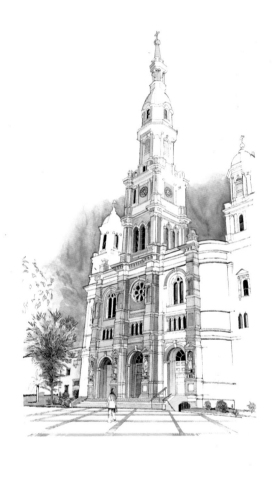

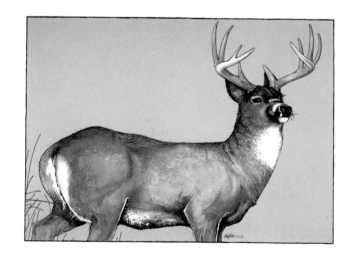

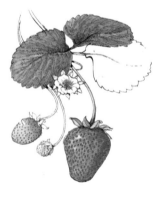

Telephone (415) 442-1822

Fax (415) 442-1823

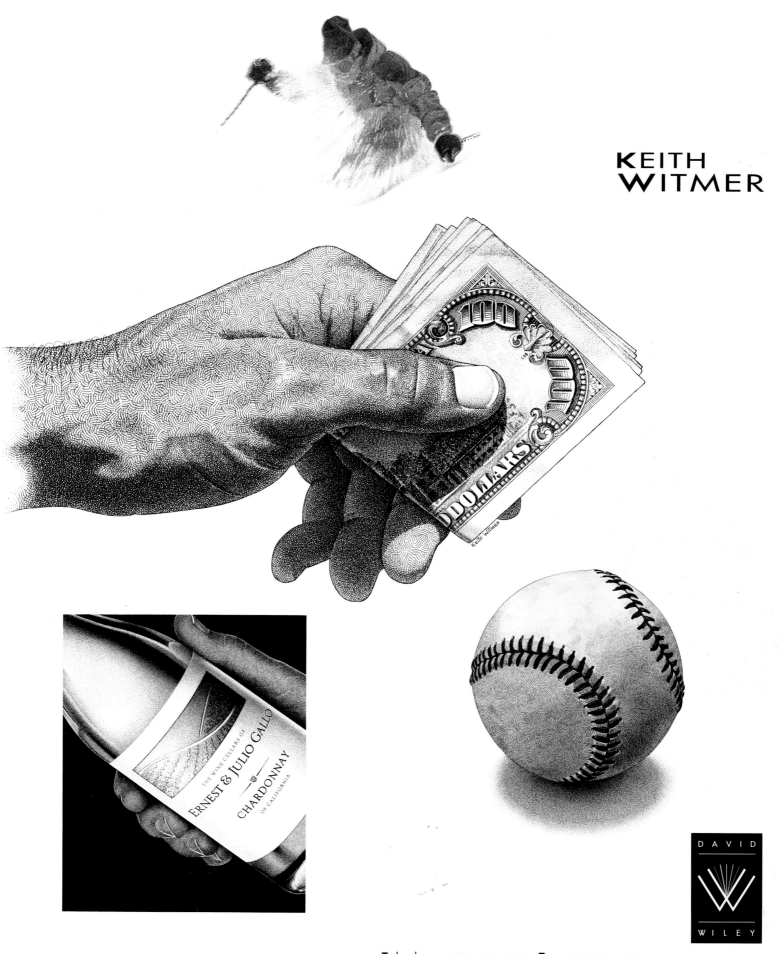

KEITH
WITMER

REPRESENTING:

LouisHenderson

airbrush
Magazine

PHOTOREALISTIC AIRBRUSHING

$5.95 CANADA

phone 612-
374-3169
JOANIE BERNSTEIN

ART REP

DAN
PICASSO
illustrator

№ P-300

812

Proof #1

Judith with head of Holofernes
after Agostino Carracci
1557–16 o2
N⁰ M-300
engraved in copper Jan. 1995

GARDEN STUDIO

GARDEN STUDIO IS A GROUP OF INTERNATIONAL ARTISTS WITH A WORLD NAME FOR ORIGINAL, HIGH QUALITY ILLUSTRATION. WE ARE EFFICIENT, AND AFFORDABLE. A FEW OF OUR STARS ARE SHOWN BELOW. YOU CAN NOW CALL US LOCALLY ON (718) 575 5667 OR FAX US LOCALLY ON (718) 261 0527. (UK TEL 011 44 171 287 9191 UK FAX 011 44 171 287 9131).

MIKE ATKINSON

MARK OLIVER

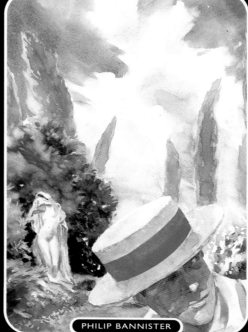

PHILIP BANNISTER

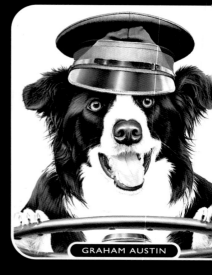

GRAHAM AUSTIN

'STIK' (alias Bill Greenhead)

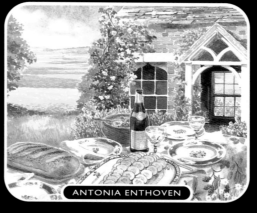

ANTONIA ENTHOVEN

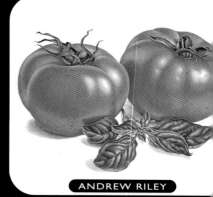

ANDREW RILEY

NICK DIGGORY

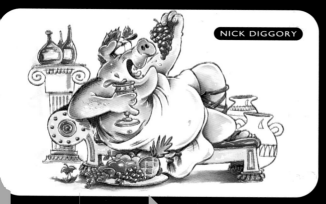

SIMON WILLIAMS

SIÂN FRANCES

JOHN -SM

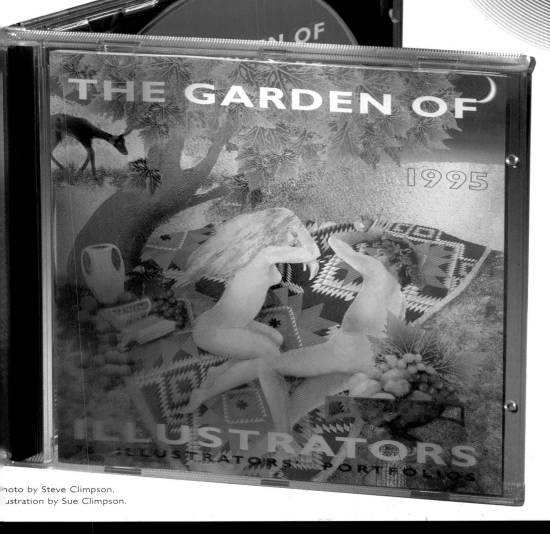

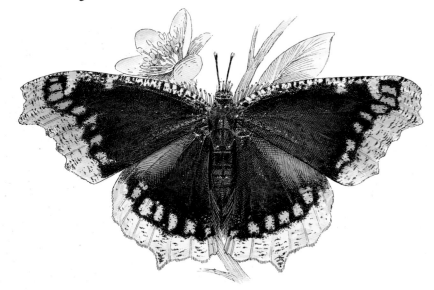

JOHN BURGOYNE

MOURNING CLOAK
BUTTERFLY
Nymphalis antiopa

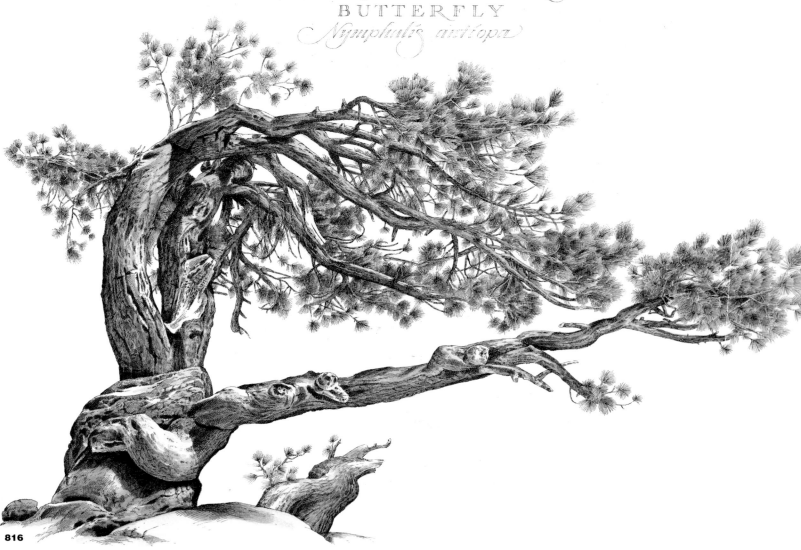

ILLUSTRATORS
200 East 78th Street
Katherine
TISE
212·570·9069
New York, N.Y. 10021
REPRESENTATIVE

JOHN BURGOYNE

RING-NECKED PHEASANT
Phasianus colchicus

Argus

Jean Hirashima

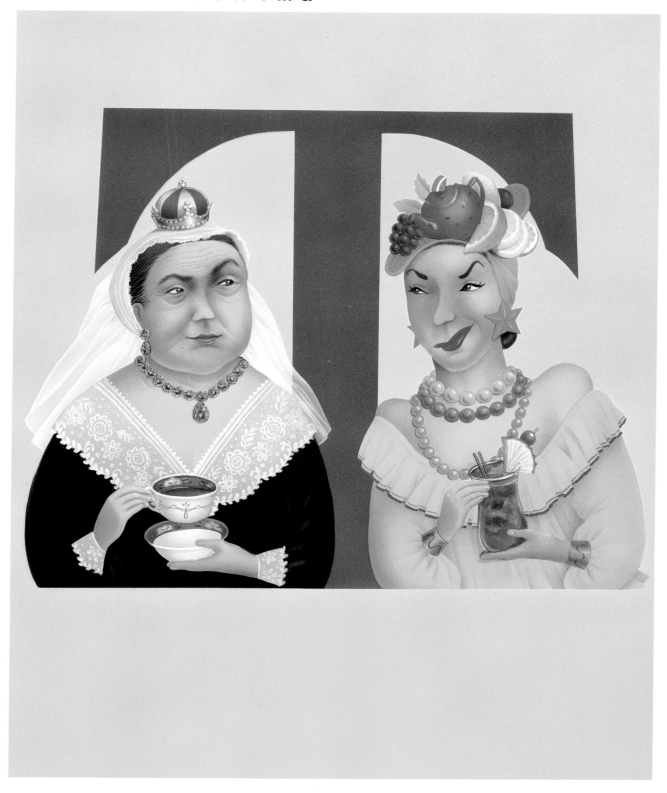

KIMBLE

David Kimble
9 1 5 · 7 2 9 · 4 8 0 2

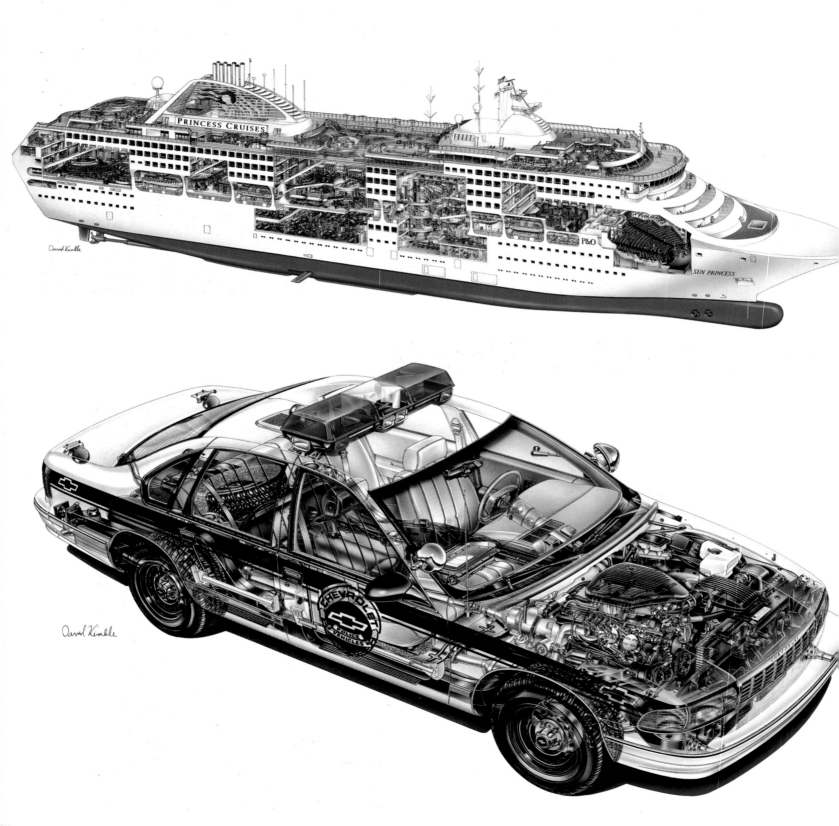

KIRSCH
R E P R E S E N T S
8 0 0 · 4 5 6 · 3 7 0 6

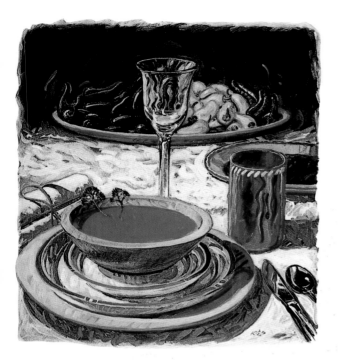

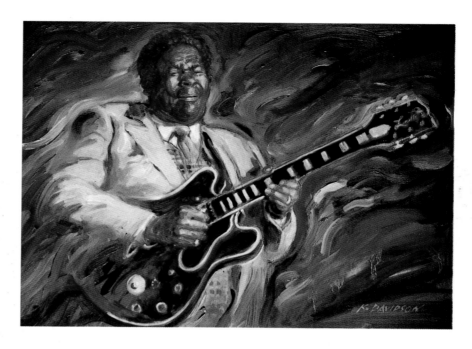

kevin davidson

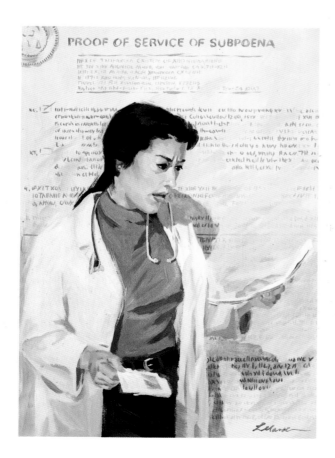

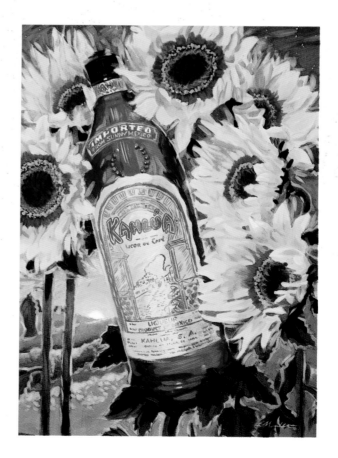

lorraine maschler

MICHAEL SOURS ROHANI
ILLUSTRATOR

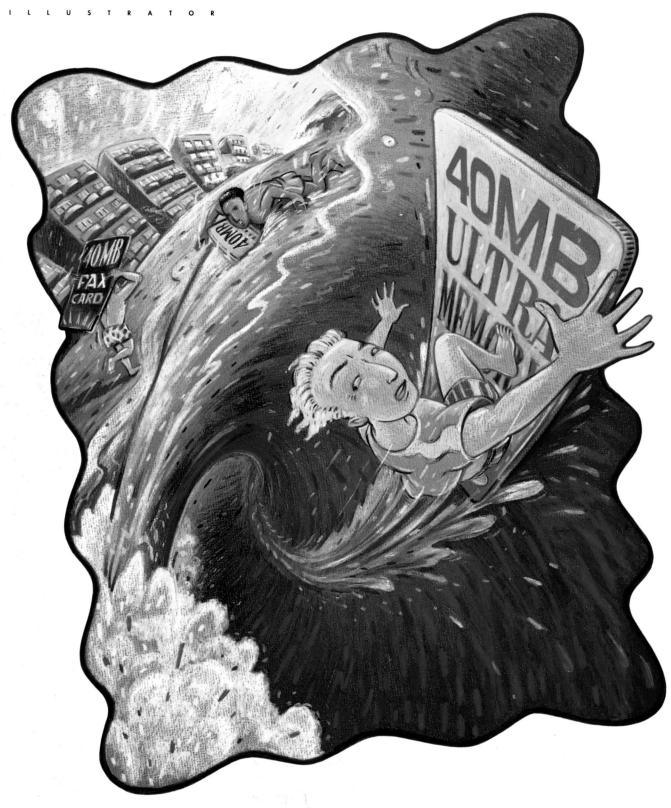

TRUDY SANDS
ARTIST REPRESENTATIVE
1350 Chemical St, Dallas, Texas 75207
214 905 9037 / Fax 214 905 9038

MUSHKA ROHANI
ARTIST REPRESENTATIVE
(FOR THE NORTHWEST)
206 771 2905 / Fax 206 771 2905

MARK WIENER

computer
generated
illustration

represented by watson and spierman productions ph: 1 212 431 4480
studio fx/ph 1 212 696 1792
http://www.goworldnet.com/markw.htm

Bruck & Moss
Nancy Bruck
(212) 982-6533 • FAX: (212) 674-0194
Eileen Moss
(212) 980-8061 • FAX: (212) 832-8778

JOEL PETER JOHNSON

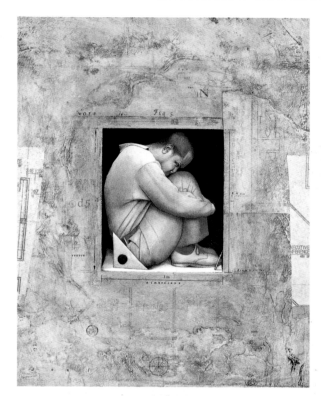

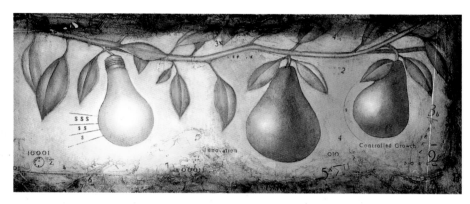

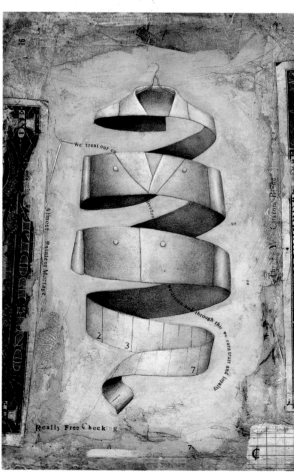

Bruck & Moss
Nancy Bruck
(212) 982-6533 • FAX: (212) 674-0194
Eileen Moss
(212) 980-8061 • FAX: (212) 832-8778

A D A M N I K L E W I C Z

Bruck & Moss
Eileen Moss
(212) 980-8061 • FAX: (212) 832-8778
Nancy Bruck
(212) 982-6533 • FAX: (212) 674-0194

BRUCK & MOSS

ELIZABETH LADA

© Elizabeth Lada 1995

Bruck & Moss
Eileen Moss
(212) 980-8061 • FAX: (212) 832-8778
Nancy Bruck
(212) 982-6533 • FAX: (212) 674-0194

BRUCK & MOSS
NANCY
EILEEN

TOM CURRY

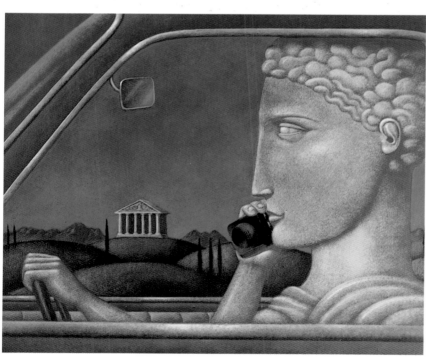

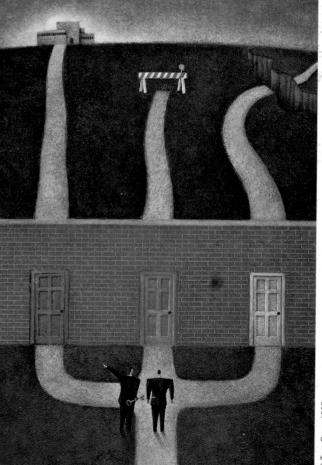

Bruck & Moss
Eileen Moss
(212) 980-8061 • FAX: (212) 832-8778
Nancy Bruck
(212) 982-6533 • FAX: (212) 674-0194

WARREN GEBERT

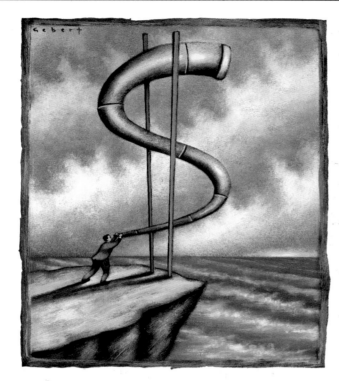

Bruck & Moss
Eileen Moss
(212) 980-8061 • FAX: (212) 832-8778
Nancy Bruck
(212) 982-6533 • FAX: (212) 674-0194

R E B E C C A R Ü E G G E R

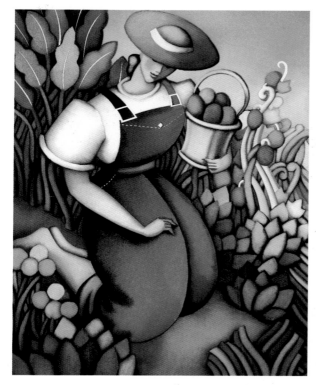

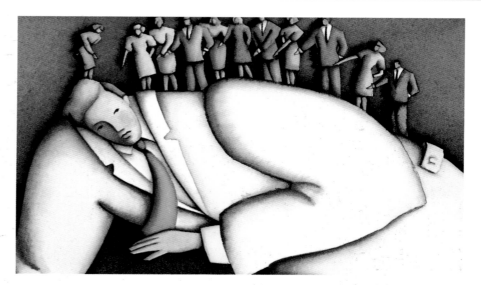

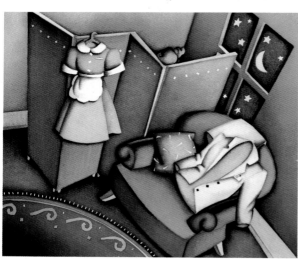

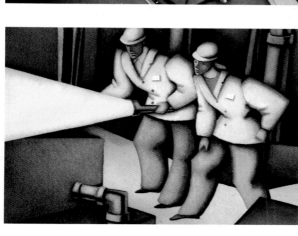

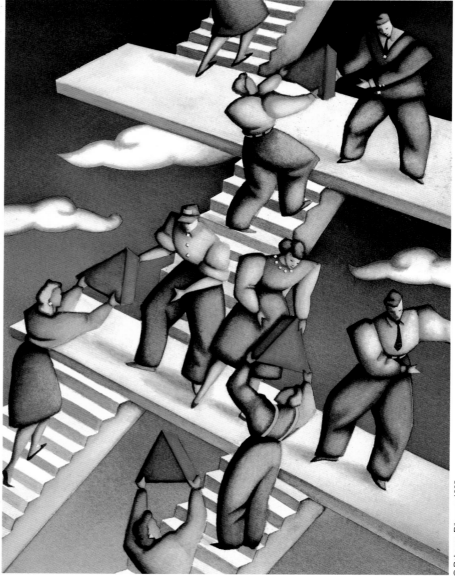

Bruck & Moss

Nancy Bruck
(212) 982-6533 • FAX: (212) 674-0194
Eileen Moss
(212) 980-8061 • FAX: (212) 832-8778

BRUCK & MOSS

DAVE BLACK

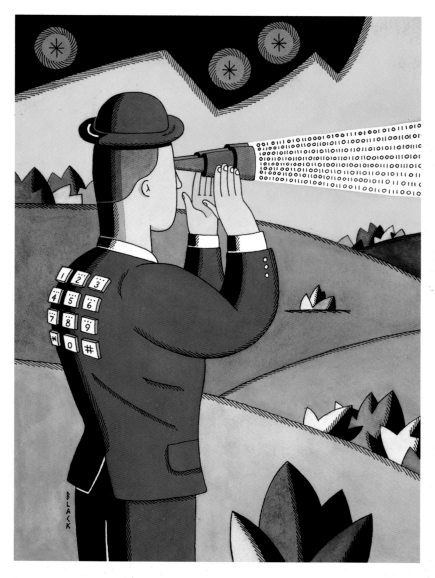

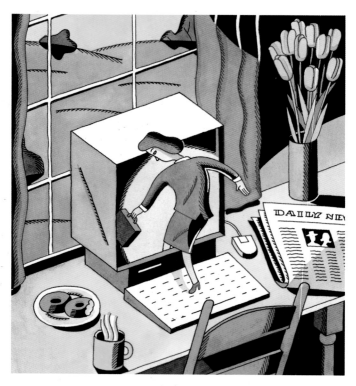

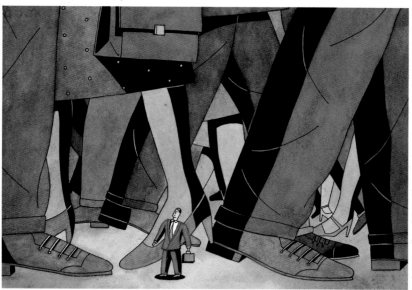

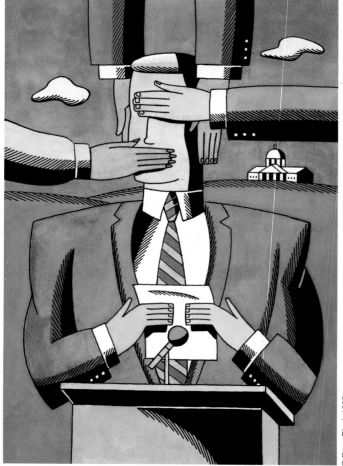

Bruck & Moss
Nancy Bruck
(212) 982-6533 • FAX: (212) 674-0194
Eileen Moss
(212) 980-8061 • FAX: (212) 832-8778

Digital Medium

S U S A N L e V A N

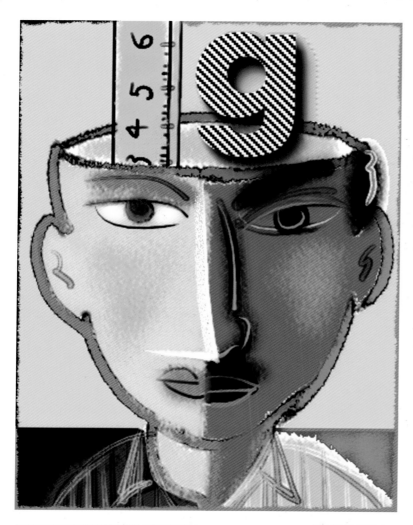

Bruck & Moss
Nancy Bruck
(212) 982-6533 • FAX: (212) 674-0194
Eileen Moss
(212) 980-8061 • FAX: (212) 832-8778

BRUCK & MOSS
NANCY EILEEN

BRET MEREDITH

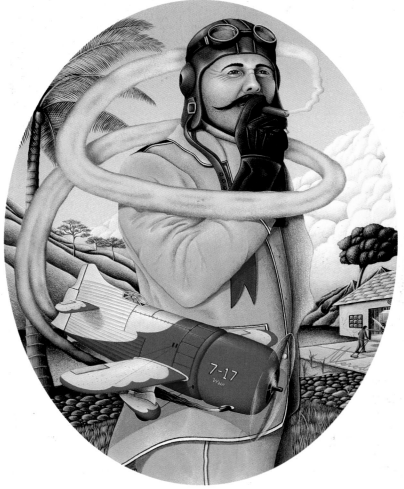

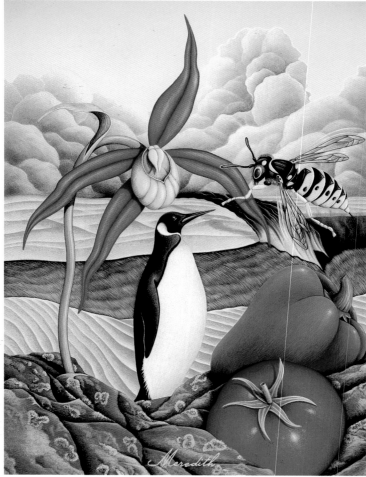

Bruck & Moss
Eileen Moss
(212) 980-8061 • FAX: (212) 832-8778
Nancy Bruck
(212) 982-6533 • FAX: (212) 674-0194

CHANG PARK

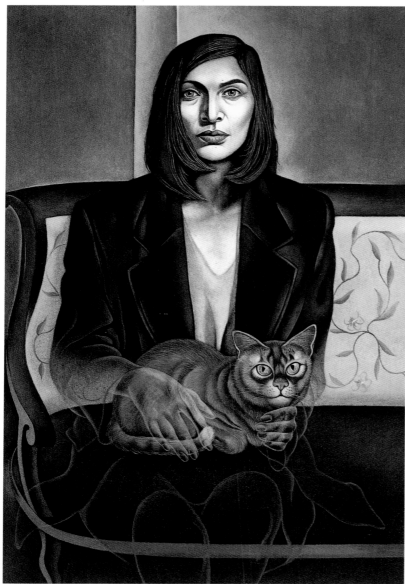

GOETHE

" We should talk less and **draw** more.
Personally, I would like to
renounce speech altogether **"**
and, like organic nature, communicate everything I have to say in sketches.

**Carol Chislovsky
Design Inc.**
853 Broadway
New York, New York 10003
(212) 677-9100
FAX: (212) 353-0954

CHISLOVSKY

MURRAY KIMBER

Carol Chislovsky Design Inc.
853 Broadway
New York, New York 10003
(212) 677-9100
FAX: (212) 353-0954

CHISLOVSKY

SANDRA SHAP

GIL ADAMS

**Carol Chislovsky
Design Inc.**
853 Broadway
New York, New York 10003
(212) 677-9100
FAX: (212) 353-0954

CHISLOVSKY

CHRIS GALL

**Carol Chislovsky
Design Inc.**
853 Broadway
New York, New York 10003
(212) 677-9100
FAX: (212) 353-0954

CHISLOVSKY

JERRY BLANK

Carol Chislovsky Design Inc.
853 Broadway
New York, New York 10003
(212) 677-9100
FAX: (212) 353-0954

CHISLOVSKY

NEIL SHIGLEY

"

God put me on this earth to

accomplish a certain number of things

Right now, I'm so far

behind

I will never die.

Das Grüp
Carrie Perlow
311 Avenue H, #D
Redondo Beach, California 90277
(310) 540-5958

Brad's Studio Hotline:
(818) 843-2249
FAX: (818) 843-3008

Pacific Northwest Representative:
Christine Prapas (503) 658-7070

For additional samples see:
American Showcase 18 and
Creative Illustration Book '95, '96

BRAD WEINMAN

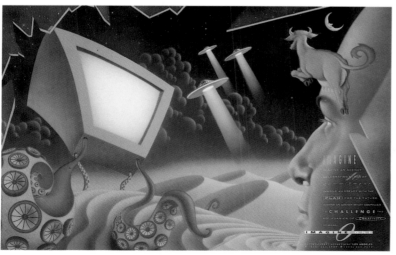

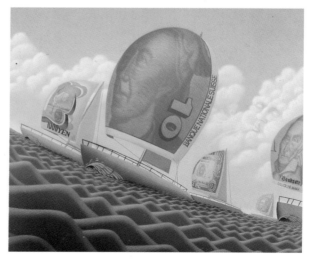

Das Grüp
Carrie Perlow
311 Avenue H, #D
Redondo Beach, California 90277
(310) 540-5958

Brian's Studio:
(310) 318-9252

Represented outside California by:
Joni Tuke (312) 787-6826

BRIAN FUJIMORI

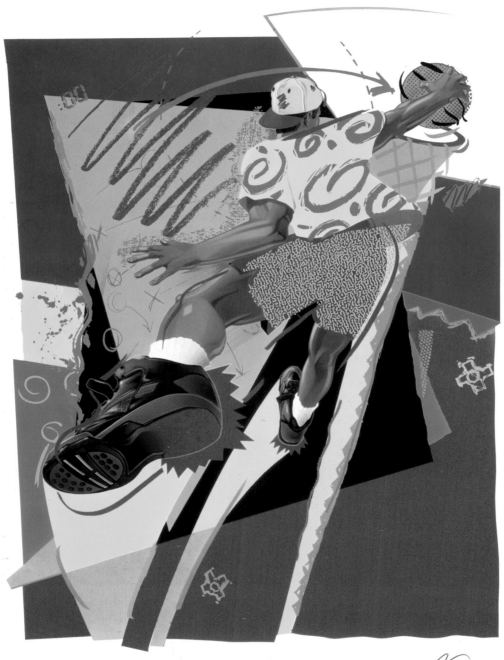

Das Grüp
Carrie Perlow
311 Avenue H, #D
Redondo Beach, California 90277
(310) 540-5958

Mike's Studio:
(909) 865-5056

For additional samples see:
Workbook '96, '95, '94, '93, '92
Creative Illustration Book '95, '94
American Showcase '95

Chicago Representative:
• Patrice Bockos (312) 661-1717
New York Representative:
• Dennis Godfrey (212) 807-0840
Northwest Representative:
• Christine Prapas (503) 658-7070

MICHAEL WEPPLO

Das Grüp
Carrie Perlow
311 Avenue H, #D
Redondo Beach, California 90277
(310) 540-5958

Loudvik's Studio:
(818) 846-4751

New York Representative:
Dennis Godfrey (212) 807-0840

LOUDVIK AKOPYAN

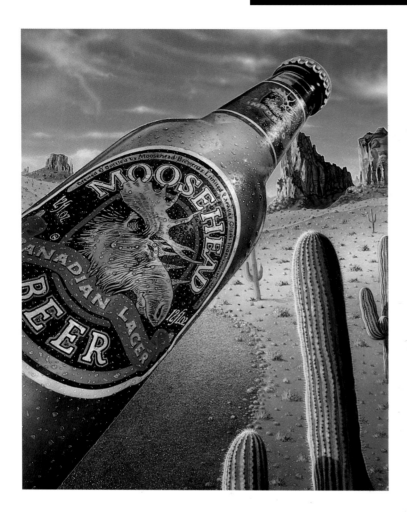

Das Grüp
Carrie Perlow
311 Avenue H, #D
Redondo Beach, California 90277
(310) 540-5958

Nora's Studio:
(818) 791-1953

Animals, landscapes,
people and product.

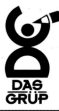

NORA KÖERBER

"**Imagination**

grows by exercise and contrary to common belief is

more powerful in the mature than in the

young."

W. SOMERSET MAUGHAM

Linda de Moreta
Represents
(510) 769-1421
FAX: (510) 521-1674

Representing:
Peter McDonnell

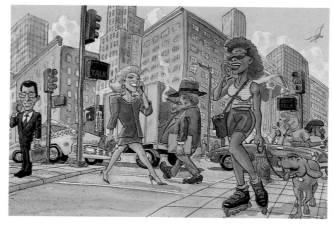

Peter McDonnell

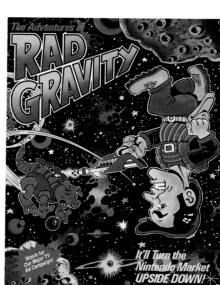

Linda de Moreta
Represents
(510) 769-1421
FAX: (510) 521-1674

Representing:
Diane Hays

Diane Hays

Linda de Moreta
Represents
(510) 769-1421
FAX: (510) 521-1674

Representing:
Michele Collier

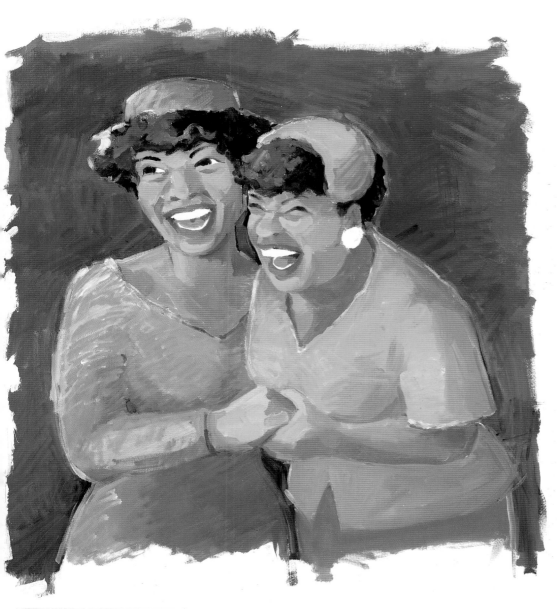

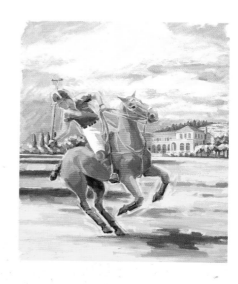

Michele Collier

Sharon Dodge
3033 13th Avenue West
Seattle, Washington 98119
(206) 284-4701
FAX: (206) 282-3499

Representing
Jerry Nelson
500 Aurora North
Suite 203
Seattle, Washington 98109
FAX: (206) 292-9186 Studio

Extensive stock illustration available
from Illustration Works.
Call (800) ART-STOCK
or (800) 278-7862
FAX: (206) 282-3499

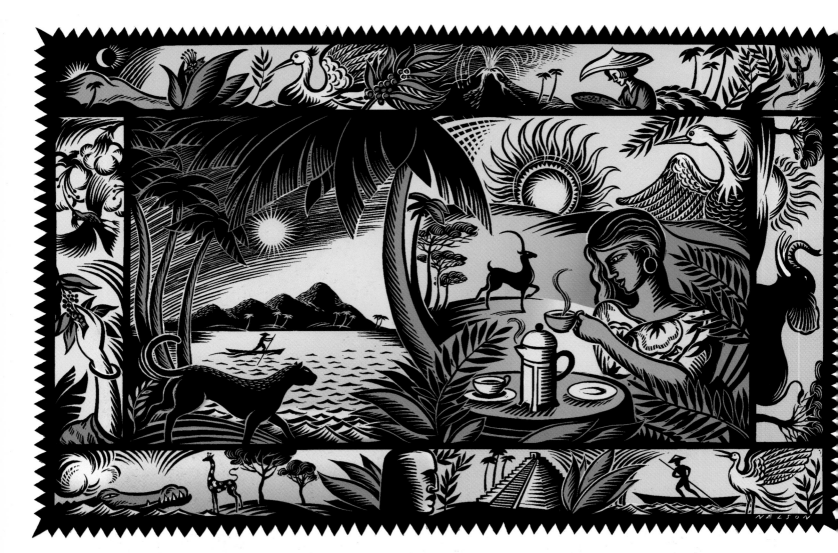

haron Dodge
033 13th Avenue West
eattle, Washington 98119
06) 284-4701
AX: (206) 282-3499

Representing
Beata Szpura
48-02 69th Street
Woodside, New York 11377
(718) 424-8440 Phone/FAX

Extensive stock illustration available
from Illustration Works.
Call (800) ART-STOCK
or (800) 278-7862
FAX: (206) 282-3499

Additional work:
American Showcase 14, 18

David Goldman Agency
41 Union Square West
Suite 918
New York, New York 10003
(212) 807-6627
FAX: (212) 463-8175

Norm Bendell

Yes, we have a great animation reel.

DAVID
GOLDMAN
AGENCY

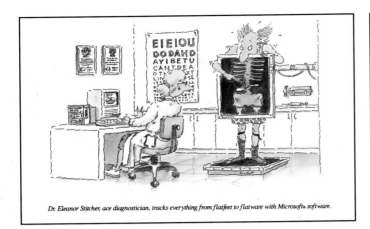

Dr. Eleanor Stitcher, ace diagnostician, tracks everything from flatfeet to flatware with Microsoft® software.

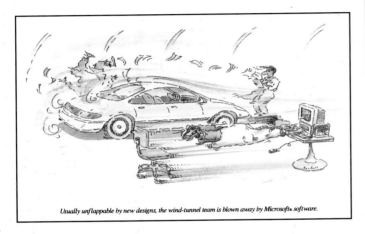

Usually unflappable by new designs, the wind-tunnel team is blown away by Microsoft® software.

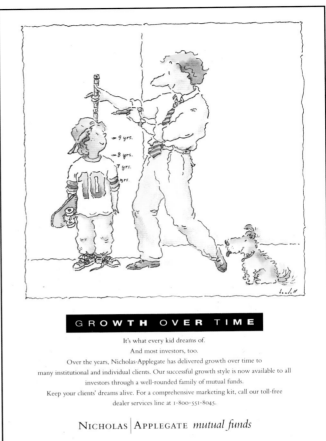

GROWTH OVER TIME

It's what every kid dreams of.
And most investors, too.
Over the years, Nicholas-Applegate has delivered growth over time to
many institutional and individual clients. Our successful growth style is now available to all
investors through a well-rounded family of mutual funds.
Keep your clients' dreams alive. For a comprehensive marketing kit, call our toll-free
dealer services line at 1-800-551-8045.

NICHOLAS | APPLEGATE *mutual funds*

David Goldman Agency
41 Union Square West
Suite 918
New York, New York 10003
(212) 807-6627
FAX: (212) 463-8175

Norm Bendell

Yes, we have a great animation reel.

Animation Clients Include:
Southwestern Bell, Budget Gourmet,
Serenity, Mellon Bank, Xerox,
& Ciba-Geigy

David Goldman Agency
41 Union Square West
Suite 918
New York, New York 10003
(212) 807-6627
FAX: (212) 463-8175

James Yang

Digital execution of art is now available,
a.k.a. "Digital Yang"

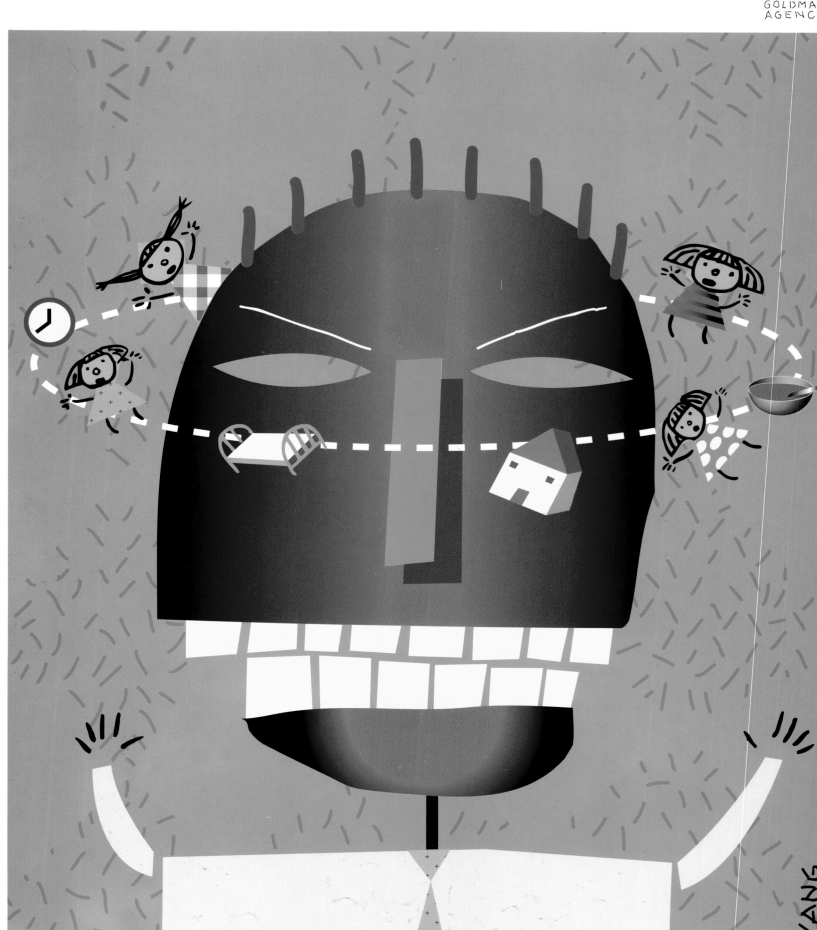

David Goldman Agency **James Yang**
 Union Square West
 uite 918
 ew York, New York 10003
 12) 807-6627
 AX: (212) 463-8175

DAVID
GOLDMAN
AGENCY

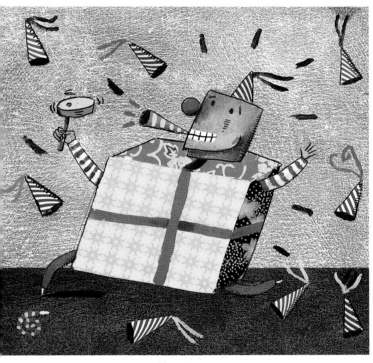

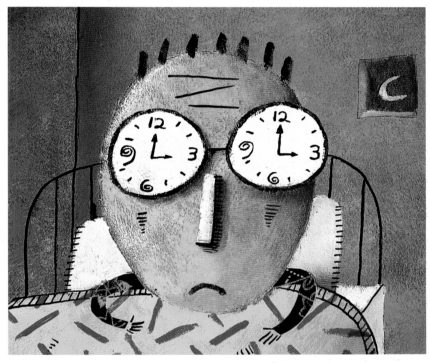

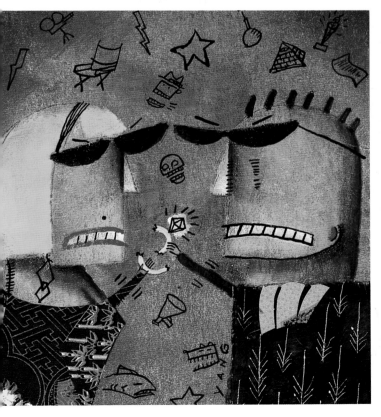

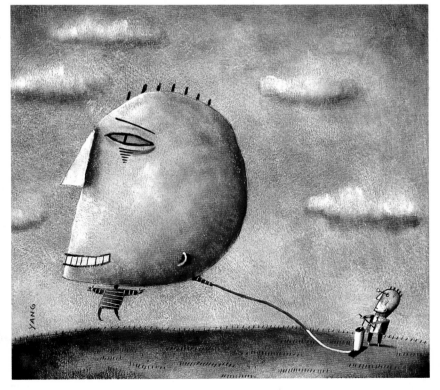

David Goldman Agency **Steve Dininno**
41 Union Square West
Suite 918
New York, New York 10003
(212) 807-6627
FAX: (212) 463-8175

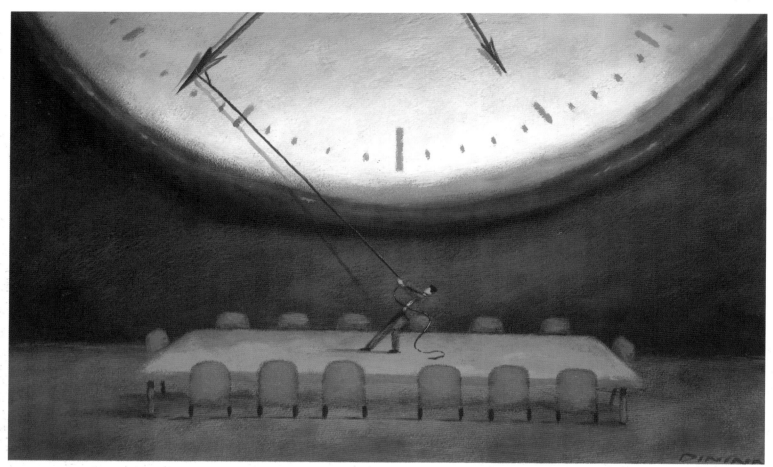

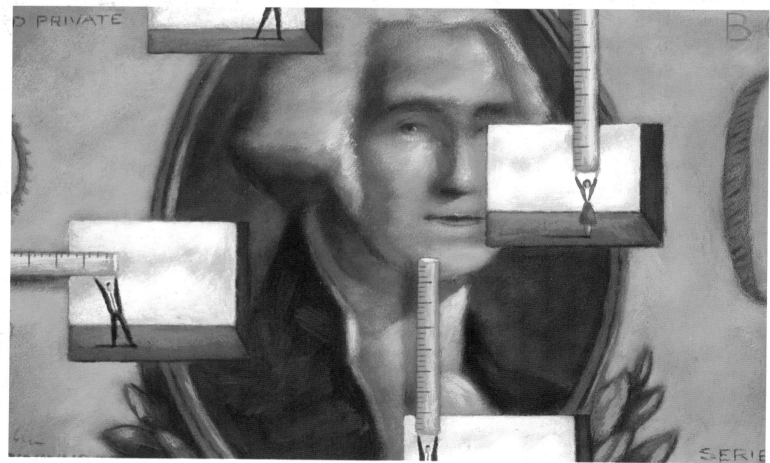

David Goldman Agency **Steve Dininno**

1 Union Square West
Suite 918
New York, New York 10003
(212) 807-6627
FAX: (212) 463-8175

David Goldman Agency
41 Union Square West
Suite 918
New York, New York 10003
(212) 807-6627
FAX: (212) 463-8175

Nishan Akgulian

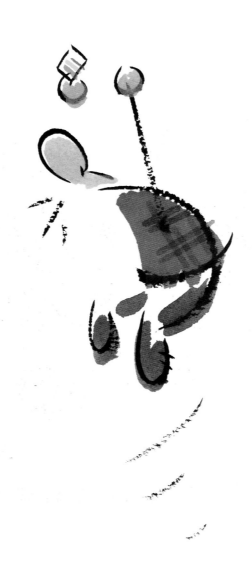

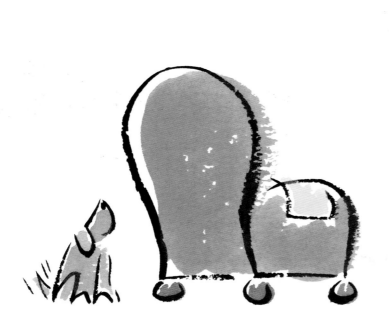

David Goldman Agency **Nishan Akgulian**
41 Union Square West
Suite 918
New York, New York 10003
(212) 807-6627
FAX: (212) 463-8175

David Goldman Agency
41 Union Square West
Suite 918
New York, New York 10003
(212) 807-6627
FAX: (212) 463-8175

Kazushige Nitta

Additional work can be seen in:
American Showcase Volumes 15, 16 & 17,
Corporate Showcase Volume 13, and
Society of Illustrators Volumes 33 & 34.

DAVID
GOLDMAN
AGENCY

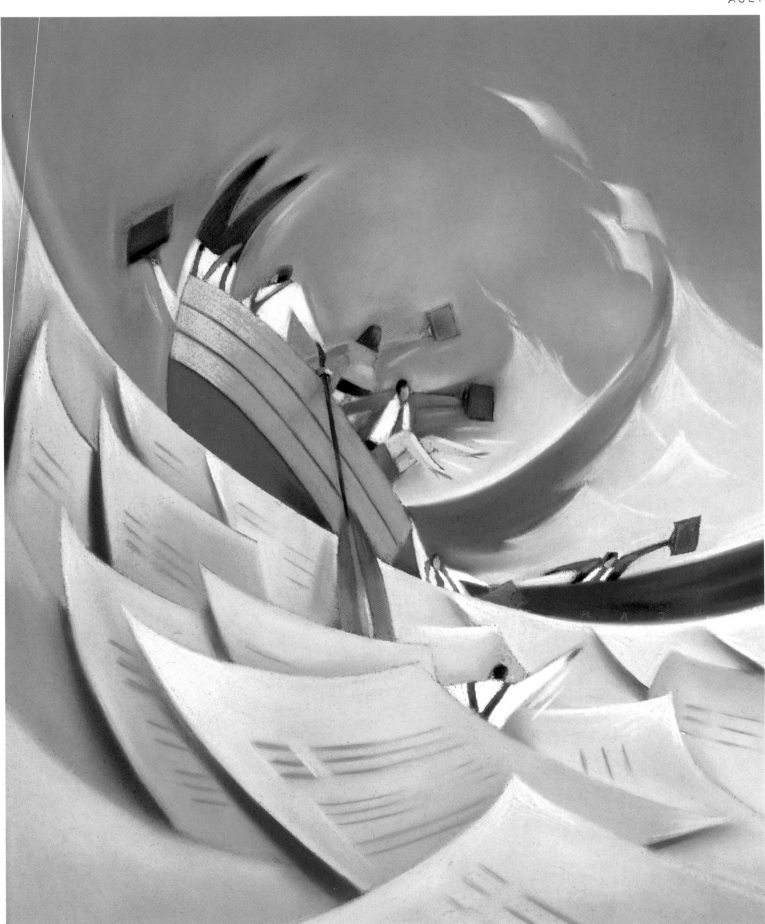

David Goldman Agency
41 Union Square West
Suite 918
New York, New York 10003
(212) 807-6627
FAX: (212) 463-8175

Kazushige Nitta

Additional work can be seen in:
American Showcase Volumes 15, 16 & 17,
Corporate Showcase Volume 13, and
Society of Illustrators Volumes 33 & 34.

DAVID
GOLDMAN
AGENCY

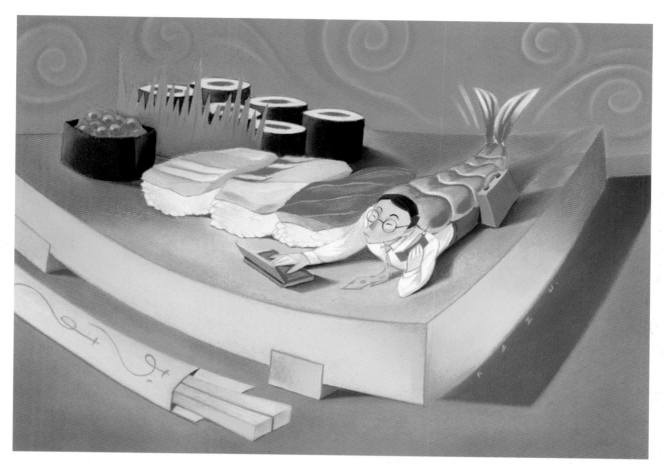

David Goldman Agency **Gary Taxali**
41 Union Square West
Suite 918
New York, New York 10003
(212) 807-6627
FAX: (212) 463-8175

David Goldman Agency
41 Union Square West
Suite 918
New York, New York 10003
(212) 807-6627
FAX: (212) 463-8175

Gary Taxali

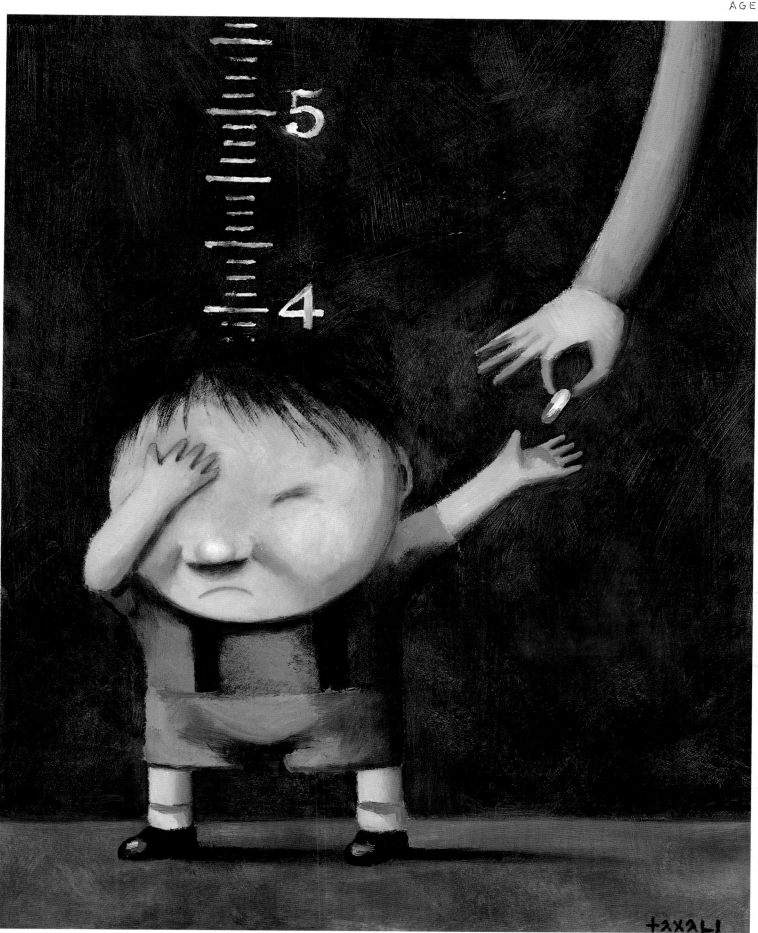

David Goldman Agency
41 Union Square West
Suite 918
New York, New York 10003
(212) 807-6627
FAX: (212) 463-8175

Pierre Fortin

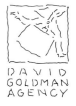

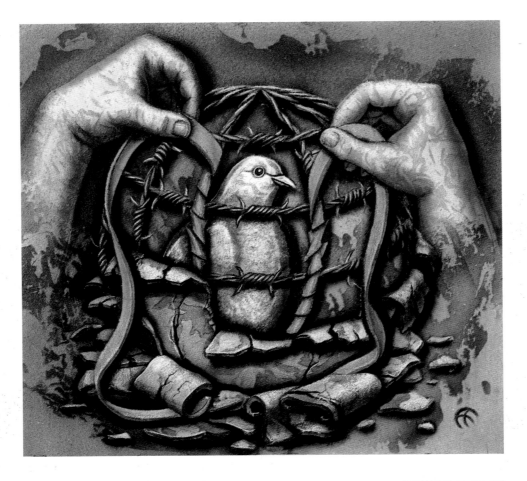

David Goldman Agency **Pierre Fortin**

1 Union Square West
Suite 918
New York, New York 10003
(212) 807-6627
FAX: (212) 463-8175

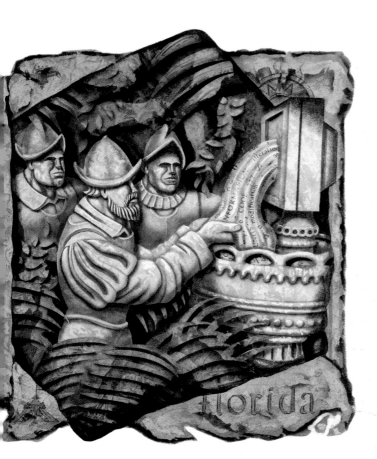

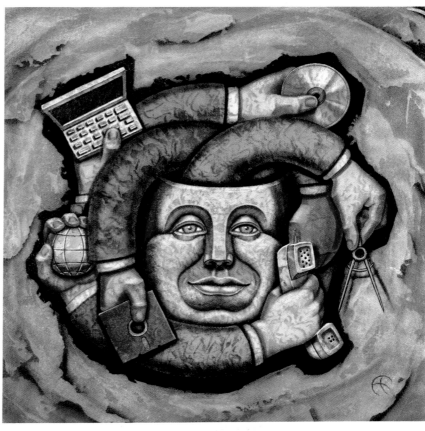

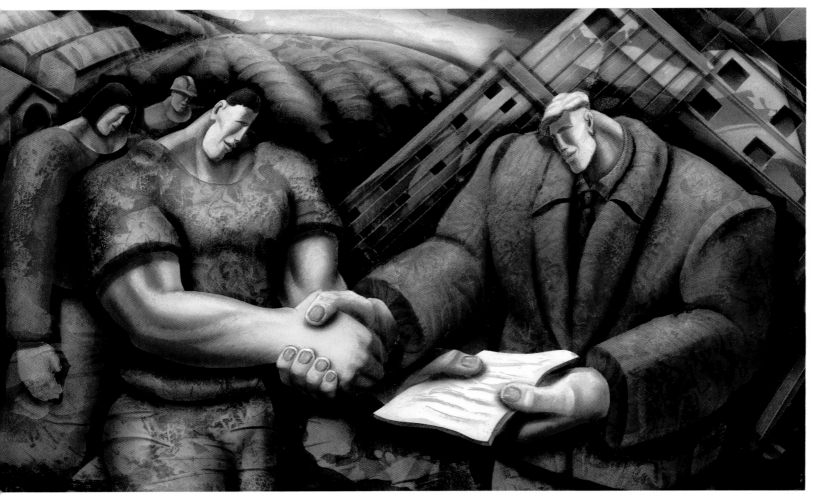

David Goldman Agency **Michelle Barnes**
41 Union Square West
Suite 918
New York, New York 10003
(212) 807-6627
FAX: (212) 463-8175

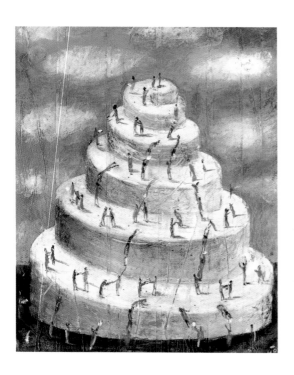

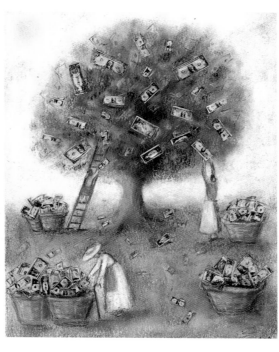

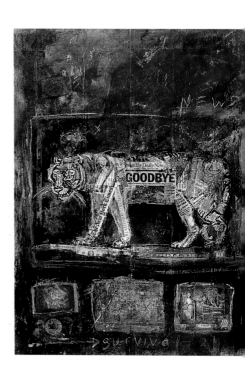

David Goldman Agency **Rosemary Fox**
1 Union Square West
Suite 918
New York, New York 10003
(212) 807-6627
FAX: (212) 463-8175

David Goldman Agency
41 Union Square West
Suite 918
New York, New York 10003
(212) 807-6627
FAX: (212) 463-8175

Mitch Rigie

"Genius goes around the world

in its youth incessantly apologizing for having large feet"

What wonder that later in life it should be inclined to raise those feet too swiftly to fools and bores.

F. SCOTT FITZGERALD

Gordon
ces
d Street
ew York 10016
14
32-4302

Representing:
Nenad Jakesevic
Sonja Lamut

Barbara Gordon
Associates Ltd.
165 East 32 Street
New York, N.Y. 10016
212-686-3514

**Barbara Gordon
Associates**
165 East 32nd Street
New York, New York 10016
(212) 686-3514
FAX: (212) 532-4302

Representing:
Michiko Shimamoto

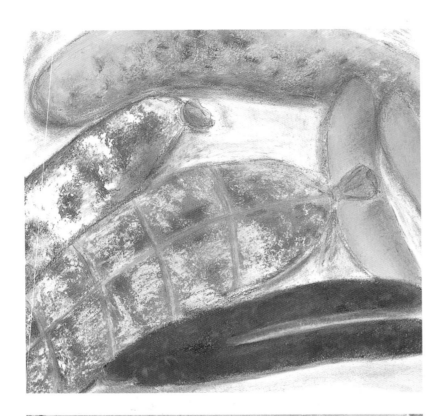

静かな生活

伊丹十三脚本監督／大江健三郎原作

音楽─大江光（日本コロムビア）／原作─静かな生活（講談社刊）／製作─玉置泰／伊丹プロダクション作品／配給─東宝株式会社

山崎努／渡部篤郎／佐伯日菜子／柴田美保子／岡村喬生／宮本信子

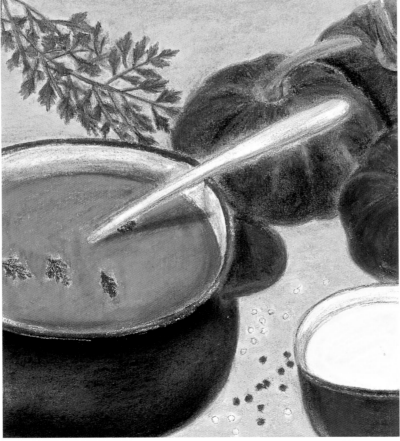

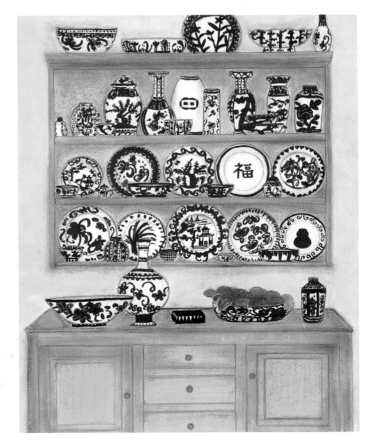

**Barbara Gordon
Associates**
165 East 32nd Street
New York, New York 10016
(212) 686-3514
FAX: (212) 532-4302

Representing:
Glenn Harrington

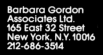

Barbara Gordon
Associates Ltd.
165 East 32 Street
New York, N.Y. 10016
212-686-3514

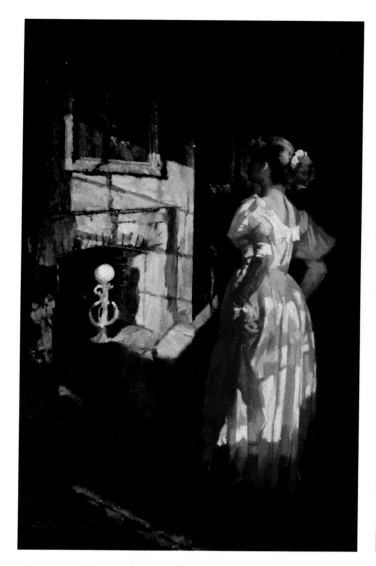

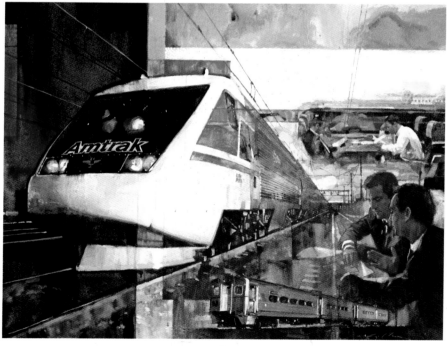

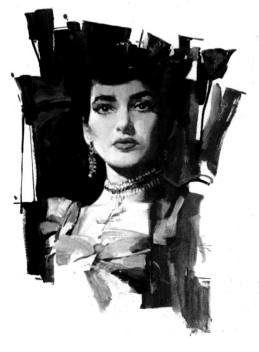

Barbara Gordon Associates
165 East 32nd Street
New York, New York 10016
(212) 686-3514
FAX: (212) 532-4302

Representing:
Jim Dietz

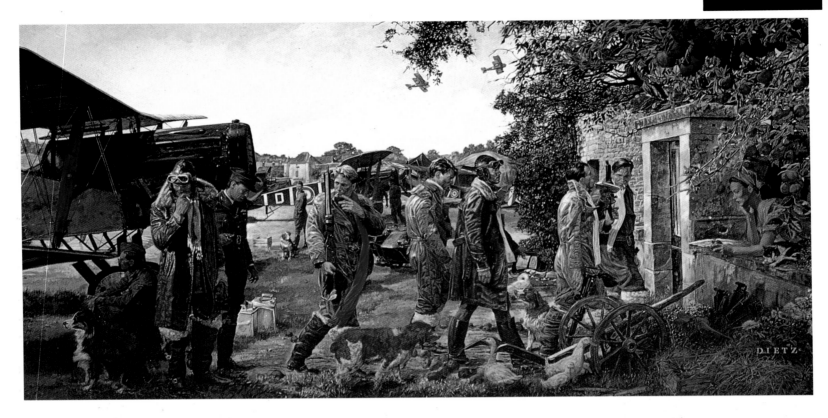

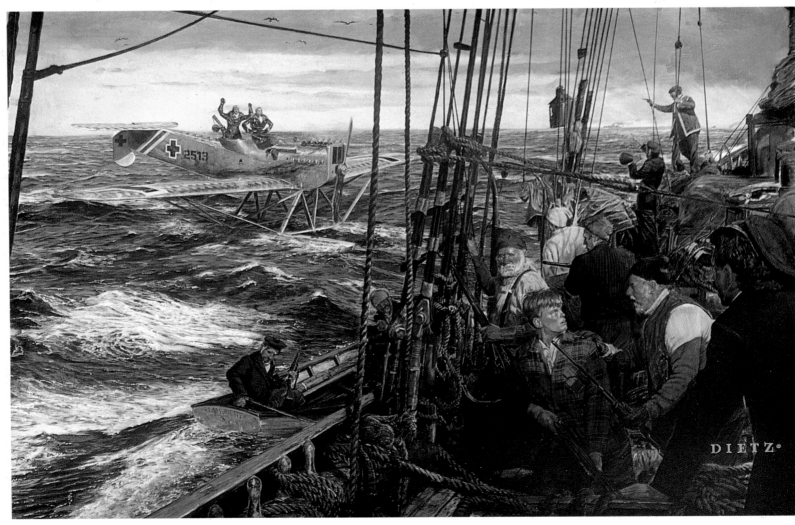

**Barbara Gordon
Associates**
165 East 32nd Street
New York, New York 10016
(212) 686-3514
FAX: (212) 532-4302

Representing:
Robert Hunt

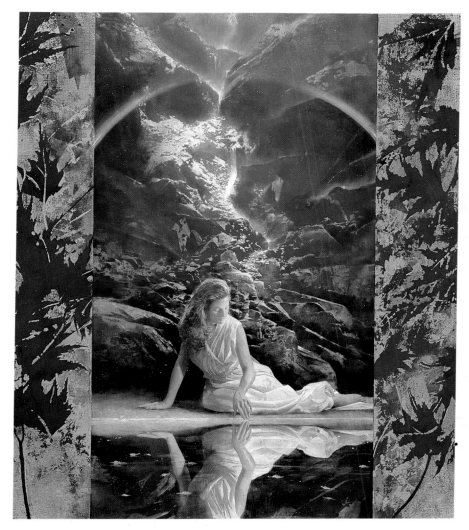

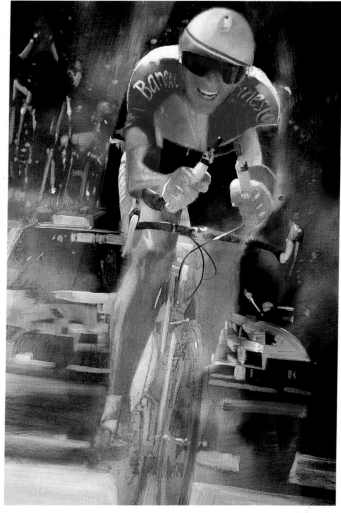

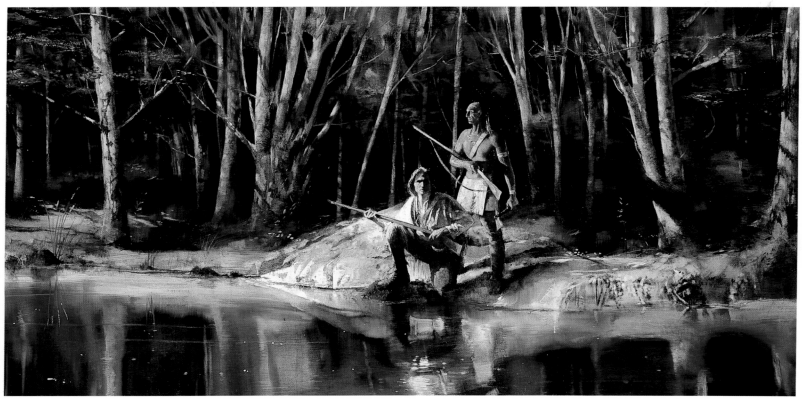

**Barbara Gordon
Associates**
165 East 32nd Street
New York, New York 10016
(212) 686-3514
FAX: (212) 532-4302

Representing:
Keith J. Paul

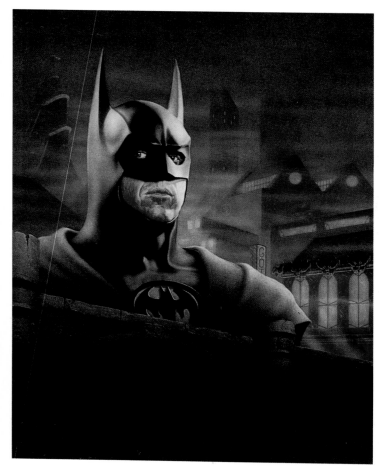

**Barbara Gordon
Associates**
165 East 32nd Street
New York, New York 10016
(212) 686-3514
FAX: (212) 532-4302

Representing:
Barbara Kiwak

**Barbara Gordon
Associates**
165 East 32nd Street
New York, New York 10016
(212) 686-3514
FAX: (212) 532-4302

Representing:
James Le Masurier

Anita Grien
155 East 38th Street
New York, New York 10016
(212) 697-6170
FAX: (212) 697-6177

Julie Johnson
Represented by Anita Grien

Betsy Hillman
Pier 33 North
San Francisco, California 94111
(415) 391-1181

Istvan Banyai
(212) 627-2953
FAX: (212) 627-5934

We want to put Apple Macintosh computers in the hands of as many people as possible.

Including yours.

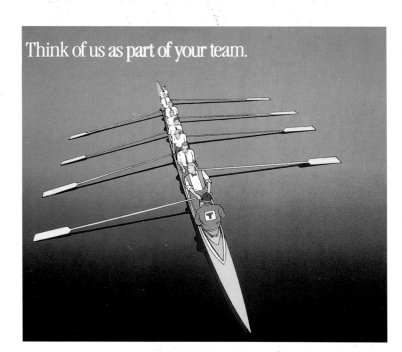

Think of us as part of your team.

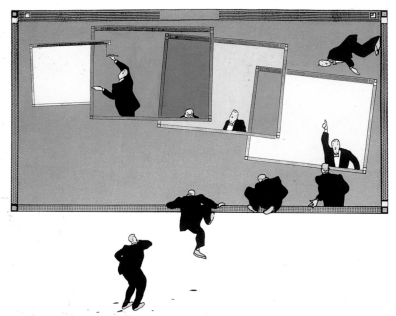

Betsy Hillman
Pier 33 North
San Francisco, California 94111
(415) 391-1181

Randy South
360 Ritch Street, Suite 201
San Francisco, California 94107
(415) 512-9010
FAX: (415) 512-9010

Graphis Award

Clients:
AT&T, GE, NYNEX, Transamerica, etc.

Tania Kimche
137 Fifth Avenue, 11th floor
New York, New York 10010
(212) 529-3556
FAX: (212) 353-0831

To view additional work,
please see Workbook
Volumes 16-18.

We have a large selection of
paintings available for purchase
or secondary usage.

ROB COLVIN

THE BERGER FUNDS

MORTENSEN DESIGN

BBDO WORLDWIDE

FOX PAVLIKA

T A N I A

TANIA KIMCHE / ARTIST REPRESENTATIV

(212) 529-3556 / FAX (212) 353-083

Tania Kimche
137 Fifth Avenue, 11th floor
New York, New York 10010
(212) 529-3556
FAX: (212) 353-0831

To view additional work,
please see Workbook
Volumes 16-18.

We have a large selection of
paintings available for purchase
or secondary usage.

R A F A L O L B I N S K I

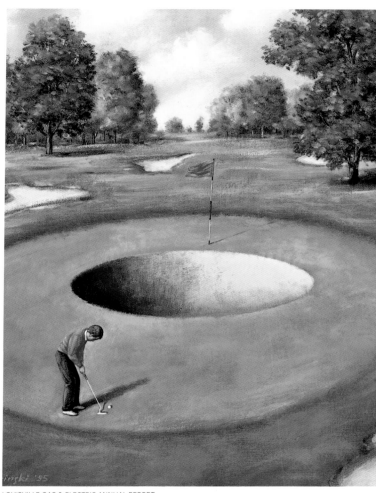

LOUISVILLE GAS & ELECTRIC ANNUAL REPORT

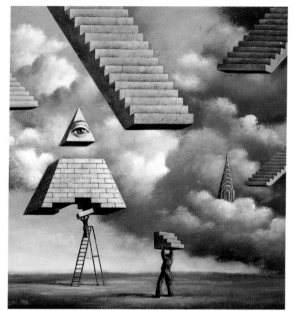

SAATCHI & SAATCHI LONDON

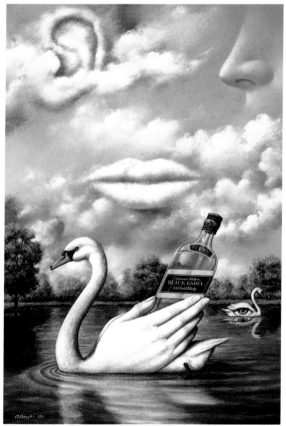

JOHNNY WALKER

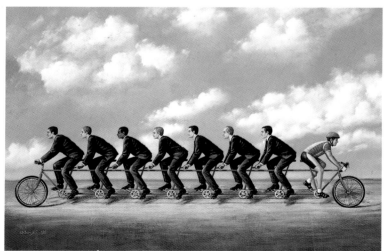

MULLEN ADVERTISING

T A N I A

TANIA KIMCHE / ARTIST REPRESENTATIVE

(2 1 2) 5 2 9 - 3 5 5 6 / F A X (2 1 2) 3 5 3 - 0 8 3 1

Tania Kimche
137 Fifth Avenue, 11th floor
New York, New York 10010
(212) 529-3556
FAX: (212) 353-0831

To view additional work,
please see Workbook
Volume 18.

We have a large selection of
paintings available for purchase
or secondary usage.

KEN McMILLAN

CREDIT SUISSE

LORD DENTSU & PARTNERS

NEST EGG MAGAZINE

SIEMENS

T A N I A

TANIA KIMCHE / ARTIST REPRESENTATIVE
(212) 529-3556 / FAX (212) 353-0831

Tania Kimche
137 Fifth Avenue, 11th floor
New York, New York 10010
(212) 529-3556
FAX: (212) 353-0831

West Coast:
Corey Graham
(415) 956-4750

To view additional work,
please see Workbook
Volumes 16-18.

KIRK CALDWELL

ALBERT FRANK GUENTHER LAW INTERNATIONAL

BMG CLASSICAL MUSIC

ALLMERICA FINANCIAL CO.

ESTÉE LAUDER

Tania Kimche
137 Fifth Avenue, 11th floor
New York, New York 10010
(212) 529-3556
FAX: (212) 353-0831

We have a large selection of
paintings available for purchase
or secondary usage.

C H R I S T O P H E R Z A C H A R O W

WORTH MAGAZINE

AMERICAN MANAGEMENT ASSOCIATION

FRINK, SEMMER & ASSOCIATES

CRN

T A N I A

TANIA KIMCHE / ARTIST REPRESENTATIVE

(212) 529-3556 / FAX (212) 353-0831

886

Tania Kimche
137 Fifth Avenue, 11th floor
New York, New York 10010
(212) 529-3556
FAX: (212) 353-0831

PAUL BLAKEY

SIMON & SCHUSTER

STANFORD UNIVERSITY

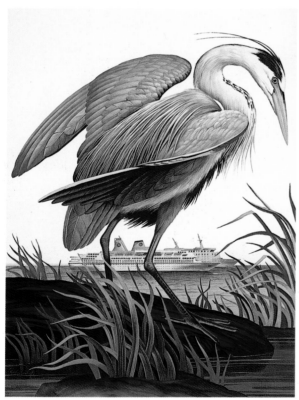

HOME LINES CRUISES

ATLANTA JOURNAL

Tania Kimche
137 Fifth Avenue, 11th floor
New York, New York 10010
(212) 529-3556
FAX: (212) 353-0831

BILL BRANDON

LA TIMES

ECLIPSE DESIGN

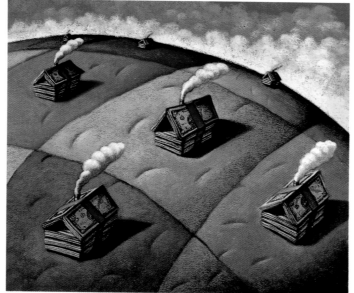

ABA JOURNAL

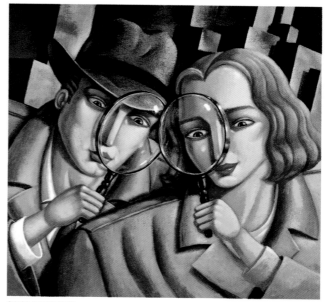

SIMON & SCHUSTER

"You cannot create genius

All you can do is nurture it.

NINETTE de VALOIS

Kirchoff/Wohlberg, Inc.
866 United Nations Plaza
New York, New York 10017
(212) 644-2020

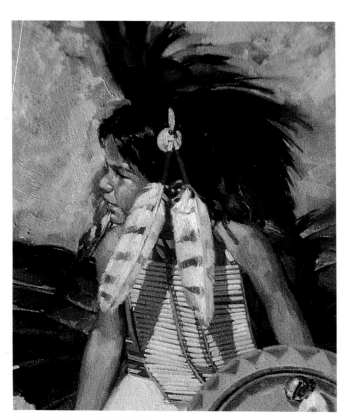

MARY BETH SCHWARK

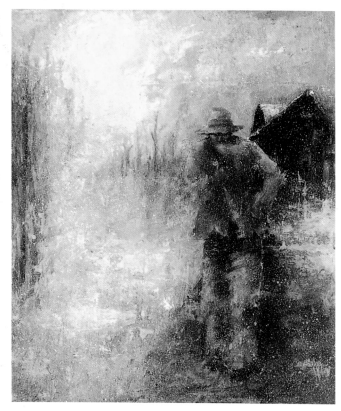

MARNI BACKER

ANDY SAN DIEGO

Kirchoff/Wohlberg, Inc.
866 United Nations Plaza
New York, New York 10017
(212) 644-2020

ROSEKRANS HOFFMAN

COLIN BOOTMAN

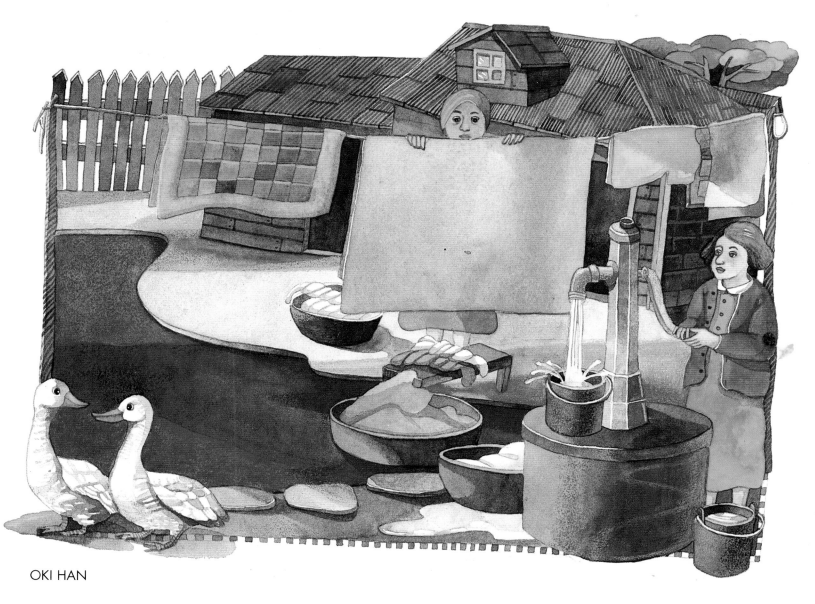

OKI HAN

Jane Klein
Northern California Rep.
1635 East 22nd Street
Oakland, California 94606
(510) 535-0495
FAX: (510) 535-0437

Representing:
Tuko Fujisaki
New York Studio
(718) 789-7472
FAX: (718) 789-3571

Represented in St. Louis by:
Teenuh Foster
(314) 821-2278
FAX: (314) 821-1667

TUKO FUJISAKI

Tuko Fujisaki
New York Studio
(718) 789-7472

Jane Klein
Northern California Rep.
635 East 22nd Street
Oakland, California 94606
510) 535-0495
FAX: (510) 535-0437

Representing:
Jannine Cabossel
Route 19, Box 90-8
Santa Fe, New Mexico 87505
(505) 983-4099

Represented in the Midwest by:
LuLu
(612) 825-7564

Clients:
McCann-Erickson; Tracy-Locke;
Foote, Cone, Belding; Letraset;
Pepsi; Scholastic Magazine;
Sea World; Ligature

Jannine Cabossel Illustration

Lehmen Dabney Inc
1431 35th Avenue South
Seattle, Washington 98144
(206) 325-8595
FAX: (206) 325-8594

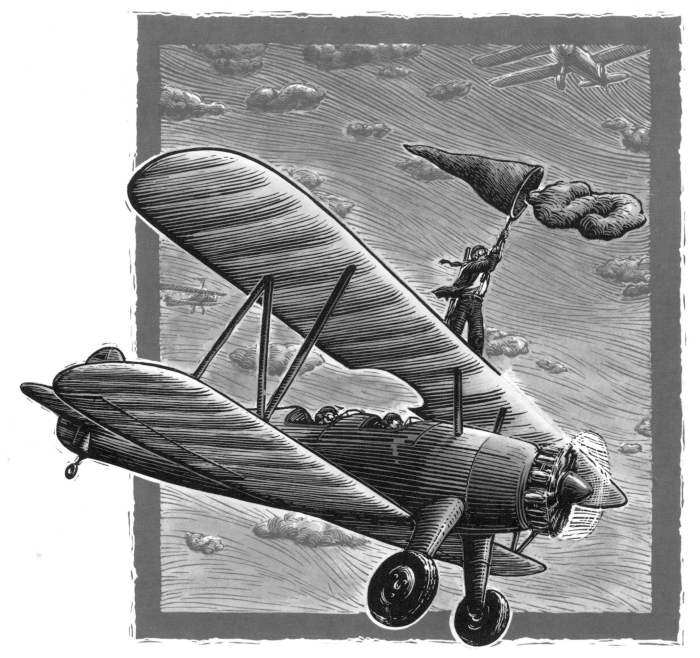

Lehmen Dabney Inc
1431 35th Avenue South
Seattle, Washington 98144
(206) 325-8595
FAX: (206) 325-8594

Obadinah Heavner
(206) 789-8899 Studio
FAX: (206) 782-1572

Clients:
Microsoft, Monsanto, Harcourt Brace,
McClanahan, Nile Spice, SkyRocket
Foods, Alaska Airlines, Kendall Hunt,
Group Health, Children's Media Network,
Skies America

LEHMEN▲DABNEY INC

Obadinah
H e a v n e r

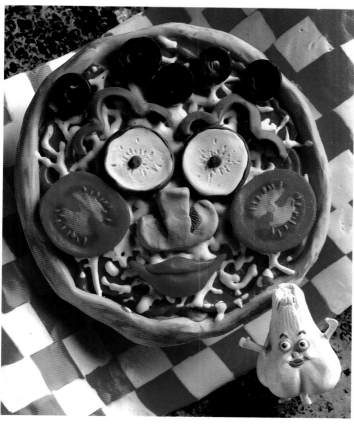

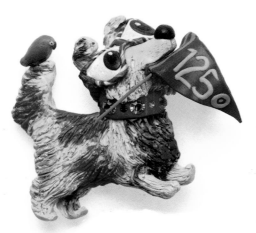

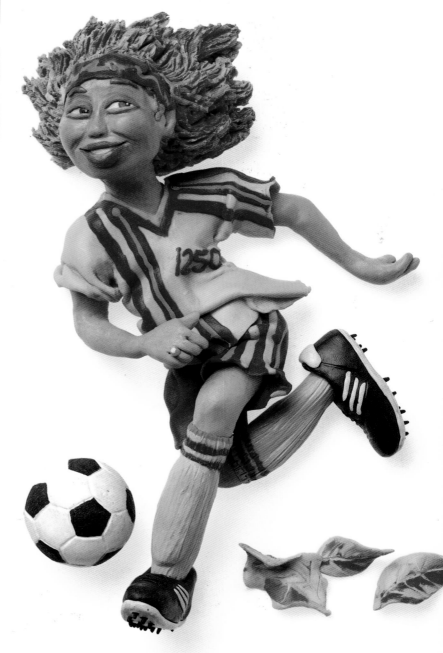

Lulu
Lulu Creatives
4645 Colfax Avenue South
Minneapolis, Minnesota 55409
(612) 825-7564 Phone/FAX

TINA HILL

LULU CREATIVE

RITA GATLIN REPRESENTS

HELEN ROMAN

MIDWEST 612.825.7564 WEST 800.924.7881 SF 415.924.7881 EAST 203.222.1608

Lulu
Lulu Creatives
4645 Colfax Avenue South
Minneapolis, Minnesota 55409
(612) 825-7564 Phone/FAX

Representing:
Tony Novak

Additional Work:
See Workbook 16, 17, 18
Society of Illustrators Annual 37

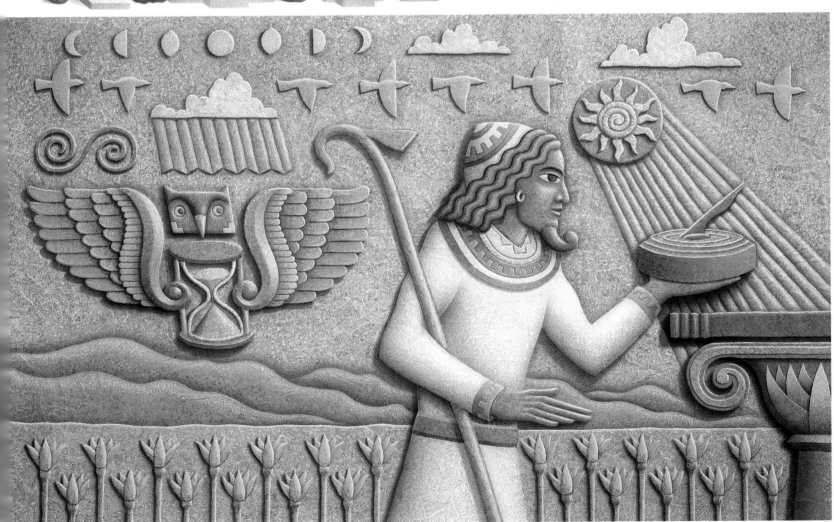

Alan Lynch
11 Kings Ridge Road
Long Valley, New Jersey 07853
(908) 813-8718
FAX: (908) 813-0076

Representing:
Janet Woolley
ARENA

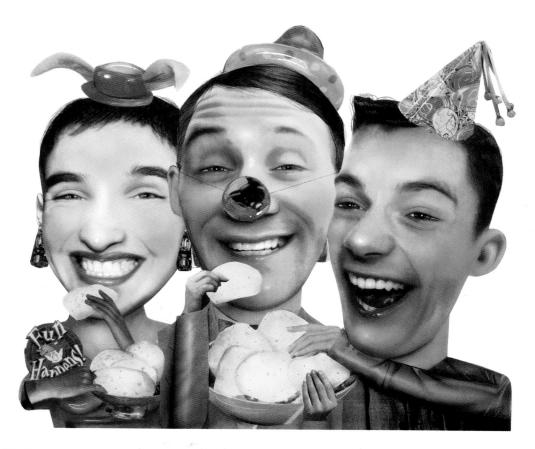

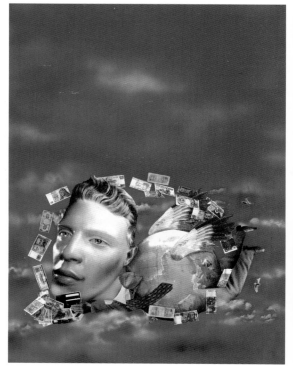

Alan Lynch
11 Kings Ridge Road
Long Valley, New Jersey 07853
(908) 813-8718
FAX: (908) 813-0076

Representing:
Peter Gudynas
ARENA

Marlena
21 East 89th Street, Suite A-1
New York, New York 10128
(212) 289-5514

Representing:
Paul Zwolak

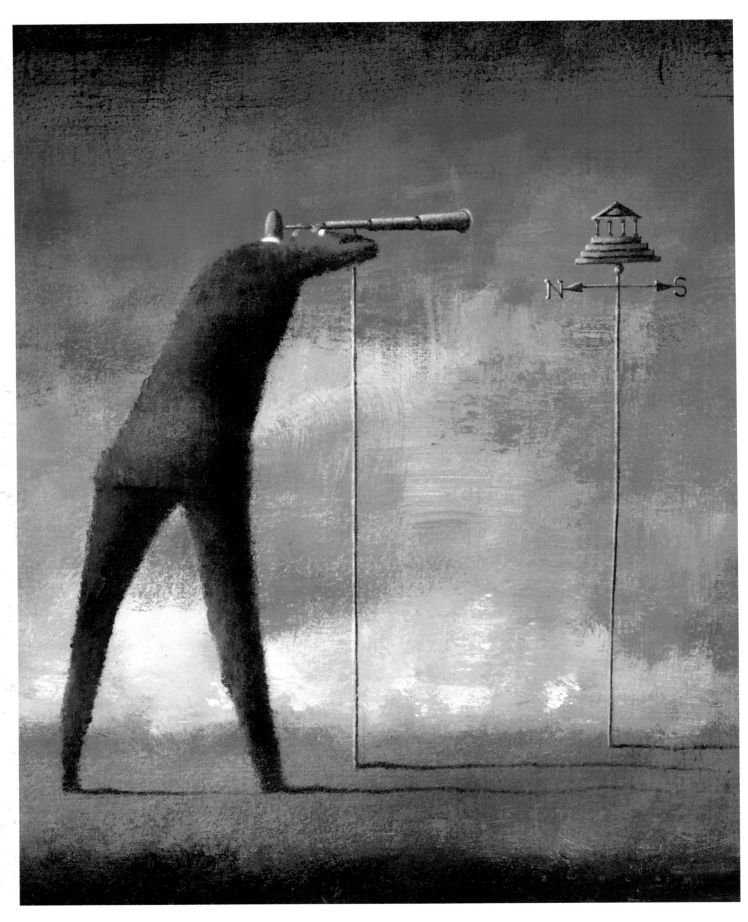

Marlena
21 East 89th Street, Suite A-1
New York, New York 10128
(212) 289-5514

Representing:
Paul Zwolak

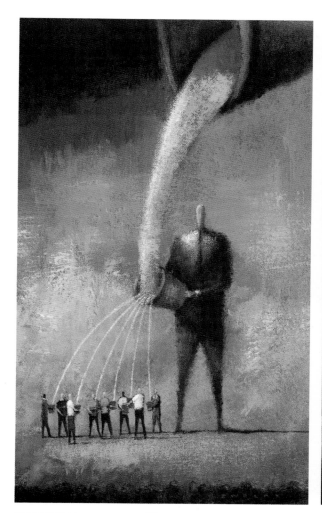

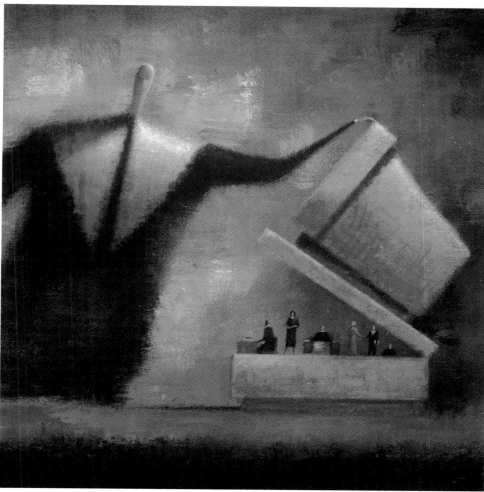

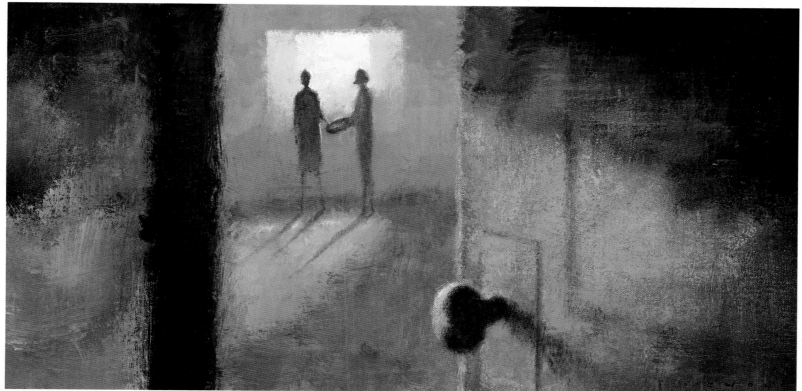

"We are just trying not to get **fired,** that's all."

HELMUT KRONE

The Neis Group
PO Box 174
11440 Oak Drive
Shelbyville, Michigan 49344
(616) 672-5756
FAX: (616) 672-5757

Represented in New York City by
Munro Goodman
(212) 691-2667.

Additional work can also be seen in
American Showcase #12 thru #18.

Partial client list includes: Anheuser-
Busch, Inc.; AT&T; Beech Craft Inc.;
Cahners Pub; Coors; Dow; Dupont;

Exxon; Ford Motor Co.; General Motors,
Inc.; Hewlett Packard; Honeywell; IBM;
Lotus; Mutual of Omaha; Merrill Lynch;
Miller Brewing; Price Waterhouse; 3M Co;
Rand McNally; Shell Oil; State Farm;
US Sprint; Zondervan, Inc.

TOM BOOKWALTER
I L L U S T R A T I O N

THE NEIS GROUP
ILLUSTRATION • DESIGN • PHOTOGRAPHY

11440 OAK DRIVE • P.O. BOX 174 • SHELBYVILLE, MICHIGAN 49344-9625
TELEPHONE 616 - 672-5756 • FAX 616 - 672-5757

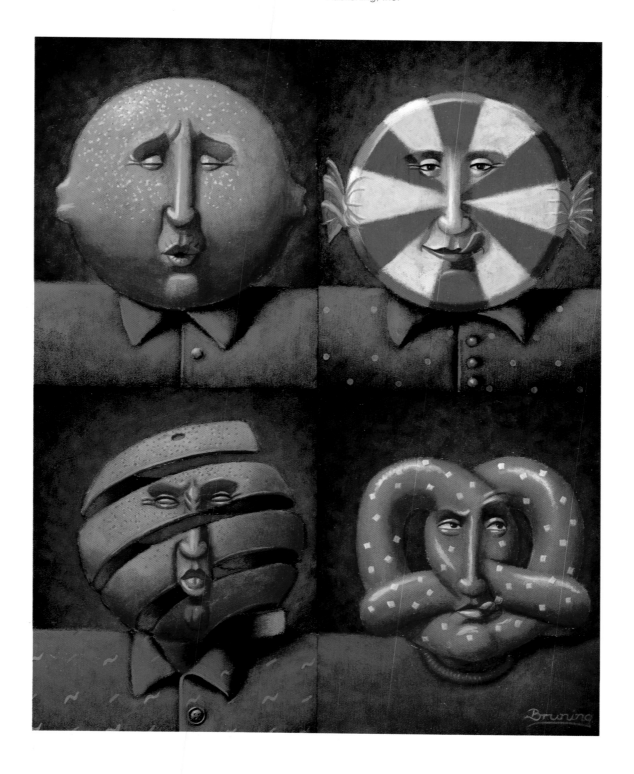

E R I K A L E B A R R E
I L L U S T R A T I O N

T H E N E I S G R O U P
ILLUSTRATION · DESIGN · PHOTOGRAPHY

11440 OAK DRIVE • P.O. BOX 174 • SHELBYVILLE, MICHIGAN 49344-9625
TELEPHONE 616 - 672-5756 • FAX 616 - 672-5757

904

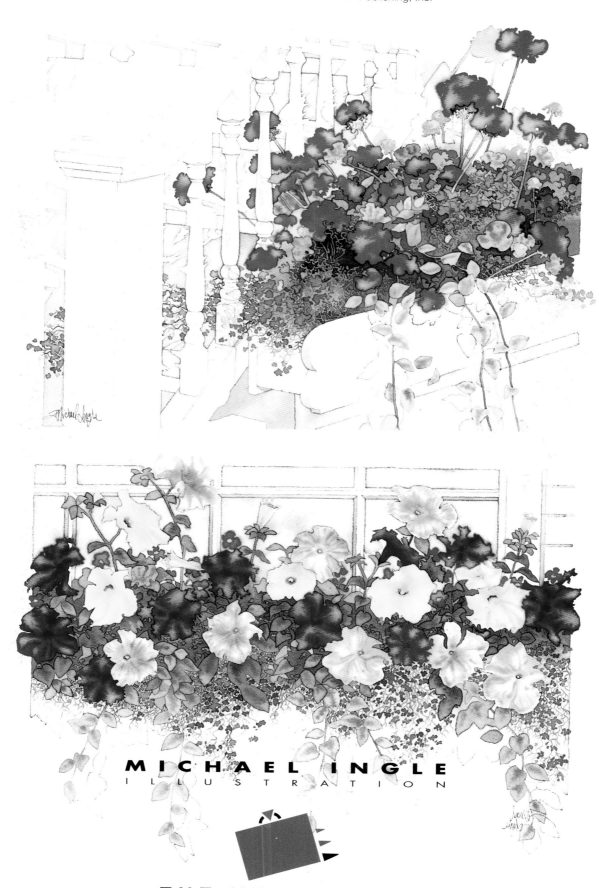

MICHAEL INGLE
ILLUSTRATION

The Neis Group
PO Box 174
11440 Oak Drive
Shelbyville, Michigan 49344
(616) 672-5756
FAX: (616) 672-5757

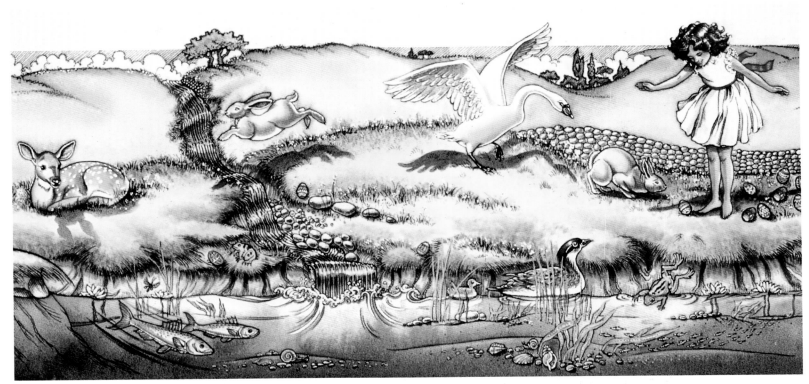

BERNEY KNOX
ILLUSTRATION

THE NEIS GROUP
ILLUSTRATION • DESIGN • PHOTOGRAPHY
11440 OAK DRIVE • P.O. BOX 174 • SHELBYVILLE, MICHIGAN 49344-9625
TELEPHONE 616 - 672-5756 • FAX 616 - 672-5757

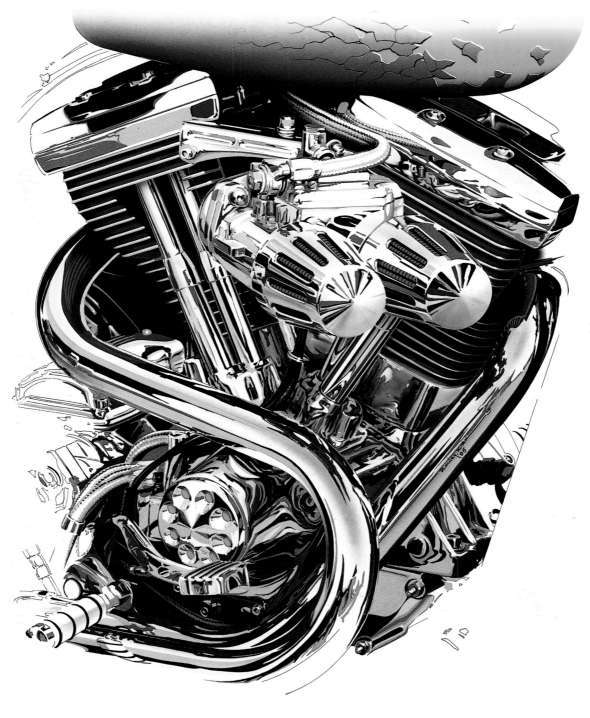

R A I N E Y K I R K
I L L U S T R A T I O N

T H E N E I S G R O U P
ILLUSTRATION · DESIGN · PHOTOGRAPHY
11440 OAK DRIVE · P.O. BOX 174 · SHELBYVILLE, MICHIGAN 49344-9625
TELEPHONE 616 - 672-5756 · FAX 616 - 672-5757

JOHNEE BEE

REPRESENTED BY

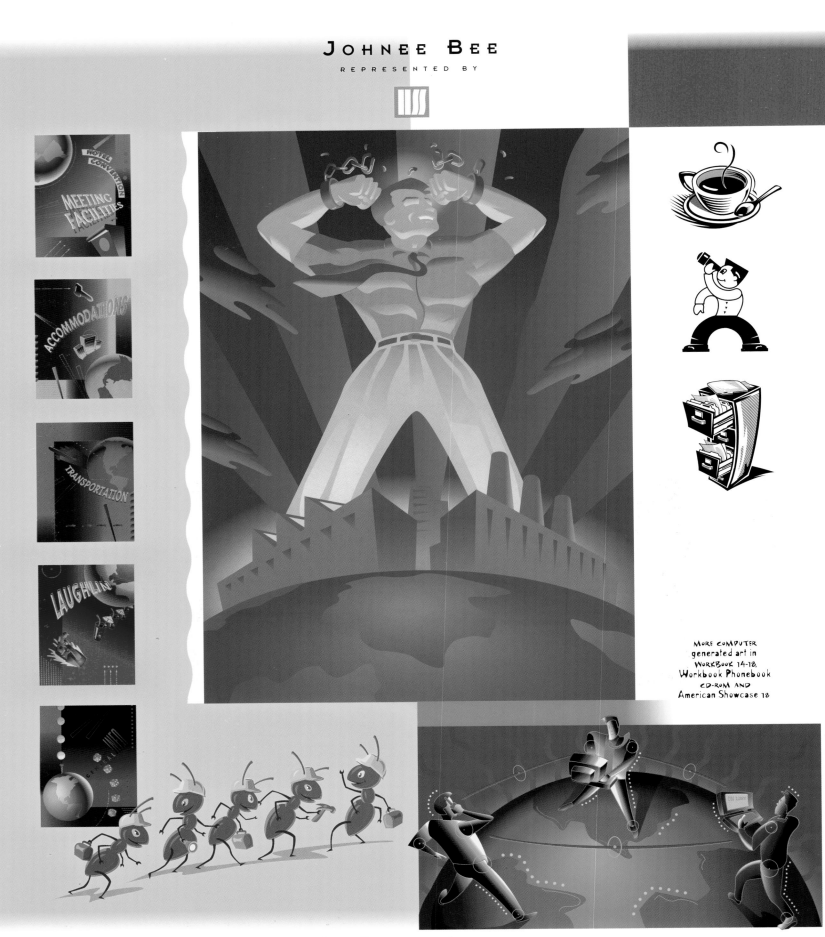

MORE COMPUTER
generated art in
WORKBOOK 14-18,
Workbook Phonebook
CD-ROM AND
American Showcase 18

LIZ SANDERS AGENCY
TELEPHONE: (714) 495-3664 FACSIMILE: (714) 495-0129

AMY NING

REPRESENTED BY

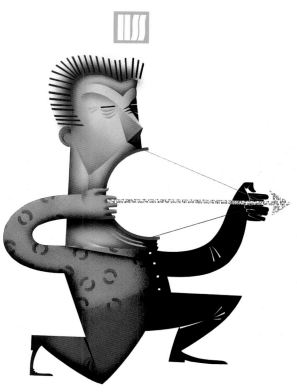

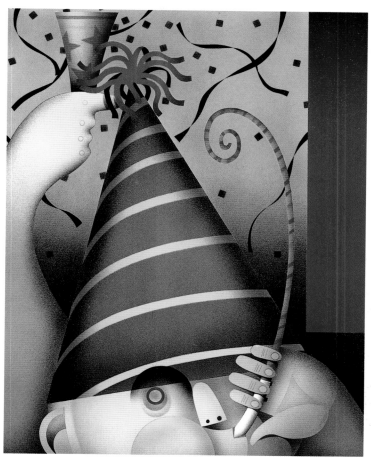

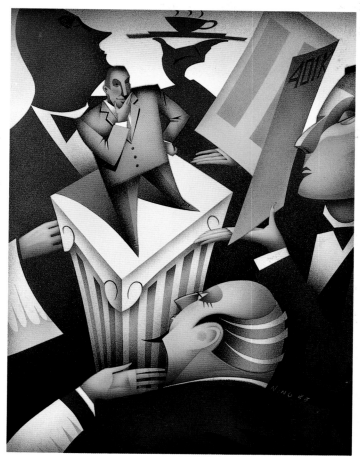

LIZ SANDERS AGENCY
TELEPHONE: (714) 495-3664 FACSIMILE: (714) 495-0129

The Schuna Group
Contact:
(612) 631-8480 JoAnne Schuna
(612) 631-8458 Frank Schuna
FAX: (612) 631-8426

Representing:
Cathy Lundeen Huber

To view additional work please refer to
Workbook Volume 16 or call for a
complete portfolio review.

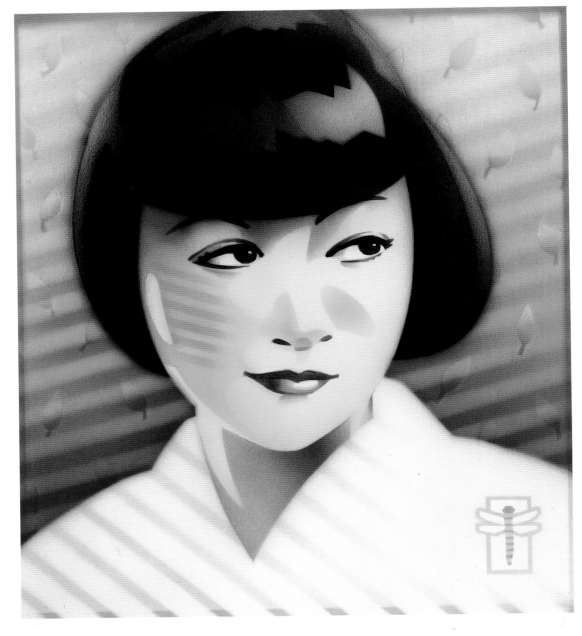

CATHY LUNDEEN HUBER

The Schuna Group
(612) 631-8480 JoAnne Schuna
(612) 631-8458 Frank Schuna
FAX: (612) 631-8426

Representing:
Jim Dryden

To view additional work
please refer to Workbook
Volumes 16, 17 and 18.

JIM DRYDEN

Tonal Values, Inc.
(305) 576-0142
(800) 484-8592 (2787)
FAX: (305) 576-0138
West Coast Call:
(415) 457-3695
(800) 484-8520 (1464)
FAX: (415) 457-6051

Nigel Buchanan

Partial Client List:
Chase
Agfa
Penthouse
Byte Magazine
WordPerfect Magazine
American Express
Whitman Hart

Land's End
Thai Airways
Qantas
Garuda Airlines
Apple
Johnson & Johnson
IBM

Nigel Buchanan

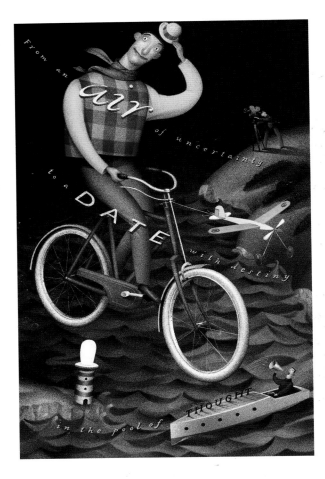

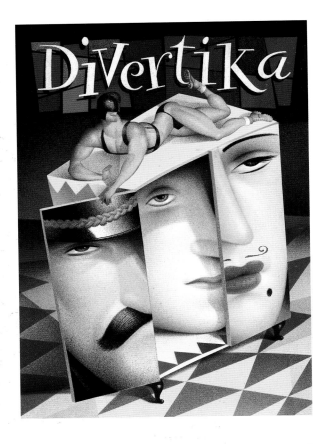

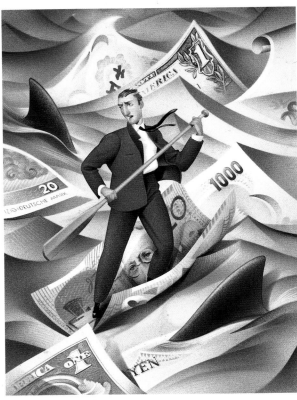

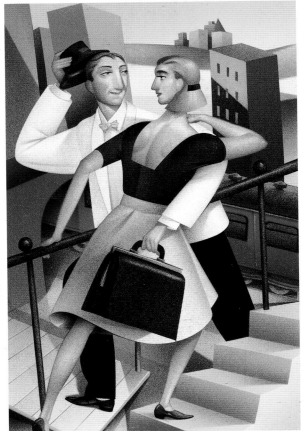

Tonal Values, Inc.
(305) 576-0142
(800) 484-8592 (2787)
FAX: (305) 576-0138
West Coast Call:
(415) 457-3695
(800) 484-8520 (1464)
FAX: (415) 457-6051

Pauline Cilmi Speers

Pauline Cilmi Speers

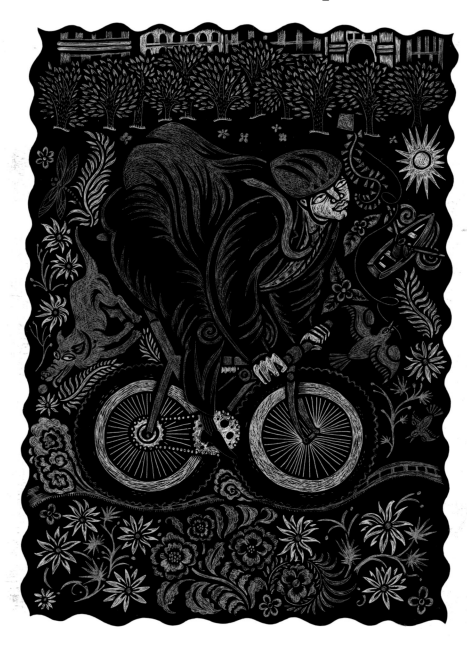

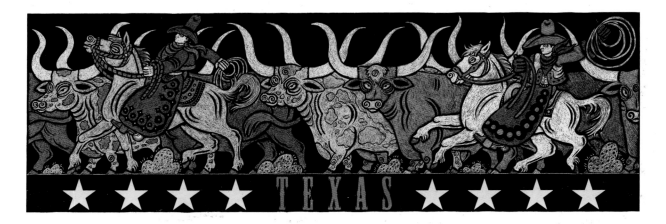

Tonal Values, Inc.
(305) 576-0142
(800) 484-8592 (2787)
FAX: (305) 576-0138
West Coast Call:
(415) 457-3695
(800) 484-8520 (1464)
FAX: (415) 457-6051

Anatoly Chernishov

Anatoly Chernishov

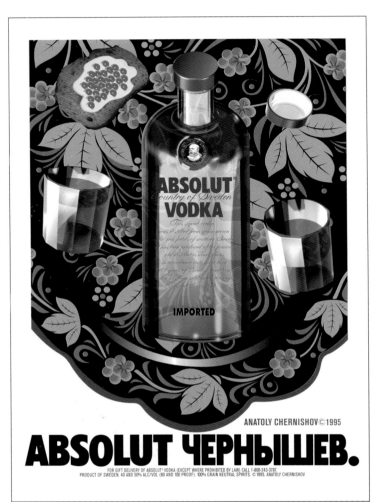

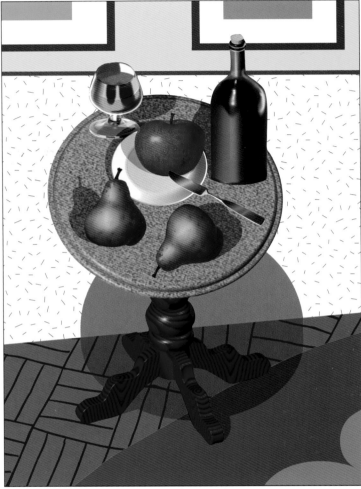

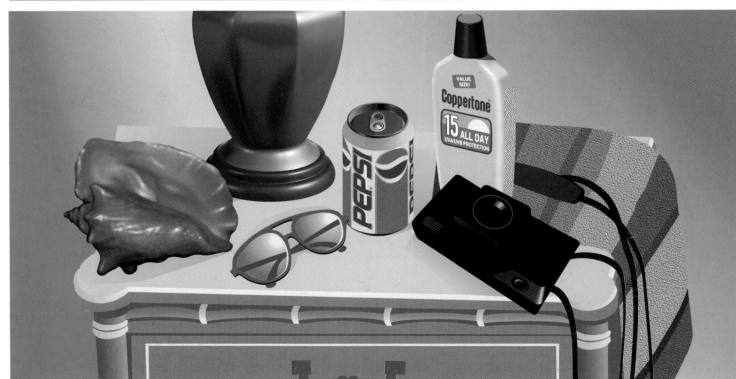

Tonal Values, Inc.
(305) 576-0142
(800) 484-8592 (2787)
FAX: (305) 576-0138
West Coast Call:
(415) 457-3695
(800) 484-8520 (1464)
FAX: (415) 457-6051

Philip Brooker

Partial Client List: L.A. Style, House
and Garden, The Washington Post,
Turner Publishing, The Miami Herald,
Latin Finance, The L.A. Times, Air France,
Computer World, Vogue.

Additional Work:
American Illustration 6, 7, 8.

Philip Brooker

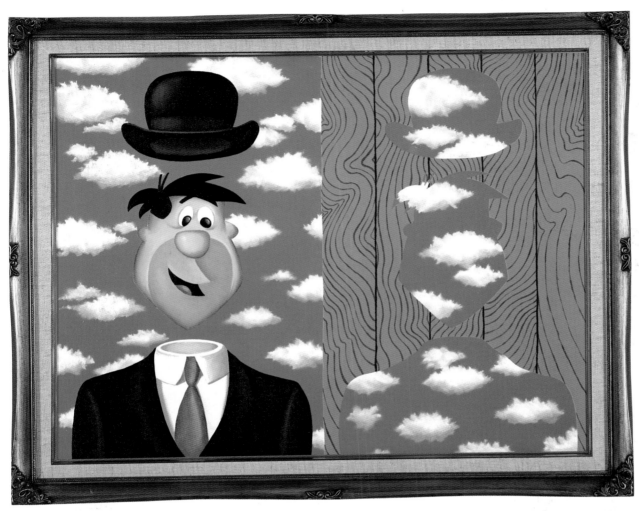

Tonal Values, Inc.
(305) 576-0142
(800) 484-8592 (2787)
FAX: (305) 576-0138
West Coast Call:
(415) 457-3695
(800) 484-8520 (1464)
FAX: (415) 457-6051

Client List:
Harvard University Press
Technology Review (MIT) (magazine)
Storytelling Magazine
Sundance Publishing

Silver Burdett Ginn
Big Blue Dot
Latin Finance (magazine)
Paradigm (magazine/newsletter)
Client/Server (magazine)

Mark Schroder

TONAL VALUES

Tonal Values, Inc.

(305) 576-0142
(800) 484-8592 (2787)
FAX: (305) 576-0138
West Coast Call:
(415) 457-3695
(800) 484-8520 (1464)
FAX: (415) 457-6051

Dean MacAdam

Partial Client List:
Del Monte
Carnival Airlines
Value Rent-A-Car
Brothers Coffee
Miami Subs
Motorola

Bud Light
Pizza Hut
Marriott Hotels
Entertainment Weekly
Latin Finance Magazine
Ocean Drive Magazine
Florida Sportsfan Magazine

Dean MacAdam

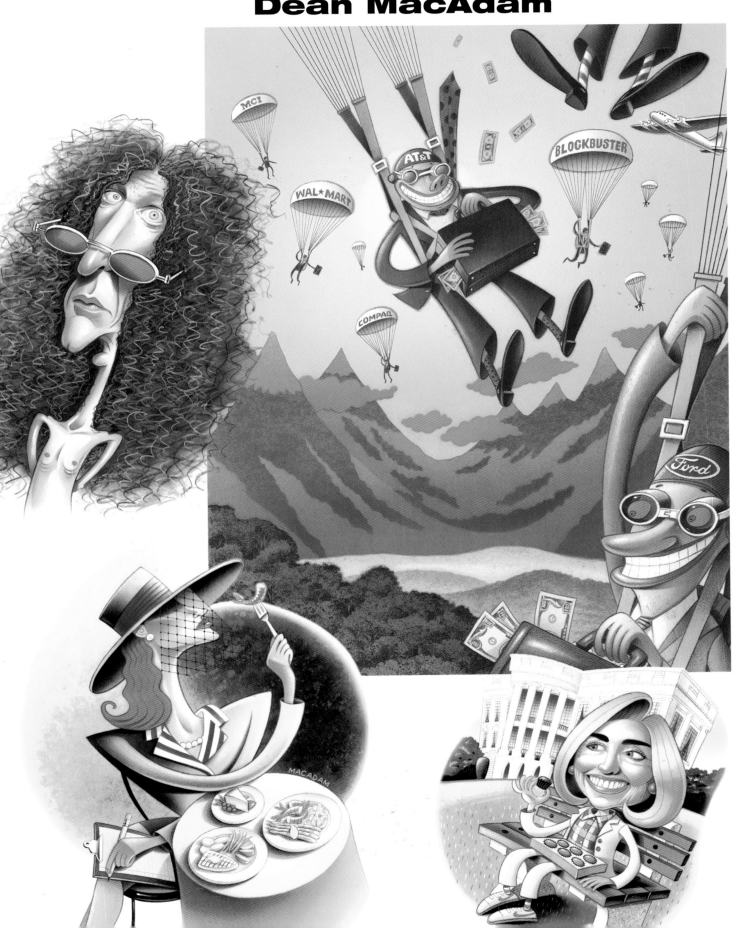

Tonal Values, Inc.

(305) 576-0142
(800) 484-8592 (2787)
FAX: (305) 576-0138
West Coast Call:
(415) 457-3695
(800) 484-8520 (1464)
FAX: (415) 457-6051

Nikolai Punin

Tonal Values, Inc.
(305) 576-0142
(800) 484-8592 (2787)
FAX: (305) 576-0138
West Coast Call:
(415) 457-3695
(800) 484-8520 (1464)
FAX: (415) 457-6051

Nikolai Punin

index

A

Abe, George 440, 441
Abraham, Daniel 1237
➤ Abramowitz 1018, 1019
➤ Accornero, Franco 228, 229
Acuna, Ed 82, 83
Adam, Winky 1238
Adams, Gil 836
➤ Adams, Kathryn 637
Adams, Lisa 1239
➤ Adel, Daniel 217
Adler, Steve 537
Aizawa, Kaz 626
➤ Ajhar, Brian 1240, 1241
Akgulian, Nishan 858, 859
Akins, Kelly 664
Akopyan, Loudvik 844
Alavezos, Gus 670
Albers, Dave 1126
Aldredge, Vaughn 594
Allen, Terry 956, 957
Alsberg, Peter 1066
Amatrula, Michele 1137
➤ Amedee Illustration 1242
American Artists 484 - 507
Anatoly 31
Anderson, Kevin 1243
Anderson, Philip 152, 153
➤ Anderson, Richard 1244
Anderson, Robert Clyde 795
Anderson, Terry 670
➤ Angelini, George 84, 85
Angle, Scott 1172
Ansley, Frank 648, 649
Anzalone, Lori 534, 535
apJones, Todd 1498
Arday, Don 1064
Argus 818
Arroyo, Fian 1245
Art Associates, Inc. 1042, 1043
➤ Artco 82 - 119
Arts Counsel 794 - 797
Artworks 600 - 615
➤ Aru, Agnes 226
Assel Studios Ltd. 1246
Atkinson, Mike 814
Atkinson, Steve 763
Attebery, Craig 542
Auger, Jacque 1060
Austin, Cary 446, 447
Austin, Graham 814
Avanti Studios 962, 963,
994, 995, 1012, 1013

B

Bachem, Paul 604
Backer, Marni 890
Bad Katz Graphics 1147
Baehr, Richard C. 541
Baher, Edward 1016, 1017
Bailey, Pat 30
Baker, Don 442, 443
Baker, Kolea 435 - 445
Baldwin, Christopher 598
Bamundo, David 1225
Bannister, Philip 814
Banthien, Barbara 78
Banyai, Istvan 880
Baradat, Sergio 50, 51
Barbaria, Steve 1247
Barnard, Bryn 566
Barnes, Kim 612
Barnes, Michelle 866
Barnes-Murphy, Rowan 270, 271
Barrall, Tim 1233
Barrett, Ron 1248
Barsky, Alexander 625
Bartczak, Peter 1249
➤ Bartels Associates, Ceci
571 - 585 Front Flap Book 1
Barton, Kent 238, 239
Baruffi, Andrea 1250, 1251
Baseman, Gary 402, 403, 406
Bauer, Carla 1084
Beavers, Sean 745
Beck, David 417
Bee, Johnee 908
Beecham, Greg 213
➤ Begin, Maryjane 230
Beilfuss, Kevin 309
Bell, Jill 1490
Bell, Ron 555
➤ Ben-Ami, Doron 116, 117
Bendell, Norm 852, 853
Benger, Brent 295
Bennett, Charles A. 1252
Bennett, Dianne 658
Bennett, James 240, 241
Benny, Mike 1253
Benson, Linda 603
Berasi, Barbara 1255
Berasi, Teresa 1416
➤ Berendsen & Associates, Inc.
715 - 719
Berendt, Eric 1205
Berg, John 1256, 1257

Berg, Ron 318
Bergin, Kieran 1258, 1259
Bergman, Eliot 66, 67
Bernstein & Andriulli Inc. 12 - 47
Bernstein, Joanie 812, 813
Berson, Julie 1491
Biers, Nanette 154, 155
➤ Bigda, Diane 733
Billout, Guy 1260
Bilter, Lori 1261
Binder, Pat 1262
Bishop, David 1109
Bishop, Don 1176
➤ Björkman, Steve 329, 948, 949
Black, Dave 830
Blackard, Rob 1085
Blackman, Barry 327
Blackshear, Lisa 1263
Blair, Dru 811
Blakey, Paul 887
Blank, Jerry 838, 1236
Blasutta, Mary Lynn 1264
➤ Bleck, Cathie 126, 127
Bleck, John 1265
Blessen, Karen 381
Bliss, Rachel 398
Bloch, Anthony 1500
Blubaugh, Susan M. 1266
Boehm, Roger 650
Boies, Alex 1008, 1009
Bolesky, John 707
Bollinger, Peter 448 - 451
Bollman, Angela 1012
Bolten, Jennifer 548, 549
➤ Bookwalter, Tom 903
Bootman, Colin 891
Bordei, Marcel 702
Borge, Rich 410
Borzotta, Joseph 1094
Bote, Tivadar 627
Botelho, Clemente 1088
Botero, Kirk 805
Bowles, Doug 1267
Bowman, Eric 1268
Bowser, Ken 1054, 1055
Boyajian, Ann 736
➤ Bozzini, James 352, 353
Bramhall, William 770
Brandon, Bill 888
Brandt, Elizabeth 1269
Braught, Mark 418
Braun Represents, Kathy
782 - 786
Brawner, Dan 553
Breakey, John 760

Bremmer, Mark 1121
Brennan, Neil 18
Brennan, Steve 610
Brice, Jeff 435
Briers, Stuart 156, 157
Brignell, Ian 1488
Britt, Tracy 434
Brodner, Steve 452, 453
Brokaw, Tanya 1270
➤ Brook Trout Studio 1271
Brooker, Philip 915
Brooks, Andrea 1092
Brooks, Nan 662, 776
➤ Brooks, Rob 362, 363
Brooks Productions, Lou 1272
Brother, Kelly 1273
Brown, Dan 613
Brown, Rick 47
Bruce, Sandra 1173
Bruck & Moss 824 - 833
Bruning, Bill 578, Front Flap Book 1
Bryant, Eric 1168
Buchanan, Nigel 912
Buckley, Marjory 670
Bull, Mike 782, 783
Burckhardt, Marc 1024, 1025
Burgio, Trish 86, 87
Burgoyne, John 816, 817
Burke, Kevin 1143
Busch, Lon 202
Buske, Gregory A. 726
Butler, Callie 1274
Butler, Steve 1159
Buttram, Andy 426

C

Cable, Annette 552
Cabossel, Jannine 893
Calabro, Carol M. 1275
Caldwell, Kirk 885
Call, Greg 454, 455
➤ Callanan, Brian 222, 223
Camp, Barbara 45
Campbell, Jenny 787
Cane, Eleni 1276
➤ Cangemi, Antonio 629
Caporale, Wende 663
Carol, Estelle 777
Carpenter, Carolyn 702
Carroll, Justin 571
➤ Carruthers, Roy 509
Carter, Abby 775
Carter, Penny 1277

➤ Artist portfolio featured on The Showcase CD number 2.

Carter, Stephanie 711
Cassler, Carl 325
Castillo, Julie 44
➤ Ceballos, John 432
Celusniak, Chris 697
Cerulli, Frank 1059
Chabrian, Deborah 611
Chaffee, James 808
Chan, Harvey 654, 655
Chan, Ron 748
Chandler, Karen 1278
Chandler, Roger 704
Charpentier, Russell 1279
Chau, Tungwai 772
Chen, David 536
Cheney, George 569
Chernishov, Anatoly 914
Chesterman, Adrian 607
➤ Chestnutt, David 639
Cheung, Phil 799
Chewning, Randy 776
Chezem, Douglas R. 1281
Chickinelli Studios 1282
Chickinelli, Mark 1282
Chislovsky Design Inc., Carol
835 - 839
➤ Cho, Young Sook 416
Chodos-Irvine, Margaret 438
Chorney, Steven 289
Chow, Jim 593
Christie, Greg 796
Christopher, Tom 1284
Ciccarelli, Gary 485
Cieslawski, Steven 292
➤ Cigliano, Bill 346, 347
Clapp, John 1105
Clar, David Austin 775
Clark, Bradley 1285
Clarke, Greg 408
Cleland, Janet 1117
Climpson, Sue 815
Cline, Richard 242, 243
Clownbank Studio 1249
Cober, Alan E. 1146
Cober-Gentry, Leslie 1286
Cohen, Adam 970, 971
Cohen, M.E. 1166
Cohen, Paula 1120
Colalillo, Giovannina 1287
Cole, Lo 622
Collier, Jan 402 - 410
Collier, John 244, 245
Collier, Michele 849
Collignon, Daniele 653 - 661
Collins, Daryll 1158

➤ Colon, Raul 678, 679
➤ Colquhoun, Eric 641
Colvin, Rob 882
Combs, Jonathan 324
Commander, Bob 798
Comport, Sally Wern 1136
Condon & White 1288
Condon, Ken 1288
Conge, Bob 1004, 1005
Conrad & Associates, Jon 1215
Conrad Represents 798 - 801
Consani, Chris 689
Cook, Timothy 1134
Cook, William 1289
Coon, Jim 646, 647
Cooper, M.D., James 702
Cooper, P.D. 1290
Corio, Paul 1229
Cornner, Haydn 25
Cosgrove, Dan 653
Couch, Greg 1067
Coulson, David 1496
Courtney, John P. 1291
Cowdrey, Richard 456, 457
Cox, Craig 995
Cox, Paul 246, 247
Craig, Dan 29
➤ Crampton, Michael 269
➤ Crawford, Denise 232
Creative Freelancers 696 - 705
Cristos 805
Crofut, Bob 1020, 1021
Croll, Carolyn 772
Curry, Tom 827
➤ Cusack, Margaret 1292
Cusano, Steven R. 1293
Cutler, Dave 1294, 1295
➤ Czechowski, Alicia 1296

D

D'Andrea, Domenick 544
Dacey, Bob 458, 459
➤ Daigle, Stéphan 367
Daily, Renée 774
Dale, Robert 1199
Daley, Joann 1209
Dammer, Mike 1297
Danz, David 1183
Das Grüp 841 - 845
Daugavietis, Ruta 1299
Davidson, Kevin 821
Davis, Gary 1037
Davis, Jack 158, 159

Davis, Jack E. 248, 249, 775
Davis, Nancy 134, 135
Dawson, Henk 1068
Day, Sam 1052, 1053
Dayal, Antar 966, 967
deMichiell, Robert 160, 161
de Moreta, Linda 847 - 849
De Musee, Christina 444, 445
De Muth, Roger 1190
de Sève, Peter 1300, 1301
Dean, Bruce 1127
Dearstyne, John 1302
➤ Dearth, Greg 430
Dearwater, Andy 54, 55
Deas, Michael J. 954, 955
Deaver, Lucas 1303
Decker, George 1304
➤ Dedell Inc., Jacqueline 120 - 151
Deeter, Catherine 780
DeGrace, John 460, 461
DeLancey, Alison 963
Delapine, Jim 704
➤ Dellorco, Chris 315
Demers, Don 543
Denise & Fernando 316
Depew Studios 488
Dervaux, Isabelle 768
Deschamps, Bob 1104
Desrocher, Jack 1305
Detrich, Susan 1204
DeVito, Grace 1195
Devlin, Bill 203
Dey, Lorraine 1306
➤ Di Fate, Vincent 88, 89
di Vincenzo, Mark 1307
Diaz, David 1113
Dickens, Holly 1499
Dietz, Jim 874
Dietz, Mike 1308
Diggory, Nick 814
DiMare, Paul 532
Dininno, Steve 856, 857
Dinser, John 1075
Dodge, Sharon 850, 851
Doniger, Nancy 1309
Dooling, Michael 1311
Doret, Michael 1497
Doty, Eldon 772
Dowd, Jason 290
Drew, Kim 595
➤ Drucker, Mort 90, 91
Dryden, Jim 911
Dudley, Don 674
Duggan, Lee 162, 163
Duke, Chris 530, 531

Dundee, Angela 80
Dunne, Kathleen 671
Dunnick, Regan 77
Duranceau, Suzanne 462, 463
Dykes, John S. 1312, 1313
Dynamic Duo 164, 165
Dypold, Pat 792
Dzielak, Dennis 1314

E

Eagle, Cameron 559
Ebersol, Rob 1315
Ecklund, Rae 409
Edelson, Wendy 568
Edens, John 703
➤ Edholm, Michael 92, 93
Edinjiklian, Teddy 671
Effler, Jim 490
Eggleston-Wirtz, Kate 588
➤ Eldridge, Gary 344, 345
Elliott, Mark 464, 465
Ellis, Jon 305
Ellis, Steve 723
➤ Ellison, Jake 718
Elmer, Richard 1316, 1317
Eloqui 984, 985
Elwell, Tristan 466, 467
Ember, Kathi 773
English, John 731
English, Sarah Jane 1318
Enthoven, Antonia 814
Evans, Jonathan 581
Evans, Robert 665
Everitt, Betsy 1319
Ewing, Richard 1320
Eyolfson, Norman 1321

F

➤ Fairman, Dolores 144, 145
Fallin, Ken 756, 757
Fancher, Lou 1361
Farber, Joan 765
Farley, Malcolm 504, 505
Farrell, Rick 694
Farrell, Russell 489
➤ Farrington, Susan 734
➤ Fasolino, Teresa 516, 517
Faust, Clifford 696
FeBland, David 1323
Fenster, Diane 1028, 1029
Fernandes, Stanislaw 996, 997

index

Fiedler, Joseph Daniel 73
Field, Ann 940, 941
Fine, Howard 468, 469
Finger, Ronald 43
Fiore, Peter 600, 601
Fisher, Jeffrey 771
Fitzgerald, Patrick 1324, 1325
Flaherty, David 964, 965
Flaming, Jon 1032
Fleming, Dean 46
➤ Fleming, Joe 208, 209
Flesher, Vivienne 1326
Flood, Richard 1327
Fluharty, Thomas L. 682, 683
Fortin, Pierre 864, 865
Foster Artists Representative, Pat
810, 811
Foster, Phil 801
Foster, Travis 1026, 1027
Fox, Laurie 1328
➤ Fox, Bill 719
Fox, Brian 1072
Fox, Rosemary 867
Fraley, Kim 1140
Frampton, Bill 660
Frances, Siân 814
Francis, John 1329
Francis, Judy 1330
Franké, Phil 324
Fraser, Douglas 57
Frazier, Jim 978, 979
Fretz, John 592
➤ Frichtel, Linda 136, 137
Friedman, Barbara 1331
Friend & Johnson 727 - 731
Frisari, Frank 759
Frisino, Jim 597
Fujimori, Brian 842
Fujisaki, Tuko 892
Fujiwara, Kim 1231
Fullmer, Margie and Howard
1332

G

Gabbana, Marc 1161
Gabel, Ed 1216
Gaber, Brad 303
Gaetano, Nicholas 382, 383
Gal, Susan 1082
Gall, Chris 837
Gallardo, Gervasio 526
Galloway, Nixon 669
Garbot, Dave 1154

Garden Studio 814, 815
Garland, Michael 1333
Garns, Allen 1114
➤ Garrow, Dan 356, 357
➤ Gast, Josef 424
Gatlin Represents, Rita
673 - 677
➤ Gay-Kassel, Doreen 1334
Gaz, Stan 124, 125
Gazsi, Ed 470, 471
Geary, Rick 698
Gebert, Warren 828
➤ Geerinck, Manuel 218, 219
➤ Gehm, Charles 216
Geiger, Nancy 1335
Gelb, Jacki 166, 167
Genzo, John Paul 666
➤ Geras, Audra 374, 375
Ghaboussi, Sina 773
Giacobbe, Beppe 399
Gillies, Chuck 291
Girvin Design, Inc., Tim 378, 379
➤ Giusti, Robert 522, 523
Glasgow & Associates, Dale
1030, 1031
Glass, Randy 204
Glazer, Art 1337
Glazier, Garth 487
Goldberg, Richard A. 1101
Golden, Jan 963
Goldman Agency, David
852 - 868
➤ Goldstrom, Robert 512, 513
Goodrich, Carter 1338, 1339
Gordley, Scott 725
Gordon Associates, Barbara
870 - 878
Gourley, Robbin 1340
Graber, Jack 1103
Graham Represents, Corey
642 - 652
Graham, Tom 1171
➤ Grandpré, Mary 414
Graphics Room, The 1341
Graves, Keith 32
Gray, Lynda 21
Greenblatt, Mitch 306
Greenhead, Bill 814
Gregoretti, Rob 1343
Grien, Anita 879
➤ Griesbach Martucci 140, 141
Grimes Design, Inc., Don 1493
Grimwood, Brian 24
Grinnell, Derek 1185
Groff, David 1180

Grossman, Wendy 1044, 1045
Gudynas, Peter 899
Guida, Liisa Chauncy 317
➤ Guitteau, Jud 364, 365
Gunion, Jefrey 1083
Gurney, John 41
➤ Gustafson, Dale 313
Gwilliams, Scott 1036

H

Haggerty, Tim 1344, 1345
Hahn, Marika 1115
Haight, Sandy 1081
➤ Halbert, Michael 278, 279
➤ Hall, Bill 988, 989
Hall, Joan 1073
Hally, Greg 1107
Hamilton, Gary L. 1346
Hamilton, Ken 1347
Hamilton, Meredith 1348
Hamilton, Pamela 494
Hamlin, Janet 472, 473
Hammer, Claudia 554
➤ Hammond, Franklin 415
Han, Oki 891
Hanley, John 804
Hannah, Halstead 754
➤ Hanson, Glen 636
Hantel, Johanna 1349
Hardesty, Debra 1350
Harrington, Glenn 873
Harrison, William 368, 369
Harritos, Pete 427
Hart, John 1351
Hart, Thomas 168, 169
Hayden, Charles 1352
Hayes, John 1226
Haynes, Bryan 13
Hays, Diane 848
Heavner, Becky 1090
Heavner, Obadinah 895
Heiner, Joe & Kathy 62, 63
➤ Hejja, Attila 323
➤ Henderling, Lisa 94, 95
Henderson, David 320
Henderson, Louis 810
Hennessy, Tom 677
Henrie, Cary 1000, 1001
Henry, Doug 492
Henry, Roger 1353
➤ Herbert, Jonathan 334, 335
➤ Hess, Mark 524, 525
Hewitson, Jennifer 1354

➤ Hickes, Andy 1110
High, Richard 1492
Hill, Charlie 806
Hill, Michael 484
Hill, Roger 336, 337
Hill, Tina 896
➤ Hilliard, Fred 225
➤ Hilliard-Barry, Pat 1355
Hillman, Betsy 880, 881
Hirashima, Jean 819
HK Portfolio 772 - 777
➤ Hoeffner, Deb 1202
Hoey, Peter 170, 171
Hoff, Terry 224
Hoffman, Rosekrans 891
Hokanson/Cichetti 778
Holder, Jimmy 1356
Holm, John 501
Holmberg, Irmeli 616 - 627
Holmes, David 26
➤ Holmes, Matthew 360, 361
➤ Hong, Min Jae 1002, 1003
Hooks, Mitchell 606
Hovland, Gary 1357
➤ Howard, John H. 510, 511
Huber, Cathy Lundeen 910
Huerta, Catherine 668
➤ Huerta Design, Inc., Gerard
Back Flap Book 1
Hughes, Marianne 788
Hughes, Neal 527
➤ Hull Associates, Scott 411 - 434
Hunt, Robert 875
Hunter, Stan 540
Hutchison, Bruce 1128
Huynh, Si 713
➤ Huyssen, Roger Back Flap Book 2
Hyman, Miles 56
Hynes, Robert 321

I

➤ Icon Graphics, Inc. 1074
➤ Ingemanson, Donna 735
Ingle, Michael 905
Ingram, Fred 564, 565
Ishige, Susan Smith 1178

➤ Artist portfolio featured on The Showcase CD number 2.

J

Jackson, Jeff 61
Jakesevic, Nenad 871
James, Bill 282, 283
James, Bob 423
Jamieson, Doug 1358
Jarecka, Danuta 758
Jaynes, Bill 1359
Jaz & Jaz 586 - 599
Jeffery, Lynn 1186
Jenkins, Bill 1038, 1039
Jett & Associates, Clare
546 - 563
Jezierski, Chet 703
➤ Jimminy 638
Jinks, John 950, 951
Johnson, Celia 172, 173
Johnson, D.B. 1360
Johnson, David 250, 251
Johnson, Joel Peter 824
Johnson, Julie 879
Johnson, Stephen T. 474, 475
Johnson, Steve 1361
Johnston, W.B. 1155
Jonason, Dave 557
Jones, Bob 612
Jones, Danielle 1023
Jones, Jeff 1362
Jones, Marilyn 1118
Jones, Phil 1222
Jones, Rebecca Grace 1363
Jost, Larry 570
➤ Juhasz, Victor 520, 521
Julien, Terry 1132

K

Kaji, Nobu 1364
Kaloustian, Rosanne 624
Kasun, Mike 793
Katz, Aliona 737
Kay, Stanford 1417
Kearin, Alan 1365
Keeter, Susan 774
Keifer, Alfons 288
Keleny, Earl 779
Keller, Steve 205
Kelley, Gary 252, 253
Kennedy, Anne 777
Kern, Michael 1366
Kimber, Murray 835

Kimble, David 820
Kimche, Tania 882 - 888
Kimura, Hiro 556
Kirchoff/Wohlberg, Inc. 890, 891
➤ Kirk, Rainey 907
➤ Kirkland, James 96, 97
Kirsch, Represents 820
Kitchell, Joyce 280, 281
Kiwak, Barbara 877
Klanderman, Leland 573
Klare, Tom 1234
Klauba, Douglas 790, 791
Klein, Jane 892 - 893
Kluglein, Karen 741
Knoll, Kimberly 671
Knowles, Philip 803
➤ Knox, Berney 906
Knutson, Doug 1367
Koelsch, Michael 476, 477
Köerber, Nora 845
Konz, Stephen 587
Kotarba, Artur 1203
Kotik, Kenneth William
1368, 1369
Kovach, Joseph Page 1211
Kovalcik, Terry 1370
Kramer, Dave 478, 479
Kramer, Peter 19
Kraus, Annette 1371
Krogle, Robert 300
Kroll, Kari 1372
Krumlauf, Vicky 994
Kubinyi, Laszlo 174, 175
➤ Kueker, Don 1373
Kung, Lingta 231
Kunz, Anita 1230
Kurtzman, Ed 746

L

➤ Labbé, John 1087
LaCava, Vincent 480, 481
Lada, Elizabeth 826
➤ LaFever, Greg 419
➤ LaFleur, Dave 420, 421
Lafrance, Laurie 400
Laish, James 1022
Lamb, Gregory 1138
Lambase, Barbara 729
Lamut, Sonja 871
Lane, Robert 1374
Lane, Tammie 1189
Langley, Stephanie 1181
Langsdorf, Henrik 1133

Lanino, Deborah 1198
Lardy, Philippe 1079
Larkin, Mary 755 - 757
Larson, Keith 700
Lascaro, Rita 1375
Lasher, Mary Ann 15
Laslo, Rudy 609
Lavaty, Frank & Jeff 526 - 545
Lawrence, John 28
Lawson, Rob 703
Le Masurier, James 878
LeBarre, Erika 904
Lebbad, James A. 1489
Lee, Eric J.W. 747
Lee, Jared D. 1010, 1011
Lee, Wangdon 1377
Lee, Yuan 998, 999
Leer, Rebecca J. 1378, 1379
➤ Leff Associates, Inc., Jerry
207 - 235
Lehmen Dabney Inc. 894, 895
Leighton & Company 758 - 764
➤ Leister, Bryan 128, 129
Lemant, Albert 773
Lempa, Mary Flock 585
Leon, Thomas 1056
Leonardo, Todd 1380
Leopold, Susan 71
Lester, Mike 980, 981
LeVan, Susan 831
Levin, Arnie 1381
Levine, Andy 1382, 1383
➤ Lewis, HB 958, 959
Liao inc., Sharmen 1057
Licht, Lisa 1384
Lilie, Jim 748 - 754
➤ Lindgren & Smith 48 - 81
Linn, Warren 768
➤ Livingston, Francis 210, 211
LoFaro, Jerry 498, 499
➤ Loftus, David 138, 139
LoGrippo, Robert 538
Lohstoeter, Lori 49
Long, Loren 755
Lopez, Rafael 800
Lott Representatives 742 - 747
Low, William 384, 385
Lu, Kong 894
Luikart, Erika 1385
Lulu Creatives 896, 897
Lund, Jonathan Charles 618
Lundgren, Alvalyn 1386
Lundgren, Tim 870
Lyhus, Randy 1210
Lynch, Alan 898, 899

Lynch, Fred 1387
Lyons, Claudia 1182
Lytle, John A. 1388, 1389
Lyubner, Boris 1006, 1007

M

MacAdam, Dean 917
MacDougall, Rob 304
MacLeod, Ainslie 1390
➤ Maddox, Kelly 233
➤ Maggard, John 431
Magiera, Rob 616
Magovern, Peg 652
Mahan, Benton 1391
Mahoney, Katherine 1392
Maisner, Bernard 176, 177
Manchess, Gregory 254, 255
Manda, Antonia 1393
➤ Mangiat, Jeff 276, 277
Manning, Michele 234, 235
Mantel, Richard 68
Manz, Paul 296
Marchese, Carole 1224
Marden, Phil 990, 991
Marie and Friends, Rita
688 - 695
Marlena 900, 901
Marsella, Valerie 1394
Marsh, Roni 1013
➤ Marshall, Byron 1080
Marshall, Craig 753
Martin, Gregory 1099
➤ Martin, John 342
➤ Martin, Larry 428
Martinez, Ed 308
Martinez, John 1194
Maschler, Lorraine 821
Maslen, Barbara 1220
Mastel, Diane 1395
Masuda, Coco 407
➤ Matsu 332, 333
Mattelson, Judy 739 - 741
Mattelson, Marvin 740
Matthews, Scott 786
Mattos, John 547, 968, 969
Mattotti, Lorenzo 256, 257
Maughan, Bill 322
➤ Mayer, Bill 932, 933
➤ Mayer-Grieve, Judy 1396
Mayforth, Hal 178, 179
McAllister, Chris 976, 977
McCauley, Adam 942, 943
McCloskey, Bill 1424

index

McCollum, Sudi 784
McCormack, Geoffrey 297
McDermott, Joe 1397
McDonald, Mercedes 727
McDonnell, Peter 847
McGowan, Dan 314
➤ McGurl, Michael 358, 359
McIndoe, Vince 52, 53
McKelvey, Shawn 493
McKinnell, Michael 710
➤ McLean, Wilson 518, 519
➤ McLoughlin, Wayne 348, 349
McMacken, David 34
McMahon, Bob 1398
McMillan, Ken 884
➤ Mead, Kimble Pendleton 118, 119
Meisel, Paul 775
➤ Mendola Artists 268 - 327
Meredith, Bret 832
Merewether, Patrick 1399
Meridith, Shelly 1232
Meyer, Jr., Ken 1400
Meyerowitz, Rick 180, 181
Michaels, Serge 1139
Micich, Paul 40
Milam, Larry 589
Miller, A.J. 702
Miller, Dave 491
Miller, Tom 1401
Milne, Jonathan 307
➤ Milot, Rene 330, 331
Minor, Wendell 1051
Mintz, Margery 1135
Mitsui, Glenn 1403
Molloy, Jack A. 813
Monge, Mary T. 1130
Moonlight Press Studio
1404, 1405
Moore, Chris 37
Moore, Monte Michael 1406
➤ Moores, Jeff 986, 987
Morgan Associates, Vicki
380 - 401
Morgan, Jacqui 952, 953
Morgan, Michele 821
➤ Morris, Burton 684, 685
Morrow, J.T. 1048, 1049
Morser, Bruce 182, 183
Mortensen, Cristine 1192
Mosberg, Hilary 730
Motown Animation 274, 275
Mouratov, Ilias 1407
Mozley, Peggy 1408
➤ Mueller, Kate 412
Mueller, Pete 42

Mulligan, Donald 1409
➤ Munck, Paula 130, 131
Munro Goodman 790 - 793
Murawski, Alex 184, 185
➤ Murphy, Chris 1410
Mysakov, Leonid 617

N

➤ Nacht, Merle 142, 143
Nagata, Mark 744
Najaka, Marlies Merk 186, 187
Nakamura, Joel 644, 645
➤ Napoleon Art 1505
Nascimbene, Yan 72
Nash, Scott 762
➤ Neis Group, The 903 - 907
Nelson, Bill 258, 259
Nelson, Craig 33
Nelson, Hilber 439
Nelson, Jerry 850
Nelson, John 620
Newbold, Greg 701
➤ Newborn Group, The 508 - 525
➤ Newsom, Tom 286
Newton, Richard 370, 371
Nicholason, Brant 1124
➤ Nichols, Garry 718
Nicodemus, Stephen 1411
Nigash, Chuck 1412
Niklewicz, Adam 825
Ning, Amy 909
Nishinaka, Jeff 39
Nitta, Kazushige 860, 861
Noble, Steven 1095
Noche, Mario 558
Noonan, Julia 720, 721
Nordling, Todd 596
Northeast, Christian 1144
➤ Notarile, Chris 287
Novak, Tony 897
Nowicki & Associates, Lori
818, 819

O

O'Brien, Tim 742, 743
O'Leary, Chris 69
O'Leary, Daniel 605
O'Shaughnessy, Stephanie 777
Ochagavia, Carlos 533
Olbinski, Rafal 883
Olimb Grafix 1413
Olimb, Robin 1413
Oliver, Mark 814
Olson, Erik 1098
➤ Olson, Rik 212
Osaka, Richard 1122
Osher, Glynnis 722
Osiecki, Lori 1414
Otnes, Fred 1078
Ottinger, John 1415
Owens, Jim 698

P

➤ Paciulli, Bruno 687
Paillot, Jim 1235
Palencar, John Jude 1089
Palmer, Jan 774
Parada, Roberto 1070
Paragraphics 1416, 1417
Paraskevas, Michael 60
Pardini, Patricia 1100
Pardo, Jackie 794
➤ Pariseau, Pierre-Paul 630
Parisi, Richard 386, 387
Park, Chang 833
Park, Darcie 1428
➤ Parker, Curtis 425
Parker, Edward 150, 151
Paschkis, Julie 599
Pastrana, Robert 982, 983
Patrick, John 413
Patti, Joyce 388, 389
Patton Brothers Illustration
1418
Paul, Keith J. 876
Paulsen, Larry 16
Pavlovich, Paul 1208
Payne, C.F. 260, 261
Pelavin, Daniel 1486, 1487
➤ Pelo, Jeffrey 354, 355
Pelo, Lisa 1200
Penny & Stermer Group, The
720 - 726

Pérez, Luis F. 1228
Perna, Jess M. 1419
Pesek, Marjorie E. 767
Pessemier, Blair 1328
Peters, David 1420
Peterson, Eric 1193
Peterson, Ron 675
Petrauskas, Kathy 1063
Philipps, Jerrod 962
Phillippidis, Evangelia 422
Phillips, Laura 38
Picasso, Dan 812
Pierazzi, Gary 1125
Pifko, Sigmund 206
Piloco, Richard 1421
Pincus, Harry 1423
➤ Pitts, Ted 429
Pollack, Scott 1108
Pomerantz, Lisa 789
Porfirio, Guy 576
Porter, John 98, 99
Powell & McCloskey 1424, 1425
Powell, Polly 1425
Prentice Associates Inc., Vicki
765 - 767
Probert, Jean 577
Przewodek, Camille 188, 189
Pulver Jr., Harry 1197
Punin, Nikolai 918, 919
Pyle, Chuck 76
Pyle, Liz 769
Pyner, Marcia 609

Q

Quon Design Office, Mike 1062

R

Radencich, Mike 302
Ragland, Greg 436
Randazzo, Tony 496, 497
Rangel, Fernando 1426
Rapp, Inc., Gerald & Cullen
152 - 206 Back Cover Book 1, 2
➤ Rasmussen, Wendy 1427
Red Hot Studios 1428
Reed, Dan 1429
➤ Reed, Dave 718
Reed, Mike 773
➤ Renard Represents 328 - 379
Rep Art 706 - 714
Repertory 802 - 805

➤ Artist portfolio featured on The Showcase CD number 2.

Riccio, Frank 319
Richards, Linda 312
➤ Richardson, Gary 716
Richardson, James Crague 1213
Riding, Lynne 621
Riedy, Mark 433
Rieser, Bonnie 590, 591
Rieser, William 692, 693
Rigie, Mitch 868
Riley Illustration 768 - 771
Riley, Andrew 814
➤ Riley, Frank 1430
➤ Ritchie, Scot 635
Roberts, Leslie 1093
Roberts, Peggi 35
Robinson, Bob 1106
Roda, Bot 486
Rodericks, Michael 1431
Rodriguez, Francisco 572
➤ Rodriguez, Robert 350, 351
Rogers, Adam 714
➤ Rogers, Lilla 732 - 738
Rogers, Paul 690, 691
Rohani, Michael Sours 822
Rohani, Mushka 822
Rohr, Dixon 1102
Roldan, Ismael 1432
Romeo, Richard 1433
➤ Romero, Javier Front Flap Book 2
Rosco, Delro 1145
Rosenthal Represents 662 - 672
Rosenthal, Marc 190, 191
Ross, Bill 1434
Ross, Dave 1435
➤ Ross, Mary 673
Ross, Scott 667
Rosser, Toby 1341
Rotblatt, Steven 1436
➤ Rother, Sue 220, 221
Rotunda, Matthew 602
Rowe, John 1184
➤ Rudnak, Theo 340, 341
Rüegger, Rebecca 829
➤ Ruff, Donna 1165
Rush, John 1097

S

Sabanosh, Michael 1494, 1495
Sack, Steve 1437
Saffold, Joe 944, 945
Sakahara, Dick 1156
Saksa, Cathy 1179
➤ Salerno, Steven 81

San Diego, Andy 890
Sancha, Jeremy 27
Sanders Agency, Liz 908, 909
Sanford, Steve 1438, 1439
➤ Sano, Kazuhiko 974, 975
Santalucia, Francesco 285
Sasaki, Goro 14
Sauber, Robert 972, 973
Saunders, Fred 586
Saunders, Rob 1206
Sawyer, Scott 651
Scanlan, Peter 539
Schleinkofer, David 301
Schmidt, Chuck 1501
Schmidt, Heidi 785
Schneider, Douglas 1163
Schongut, Emanuel 750
Schreer, Jason 1440
Schroder, Mark 916
Schuchman, Bob 1119
➤ Schudlich, Steve 574
➤ Schulenburg, Paul 1112
Schumaker, Ward 1227
Schuna Group, The 910, 911
Schwab, Michael 376, 377
Schwark, Mary Beth 890
Schwarz, Joanie 390, 391
Scott, Bob 1441
Scott, Elizabeth B. 1442
Scudder, Brooke 1214
Seaver, Jeff 1034, 1035
Seigel, Fran 778 - 781
Senn, Oscar 1218
Shanahan, Danny 771
Shannon · Associates 446 - 483
Shap, Sandra 836
Shaver, Mark 1169
Shaw, Ned 1207
Shay/Studio X, R. J. 1443
Sheehy, Michael 22
➤ Shelly, Jeff 1444
➤ Sherman, Oren 100, 101
Shigley, Neil 839
Shim, Jae 1445
Shimamoto, Michiko 872
Shoffner, Terry 1196
➤ Shohet, Marti 680, 681
Siboldi, Carla 561
➤ Sibthorp, Fletcher 146
Sigberman, Rich 1446
Silvers, Bill 294
Simard, Rémy 776
Simpson, Gretchen Dow 770
Sinclair, Valerie 338, 339
Singer, Phill 739

Sipp, Geo 699
Sisco, Sam 960, 961
Siu, Peter 614, 615
Slemons, Jeff 1217
➤ Sloan, William 934, 935
Slonim, David 1170
Smith, Douglas 262, 263
Smith, Elwood H. 1447
Smith, James Noel 728
Smith, Jere 437
Smith, Laura 1174
Smith, Mary Ann 1448
Smith, Rick 1065
Smith, Ryle 1283
Smith, Theresa 772
Smythe, Danny 695
Sneberger, Dan 781
Soderlind, Kirsten 396
Sofo, Frank R. 1449
Solomon, Richard 236 - 267
➤ Soltis, Linda DeVito 147
South, Randy 881
Spalenka, Greg 1153
Spector, Joel 936, 937
Speers, Pauline Cilmi 913
Speidel, Sandra 1116
Spilsbury, Simon 20
Spirin, Gennady 264, 265
Spollen, Chris 1404, 1405
➤ Springer, Sally 1450
Sprouls, Kevin 946, 947
Spurll, Barbara 1451
➤ Staake, Bob 1162
Stadler, Greg 567
➤ Stampatori, Riccardo 628
Stankiewicz, Steven 764
➤ Stanley, Anne 634
➤ Starr, Jim 1164
Steadman, Broeck 608
Steam 401
Steele, Robert Gantt 79
Steinberg, James 192, 193
Steininger, Otto 1133
Steirnagle, Michael 1033
Stentz, Nancy 227
➤ Stephens, John 102, 103
Stermer, Dugald 749
➤ Sterrett, Jane 1014, 1015
➤ Stevens, Daryl 1221
Stewart, Don 804
Stewart, J.W. 58, 59
Stirnweis, Shannon 1452
Stott, Dorothy 1453
Strauss, Matthew 1454
Strebel, Carol 1148

Stromoski, Rick 724
➤ Struthers, Doug 104, 105
Struzan, Drew 194, 195
Studio 212° 1038, 1039
➤ Studio Liddell 545
Studio Macbeth 106, 107
Studio MD 1403
Sturman, Sally Mara 797
Stutzman, Laura 985
➤ Stutzman, Mark 984
Suchit, Stu 366
Sullivan, Steve 704
Sully, Tom 1455
Surnichrast, Józef 372, 373
Summerlin, Stephanie 1456
Summers, Ethan 506, 507
Summers, Mark 266, 267
➤ Susan and Company 564 - 570
Sutton, Andrea Boff 1123
Sweet, Melissa 623
Sweny, Stephen 1457
Szpura, Beata 851

T

➤ Tachiera, Andrea 664
Taillefer, Heidi 108, 109
Takagi, Michael 709
➤ Tamura, David 700
Tanenbaum, Robert 293
Tanovitz, Ron 1458
Tarabay, Sharif 1131
Tarnowski, Glen 703
Tarrish, Laura 1459
➤ Tate, Don 1461
Taugher, Larry 110, 111
Tavonatti, Mia 1191
Taxali, Gary 862, 863
Taylor, Dahl 392, 393
➤ Teare, Brad 605
➤ Terreson, Jeffrey 311
Thelen, Mary 214, 215
Theodore, Jim 1151
Thermes, Jennifer 761
Thomas, Charles 575
Thompson, Emily 1462
Thompson, George 1463
Thompson, Stephen 579
Thompson, Thierry 326
Thomsen, Ernie 706
➤ Thornburgh, Bethann 75
Three In A Box 628 - 641
Thurston, Curt 1223
Tiani, Alex 659

index

Tibbles, Jean Paul 23
Tilbury, Gingi 1150
Tilley, Debbie 1464
Tillinghast, David 642, 643
➤ Tise, Katherine 816, 817
Todd, Susan 631
Toelke, Cathleen 992, 993
➤ Tonal Values, Inc. 912 - 919
Torline, Kevin 715
Torp, Cynthia 560
Torres, Carlos 482, 483
Toyama, Ken 807
Trang, Winston 700
Traynor, Elizabeth 676
Tucker, Ezra 752
Tull, Jeff 1129
➤ Turk, Stephen 1141
➤ Tuschman, Richard 132, 133
2H Studio Back Flap Book 1, 2

U

Uhl, David 1465
Ulrich, George 777
United Illustrators 1133
Uram, Lauren 1188
Urbanovic, Jackie 802

V

Vaccaro, Lou 698
Valenti, Lisa 1096
Valley, Gregg 1142
➤ Van Dusen, Chris 1466
➤ Vann, Bill 298
Vasconcellos, Daniel 1069
Vass, Rod 502
Vella, Ray 1167
Ventura, Andrea 196, 197
Verkaaik, Ben 528, 529
Verougstraete, Randy 776
Vibbert, Carolyn 1175
➤ Vincent, Eric 1152
Vincent, Wayne 272, 273
➤ Vitale, Stefano 70
Vitsky, Sally 112, 113
Viviano, Sam 1046, 1047
von Haeger, Arden 1077
von Kap-herr, Victoria 1467
Voss, Tom 766

W

W/C Studio 1136
Wack, Jeff 1076
Wagner, Brett 1469
Wagner, Marijke Paquay 1468
Waldman, Bruce 1470
Wall, Pam 17
Wallace, Peter 1212
Ward, John C. 1471
Ward, John T. 1177
Ward, Sam 938, 939
Ware, Richard 1071
Wariner, David 563
Warshaw Blumenthal, Inc. 1506
Watford, Wayne 580
Watkinson, Brent 36
➤ Watson, Paul 640
Watson and Spierman Productions 823
Watts, Mark 1187
Watts, Stan 500
Weaver, Michael E. 1472
Webb, Quentin 698
➤ Weber Group, The 678 - 687
Wegner, Brad 1473
Weinman, Brad 841
➤ Weinstein, Ellen 686
Weisbecker, Philippe 769
Weissenburger, Joe J. 1474
Weller, Don 661
Wenzel, David 774
Wepplo, Michael 843
West, Jeffery 1160
Westbrook, Eric 1111
Westerberg, Rob 1091
Wexler, Ed 1475
➤ Whamond, Dave 632
➤ Wheatley-Maxwell, Misty 717
Wheaton, Liz 1157
Wheeler, Rick 1476
Whelan, Patrick 1477
White, Caroline 1288
➤ Whitesides, Kim 343
➤ Wieland, Don 299
Wiemann, Roy 550, 551
Wiener, Mark 823
Wiggins, Mick 122, 123
Wilcox, David 514, 515
Wiley, David 806 - 809
Wiley, Paul 114, 115
Williams, Kurt Alan 1478
Williams, Simon 814

Williamson-Green Designs, Inc. 1061
Wilton, Nicholas 404, 405
Wiltse, Kris 394, 395
➤ Wimmer, Mike 268
Winborg, Larry 310
Wink, David 1219
Winston, Jeannie 1479
Winters, Lorne 708
Wisenbaugh, Jean 74
Witmer, Keith 809
➤ Witschonke, Alan 738
Witte, Michael 198, 199
➤ Wolf, Elizabeth 1480
Wolf, Paul 562
Wolfe Limited, Deborah 787 - 789
Woods, Paul 1040, 1041
Woolley, Janet 898
Wortsman, Wendy 712
Wray, Greg 1201
Wray, Wendy 397
Wright, Ted 582 - 584
Wunderlich, Dirk J. 672

X

Xavier, Roger 1149

Y

Yaccarino, Dan 65
Yang, Eric 1086
Yang, James 854, 855
Yankus, Marc 1058
Yemi 705
Yiannias, Vicki 657
York, Jeff 1050
Young, Amy L. 1481
Young, Eddie 503
Young, Mary O'Keefe 1482
➤ Younger, Heidi 148, 149

Z

Zacharow, Christopher 886
Zellin, Lisa 1483
➤ Zgodzinski, Rose 633
Zick, Brian 64
Ziemienski, Dennis 656, 751
Ziering, Bob 200, 201
Zingone, Robin 619
Zito, Andy 495
Zlotsky, Boris 284
Zwolak, Paul 900, 901

➤ Artist portfolio featured on The Showcase CD number 2.